ART

A History of Changing Style

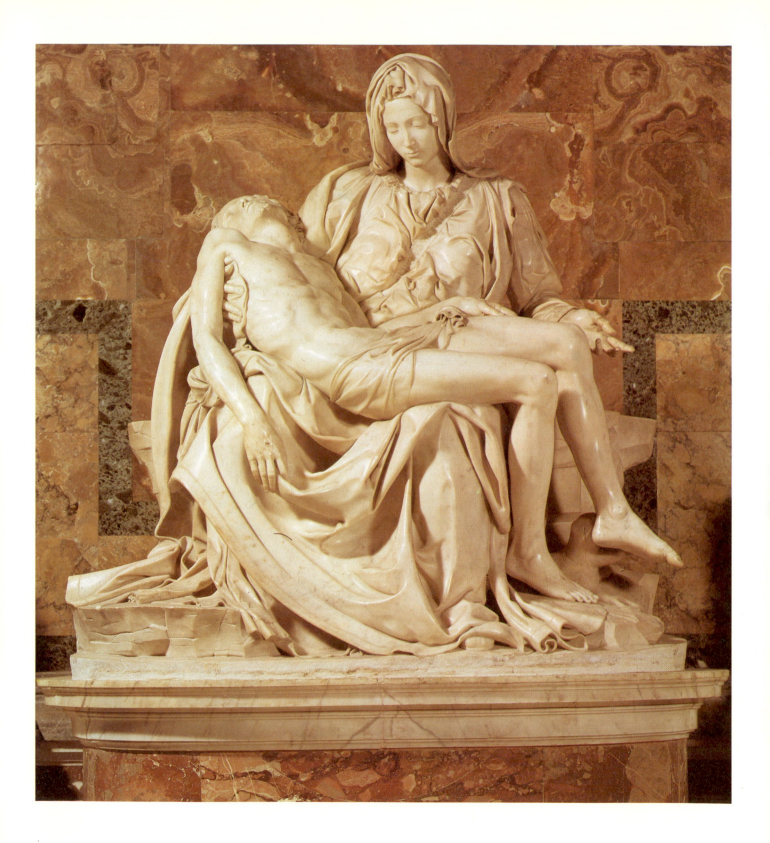

ART

A History of Changing Style

Sara Cornell

PRENTICE-HALL, INC.

ENGLEWOOD CLIFFS, NEW JERSEY 07632

Library of Congress Cataloging in Publication Data

Cornell, Sara.
 Art, a history of changing style.

 Bibliography: p.
 Includes index.
 1. Art – History. I. Title.
N5300.C724 1983 709 82–15029
ISBN 0–13–047126–7
ISBN 0–13–047118–6 (pbk.)

North American edition published by
Prentice-Hall, Inc.
Englewood Cliffs, N.J. 07632

Designed by Sarah Tyzack
Produced by Phaidon Press Limited, Oxford

Printed and bound in West Germany
by Mohndruck Graphische Betriebe GmbH

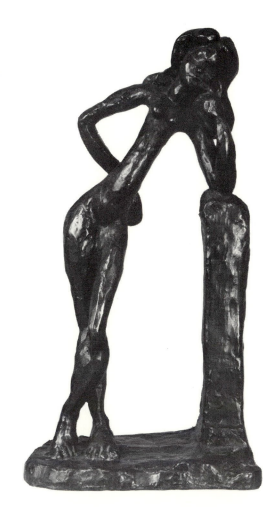

Contents

Preface 7

Introduction 8

Part 1: The Ancient World

 1. Ideas Made Visible: Greek Art and its Background 17

 2. Empire and Cross: Roman and Early Christian Art 37

Part 2: The Middle Ages

 3. The Forging of Christendom: Western Art through the
 'Dark Ages' 61

 4. Crusades and Pilgrimages: The Age of the Romanesque 84

 5. Art as Metaphor: The Gothic 102

 6. Loss of Synthesis: Late Gothic 122

Part 3: The Renaissance

 7. Man the Measure of All Things: The Early Renaissance 150

 8. Wholeness and Harmony: The High Renaissance 187

 9. Retreat from Harmony: Mannerism 219

10. Art of the Absolute: The Baroque 241

Part 4: The Romantics

11. Rational Romanticism: Rococo to Neoclassicism 278
12. Revolution and the Romantic Movement 302

Part 5: The Modern World

13. Dealing with the Contemporary World 334
14. Late Century Romantics 365
15. Being Avant-Garde: Modern Art before the First World War 380
16. Art Between the Wars 402
17. Late Modern Art 418

Bibliography 437

Sources of Quotations 441

Index 443

MAPS

1. The Ancient World 25
2. Medieval Europe 66
3. Renaissance Italy 156

CHRONOLOGICAL CHARTS

1. The Ancient World 20
2. The Dark Ages and Early Middle Ages 65
3. The Gothic Age 105
4. The Renaissance, 1400–1600 153
5. Late Renaissance: the Baroque Age, 1590–1750 245
6. The Eighteenth Century and the Romantics, 1700–1830 281
7. The Nineteenth Century, 1830–1900 337
8. The Twentieth Century 384

Preface

This book grew out of my experiences teaching art history to secondary
school students. I wanted, and could not find, a textbook that would
stimulate those unfamiliar with the subject to enjoy looking at works of art
and to appreciate their importance as a vital part of our civilization. This
led me to avoid the usual approach of treating each period as an individual
unit, and painting, sculpture, and architecture as separate developments,
and instead to describe the history of art in the Western world as a
continuous evolution of style. I have focused on the continuity between art
and architecture of different epochs and on connecting links between all
the arts at any given time. Wherever possible I have alluded to the
literary, social, and philosophical context surrounding artistic develop-
ment. In emphasizing the whole rather than its various parts, I have had to
omit many works and artists that some will feel I should have included. My
excuse is that I believe the primary aim of an introduction to art history
should be to set out in as interesting and informative a way possible an
overall framework, one into which the reader can easily fit additional
pieces gathered in the course of further study.

Besides the enthusiasm and stimulation I received from my students and
colleagues at the Brearley School in New York City, I have been given
much assistance by Molly O'Connor, Jean Hill, Janice Hodges-Dimmick,
and Claudia Yatsevitch of the Sherman Art Library at Dartmouth
College. Their unfailing courtesy and interest kept me going during the
years of research and writing.

The friendly support I have received from Phaidon Press has made the
stages of re-writing and preparing the book for press a surprisingly happy
experience. I would like to thank in particular Jean-Claude Peissel, whose
enthusiasm rekindled my own faith in the book, and Bernard Dod, who has
been as patient and skilful an editor as any writer could wish for.

Last but not least my thanks go to my husband, Dr. Louis L. Cornell,
who read and re-read the manuscript through all its permutations and
whose knowledge and advice were of enormous benefit to me.

Introduction

Two major problems face us today in looking at art from the past. The first is that most of the works we see are no longer in their original settings but are packed together in museums, so that we pass rapidly through a succession of styles and periods all out of context. The second arises even when the work is still in its original place, for example the sculpture and stained glass decorating a Gothic cathedral. We cannot easily recapture the spirit in which these works were originally created, for we have accumulated far more visual experience than artists of the past, or their audiences, possessed. At the same time, we have lost much of the familiarity with Biblical and classical stories a painter or a sculptor once took for granted; we have difficulty appreciating works that depend for their effect on the recognition of a now unfamiliar subject. We tend to like what we readily understand and dislike what has to be explained; this is one reason for the continuing popularity today of landscapes, which can easily be connected to our own experience.

To penetrate the increasingly remote works on Christian and classical subjects we have to relearn the set of fixed symbols called *iconography* (from the Greek words meaning 'image' and 'drawing') that past artists used. This requires a greater effort than the artist ever intended us to make just to understand what a work is about. Only then can we appreciate it with more than a response of the senses to colour or form.

Recognizing the subject of a work of art is only part of understanding the artist's intentions, for these are also connected to the social conditions of his time and the demands of his public. The enjoyment of any work is increased by a knowledge of its background. But there is still a further difficulty to our appreciation of works from times gone by; art presents us first of all with a visual stimulus, and we see it all, whatever its original context, through the lens of our cumulative experiences. Before the Renaissance no one expected painted space to perfectly represent real space. But once artists had mastered an illusion of three-dimensional

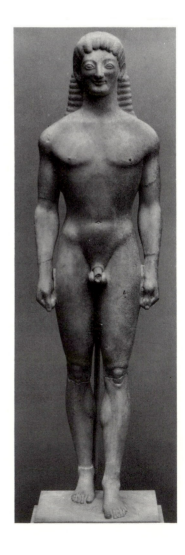

1 (*left*) Kouros from Tenea near Corinth, Greece, *c.* 575–550 BC. Marble, height 60 in (1.53m). Munich, Glyptothek. (See below, pp. 23–4)

2 (*below*) Praxiteles (?), *Hermes with the Infant Dionysus*, *c.* 330–320 BC. Marble, height 96 in (2.4 m). Olympia, Museum. (See below, p. 32)

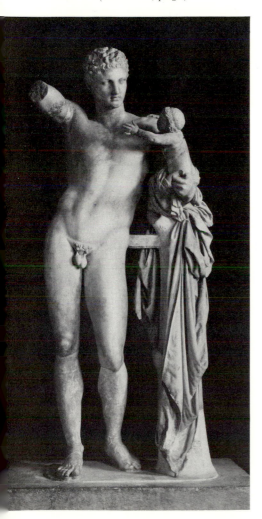

perspective, they changed the expectations of the public, so that any composition not receding back in well-defined stages to a distant horizon (fig. 3) seemed wrong. Later on, the camera challenged our perceptions again; a photograph flattens forms and brings the background in close to the surface of the picture. Manet knew this and was influenced by it (fig. 5), but his public was so conditioned to accept the Renaissance version of space and form that they could not accept his perspective as true art. Accustomed to the far greater shocks of twentieth-century painting, we easily accept Manet's illusionism, yet have a hard time viewing medieval art as it was originally seen, by eyes that had never known Renaissance perspective.

If we are to avoid the pitfalls of judging all art by our own experience and our own subjective views, we have to learn the background against which a work was created; what the historical and social conditions were under which the artist lived and worked, who his patrons were and what their influence was on taste and style, and what philosophical views affected the artist's (and everyone else's) way of seeing the world. At the same time, we need to know the artist's practical experience, his training, his views on art, and the techniques and materials available to him before we can fully appreciate his style or his choice of subject.

Western art history does not fall into separate chapters conveniently divided by political events. There is a continuous development of style modified by the experience of artists and the expectations of their public. A painter or a sculptor is necessarily a man of his times, influenced by the political and social framework of his age. At the same time, he is influenced by styles and conventions of art surrounding him. What critics have sometimes seen as visible proof of the emotional effects of historical events may in fact be more the result of an artist's conscious modification of an earlier style. When Michelangelo worked on the sculpture for the tombs of two Medici dukes, shortly after the Reformation, it was a time when faith in the Catholic Church and in Renaissance humanism had been shaken. The religious and political upheavals of the period do seem to be reflected in the tense pose and fearful expression of the personification of Day (fig. 7).

But Michelangelo was an artist of genius who lived a long life and was never satisfied with what he had already accomplished. No sooner had he achieved the smooth grace of his early *Pietà* (fig. 236) than he abandoned it; all his life he kept setting himself new problems of form and balance. The knotted, contorted posture and bulging muscles of *Day* can be attributed as much to the artist's attempting new difficulties in composition as to his reactions to civil and religious strife. This dialectical progression in which artists seek a solution to a problem, find it, and then force that solution to the breaking point is mirrored in the history of Western art. Figures 1, 2 and 6 illustrate the three phases of Greek sculpture, in which the problem of rendering the human body was first tackled experimentally

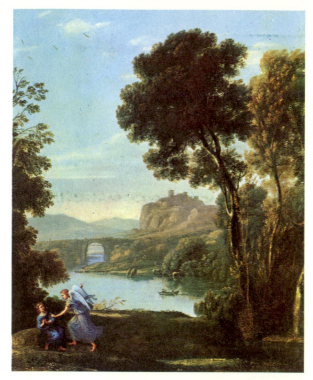

3 Claude Lorrain, *Landscape with Hagar and the Angel*, 1646. Oil on board, 20½ × 17½ in (52 × 44 cm). London, National Gallery

4 Thomas Cole, *Expulsion from the Garden of Eden*, c. 1827–8. Oil on canvas, 39 × 54 in (99 × 137.2 cm). Boston, Museum of Fine Arts, M. and M. Karolik Collection

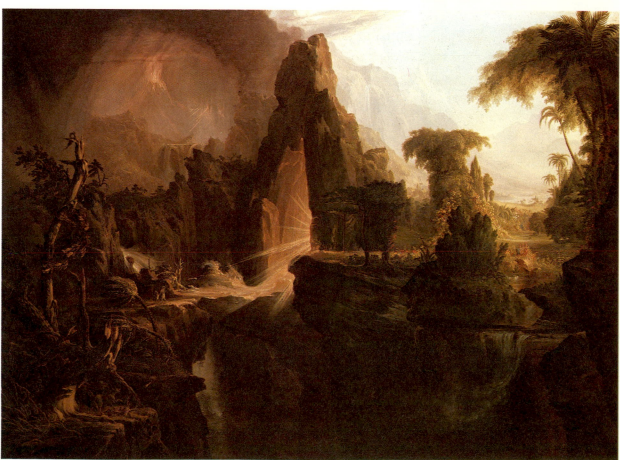

in the Archaic period (fig. 1), then mastered in the Classical period by sculptors like Praxiteles (fig. 2), and finally, in the Hellenistic period, pushed to extremes of dynamic complexity by artists no longer content with the harmony and balance of the Classical stage (fig. 6). The development of style is always influenced by artists' awareness of past solutions; the contortions of Michelangelo's Medici tomb figures owe much to the *Laocoön*, which had been rediscovered twenty years before.

In understanding the history of style in Western art, we have to strike a balance between the one extreme of interpreting all art as the result of social and political developments, as if artists existed only to document their times, and the other extreme of seeing only a shift in styles, as though artists lived in an ivory tower, unaware of contemporary events and independent of the changing tastes of the patrons and public on whom they depended for their support. Within every period, the development of style is affected by artists' responses to the particular synthesis of philosophy, the social and economic climate, and the modes of expression of their age. For example, Praxiteles' statue of Hermes with the infant Dionysus (fig. 2) evokes everything the word *Classical* has come to mean to us. It marks the high point of naturalistic style reached in Greek art. Hermes is a solid, flesh and blood figure, correctly proportioned and representing the highest ideal of male beauty. He stands in the favourite Classical posture, called *contrapposto* because it sets two forces of balance against each other; his torso is twisted so that his body follows a vertical line from the head to the pelvis and down to the leg that supports him. He leans on a half column with one arm around the infant Dionysus; the two figures and the column form a triangle. The naturalism is not exact realism. Imperfections that exist in every normal human body are smoothed over to produce an idealized version of a man who seems, more than is, real. And in this, the statue is Classical in more than just its style. The sculptor's intentions are made clear by the way in which he has closed the composition so that no line leads outside the triangle; the two gods look at each other, unaware of our existence, for we remain outside the space they inhabit. Although restrained, the work is not without feeling; it expresses the ancient Greeks' belief in a universe where man was central and the gods perceived as perfectly beautiful human beings.

Compare the Hermes and Dionysus to Thomas Cole's painting *Expulsion from the Garden of Eden* (fig. 4), from the Romantic period in the early nineteenth century, a work in which the emotional content is heightened and expressed by the forces, rather than by the forms, of nature. The two human actors in this drama, far from being substantial or important to the composition, are barely visible. Everywhere the terrifying power of nature dominates, from the blast of light within the craggy gate of Eden to the dark, withered forms in the foreground. The relationship between man and God has been shifted here from the strong humanity of Praxiteles' gods to the portrayal of divine power through the forces of nature. In the

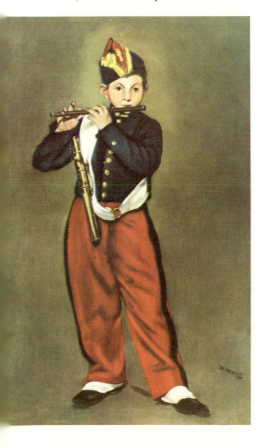

5 Édouard Manet, *The Fifer*, 1866. Oil on canvas, 63 × 38¼ in (160 × 97 cm). Paris, Musée de l'Impressionisme

Greek statue space is enclosed within the triangular composition; in Cole's painting it spills forward out of the frame, while the background melts into an infinite distance. If the Classical Greek artists emphasized form over feeling, Cole certainly did the opposite; his forms, although recognizable, are distorted and dramatized by eerie light and dark shadows that heighten the sense of fear and loss.

Thus the composition of a work — the way in which figures fill up space and define its limits — is connected to an artist's attitude towards God, nature, and man's place in the universe. The choice of a particular style, in so far as it is consciously chosen, is determined by the effect the artist wishes to make on the spectator. The order and harmony expressed in Praxiteles' Classical statue and the mystery and supernatural force of Cole's Romantic painting are two poles between which lie countless combinations of form and feeling.

The history of Western art as it passes through various pendulum swings between emphasis on form and emphasis on feeling and imagination is the history of a continuous tradition modified by the unique circumstances of each period. This tradition takes us back to ancient Greece. Greek civilization developed from about 1200 to 800 BC into a culture radically different from any other in the whole ancient world. The break the Greeks made with the political, social, and religious framework of the kingdoms of the Near East created a cultural divide that separates us from the rest of the world. Our whole way of looking at the world — our sense of history and of the importance of human events, our art, literature, science, philosophy, and political thought — is inherited from the Greeks and differs from the cultural experience of the non-Western world.

The Classical tradition as it emerged in Greece came to dominate the whole Mediterranean world through the mediation of the Romans, who in absorbing Greek territories into their own realm assimilated also the whole of Greek culture. Roman character and the changing conditions within the Empire bent the shape of Greek art to suit different needs without altering its fundamental intentions. After the destruction of the Western Empire, the emergent barbarian kingdoms evolved into the Christian states of early medieval Europe; in this atmosphere, the Classical tradition survived but was transformed. The Romanesque style of the eleventh and twelfth centuries is so called because it derived from surviving examples of Roman Classical art and architecture, yet its appearance is very un-classical, so changed were the original forms by medieval people's desire to express the deep piety of their faith. A reassertion of Classical naturalism emerges in Gothic art in the thirteenth century, reflecting a recovering economy at a point at which men and women could again take pleasure in the natural world. In the late Middle Ages the influence of the Church declined, while new conditions brought new experiences and expectations; art became increasingly secular and centred on explorations in technique and style. The Renaissance of the fifteenth and sixteenth centuries was a

true and far-reaching rebirth of Classical art, closely tied to a simultaneous revival of Classical philosophy and letters. The remarkable achievements of Renaissance art have affected us ever since; until the twentieth century, artists and public alike were all too ready to believe that no one could ever again achieve the excellence of Michelangelo or Raphael. This assumption created a sharp separation in the late eighteenth and early nineteenth centuries between form and imagination, between Neoclassical defence of classical clarity and Romantic espousal of imagination and feeling. The struggle to escape the confining attitude of critics and a public too wedded to a classical style to appreciate the realism of Manet or the Impressionists lies behind the fact that the era of Modern art has seen a conscious and determined effort to overthrow the domination of the Classical tradition altogether.

Yet the forms of Classical art refuse to die out and persistently show signs of reviving; our experience and our expectations are still rooted in the achievements of Classical Greece. It is with the history of Greek art that our story begins, and with the relationship between the emerging Greek peoples and the ancient kingdoms of Egypt and Mesopotamia which contributed much to the evolution of Greek art, and yet whose art seems so much less accessible to us.

6 (*below*) *Laocoön and his Sons*, Roman copy of a Greek original of the late 2nd century BC, by Athanadorus, Hagesandrus, and Polydorus of Rhodes. Marble, 7 ft (2.1 m). Rome, Vatican Museum
This sculpture was discovered in Rome in 1506 by workmen digging the foundations for a new building.

7 (*right*) Michelangelo, *Day*, detail from tomb of Giuliano de' Medici, 1524–34. Marble, width 73 in (185 cm). Florence, church of San Lorenzo, New Sacristy

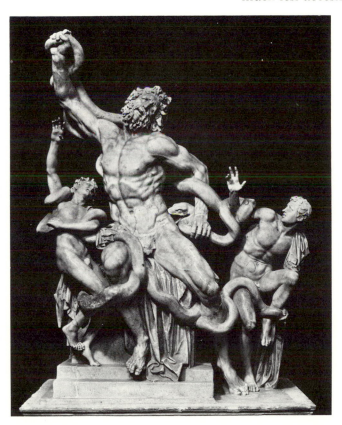

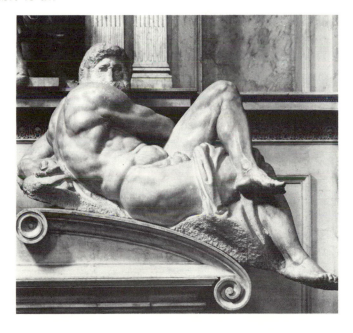

8 Detail of ceiling mosaics from the ambulatory of the church of Santa Costanza, Rome, 325–30 AD. (See below, figs. 51, 52)

PART 1 The Ancient World

PART 1: THE ANCIENT WORLD

INTRODUCTION

Apparently from earliest times mankind has felt a supernatural relation-
ship to exist between objects in the visible world and images created in
their likeness. Stone Age tribes carved or painted images to ensure fertility,
to heal the sick, or to injure an enemy; the remarkably life-like Palaeolithic
cave paintings of the animals upon which these hunters depended (fig. 9)
were apparently intended to promote the health and abundance of the
herds. This primitive association between an image and the spirit world
was developed in the early civilizations of Egypt and Mesopotamia, and in
these ancient kingdoms art evolved into a sophisticated programme de-
signed to articulate the power of gods and kings. When the ancient Greeks
evolved the distinctive Classical style that has left its mark on the whole
history of Western art, their starting-point was the art and architecture of
these more ancient civilizations of the Near East.

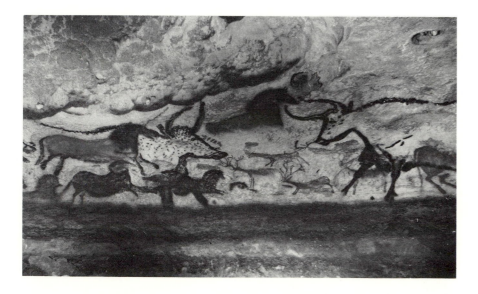

9 Procession of animals, cave paintings
from the cave at Lascaux in south-
west France, *c.* 15,000 BC.

CHAPTER 1

Ideas Made Visible: Greek Art and its Background

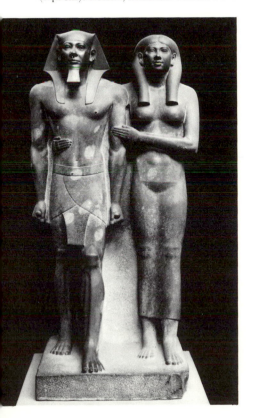

10 Mycerinus and Queen Khamerernebty, from the tomb of Mycerinus, Giza, Egypt, 4th Dynasty, after 2270 BC. Schist, height 56 in (142 cm). Boston, Museum of Fine Arts

Art of the Ancient Near East

Egypt was united under one central government just after 3000 BC by the first of a long succession of pharaohs who exercised control through a tightly organized bureaucracy of officials. The state was a theocracy, drawing no distinction between religious and secular matters. The pharaoh, regarded as semi-divine, dominated all facets of his people's lives. Most of the art that has survived from ancient Egypt is from the tombs of the great and owes its form to the belief that in afterlife the spirit could find pleasure wandering unseen among the living. The tombs of the pharaohs and their most important officials were elaborately decorated and were filled with beautiful artifacts intended to create a gateway through which the souls of the dead could enter the living world. It was thought that a statue of a dead king could provide a permanent home for his soul; it was often accompanied by one of his wife (fig. 10) to ensure him her companionship. The statue was placed so that the soul of the deceased could gaze on carved and painted scenes of activity representing the living world (fig. 14). Statues like this one of the pharaoh Mycerinus (2288–2270 BC) and his queen were originally painted with life-like detail in bright colours, which added a human realism as well as enhancing the magnificence these decorated burial chambers conveyed upon their occupants.

Circumscribed by its close ties to religious ritual, Egyptian art from the beginning depended more on ideas than on natural appearance. If the carved or painted image was to be the equivalent of a living being, no part could be left out; thus, although three-dimensional statues like figure 10 express a real sense of human warmth despite the formality of the pose, in pictures drawn or carved on a flat surface we find that the schematic mannerisms of early attempts to capture three-dimensional bodies on a two-dimensional surface were passed down from generation to generation

essentially unchanged. In both figure 12, dating from *c*.2650 BC, and in figure 14, over 1,200 years later in date, the human body is depicted with its face and legs in profile, but with the shoulders and chest as viewed from the front. Only one eye is shown, as in a correct profile view, but it is painted frontally.

Figures in Egyptian art were composed hierarchically; size and placement depend on importance, not on natural perspective. In figure 14 the landscape is not painted from one particular point of view; the river is drawn vertically on the wall as if we were looking down on its surface, while the fish, birds, reeds, boats, and figures hunting among the reeds are all depicted in profile, as seen from the viewer's actual stance in front of the picture. This unrealistic treatment of picture space does not mean that artists lacked interest in the world around them; indeed, the birds and plants are drawn with such accurate detail that we can identify the individual species. But a naturalistic depiction of forms as we actually see them was not important in this symbolistic style.

Even in such scenes of ordinary life, Egyptian artists avoided any sense of a particular moment. Rather, they created an ideal of eternity. There is never any sense of dramatic narrative, even when figures are clearly acting together. In the ancient kingdoms of Mesopotamia — the Sumerians, Akkadians, Babylonians, and Assyrians — art developed, as in Egypt, under the patronage of royal courts. These rulers, however, seem to have been more intent upon advancing their own reputations and less concerned with visual images of the hereafter. From ancient times, art in the Near East was employed to celebrate actual history in compositions emphasizing group action. Figure 11 was carved only about four centuries later than the wooden panel from Saqqara; it shows the same schematic combination of profile and frontal view in the treatment of individual figures. But it is a far more lively scene set in a landscape that is more naturalistically composed than that of the much later Egyptian painting from the tomb of Menna. Carved on a stone slab over six feet high, this scene dramatizes a victory won by the Akkadian king Narim-Sin (2291–2255 BC). It takes place in a mountain pass; the king, at the head of his army, has reached the pass, while his soldiers toil up the steep and winding path through a wood (indicated by two very life-like trees). Realism and symbolism work together in this composition; the king, at the head of his army, is also the highest figure in the scene and is portrayed as larger than the rest to show his rank. He has already vanquished his foes; one falls, wounded, while others tumble off the mountain's steep slope, and still others beg for mercy. This lively style of narrative art, emphasizing action of a specific time and place, was passed down from the successive Mesopotamian kingdoms to the West along with the timeless and idealizing style of Egypt.

Architecture in the ancient kingdoms, whether for the living or the dead, aimed at creating overwhelming impressions of kingly power. The

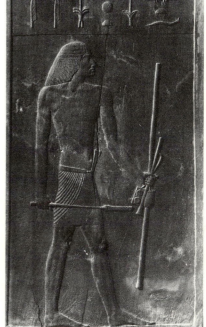

11

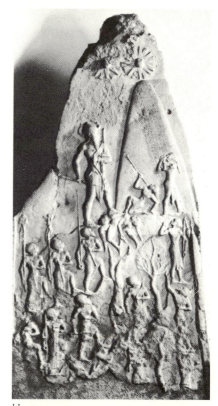

12

11 Victory Stele of King Naram-Sin, found in Susa, *c.* 2250 BC. Height over 72 in (183 cm). Paris, Louvre

12 Portrait of Hesy-ra, from Saqqara, *c.* 2650 BC. Wooden panel, height 45 in (112.5 cm). Cairo, National Museum

13 Terracotta vase with polychrome decoration, *c.* 1600–1500 BC. Length 20 in (49 cm). Athens, National Museum

14 Hunting in a papyrus thicket, wall painting from the tomb of Menna, Thebes, Egypt, *c.* 1425–1417 BC. Cairo, National Museum

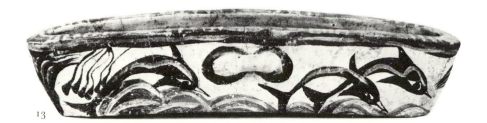

13

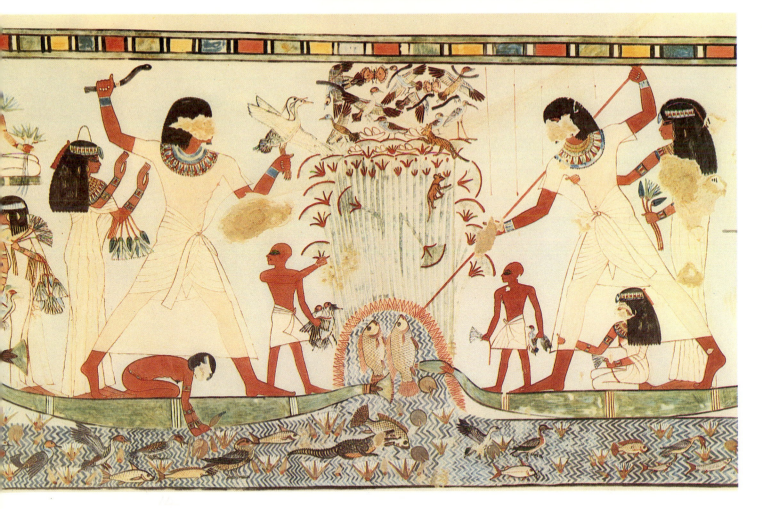

CHART 1 THE ANCIENT WORLD

EVENTS	BC		ART AND CULTURE
	BC		
15000 Palaeolithic period	15000		15000 Cave art in France and Spain
3200 Sumerian civilization emerges in Mesopotamia			
3100 First Egyptian dynasty	3000		
			2600 Great Pyramids of Egypt
c. 2350-550 Succession of kingdoms in Mesopotamia: Akkadians, Babylonians, Assyrians			
	2000		2000 Victory stele of Naram-Sin
c. 2000-1500 Flourishing Minoan civilization in Crete			c. 2000-1500 Minoan pottery and frescos
c. 1480 Destruction of Knossos			
c. 1450-1250 Mycenae at the height of its power			
c. 1250 Possible date of Trojan War and sack of Troy			
c. 1100 Destruction of Mycenae; beginning of 'dark age'	1000		
c. 800 Emergence of city-states of Classical Greece			
776 Founding of Olympic Games	750		c. 750 Kouroi — archaic nude male statues
489-478 Persian invasion defeated by Greeks	500		c. 520 Temple of Athena at Paestum
478-430 Period of Athenian supremacy			456 Death of Aeschylus
			447-432 Building of the Parthenon
430-403 Peloponnesian War between Athens and Sparta: Athens defeated	400		
			360-340 Praxiteles flourished
			347 Death of Plato
359-336 Rule of Philip of Macedon			
336-322 Rule of Alexander the Great			322 Death of Aristotle
After 322 Alexander's empire divided into three parts: Macedonia, Syria, and Greece	300		
	200		
197 Macedonia becomes Roman province			197-159 Altar of Zeus at Pergamum
146 Rome defeats Carthage and becomes dominant power in Mediterranean	100		
31 Octavian defeats Antony and Cleopatra at Actium			
27 Octavian (Augustus) becomes first Roman emperor			
	AD		
			7 Ara Pacis commissioned
79 AD Eruption of Vesuvius			c. 80 AD Colosseum completed
98-117 Rule of Trajan	100		107-13 Trajan's Column erected
117-38 Rule of Hadrian			118 Pantheon begun
161-80 Marcus Aurelius emperor in the West, beginning the partition of the Roman Empire			c. 176 Column of Marcus Aurelius erected
193-211 Rule of Septimius Severus	200		203-4 Arch of Septimius Severus
			270 Death of Plotinus
306-37 Rule of Constantine	300		312-15 Arch of Constantine
313 Christianity becomes legal			
324 Founding of Constantinople			325-50 Santa Costanza
			c. 333 Old St Peter's
			c. 359 Tomb of Junius Bassus
380 Theodosius makes Christianity State religion			c. 382-405 St Jerome translates Bible into Latin
402 Honorius makes Ravenna his capital	400		
410 Rome sacked by Alaric the Visigoth			
			c. 420 Santa Maria Maggiore
			c. 425 Mausoleum of Galla Placidia
			430 Death of Saint Augustine
452 Pope Leo I confronts Attila the Hun outside Rome			
475-6 Romulus Augustulus: last Roman Emperor in the West			
493-527 Theoderic, king of the Ostrogoths, rules Western Empire			493 Sant'Apollinare Nuovo, Ravenna
527-65 Rule of Justinian	500		537 Santa Sophia, Constantinople, completed

Center vertical labels: ARCHAIC · CLASSICAL · HELLENISTIC

great pyramids rise from the desert like man-made mountains to impress the viewer from a considerable distance. The once-mighty cities and palaces, whose ruins are still being excavated, must once similarly have awed those who saw them by their sheer size and wealth of detail and by the stark contrast between a king's palace and the rude shelters housing the poorer people. The palace art and architecture of the ancient kingdoms was intended to emphasize a hierarchical ordering of society from the ruler down to his subjects.

The Origins of Greek Art

An appreciation of beauty for its own sake was not important to the symbolistic and programmatic art of Egypt and Mesopotamia. This concept was born in Greece; the Greeks were the first to formulate an ideal of beauty in art as a system of aesthetics. But the idea that art had only to be beautiful already existed in the Aegean well before 'Greece' proper existed, in the kingdoms of the Minoans and the Mycenaeans.

In c. 2800 BC, when the first kingdoms were emerging in Egypt and Mesopotamia, the Greek mainland and its islands were invaded and settled by non-Greek tribes from Asia Minor. On Crete, the biggest of the islands, a civilization evolved to rival the wealth and sophistication of Egypt or Babylonia. This has been named Minoan after the legendary king Minos; the enormous and labyrinthine palace at Knossos can well be imagined as the setting for the slaying of the fabulous Minotaur by the Athenian hero Theseus. By c.2000 BC the Minoans had become wealthy from trade with the Near East. Remains of frescoes that once decorated the palaces, metalwork, and painted pottery decorated with highly naturalistic details of native flora and fauna (fig. 13) provide us with a picture of a society that loved beautiful objects and found a purely secular pleasure in art. Minoan culture dominated the Aegean islands until c. 1480, when it suddenly collapsed in the wake of violent natural cataclysms followed by invasions from the mainland.

The Minoans seem to have been protected by their island geography, for from the first migrations in c. 2800 BC to the destructions of c. 1480 they developed unhindered by outside aggression. The mainland, however, was occupied in c. 2000 by the first true Greeks to settle the area. These were a warlike people whose later exploits in c. 1300–1200 formed the substance of Homer's epics and whose epoch was regarded by later Greeks as a Heroic Age. This civilization has been labelled Mycenaean after the city of Mycenae, from which site King Agamemnon is supposed to have set out for Troy. By c. 1450 the Mycenaeans had become the dominant power in the Aegean, in the process adopting much of the art and culture of the Minoans whom they replaced. The Mycenaean civilization came to an abrupt end in c. 1100, destroyed by southward migrations of other Greeks,

the Dorian tribe. Protected by its high hill, the Acropolis, the Mycenaean town of Athens fended off the Dorians, but Mycenaean culture disintegrated completely and the Aegean world entered a period as dark as the early Middle Ages in Europe following the destruction of Rome.

The phoenix that rose from the ashes of Mycenae was Classical Greece; in comparison with medieval Europe the new Greek civilization matured remarkably quickly. By *c.* 800 the Greek peoples were established on the mainland, the islands, and the coast of Asia Minor. They were trading profitably with the Near East and were sufficiently organized to explore the western Mediterranean, establishing colonies on the coasts of southern Italy, Sicily, Spain, and France. By the middle of the eighth century BC, a culture emerged that was influenced by but distinct from that of the Near East and from that of its Minoan and Mycenaean predecessors. These early Greeks had developed a form of monumental art in the large pottery vases they used to mark the graves of their dead. These eighth-century vases, whose size and function bring them closer in concept to sculpture than to ordinary pottery, were painted in abstract and geometrical patterns with no reference to the illusionistic naturalism of Minoan and Mycenaean art. In figure 15 even the figures of the mourners carrying the bier of the deceased are drawn in flat geometrical shapes. The Geometric style gives no indication of the human emphasis we associate with Classical Greece, but it does indicate the mathematical regularity underlying the variety and naturalism of the Classical period.

From the eighth century BC, the Hellenic world (the Greeks called their country Hellas, and themselves Hellenes) developed rapidly, simultaneously absorbing influences from the East and passing their own achievements on to the more primitive Etruscans and early Romans in Italy. Traders and borrowers, the early Greeks demonstrate that the lack of an inherited culture may be an advantage. They adopted the alphabet invented by the Phoenicians, replacing the earlier picture and sign writing with a much more flexible phonetic script. This encouraged the spread of literacy. Even in this early period of aristocratic rule, we have a sense of the importance of literacy which was such factor in the later emergence of democracy, a concept of government inconceivable to the hierarchical kingdoms of the Near East. The rugged and mountainous geography of Greece undoubtedly contributed to the development of an independent spirit by making centralized government difficult, but self-reliance seems to have been part of the Greek character from the start.

The Archaic Period

In the seventh century BC the forms of the natural world began to infiltrate the geometrical designs in pottery painting and sculpture. The Greeks borrowed much from Mesopotamia, Phoenicia, and Egypt, but they never

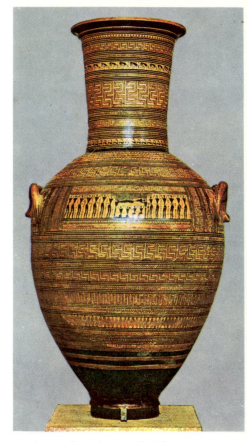

15 An amphora (storage jar) from a grave in Athens. Geometric style, *c.* 750 BC. Height 5 ft (1.5 m). Athens, National Museum

copied directly, for they were experimenters from the first. In the end they succeeded in liberating the image from its context of a symbol to give art a new and purely aesthetic value based on visual perceptions. When Greek art was put into the service of religion in representations of the gods or of figures commemorating the dead, it was without the association of supernatural power in an image characteristic of Egyptian art. Rather, the early Greeks sought to stir the soul by the appeal of outward beauty.

The early Greek artists learned figure carving from contacts with Egypt and Phoenicia. From the middle of the seventh century BC they experimented with life-sized figures closely related to Egyptian tomb sculpture. But the Greek statues were never meant as portraits of individuals but rather as a generalized ideal. Figures carved to mark graves are indistinguishable from those made for religious shrines. Archaic sculptors developed two specific types: a young man (*kouros*) and a young girl (*kore*). The kouros was generally nude, the kore clothed; female nudity in art did

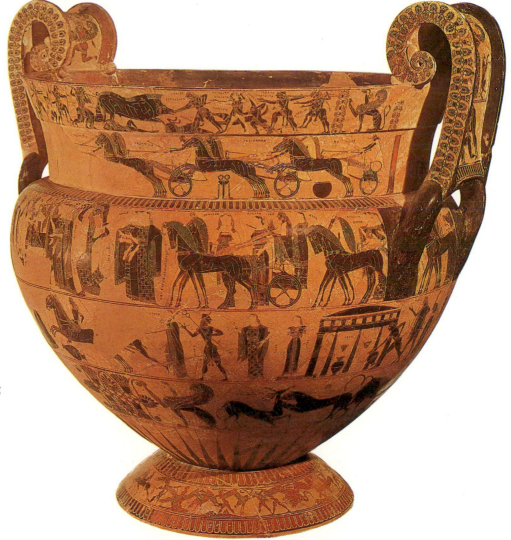

16 The François Vase, a krater (mixing bowl) made by the potter Ergotimos and painted by Kleitias.
Height 26 in (66 cm).
Florence, Archaeological Museum
This is an example of the Black Figure style, with the figures in black on a red background.

not become customary until well into the Classical period. From early in the Archaic period nudity in a male figure was associated with divine perfection and used to indicate heroism. The result of this dual treatment of nude male and clothed female was to lead artists in two different directions: on the one hand, focusing on the basic human form through correct anatomy, and on the other, concentrating on a variety of effects on the surface through manipulating folds of drapery (see fig. 27).

The pose of the kouros (see fig. 1) owes an obvious debt to Egyptian precedents. The timeless character of Egyptian works such as figure 10 appealed to Greek artists, but there is a fundamental difference in the way the two cultures thought of a figure in relation to the space that surrounds it. Egyptian statues, however human, always stress the symbolic over the actual; in figure 10 the spaces between parts of the body were left filled in in rough stone, drawing a visual but not a physical distinction between the body and the space around it. The kouros in figure 1 was created as a free-standing figure meant to be seen from all viewpoints, although front, back, and sides are somewhat awkwardly related to one another. His arms are connected to the torso only at the hips; the artist carved away the stone in between arm and body to articulate the difference between flesh and air.

For all its freshness, this kouros is a static figure and still resembles the block of stone from which it was cut more than it does a moving body. In Archaic Greek art motion was rendered naturally first by painters, who developed a highly pictorial art in decorating the various pots and urns that were an important part of both ceremonial and daily life. A vase such as figure 16 was clearly intended for a wealthy customer (it was found in Italy, apparently imported by an Etruscan nobleman), but the sheer volume of pottery that has been found from the Archaic period suggests that beautiful artifacts were part of the lives of ordinary people as well.

Vessels such as figure 16 were made in workshops of highly skilled artisans who were well thought of and known by name; this krater was signed by both its potter, Ergotimos, and its painter, Kleitias. Each pot was shaped according to its use — wide-mouthed bowls for drinking, narrow-necked vases for storing, or rounded jugs with handles (like this one) for carrying and mixing liquids. When figures in scenes of action were added to the rigid patterns of Geometric decoration, the painters adhered to the logic of the earlier style by composing the scenes to fit into the shape of a particular vase. Until the fifth century the figures were drawn on a light ground and filled in with black; lines were incised to indicate the contours of the body or folds of garments, while other details were emphasized by patches of purple or white paint.

The impulse to depict scenes of human activity was the same that led the Greeks — alone of all the ancient peoples — to transform their myths from stories of supernatural beings acting against natural laws into dramatic narratives in which the gods behave like people. As we saw in figure 11, the Near East had produced examples of narrative art, but no one before the

Greeks put so much value on human action; from this came a narrative art totally free of hierarchic symbolism. Its subjects were the myths and legends that from the time of Homer became as a bible to the Greeks; figure 16 illustrates episodes from the life of Achilles, hero of the *Iliad*. The *Iliad* and the *Odyssey*, Homer's two great epics, provided many of the subjects for vase painting; these subjects were used by later Classical painters and became part of the classical tradition in Western art because they provided the aesthetic appeal of a dramatic composition combined with the value of human heroism and moral action.

This flexibility of pictorial composition within the rigid framework of the vase is related to Greek architecture as it evolved in the same period. Architecture advanced rapidly in the Archaic period; more revolutionary than the vase paintings or the kouroi was the emergence of the temple form dependent on the use of the column. Columns spaced regularly apart can carry a load as efficiently as a solid wall; the alternation between mass

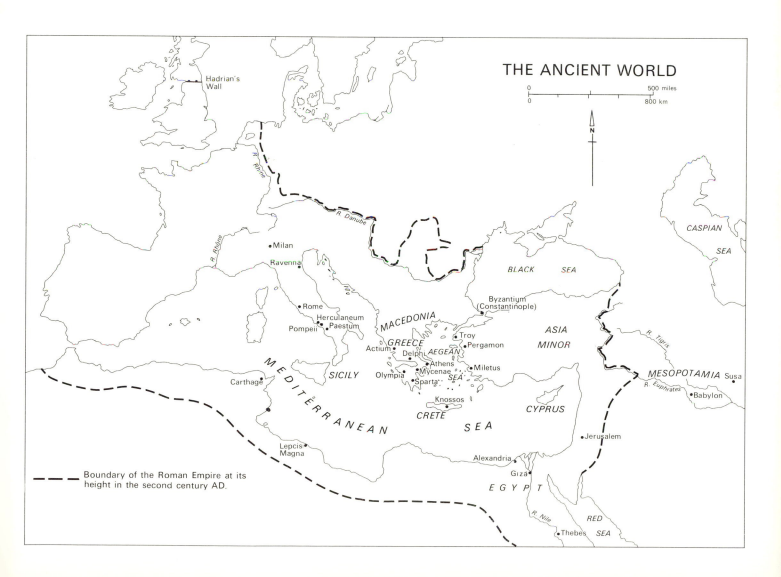

THE ANCIENT WORLD

Boundary of the Roman Empire at its height in the second century AD.

and space in a row of columns (colonnade) gives a rhythmic and sculptural effect in contrast to a blank wall. Columns had been used in this way to lighten the massive effect of solid masonry in Egypt and in Crete, but never as the central component of a style of architecture. The Greeks were not primarily concerned with vast size in building; their architecture remained in a sense technologically primitive, with the limitations of wooden post and lintel construction. Perhaps because of its structural simplicity, it developed rapidly; the basic Greek temple as we know it emerged by the end of the seventh century BC. It consists of a windowless room called a *cella*, in which a cult image and votive offerings could be protected from the weather and from theft, a porch flanking its entrance, and a colonnade surrounding all four sides and supporting a ridged roof (fig. 19). An altar where sacrifices were performed stood outside the temple in front of its entrance.

This deceptively simple formula involved a tight integration of structural and decorative elements organized into repeated units. The unit was the order, a name given to the column (with its head, or capital), together with the section of roof it supports (fig. 17). The weight of the lintel is shifted to the vertical support of the column through the cushioning effect of the capital. The Archaic Greeks developed the two orders shown in figure 17: the Doric, the most pervasive on the mainland, and the Ionic, which evolved in Ionia, in Greek Asia Minor. They differ only in their decorative elements, the Ionic being the more elaborate. Devised to relieve the blankness of the marble surface, these decorative elements are not structural in the sense of being necessary for support, but they are architectural, being built into the design. Originally the details were painted in bright colours, which would have strengthened their effect considerably.

To break the monotony of the long horizontal courses, the Greeks developed different patterns of decorative mouldings drawn from plant foliage, each one adapted to a different part of the building (fig. 18). It was the running frieze of the Ionic order that provided Archaic sculptors with a ground for compositions of dramatic scenes much like those on the painted vases (fig. 20).

Once established by the Archaic builders, the decorative details distinguishing the orders became standard; in the Classical period architects added the Corinthian order (see figure 32), essentially Ionic except for its capital ornamented with acanthus leaves. Thus every Doric temple is instantly recognizable as Doric. In more recent times, Western architects became obsessed with a 'correct' handling of the orders. The temple at Paestum (Poseidonia) looks familiar because it has been reproduced throughout Europe and America, here as a bank, there as a library or a museum. But it was only the Greeks themselves who achieved a sense of variety and freshness within such rigid formulas.

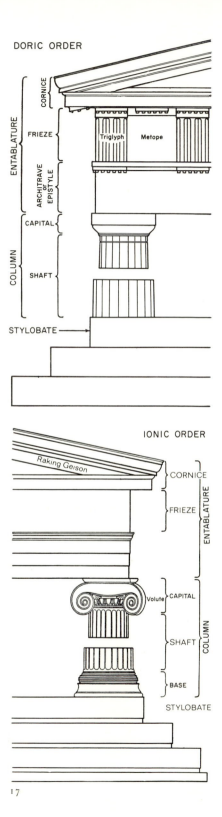

17

17 The Doric and Ionic orders. After Grinnell

18 Moulding patterns from an Archaic treasury at Delphi, late 6th century BC. Delphi Museum
Delphi was the most famous shrine of Greece, and the various city-states built 'treasuries' there to house votive offerings.

19 Temple of Athena, Paestum, Italy, *c.* 520 BC.

20 Battle of gods and giants. Marble frieze from the Siphnian Treasury at Delphi, *c.* 530 BC. Delphi Museum

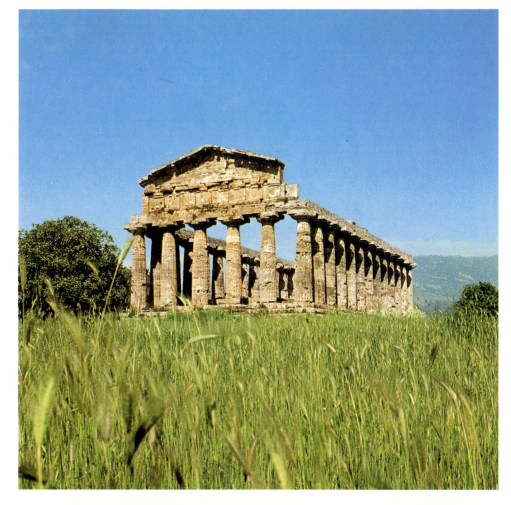

18

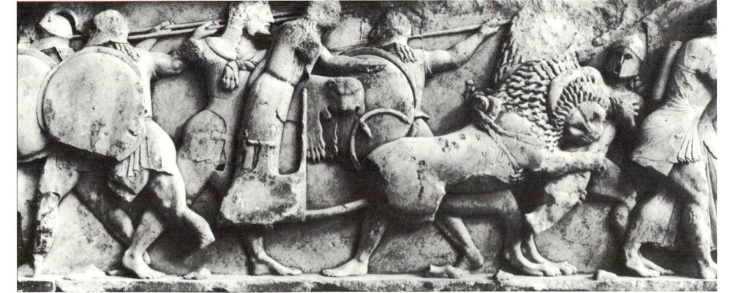

The Classical Period

The Classical period of Greek art runs from the Persian Wars (499–478 BC), when the various Greek city-states were able to act together to defeat the threat of foreign invasion, through the Peloponnesian War (431–404) that ended this cohesion, down to the death of Alexander the Great, the Macedonian king who established an empire and spread Greek culture among the peoples he conquered. The fifth century was dominated by the city of Athens; this was the brilliant epoch of Athenian drama and poetry, philosophy, and politics. Political dates are paralleled by cultural ones: Aeschylus, the first of the great Classical dramatists, fought in the Persian Wars; Socrates and Plato lived through the Peloponnesian War; Aristotle, the last of the great Classical philosophers, died in 322, a year after Alexander.

Archaic artists had made great strides in two directions: in the natural-ness of action in narrative painting and relief carving, and in the idealizing emphasis on human dignity in free-standing sculpture. Even by the time of the Persian Wars, these two strains came together in life-size statues that combine the dignified reserve of the kouros with natural movement of human anatomy. Figure 21, called the Kritios Boy because it has been attributed to the Athenian sculptor Kritios, stands still in the manner of a kouros, but where the Archaic figures stand with one foot advancing stiffly in front of the other, this youth relaxes into a natural stance approaching the contrapposto of Praxiteles' Hermes (fig. 2).

Throughout the fifth century, sculptors directed their efforts towards combining heroic stature and dignity with the natural motions of a perfectly formed body. With the discovery of the lost-wax process, a method of casting in which molten bronze is poured into a wax-coated mould, melting and replacing the wax, artists were able to create large-scale figures which had no visible joints and were free from the limitations imposed by carving a statue from a block of stone. Figure 22 is a more than life-size statue either of Zeus hurling his thunderbolt or Poseidon aiming his trident (the weapon which would identify the figure is lost). He is clearly a god in the act of killing an enemy; arms fully extended, he bears no trace of the confining marble block suggested in the Kritios Boy.

We have none of the paintings that were famous in their own times, only a few fragments, tantalizing accounts by ancient writers, and Roman copies of a much later date to indicate the strides Classical artists made in rendering a human figure illusionistically in three-dimensional per-spective. We know from writers like the Roman Pliny the Elder that Classical Greece gave birth to painting as an art form separate from pottery painting and not considered as mere decoration; whether on walls or smaller panels, painters strove to reproduce the natural world as the human eye perceives it. From the stories that have come down to us, we

21 The Kritios Boy, 490–480 BC. Marble, 34 in (85 cm). Athens, Acropolis Museum

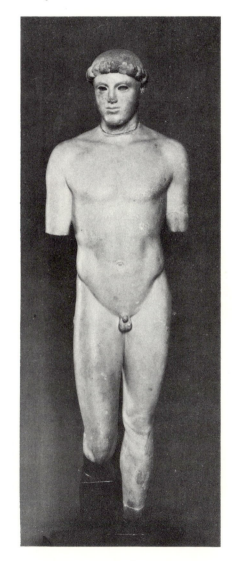

learn that in the fifth and fourth centuries artists were important enough to be talked about; we know not only their names and what works they painted but something of their character and the seriousness with which they pursued their art. Pliny tells us, for example, of a competition

22 Zeus, or Poseidon, 460–450 BC, found in the sea off Cape Artemisium. Bronze, 83 in (2.08 m). Athens, National Museum

between two painters, Zeuxis and Parrhasius, to see who could paint the most naturalistic work. Zeuxis painted a bunch of grapes so real that the birds flew down to pluck them, whereupon the proud artist turned to his rival and begged him to unveil his picture. To his chagrin, Zeuxis then realized that Parrhasius had fooled him with a painting of a curtain.

As picture painting became so important, vase painting became separated off as a craft rather than a fine art. However, we can see from surviving pottery that the illusionism described by Pliny was practised by the vase painters too. At the end of the Archaic era painters in Athens had developed a technique of painting the background black and leaving the figures to stand out in the red of the clay, which permitted more variety in painting in the details. This is called the Red Figure style. In the mid-fifth century some painters refined this by using a white ground and painting the subject in several colours, which allowed for some contrast of light and shadow to indicate the contours of the body (fig. 23).

Something of the discoveries that painters were making in showing the human figure as it appears to the eye, rather than as the mind knows it to exist, can be seen in the related art of relief carving. In figure 25 one of the riders bends his left arm so that it seems to thrust out into space. The sculptor achieved this illusion of depth by foreshortening; the limb is literally shortened and compacted, the forearm drawn in front of the upper arm, to give the appearance, rather than a literal rendering, of correct proportion. The Greeks were using their eyes, not rules, to achieve the correct effect.

The same appreciation of visual perception led Classical architects to achieve a new sense of space and proportion, not only in single buildings but in the grouping of several structures so as to take account of different viewpoints. Figure 24 shows that a Greek temple is as impressive when seen from an angle as from in front of its main portico. When the Athenian Acropolis, whose buildings had been destroyed by the Persians in 480 BC, was rebuilt under Pericles in the second half of the fifth century, its buildings were placed asymmetrically one to another, taking advantage of the uneven ground to gain different prospects from different viewpoints. The individual structures display more variety of form than the sixth-century temples. Architects felt free to introduce Ionic details into a Doric structure; in the Doric gateway to the sacred precincts the central roadway

passing through is flanked by Ionic columns, while in the major temple, the Parthenon, an Ionic running frieze was placed inside the colonnade, high on the outside walls of the cella. The most ornamental and surprising of the structures on the Acropolis is the Erechtheum (fig. 26), an Ionic temple richly decorated in carved moulding ornament and given an asymmetrical form by two porches, of unequal size, that jut out from the main body of the building. In the smaller of the porches, six female figures (called caryatids) were used instead of columns to support the roof.

The Parthenon is the largest of the temples and crowns the Acropolis. The most famous Greek building in the world, it epitomizes for many the Greeks' ability to follow rational and mathematical rules in a building that is completely satisfying to the eye. It was designed to be grasped as a single whole and actually seems smaller than it is because of the complete visual harmony — even without its roof — between vertical and horizontal lines. Whether by accident or design, its original form fits the geometric ratio known as the Golden Section (approximately 1: 1. 618), so-called for its universally recognized aesthetic appeal; buildings following this ratio will invariably seem beautifully proportioned. Imposing though it is, the Parthenon's scale is that of the human world; it is a visual statement that man was the centre of the Greek universe, the scale by which his buildings should be measured.

Today the Parthenon, like all Greek ruins, presents a far more severe aspect than its builders intended, for the strict geometry of Greek architecture was originally lightened and enlivened by the paint and sculpture that decorated it. From drawings made before the Parthenon was badly damaged by an explosion in 1687, as well as from archaeological evidence, scholars have been able to reconstruct the pictorial programme that once decorated it. The sculptural compositions were under the direction of a famous sculptor, Pheidias, who made a gigantic statue of the goddess Athena, of gold and ivory on a wooden core, to stand inside the cella. How much of the architectural sculpture is his design we cannot know, but the figures were brilliantly composed to fit into the framework of the building and at the same time demonstrate a superb feeling for human anatomy. The pediments, whose triangular shape posed the most awkward problem in composition, were filled with a number of more than life-size figures carved as if free-standing and finished on all sides. Figure 27 demonstrates the way in which the artist, whether Pheidias or another, coped with the triangular frame. The end figure in this group of three goddesses reclines, her legs extended to fit the narrowing angle of the corner. She leans on the lap of a sister goddess, who bends over her to form a tightly knit unit, while the third, holding herself more erect to fill the widening space, turns slightly to lead the spectator's eye towards the centre of the pediment, where the main action (the birth of Athena) was shown. The composition is completely self-contained within its architectural frame; the figures interact among themselves without involving the spectator in their drama.

23 White-ground *lekythos* (oil flask) showing a soldier taking leave of his wife, *c.* 440 BC. Height 16¾ in (42.5 cm). The artist is known as the Achilles Painter. Athens, National Museum

24 The Parthenon, Athens, 447–438 BC. The Parthenon remained remarkably intact until 1687, when a shell fired from attacking Venetian ships exploded ammunition stored in the temple by the Turks.

25 Two riders from the west frieze of the Parthenon, 447–432 BC. Marble, height 43 in (107.5 cm). London, British Museum
These riders and the three goddesses in figure 27 are among the fragments of the Parthenon sculpture brought to England in 1801–3 by Lord Elgin.

26 The caryatid porch of the Erechtheum on the Athenian Acropolis, 421–406 BC. The caryatids supporting the roof are copies, the original statues having been transferred to the National Museum in Athens

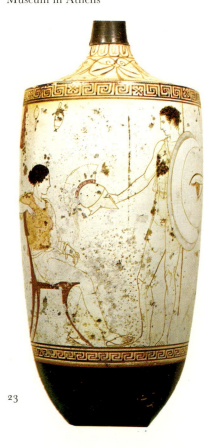

23

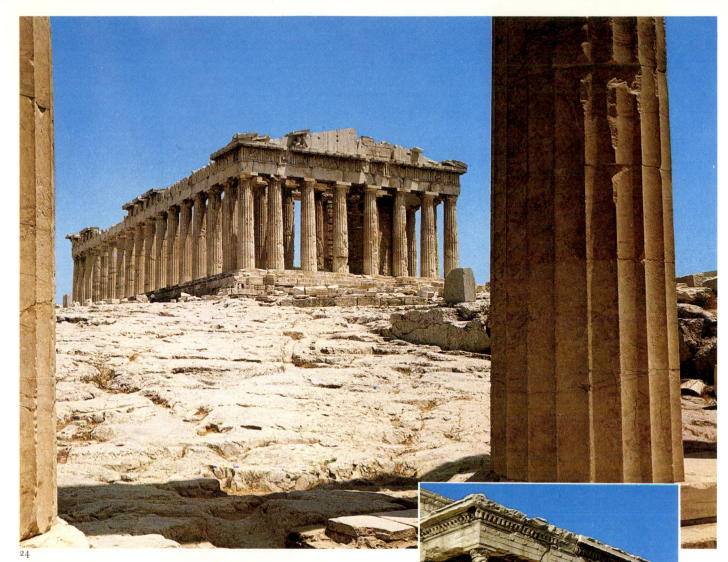

24

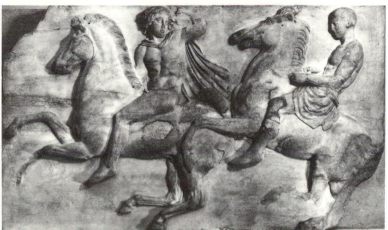

25

26

Looking at these figures we are aware of solid flesh beneath the thin drapery that falls in intricate and delicate folds. These goddesses are human and move naturally, while at the same time they assert a sense of great dignity and power. Even in the gods we are made to feel the importance of human intelligence. It was the humanism of the Greeks — their devotion, even in their religion, to human interests — that so markedly separates Hellenic art from that of Egypt and the Near East which stressed superhuman power.

The horsemen in figure 25 were once part of the frieze that ran around the walls of the cella, inside the colonnade. This band, 525 feet long, posed a different problem in composition; the challenge here was to create a sense of continuity without being boringly repetitive. The narrative celebrates the Athenian procession held every four years to honour the goddess Athena by bringing a new robe for her cult statue. The figures in the procession are broken into a number of small groups who interact with one another to form a composition easily grasped in a single glance. The action flows from one group to the next in a continuous rhythm that leads the eye along the length of the procession.

The Parthenon decorations represent a high point of Classical achievement. It is indicative of the seriousness with which the artists approached their work that so much care was taken with the decorative sculpture which, once in place, was too remote for close inspection. No one looking up from the ground level could have grasped the details of the procession or seen that the statues set in the pediment were finished at the back as well as in the front.

By the time the Parthenon was finished, Athens was on the eve of the Peloponnesian War with Sparta that effectively ended her political dominance. Yet the arts continued to flourish; the Erechtheum was built in the darkest days of the war, but although shortage of funds seems to have prevented completion of its decoration, no sign of the city's misfortunes is mirrored in its delicate and ornamental lines. Artists continued to develop mastery over the human form even after Philip of Macedon brought the Greek states under his rule (359–336 BC). The art of Praxiteles, who may have lived into the reign of Philip's son Alexander the Great, seems the epitome of Classical humanism. The Hermes and infant Dionysus (fig. 2) is now thought to be a later copy of his original, but even so its firmly controlled balance between form and emotion reflects the Classical Greek feeling for containing individual passions within a rational and inviolable frame. This balance, integral to Greek thought, was taught by Praxiteles' contemporary — and the teacher of Alexander the Great — Aristotle.

Modern taste leans toward the roughness of a sketch as opposed to a smooth and polished finish, so that to many even the Hermes seems to have passed from the pure style of the Parthenon sculpture into a virtuoso display of skill. There is certainly a self-consciousness in the technical execution of the work, especially in the elaborate folds of drapery falling

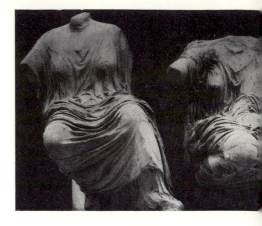

27 (*above*) Three goddesses, from the east pediment of the Parthenon, 438–432 BC. Marble, over life-size. London, British Museum

28 (*below*) Aphrodite (Venus) of Cnidos, Roman copy of Greek original by Praxiteles, 350–330 BC. Marble, 80 in (2 m). Rome, Vatican Museums Greek statues were originally painted, which would have further enhanced the life-like realism of Praxiteles' figures.

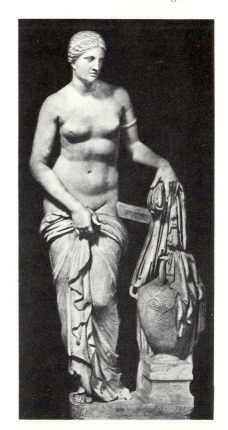

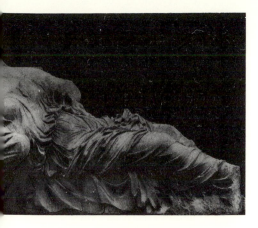

from the god's arm, in which the artist makes the marble appear to have the soft and pliable quality of cloth. If this is a copy, the artist must have imitated the original closely, for Praxiteles was famous in antiquity for his ability to make marble look like human flesh. He was the first, as far as we know, to exploit this skill in life-size nude statues of a female goddess. His famous Aphrodite of Cnidos exists for us only in rather heavy-handed Roman copies, but even in one of these (fig. 28) we can glimpse the graceful, sensuous feminine type Praxiteles created as a counterpart to the masculine ideal of the Hermes.

The Hellenistic Period

Later sculptors continued to show off their abilities by portraying more difficult poses and more expressive effects. This late phase of Greek art spans the period from the death of Alexander the Great in 323 BC to the Battle of Actium in 31 BC, when Octavian (later the Emperor Caesar Augustus) defeated the Egyptian queen Cleopatra and her Roman ally Mark Antony to bring Egypt under Roman domination. Alexander, although a Macedonian and not a true Greek, was thoroughly Hellenized; he spread Greek culture throughout the lands he conquered. After his death his empire was split into three parts under three of his generals, into kingdoms roughly comprising Macedonia (including Greece), Syria, and Egypt. Greek art and thought continued to dominate these areas in spite of the decline of Greece's political fortunes. But, far from its homeland, Greek art underwent profound changes as it no longer served the popular needs of the city-state but the worldly ambitions of powerful monarchs or wealthy citizens. For this reason this phase of Greek culture is called Hellenistic to distinguish it from the true Hellenic culture of the Archaic and Classical periods.

Classical Greek art and architecture are characterized by the ability to create a fresh and natural appearance within seemingly inflexible rules. In the Hellenistic period these rules were severely strained in order to emphasize the emotions that had been held in check in Classical art. In fifth-century Athens art was for the most part public art, promoted for the benefit of the whole populace; it was not intended to express individual personality. Hellenistic art evolved in Egypt and the Near East, where outlook and conditions had been little changed by new political realities. The expressionism of Hellenistic art sprang both from the patron's desire for self-glorification and from the artist's urge to display his own virtuosity, two conditions never possible in Classical Greece. Figure 31 is a Roman copy of a statue created as part of a group to celebrate the victory of Attalus I, king of the city of Pergamon, in Asia Minor, who defeated a tribe of barbarians (the Tolistoagian Gauls) in 238 BC. The Gauls are shown in defeat yet appear almost as the heroes of the drama, engaging our

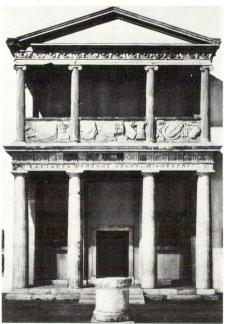

29 Propylaion (entrance) of the sanctuary of Athena, from Pergamon, first half of the 2nd century BC. Height 29 ft (8.8 m). Berlin, State Museum

sympathy and respect. Obviously the artist admired the indomitable courage of these people who preferred death to capture. The limp and passive form of the dead woman is contrasted to the fierce vitality of the husband who has just killed her to prevent her capture and now plunges his sword into his own breast. This contrast heightens the pathos and provokes our emotional reaction as if we were watching a Greek tragedy. This deliberate theatricality was emphasized in Hellenistic art; in the Laocoön (fig. 6), the preoccupation with death and disaster becomes positively morbid. The story is that of a Trojan priest who warned his people not to accept the wooden horse (in which Greek soldiers lay hidden); the god Poseidon, who favoured a Greek victory, sent two sea-serpents who killed Laocoön and his two sons. It is told in this work with all the exaggeration of expression and gesture appropriate to the theatre and is designed to achieve the same dramatic impact.

The striving for effect extended to the other arts in the Hellenistic period; architecture became elaborately ornamental, emphasizing a play of light and shadow rippling across the surface. Buildings like the Parthenon were designed to be seen from all sides with equal effect, but Hellenistic structures were focused on one dominant view centring on the main entrance, usually marked by an elaborate version of the temple portico. Figure 29, a two-storey portico from a temple in Pergamon, combines two orders, the Doric on the lower floor and the Ionic above. The upper storey is heavily ornamented with deeply carved foliage and a massive frieze that catches reflections of light and shadow. The use of a different order for each floor added variety to multiple storey buildings built by the Hellenistic kings and by the Romans after them.

Figure 30 is an example of Hellenistic influence on Roman architecture; it is a gateway to a marketplace from the city of Miletus, in Greek Asia Minor, which came under Roman rule when the Romans conquered Macedonia between 197 and 168 BC. Here the flat wall of the gateway is treated more as a piece of sculpture than as an architectural structure. Non-functional columns standing out from the façade are topped with a heavy cornice which juts out to form sharp angles in a strong contrapuntal rhythm. In keeping with the elaboration of Classical design, the decorative motifs are more complex here; the older orders are replaced by the Corinthian order on the upper storey, while the ground-floor order is a mixture of Ionic and Corinthian called Composite (see fig. 32). Both orders include ornate and intricately woven friezes of carved foliage.

In Hellenistic painting the emphasis seems also to have been on creating a theatrical effect. Here, as earlier, we have chiefly to depend on the written accounts of later writers and on Roman mural painting derived from Hellenistic originals. This evidence points to a steady development from Classical painting in creating an illusion of three-dimensional space on a two-dimensional surface. Figure 33, a Roman adaptation of a Hellenistic work, creates an illusion of space opening out through the wall.

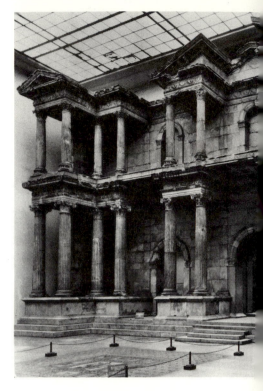

30 (*above*) The Great Gate from the South Agora, Miletus, *c.* 160 BC (restored). Berlin, State Museum

31 (*far right*) Dying Gaul and his Wife, Roman copy of Hellenistic work, part of a victory monument from Pergamon, late 3rd century BC. Marble, height 92½ in (2.11 m). Rome, Terme Museum

32 (*right*) The orders. Engraving from Vignola's *Regola delli Cinque Ordini d'Architettura* (Rome, 1607) The Tuscan and Composite were Roman additions to the three Greek orders, the Doric Ionic, and the Corinthian.

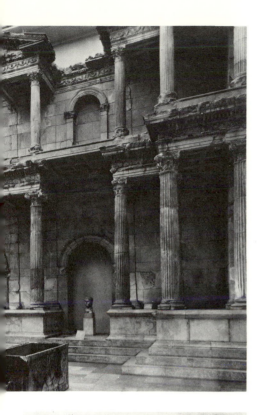

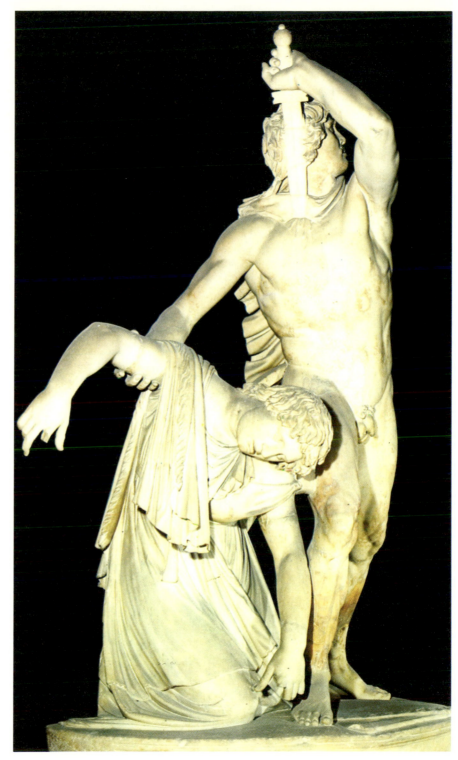

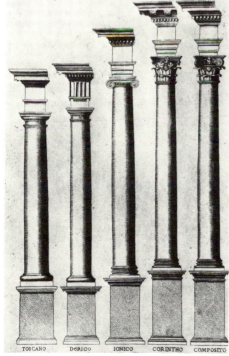

Its composition demonstrates a Classical feeling for harmony and balance. The three figures, representing the three Graces of Classical mythology, are united in a perpetual chain, swaying to a single rhythm. At the same time, each appears lost in her own thoughts, putting a slight emphasis on individual personality. The psychological impact arises in part from the artist's skill in using colour to achieve the effects of light and shadow; he not only moulded the three forms into solid bodies that cast shadows; he also used light and shade to form the landscape background into a shallow, curved recess so that air and space seem to flow around the dancers. Such luminous beauty is what survives of Antique achievement, and the memory of such illusions lingered on long after the destruction of Rome, to be gradually and painstakingly relearned in the Renaissance.

This painting illustrates our difficulty in assessing much of Greek art, for it is impossible to say how much of its technique and style is taken directly from Greek models. Little original Classical sculpture, so highly praised in its time, remains; the buildings are in ruins. Yet even the ruins and fragments sum up the Greek achievement, for they still have the power to stir our imagination and our love of beauty. Indeed, our Greek heritage exerts as strong a hold on us when we come face to face with its remains as it had on the ancient world.

From the Dark Ages until nearly modern times, the West had little contact with Greece. During the Roman Empire, the ornament and drama of late Hellenistic classicism and the influence of Egyptian style profoundly altered the forms of earlier Classical art. It was this hybrid that moulded the European understanding of 'Classical' art until the eighteenth century, when venturesome travellers reached Athens and rediscovered the art and architecture of the fifth century BC.

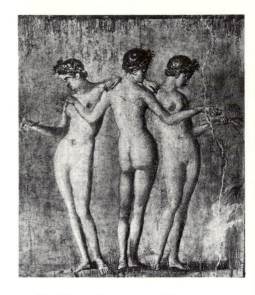

33 The Three Graces, mural from Pompeii, 1st century AD. Naples, Museo Nazionale

CHAPTER 2

Empire and Cross: Roman and Early Christian Art

The Gospel according to Saint Luke begins with a decree from the Roman emperor Caesar Augustus that required everyone within the Empire to register in the town of his or her birth, 'that all the world should be taxed'. This decree signifies the power of the emperor and heralds the birth of Christ; thus it brings together the two most powerful influences on the formation of medieval Europe, the Roman Empire and the Christian Church. The appearance of Christianity in Rome in the first century AD resulted in a marriage of opposites; the rational, human-centred philosophy that Rome absorbed from Greece was combined with a mystical, god-centred religion that valued the endurance of faith more than heroism in battle. After the collapse of Roman government in the West, it was the Christian Church that provided the basis for the formation of a new civilization. The post-Roman history of Europe, founded largely on this uneasy mixture of humanism and spiritualism, reflects a continuing alternation between belief in man's ability to shape his own destiny and faith in the universal power of God.

After the fall of Rome the forms of Greek and Roman Classical art filtered into European culture through the Christian Church, the only real source of artistic patronage in the perilous centuries between the end of Roman government and the emergence of new kingdoms. Christian art began squarely within the frame of the pagan culture surrounding its birth; for the first 300 years of its existence, Christianity was outlawed and its art literally an underground art, the decoration of funerary chambers and sarcophagi (decorated stone coffins) in the catacombs, the burial chambers dug underneath Rome. This decoration was executed by artists who were employed for the same purpose by pagan Romans. Therefore the art of Europe as it emerged after the fall of Rome began with the Classical forms Rome had adopted from Greece.

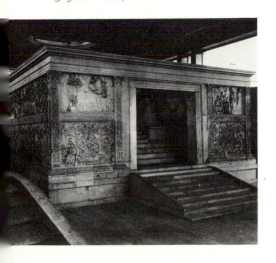

34 Reconstruction of the Ara Pacis, 13–9 BC. Rome, Ara Pacis Museum

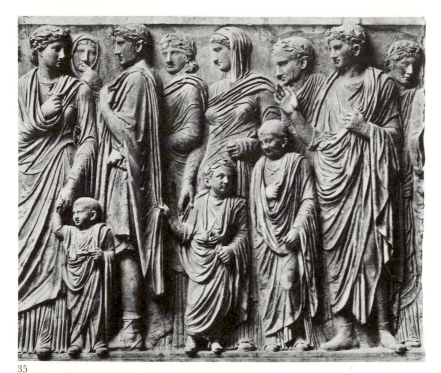

35

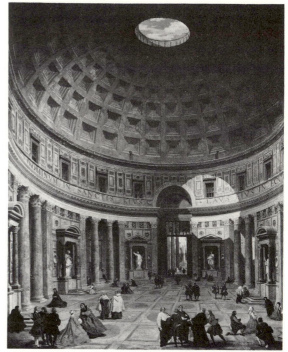

36

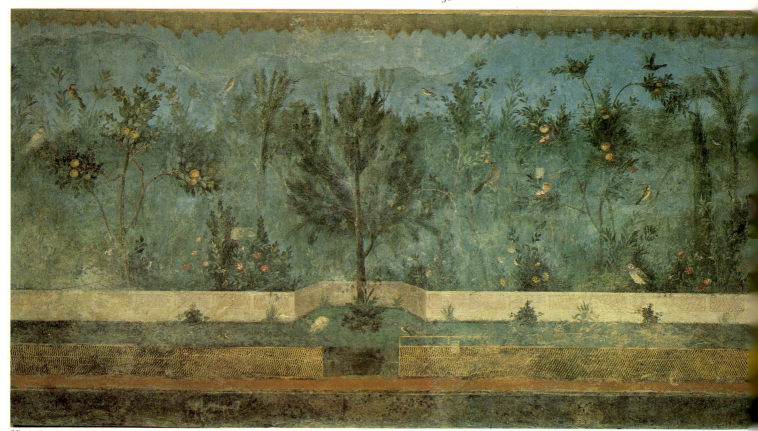

37

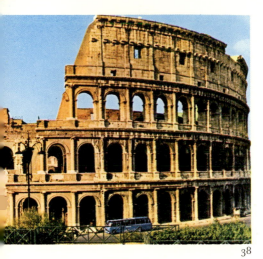

38 The Colosseum, *c.* 80 AD. Rome

35 Detail of frieze, Ara Pacis, 13–9 BC. Marble, 63 in (160 cm) high

36 The Pantheon (Temple of All the Gods), 118–125 AD. Rome. Painting by Pannini, *c.* 1750 (Washington D.C., National Gallery of Art, Samuel H.Kress Collection)

37 Wall painting of a garden scene from the Villa Livia, Prima Porta, *c.* 20 BC. Rome, Museo delle Terme

Classical Art in the Roman Empire

At the time of Athens's glory in the fifth century BC, Rome was little more than a village, aloof from the Greek colonies in the south of Italy and not yet ascendant over the Etruscan tribes which surrounded it. Within 300 years the Republic of Rome had become the dominant power in Italy and was beginning to fill the vacuum of power left by the break-up of Alexander's empire to the east. The Romans defeated their only serious rival for domination of the Mediterranean, the old Phoenician city of Carthage on the coast of North Africa, in the three Punic Wars ending in 146 BC. By this time they were already turning their attention eastwards to acquire, by force and by diplomacy, the various successor-states to Alexander's empire. When in 31 BC Octavian (later Caesar Augustus) defeated Cleopatra at the Battle of Actium, he brought Egypt under Roman rule. In 27 BC, Octavian received the honorary title Augustus; under the fiction of restoring the Republic he became Rome's first emperor.

It was the subjugation of the Hellenistic East that led to Rome's wholesale adoption of Greek culture, including its mythology. Earlier contacts with the Greek colonies in Italy had less impact; Republican Rome distrusted the refinements of civilization as signs of weakness. But by the time of Augustus, Rome was ready to admire all phases of Greek art and architecture. The spoils of the eastern campaigns had been flooding Rome with Greek art for over a century; the Romans were now passionate collectors of Greek art and were promoting a lively trade in Roman copies of Greek works.

Although Roman art took its outward forms from Greece, Roman attitudes towards artists were different. Greek artists had been held in high esteem, on a level with poets, philosophers, and statesmen. In Rome, although the age of Augustus was the age of the poets Virgil, Ovid, and Horace, we know very little of the artists or architects. This was not just because the Romans preferred 'old masters' to contemporary figures; by the first century AD the Roman state had become a complex bureaucracy closer to modern mass society than to the old city-state. Art flourished under both public and private patronage on a scale such as had never been seen before, but it was predominantly as a means of self-advertisement for its patrons, whether emperor or private citizen. When we think of Rome, we think of public forums, aqueducts, and baths, as well as temples. The luxurious decorations of private houses show us that quite ordinary people loved to be surrounded by beautiful paintings and sculpture. It was, on the whole, a worldly art that tells us more about the people who commissioned it than about the artists themselves.

The fact that art flourished on such a vast scale, and in an empire that now included so many different nationalities, resulted in a proliferation of

different styles at any given time. Artists trained in different traditions were employed by patrons of varying tastes. Nevertheless, until the fourth century the hub of the Roman Empire was the city of Rome; the source of patronage most visible and therefore widely influential was the emperor. The changes of style that we see in the course of the Empire's history were closely tied to changes in the background and taste of the emperors and their households.

Augustus preferred the style of fifth-century Athens to the more expressive and ornamental late Hellenistic art. His influence promoted a resurgence of the purer forms of Classical Greek sculpture, as can be seen in an altar erected by the Senate to honour the peace established by his victory at Actium; this altar was named the Ara Pacis, or altar of peace (fig. 34). It sits on a raised platform, approached by steps and surrounded by a stone screen separating the inner sanctuary from the outside world. The lower half of this wall is carved with delicate vine scrolls. On the upper portion is a line of figures representing an imperial procession, probably the actual ceremony of dedication (fig. 35). The motif of a processional frieze was adopted from Greek art and reminds us of the Parthenon frieze (fig. 25). The figures on the Ara Pacis are portraits of actual members of Augustus' official household, some of whom can still be identified. The scene is calm and dignified, yet full of human touches: a youth reassures his younger brother, a couple chat, while a woman hushes them, reminding them of their approach to the inner sanctuary.

These figures hark back to the Classical style of the Parthenon figures (figs. 25, 27) and express similar dignity and restraint. Here too the scene takes place in its own, enclosed world; figures react to one another but are unaware of the spectator. This frieze reflects the Romans' view of their own importance to history, an importance we see on another public work of narrative sculpture, a column erected between 107 and 113 AD to celebrate the successful campaigns of the emperor Trajan against the barbarian Dacians (fig. 40). This column is carved in a spiral frieze portraying vividly the actual battles; the dramatic, life-like style gives us a sense of being on the scene. Its immediacy reminds us of the Victory stele of Naram-Sin (fig. 11), rather than the remote and idealized Parthenon procession. Here, however, the emperor is not portrayed hierarchically as larger than his subjects or aloof from them; shown many times, he is always directly engaged in the action. Indeed, even the river god personifying the Danube seems to take a direct, human interest in the outcome.

In Rome, as in Greece, the focus on human action was complemented by a love of natural beauty. Hellenistic artists developed landscape painting, chiefly as a decorative background. As we see in figure 37, painters of the Roman period were able to convey not only the forms of landscape but also a soft, hazy atmosphere that suggests the enchantment of a perpetual spring. In figure 37 we find such pastoral charm portrayed as a walled garden, a motif that came from Persia. The Persian name for such a

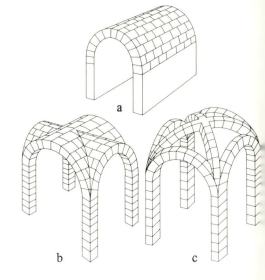

39 (a) the barrel or tunnel vault; (b) the groin vault: (c) the rib vault, a medieval development of the groin vault (see below, p. 100)

40 Detail of spiral frieze, Trajan's Column, erected 107–13 AD. Rome

garden gives us our word 'paradise'. The image of Paradise as a beautiful enclosed garden found so frequently in medieval art was derived from Classical prototypes in this vein. Painted for Augustus' wife Livia in her country villa at Prima Porta, it is a continuous mural that once extended around all four walls of a room, giving it the illusion of opening out into a garden. As the room was underground, it was probably designed as a cool retreat from the midday heat, when the real garden would be too hot to enjoy. Here every flower is in perfect bloom; the details are so realistic that we can identify the species of birds and trees, but this is not a real scene painted by someone looking at it; it is an idealized version drawn from memories of many beautiful gardens.

Classical ideal beauty and humanism were also integral to the architecture of the early Empire. It is in architecture that we first find signs of a distinctly Roman style. The Romans were more ambitious engineers than the Greeks; having learned the principles of the stone arch from the Etruscans, they made it as central to their architecture as the order is to the Greek temple. They developed concrete, made from stone rubble mixed with a mortar of clay, sand and water, enabling them to build large structures cheaply; concrete is strong and durable as long as it is faced in some more weatherproof material. It is also much lighter than stone, thus providing a suitable material for vaulting. The Romans used the barrel, or tunnel, vault which is simply an extended arch, as well as the more complex and stronger groin vault, in which two arches are placed diagonally, to cross at the centre (fig. 39). This concentrates the weight of the ceiling at the corner piers rather than spreading it continuously, as in the tunnel vault. Such vaults allowed for large multi-storey structures such as the Colosseum (fig. 38); by using sophisticated techniques of temporary supports (called centring), the Romans could also cover vast spaces with stone and concrete vaults, including circular domes (fig. 36).

But for all this technical virtuosity, the Romans remained wedded to the Classical orders and to Greek principles of symmetry and proportion. The classicizing taste of Augustus is mirrored in a book written during his reign by the architect Vitruvius, which codifies the major precepts of Classical architecture, concentrating on the principles of symmetry and proportion:

> The design of a temple depends on symmetry, the principles of which must be most carefully observed by the architect. They are due to proportion ... Proportion is a correspondence among the members of an entire work, and of the whole to a certain part selected as standard. From this result the principles of symmetry. Without symmetry and proportion there can be no principles in the design of any temple; that is, if there is no precise relation between its members, as in the case of those of a well-shaped man.
>
> *De Architectura*, Book III

It was not only in the temples to the gods that the Romans adhered to these rules; in an amphitheatre such as the Colosseum we can see how the arch and vault are combined with a decorative use of the order, the element that dictates proportion. Here, since the arch carries the load, the columns are non-structural and are simply applied to the fronts of the arcades, yet it is the height and spacing of the columns that dictate the size and spacing of the arches behind, thereby establishing the proportion of the whole structure.

This ability to build domes enabled the Romans to build circular temples, which they considered to be the most perfect geometrical form; the hemispherical dome was seen as a symbol of the heavens. The Pantheon (fig. 36), built between 118 and 125 AD, is a monumental structure, yet because of the careful control of proportion it does not overwhelm us. The height of the dome at its centre is the same as the diameter of the floor. Light pours into the interior through the circular opening (oculus) at the centre of the dome, providing a view of the skies to symbolize the planetary deities to whom the temple was dedicated. We are enveloped in a single space; the eye moves continuously from the recesses behind openings cut into the wall behind the columns to the statues that jut out into the room. Space is not rigidly bound but varied; however, it is clearly defined by the walls. From the Pantheon we can see that the Classical ideal in architecture may be defined not only by specific structures such as columns and pediments but also more importantly, by a certain attitude towards the visible world. Like Livia's Garden and the friezes on the Ara Pacis and Trajan's Column, the Pantheon presents us with a universe that is rationally ordered and defined.

The Erosion of Antique Style

The Pantheon suggests an optimistic faith in Rome and in the pagan gods that did not last long beyond its completion. Although grandeur and luxury continued to inspire magnificent buildings and lovely works of art, the sense of calm and control gave way to a new outlook, reflecting in part new pressures on the Empire. In the late second and third centuries AD the over-straining of resources produced a disastrous cycle of inflation, failures of trade, and abandonment of farms, followed by food shortages and more inflation. The difficulty of dealing effectively with these problems contributed to political and social corruption. The pressures of invading barbarian tribes grew more intense, while the enlistment of non-Romans into the army created an unstable situation as foreigners, loyal because they owed their prosperity to the emperor, were advanced at the expense of the Roman nobility.

The reign of Marcus Aurelius (161–80 AD, fig. 42) was long afterwards seen as a golden age. Yet already in his time public monuments suggest

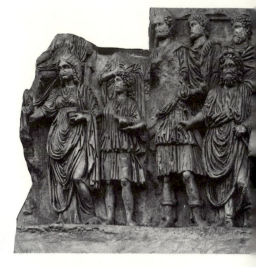

41 (*top*) Detail of frieze from the Arch of Septimius Severus, 203–4 AD. Lepcis Magna, North Africa

42 (*above*) Equestrian statue of the Emperor Marcus Aurelius, *c.* 176 AD. Gilded bronze, over life-size. Rome, Capitoline Square (now removed for restoration)

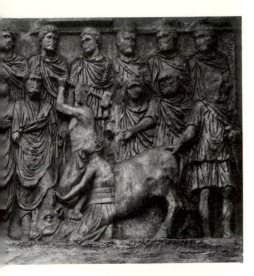

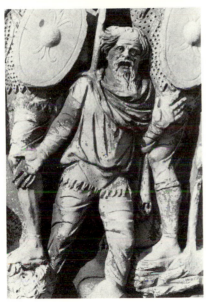

43 Detail of spiral frieze, Column of Marcus Aurelius, 180–192 AD. Rome

new and non-classical attitudes. A column erected to commemorate his victories over Germanic tribes (fig. 43) was modelled on Trajan's Column and gives the same sense of lively, on-the-spot reporting. But as we look at the individual scenes we find an exaggeration of emotional impact. The barbarians shown in defeat are contorted to provide an expressive picture of the horrors of war; balance and proportion are to some degree sacrificed to emphasize the feeling the scenes convey. The barbarian shown in figure 43 flees from two Roman soldiers, his hair flying, his arms thrown out, his mouth and eyes wide open to express fear and despair. Although the twisting, serpentine rhythms remind us of Hellenistic art, this is far from the heroic manner of dying portrayed earlier in the statue from Pergamon (fig. 31). This figure stares out at us and moves rapidly towards us to involve us in his struggle, thus signalling a radical break with the self-containment of Greek sculpture.

The art promoted by succeeding emperors shows further decay of Classical values. These rulers became increasingly isolated from their subjects and adopted a god-like role far from the human dignity of Trajan as he is shown on his column. The Severan emperors, who followed Marcus Aurelius, came from North Africa and Syria. They consolidated their power by promoting men from their own provinces. Foreigners came to Rome looking for advancement, among them artists trained in the more hierarchic style of the eastern Mediterranean. A four-way arch commissioned by Septimius Severus in his native town of Lepcis Magna shows a sharp contrast with the Classical handling of space and perspective (fig. 41). The reliefs on this arch are arranged on hierarchic principles, working upwards from the least important to the most important subject. This evidently suited the emperor's idea of his role in an increasingly hierarchical government. He is represented as isolated from his subjects, who are arranged not in naturalistic poses but simply stacked in two rows. There is no sense of receding space; the figures in the back row are as large as those in front. Nor is there any sense of depth achieved through modelling. The figures are sharply linear and their hair, cut with a drill rather than carved, seems more ornamental than real. While the sense of background space has disappeared, these figures connect with our space; like the barbarian on the Aurelian column, they stare out at us.

At first glance this work seems to support the Roman historian Dio Cassius, who said, 'after the death of Marcus [Aurelius] history passed from a golden empire to one of rusty iron.' But this linear treatment of human form was not just a debased imitation of Classical art; it was deliberate and represented a meeting of two worlds. The artist could not quite synthesize the Classical elements with the Near Eastern, but what his work lost in naturalism it gained in a sense of mystery and other-worldliness. Until the end of the Roman Empire we can follow a tug-of-war between a conservative love of Classical beauty and an emotional desire for an art that could symbolize the non-visible and the supernatural. This

decline of Classical style coincided with the emergence of Christianity as a dominant force in Roman affairs.

Art in the Catacombs

The earliest works of art we have from the Christians in Rome are adaptations of the pagan art we have just studied and show the same Classical beginnings and later romantic influences. The second- and third-century Christians included wealthy Romans of noble birth and conservative taste as well as poorer folk, many of them from the eastern provinces. Apart from paintings in a house used as a church, discovered in Syria, the examples of Christian art we have left dating from before the fourth century are chiefly the funerary art that decorated the Roman catacombs. These burial chambers, dug into the soft rock under the suburbs of Rome, consisted of cubicles with rows of shelves connected by passages. Pagans and Christians often shared the same cubicle, and the early Christians adopted pagan mythological subjects suitable to the theme of passage from this world to the next. At first these were little more than simple ornament, but through an extraordinary synthesis the pagan myths became grafted onto the Biblical stories they appeared to parallel. Thus, out of a rich confusion of pagan and Christian images we find an iconography developing that served to teach the faithful as well as to commemorate the dead. By this process we find that Bacchus (another name for Dionysus, god of wine) became a model for images of Christ because the wine-drinking associated with him seemed to mirror the Christian Eucharist. In the Christian use of Bacchic symbols like the pagan cupids gathering grapes in the Catacomb of Domitilla (fig. 44), we glimpse the confusion of mind of those early converts, brought up in one religion and adopting another.

Another favourite model for Christ was Orpheus, the legendary poet who served Apollo, whose history has many parallels to the life of Christ. In figure 47 Christ is seen seated with a lyre, a reference to Orpheus as poet and singer (connected to Christ through the latter's descent from David, the psalm-writing king of the Jews). He is surrounded by goats and sheep, recalling Christ as the Good Shepherd (John 10: 11–12). The figures are delicately modelled through the use of light and shadow and are set in a pastoral landscape evoking both Christian and Classical paradise.

Such ideal beauty could easily represent the early Christian view of Heaven, but the mystical fervour that enabled the sect to survive every effort to stamp it out could only be portrayed in a more expressive style closer to the deliberate emotion of the figures on the column of Marcus Aurelius or to the hierarchic style of the Severan arch. From the third century onwards, a pagan philosophy emanating from the city of Alexandria, in Egypt, found its way into the heart of Christian doctrine and art. Neoplatonism as taught by the philosopher Plotinus (c.205–70 AD) ad-

44 Detail of mural painting from the Catacomb of Domitilla, showing cherubs and wine harvesting, early 4th century. Rome

apted Plato's theories and viewed the world as a hierarchical pyramid drawing everything upward from the senses at the bottom to the pure spirit at the top. Plato had taught that the human soul needed to be freed from its fleshly prison in order to apprehend the supreme good; Plotinus set this idea in a mystical framework which could readily be expressed in Christian terms.

This Neoplatonic negation of the flesh influenced both pagan and Christian art; a bust portrait supposed to be of Plotinus himself (fig. 45) shows an unclassical distortion of natural form and proportion, conveying a sense of mystical trance. The whole face is elongated and hollowed out, with an expressive emphasis on the large and staring eyes. This wide-eyed stare derived from the belief that the eye was the mirror of the soul. It appears in Christian painting to suggest mystical revelation and is especially evident in praying figures, called Orantes, whose role was to assist the soul in its passage to the next world. The large and commanding figure of a female Orans from the Catacomb of Priscilla (fig. 49) evokes just such a trance-like state; her intense emotion dominates the scene.

Both the bust of 'Plotinus' and the mural of 'Donna Velata' indicate a retreat from the humanism of Classical art to a set of values that seemingly ignores the natural world and negates the importance of human activity. This was seen by later historians as a degeneration caused by the Christian focus on spiritual matters. But even before the Church became a prominent factor in Roman life, the old religion seemed unsatisfactory to many people. Moreover, the Empire was too large and too cumbersome to be saved by old-fashioned heroic action.

Imperial Christianity

Before the year 312 it would have been difficult to guess that Christianity was to become the determining factor in the development of Western civilization. Up to that time it was only one of a number of new religions competing for attention in a world that was dissatisfied with the old gods and anxious for anything new and exciting. Indeed, there had been a renewal of persecution just before this period under the emperor Diocletian, who tried in vain to restore Rome to its former virtues of patriotism and heroism. The Empire was by this time so difficult to administer that it was divided under two emperors, one in the east and one in the west. In 312 Constantine met his rival for the western throne, Maxentius, at the Milvian Bridge. In the night before the battle Constantine had a dream in which he saw a sign in the sky with these words written on it: 'hoc signo vince' (by this sign win your victory). Constantine ordered a symbol made up of the first two letters of Christ's name in Greek, chi and rho (✳), to be put on the shields of his soldiers. He won the battle.

Constantine followed his victory by defeating the eastern emperor to become the sole head of state. From the beginning he saw the Christian

45 Portrait bust, Plotinus (?), late 3rd century. Marble, life-size. Ostia, Museum

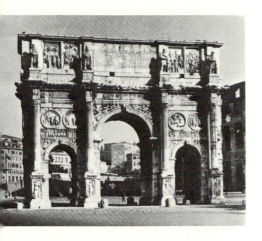

48 (*top*) Arch of Constantine, 312–15 AD. Rome

49 (*above*) 'Donna Velata', orant figure from a mural in the Catacomb of Priscilla, early 4th century. Rome
The name 'Donna Velata' comes from the title of a famous portrait by Raphael.

Opposite

46 (*top*) Arch of Constantine, detail of north frieze (over west arch) showing the emperor distributing largesse. 312–15 AD. Rome

47 (*bottom*) Mural painting from the Catacomb of Domitilla, showing Christ as Orpheus, early 4th century. Rome

Church as a powerful ally in binding together the disparate elements in the Empire. Under his patronage the once persecuted secret society became a vast, cohesive body. Although Constantine was not baptized until his deathbed, from the Edict of Milan in 313 giving the sect legal toleration, the Church was invested with the trappings and the bureaucracy of the imperial government. In becoming an arm of the state, a position made official by Theodosius in 380, the Church lost its original autonomy but gained the power and organization that enabled it to be the single cohesive force both to weld together a new civilization and to preserve the remnants of Roman law and culture after the collapse of imperial authority.

The ideological ties between Church and state under Constantine are visible in the public works erected to celebrate secular events. A triumphal arch erected in Rome at the beginning of his reign (fig. 48) contains relief carving that recalls the earlier Severan taste for hierarchy, but the decorative programme of the arch as a whole suggests a new attitude towards the idea of the state. This arch neither commemorates the past in narrative sequence nor isolates the present. Literally drawing together past and present, Constantine removed reliefs from monuments already erected to Trajan and Hadrian and Marcus Aurelius and incorporated them in his own monument, thereby stressing his reign as a continuation of the illustrious past. Two new friezes were carved in a style close to the linear carving on the Lepcis Magna arch. The figures are front-facing and flat, cut with deep grooves instead of being modelled into plastic forms. The style is more abstract than naturalistic and symbolizes, rather than represents, Constantine and his court.

The emperor appears isolated from the people, sitting on his throne and distributing largesse (fig. 46); seat and figure combine to fill the space occupied by two rows of courtiers. These figures, marshalled in ranks beside him, are paralleled in Christian art by new compositions of Christ enthroned with ranks of Apostles beside him (see fig. 53). From this point on imperial and Christian iconography were intertwined, just as the concept of the god-like emperor, absorbed into his office and cut off from ordinary humanity by virtue of that office, was extended to the pope.

With the right to hold property established by the Edict of Milan in 313, the Church embarked on a building programme on a scale hitherto only seen in imperial projects. The Church had to cope, for the first time, with the creation of an architectural design suited to its growing needs. The Romans built small, centrally planned temples with an altar at the centre. This design could be adapted to suit the celebration of the mass, or Eucharist, but left no room for large assemblies. The *catechumens*, those who were preparing for baptism but not eligible to celebrate the Eucharist, needed their own area where they could hear the sermon but be out of the way. Also, special services were held over the relics of the martyrs, and incorporating these devotions into regular services required moving from place to place. As the Church became more closely associated with im-

perial functions, the model of an imperial procession became an integral part of the service. The hierarchic order of the procession, with emperor and bishop at the head and common people at the rear, was adapted from secular protocol and is still the common form in ecclesiastical processions.

The design for the new Christian churches was taken from the basilica, a rectangular hall used in the Roman Empire for public functions. The type adapted by the Church had an entrance at one end, with a courtyard before it, and at the opposite end a raised dais on which the emperor sat. In the Christian version the altar took the place of the dais, and the open courtyard, called the atrium, became the place where the catechumens could gather to hear the sermon. The centralized form was used for separate buildings holding special functions: baptisteries, where initiates were baptized into the faith by submersion; and mausoleums, where the tombs and relics of the martyrs were placed. It was also adapted as the apse, a semicircular structure at the altar end of the basilica.

The old basilica of St. Peter's (fig. 50), erected perhaps as early as *c.* 333, was a five-aisled hall which added to the basilica model a cross-arm, called a transept; this was designed to cope with the processions to the tomb of Saint Peter adjacent to the church. The transept joined the apse to the main hall, called the nave (from the Latin word for ship), and the aisles beside the nave. The nave was lit directly only from the clerestory windows high up under the roof; additional light filtered in from ground-floor windows in the aisle walls through the open rows of columns supporting the nave walls. This church was replaced during the Renaissance by the present building.

For all its classicism of form, an early Christian basilica stressed a hierarchical note opposing the Classical unity of space; the design makes us aware of separate stages of a journey from the entrance to the triumphal arch, and through this to the climax, the Eucharist, celebrated in the apse (see fig. 54). This tendency to stress the parts rather than the whole appears even in circular Christian buildings like the mausoleum built for Constantine's daughter Constantina. Once attached to the old church of St. Agnes, this structure is closer in its aesthetic effect to a longitudinal basilica than to circular temples like the Pantheon. Here, the visual distinction between areas is articulated by the row of double Corinthian columns separating the central space from the ambulatory around it (fig. 52).

Originally the ceilings and pavements at Santa Costanza were covered with mosaics, which are pictures made of small pieces of coloured glass, marble, or ceramic called tesserae. Mosaics had been used extensively from early times in Roman architecture, especially as patterned floor pavements. It was later realized that on walls and ceilings the tesserae can be tilted so as to reflect the light, which creates a brilliant glittering effect. Only the ambulatory ceiling mosaics remain in Santa Costanza, plus two niche mosaics heavily restored and probably of a later date. The mosaics on the ambulatory ceiling (figs. 8 and 51) depict Bacchic grape-harvesting

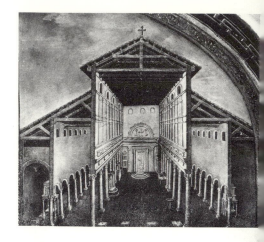

50 The interior of old St. Peter's, Rome, *c.* 333 AD. Taken from an 18th-century fresco

52 (*right*) Santa Costanza, Rome, 325–50 AD.
Formerly the mausoleum of Constantine's daughter Constantina, who was canonized after her death, this building is now the Church of Santa Costanza.

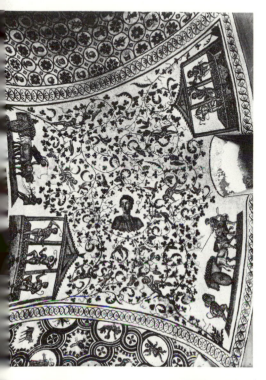

51 Detail of ceiling mosaics from the ambulatory of the church of Santa Costanza, Rome, 325–50 AD. (See also fig. 8.)

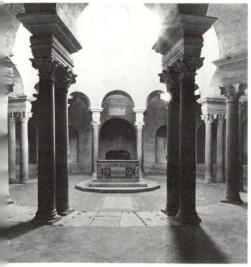

scenes familiar from the catacomb paintings; the same motif was carved on Constantina's sarcophagus.

The style and subject of the ambulatory decorations at Santa Costanza reflect the Classical taste of the Roman upper class, in contrast to the public sculpture on Constantine's arch. Like his predecessors, Constantine consolidated his control over the Empire by increasing the role of the civil bureaucracy at the expense of the Roman senatorial families. He further undercut their power when he moved his capital from Rome to the Greek city of Byzantium on the Bosporus in 324, renaming it Constantinople. The conservative reaction of the nobility in the face of continual erosion of their power is seen in their fostering a revival of Classical humanism in art late in the fourth century.

Upper-class taste for Classical forms and modelling promoted art works of great skill and elaborate technique, suggesting that the stylized, linear treatment of figure in the Constantine arch friezes was deliberate and not the result of a loss of technique. The sarcophagus of the prefect Junius Bassus, a convert who died in 359 AD, is a striking synthesis of Christian and Neoplatonic hierarchism and Classical principles of unity and symmetry (fig. 55). The front is divided into two registers of five scenes each, separated from each other by columns and pediments. On both registers the central figure is Christ. Above, he sits on a throne giving the law of the Church to Peter and Paul. He is in his heavenly kingdom; his foot rests on a pagan personification of the sky, Coelus. Beneath this scene he rides into Jerusalem, the earthly counterpart of the kingdom of Heaven.

The scenes flanking the two representations of Christ are of Old and New Testament stories connected to the theme of Christ's sacrifice. For example, Abraham is shown preparing to sacrifice Isaac (top left). In this Classical composition all motion is contained within the frame, concentrated on the triangle formed by Abraham and Isaac. The scene is not without emotion, for the action is arrested at its most dramatic moment, just as Abraham is about to plunge the knife into Isaac's bosom. But we are reassured before our emotions can overcome us; the ram which is to be sacrificed instead peers up at Abraham from behind his knee, and an angel is on the point of tapping Abraham on the shoulder to call his attention to the ram. There is no frightening sense of infinite void in this enclosed space; it represents a world measured by a human scale and governed by a humane God.

By the end of the fourth century the Church had become an attractive profession for the well-educated sons of noble families. This and the fact that it was usually the wealthy who paid for ecclesiastical art ensured the survival of Classical forms in art; upper-class taste also accounts for the survival of many pagan manuscripts like the Vatican Virgil (see fig. 59). Despite such men as Saint Jerome, who translated the Bible into the Latin of common speech (hence it is known as the *Vulgate*) because he felt the Church should have nothing to do with the Classical Latin of the pagan

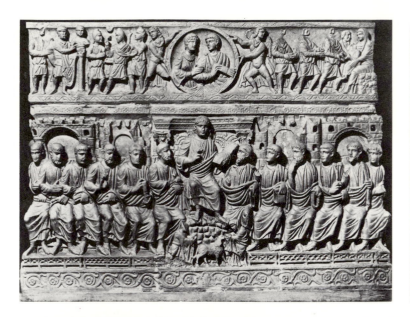

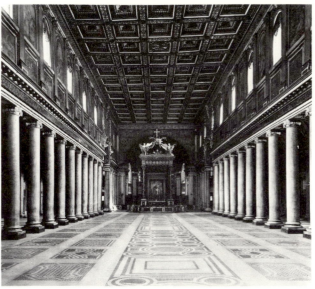

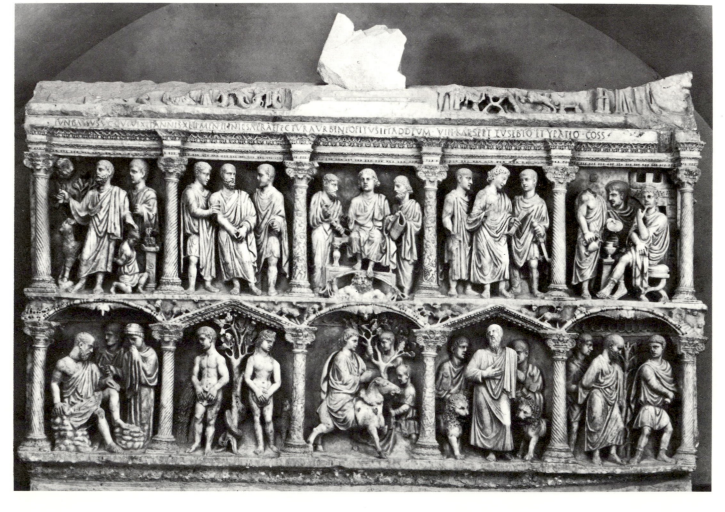

53 (*far left*) Sarcophagus of Stilicho (?), *c.* 395 AD. Milan, Sant' Ambrogio

54 (*left*) Basilica of Santa Maria Maggiore, Rome, *c.* 430 AD.

55 (*below left*) Sarcophagus of Junius Bassus (d. 359 AD). Marble, $46\frac{1}{2}$ × 96 in (116 × 240 cm). Rome, crypt of St. Peter's

56 The Three Women at the Sepulchre and the Ascension, 4th century AD. Ivory panel, height $7\frac{1}{2}$ in (18.7 cm). Munich, Bayerisches Nationalmuseum

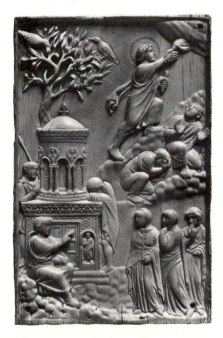

authors, and Saint Augustine, who repudiated the pagan Classical literature he had loved in his youth because of its appeal to the senses, the Church did more to promote works in a Classical style than the imperial court, where the influence of an increasingly abstract and symbolic art was strong. Works like figure 56, an ivory panel from the north of Italy, kept the influence of Classical art alive long after the milieu that produced them had disappeared. This little panel is in a style that rejects any hint of the supernatural even though it deals with two of the most supernatural events in the Gospels, Christ's resurrection from the dead and his ascension to Heaven. The risen Christ confronts the three Marys in a stoutly corporeal form, seated naturally on the steps of his tomb; above he ascends to Heaven as if he were climbing a hill.

In contrast to the vitality and naturalism of this ivory carving and of the Junius Bassus sarcophagus, a sarcophagus from Milan, the western capital under Theodosius, shows the mannered insubstantiality of works being produced in court circles (fig. 53). This sarcophagus may have been made for Theodosius' trusted commander in the West, the Vandal Stilicho. Here Christ is seen enthroned before a row of arches and fortifications signifying the walls of the heavenly city. On either side of him the Apostles are ranked in the manner of the emperor's courtiers in figure 46. These figures are elongated and insubstantial; twisted into exaggerated poses, some of them seem in danger of falling off the bench.

Fifth-century Synthesis

During the fifth century, ironically at the time when Rome was floundering under repeated waves of barbarian attacks and when civil government declined to virtual non-existence, art in Rome and its environs reached new heights under the auspices of the Christian Church. From the first sack of Rome by the Visigoths in 410 to the year 476 when the barbarian Odoacer deposed the reigning western emperor, a child named Romulus Augustulus, the vacuum left by the collapse of imperial power was filled by churchmen; when in 452 Attila the Hun menaced the gates of the city, it was Pope Leo I who met him and persuaded him to withdraw.

Despite the uncertainty of the times, the architecture and decoration of the churches built in Rome during this century display a new confidence of style in a final Roman synthesis of Classical style and Christian thinking. Santa Maria Maggiore (fig. 54), built just after the Council of Ephesus reaffirmed that Christ was the son of God even during his earthly life, was dedicated to Mary as the mother of God.

The mosaics decorating the interior elaborate the theme of the Old Testament as a precursor of the New. The Old Testament scenes are spread out in bands above the Ionic colonnade that separates nave from aisles; the communicant passes through the old law on his way to the new,

reaching a triumphal arch at the crossing which is decorated with scenes from the New Testament, elaborating the new role of Mary as Queen of Heaven. The effect is now somewhat spoiled by an elaborate Baroque tabernacle at the crossing, but the eye still perceives the separate stages of the journey.

The Old Testament scenes tell their story in a particularly vigorous and picturesque manner that emphasizes action. The figures are naturalistically drawn and are set in backgrounds that give an illusion of depth and defined space. At the same time, the story is more important than visual accuracy, and a new and unclassical crowding of details appears. In figure 58, every detail important to the story of the Israelites crossing the Red Sea is included. Moses causes the waters to come together again, catching the Egyptians in the flood. The drowning soldiers appear as large as the figures in the foreground, and a good deal bigger than their countrymen still on the far bank. The eye jumps from detail to detail; there is no one central focus in this crowded composition, for all the elements are important to the story. The perspective is not exact; the city gate rises the full height of the picture space on one side and comes down only a short way on the other, joining the city walls in the background. This does not bother us as the architecture is obviously designed as a frame for the soldiers who pour out from it. The blend of decorative and factual detail is skilful and convincing. The artists have not just mixed a collection of borrowings from several models; they have worked various elements into a true synthesis with enough realism to be recognizable while including everything in the story.

The fifth-century renewal of Classical naturalism was the last flowering of the antique style in antique times. Enough of it survived the barbarian upheavals to provide enduring examples of Classical art and architecture to be absorbed and reabsorbed into the art of subsequent periods. Santa Sabina (fig. 57), built soon after the sack of 410, and shortly before Santa Maria Maggiore, was a favourite model for later ages of a Christian church built according to the principles of symmetry and proportion and unity of space as defined by Vitruvius. His treatise survived in manuscript copies and was never entirely forgotten, not even by architects of such unclassical buildings as the great Gothic cathedrals. Antique painting survived through the medium of book manuscripts, bound parchment volumes that replaced papyrus scrolls by the fourth century and were copied and recopied until the invention of the printing press. In a manuscript of Virgil produced at the beginning of the fifth century we find a lively scene of action, similar in style to the mosaics in Santa Maria Maggiore, that gives us a record of fourth- and fifth-century building techniques (fig. 59). This compact, vigorous narrative style of composition was passed down through succeeding generations; we will see its influence on Carolingian, Romanesque, and Gothic art.

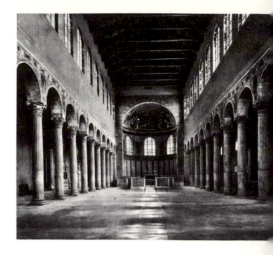

57 Church of Santa Sabina, Rome, *c.* 422–32 AD.

Ravenna and Byzantine Art

In the sixth century the vigorous naturalism of the fifth-century style yielded to a different and otherworldly style imported from the eastern city of Byzantium, now Constantinople. Byzantine art was a court art whose influence contributed to the ethereal quality of the sarcophagus associated with Stilicho (fig. 53). The importation of this style into Italy was fostered by the imperial government; in 402 the emperor Honorius changed the capital of the Western Empire from Milan to Ravenna because the harbour at nearby Classe (now silted up) provided a quick escape route to Constantinople. We can trace the change from Classical naturalism to more abstract and decorative forms in the three stages of Ravenna's history as a capital city. The first began in 402 and lasted until 493, when the Ostrogoth king Theoderic made himself emperor. Theoderic's reign was the second stage; the third and most dazzling was during the reign of the emperor Justinian (527–65).

When Honorius made Ravenna his capital, he engaged in turning the provincial town into a suitable imperial city. His sister Galla Placidia carried on his building programme after his death while she was regent for her son. A mausoleum built for her in about 425 provides an example of this phase of Ravenna's history (fig. 61). Its form, favoured by the Church in the Eastern Empire, is that of a cross with four arms the same length; it is called a Greek cross to distinguish it from the Latin cross used in the West, in which the nave is longer than the transept. The web of supports at the crossing is hidden behind a square tower; this simple, yet powerful form provided an easily assimilated model for the early Middle Ages, as we shall see. The interior is decorated with mosaics similar in style to the contemporary ones in Santa Maria Maggiore.

The next stage in Ravenna's development came when the Ostrogoth Theoderic seized the throne. Having a barbarian's admiration for glitter and pomp, Theoderic was more influenced by Constantinople than by Rome; the mosaics made under his direction reflect the growing abstraction emanating from the eastern capital. In Byzantine art, the rules of Classical composition became mannered and refined, as happens when a style is copied long after the world that originally produced it has disappeared. Byzantine figures became more decorative and less alive and warm-blooded. In part it was an attempt to preserve and freeze a past culture by a civilization rejecting its own times. Classical beauty was transformed in Byzantine art from a mirror of nature to a glittering artifice well suited to the spiritual emphasis of the Christian faith.

The church of Sant'Apollinare Nuovo in Ravenna was begun by Theoderic in 493. This church follows the design of fifth-century churches like Santa Sabina and is decorated with mosaics originally designed to progress hierarchically from the earthly kingdom upwards to the kingdom

58 (*below*) The Crossing of the Red Sea, detail of nave mosaics, Santa Maria Maggiore, Rome, *c*. 430 AD.

59 (*bottom*) Aeneas watching the building of Carthage, miniature from the Vatican Virgil, *c*. 400AD. 8⅝ × 7¾ in (21.9 × 19.6 cm). Rome, Vatican Library

of heaven, represented by scenes from the New Testament. Because Theoderic was a member of the heretical Arian sect who denied Christ's divinity, when Ravenna reverted to imperial control under Justinian, the scenes depicting Theoderic and his queen and their courtiers on the bottom tier were removed and replaced with processions of saints and martyrs, thus weakening the original intention.

The scenes dating from Theoderic's reign are composed for their role in the total effect of glittering colour. Classical models were used where possible, but we find a curiously primitive lack of three-dimensional form where no models existed. In the scene where the women confront an angel before Christ's empty tomb (fig. 63), the angel, for whom the artist could use a Classical pose, is more human in form than the wooden figures of the women; they are flat and two-dimensional, while he sits naturally and inhabits real space. The desire to draw perspective had also weakened. The empty coffin seems to stand on end with its lid projecting at an awkward angle; the lid is either too short for the coffin or it disappears in the manner of a conjurer's trick into the box. Proportion and perspective did not matter to these artists; the Classical handling of space and solidity seems to have survived only in direct quotations from older sources. What did matter was the overall decorative effect, a beauty not of the flesh but of the spirit. The deliberate artificiality is its own aesthetic, as the twentieth-century poet William Butler Yeats saw:

Once out of Nature I shall never take
My bodily form from any natural thing
But such a form as Grecian goldsmiths make
Of hammered gold and gold enamelling…

YEATS, *Sailing to Byzantium*

When Justinian came to the throne in Constantinople a year after Theoderic's death, he was immediately faced with riots, during which many of Constantine's buildings in the eastern capital were destroyed. Once in power, Justinian embarked upon a vast rebuilding programme in Constantinople; when his general Belisarius retook Ravenna from the Goths in 540, it, too, became a showplace of Byzantine art.

Justinian's architects surpassed even the engineering skill of the Romans. As the Pantheon shows, the Romans were able to cover circular spaces with hemispherical domes, but as Christian churches were built on square or rectangular plans, to cover them with domes meant turning a square into a circle. The dome of Galla Placidia's mausoleum illustrates the fifth-century solution: on the outside the 'dome' is a square tower with a peaked roof. Inside, it is made round by the use of pendentives, concave, spherical triangles of masonry rising from the corner piers to fill in the space between the four side arches. They curve inwards so that by the level of the tops of the arches the area has become circular.

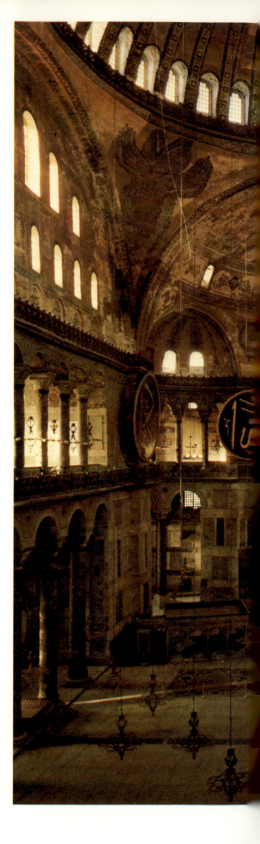

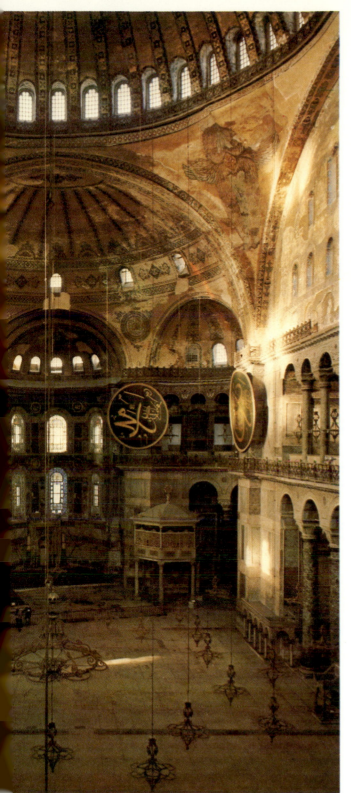

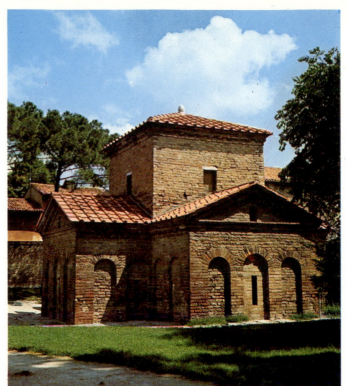

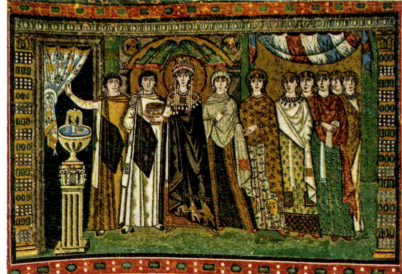

60 (*left*) Santa Sophia, Istanbul (formerly Byzantium, then Constantinople), completed 537 AD.

61 (*top*) The Mausoleum of Galla Placidia, Ravenna, 440 AD.

62 (*above*) The Empress Theodora and her courtiers. Mosaic in the choir of San Vitale, Ravenna, before 547

Justinian's famous church in Constantinople, Santa Sophia, has one full round dome and two semi-domes that cover a span of 100 feet by 200 feet (fig. 60). The half-domes cover the two apses and are lower in height than the central dome. Together, resting lightly on pendentives, the domes cover an oblong within a square; the centripetal force created by the central dome brings the whole structure together in a unified, soaring, yet contained space.

The smaller church of San Vitale in Ravenna shares this sense of unified space. It departs from the basilica model, being octagonal, although it has an ambulatory around its eight sides. The ambulatory is separated from the central space by eight two-storey arches, seven of which open back into curved bays; at the gallery level the bays are covered by semicircular vaulted ceilings (fig. 64). The dome rests on the eight arches, carried down by pendentives to eight massive pillars between the arches. There is no separation here of form and function; all the members serve a structural purpose, yet all contribute to the overall aesthetic unity of the church. Not even the one feature alien to the centralized plan, the sanctuary opening from the eighth arch, breaks the sense of being in a single, cohesive space.

The feeling of harmony at San Vitale comes from the integration not only of architecture and decoration but also of art with philosophy. San Vitale is as much the expression of sixth-century Christianity and its outlook as the Pantheon is of Classical Roman paganism. The complex geometrical forms of architecture and the elaborately worked out programme of decoration were deliberately designed to emphasize the mystical and hierarchical aspects of the Christian faith.

The Neoplatonic rejection of the flesh and upward striving of the spirit made visible in San Vitale were by this time an integral part of the Christian faith. Neoplatonism was codified in Christian terms in the treatises of a fifth-century theologian who, probably to give his writings more authority, wrote under the name of Dionysius the Areopagite, recorded in the first century as a companion of Saint Paul. These writings were long believed to be the work of a man close to Saint Paul, and were therefore enormously influential. To present-day scholars their dependence on a fifth-century pagan named Proclus makes their true date obvious, but their importance lies in the enormous prestige they enjoyed throughout the Middle Ages. 'Dionysius' did not invent anything new, but he codified Neoplatonic ideas into a set of laws governing a Christian universe. Following the Neoplatonic image of a pyramid, he described a system in which the common mass of people are at the bottom, striving upwards towards God, who is at the top of the pyramid, and who reaches downwards to man through Christ and the Apostles. 'Dionysius' applied the term *hierarchy* specifically to his ranking of the angels into three groups of three orders each, leading upwards from the least to the most important; in a more general way, everything in the universe was ranked and linked through its proper place to the whole chain of existence.

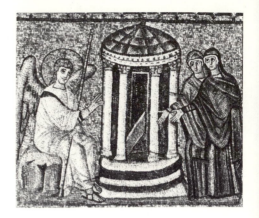

63 The Two Women at the Sepulchre, detail from the nave mosaics, Sant' Apollinare Nuovo, Ravenna, 490 AD.

This complex linking of all creation into a proper order had become an integral part of Christian iconography by the time San Vitale was built. The rounded ceiling of the apse has a representation of Christ enthroned with four angels in Heaven; below, the earthly rulers march towards the apse bearing their offerings of chalice and paten, which symbolize not only the spiritual gifts of Christ but also the rulers' gifts of money that built the church. They are seen enacting an ecclesiastical ritual, the dedication ceremony; the Empress Theodora and her ladies enter through one side (fig. 62), Justinian and his courtiers through the other. The symbolism has developed here from the separate stages represented by Theoderic at Sant' Apollinare; the secular role of king and queen is linked in a complex way to the temporal church, its building and its services, and thence to the eternal and supernatural side of the faith.

Just as Classical humanism was submerged in this upward-striving philosophy, so in the mosaics at San Vitale the Classical style became abstract and immaterial. From Classical substance and natural form, Byzantine art turned to insubstantial and supernatural images; from an enclosed, three-dimensional space to an undefined two-dimensional infinity.

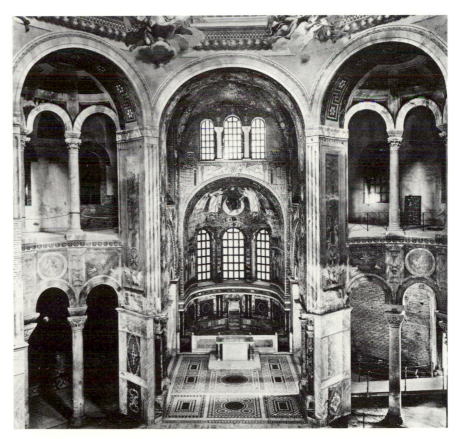

64 The church of San Vitale, Ravenna, 526–47 AD, showing the sanctuary

65 Ambrogio Lorenzetti, *Country*, from the *Allegory of Good Government*, 1338–40 Fresco. Siena, Palazzo Pubblico

PART 2 The Middle Ages

INTRODUCTION

With Justinian's death in 565 the Roman Empire came to an end in the West. Indeed, apart from his brief reconquests in Italy, the Empire had already ceased to exist, for after the barbarian Odoacer deposed Romulus Augustulus in 476 (see above, p. 51) there was never another *Roman* emperor in the West. But neither was there any sharp break with the Classical past. The Byzantine Empire, never entirely cut off from the West until its capture by the Turks in 1453, remained a religious, political, and artistic link with the past. And the barbarian kings who replaced the Romans in the West had already beeen Romanized to a large extent; Roman laws became grafted onto barbarian tribal customs and in this way filtered down into medieval judiciary systems. In the same way, Roman art survived, much modified; the Classical tradition remained alive and acted as a vital influence on the emerging art styles of the Middle Ages — the Carolingian, Romanesque, and Gothic.

The term Middle Ages is used as a convenient label for the whole period, almost 1,000 years, which stretched between the end of the Roman Empire and the Renaissance in the fifteenth century, and which finally saw the emergence of a Christian European civilization of nation-states.

CHAPTER 3

The Forging of Christendom: Western Art through the 'Dark Ages'

It was the Renaissance that saw the whole of medieval history as a dark period of barbarism between two golden ages, but the period between the end of Roman authority and the emergence of a recognizable Europe does not deserve to be called the 'Dark Ages'. True, from the fifth to the tenth century the West was a place of violence and instability, but this age was also the seedtime of the two organizations that changed Western civilization from Roman to European: monasticism and feudalism. The monastery and the castle developed simultaneously and independently, the one as the centre of religion and culture, preserver of the past and hope of the future, and the other as the guardian of the present, fortress and centre of economic and political life. Both were self-supporting and autonomous; the destruction of one monastery or castle could touch neither the monastic nor the feudal system. So the cultural traditions of the past survived in the work of learned monks who read and copied earlier texts and carried them along when they fled from invading enemies. And in feudalism, an intricate system linking the tenure of land to military duty and establishing a man's obligations and rights from the king down to the peasant, a working order developed that equalled the efficiency of the Roman administrative system without its cumbersome bureaucracy.

The period when the barbarian tribes were fighting among themselves and fending off the Muslim and Norse invaders was also an age of heroes and legends; of King Arthur, probably a British general fighting off the Saxons in the sixth century, and of Roland, who defended the Roncevalles Pass against the Muslims in the time of Charlemagne. The rearguard actions of Arthur and Roland sum up the spirit of the times; each managed even in defeat to kindle a legend that had more impact on Western civilization than the actual battles they fought.

We can trace the rise of monasticism and feudalism from the sixth century to the early twelfth, by which time Europe had a working political and economic system, a strong and unifying religion, and the first

66 Swedish medallion, 7th–8th century. Gold. Stockholm, National Museum

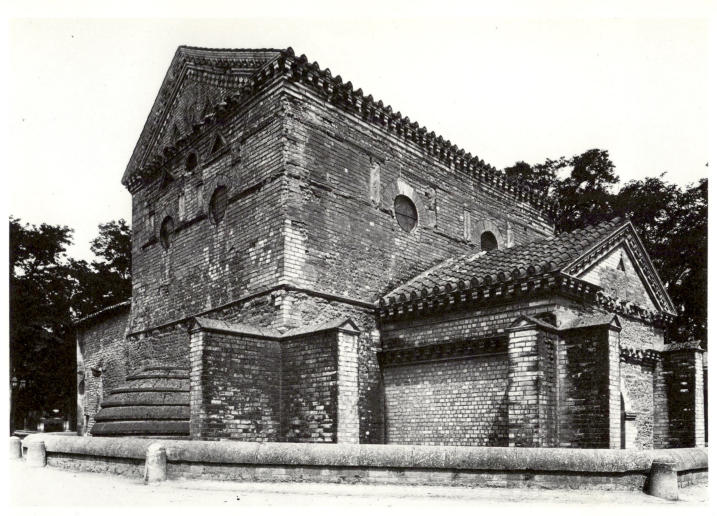

Opposite

67 (*top*) The Merovingian baptistery of St John, Poitiers, 7th century

68 (*bottom*) A plate from the helmet of Agilulf, king of the Lombards (590–615). North Italian, early 7th century. Florence, Museo Nazionale (Bargello)

69 Ostrogoth cloak pin, from northern Italy *c.* 500 AD. Bronze, decorated with cloisonné enamel. Nuremberg, Germanisches Nationalmuseum

genuinely European art style, the Romanesque. This style grew out of a mixture of Classical models, as its name suggests, and Eastern hierarchism, barbarian energy, and Christian faith. It was primarily a religious art, and the Church was its chief patron.

The Beginning of Early Medieval Art: Barbarian Artifacts

Most of the barbarian tribes were still pagan and, by Roman standards, uncultured. Largely illiterate, they had their own legends of heroic deeds passed down by word of mouth, and they had their own art in metalwork and jewellery. As tribes came into contact with the Romans they adopted Roman ways, including technology, language, and aesthetic preferences. We have already seen how the Ostrogoth King Theoderic admired and imitated the art of Byzantium (see above, p. 53). The Franks who established themselves in Gaul, the Visigoths in Spain, and the Lombards in Italy also adopted much from the art and architecture of Rome.

The art the barbarians brought with them when they settled in Roman territory was of necessity portable and a source of exchangeable wealth. The nomadic tribes who moved across the continent left no buildings or monumental sculpture, but they were skilled at making armour and fine jewellery. Their habit of burying their dead with all the trappings of wealth has left us examples of this art, which demonstrates their love of bright colours and abstract design. As they came into contact with Roman culture, barbarian jewellers adapted Roman and Byzantine methods of metalwork to their own designs. Figure 69 is a cloak pin made in the time of the Ostrogoth Theoderic (see above, p. 53) which shows a barbarian artist's skill with filigree, a form of metalwork making a pattern of fine metal wires, and cloisonné, in which small enamel panels are separated by thin metal bands. The eagle form of this pin and its design, indicating only the outline of the bird and a jewelled eye, came from Germanic art. The cross in the circle at the centre was a Christian adaptation; the Ostrogoths were converted early, albeit to the heretical Arian sect.

Even barbarian art far from the centre of the Empire reflects a knowledge of Classical forms. A gold medallion from Sweden (fig. 66) was influenced by Roman coins that portrayed the emperor on horseback. Here the artist has formed the head in profile, set on the back of a tiny and crudely drawn, but energetic horse. The abstract designs around the edge of the medallion are of barbarian origin and occur frequently in early medieval art.

The sixth-century barbarians' love of abstract design and colourful patterns and their lack of concern for sculptural modelling and shading meshed with a contemporary retreat from naturalism in Byzantine art. But they contributed their own sense of drama and action. A piece from the helmet of a Lombard king (fig. 68) shows the influence of Roman imperial

iconography; the king is enthroned, facing forwards, and is flanked by two soldiers in Roman garb. The stiff frontal pose, staring eyes, and lack of motion in these figures remind us of the hierarchic style of the Severans and of Constantine. Less constrained are the figures of two winged Victories (a motif which Christian art adapted for angels) and men bearing gifts; they are in motion, squeezed into the narrowing corners of the helmet.

Monasticism and Early Medieval Culture

The Franks in Gaul were the first tribe to ally themselves with the papacy in Rome, a friendship from which their kingdom derived great strength. This alliance went back to 496, when the Frankish leader Clovis was converted to the Catholic faith of Rome and received the pope's blessing to attack the Arian Visigoths. With the papacy behind him, Clovis welded the Frankish tribes together into the beginnings of a nation; his successors, the Merovingians, ruled the Franks until the eighth century. Borrowing from Roman administrative hierarchy, Clovis re-established the concept of the royal palace as a fixed centre of authority in both ecclesiastical and civil matters. It was upon the king's chief minister, the mayor of the palace, that the actual business of administering the government devolved; by the eighth century this was a position of great power.

When the newly Christianized Franks set out to build churches, they were sometimes able to use existing Roman buildings as a starting point. The Merovingian baptistery of St. John in Poitiers (fig. 67) was rebuilt from a fourth-century Roman baptistery and altered again in the tenth century. Its form resembles the mausoleum of Galla Placidia (fig. 61), but its rather grim exterior has little of the aesthetic balance or proportion of the older structure. Apart from the round windows, added later, the decoration of the baptistery walls probably dates from Merovingian times (although not all in its original position) and shows the manner in which the Franks adapted the late Roman motifs they copied. The coloured tiles under the roof pediment imitated the polychrome facing stones used by the Romans to form patterns on exterior walls. The rather crudely carved pilasters on the upper wall are applied to the wall simply as ornament, with no reference to the structural origins of the motif. The Romans had used pilasters as decoration, but always connected to a storey, still suggesting the support function of a free-standing column. The artist copied the acanthus leaves from the capitals of Corinthian columns, but in a stylized manner more suggestive of barbarian abstract design like the bands decorating the Swedish medallion in figure 66.

When in the later Middle Ages an old church was rebuilt or enlarged, sometimes a part of the original structure was incorporated in the new building, often in the partly subterranean crypt containing the tombs of nobles, bishops, or saints and their relics. One Merovingian interior has

CHART 2 THE DARK AGES AND EARLY MIDDLE AGES

EVENTS		ART AND CULTURE
432-60 Saint Patrick converts Ireland to Christianity		470 Abbey of St Martin, Tours
496 Clovis, King of the Franks and founder of the Merovingian dynasty, converted to Christianity	**"DARK AGES"** — 500	c. 500 appearance of works of 'Pseudo-Dionysius' c. 523 Boethius, *On the Consolation of Philosophy*
527-65 Reign of Justinian 529 Saint Benedict founds monastery at Monte Cassino		532-47 San Vitale, Ravenna
c. 550-700 Celtic Church in Ireland at its height, sending missionaries to Britain and the Continent 635 Monastery at Lindisfarne founded by Irish monks	600	c. 650-700 Baptistery of St John, Poitiers Jouarre Abbey founded by Irish missionaries c. 650-670 Book of Durrow
664 Synod of Whitby favours Roman liturgy		c. 698 Lindisfarne Gospels
732 Muslim invaders defeated at Poitiers by Charles Martel	700	735 Death of the Venerable Bede
751 Pepin becomes king of the Franks	**CAROLINGIAN**	781 Alcuin heads Charlemagne's court school at Aachen 792-805 Palace Chapel at Aachen
800 Charlemagne crowned emperor c 800-900 Viking raids on Britain and Continent 814-40 Louis the Pious emperor	800	816-23 Utrecht Psalter c. 830 Bishop Ebbo's Gospel book c. 855-8 John Scotus Erigena translates works of the 'Pseudo-Dionysius' into Latin
871-900 Alfred the Great king of Wessex 875-7 Charles the Bald emperor		873-85 Corvey Abbey, westwork
910 Founding of monastery of Cluny 911 Rollo the Viking becomes Duke of Normandy 962-73 Otto the Great emperor 973-83 Otto II emperor 987-96 Hugh Capet king of France 966-1002 Otto III emperor	900 — **OTTONIAN** — 1000	c. 980 Bishop Gero's crucifix
1066 Norman Conquest of England 1071-90 Norman kingdoms in Southern Italy and Sicily	**EARLY ROMANESQUE**	1000 Otto III's Gospel book 1001-26 St-Martin-du-Canigou c. 1015 Church of St Michael, Hildesheim
1077 Emperor Henry IV submits to Pope Gregory		1075 Pilgrimage church of Santiago di Compostela 1077 Bayeux Tapestry celebrates Norman Conquest 1080-1120 St Sernin, Toulouse 1088 Great church at Cluny begun
1095 First Crusade 1099 Crusaders capture Jerusalem	1100	1093-1104 Durham cathedral, choir St Etienne, Caen 1100 Moissac abbey, cloister and sculptures 1110 Statue of Isaiah at Souillac
1115 Saint Bernard founds Cistercian monastery at Clairvaux	**HIGH ROMANESQUE**	1120 Sainte Madeleine, Vézelay c. 1135 Autun cathedral
1137-80 Louis VII king of France	1150	1140-4 Abbot Suger rebuilds abbey of St-Denis

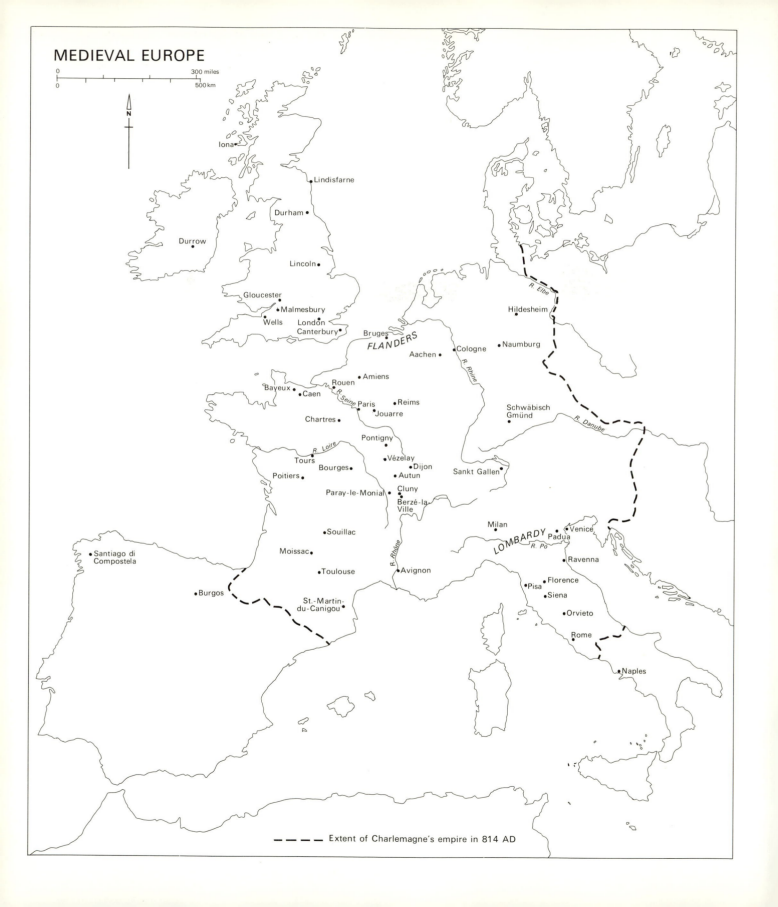

MEDIEVAL EUROPE

0 300 miles
0 500 km

N

Iona
Lindisfarne
Durham
Durrow
Lincoln
Gloucester
Malmesbury
Wells London
Canterbury Bruges
FLANDERS
Aachen Cologne Naumburg
Hildesheim
R. Elbe
Amiens
Bayeux Rouen
Caen *R. Seine* Paris Reims
Jouarre
Chartres
R. Rhine
Schwäbisch Gmünd
R. Danube
Pontigny
R. Loire
Tours Vézelay
Bourges Dijon
Poitiers Autun Sankt Gallen
Paray-le-Monial Cluny
Berzé-la-Ville
Milan
Souillac *LOMBARDY* Venice
Padua
R. Po
Santiago di Compostela
Moissac Ravenna
Toulouse Avignon
R. Rhône
Pisa Florence
Burgos Siena
St.-Martin-du-Canigou
Orvieto
Rome
Naples

– – – Extent of Charlemagne's empire in 814 AD

come down to us in this way; the crypt of the church of St. Paul at Jouarre Abbey, near Paris, survives from the seventh-century church (fig. 70). Its west wall (fig. 72) demonstrates a more skilful adaptation of Roman ornamental masonry than that on the Poitiers baptistery.

The artists working at Jouarre Abbey appear to have been a cosmopolitan group. There is evidence of training in Roman Classical style; there is also a sarcophagus, supposedly made for Bishop Agilbert, a relative of the first abbess at Jouarre, which suggests the influence of Coptic art. The Copts were a sect of Egyptian Christians, many of whom fled to the West in the seventh century to escape the advance of Islam. Whether this sarcophagus was carved by a Coptic artist at Jouarre or by a Frank who had learned the style, it combines the plasticity of Classical figure carving with the hierarchical composition of Eastern art. Its scheme was taken from the Book of Revelations, which describes the Last Judgement. On one side Christ is shown seated in Heaven among the elect, who raise their arms in the manner of Orantes (see above, p. 45). On one end of the tomb (fig. 71) Christ is shown enclosed in a mandorla, an almond-shaped frame symbolizing rays of light. This is an Eastern motif that serves to isolate Christ from the figures around him. The four creatures accompanying Christ also come from the Book of Revelations:

> In the centre, round the throne itself, were four living creatures, covered with eyes, in front and behind. The first creature was like a lion, the second like an ox, the third had a human face, the fourth was like an eagle in flight.
>
> *Revelations 4: 7–8*

These four creatures were established in early Roman Christian iconography as the symbols of the authors of the four Gospels: the lion for Saint Mark, the Ox for Saint Luke, the man-figure with human face for Saint Matthew, and the eagle for Saint John. It is in this role that they appear here, symbolizing the transmission of Christ's teachings through the New Testament. Note the way in which they face outwards, radiating away from Christ in an unclassical direction outside the composition.

Until the twelfth century saw a revival of towns, monasteries provided the chief source of cultural activity. Monasticism as a way of religious life goes back to the early days of the Church; since the fourth century devout men had often banded together for mutual protection and subsistence, but such groups did not live according to specific rules of communal worship. The Irish Church, which founded Jouarre Abbey, was organized in this manner, based on the existence of separate hermitages, each one autonomous and under the control of its own abbot. The Irish were a Celtic people, originally converted in the fifth century by the Romanized Briton Saint Patrick and then cut off from the Roman Catholic Church in the sixth century by Saxon invasions of Britain. For this reason, the Irish Church developed independently, adapting many Celtic traditions into the new

70 (*left*) The north crypt of Jouarre Abbey, near Paris, Merovingian, 7th century

71 (*below*) Christ in Majesty, with symbols of the Four Evangelists, from the sarcophagus of Bishop Agilbert in Jouarre Abbey, 7th century
The almond-shaped frame around the figure of Christ is known as a mandorla.

72 West wall of the north crypt, Jouarre Abbey, showing details of the ornamental masonry

faith. By the seventh century it was a thriving institution with a comparatively high level of intellectual and artistic life. Irish monks went far afield in founding new abbeys and were instrumental in converting many Germanic tribes to Christianity.

The artistic and intellectual life of a monastery centred on the activity of studying and copying manuscripts. Books were portable and often given as gifts, so that their influence was naturally more widespread than that of sculpture or architecture in disseminating new modifications of older Classical models. The Irish style of illumination demonstrates a high level of invention in creating elaborate interlacing patterns derived from Celtic pagan art. In figure drawing, the Irish style was schematic and relatively crude, as we can see in figure 74, from the beginning of the Gospel of Saint Matthew in the Book of Durrow, from the second half of the seventh century. This rendition of the man-symbol of Saint Matthew suggests the possible influence of Coptic as well as Classical art; he is pictured in a manner similar to Egyptian art, his body facing forward but his feet shown in profile. The features are stylized, but modelled with a sense of light and shadow. The body, however, disappears completely behind the bright chequer-board cloak.

The designs around the border of this page indicate the skill and sophistication of Irish decorative embellishment. Christianity had never stamped out the old Celtic mythology and its wonderful fantasies; the dominant motif in Irish art was an intricate line that wove together ornamental vines and fantastic creatures in a complex yet never random pattern half way between representational and abstract art (fig. 75). This serpentine line keeps twisting back on itself, but its pattern is rigidly controlled within the rectangular frame. The Irish style of illuminating manuscripts was spread throughout the continent by the Irish monks and was a strong influence on the development of style in medieval art, even as the influence of the Irish Church waned.

By the seventh century a new and more organized system of monastic development began to collide with the autonomous hermitages of the Irish Church. This was based on a monastic order that went back to the early sixth century, when Saint Benedict had founded four monasteries, including one at Monte Cassino. Appalled by existing disorder among the monks, he devised a set of guidelines which was so successful that it eventually became the rule for all monasteries until the twelfth century. Benedict was not trying to establish a new order; he was attempting to preserve and make workable an older system. But the Benedictine order, which consisted of a series of independent, self-sustaining units under a well-defined line of authority, created a prototype of the feudal system. The Rule of Saint Benedict spread throughout the continent in the sixth and seventh centuries and gained a firm hold in the Carolingian period.

In 664 there was a synod, or council, at the abbey of Whitby in Anglo-Saxon Northumbria, at which the Irish Church was forced to yield to the

73 (*left*) Carpet page facing the opening page of Saint Mark's Gospel, from the Book of Durrow, *c.* 675. Dublin, Trinity College.

74 (*below*) Symbol of Saint Matthew, from the Book of Durrow, *c.* 675. Dublin, Trinity College
The manuscript takes its name from the monastery of Durrow in Ireland, where it is known to have been at the end of the 11th century. However, it is not certain whether it was originally written in Ireland, Northumbria, or Iona in Scotland.

75 (*right*) Carpet page facing the beginning of Saint John's Gospel, from the Lindisfarne Gospels, *c.* 698. London, British Library

liturgical practices and the calendar of the Roman Catholic Church. Although the issues — principally the style in which the monks wore their hair and the dating of Easter — seem slight to us, the real issue was one of authority. But although the Irish Church declined in political influence, its style lingered on; even the Anglo-Saxons who opposed the Irish at Whitby were trained in the Celtic style of manuscript illumination.

There is a Gospel book from Lindisfarne Abbey in Northumbria that demonstrates this survival of Celtic motifs in Northumbrian Anglo-Saxon art. Lindisfarne had been founded by the Irish monks who converted the Northumbrians. In figure 75 we can see the development of the style of the Book of Durrow in the complex interlacing of the fantastically elongated and serpentine bodies of birds and animals. Eadfrith, the Anglo-Saxon monk who illuminated the Lindisfarne Gospels, adhered to the rules of Celtic art in never letting the organic shapes break into the geometrical pattern of the page; every line is tightly controlled. In his portraits of the Evangelists Eadfrith was influenced by Antique Italian manuscripts which had found their way into the library of the nearly monastery of Wearmouth–Jarrow.

The seventh and eighth centuries were a time of high cultural achievement in Anglo-Saxon England, particularly in Northumbria. This was the age of the Venerable Bede (673–735), the Northumbrian monk who revived Classical Latin to a standard not seen since the end of the Roman Empire, and who presided over a remarkable library of manuscripts at Jarrow that included Classical texts and illuminated manuscripts from Italy. This was also the period in which the finest Anglo-Saxon poems, including the *Beowulf,* were written down, taking their alliterative style from an ancient tradition of oral poetry.

This oral tradition, harking back to the entertainment of guests at barbarian feasts, was the background of written verse on both heroic and Christian themes. Its evolution from pagan entertainment into Christian poetry is evoked in a story told by Bede of Caedmon, a lay worker in the abbey of Whitby at the time of Saint Hilda, its founder and abbess at the time of the famous Synod. It was the custom at a feast for all those present to take a turn entertaining the company by chanting a poem to the accompaniment of a harp, but Caedmon, embarrassed by his lack of skill, would leave the feast whenever the harp drew near him, until one evening when, after he had withdrawn to a stable and had fallen asleep, a man appeared before him and commanded him to sing.

> 'I don't know how to sing', he replied. 'It is because I cannot sing that I left the feast and came here.' The man who addressed him then said: 'But you shall sing to me.' 'What should I sing about?' he replied. 'Sing about the Creation of all things,' the other answered. And Caedmon immediately began to sing verses in praise of God the Creator that he had never heard before, and their theme ran thus: 'Let us praise the Maker of the kingdom of heaven, the power and

purpose of our Creator, and the acts of the Father of glory. Let us sing how the eternal God, the Author of all marvels, first created the heavens for the sons of men as a roof to cover them, and how their almighty Protector gave them the earth for their dwelling place.'

BEDE, *A History of The English Church and People*

Caedmon spent the rest of his life using this miraculous gift to turn the scriptures into verse. We have already seen how easily barbarian art forms could be adapted to Christian purposes; this story points up the same process in literature. Its ability to absorb and use so much foreign material was for the early churchmen proof of the universality of the Christian faith.

Carolingian Art

The seventh and early eighth centuries that saw the flowering of Celtic and Anglo-Saxon culture were a low water-mark in the history of the Franks. The Merovingian descendants of Clovis became progressively weaker, handing over the real power to the mayors of the palace (see above, p. 64). This became a hereditary office and a powerful one, combining civil and military authority. The most able of the mayors was Charles Martel, who saved the Franks from the threat of Muslim invasion when he defeated the Moors decisively at Poitiers in 732. Charles was never recognized as a king, but his son Pepin deposed the last Merovingian king and received his crown from the hands of Pope Stephen II. In return, Pepin forced the Lombards to cede some of their territory to the Papacy. This territory, which included Ravenna, became the nucleus of the Papal States; from this point on the pope was a temporal as well as a spiritual ruler, while the king became the defender of the faith as well as head of state. When in 800 Pope Leo crowned Pepin's son Charlemagne emperor of a new, Christian, Roman Empire, this signalled a further interdependency between religious and secular authority.

Charlemagne saw himself as heir to the Christian Roman emperors. His success depended more on his own ability as a brilliant general and administrator than on an efficient system of government; within two generations after his death his empire had split into three parts; the ninth century was more calamitous than the seventh. But Charlemagne succeeded in crystallizing the idea of a united Christian Europe, functioning as a single state, the earthly counterpart of the kingdom of Heaven under joint rule of pope and emperor. Politically this unity was never achieved, but the concept of a single Europe united by its common culture is still alive.

Charlemagne was one of those heroes who seem to have loomed as large in their own times as in the pages of history. The Carolingian period has

76 Equestrian statue of a Carolingian king, possibly Charlemagne himself, from Metz Cathedral, *c.* 810. Bronze, height $9\frac{1}{2}$ in (24 cm). Paris, Louvre

been called a renaissance, deliberately suggesting a parallel with the fifteenth-century Italian Renaissance. Although like the Medici Charlemagne gathered around him a court of artists and intellectuals, the Carolingian revival of learning differed from the fifteenth-century Renaissance, for it concentrated on preserving and emulating Roman Early Christian models.

It was in Charlemagne's time that monasticism became a positive cultural and social force in the formation of a new society. No previous Western ruler had recognized the need for educated administrators; it was Charlemagne who saw the monastic schools as a system of education to train the sons of nobles. He appointed the foremost scholar and teacher of his day, the Anglo-Saxon Alcuin of York, to head the court school at Aachen. At Aachen and in the Carolingian monasteries books were copied at a rate not seen since the fall of Rome, in a new and more legible script. We owe the survival of many Classical Latin texts to the activity of these monks and scribes.

In seeking to renew the Western Roman Empire, Charlemagne turned to the art and architecture of Rome for models, in a more conscious and comprehensive manner than his predecessors. We saw that elements of Classical art survived in Merovingian and Irish art, and some of Charlemagne's painters were clearly familiar with the art of the eastern empire, where Classical techniques had never wholly died out. His architects relearned much of Roman building techniques. The sculptural arts achieved a classical high relief and naturalism of figure modelling by drawing directly on Roman models (see fig. 84). Figure 76, a free-standing equestrian statue of a king and possibly a portrait of Charlemagne, is obviously modelled on Roman statues such as the one of Marcus Aurelius (fig. 42). The Carolingian figure, though, is dressed in the clothes of his own period; his face has a markedly Frankish aspect and suggests the fierce and warlike courage of a barbarian king more than the controlled invincibility of a Classical hero.

Building in the Carolingian Empire developed from a steady absorption of techniques borrowed from Roman and Byzantine models, adapted to medieval needs. Charlemagne's architects used principles of construction such as groin vaulting (see above, p. 41), which enabled them to build sturdy and lofty buildings without losing the classical openness of columns and arcades. But it is not only a reassertion of engineering skill that marks Carolingian architecture; Charlemagne's builders had also a more fundamental appreciation of Classical aesthetics than the Merovingians. The gateway to Lorsch Abbey (fig. 77) suggests a Classical balance and symmetry, not merely a superficial ornamentation of columns and pilasters. The abstract design of the coloured facing stones and the wooden triangles simulating classical pediments recall the energetic and picturesque aspects of Merovingian buildings; here, however, the decorative elements blend into the symmetry of the whole design. The round towers, whose steep

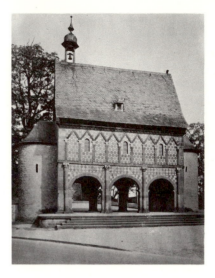

77 Gateway of Lorsch Abbey, Germany, *c.* 800

Right

78 (*top*) Interior of the westwork, Corvey Abbey, Germany, 873–85

79 (*bottom*) The Palace Chapel at Aachen (Aix-la-Chapelle), consecrated in 805

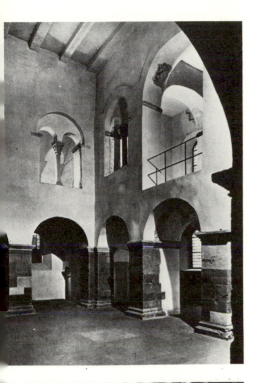

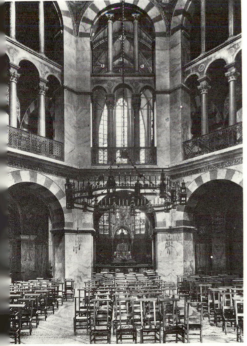

gables were added in the later Middle Ages, create a compact and un-classically vertical accent that converts the structure into something closer to a medieval castle than a Roman gateway.

Frequently the Carolingian abbey had to fulfill a triple function. First it was the inward-turning world of the monks and lay-workers who lived there. Second, it was a state-supported institution and answerable to the king's authority. Thirdly, its church was often the goal of visits by pilgrims whose legitimate claims to revere relics of martyrs and saints must often have interfered with the routine of monastic life. To cope with this multiplicity of function, the churches became double-ended, with the western end containing a second sanctuary, including chapel, galleries, and aisles, on the upper-storey level. In the abbey church at Corvey, the upper storey is supported by a groin-vaulted lower porch strong enough to allow for a sanctuary that is massive yet open, with its network of round arches and openings divided by columns (fig. 78).

Even Charlemagne's own palace chapel at Aachen, whose polygonal shape derived from San Vitale (fig. 64), is double-ended (fig. 79). The western entrance was linked to the palace, since destroyed, so that the emperor had his own entrance to his private sanctuary. As at Corvey, aisles on both storeys connect the western end, called the *westwork*, to the main sanctuary opposite (rebuilt in the Gothic period). The public entrance was on the ground floor underneath the emperor's private doorway. The variety of needs to be met by this one building influenced its style; despite the similarity of its plan to San Vitale, it has none of the sense of flowing space of the Byzantine church.

The necessity of developing an architectural type to serve the needs of the theocratic state resulted in a strong unity of style in Carolingian architecture. Painting, on the other hand, developed with the burgeoning activity in manuscript copying in a eclectic manner, borrowing elements from different styles in a rapid succession of trends and fashions. The influence of the palace workshop spread to abbeys outside Aachen, so that we can trace the diffusion of each separate style over much of the Carolingian Empire. At the same time, there were artists of different backgrounds working in one place, so that a single manuscript may have illustrations done in a variety of styles. Pepin's conquest of Lombardy had made ties with Italy closer, bringing in a strain of late Roman classicism as it had been adapted by Lombard artists in a style descended from the lively manner of figure-drawing we saw in figure 68. Charlemagne's renewed contacts with Constantinople opened the door to Greek artists who flocked to the West at this time because the Eastern Church forbade religious image-making, putting its artists out of work until 843, when sacred art was permitted once more. Thus there were artists in Aachen who employed a late Antique naturalism which had never died out in the Byzantine Empire. And the presence of Alcuin at the court furthered the traditions of Irish and Anglo-Saxon art. Imperial patronage favoured one

TILIACAELI ETPULCHRITU MEOSREIRORSUM; HONORIFICABIME
DOACRIMECUMEST; SIUIDEBASFUREMCURRE ETILLICITERQUODOSTEN
SIE SURIERONONDICATIBI; BASCUMEO ETCUMADUL DAMILLISALUTAREDI;

80

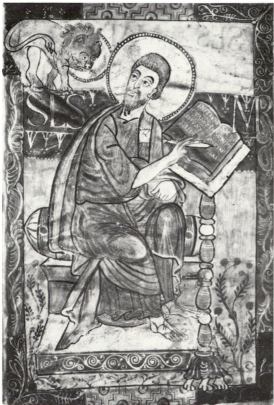

81

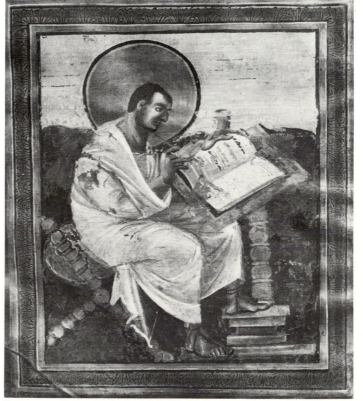

82

80 Illustration of Psalm 50, from the Utrecht Psalter, *c.* 820–32. Utrecht, University Library

81 Saint Mark, from the Godescalc Gospels, 781. Paris, Bibliothèque Nationale

82 Saint Matthew, from the Coronation Gospels, *c.* 800. Vienna, Schatzkammer

83 Saint Matthew, from the Gospel Book of Bishop Ebbo, *c.* 830. Épernay, Municipal Library

school and then another, so that styles followed changing tastes rather than a logical sequence of development.

The earliest of the Gospels surviving from Charlemagne's workshop at Aachen is the Godescalc Gospels, named after its scribe, and commissioned by Charlemagne in 781 (fig. 81). Its illustrations display elements of Byzantine, Lombard, Anglo-Saxon, and Irish art. The Evangelists are shown seated, pen in hand, in the act of writing the Gospels, a composition taken from Byzantine art. The haloes and the inclusion of each Evangelist's symbol come from western Early Christian tradition. It was also a western tradition to illustrate the writers of the Gospels as if taking dictation from their symbols. The mixture of influences produces a disjunction between the naturalism of Saint Mark's pose and the ornamental seat and desk that occupy no three-dimensional space.

In contrast to the two-dimensional, decorative aspects of the Godescalc Gospels, the Coronation Gospels were painted by artists versed in a true classical naturalism. These artists were predominant for only a short time, but they were responsible for a new infusion of classicism into Western art. This Gospel book received its name because Charlemagne's heirs traditionally took their oath upon it; it was said to have been found on Charlemagne's knees when Otto III opened his tomb in 1000. It is no wonder he was fond of it; the illustrations are comparable to Antique Roman painting, especially in the impressionistic rendering of the landscape backgrounds (fig. 82). Only in the large halo given each Evangelist did the painter of these portraits yield to Western convention. Saint Matthew sits in the same pose as the Godescalc Saint Mark, but he is no longer twisted around to listen to a visible source of inspiration behind his shoulder; he is inspired from within and from the natural world around him. He is a solid person, comfortably seated on his chair and bent over his desk, supported by his foot resting on the pedestal. The scene is illuminated by a natural light and has the beauty of a Classical ideal pastoral landscape.

A generation later, in the reign of Charlemagne's son Louis the Pious, a Gospel book was made for Louis's friend Bishop Ebbo of Reims. This work was modelled on the Coronation Gospels, but the style is very different. Saint Matthew (fig. 83) sits in the same pose, again solidly placed on his chair, and again seated in the open. But instead of modelling his figure with classical use of light and shadow, this artist used a nervous, jittery line that dances and quivers as if the saint's hair and robe had a life of their own. Instead of relying on pastoral idealism to convey the message of spiritual revelation, this illustration suggests that the Evangelist wrote his Gospel in a frenzy of mystical transport, reverting to the Latin tradition of dictation from the saint's symbol (shown here as an angel), who reads from a scroll that seems to pour into the author's ink horn.

The lively little angel and the Classical temples on the horizon link the Ebbo Gospels to another book produced by the school at Reims at about

the same time: the Utrecht Psalter (fig. 80). Both books combine Classical forms with an expressive quality descended from barbarian art. But whereas in the Ebbo Gospels the unclassical, expressive side pre-dominates, in the Utrecht Psalter there is an emphasis on Classical form and space. Its illustrations remind us of the narrative sculpture of Trajan's Column, the mosaics from Santa Maria Maggiore, and the illustrations of the Vatican Virgil (figs. 40, 58, 59). The scenes are full of action and drama, composed in a natural setting framed by rolling hills rather than by artificial borders. At the same time, they suggest the same nervous energy that we find in the Ebbo Saint Matthew.

There were several artists working on the Psalter, some of them more classical in style than others. But in all of the scenes we find a mixture of the symbolic and the realistic. The general laments and promises of the Psalms are illustrated in graphic terms by specific Biblical stories. Thus the penitential prayer of Psalm 50, with its apocalyptic vision:

> Our God shall come, and shall not keep silence; there shall go before him a consuming fire, and a mighty tempest shall be stirred up round about him.
> He shall call the heaven from above, and the earth, that he may judge his people.

is illustrated by a Biblical episode from 2 Samuel, 12:1–7. This relates the prophet Nathan's upbraiding of King David for sending Uriah to his death in battle and then marrying Uriah's wife, Bathsheba. Nathan told David a parable of a rich man who took the one ewe lamb away from a poor man who had nothing else. When David exclaimed at the villainy of the rich man, Nathan replied, 'You are the man.' The illustrator of Psalm 50 combined all the elements of the Biblical story into a single, coherent composition, with the main drama on the left and the parable on the right. The skilful narrative technique that combined realism with drama came from the copying of Classical models; the Utrecht Psalter provided an important source for classical elements in later medieval art.

Carolingian Art after Charlemagne

Charlemagne's empire did not long survive the loss of his strong per-sonal rule. His son Louis the Pious was twice deposed by his own sons and twice reinstated through the auspices of the Church. Finally, after 877, the realm was split into three parts roughly the equivalent of modern France, Germany, and northern Italy. Thus ended Charlemagne's dream of a united Christian Europe. Even during his lifetime, his empire was as-saulted by increasing attacks from new waves of barbarians; in crushing the Saxon tribes in the north, he had left the coast open to raids from the Vikings. As the ninth century progressed, the shallow-draft ships of these ferocious Scandinavians penetrated farther up the rivers into the heart-

land of Europe; the prayer, 'from the fury of the Northmen, good Lord deliver us', was heard far inland, even in Paris. In addition, the Muslims, held in check during Charlemagne's life, became increasingly aggressive, as Saracen raiders attacked Europe from the Mediterranean. And in the east a new menace arose, the fierce Magyars, who settled in what is now Hungary. Attacked from all sides, Christendom nearly foundered; monastery after monastery was destroyed and the precarious civilization Charlemagne had established was nearly extinguished.

Yet the very strength of Carolingian society lay in its flexibility. Had they destroyed all the monasteries in Europe, the invaders could not have destroyed monasticism. The monks fled, carrying their books and their relics, to return when they could to build anew. The church even penetrated the strongholds of the enemy; by the tenth century the Magyars had been converted to Christianity, eventually to form a bulwark between western Europe and the Muslims in the east. In 911, the French king Charles the Simple gave the Viking chieftain Rollo the nucleus of the territory which later became the Duchy of Normandy, in exchange for which Rollo swore feudal vows of allegiance. These former poachers proved excellent gamekeepers in keeping their Viking relatives out of France. Once christianized, the Normans, as they came to be known, played a leading role in the development of European culture.

That Charlemagne did leave a lasting inheritance in the arts is demonstrated by the high level of culture that continued throughout the ninth century. Weak and divided politically, Charlemagne's heirs continued to be patrons of the arts; the productions under Charles the Bald even exceeded those of his grandfather in splendour and quality.

Charles the Bald was heir to that part of Charlemagne's empire roughly corresponding to modern France. Paris was his chief capital, and the old Benedictine abbey of St.-Denis the main centre of art and learning; the head of the abbey school, an Irishman named John Scotus Erigena, was the foremost Christian scholar and thinker of his time. In St.-Denis Erigena had access to the works of the false Dionysius (see above, p. 56). By the ninth century, this 'Pseudo-Dionysius' had become confused with the patron saint of the abbey, Saint Denis, first bishop of Paris, whose name is the French form of Dionysius. Erigena translated these works from Greek into Latin between 855 and 858; throughout the Middle Ages they exerted a tremendous influence on Christian philosophy and doctrine.

Erigena's interest in Dionysius's hierarchies is paralleled in the growing hierarchism of style in Carolingian art under Charles the Bald. Dionysius's image of the pyramid reappears in the San Callisto Bible, a work probably intended as a gift to the pope on the occasion of Charles's coronation in 875. Figure 87 shows the Ascension of Christ and the Feast of Pentecost (Acts 2: 1–2). The Ascension, being more important, is placed above the Pentecost scene. As it is composed of the one figure of Christ and the hand of God reaching down to him, it naturally forms the head of a pyramid

composition. Underneath, the Apostles receiving the Holy Spirit at Pentecost form a separate scene, isolated by the framework of an octagonal city. Below this crowds of ordinary people form the base of the pyramid. They have no direct role in either of the two episodes as related in the Bible, but they are important to the theme that coordinates the whole picture; God's grace flows down through the mediation of Christ and the Apostles to ordinary men and women. There is no naturalistic rendering of picture space here; the composition is two-dimensional and arranged for meaning, not for pictorial sense.

The thin, fluttering figures in this picture are close to the romantic style of the Ebbo Gospels. The ivory carvings from Charles's workshops show a greater degree of classical modelling, but here too there is an emphasis on hierarchic composition. An ivory panel contemporary with the San Callisto Bible has come down to us as the cover of a book once belonging to the Emperor Henry II (fig. 84). This work portrays the Crucifixion, the Resurrection, and the Ascension. There are classical touches copied from older models, including pagan deities, the god Oceanus and personifications of Greece and Rome, who form the bottom row as pagan precursors of Christ. They draw our attention to the Day of Judgement above them, where the dead rise from their coffins. Above this the three Marys approach the empty tomb; they and the temple-like tomb are strongly reminiscent of the style of the Utrecht Psalter. The scenes are placed in order of importance, not chronology, for the Crucifixion comes between the scene at the tomb and the Ascension. The pyramid composition is somewhat weakened by the artist's desire to crowd his picture space and to show off his technical skill. No space is left empty in this crowded little work; even the top corners are filled in with Classical symbols of the sun and the moon.

Ottonian Art

Carolingian art as a separate and coherent phase of Western cultural history ceased with the death of Charles the Bald in 877. His heirs became progressively weaker until in 987 Hugh Capet, a noble from the environs of Paris, was chosen as king and founded a dynasty that lasted until the fourteenth century. Meanwhile the focus of artistic development shifted to the eastern part of the empire. In 962 Otto, king of Germany, was chosen emperor. From this point on the title of emperor remained with the German states, to which Otto added Italy when he married the widow of the Lombard king. From this union the Classical naturalism still strong in Lombard art came to influence the style of painting that developed in the workshops of the Ottonian empire. In 972 Otto's son Otto II married the daughter of the eastern emperor, thus opening up new contacts with Constantinople; from this Ottonian artists became familiar with

84 Scenes from the New Testament, from an ivory panel, c. 870, later set into the cover of Henry II's Book of Pericopes. Munich, Bayerische Staatsbibliothek

85 St. Michael's church, Hildesheim, c. 1000 (reconstructed after World War II)

86 Adam and Eve after the Fall, detail from doors now on the cathedral at Hildesheim, completed in 1015. Bronze, 23 × 43 in (58 × 109 cm)
Made for Bishop Bernward's church of St. Michael, these doors were moved to the cathedral of Hildesheim by c. 1025.

87 The Ascension and Pentecost, from the San Callisto Bible, c. 870. Rome, St. Paul's Without the Walls

86

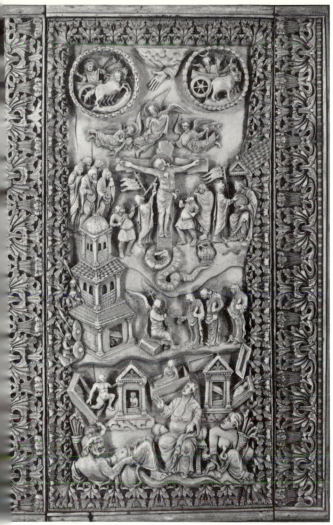

84

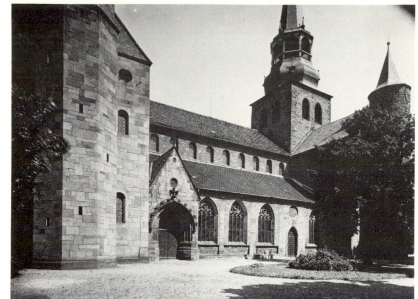

85

87

Byzantine symbolism and hierarchy as well as with Greek painterly techniques such as we saw in fig. 82. From all this arose a new synthesis of old elements in a more expressionistic and symbolic mode than had appeared so far.

One of the most enduring motifs in medieval art was the crucifix. The Crucifixion was a subject avoided by the early Christians; it was the Ottonian artists who first used it to portray a grim and direct picture of human suffering. The large wooden crucifix carved for Bishop Gero of Cologne (fig. 89) is like nothing we have seen before. Gone entirely is the smooth and idealized anatomy of Classical art; this is a suffering human being who actually hangs from the cross, his stomach muscles bulging from the strain of his weight. The figure is elongated, drawn downwards; the proportions are not naturalistic but the expression of suffering is. The realism of forms has been replaced by a realism of psychology, and works like this point sharply away from the pastoral bliss of Heaven to focus on the sufferings demanded in this world, with Christ as the supreme example.

This powerfully dramatic image was not exceptional in Ottonian art. A contemporary crucifix (fig. 90) suggests by its elaborate setting of gold, enamel, pearls and other jewels that its purchaser, the Abbess Matilda of Essen, was a person of refined taste. Yet here too the figure of the crucified Christ is emaciated and in agony. The apparent disharmony between the realistic portrayal of pain and its elegant, aristocratic setting does not appear to have seemed incongruous to well-born patrons like this.

One of the most influential patrons of Ottonian art was Bishop Bernward of Hildesheim, tutor and friend to Otto III, whose interest pushed into prominence an outstanding workshop of bronze-casting. His travels to Italy in the company of the emperor gave him first-hand experience of Classical art that influenced the productions of the local workshop. This workshop produced a pair of doors for the church of St. Michael in Hildesheim, decorated with bronze relief sculpture. These doors are divided into eight horizontal compartments reading down on the left and up on the right; the left door has scenes from the Old Testament, the right-hand one illustrates the New. This suggests a hierarchical scheme, but there is also a dramatic emphasis on individual stories. In figure 86 the Fall is vividly portrayed to give full weight to the meaning of the calamity for its authors. God gestures angrily at Adam, who cowers at this blast of divine fury and tries to pass the blame on to Eve, crouching low in an agony of shame and pointing in self-defence at the reptile at her feet. This forceful scene demonstrates the power the Bible had for medieval Christians.

The church for which these doors were originally made may well have been designed by Bishop Bernward himself. Badly damaged in World War II and since reconstructed, St. Michael's none the less still illustrates the consolidation of the Carolingian double-ended basilica. It is a symmetrical

88 Saint Luke, from the Gospel Book of Otto III, *c.* 1000. Munich, Bayerische Staatsbibliothek

89 (*right*) Crucifix of Bishop Gero, *c.* 975–1000. Oak, height 74 in (1.86 cm). Cologne, Cathedral Treasury

90 (*far right*) Crucifix of Abbess Matilda of Essen, 973–82. Enamel, pearls and precious stones set in filigree on a gold ground. Essen, Cathedral Treasury

building with a transept at each end; its silhouette is that of two massive blocks joined by a nave (fig. 85). It was designed with one main entrance in the middle of the nave.

A Gospel book made for Otto III in *c.* 1000 combines mystical fervour and psychological force with Byzantine hierarchism. In figure 88 Saint Luke is isolated within a mandorla (see fig. 71) and holds up pictures of five prophets accompanied by angels and his ox-symbol, all framed in circles representing clouds. God's word streams down from heaven through Saint Luke's Gospel (seen on his lap) to the lambs, Christ's flock, who drink from life-giving springs of water beneath the Evangelist's feet. Through the mediation of Saint Luke's Gospel, the prophecies of the Old Testament are brought to fruition in the teachings of Christ, which bring salvation through the waters of baptism. The static effect of so much symbolism is counteracted by the dynamic quality of the figures; the painterly skill of Ottonian artists acquainted with Classical shading and modelling adds to the work's expressive power so that we feel the whole picture is on the point of bursting out of its frame.

It is this expressive and romantic portrayal of the supernatural that the Ottonians passed on to Romanesque art. Throughout the West, the fervent Christian mysticism of the eleventh and twelfth centuries found visual expression in visionary yet powerfully real figures that writhe and dance their way over Romanesque churches and the pages of Romanesque manuscripts.

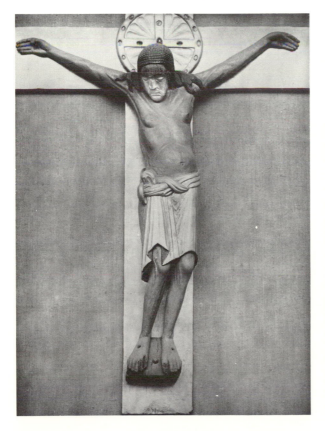

CHAPTER 4

Crusades and Pilgrimages: The Age of the Romanesque

The tenth century was a time of wholesale destruction and terror during which the civilization Charlemagne had brough to flower nearly perished. Yet by 1095, Europe was able to gather an army for the first of the great crusades undertaken to recapture the Holy Land from the Muslims. The eleventh and twelfth centuries were a time of revitalization of all aspects of life in Europe. Increased trade and new techniques in agriculture went hand in hand with an increase in population. Expanding horizons and new information stimulated intellectual and artistic growth; after centuries of poverty and bare subsistence, the period of Romanesque art and architecture, from *c.* 1000 to *c.* 1150, saw the emergence of an extraordinarily vital cultural life.

In the eleventh century much was accomplished towards establishing the internal security necessary for cultural development. By this time the Normans and Magyars had been integrated into the Christian community and so provided barriers against invasions from the north and east. Muslim domination of Spain began to weaken, permitting the gradual reconquest of the old Christian kingdoms there. The Normans, their Viking energies untamed, extended their territory and in so doing strengthened the unification of Europe; by defeating the Anglo-Saxons in 1066, William the Conqueror brought England into much closer contact with the continent, as the new Norman lords of England were also landholders in France and bound by feudal vows to the French king. Other Normans took the cities in southern Italy that were the last western strongholds of the Byzantine Empire by 1071, and drove the Muslims out of Sicily 20 years later. The new Norman kingdoms in Sicily and in Italy not only protected the southern flank of Europe against Muslim attacks from the Mediterranean; they also brought Europe into a new and revitalizing contact with the much more advanced learning of the Byzantine and Arab civilizations of the conquered territories.

Although the Norman kings in England, the house of Capet in France,

and the German emperors sought throughout this period to strengthen the power of the throne, there was little sense of nationality in Europe, and frontiers were no barrier to travellers. Europe was still a rural society, made up of independent and self-sustaining units supported by agriculture; only in the second half of the twelfth century did the towns begin to emerge as an important base of economic prosperity. The one recognized source of authority throughout Europe was the Catholic Church; as monarchs sought to extend their power, so did successive popes seek to contain them, using the threat of excommunication and invoking the religious ties that bound the crown to the Church. One revealing event of the eleventh century was the humiliation of the German emperor Henry IV by Pope Gregory VII in January 1077. The pope forced Henry to stand barefoot in the snow for three days outside the castle at Canossa before he would release the emperor from the sentence of excommunication. The issue was over who had the right to appoint bishops within a country, its king or the pope; the drama of the event distorts its importance (actually Henry gained considerable support from his act of penance), but it does indicate the extent to which, in the absence of strong central government within the European kingdoms, the Church provided the unifying factor.

It was, therefore, largely under ecclesiastical auspices that the eleventh century moved forward to new levels of civilization. This was the high point of the monastic movement, a period when dedicated and able men oversaw the rebuilding of old monasteries and founded new ones. Nor were their efforts limited to administration; it was under clerical leadership that the armies of the crusades were gathered. The reconquest of Spain, begun by the tenth century, was reinforced by religious pilgrimages.

The story of the medieval pilgrimages is a compound of faith, superstition, economic opportunism, and political acumen. When the Church began to encourage pilgrimages as a means of redemption, growing numbers of people flocked along the great pilgrimage roads, enjoying the freedom from the daily grind at home as much as the assurance of salvation awaiting them at the end of the journey. Pilgrimages were still popular in the fourteenth century; as Chaucer says in the prologue to the *Canterbury Tales*, in the spring the lure of the road was strong:

> When the sweet showers of April fall and shoot
> Down through the drought of March to pierce the root,
> Bathing every vein in liquid power
> From which there springs the engendering of the flower,
> When also Zephyrus with his sweet breath
> Exhales an air in every grove and heath
> Upon the tender shoots, and the young sun
> His half-course in the sign of the Ram has run, . . .
> Then people long to go on pilgrimages
> And palmers long to seek the stranger strands
> Of far-off saints, hallowed in sundry lands.

As the pilgrims grew in number, monasteries proliferated and expanded along the way to cater for the travellers with as sharp an eye on the main chance as any hotel owner who capitalizes on the modern sightseer. Monasteries were the only hostels in rural areas, and their counterpart to the modern tourist attraction was their possession of relics. Abbeys not actually on the main routes lured pilgrims by advertising their relics. We have several fascinating accounts written throughout the Middle Ages by the pilgrims themselves. *The Pilgrim's Guide*, written sometime between 1139 and 1173, its author tentatively identified as a Frenchman named Aimery Picaud, describes the roads, the countries through which one passed, the inns, the food, and the treatment pilgrims could expect to receive, bringing the age to life with a startling clarity. Gascony had wonderful white bread and good wine, but the Gascons were boasters and mockers and indelicate of behaviour. The people of Navarre were worse — perverse, perfidious, disloyal, corrupt, libidinous, and given to all sorts of violent and illicit conduct. His suspicions of foreign food and strange customs sound remarkably like the complaints of modern tourists. He lists all the major shrines, giving the background of the local saint and a summary of his major miracles. The pilgrims seem to have been eager to visit all the shrines, and if the road was long and hard, they were protected to some extent from injury and theft by the Church's threat of excommunicating anyone who cheated or harmed them.

There were three major sites to which the medieval pilgrims journeyed. Two of them, the Holy Land and Rome, had been the goals of pilgrimages since the beginnings of Christianity. The third was added in Carolingian times, when in 830 the Spanish Bishop Theodemir discovered what he believed to be the tomb of Saint James, one of the Apostles of Christ, on the site now occupied by the basilica of Santiago (St. James) in Compostela. The sanctity of the corpse was proved by the fact that no one could remove it from its tomb; according to Aimery Picaud Saint James shared this miraculous quality with three other saints. Soon his burial place became a shrine visited by numbers of pilgrims who proudly wore scallop shells gathered in the vicinity to show that they had been there. The shrine of St. James at Compostela came to rival the other two pilgrimage sites, and a network of roads wound through southern France and over the Pyrenees to converge on Compostela.

Early Romanesque

The steady traffic along the pilgrimage routes led to new ideas mixing with local customs during a period of church building so universal that half-way through the eleventh century the Benedictine monk Raoul Glaber said, 'so it was as though the very world had shaken herself and cast off her old age and were clothing herself everywhere in a white garment of churches'. It

91 Church of St.-Martin-du-Canigou, south-west France, 1001-26, restored in the 20th century

92 (*below*) Crypt, Chartres Cathedral, 858

93 (*bottom*) St. Sernin, Toulouse, interior of nave, *c.* 1080–1120

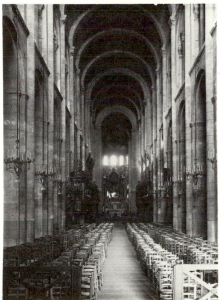

was not uncommon for pilgrims to travel both to Rome, passing through Lombardy, where Classical building techniques had never wholly died out, and then on to Compostela, providing contact with Islamic art in Spain, while those who survived the long and dangerous journey to Jerusalem brought back memories of the Near East and Constantinople. All of these influences combined with the indigenous traditions of Carolingian and Ottonian art to create a style whose works have the definite flavour of a particular province, yet share common elements of an international style.

Romanesque architecture developed in response to the need to rebuild monasteries destroyed by invasions and to provide new facilities for an increasing population. It appeared simultaneously all over Europe, never dependent on a single centre or court as Carolingian and Ottonian art had been, but chiefly promoted and diffused through the auspices of the Church. Secular buildings of the time shared the basic characteristics of the Romanesque style, but the monuments upon which the most money and càre were lavished were the churches; it is not only because religious buildings are more likely to survive than secular ones that the overwhelming number of major Romanesque buildings are churches; it was a predominantly religious art.

Two of the developments which separate the mature Romanesque church from its Carolingian and Ottonian predecessors are the improvement of vaulting techniques enabling whole structures to be roofed in stone, and a new design encircling the sanctuary with an ambulatory and radiating chapels. The experiments in more extensive stone vaulting were stimulated by the urgent need to make buildings more fireproof against both enemy attacks and natural disaster. The first steps in stone-vaulting a nave were on a small scale and led to forms rather different from the larger and lighter timber-roofed structures such as St. Michael in Hildesheim. The abbey church of St.-Martin-du-Canigou, built at the same time as St. Michael, is really an example of the first stage of Romanesque architecture rather than a continuation of Carolingian style (fig. 91). It sits in a picturesque spur of the Pyrenees, invisible from the road winding up from the valley until one rounds the last corner. Although never attacked during the Middle Ages, it was abandoned after the French Revolution and allowed to fall into decay; in the mid-twentieth century it was restored and forms one of the best surviving examples of early Romanesque architecture.

In *c.* 1001–26 the monks vaulted over the first church, which became the crypt, and built the present church above it. This had a barrel-vaulted nave and two aisles, almost as high as the nave, roofed with half-barrels. The stone vaults are carried on amazingly slender columns with capitals skilfully decorated in carved scroll-work derived from Islamic art. Only in the centre, where the weight is heaviest, is the roof supported by a pair of stout piers. Compared to St. Michael in Hildesheim, or the upper storey at

Corvey, St.-Martin seems dark and tunnel-like, yet it has the simplicity and charm of a style in the making.

The ambulatory with radiating chapels developed in France, in response to the effect of large numbers of excitable pilgrims on monastic routine. The crowds pressing to see the relics they had come so far to venerate often trampled one another, and the monks were distracted from their prayers. To make it easier for the pilgrims to see the relics (which included what was believed to be a piece of the Virgin's tunic) the monks at Chartres, rebuilding after a Norman raid in 858, put an ambulatory around the apse of the crypt (fig. 92). This arrangement was improved upon in *c.* 1020, after another fire; this time a larger ambulatory enveloped the earlier one and opened into three chapels, enabling pilgrims to withdraw from the mainstream of traffic without halting the progress of others. This unit of apse and ambulatory with radiating chapels, called a chevet, became an integral feature of many mature Romanesque churches from which they derived the characteristic exterior appearances of square or semi-circular blocks piled up in ascending masses to the crossing tower (fig. 102).

The Mighty Fortress of God: High Romanesque

By the end of the eleventh century the first tentative experiments in vaulting and in the chevet had matured, though architects continued to improve further on past experience. A twelfth-century pilgrim arriving in Toulouse, the capital of Languedoc, would not fail to visit the church of St.-Sernin, built between 1080 and 1120. Aimery Picaud refers to it as an 'immense basilica', and he must have been impressed by a sense of unity and harmony in its design. The architect was still experimenting with new forms, but by this time with the knowledge of earlier buildings such as St.-Martin and Chartres. At St.-Sernin the nave is barrel-vaulted throughout (fig. 93), and visitors could process in orderly fashion around the monks' sanctuary along the ambulatory, stepping into one of the apsidal chapels if they wished. The continuous flow is visual as well as physical. We can see how the architect achieved the unity of his design from the plan of the church (fig. 94). The geometrical harmony comes in part from the fact that a single module, the aisle bay, governs the dimensions of the whole building. The aisle vaults are not half-barrels as at St.-Martin-du-Canigou; they are groin vaults, as in the tribune at Corvey. The advantage of groin- over barrel-vaulting is that the diagonal arches that form an X across the square or rectangular bay carry the weight to the supports at the four corners, localizing the thrust at specific points that can be designed to carry the load. A barrel vault, on the other hand, deposits its weight continuously and is only reinforced by transverse ribs. Such ribs do not direct the thrust to any particular point.

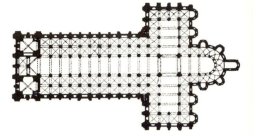

94 Plan, St. Sernin, Toulouse

95 Relief of an angel, from St. Sernin, Toulouse, *c.* 1090 (now in the ambulatory)

96 (*below*) Saint Peter, from the abbey cloister, Moissac, *c.* 1120

97 (*bottom*) Two kings, frontispiece from Josephus, *De Bello Judaico, c.* 1070. Paris, Bibliothèque Nationale

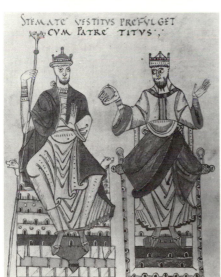

Each groin and the piers supporting it form a single bay. The sense of unity is increased in St.-Sernin because the architect divided the nave into bays of the same length and twice the width of the aisle bays. The transverse ribs which emphasize this division rest on long semicircular columns, called responds, running the entire height of the nave from floor to vault. The piers that carry the weight of the vaults face squarely towards the altar, marking off the space between bays; the eye moves rhythmically forward bay by bay. This horizontal progression towards the altar is a major feature of Romanesque churches.

To the Romanesque architect, a building was a bare stage to be filled with ornament. Lamps, jewelled crosses and reliquaries, and other gilt and jewelled furnishings added a rich glitter. Sculpture was covered with bright paint, and architectural members as well were often painted in colourful designs, which intensified their ornamental aspects. As is the case with ancient Classical ruins, we see Romanesque buildings like St.-Sernin as much more stark and severe than they appeared originally.

The sculpture at St.-Sernin that dates from the period of its construction lacks the maturity of the architecture. Figure 95 is a large relief apparently modelled on examples of Roman sculpture. Nevertheless, it was carved with more attention to the decorative lines of wings and robe than to physical solidity; this angel begins with a life-like head and shoulders, but his corporeal presence disappears into the abstract drapery, to re-emerge in the beautifully modelled feet.

Despite the classical elements, this sculpture is actually closer to the style of manuscript drawing than to that of Roman sculpture, although examples of Classical statues must have been known to the artist. The abstract and linear quality descended from Irish and Carolingian manuscript illumination was a predominant influence on Romanesque art, as we can see from an early Romanesque manuscript made around 1070 at the abbey of Moissac, near Toulouse (fig. 97). And if we compare this drawing of two Old Testament kings to another contemporary relief carving, an Apostle also from Moissac (fig. 96), we can see that the same conventional linear patterns are used in both to indicate joints and bulges in anatomy and folds of clothing.

The basic form of the Romanesque basilica appeared throughout Europe, modified by local custom and influences, so that there are almost as many variations to the style as elements in common. Thus two buildings as different as St. Mark's in Venice (fig. 98) and Sant' Ambrogio in Milan (fig. 100) are both Romanesque, although the former, which stands in the city most continuously in contact with the Byzantine Empire, has a more-than-Oriental splendour in its soaring domes and glittering mosaics that recalls Santa Sophia (fig. 60), while Sant' Ambrogio takes us back through Lombard traditions to the massive solidity of ancient Roman architecture. Three of Sant' Ambrogio's four nave bays are vaulted with ribbed groin vaults. The ribs rise from the piers supporting the four massive arches of

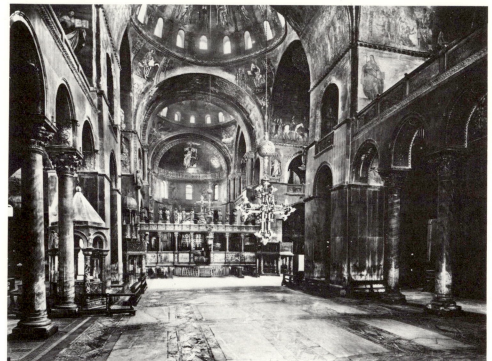

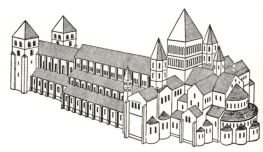

98 (*left*) Basilica of St. Mark, Venice, begun 1063

99 (*above*) Elevation of the third abbey church at Cluny, begun in 1088

100 (*below left*) Interior of nave, Sant' Ambrogio, Milan, begun in the late 11th century

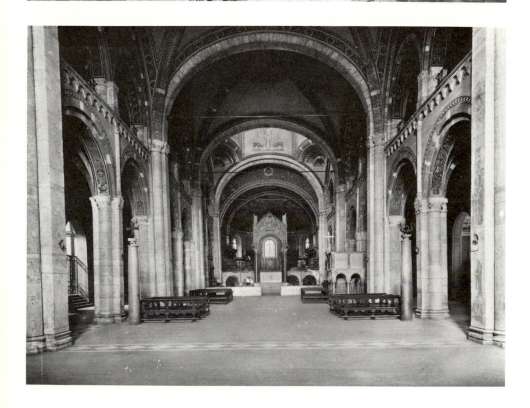

Right

101 (*top*) Interior of the church of the Sacre Coeur, Paray-le-Monial, *c.* 1100

102 (*bottom*) Paray-le-Monial, view from the east

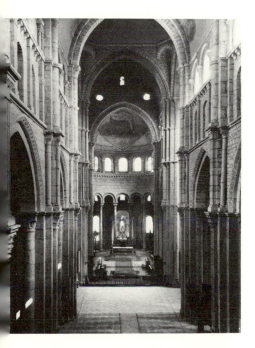

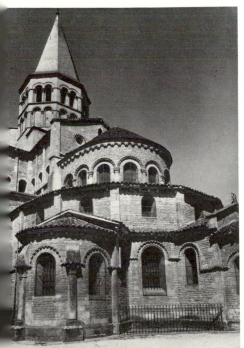

each bay. The vaults rise into semicircular quasi-domes, but with an entirely different effect from the soaring quality of St. Mark's true domes. Yet both buildings, so different in their immediate effect, articulate the same combination of the real and the supernatural, of mysticism and militancy, that made up the eleventh-century faith. It is this aesthetic expression of medieval Christianity, not only the shared use of elements such as round arches, barrel- or groin-vaulting, and columns or pilasters, that makes a church Romanesque.

The most powerful monastic order in Romanesque Europe was the Benedictine order of Cluny. Founded in 910, the Burgundian abbey of Cluny was specially authorized by the pope to found new abbeys under its direct control and, in some cases, to take over existing foundations, thereby establishing a system organized like a feudal hierarchy where hitherto all institutions had been autonomous and answerable only to Rome. A series of abbots who were men of culture and learning as well as devout and dedicated monks fostered the arts in Cluniac establishments in different parts of Europe. The high point of Cluny's power came under its most brilliant abbot, Hugh of Semur, who began a new church at Cluny, its third, which he intended to be the greatest church in Christendom. Unfortunately for us it was sacked during the French Revolution and subsequently blown up for use as building materials. All we have left are a number of columns with sculptured capitals and one arm of a transept. But from the number of buildings remaining that imitated Cluny, we can trace the influence of the great church on Romanesque art.

The church was begun in 1088. It was designed with a chevet, and had two transepts (fig. 99), a motif copied as far away and as late as the thirteenth century in the cathedral of Salisbury in England. The barrel-vaulted nave at Cluny rose 98 feet, an audacious venture, for the vaults collapsed in 1125, after which they were rebuilt with a prototype of the flying buttress. The barrel vaults were slightly pointed, foreshadowing the development of the Gothic vault. The pointed arch, a feature probably derived from the Near East, was used also in the nave arcade supporting the vaults. The pointed arch has the advantage over a round one in that the weight of the vault does not rest squarely on the centre of the arch but is carried down the peaked sides to the piers from which the arch springs.

The advantage of this distribution of weight can be seen in a miniature version of Cluny at Paray-le-Monial (fig 101); the pointed arch allows for a clerestory that illuminates the nave directly. As at Cluny, the architect at Paray reduced the gallery level to a flat blind arcade articulated by fluted Corinthian pilasters. This makes an elegantly subtle transition between the nave arcade and the clerestory, foreshadowing the treatment of storeys in the great Gothic cathedrals. The nave arcade is more ornamental than the plain grouped piers and unadorned arches of St.-Sernin. A series of pilasters and half-columns rise in marked levels to the vaults, while the pointed arches are decorated with a band of ornamental carving. In the

ambulatory the motif of abstract ornamental stone-banding appears again to form a purely decorative blind arcade around the ground storey that echoes the curves of the ambulatory vaults and the clerestory above.

If the interior of Paray-le-Monial seems more feminine and sophisticated than the sturdy churches of the pilgrimage roads, the exterior presents the same fortress-like mass of blocks climbing in levels to the crossing tower (fig. 102). Unlike the floating, shimmering view one has of a Gothic cathedral from far off, we see Romanesque churches as firmly attached to the earth. The militant image of the church as a fortress was appropriate to a faith whose members were then turning out the largest army that had ever been amassed in Christendom. The high altar at Cluny was consecrated in 1095 by Pope Urban, himself a Cluniac, who was in France to preach the First Crusade, and it was fitting to Cluny's place in Western Christendom at this time that the most sacred part of its new church should have been ready for consecration at the moment when Europe, so long battered and on the defensive, was ready to launch an offensive against the infidel in the Holy Land itself. The high altar stood within a semicircle of slender columns, imitated by the colonnade at Paray. The motif at Cluny was possibly derived from Constantine's rotunda around the Holy Sepulchre, the shrine in Jerusalem that the First Crusade set out to recover.

Romanesque sculpture combined the desire to ornament with the need to instruct, even in the carving of the capitals of the columns high overhead. At Cluny, the sanctuary capitals, circular at the base and square at the top, were carved according to a complex and learned programme illustrating the mathematical and harmonious properties of the universe. The idea of a universal law based on number symbolism goes back to ancient times. In *c.* 1047 the monk Raoul Glaber, who ended his days at Cluny, wrote out a system by which all the workings of the universe are governed by quaternities, or sets of four. He paired the four Gospels, for example, with the four elements of air, fire, water, and earth. Likewise, the four virtues (Justice, Prudence, Fortitude, Temperance) complement the four rivers of Paradise. He went on to connect each of the Evangelists with a particular virtue and element (Matthew was characterized by earth and justice; Mark by water and temperance). The four-sided capitals from the sanctuary colonnade illustrate Raoul's quaternities and add others of their own. Figure 103 depicts the four rivers, personified as figures with fountains gushing forth at their feet, surrounded by four trees: the apple and the fig, associated with the Fall, the grape-vine associated with the Eucharist, and the almond, connected to the Resurrection through the blossoming of Aaron's rod (Numbers 17:8).

Music held a high place at Cluny. The Cluniacs perfected the Gregorian plainsong, which is based on eight tones, each belonging to a separate mode; each mode is associated with a special quality. Thus the eight tones form a double quaternity, illustrated on the capitals with loving

103 (*below*) Capital showing the four rivers of Paradise, originally from the sanctuary of the abbey church, Cluny, *c.* 1095. Now in the Musée Ochier, Cluny

104 (*bottom*) Capital showing the first note of plainsong, *c.* 1095. Cluny, Musée Ochier

Right

105 (*top*) Christ in Glory, *c.* 1100. Fresco in the apse of the chapel at Berzé-la-Ville, near Cluny

106 (*bottom*) The Annunciation, from a lectionary, *c.* 1120. Paris, Bibliothèque Nationale (N.A.L. 2246)

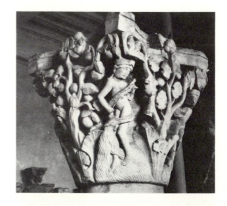

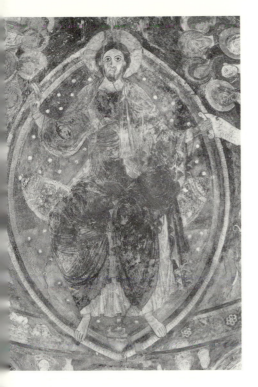

care, each as a musician playing an instrument suitable to the character of the mode beginning with that tone (fig. 104).

These charming and life-like figures from Cluny show an advance in skill over the figures at St.-Sernin and Moissac. They are carved with more plasticity and move freely within their almond-shaped frames. The increased naturalism did not come from a closer observation of nature or of human models; rather, it was a more experienced and assured adaptation of the linear style of manuscript illustrations; the little capital figures take us back to the Utrecht Psalter drawings (fig. 80). A lectionary produced at Cluny (fig. 106) in c. 1120 shows the same diagonal lines of drapery with circular folds to denote bulging anatomy. This crisp treatment, still more decorative than naturalistic, became a standard convention in Romanesque painting and sculpture.

From surviving Cluniac frescoes we can see how these conventions were developed in large-scale painting as well as in small illuminations. The Romanesque period revived the technique of large-scale mural painting, although not the true fresco of Roman painting, which involves painting on wet plaster. The fresco painting at Cluny was done on a wall prepared with tempera, or pigments mixed with egg or some other binding substance. The apse at Cluny had a great painting of Christ in Majesty, surrounded by an almond-shaped mandorla and flanked by the symbols of the four Evangelists. A smaller version, quite likely by the same artist, survives in the little chapel built at the abbey's farm in Berzé-la-Ville, Abbot Hugh's favourite retreat (fig. 105). The stiff frontal pose and almond-shaped eyes derived from Byzantine sources. But no Byzantine Christ would have expressed such tension and drama; this figure threatens to burst out of the confines of the mandorla. The elements drawn from Ottonian, Carolingian, and Byzantine art have been synthesized into a mature style, confidently handled.

Romanesque Art as a Portrayal of Christian Faith

The fact that Romanesque art appeared all over Europe virtually simultaneously makes it impossible to pinpoint one particular source as the dominant influence on its formation. Extensively promoted by the expanding monastic orders, the style also drew on the common background of early medieval art. As wealth and population increased, art and architecture burgeoned, influenced everywhere by a steady influx of new ideas. Pilgrims and crusaders returned home to tell of what they had seen, manuscripts were presented as gifts, helping to disseminate the conventions of the style, and everywhere the desire to build to the glory of God forged the expressive aesthetic of the militant Church.

Throughout this period the deep spiritual faith in Christian teaching prevented any real separation between secular and religious aspects of life.

Political decisions were guided by religious considerations. Before William, Duke of Normandy, set out to conquer England, he made clear his legal claim to the throne, based on the irrevocable nature of a feudal oath sworn before God. The famous eleventh-century tapestry that celebrates his victory in 1066 is not just a secular account of the Conquest, although each episode is shown in detail to give us a vivid picture of eleventh-century warfare (fig. 111). It was a religious document as well, probably made for Bayeux Cathedral in Normandy; the victory was won, in Norman eyes, because William's claim was just in the eyes of God.

The Christian faith that bound Europe together was a literal-minded mysticism, in which the miraculous was as real as the everyday commonplace and the ordinary as strange and wonderful as the miraculous. There are countless examples of the power of medieval religion. The author of *The Pilgrim's Guide* speaks with genuine fervour of the healing power of the bodies and clothing of the saints, pointing out the relics a pilgrim should not fail to visit. He cites again and again the benefits gained through the intercession of the saints; a sick man touches the tunic of Saint Giles and is healed, a man bitten by a poisonous snake is cured, a tempest at sea is calmed. He speaks in a rational and convincing tone which is very different from the self-induced hysteria of late medieval pilgrims, for whom the separation between the miraculous and the everyday world became tragically acute.

It is the power of faith that imbues all Romanesque art with its special character, whatever its local characteristics. The mannerisms that passed quickly into the repertory of artists everywhere, either through direct contact or from manuscript illustrations, were those that provided a way of expressing the dynamic energy of the religion. For example, a motif first found in Languedoc, the region of Toulouse and Moissac, soon appeared in regions far from Languedoc. The cross-legged pose seen in figure 107 was originally connected with a ritual dance; we see it frequently associated with dance or music (see fig. 114). But it was also used, along with the wide-eyed stare from Byzantine art and draperies tossed up by an unseen wind, to suggest mystical possession; the prophet Isaiah from Souillac (fig. 107) is moving to an inner rhythm known only to himself. We find the same pose used to express powerful religious emotion or mystical trance throughout Europe, as, for example, in a Virgin and Child from Lombardy (fig. 108), and at Malmesbury Abbey in Wiltshire, England (fig. 109). There are local variations; the Anglo-Norman sculpture at Malmesbury is heavy and suggests brute force as much as mysticism, while the statue from Lombardy has marked elements of classical humanism. It is a closed composition and excludes the spectator from direct participation in the urgency with which the pair embrace, an urgency foreshadowing the tragedy of the cross. But the classicism of form has less impact than the expression of feeling; although the Virgin and Child are modelled with rounded limbs and real weight, in contrast to the elongated

107 Isaiah, relief from the church of Sainte Marie, Souillac, *c.* 1130

108 Virgin and Child from Lombardy, lake 12th century. Polychrome stone, height 29 in (74 cm). Boston, Museum of Fine Arts, Maria Antoinette Evans Fund

109 Tympanum of the south porch, Malmesbury Abbey Church, *c.* 1155–65

110 Trumeau from the porch of the Church of St. Pierre, Moissac, early 12th century. The prophet is usually identified as Jeremiah

111 A scene from the Bayeux Tapestry, *c.* 1080. Height 19 in (48 cm). Bayeux, Museum
This is not actually a tapestry; the design is done in needlepoint rather than woven into the fabric. The whole tapestry is 230 feet long.

107

108

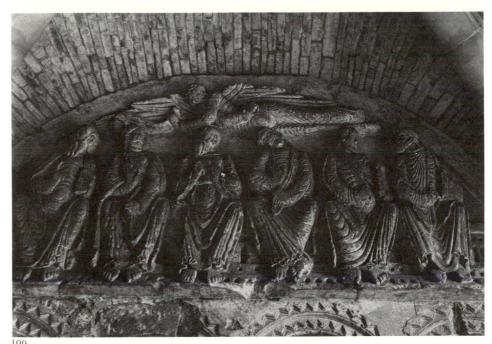

109

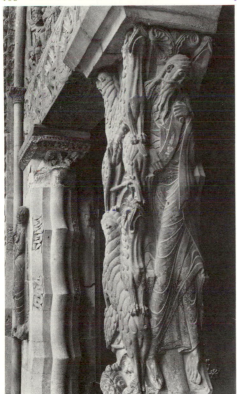

110

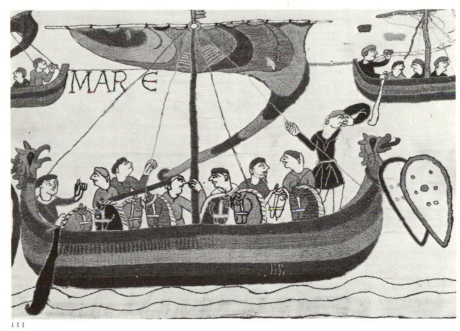

111

form of the Isaiah at Souillac, both works express directly the fervent emotion of medieval Christianity.

Romanesque sculpture developed in close alliance with Romanesque architecture; some of its special power comes from the fact that the figures conform to their architectural frames rather than to human proportions. The arrangement of ornament was apt to be haphazard. Despite the organization of design seen at St.-Sernin and at Cluny, Romanesque churches give an impression of their single parts more than of a single whole; we see a series of views glimpsed through aisle colonnades, into chapels, and around corners. We read the parts separately and cumulatively. Figures sprout organically from the various shapes of the architectural elements, with little sense of natural space. In figure 109, the figures are crowded into the tympanum, the semicircular frame over the door; the angel floating over the heads of the seated Apostles is stretched and thinned out to fit the narrow space left for him. One Apostle has to duck his head in an uncomfortable twist to make room.

The trumeau, or post between the doors, was even more confining; in figure 110, from Moissac, lions criss-cross on the front and back faces, while human — but scarcely human — figures are set into each side. The prophet shown here was the model for the Isaiah at Souillac, but he is elongated all out of proportion and jammed into his narrow space, whereas Isaiah, originally placed on the door jamb at Souillac, had more room for his spirited dance. Yet both express the frenzy of inspiration; indeed, the prophet at Moissac seems to gain a sense of suppressed energy from his imprisonment in the architecture.

The stylistic connection between the various branches of the arts in the Romanesque period is striking. The trumeau at Moissac, with its figures interwoven into the architectural frame, reminds us of the way in which manuscript illuminators ornamented capital letters. The same delicate interweaving of organic and inorganic forms occurs on a gilt candlestick made for Gloucester Cathedral, in England (fig. 112). This Norman candlestick also shows the influence of Celtic design on the Romanesque style; compare the lions on the trumeau at Moissac and the figures on the candlestick to the interlacing figures decorating the carpet page of the Lindisfarne Gospels (fig. 75).

Already by the time the Moissac and Souillac prophets were finished, the delicate lines of earlier Romanesque carving had become hardened by repetition; we find in twelfth-century sculpture a more pronounced decorative fussiness and a reluctance to leave any bare space (fig. 114). That Romanesque sculpture did not become sterile with the repetition of familiar forms was due in part to the infusion of a theatrical sense of scene that came from the increased use of drama to enliven the church liturgy. The plays performed on feast days vividly enacted the Bible stories, and scenes from them were adapted to sculpture. In figure 114 Salome dances seductively before King Herod, who chucks her under the chin. It was as

112 Candlestick made for Gloucester Abbey Church (now the cathedral), 1104–13. Gilt bell metal, height 23 in (58.5 cm). London, Victoria and Albert Museum

113 (*top*) The Angel appearing to the Wise Men, from Autun Cathedral, *c.* 1135–40. Autun, cathedral chapter room

114 (*above*) Herod and Salome, capital from the cloister of the monastery of St.- Étienne, Toulouse, *c.* 1130. Toulouse, Musée des Augustins

her promised reward for entertaining him that she demanded the head of John the Baptist. Figure 113, from Autun, is a scene from the story of the Three Wise Men (Matthew 2:1–12), performed on the feast of Epiphany. An angel appears to the Wise Men in a dream, warning them not to return to King Herod. To fit everything in, the sculptor sacrificed perspective and stacked the kings vertically, curving the bed to leave room for the angel. But he achieved a surprising realism in the way in which the angel gently touches the hand of one king, who opens his eyes sleepily, as one still in a dream.

Art and Christian Doctrine

The liturgical drama grew out of a need to put the church services, which were in Latin and must have seemed remote to most worshippers, into a more vivid and concrete form involving everyone in the story. In the same way, depicting parables and legends in sculpture brought the Bible to life for the illiterate peasant. The urge to visualize the teachings of the religion led to a programmatic and complex synthesis of art and dogma, most thoroughly worked out in the decoration of the main door at the west end of a church. The iconography may have developed partly from an erroneous association of the word *occidens* (west) with the word *occidere* (to kill), thereby associating the western façade with death. But it also must have seemed increasingly fitting that the entrance of a church should hammer out the need for repentence, while the sanctuary end should stress forgiveness and redemption. Thus the subject of the sculpture over the western portal usually centred on the Day of Judgement, from the Book of Revelations. On the tympanum at Autun (fig. 115) the theme is vividly expounded; on the bottom row the dead awaken, in great fear, from the grave; above, Christ separates the blessed (on his right hand) from the damned. An angel and a devil are busy weighing souls; the one in the scale is saved, for his good deeds outweigh the bad; the devil howls in rage at this escape. The Burgundian artist who signed his name, Gislebertus, to this work was particularly adept at portraying demons, who appear as half human, half monstrous creatures. The damned convey their despair more powerfully than the blessed their happiness, for the tortures of damnation were more vivid to the medieval mind than the bliss of salvation.

At the nearby monastery of Vezelay, though, there is a tympanum in the narthex of the church of the Madeleine contemporary with the one at Autun that softens the message to emphasize redemption over judgement (fig. 116). This scene also comes from Revelations, but from a part stressing the promise of eternal life for all men:

Then he showed me a river of the water of life, sparkling like crystal, flowing from the throne of God and of the Lamb . . . On either side of the river stood a tree of life, which yields twelve crops of fruit, one for each month of the year;

the leaves of the trees serve for the healing of the nations. Every accursed thing shall disappear. The throne of God and of the Lamb will be there, and his servants shall worship him; they shall see him face to face, and bear his name on their foreheads. There shall be no more night, nor will they need the light of lamp or sun, for the Lord God will give them light; and they shall reign for evermore.

Revelations 22: 1–5

Christ sits between the spring of the water of life and the tree whose leaves heal the nations. The nations to be healed are represented by the figures around the edge of the tympanum; some are shown as cripples, and some are legendary figures representing far-flung tribes, including dog-headed men popularly supposed to dwell in India and pig-snouted figures located in Ethiopia. No tribe was too strange or too far off to be brought into the Christian faith.

The rays that stream from Christ's right hand represent the knowledge of God, the light that Revelations says will replace the light of day. This is passed down to us through the Apostles, who are receiving their commission to convert the heathen. The idea of knowledge as rays of light came from the writings of the Pseudo-Dionysius (see above, p. 56), who compared the passing down of the knowledge of God from its source to the way in which the sun's rays illumine the world. The water of life is connected to the light of divine knowledge through the rite of baptism, and, appropriately, Saint John the Baptist stands on the trumeau under the tympanum.

If the message at Vézelay departs from the judgement theme at Autun, the style of carving is very similar in both. The compositions are crowded, not only because of the encyclopedic nature of Christianity that drew on the whole universe for its iconography; the crowding reflects the feelings of the artist as well as of the churchmen behind him. No space was left blank if a figure could be included, and no figure was left with a plain surface. Monsters, fabulous creatures from the Classical bestiaries and Irish art, strange foliage and ornamental design all appeared as much for their own sake as for their religious significance.

Not every churchman approved of this luxuriant growth of ornament. Saint Bernard of Clairvaux (*c.* 1090–1153), puritan and reformer, thundered against the proliferation of profane figures:

In the cloister, under the eyes of the brethren who read there, what profit is there in those ridiculous monsters, in that marvellous and deformed beauty, in that beautiful deformity? To what purpose are those unclean apes, those fierce lions, those monstrous centaurs, those half men? ... In short, so many and so marvellous are the varieties of shapes on every hand, that we are more tempted to read in the marble than in our books, and to spend the whole day wondering at these things rather than in meditating the law of God.

115 (*top*) The Last Judgement, west tympanum, Autun Cathedral, *c.* 1130–5

116 (*bottom*) Christ's commission to the Apostles, narthex tympanum of the Church of La Madeleine, Vézelay, *c.* 1120

Saint Bernard spoke for all puritans in his distrust of art because its sensuous appeal may distract the mind from higher thoughts.

Transitions and Experiments: the Rib-Vault

Romanesque art and architecture did not come to an abrupt end but gave way, more rapidly in France, more gradually elsewhere, to a new style, the Gothic, that began in the Île de France, the area around Paris. The Gothic style was a natural development of Romanesque techniques; all its elements can be found in Romanesque buildings, though never combined together. The basis of the Gothic style lay in the results of the ceaseless experiments of Romanesque builders in techniques of support which finally arrived at the rib-vault (see fig. 39 above).

As Vézelay marks a transition in the programme of its entrance portal, so it provides us with a transitional stage in vaulting. The nave (fig. 117) was not finished until after a fire in 1120, and it is not barrel-vaulted but groin-vaulted. The advantage of this, as we have seen, is that weight is directed to the corners of each bay rather than continuously along the wall. This meant that Vézelay could be given a much larger clerestory than was possible in the barrel-vaulted nave of Paray-le-Monial without weakening the support of the vaults.

The possibilities of the groin-vault were not fully realized until the addition of masonry ribs which strengthened the groin. The origins of the medieval rib-vault have puzzled art historians; it was a technique known to the Romans and may have come into medieval architecture through Lombardy, where the rib-vaults in Sant' Ambrogio (fig. 100) may have been built as early as 1100. Rib-vaulting was also used in Islamic architecture, at least in a decorative fashion; pilgrims and crusaders were familiar with examples in Spain and in Syria. Whatever its source, it was the Normans who developed the rib-vault into its definitive form, which passed into the Gothic style.

The Normans, indefatigable travellers and energetic builders, wanted height in their churches, which the employment of the rib-vault helped them to achieve. The first example that we know of occurred in England, in Durham Cathedral. This church was built over a considerable period of time, allowing for improvement and experiment. The earliest rib-vaults are in the choir aisles (1093–1104). By the time the nave was vaulted in 1107–28, the architect was experienced enough to achieve an impressive three-storey elevation that included both a gallery and a clerestory (fig. 118). Each double bay in the nave is a rectangle twice the length and twice the width of each aisle bay, and has two pairs of diagonal ribs forming a double X. The transverse arches rest on enormous grouped piers, but the intermediate diagonal ribs rest on comparatively slender columns, creating a new visual rhythm of alternating supports. We can see the stages of

119 Interior of the nave, St. Étienne, Caen, *c.* 1115–20

Left

117 (*top*) Interior of the nave, Vézelay, *c.* 1120–40

118 (*bottom*) Interior of the nave, Durham Cathedral, 1098–1128 In England, high Romanesque art is Norman art, introduced after the Norman Conquest.

experimentation as we look down the nave towards the choir. The transverse arch at the crossing is round, but the next arch is pointed, enabling it to reach the height of the diagonal ribs. By this time, the architect had become fairly sophisticated in handling weight and thrust.

In Caen, the capital of the Duchy of Normandy, the abbey church of St.-Étienne, founded in 1063 by William the Conqueror, carries the Durham experiments a stage further. At the time of its foundation, St.-Étienne was designed as a wooden-roofed church with a three-storey elevation including a clerestory. By the time it had risen to the level of the vaults, the experiments at Durham led the architect to employ stone rib-vaults (fig. 119). He divided his bays somewhat differently from Durham; each double bay has a single pair of ribs with a transverse rib bisecting them. This sexpartite vault is stronger than one divided by a simple pair of diagonal ribs and enables the transverse arch between the bays to be lighter. The effect is more harmonious than at Durham.

The rib-vault combined with a pointed arch is a feature of Gothic architecture, but in these Norman churches the effect of ribs resting on front-facing piers is still solidly Romanesque and emphasizes horizontal movement towards the altar. Throughout its technical evolution, Romanesque architecture adhered to an aesthetic intention opposite to the lightening effects that logically result from the combination of pointed arch and rib-vault; it remained massive and horizontal, the solid fortress of a militant and rural Church.

By the second half of the twelfth century, the predominantly rural life of the manor and the monastery was being challenged by a quickening pace of life in the towns. Power within the Church shifted correspondingly from the rural monastery to the town cathedral; the sturdy Romanesque building atop a hill yielded to the high, thin spires visible above town roofs. The increasing importance of urban centres led to the growth of craft guilds, organizations run by the artisans themselves, and the chiefly clerical patronage of Romanesque art gave way to the increasingly secular-minded patronage of king and aristocracy.

CHAPTER 5

Art as Metaphor: The Gothic

The thirteenth century was a period of profound change in European life. Europe was still predominantly an agrarian society (and would remain so for many centuries to come), but the focus of activity was clearly shifting to the towns. With the revival of trade and the emergence of a middle class, European society became a much more complex organism. Trade reached levels not seen since the Roman Empire. Whole areas became prosperous from one commodity; Flanders profited early from the wool trade to become a thriving centre of middle-class mercantile power. Venice built up a maritime empire by exploiting her location as a port city on the Adriatic. New wealth shifted the balance of power; a few merchants became rich enough from investing the profits of their trade to finance the affairs of state, even to the raising of armies. Already in the thirteenth century money was trickling down to the lower ranks; serfs paid to perform certain extra services were sometimes able to save enough to purchase their freedom.

The influx of capital strengthened the position of the towns, enabling many to buy their independence from the local lord. Trade also aided the crown through taxes on exports and imports. Although change was gradual, there was a steady development towards centralization of government and an awareness of national identity.

The growing role of towns in European life created a more complex cultural climate and weakened the control the Church had earlier maintained over secular affairs. Before the twelfth century, the schools run by cathedrals and monasteries were the sole source of education, and the curriculum had been restricted to the seven Liberal Arts: grammar, rhetoric, and logic (called the trivium), and arithmetic, astronomy, geometry, and music (called the quadrivium). Its limitations may be imagined when we remember that in the case of arithmetic all calculations were carried out in Roman numerals. The adoption of the Arabic numerals we use today was one of the many advances gained from contacts with Arab and

Byzantine culture in the twelfth century. The Norman conquests in Sicily and southern Italy, the recapture of Spain, and cultural links with Byzantium created new access to ancient writings that had been preserved by Arab and Jewish and Greek scholars. New Latin translations of Aristotle, Euclid, Ptolemy, and of the Greek physicians not only revitalized the Liberal Arts but made possible a degree of specialization not achieved earlier. The University of Paris, an outgrowth of the cathedral school of Notre-Dame, became famous for the teaching of theology. Bologna was pre-eminent in law because it was there that Justinian's codification of Roman law, newly restored to the West, was studied and interpreted. Montpellier became a famous centre for medicine.

The university as an organization distinct from the monastic schools emerged from unions of students who were granted charters by the crown; the students at Bologna were guaranteed certain privileges by the emperor in 1158. The university faculties were organized in the thirteenth century into guilds, or colleges, that restricted entrance into the teaching profession by setting examinations and awarding degrees to successful candidates. Although the universities were under clerical authority, scholars were now a professional class set apart from the preaching clergy, while the students were protected by royal charters.

The revival of urban life meant an increased independence also for the various trades that grew and prospered within the towns. Each craft had its own guild, an organization largely self-governed that controlled the standards of the work produced and the conditions of entrance into the trade. Painting was on the same level as other crafts such as the making of shoes, barrels, or bread. Masons, however, achieved a somewhat higher eminence than painters or metal-workers because they could rise to the status of an architect in charge of a building's design and construction.

Despite the fermentation of new ideas and the changing situation, there was no apparent weakening of religious faith in the thirteenth century. The interpenetration of religious and secular themes was evident everywhere. Politics were still governed by the semi-religious feudal oath. The institution of a knight was as much a sacred as a secular ceremony; to break a feudal oath was a sin as well as a crime. The courtly romances invented to amuse the nobility acquired the trappings of religious ceremony, elevating the chivalrous deeds and love affairs of their heroes. The Church had its own heroine in the Virgin; the images of Mary invest her with the same grace and beauty as the troubadors ascribed to the ladies for whom knights performed valorous deeds, while the knights treated their ladies with the awe and adoration accorded to the Virgin.

The new art style that emerged in the late twelfth century was given the name *Gothic* by later critics, who found the frothy façades and soaring spires barbaric. The name is a misnomer as well as an unfair criticism, for the style did not originate with the Goths, but in France, near Paris, but like other misnomers in history the term has stuck. It was an entirely new

development in European art, and the modern art of its day. Romanesque architecture grew from Roman technology and evolved from Carolingian and Ottonian experiments over several centuries. Gothic art and architecture borrowed techniques from the Romanesque but put them together in a revolutionary aesthetic opposed to that of its predecessor. It took only three-quarters of a century for the style to pass from the experimental stage to its high point.

Early Gothic

An early step in the development of a new style came in part as a redirection away from the luxuriant and ornate aspects of Romanesque art. The churches of the Cistercians, a reformed Benedictine order headed from 1115 to 1153 by Saint Bernard of Clairvaux (see above, p. 98), reflect his ascetic and puritanical character. Because he mistrusted any appeal to the senses, Cistercian buildings were unornamented, which effectively redirected attention to the pure architecture. What Saint Bernard did desire in a church was light, which he saw as a symbol of the divine. Cistercian churches show his predilection for light in large windows and make more use of the pointed arch and rib-vaulting to allow for larger clerestories. In the abbey church at Pontigny (fig. 120), we can see that the pointed arches and rib-vaulting add a sense of loftiness not usually found in Romanesque buildings. The plain lines of the architecture, flooded with light from the windows, have a new sense of clarity and simple beauty.

120 Interior of the nave, Abbey Church, Pontigny, c. 1150

Under Saint Bernard, though, this new focus on architectural line remained primarily reactionary, purifying an existing style. The logical conclusion of the pointed arch and rib-vault is to open out the wall and lighten the effect of mass. This the early Cistercian architects did not do. Despite its vertical lines, the nave at Pontigny seems heavy; it is closer in its aesthetic impact to St.-Etienne at Caen than to a Gothic cathedral.

It was another monk, Abbot Suger of the royal abbey of St.-Denis, near Paris, who took the further step of integrating the pointed arch and the rib-vault into a new style. Suger had two ambitions: to aggrandize St.-Denis and to strengthen the power of the French throne over the aristocracy. A former schoolmate of King Louis VII, Suger served him as a diplomat as well as a priest. His determination to enlarge the old, and by his account decrepit, church stemmed both from his feeling of the importance of St.-Denis to the French throne and from his desire to create a new and beautiful work of art. Although St.-Denis was undeniably too small and in bad repair, it was a historic monument dating back at least to the eighth century; to suggest pulling it down and starting afresh would have seemed like a present-day bishop proposing to replace Chartres Cathedral with a modern edifice of glass and steel. Suger carefully spoke of enlarging and

CHART 3 THE GOTHIC AGE

EVENTS			ART AND CULTURE
1137-80 Louis VII king of France		EARLY GOTHIC	1144 Abbot Suger completes first stage of St-Denis
1147-9 Second Crusade	1150		c. 1150 Chartres Cathedral, Royal Portal c. 1150-1250 Emergence of the medieval universities
1152-97 Frederick Barbarossa emperor			1153 Death of Saint Bernard 1175 Canterbury Cathedral choir begun
1187 Muslim leader Saladin captures Jerusalem			1194 Chartres Cathedral rebuilding begun
1197-1250 Frederick I king of Sicily	1200		
1204 Fourth Crusade		HIGH GOTHIC	1220-30 Amiens Cathedral 1230-55 Wells Cathedral
1236-70 Louis IX king of France	1250		1243-8 Sainte-Chapelle, Paris c. 1250-1350 'Decorated' style in English architecture 1260 Nicola Pisano, Pisa Baptistery pulpit c. 1270-1370 'Rayonnant' style in French architecture 1274 Death of Saint Thomas Aquinas 1285(?) Cimabue, *Madonna Enthroned*
1285-1314 Philip the Fair king of France 1297 Louis IX canonized	1300		
1303 Pope Boniface VIII defeated by Philip the Fair			1302 Giovanni Pisano, Pisa Cathedral pulpit
1309-78 'Babylonian Captivity': Papacy removed to Avignon			1304-6 Giotto's frescoes in the Arena Chapel, Padua 1308-11 Duccio, Maestà Altarpiece
			1314 Dante's *Divine Comedy* c. 1325 Jean Pucelle, Book of Hours of Jeanne d'Évreux c. 1328 Simone Martini, portrait of Guidoriccio da Foligno
1337 Beginning of the Hundred Years War between France and England 1346 English defeat French at Battle of Crécy 1348 Black Death in Europe	1350	LATE GOTHIC	1350-1550 'Perpendicular' style of architecture in England; 'Flamboyant' in France
1363-1404 Philip the Good duke of Burgundy			1374 Death of Petrarch
1378-1417 The Great Schism: rival popes in Avignon and Rome 1384 Dukes of Burgundy become rulers of Flanders			
1399 Richard II of England deposed; Henry IV of Lancaster succeeds	1400		1386 Chaucer's *Canterbury Tales* 1395 Claus Sluter's Moses Well at Dijon
1415 English Henry V defeats French at Battle of Agincourt			c. 1400 The Wilton Diptych
1429 Joan of Arc raises seige at Orleans 1431 Joan of Arc burnt at Rouen			c. 1416 The Limbourg brothers, *Les Très Riches Heures*
	1450		1434 Jan van Eyck, *The Betrothal of the Arnolfini*

shoring up the old parts, keeping 'as much as we could of the old walls . . . so that the reverence for the ancient consecration might be safeguarded'.

He began with the narthex, which did not involve pulling down the body of the church proper. Then he left the nave for the moment and proceeded with the sanctuary. He kept a careful account of the rebuilding in which he speaks of his role as a partnership with God through which workmen were miraculously provided with whatever materials they needed. When the carpenters protested that they could not find trees big enough to provide beams for the new construction, Suger led them into the forest. There, to the amusement of his foresters, who 'wondered whether we were quite ignorant of the fact that nothing of the kind could be found in the entire region', he proceeded to search for himself. He found no fewer than twelve suitable trees where presumably none that large had existed before. Everywhere he discerned God's collaboration: 'through a gift of God a new quarry, yielding very strong stone, was discovered.' During a downpour the labourers who pulled the stone from the quarry left their post, leaving the ox-drivers to complain that they were losing time. So a handful of boys and a priest pulled what normally took at least 100 men to haul from the quarry bottom.

Suger's plans for St.-Denis were indebted to the writings of the Pseudo-Dionysius (see above, p. 79), who refers to the metaphors in the scriptures which clarify the mysteries of spiritual knowledge. Suger deliberately employed art as a metaphor; he saw the three doors of the narthex as symbolizing the Trinity, and spoke of stained glass windows as 'urging us onward from the material to the immaterial'. Stained glass had been used in Romanesque churches, but never in such profusion. In the windows of the twelfth- and thirteenth-century cathedrals the individual pieces of glass were small and were bonded together with lead strips, a technique related to enamel work with gold filigree (see fig. 69). But in the case of stained glass, the light shining through the window is an aesthetic element, so that the leading needed to hold the picture together becomes part of the whole design (see fig. 136). Without the articulation of the lead bands the colours would tend to run together and the design would be less clear. At the same time, the light shining through these multicoloured windows is broken up by the leading, making the whole wall seem light and shimmering, appearing to dissolve the boundaries between wall and window.

It was not only the outer windows that opened up in Gothic architecture. The sanctuary at St.-Denis has been remodelled since Suger's time, but from the ambulatory around it we can see the elasticity of space in the design (fig. 124). Unlike the sharply divided spaces of a Romanesque sanctuary, in which the apsidal chapels jut out from the ambulatory (fig. 94), the apse at St-Denis follows a complex geometrical design visible in the plan (fig. 122). The architect designed a double ambulatory and included the seven chapels within the same spatial organization. The chapels are linked to the outer ambulatory by their vaults,

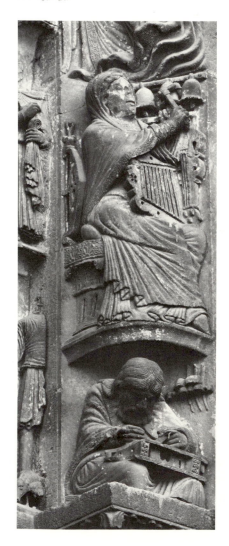

121 Pythagoras, from the archivolts of the Royal Portal, Chartres Cathedral, *c.* 1145–55

122 Plan of Suger's sanctuary, St.- Denis

123 The Royal Portal (west doors), Chartres Cathedral, *c.* 1145–55

124 Ambulatory of the sanctuary, Abbey Church of St.-Denis, Paris, *c.* 1140–3

125 Jamb figures from the Royal Portal, Chartres, *c.* 1145–55

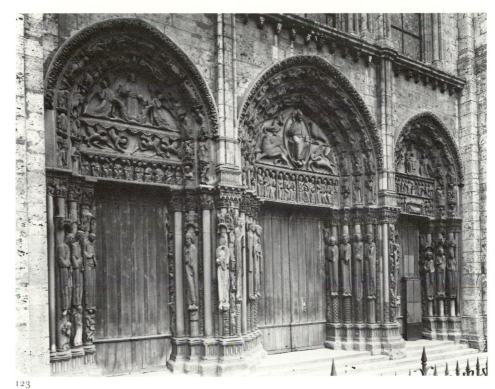

123

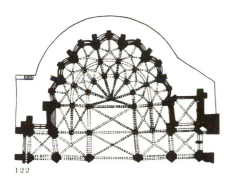

122

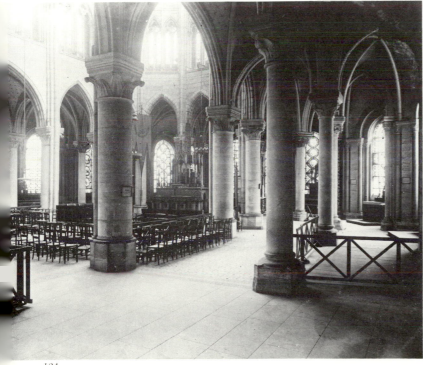

124

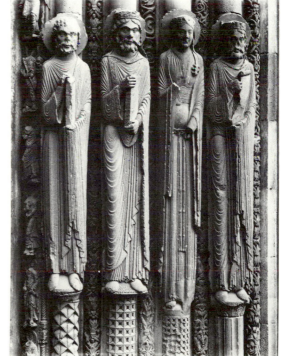

125

which are segmented by five ribs. The inner ambulatory vault is divided into four segments. The ribs turn inwards at the inside to meet the vaults of the sanctuary. The diagonal ribs of each ambulatory bay are round, but because they change direction at the centre they look pointed. The transverse ribs *are* pointed, so that they reach the same height as the diagonals. Structurally the vaults are still divided into bays; aesthetically they form a continuous design, and it is this that divides Romanesque style from Gothic.

Suger was able to progress so rapidly — the narthex and choir were dedicated in 1144 — because he began the project at the moment when building techniques had advanced enough to provide a new unity whose visual effect could be foreseen before the building was started. Suger even benefited from the fact that there was no first-rate school of artisans centred in the Île de France, the area around Paris under the direct control of the French king, for he was in a position to call in artists from wherever he wished. His architect came from Normandy, hence his skill with the rib-vault, but the pointed arch and the rib-vault had never before been used with such a deliberate intention of opening up a continuous flow of space.

Suger's innovations caught the imagination of church builders and spread rapidly, radiating out from the Île de France. Although St.-Denis was an abbey church, the new style coincided with the rapid expansion of towns and the need to enlarge the cathedrals that became the important focus of religion in the thirteenth century.

It was at Chartres that the early Gothic experiments were carried a step further towards the total synthesis of religious doctrine and aesthetics. Chartres was a small town, not a royal domain, but its cathedral school was a learned institution; its particular blend of philosophy, religion, and logic in the twelfth century underlies the art and architecture of the cathedral. Chartres had its fair share of pilgrims, attracted by the cathedral's possession of a piece of a tunic supposed to have been worn by the Virgin when she gave birth to Christ. By the twelfth century the narthex of the cathedral apparently seemed too small. This was a period of face-lifting in many churches, and apparently the original intention at Chartres was to build a bigger narthex on the model of Vézelay, with the main entrance inside. By the time building commenced, however, the example of St.-Denis showed the benefits to be gained by putting the main sculptural decoration out in the daylight. The portal was apparently brought forward and was placed between the two towers (fig. 123).

The sculptural programme of this façade was influenced by sculpture at St.-Denis, and in part executed by the same artists, but here the scheme was enriched by the cathedral school's doctrine that during his earthly life Christ was not only God but also fully human. Here as at St.-Denis the three doors were seen as symbolizing the Trinity; they also portray Christ's human ancestry. The kings and queens of Judah, the royal house of King David, appear on the jambs of the central door (fig. 125), flanked by Old

Testament prophets and heroes; the entrance was aptly named the Royal Portal.

Looking at the figures attached to the columns of the door jambs, we are aware of a startling change from the prophets at Moissac and Souillac (figs. 107, 110). Romanesque linear conventions still appear in the handling of drapery, but here the folds of cloth are allowed to fall straight and are not tossed by some supernatural wind. The kings and queens and prophets are elongated and as much out of proportion as the Isaiah at Souillac, but they stand straight and, no longer prisoners of the architecture, they form an integral part of the column. Most noticeable of all, their expressions are calm and self-contained, suggesting human understanding rather than mystical vision.

This shift from a highly romantic to a more classical style was connected to the doctrinal focus on Christ's humanity, and we can see an increasing naturalism in the small figures placed on the archivolts, the mouldings on the face of the arches framing the tympanum. The importance of the seven Liberal Arts in the school curriculum is seen on the archivolts of the right-hand door (fig. 121). Each of the arts is represented by an allegorical figure under which is a historical personage associated with it. Pythagoras, the Greek mathematician, was the first to recognize the mathematical ratios between notes in a scale; it was because of its mathematical properties that music was recognized as one of the seven Liberal Arts. As vigorous and expressive as the capital figures at Cluny, the archivolt figures at Chartres are more accurate in the rendering of human anatomy.

A yet more fundamentally classical element in the Royal Portal is the strict organization of the overall programme. The doctrine of the Trinity, the dedication of the church to Mary, and the human side of Christ are all fused together in the scheme of the three tympana. Mary sits in glory over the right-hand door; underneath are scenes from Christ's earthly life, the Nativity and the Presentation in the Temple (Luke 2: 21–38). The passage of Christ from temporal to eternal existence is shown above the left door by the Ascension, below which the awe-struck disciples receive the Holy Spirit at Pentecost. The dominating figure is the Christ in Majesty over the central door, surrounded by the symbols of the Evangelists, and with the Apostles on thrones below him. Even in Heaven, Christ personifies a human ideal of calm and dignity: divine mercy and justice have replaced the terrible threat of damnation so evident at Autun.

The High Gothic Synthesis

This new passion for ordering everything according to a well-planned outline became more pronounced as the philosophical system behind it evolved in the thirteenth century into a systematic re-ordering of doctrine and faith. As theological scholarship became more organized in the schools

126 Flying buttresses, Chartres Cathedral, 1200–60

and universities, so the control over design and decoration in cathedral building came more completely under the dual control of architect and clergy. At Chartres we can follow the development of aesthetics and philosophy, for in 1194 the Romanesque nave and sanctuary burned to the ground, leaving the crypt (which fortunately contained the Virgin's tunic) and the new west façade. Disaster was turned to opportunity; the nave and sanctuary were rebuilt at the point when the Gothic style had passed through its experimental stage, so that when we enter the Royal Portal we not only pass through the Old Testament to the New; we move from early to high Gothic style.

Standing in the middle of the nave (fig. 128), we are at once aware of a complete contrast between Romanesque and Gothic architecture. Where a basilica like St.-Sernin in Toulouse or Sainte Madeleine at Vézelay marches forward in a horizontal progression, Chartres soars upwards and embraces all parts of the building in one single and continuous space. In Romanesque architecture one is made aware of the unity of design by seeing how the various parts fit together. In mature Gothic buildings all the elements are constructed so that space flows around them; the nave arcade piers are set diagonally rather than frontally, so that they do not interrupt the eye's progress.

At Chartres the sense of unified space and of soaring height is achieved by omitting the gallery level and substituting instead a triforium, an arcaded wall passage that gives access for repairs but is not as obtrusive to the eye as a gallery. The columns in front of the wall open and lighten its mass in the same way as do the blind arcades in the Pantheon (fig. 36). The triforium acts as a subtle and elegant transition between the high arcade with its monumental piers and the light transparency of the clerestory above.

It is the beauty of the clerestory windows that holds the eye. The multicoloured light that floods the nave with a mysterious glow creates a powerful image of the faith for which the cathedral was built. In Suger's words, it urges us onward from the material to the immaterial. Each bay has a pair of windows with a small rose over them; the design is further proof of the sophistication the style had reached by this time.

Outside we can see what makes such a large clerestory possible (fig. 126). The shimmering, mobile quality of the exterior of a Gothic cathedral comes from the use of flying buttresses. These were technically descended from buttresses hidden beneath the gallery roof in Romanesque buildings, but were deliberately exposed in Gothic architecture for an aesthetic effect as well as a structural purpose. Here there is a total harmony of form and function; the use of the rib-vault allowed the weight of the roof to be met at certain points by the buttresses cascading down over the outside wall, while at the same time allowing for huge areas of the nave wall to be filled with glass, so that we are almost unable to say where mass leaves off and space begins. The weight spreads downwards, following the laws of gra-

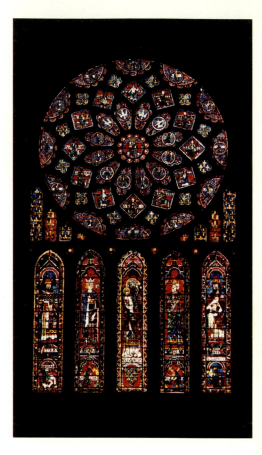

127 North transept rose window, Chartres Cathedral, begun *c.* 1225

128 Interior of the nave, Chartres Cathedral, 1194–1220

Burgos (fig. 142). In Italy, on the other hand, Roman and Romanesque traditions maintained a respect for the wall; at Santa Croce in Florence, for example, the Gothic lightness and sense of space gained by the pointed arcade are held within solid walls and a trussed wooden ceiling (fig. 144).

The degree to which artists travelled and communicated with one another is strikingly evident in the field of sculpture. At Naumburg, for example, there is a choir screen carved by artists who knew the French style (fig. 145). This screen, designed to mask the sanctuary, the most sacred part of the church, is really a stage for a sculptural drama which is so deeply carved as to be almost independent of its architectural setting. Gothic naturalism and classical modelling are combined with a feeling for dramatic action; in our illustration the enraged Saint Peter is in the act of cutting off the ear of the high priest's man come to arrest Christ (John 18:10), while Judas betrays Christ with a kiss. In general more expressive than the French examples, German Gothic art inherited a psychological forcefulness from Ottonian art. Despite the difference in style, there is a shared sense of dramatic scene between this work and the illustration of the Fall on the doors at Hildesheim (fig. 86).

In Italy a school of sculpture emerged in the second half of the thirteenth century that was close to the French. However, it apparently originated less from actual contact with France than from a direct use of the same source of naturalistic art: the remains of Antique Roman sculpture. The first appearance of this new style, in the early work of Nicola Pisano (active 1258–78), makes an interesting comparison with the figures at Chartres, Amiens, and Naumburg.

Nicola found a fertile field for sculptural scenes on the polygonal stone pulpits that were an Italian innovation in church furniture. His first known pulpit was done for the baptistery in Pisa. The sides of this hexagonal pulpit are carved with New Testament stories whose figures hark straight back to Roman models. The episodes are crowded together in the manner of Romanesque and early medieval art, but with a more classical sense of organized composition. Figure 146 shows four scenes, the Annunciation to the Virgin, the Nativity, the washing of the Christ Child, and the Annunciation to the Shepherds, all interwoven in one picture space, but in such a way as to focus on the commanding presence of the reclining Virgin of the Nativity. Although larger than the other figures, she is an entirely Classical Roman matron; none of the figures has the medieval appearance of contemporary sculpture north of the Alps.

In 1265–8 Nicola carved another pulpit for the cathedral of Siena. Here the style is closer to the French sculpture at Chartres and Amiens. Figure 147 shows the Journey of the Magi and the Adoration of the Magi in one frame, composed with a clear sense of spatial relationships between the figures. A lively procession of figures on horses and camels winds through the foreground; the background figures are clearly at a distance behind those in front.

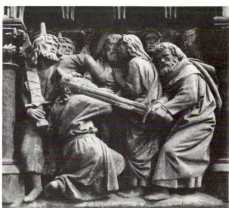

144 (*top*) Nave, Santa Croce, Florence, *c.* 1295

145 (*above*) The Arrest of Christ, from the choir screen, Naumburg Cathedral, 1250–60

Sculpture and painting were influenced most quickly, and totally; the closeness of much thirteenth-century statuary in England and Germany to that of Reims and Amiens suggests actual contact between artists, and royal gifts of manuscripts from the French workshops speeded the adoption of high Gothic forms and features in both painting and sculpture. Architecture is by its nature slower to change and depends more on local tradition and technique. Abroad as well as in France, cathedrals were the chief focus of building expansion, and their size and location in the middle of a town made Gothic height desirable, but often a cathedral was begun with solid Romanesque walls, reaching the upper levels before the influence of the new style was felt, so that we find Gothic vaults resting on Romanesque arcades, and massive towers suddenly opening up in the top storey.

Even when Gothic architecture was imported directly, strong provincial tendencies modified the purely French design. Because of the strong ties between the French crown and the Plantagenet kings of England, whose vast French holdings made them vassals of France, the early Gothic of St.-Denis arrived in England while it was still in the experimental stage in France. It was imported by the most direct method of all, the hiring of a French architect, William of Sens, to rebuild the choir of Canterbury Cathedral after a fire in 1174. The new choir, begun in 1179, is in a direct line of development of the Gothic style as it matured in France (fig. 141). But while in France that style developed into soaring verticality, in England the Norman predilection for horizontal solidity and ornamental design modified the French model.

The façade of Wells Cathedral is contemporary with Amiens, and its sculpture is very close to French examples (fig. 143). But the design of the façade itself indicates the different path English Gothic took after Canterbury (fig. 140). It is wider than the French type, for the towers were built beside, not in front of, the side aisles. But even without this, the horizontal effect would be more marked, for whereas at Amiens the structural buttresses and towers are integrated with the decorative bands of statues, balancing horizontal and vertical pull, at Wells the sculpture forms a screen in front of the architecture and so resembles the sculptural screens used inside to mark off the sanctuary area. However, this façade shares with its French contemporaries more than the superficial use of Gothic trefoils and quatrefoils, niches and pointed arches; it shows the same fundamental attitude towards space and mass in the way it opens up the wall to weave together stone and air.

Throughout Europe local taste and local inventiveness modified the French Rayonnant design while maintaining the basic aesthetic of mass penetrated and lightened by space. In Spain a feeling for lacy, ornamental details inherited from Moorish architecture and from Spanish Romanesque led to an exaggeration of the decorative aspects of the architecture, as in the large and ornamental triforium level in the cathedral at

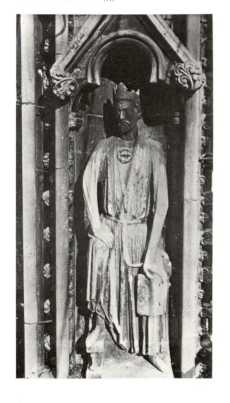

143 King, from the west façade, Wells Cathedral, 1220–55

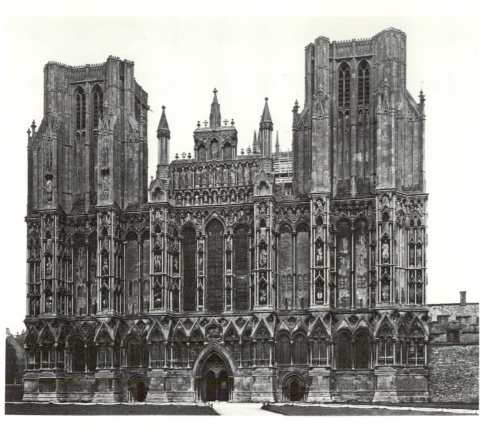

140 (*left*) West façade, Wells
Cathedral, 1220–55

141 (*below left*) Interior, choir of
Canterbury Cathedral, begun 1179

142 (*below*) Choir, Burgos Cathedral,
1221

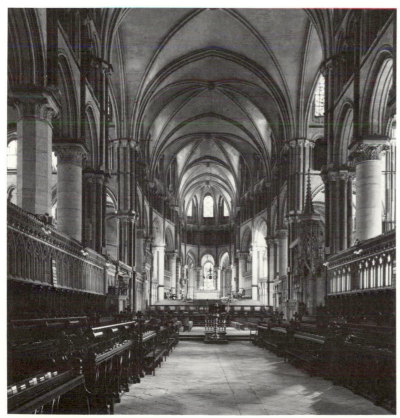

tecture, in reference to the ray-like lines of tracery that break rose windows like figure 138 into complex and intricate designs of a more mobile character than the earlier windows at Chartres. Tracery, originating as a structural necessity, was so admired for its own sake that it became divorced from function and was applied as decoration to walls, inside and out (see fig. 154) as a way of cutting a flat, solid mass into lacy forms, half stone, half air.

The ornamental aspect of the Rayonnant style emanating from the circle of Louis's court in Paris reflects the secular authority of the king's own workshop, operating outside strictly clerical control, and designing works to dignify the crown and to impress the public. Manuscript illumination in the court workshops became a sumptuous art more intent upon coherent composition and stunning effect and more lavish in the number and size of illustrations than had been the case with the output of the monastic scriptoria. A Psalter produced for Louis IX has 78 full-page illustrations, framed by Gothic architectural motifs and surmounted by a Rayonnant Gothic church similar to the Sainte-Chapelle. Within the frame each scene is composed with a sense of space that recalls the limited realism of the mosaics at Santa Maria Maggiore (fig. 58). Figure 139 shows Joshua's sack of Jericho; the Israelite warriors are within the city's walls, which are absurdly small for them; the soldiers fight vigorously with a natural sense of action, in contrast to the block of elegantly sinuous figures blowing ramshorns. All of these figures share the same conventional features, which had passed from sculpture into the painter's repertory.

In court art produced in the royal workshops, classical weight and natural form were not as desirable as elegance and decorative effect. Under the influence of royal patronage the classical form in Gothic art gave way increasingly to a more mannered refinement foreshadowed in the attenuated curves of the horn-blowing Jews in figure 139. But even as the Rayonnant style was growing more ornamental at home, the classical trends of early and high Gothic style were appearing elsewhere in Europe.

139 Joshua's Sack of Jericho, from Saint Louis's Psalter, *c.* 1256. Paris, Bibliothèque Nationale

Diffusion of Gothic Style: First Stages

The diffusion of a new style from the place of its birth depends greatly on extra-artistic factors such as routes of communication, political ties, and the social and economic status of patrons. The Romanesque style developed within an ecclesiastical context and was little concerned with secular needs. Although Gothic architecture made an early appearance outside France through the expansion of the Cistercian order, in the main the style owed its spread more to the influence of the French court, and was carried first into areas where ties with Paris were strongest. Adopted in imitation of French taste, the style lost much of its earlier connection with scholastic philosophy and became a mark of fashion and modernity.

without meaning, and such secular 'signatures' play their appropriate role in the universal scheme. In these scenes a new naturalism of style appears even within the relatively abstract medium of stained glass. In the Stone-masons' Window at Chartres (fig. 136), a sculptor stands surveying his finished work, an effigy for a knight's tomb, with an expression that brings to life any artist's feelings as he appraises his work.

High Gothic as a Court Art

Throughout the thirteenth century, the close interpenetration of religious and secular life humanized the spiritual side of things while investing the ordinary with an air of mystery. The statue of the Virgin in the south porch at Amiens (fig. 134) expresses the miraculous nature of her child's birth in her exaggeratedly beaming smile; at the same time she conveys the appeal of a human mother, holding a real and playful baby. As she invites us to share in adoration of her child, she is not only a perfect image of the blessed Virgin but also the ideal woman, counterpart to the troubadours' courtly heroines.

In the same mixture of spirit and flesh, the lives of the saints were made more interesting by the inclusion of human details, while the adventures of the knights of the Round Table were made more profound by the quest for the Holy Grail, the cup used by Christ at the Last Supper. By the second half of the century we find a shift towards the enjoyment of an easier and more gracious style of living, characterized by a courtly art delighting in beauty and effect for their own sake. The crusades provided continuing contacts with the exotic and fascinating courts of Islam, and some of the luxuries of the Orient were reaching the courts of Europe. Ironically, the scholarly art of Chartres and Amiens took on a secular elegance in the court of the only French king to achieve sainthood, Louis IX of France (1226-70).

It was not only the pressures of secular society that made Gothic artists and architects turn towards elegance and fashion. The achievement of height and lightness at Amiens and Chartres immediately suggested the possibility of still higher walls, thinner vaults, and bigger windows. When Louis commissioned a chapel to house relics he had bought, the chief of which was a piece believed to be from Christ's crown of thorns, the result was a building of unusual height in proportion to its size which gives the effect of an almost total lack of wall (fig. 137). The windows are more conspicuous than the narrow bands of stone between them; from inside the high vaults seem to rest on the glass. The leading that frames the small medallions and the stone tracery that holds the glass in place are such an integral part of the design at Sainte-Chapelle that we almost forget their function. The use of tracery was so important a part of the style that the name 'Rayonnant' was later given to this phase of French Gothic archi-

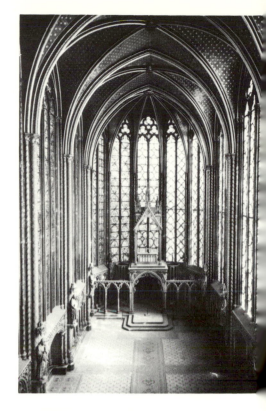

137 (*top*) Interior, upper storey, Sainte-Chapelle, Paris, *c.* 1245-8.

138 (*above*) Rose window, north transept, Notre Dame Cathedral, Paris, *c.* 1257

134 (*far left*) Vierge Dorée, south porch trumeau, Amiens Cathedral, *c.* 1250

135 (*left*) February, from the Labours of the Months, west façade, Amiens Cathedral, 1220–30

136 (*below*) The Stonemasons' Window, Chartres Cathedral, 13th century

Classical Roman art around them. Sculptors in the first half of the thirteenth century learned enough from Classical models to carve drapery that falls in natural folds, and to group their figures in natural poses, interacting with one another, but they quickly established their own repertory of facial characteristics and gestures, exemplified by the Saint Theodore at Chartres.

In painting and drawing, the models from Classical art were further removed from nature than in sculpture; they had been sifted down through the copies made throughout the Middle Ages so that it was harder to relearn the principle of rendering three-dimensional space on a flat surface. From the notebooks of a thirteenth-century architect named Villard de Honnecourt we can see how far Gothic artists were from being able to draw directly from nature. Villard assures us that his charming lion was drawn from real life (fig. 133), but we see it as a series of circles. Villard found it easier to copy statues, and we can see from figure 132 how easily the features, gestures, and drapery of Gothic statues entered the repertory of Gothic painting. Whereas Romanesque carving took its linear and flattened form from manuscript drawings, in Gothic art it was the other way round; drawing eventually gained a naturalistic style from sculpture.

Throughout the thirteenth century, a love of nature for its own beauty balanced the symbolism invested in natural forms. Gothic classicism replaced the Classical acanthus leaves on capitals with naturalistic vine and oak leaves; at Amiens realistic vegetation sprouts on the trumeau of the south transept entrance behind the statue of the Virgin (fig. 134).

Everything in the natural world had its place in the great scheme of things and therefore its symbolic value in the decorative scheme of a cathedral, but looking at the many everyday scenes ornamenting these buildings, we find along with the instructional purpose a great joy in depicting the ordinary round of life. The custom of decorating churches with symbols of the months and seasons, incorporating the seasonal round of agricultural labour in planting, tending, and harvesting the crops, was inherited from early Christian times. But in the Labours of the Months, little scenes carved in quatrefoil frames, the loving attention to detail goes well beyond symbolism. In February the peasant sits by the fire warming his toes (fig. 135), and we can feel his pleasure at being indoors and warm. In March he is out pruning and tilling the vines. By April the weather is warm enough for him to enjoy the sunshine, working without his heavy cloak.

A wholly secular note was allowed to appear in some of the stained glass windows of thirteenth-century cathedrals. In order to encourage the various guilds to pay for the costly windows, the clergy permitted each guild to 'sign' its window with scenes of the trade that would identify the donor. So we have accurate portraits of the whole round of medieval business — coopers, wine-merchants, masons — with no religious significance. But in the all-encompassing universe of the cathedral, nothing was

132 (*top*) Group of figures, from the Notebooks of Villard de Honnecourt, *c.* 1240. Paris, Bibliothèque Nationale

133 (*above*) Lion, from the Notebooks of Villard de Honnecourt, *c.* 1240. Paris, Bibliothèque Nationale

Scholasticism and High Gothic Art

By the time the south porch at Chartres was finished in c.1230, this new classicism had spread to other cathedrals in the environs of Paris. Some of the sculpture now appearing owed a more pronounced debt to Antique Roman art than anything in Europe since the fall of Rome; not even the Carolingian ivory carvings surpass the Gothic statues at Amiens and Reims for naturalness of figure and pose. The new infusion of classical realism came from the close synthesis in the early thirteenth century of art and philosophy. The classic phase of the Gothic style coincided with the new scholastic philosophy emanating from the University of Paris.

Scholasticism, as its name suggests, was evolved by clergymen who were more scholars than active priests, and who were working in an atmosphere increasingly free of interference from the cathedral clergy. Saint Thomas Aquinas (1225–74), the foremost of these new scholars and the chief exponent of scholasticism in his time, was an original thinker and a man of great learning; he also had an enormous advantage over earlier scholars in having access to all of Aristotle's works, many of them in new or revised translations from the Greek. Aristotle placed much more emphasis on the value of human experience than Plato and the Neoplatonists; Saint Thomas's efforts to reconcile Aristotelian thinking with Christian doctrine had a profound influence in turning the high Middle Ages away from an exaggerated emphasis on mysticism in order to give a greater weight to human intellect and experience.

Paralleling scholastic philosophy's reassertion of the value of experience, artists turned their attention to Classical models in sculpture in order to regain the forms of nature. In place of the expressively distorted proportions of Romanesque figures, we find a new solemnity and dignity that emphasizes the physical reality of human beings. This renewed focus on the natural human form was not, however, quite the humanism of Classical art. Whereas Aristotle valued sensory experience because it led to knowledge through the ordering of experience, Saint Thomas used sensory experience to prove a theory already held; that the existence of God was the prime cause of everything in the universe. The new realism of proportion, gesture, and stance in figure carving, and the naturalism of the plant life that grows so profusely in Gothic art were never more than a realism of parts; the whole was still the mysterious and hierarchic Christian universe in which everything had its proper place and its ordained relationship to everything else.

Gothic Naturalism

The Greeks had reached a high degree of naturalism in their art by copying nature; medieval artists, however, copied from the fragments of

131 West façade, Amiens Cathedral, 1220–88

Left

129 (*top*) Saint Simeon and Saint John the Baptist, from the north porch, Chartres Cathedral, c. 1205–10

130 (*bottom*) Saint Theodore, from the south transept porch, Chartres Cathedral, 1210–20

vity, but the opposite appears to be the case; inside and out, to the eye, Chartres soars upwards.

The logical end of opening up the wall is to blur distinctions between mass and space and to let space enter the design as much as the line that contains it. We can follow this aesthetic evolution in the rose windows at Chartres. The west rose was cut into the early Gothic façade when the new nave required a heightening of the old front. This window is cut in a wheel design whose spokes imitate the nave buttresses. The design is simple, with a clear delineation between wall and glass. As the style developed, the stone between the pieces of glass came to imitate the leading holding the glass together. By the time the north transept reached the level of its rose window, the design had moved away from the wheel pattern to one of radiating geometrical shapes: squares, triangles, and semicircles that imitate the mobility and transparent lightness of the whole building (fig. 127).

Classical style articulated the boundaries between architecture, sculpture, and painting even when all three are coordinated within an overall design. Gothic building, even at its most classical balance between structure and decoration, combined all three arts into one sculptural effect. The entrance porches masking the transept arms at Chartres demonstrate this effect. The aesthetic function of the porch is to break up the flat surface and the vertical line of the buttresses flanking the portals. The high Gothic façade evolved from this plastic treatment of architecture into a complex and precarious balance between the vertical thrust of the towers and the horizontal bands of sculpture which cut into the wall. At Amiens (fig. 131), the deep porches, which break into the line of the buttresses, blur the architectural boundaries to create an effect of movement that is accentuated by the changing light of the sun.

The Chartres transept porch sculpture indicates the passage from early to high Gothic style. In the north portal decoration the statues are still part of the structure of the columns, although they are carved in greater depth than those on the Royal Portal. They stand in more natural poses and are nearer to human proportions. The conventions of Moissac and Souillac are still evident, especially in the hair and beard of Saint John the Baptist (fig. 129), but garments now fall in natural folds.

By the time the statues for the south porch columns were finished, the trend to naturalism was more pronounced. These figures (fig. 130) are posed in classical groupings, bent into a natural contrapposto, and are so deeply carved as to be virtually free-standing. Here we find a new synthesis of classical forms and contemporary appearance. Saint Theodore is dressed in the armour of a thirteenth-century crusader. His features, in contrast to those of wilder, primal Saint John, seem those of an ordinary man of his time; we will find these features becoming a standard convention in Gothic art.

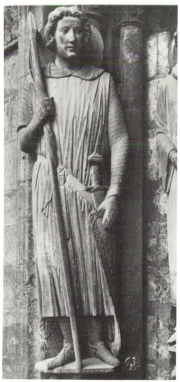

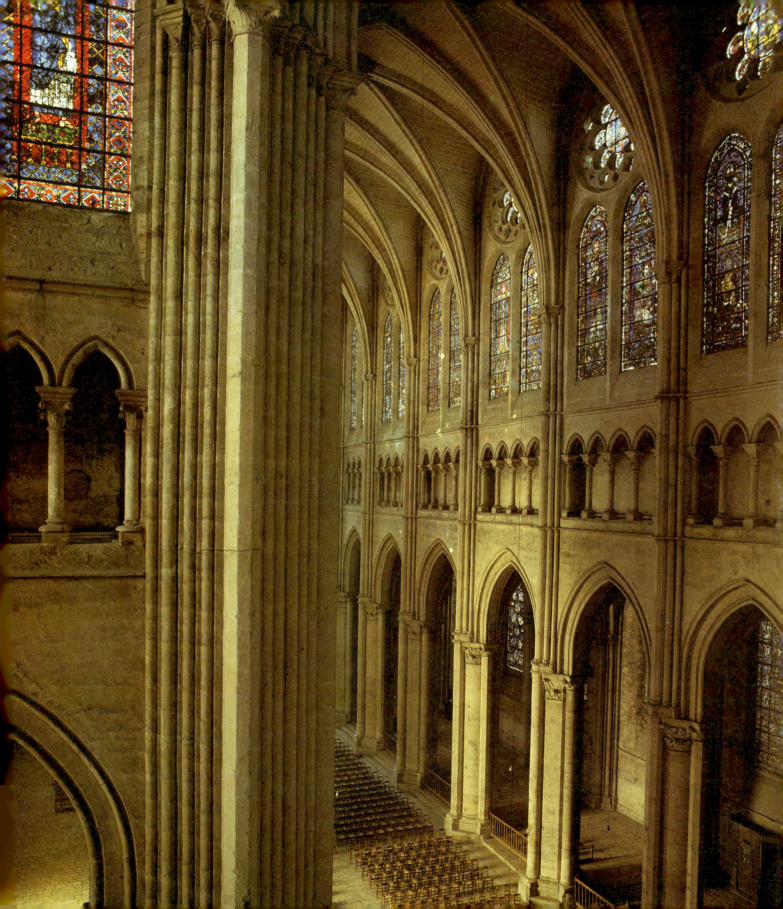

This sense of perspective and limited space is suggested also in the Naumburg choir screen and in the illustrations of Louis IX's Psalter. But naturalism and solid figure modelling soon came to clash with a desire for sinuous elegance and swaying motion; the intentions of Gothic art in the fourteenth century were at odds with the illusions of three-dimensional perspective and defined space.

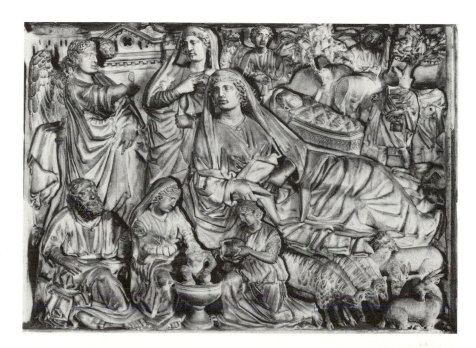

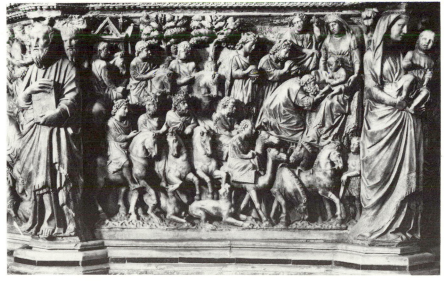

146 (*above*) Nicola Pisano, Nativity, from the pulpit of the Baptistery, Pisa, 1260
Nicola is one of the earliest artists for whom we have any real biographical record, thanks to the 16th-century art historian Vasari, who wrote down accounts of the lives of Italian artists from Nicola to his own time.

147 (*below*) Nicola Pisano, Journey and Adoration of the Magi, pulpit in Siena Cathedal, 1265–8.

CHAPTER 6

Loss of Synthesis:
Late Gothic

During the whole of the Middle Ages artistic developments were closely tied to political, economic, and social changes. The artist was never an independent agent but a member of a guild; his dependence on the guild for employment and advancement had a restrictive effect on individuality in style, while his choice of subject-matter for a painting or a sculpture was dictated by the purchaser. The transformations that we shall see between the Gothic art of the 1200s and late Gothic art in the fourteenth and fifteenth centuries occurred because great changes took place in European society. Italy's political history differs from the rest of Europe; it was a land of small city-states caught between the conflicting territorial claims of the Pope, the Norman kings of Sicily and Naples, and the Holy Roman emperors. But north of the Alps, there was a steady centralization of power under the monarchies. As kings consolidated their authority, the power of the papacy declined, and a new class of administrators appeared. By the fifteenth century the centre of power had shifted from monastery or castle to the king's court, where all ambitious nobles now came, looking for advancement. This caused a centralization of art patronage; late Gothic art became a courtly art of a secular character even when its subject-matter remained religious.

The rise of the monarchy and the decline of the papacy ran in tandem as northern Europe, previously a multitude of tiny feudal states, came to consist of a smaller number of independent nations. Monarchs gained from the increase in capital, which could be taxed; when they could raise paid armies, their dependence on the aristocracy was lessened. The emergence of parliaments acted as a counterweight to the power of the throne by the later Middle Ages, but their effect was to increase the centralization of government and the people's sense of national identity.

The eleventh century had seen Pope Gregory VII humiliate the German emperor (see above, p. 85); the fourteenth, by contrast, saw the French king Philip the Fair defeat Pope Boniface VIII. In 1303, after the

148 Pietà, early 14th century. Wood, height 34¼ in (86.3 cm). Bonn, Rheinisches Landesmuseum

149 Master of the Garden of Paradise, *Garden of Paradise*, c. 1410. Panel, 9½ × 12¼ in (24 × 31 cm). Frankfurt, Städelsches Kunstinstitut

pope had refused him the right to tax the French clergy, Philip sent an army into Italy. His soldiers succeeded in imprisoning the pope, who yielded and was freed, to die soon after. From 1309 until 1378 the popes were not only French but resided in France, in a sumptuous new palace built in Avignon. The return of the papacy from this 'Babylonian Captivity' to Rome in 1378 resulted in the French electing a rival, creating the Great Schism, which lasted until 1417. From this point, the papacy never recovered its former political influence.

The ambitions of the French and English kings brought these two nations into open conflict in the fourteenth century; the heirs of William the Conqueror claimed nearly half the territory of France as their feudal holdings. The French kings, who sought to extend their authority over these lands, resisted the English claims, while the English kings found it intolerable that they, as independent rulers, should have to swear feudal oaths of homage to the French king. War broke out in 1337 and was pursued intermittently until 1453. For a long time the English were victorious; the tide turned after 1429, when Joan of Arc succeeded in raising the patriotic spirit of the French. The Hundred Years War devastated much of France and effectively destroyed both the system of feudal allegiance and the concept of a united, Christian Europe.

In addition to war, the later Middle Ages suffered from recurrent outbreaks of plague, or Black Death, the worst sweeping Europe in 1348. Then, too, emergent capitalism showed its dark side in a series of financial failures. Given the contrasts and tensions of a rapidly changing world, it is not surprising that we see a loss of the joyous faith that is so pronounced in Chartres Cathedral. From the beginning of the fourteenth century a gap widened between the depictions of salvation in picturesque but trivial little scenes of Paradise as a medieval garden, peopled by elegant lords and ladies amusing themselves with cultural pursuits (fig. 149), and the darker, penitential side pictured in exaggerated and distorted reminders of death, called *memento mori*, and *Pietàs*, portrayals of the sorrowing Virgin holding her dead son. In figure 148 realism of form has yielded entirely to a heightening of sorrow and pity. The increasing tension within late medieval society led to extremes: on the one hand excessive piety like that of Margery Kempe, a fifteenth-century pilgrim who wept and postured her way to Jerusalem, and on the other the excessive worldliness of the wealthy and powerful.

Separation of Form from Function

In England and France, the most innovative centres of architectural design, the three phases of early, high, and late Gothic show influences shared between the two countries, but the developments were not exactly parallel. England, as we saw, evolved its own idiom after the importation

of early Gothic at Canterbury. In England, as in France, the emphasis was towards larger windows with more profusion of stone tracery. The English developed tracery into a highly decorative curving line (fig. 150) that gave the high Gothic style in England the name of 'Decorated' (*c.* 1250–1350).

The sinuous curlicues of Decorated Gothic influenced the French to elaborate on the motif, changing the complex but essentially static Rayonnant style into a flickering, flame-like patterns of forms seen in figure 151. This style earned the name 'Flamboyant', a word literally meaning flame-like; its modern connotation of something over-dressed and ostentatious also fits the late Gothic in France, when tracery became part of the building itself, as in figure 154. Here space and mass are interwoven in an elaborate play of forms that deliberately obscures the physical limits of the building.

The Flamboyant style in turn influenced English architecture, but the third phase of English Gothic began as a reaction against both the native Decorated and the French Flamboyant (fig. 152). Called 'Perpendicular' for its straight vertical lines, this style restored a clear, static quality to the windows that is very different from the mobile effect of the French Flamboyant rose.

The unity of high Gothic style came from the close co-operation between all the workmen involved in a project. In the late Gothic period this close coordination disappeared. The architect's control over the building design increased, but the stained glass and sculpture were no longer done on the site but in the guild workshops, weakening the close ties between construction and decoration. The glaziers experimented and developed the technology of stained glass painting, sculptors learned new skills and conventions in stone and wood carving, while architects strove for greater height and illusions of weightlessness, all independently, without the synthesizing vision that is so evident at Chartres.

The desire to let in as much light as possible not only led to larger windows and thinner tracery but also to less use of coloured glass. The discovery, around 1310, that silver chloride applied to glass would produce varying hues of yellow and gold when fired made it possible to use one piece of glass showing various hues instead of a mosaic of separate pieces for each colour. Late Gothic glaziers used less variety of colour, gaining light and flexibility of composition, but losing the mysterious glow shimmering through the deep colours of the thirteenth-century glass.

It was the development of the rib-vault combined with the flying buttress that had allowed for the increased size of the clerestory windows, and it was in techniques of vaulting that the changes separating late from high Gothic first appeared. The ribs in high Gothic vaults are strictly functional, however aesthetically pleasing they may be. But as early as 1239 builders at Lincoln Cathedral added a purely decorative rib to smooth out a chunky design in the choir vaults, and the addition of decorative ribs caught on. The tracery patterns of perpendicular windows

150 (*below*) East façade of the Angel Choir, Lincoln Cathedral, 1256–1320

151 (*bottom*) Rose window from the south transept, Amiens Cathedral, 14th century

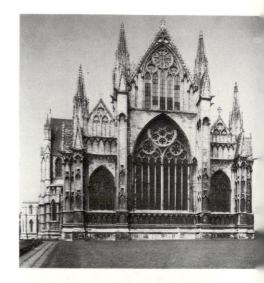

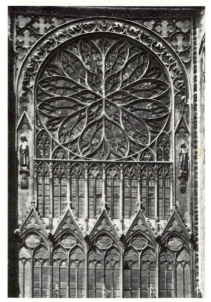

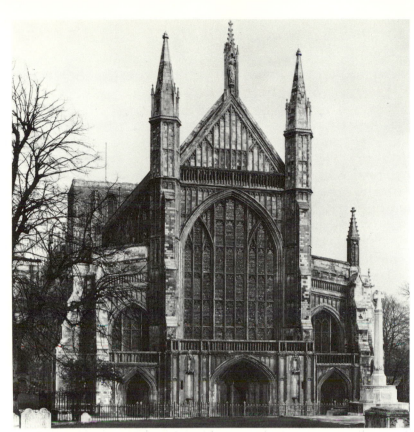

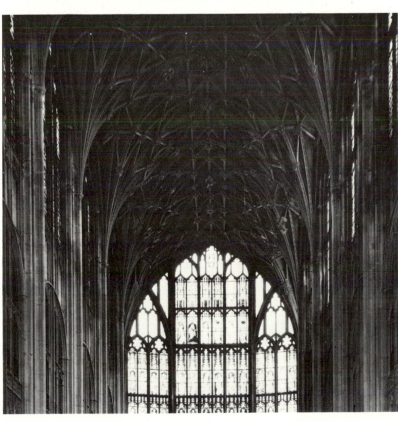

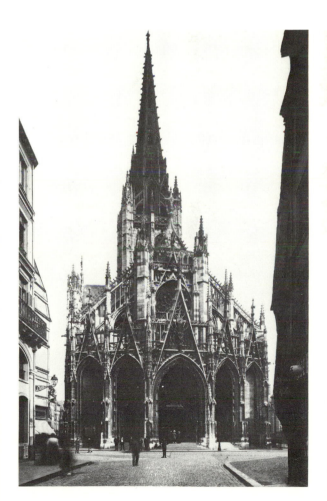

152 (*left*) West window, Winchester Cathedral, *c.* 1360–1400

153 (*below left*) Choir, Gloucester Cathedral, 1332–57

154 (*below*) Church of St. Maclou, Rouen, begun 1434

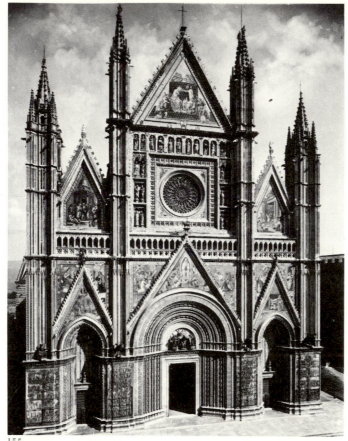

155

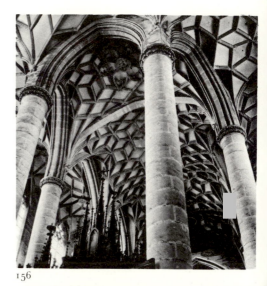

156

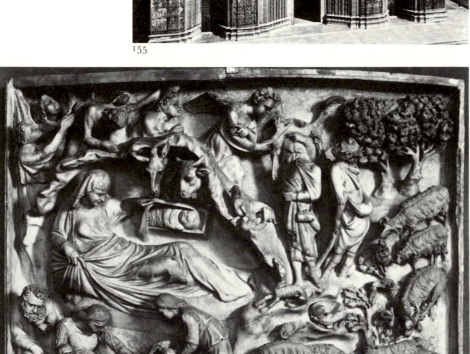

157

158

155 Lorenzo Maitani(?), façade of Orvieto Cathedral, begun 1310

156 Church of the Holy Cross, Swäbisch Gmünd, c. 1350

157 Giovanni Pisano, Nativity, from the pulpit in Pisa Cathedral, 1302–10

158 Scenes from the Last Judgement, detail from the façade of Orvieto Cathedral, c. 1320

were matched by a style of vaulting which we can see in the choir of Gloucester cathedral (fig. 153). Here a screen of rib-vaulting effectively hides the structural form under a webbing of parallel lines. This stylistic forcing of technology actually breaks the harmony; the huge vertical responds sweep the eye up to the vaults, but there, where the the rib design should knit together the spatial unit of the bay towards the centre, instead the proliferation of ribs leads the eye away from the centre. The Perpendicular vault went on to evolve into ever more fantastic forms, appearing as fans, cones, or the stalactite knobs hanging from the ceiling of the Henry VII chapel at Westminster Abbey. On the continent, the decorative lines of vaulting were often formed into complex star patterns bursting like rockets from slender supports (fig. 156). In all cases, the chief purpose of late Gothic decorative line was to create an open interweaving of mass and air that blurs the line where mass leaves off and space begins.

Retreat from Classicism

If high Gothic art and architecture are characterized by their sculptural effect, late Gothic tended towards the painterly and the picturesque in all the arts. By 1300 sculpture and painting had moved away from the classicizing naturalism of high Gothic. Here, as in the vaulting, the seeds of change were present in the style at its height; the curving posture of the Vierge Dorée (fig. 134) and the elegant twist of her neck were exaggerated in later works into a more mannered contortion, elongated and thinned out into a style that appealed to courtly circles for its very lack of solidity.

This trend towards a more expressive style appeared in Italy in the work of Nicola Pisano's son Giovanni (active 1265–1314), who made a decisive break with the classical form and organization of space learned from his father. The pulpit he carved for the cathedral in Pisa in 1302–10 makes an instructive comparison with Nicola's pulpit in the baptistery. Giovanni's Nativity panel (fig. 157) follows the same iconographic scheme as his father's, but it is composed with an entirely different feeling for the relationship of figures to space. Nicola's figures are monumental in character and are fitted closely together, shown facing the viewer. Giovanni's figures are light and delicate, separated by space, and shown as if seen from above. The Madonna still dominates the composition, but space circles around her, framing and articulating each scene. Human interest is very evident in this work; the shepherds are excited by the angels' news; Joseph watches intently as the servant preparing to bathe the Christ Child tests the water with a more mannered gesture than her business-like counterpart on Nicola's pulpit. The technical skill in foreshortening figures so that they emerge from the surface was developing steadily, yet in Giovanni's picturesque scene, as in Flamboyant architecture, space plays an active role in creating an effect.

'Picturesque' and 'painterly' are words that also describe the Gothic architecture appearing in Italy by the beginning of the fourteenth century. Italian architects devised their own solution to the problem of masking the front of a church with a design that shares the Gothic intentions of lightening the wall but is markedly different from both French and English façades. Instead of masking the aisles with massive buttresses and towers, the Italian solution was a delicate combination of geometrical shapes articulated by thin vertical shafts and spires (fig. 155); the squares and triangles give a picture-frame effect and either contain actual painting or painterly glass and sculpture. Lorenzo Maitani (c. 1275–1330) is credited with the design of the façade at Orvieto and with most of the sculpture that covers the lower piers in a lacy screen of small-scale relief carving instead of monumental jamb figures. The scenes forming this decorative screen are carved with a painterly use of light and shadow to model figures (fig. 158). The delicacy of handling is combined with a remarkable psychological force; the tortures of the damned are every bit as real here as on the Romanesque tympanum at Autun (fig. 115).

Space and Illusionism in Italian Painting of the 1300s

Italy was throughout the Middle Ages the focus of a three-way struggle between the German emperors, the papacy, and the Norman kingdom in the south. The German emperor Frederick Barbarossa (ruled 1152–90) renewed Carolingian and Ottonian territorial claims over Italy, initiating a long period of conflict with the papacy during which intermittent German invasions of Italy reached even into the kingdom of Naples in the south. But the Germans were never able to maintain control over Italy, which remained split into independent towns feuding with one another and divided between adherents of the pope (called Guelphs) and those favouring the emperor (called Ghibellines).

Despite the continuing internecine warfare, the Italian towns grew wealthy in the economic revival of the twelfth and thirteenth centuries. By the 1200s the institution of banking, an outgrowth of merchants lending and handling money for a profit, had taken firm root in Italy. Here, more than in any other part of Europe, political power was achieved by those who amassed fortunes through trade.

The rivalry between towns had its beneficial side for artists, as each commune tried to outdo the others in the size of its cathedral and the splendour of its public art. This cultural rivalry created competing schools of artists, which had the dynamic effect of rewarding experiment and innovation, in marked contrast to the situation north of the Alps. So it was in Italy that we find the first really forward-looking changes in painting. Although influenced by the wide variety of foreign influences present in Italy, Italian artistic development was also firmly rooted in the Classical past.

Right

159 (*above*) Cimabue, *Madonna Enthroned*, c. 1280–90. 151½ × 84 in (379 × 210 cm). Florence, Uffizi

160 (*below*) *Madonna Enthroned*, Byzantine, 13th century. Panel, 32 × 19½ in (80 × 49 cm) Washington D.C., National Gallery (W. Mellon Collection)

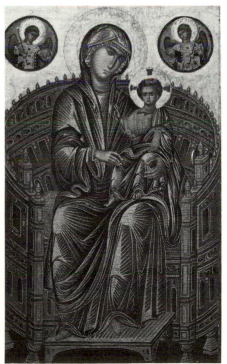

The first of the great Gothic painters in Italy to break new ground was the Florentine Cimabue (active *c.* 1272–1302). He was influenced by Byzantine art, then undergoing a rebirth; we can see both the extent of his borrowings from this style and his innovative departure from it by comparing his *Madonna Enthroned* (fig. 159) to a contemporary Byzantine painting of the same subject (fig. 160). This was a traditional subject in Byzantine art and was handled in a similar way from the sixth century to the thirteenth; its stiff and frozen style was meant to indicate the separation of the pair from our world. The drapery in this example is handled in an ornamental way with little recognition of a body beneath the folds; the style is still very close to that of the Ravenna mosaics. The two-dimensional figures are set in front of an elaborate throne, rather than sitting on it, reminding us of Carolingian art derived from the Byzantine style (fig. 81).

Despite its ornamental artificiality, the Classical heritage of art is still discernable in this painting. Its composition is symmetrical and creates a sense of finite space through the circular sweep of the throne. The Virgin's features and tender expression were carried over from Classical painting. The restrained and controlled emotion of Classical art is evident; what is missing is the humanism the ancient Greeks had invested in their art.

It is this humanism that returned to Western painting in the work of Cimabue and his contemporaries. Because Byzantine icons assumed for the faithful a mystical power of their own, there was little room in icon painting for innovation; a departure from tradition would have seemed a heresy. In the West art was treated with reverence but was never an object of worship; even the elaborate iconography of medieval art left room for experiment. Cimabue's *Madonna Enthroned* is very close to the Byzantine example; the Virgin's face is especially similar, except that she looks directly at us. The child raises his hand in the same gesture of blessing. But this Christ child has a decidedly Italian aspect and resembles a real infant. The crisp folds of the Virgin's robe fall in more natural, less ornamental lines, probably influenced by the sculpture of the two Pisanos. Although the figure drawing is still linear and two-dimensional, the Madonna and child suggest the forms of this world; when we move from them and from the graceful angels flanking them to the four saints below, we are in the company of four lively medieval personages painted in the French Gothic style.

Cimabue's naturalism influenced a younger painter, a Sienese artist named Duccio di Buoninsegna (active 1278–1319), in whose work the feeling for form and space became bolder and less tentative. The large altarpiece he painted for the cathedral in Siena in 1308–11 has on its front a *Madonna Enthroned* (fig. 161) composed on lines similiar to Cimabue's but with even more feeling for the human form beneath the clothing. In softening the stiff, sculptural folds of Cimabue's drapery, Duccio used a skilful blending of light and shadow, which is the painter's particular province, to make the Virgin's robe seem like real cloth. The angels are still

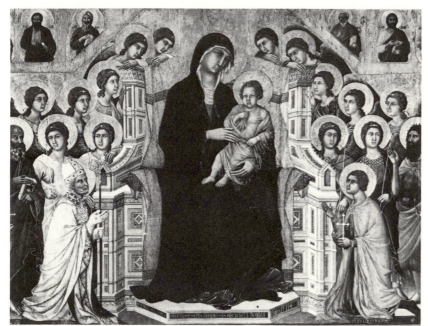

161

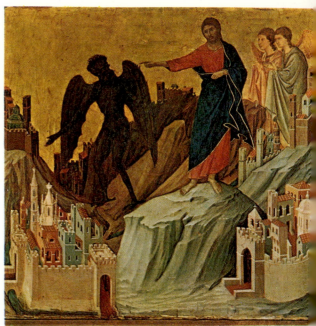

162

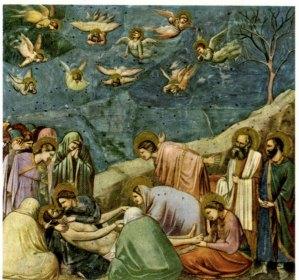

163

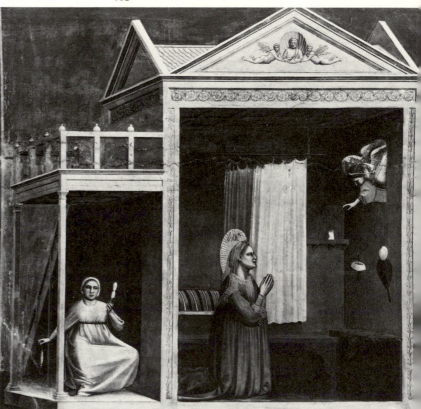

164

161 Duccio di Buoninsegna, *Madonna Enthroned*, detail from the Maestà Altarpiece, 1308–11. Panel, height 82½ in (206 cm). Siena, Museo dell' Opera del Duomo

162 Duccio, *Temptation of Christ on the Mountain*, from the Maestà Altarpiece, 1308–11. 17 × 18⅛ in (43.2 × 46 cm). New York, Frick Collection

163 Giotto, *Lamentation over Christ*, 1305–6. Fresco, 80 × 74 in (200 × 185 cm). Padua, Arena Chapel

164 Giotto, *Annunciation of the Virgin's Birth to Saint Anne*, 1305–6. Fresco, 80 × 74 in (200 × 185 cm). Padua, Arena Chapel

ranked symmetrically around the throne, but in more natural poses; some lean on the throne, displaying a human interest in the infant Christ. The Madonna sits on her throne, no longer floating in front of it. Duccio was experimenting with something scarcely seen in European painting since Classical times, the illusion of three-dimensional space on a flat surface.

It is in the small scenes from the back of the altarpiece that we see how innovative Duccio's handling of picture space was. Here, whether his figures are placed in a landscape or in an architectural setting, he put them properly inside the composition. In the *Temptation of Christ* (fig. 162) the treatment of the story was not new; the stylized rocky outcrops indicating mountains can be traced back to late Antique and early Byzantine art. But Duccio drew these outcrops to lead the eye diagonally back from the left-hand foreground and up to the angels hovering protectively behind Christ. The miniature towns, which signify the temporal power offered in the second temptation, are also composed so as to lead the eye back into the picture space.

Duccio probably learned something of the technique of rendering space in a three-dimensional perspective from a contemporary, the Florentine Giotto di Bondone (active c.1304–1337). Giotto not only set his figures naturally in space; his solid, even massive forms depart from Gothic attenuated elegance. Tradition makes Cimabue his teacher, but his style has more in common with the sculpture of the Pisanos and shows an awareness of Classical art paralleling the classicism in the writings of Dante and Petrarch. Giotto is the first artist since Greek times for whom we have so much evidence of the fame he enjoyed in his own lifetime. Dante mentions him in the *Divine Comedy*; he was the first painter to be put in charge of a major building project, the cathedral of Florence.

In painting Giotto showed a feeling for solid human figures placed in an ordered composition with a sense of natural space. The earliest works that we know for certain to be his are a fresco cycle in Padua depicting the life of the Virgin and of Christ where his treatment of spatial illusion may have influenced Duccio's Maestà altarpiece. Fresco was a medium suited to Giotto's style; a technique of applying paint to a wet plaster wall, it necessitates working quickly, before the plaster dries, and favours a rapid, flowing line.

Like Duccio, Giotto used techniques of composition to produce a passably realistic imitation of three-dimensional space on a flat surface. In figure 164, *The Annunciation of the Virgin's Birth to Saint Anne*, the room seems too small and light for its substantial inhabitant, and resembles stage-scenery more than a real background, but its details are carefully drawn to lead the eye back. The wooden bench is clearly behind Saint Anne and the chest is at right angles to her, set diagonally to draw a line back to the curtain hanging in the corner; we see two sides of the curtain.

In Giotto's rendering of space figures are arranged in a way that draws attention to the psychological aspect of the story. Near the end of the cycle

at Padua there is a scene set outdoors, in which the Virgin and the disciples lament over the dead Christ (fig. 163). The earthy peasant forms firmly occupy the space they are placed in; those standing are correctly placed behind the kneeling figures in front. Behind the group, a conventional rocky outcrop leads the eye from the heads of Christ and the Virgin back and to the right, into the middle ground, where a realistic and appropriately dead tree directs the eye to the lamenting angels overhead. These angels clearly inhabit a space further back as well as above the mourners in the foreground. The composition is stark, with no unnecessary detail; space and landscape contribute to the intensity of sorrow and loss exhibited by the mourning figures.

The angels overhead are daringly portrayed in difficult postures, foreshortened so that they appear to fly forward out of the picture space. The portrayal of figures from odd angles had been skilfully handled by the Pisanos, but the effect is easier to achieve in a plastic medium; in painting the artist must radically flatten the figure to trick the eye into believing in the illusion of depth. Until the 1400s, no other painter could handle the technique of foreshortening as well as Giotto did; other artists imitated Duccio's manner of painting two-dimensional figures in a three-dimensional space.

The illusion of a natural and definable background, whether an enclosed room or a receding landscape, became an object of technical experiments in late Gothic painting. A cycle of frescoes painted by Ambrogio Lorenzetti (active 1319–48) in Siena's town hall shows a new and broader vision of landscape. The subject of the cycle is a traditional medieval allegory of the effects of good and bad government on both town and countryside. But the viewpoint is new; in this panoramic fresco we see the countryside, populated with busy workers, as if from a hill nearby (fig. 65), and we are aware of vast dimensions of space unrolling away from us as we follow the winding road and hills back from the foreground to the smaller details further away.

International Gothic Style

The social changes that shook the foundations of medieval society in the fourteenth and fifteenth centuries created new opportunities in the arts, which blossomed with renewed vigour. A late Gothic style emerged so widespread that it has come to be called 'International Gothic'. This was a style of great technical virtuosity, yet it also reflected the growing apprehensions of a society facing changes it could not control. The late Middle Ages retreated into a dream of an older and safer world; nostalgia for the age of chivalry brought about a revival of all its trappings in new orders of knighthood and showy, artificial tournaments. The pomp and heraldry testify to the romantic notion of knights in shining armour that prevailed

when the original role of knighthood had all but disappeared. The growing separation of the artificial ceremonies of chivalry from the more brutal realities of war is reflected in the elegant and courtly art that developed from the painting of Giotto and of the Sienese and appeared almost simultaneously in the major centres of Europe.

The Sienese followers of Duccio were the immediate trend-setters, developing a decorative style characterized by a sinuous, curling line that corresponds to the curlicues of Flamboyant architecture. This style was also characterized by a sense of space that isolates a scene in its own little world, a more elaborate version of the enclosed *Paradise Garden* such as figure 149. An illusion of depth of space was achieved with increasing skill in International Gothic painting, but never to mirror the real world; rather it was to create a charming and artificial realm shut off from the evils of reality. In panel painting the illusions of three-dimensional recession are often at odds with the flattening effects of gold leaf, which was popular in Gothic painting because it created a bright, glittering effect in dark interiors. The courtly patrons of International Gothic art also favoured gold leaf because it was expensive and emphasized the wealth and status of the purchaser.

A Sienese painter whose work demonstrates the International Gothic decorative line and theatrical setting was Simone Martini (active *c.* 1315–1344). His painting often combines the ornamental and two-dimensional effects of bright colour and gold leaf with a landscape background suggestive of stage-scenery. In his portrait of Guidoriccio da Fogliano, for example, there is a curious tension, a sense of action caught and frozen in time (fig. 166). Not even the raised foreleg makes us see the horse as actually walking through the landscape. The background details are softened to suggest distance, but this hint of atmosphere and distance is overwhelmed by the flattening effect of so much gold. The form of the rider disappears into the design of the cloak and matching saddlecloth; both he and his mount seem to hover in an undefined space.

North of the Alps, International Gothic emerged as a style of painting excellently suited by its graceful enchantment to please patrons who were predominantly kings and courtiers. In the French court, illusionistic techniques were transferred to the medium of manuscript illustration, in small decorative scenes that appear unhinged from their background, like three-dimensional scenes glimpsed through a window in an otherwise obviously flat page (fig. 165). Jean Pucelle (*c.*1300–1355), the foremost court painter during the reign of Charles IV, was influenced by Sienese art, but works like this also show the line of a tradition in French manuscript painting descended from the Louis IX Psalter (fig. 139). It is from a Book of Hours, or service book, made for Jeanne d'Evreux, Charles's queen. Pucelle's skill in depicting three-dimensional space is equal to Duccio's, but his intentions appear to have been more ornamental than naturalistic; the *Annunciation* is separated from the rest of the page, floating above the

165 Jean Pucelle, *Annunciation,* from the Petites Heures of Jeanne d'Evreux, *c.* 1325. 3½ × 2½ in (8.75 × 6.25 cm). New York, Metropolitan Museum of Art, the Cloisters Collection
Jeanne d'Evreux is seen at her prayers inside the letter D. The figures below are playing a form of tag.

letters. Inside a capital D we find the queen at her prayers, as if the letter were a little room.

The technical skill that is the most impressive quality of International Gothic art shows how greatly its patrons admired complexity and virtuosity as a hallmark of beauty. It was a sophisticated art that wound several levels of meaning into an intricate allegory. This virtuoso interweaving of symbolism and painterly charm is typified by the Wilton Diptych (fig. 167), which portrays the English king Richard II being presented to the Virgin.

The king kneels in the left-hand wing, which signifies the earthly terrain he is about to leave; the Virgin and Christ Child and a retinue of angels are in Heaven, to which Richard is being recommended by three saints. That he will be received into the company of Heaven is suggested by the gesture of the angel who holds the banner of Christ as if offering it to the king. As a particular compliment, not only the saints but the angels are dressed in the livery of Richard's household, wearing the personal badge of the white hart and collars of broom pods which was popular among his courtiers near the end of his reign. This suggests that he is worthy to be admitted to the company of angels; the fact that there are eleven angels, the number of Christ's disciples after the defection of Judas, has been interpreted as signalling this particular honour.

The exaggerated symbolism and the painterly charm of the Wilton Diptych are typical of International Gothic painting. Although the work was probably done by a foreigner, there is a nationalistic, English, note in the subject; by the end of Richard's lifetime, England had ceased to be a nation of Norman lords and Anglo-Saxon peasants and felt its own identity as an English nation. Accompanying Richard's patron saint John the Baptist are two Anglo-Saxon saints, Saint Edmund, a king killed by the Danes in 869, and the last Anglo-Saxon king, Edward the Confessor. This emerging sense of being one country was accompanied by the disappearance of Norman French as the court language, in favour of English; under Richard's patronage the first fine flowering of poetry written in the medieval English language took place. In the hands of Geoffrey Chaucer and the anonymous poet who wrote *The Pearl* and *Gawaine and the Green Knight*, English rose to splendid heights as a poetic medium, a feat paralleled in the development of Italian as a language of poetic diction in the works of Dante and Petrarch.

It is in English poetry that we find the originality and virtuosity of International Gothic art, for there was no school of English painters equal to Jean Pucelle or Simone Martini. But the poets shared with the painters an emphasis on skill and technical complexity. Earlier medieval literature had separated allegory, which developed meaning through multiple levels of imagery, and romance, where the emphasis was on an exciting plot. In late medieval poetry the two strains were brought together in an intricate interweaving of themes and images operating on different levels of mean-

166 (*top*) Simone Martini, *Guidoriccio da Fogliano*, 1328. Fresco. Siena, Palazzo Pubblico

167 (*bottom*) The Wilton Diptych, *c.* 1400. Two panels, each 18 × 11½ in (45 × 28.8 cm). London, National Gallery

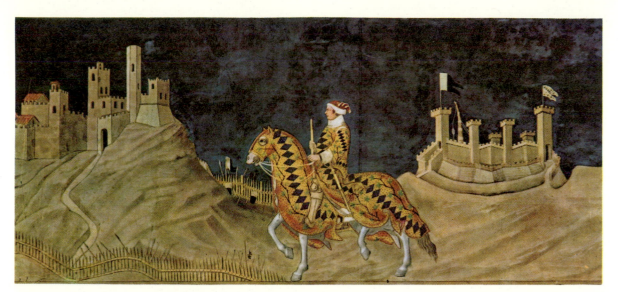

ing while simultaneously developing adventurous plots and appealing characters. For example, *Gawaine and the Green Knight* weaves two older stories together, a test of loyalty in the face of temptation and a test of courage, in a manner that shows off the poet's consummate skill in handling several levels of meaning in a fresh and entertaining story told in beautiful and sophisticated verse, in the West Midland dialect of his time. There is a moral at the end of the story, as Gawaine survives his dual test almost, although not wholly, intact, but it is the cleverness with which the moral is approached that counts.

Mixed in with the theme and plot of Gawaine's story is the poet's praise of medieval culture, a theme echoed in International Gothic art. As Western civilization was buffeted by war, plague, and economic disasters, art reflected that civilization all the more gloriously. Gawaine's ride through the wet, cold, fearsome wilderness is contrasted with the civilized beauty of Arthur's court, richly decorated with Persian carpets and other exotic trappings, while the surrounding countryside passes through the seasons with all the pastoral charm of the Labours of the Months on Amiens cathedral.

International Gothic as a Style of Living

By 1400 the tenor of life in the waning Middle Ages reflected the deliberate complexity and display of proficiency so evident in art and literature. Late Gothic architecture housed the great and the small in picturesque structures ranging in scale from the extravagant palaces of the wealthy nobility (fig. 168) to the half-timbered houses leaning out into the crowded streets of the towns (fig. 169). Even the middle class sometimes lived surrounded by luxury and charm; in Bourges there is a large and elaborately decorated house built by a fifteenth-century merchant-banker named Jacques Coeur. Coeur amassed the fortune with which he built this house by the precarious occupation of lending money at interest. He lost his fortune and his livelihood because he loaned vast sums to the king, who, rather than pay back what he owed, allowed the banker to be imprisoned on a false charge of treason, and confiscated what was left of Jacques Coeur's fortune.

The house in Bourges remains as a testament to its owner's happier days. Begun in 1443, it is a fine example of domestic Flamboyant architecture. From the street it presents a fortress-like exterior (fig. 170); the house was also a bank, where large sums of money were kept guarded. Note that its tower is covered with a lacy web of tracery similar to that on the towers of the castle in figure 168. Inside, the house is an asymmetrical arrangement of apartments opening off one another. One has the continual sense of going around corners and coming upon some surprise. Small stone faces pop out from crockets and corbels, and in one room a whole cast of

168 (*below*) The Limbourg brothers, *The Temptations of Christ*, from *Les Très Riches Heures du Duc de Berry, c.* 1413–16. $6\frac{5}{8} \times 4\frac{1}{2}$ in (16.9 × 11.4 cm). Chantilly, Musée Condé

169 (*bottom*) Fifteenth-century houses, Rouen. Restored

170 Hôtel Jacques Coeur, Bourges, street façade, begun 1443

characters leans out of 'windows' carved in the chimney-piece to engage our attention (fig. 172). This intricate and illusionistic piece of architecture was designed both to elevate its owner's status and to provide a comfortable and pleasant dwelling; on the scale of this house, Gothic design was admirably suited to the task.

The greater lords lived in more ostentatious and less comfortable palaces furnished with all the luxury and beauty so lovingly described in *Gawaine and the Green Knight* and portrayed by the Limbourg brothers, Flemish artists working for John, Duke of Berry. It is for the courts of the Duke of Berry and his brother the Duke of Burgundy, both sons of King John II of France, that the most stunning visual counterparts of the imaginary Camelot were created.

The Duke of Berry was fonder of collecting art than he was of the tortuous political intrigues of the time. He lived during France's worst reversals in the Hundred Years War; having spent some time as a hostage in England after the French defeat at Poitiers in 1356, he died just after Henry V's victory at Agincourt in 1415. Yet from the world glimpsed in the paintings done for him throughout these dangerous times we would think he lived in a paradise of security and good fortune. He built a series of enormous and elaborate Flamboyant Gothic palaces, almost all since destroyed, but their appearance was faithfully depicted in the background of manuscripts illustrated for him. The castle seen in figure 168 was no fairy-tale invention but an accurate portrait of his castle of Mehun-sur-Yèvres.

In a period of fine craftsmanship, there was no separation between furnishing and painting or sculpture; just as some of the structural members of a building became elaborately sculptural, so ordinary furnishings became gorgeous works of art, and the workshops providing these household goods became prestigious artistic centres. In the International Gothic period tapestries, which were practical hangings to keep out draughts and had been decorated with simple geometric or heraldic designs, became as carefully designed as a painting. Figure 173 is a tapestry from a set that belonged to a younger brother of the Duke of Berry, Louis, Duke of Anjou. It is a series of illustrations from the Book of Revelations; in this example, Saint John, the author of the book, watches contemplatively from a small room reminiscent of the little buildings in the Utrecht Psalter (fig. 80), while Saint Michael and attendant angels swoop down on Satan and cast him out of Heaven. This tapestry scene displays the same sense of pictorial space that we find in painting.

The most detailed and most beautiful picture of life in the International Gothic period comes from a book of hours aptly called the *Très Riches Heures* (the Very Rich Hours), made for the Duke of Berry in *c.*1416. It was illustrated by the three Limbourg brothers. The full-page illustrations of the Labours of the Months follow the iconography of the little quatrefoils on the thirteenth-century cathedrals, but in the full

171 (*left*) The Limbourg brothers, *February*, from *Les Très Riches Heures du Duc de Berry*, c. 1413–16. 8¾ × 5⅜ in (22.3 × 13.6 cm). Chantilly, Musée Condé

172 (*below left*) Chimney-piece, Hôtel Jacques Coeur

173 (*right*) Satan cast down from Heaven by Saint Michael, a panel from the Apocalypse tapestry, 1373–9. Château d'Angers, Tapestry Museum

174 (*below*) The Master of Flémalle (Robert Campin?), *The Annunciation with Donors and Saint Joseph* (the Mérode Altarpiece), *c.* 1445–8. Oil and tempera on panel, height $25\frac{1}{2}$ in (63.8 cm); width, centre panel 25 in (62.5 cm), left wing $10\frac{3}{4}$ in (26.8 cm), right wing 11 in (27.5 cm). New York, Metropolitan Museum of Art, Cloisters Collection

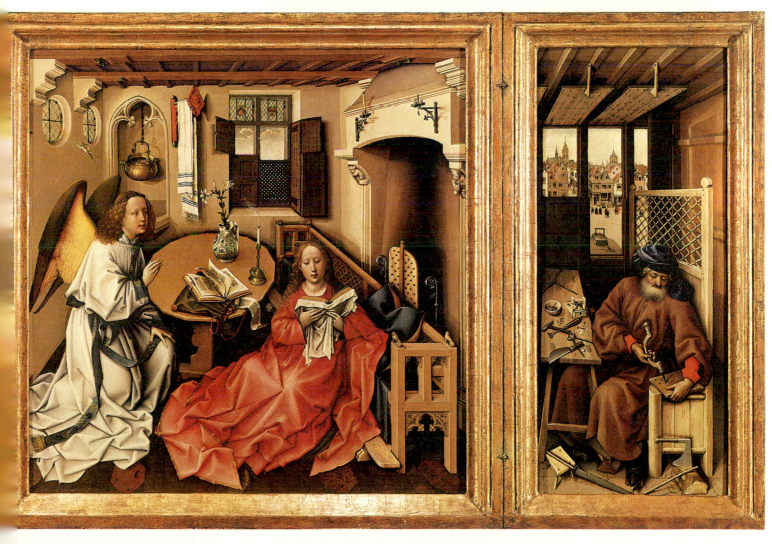

pictorial scale of International Gothic style. They are remarkably convincing portrayals of fifteenth-century manners, dress, and style, and even of methods of agriculture. The illustration for February (fig. 171) has the same image of peasants warming their feet by the fire that we saw at Amiens (fig. 135). But here we see not only the interior of the hut (its wall conveniently removed to let us see inside) but also the farmyard in which it is set, and the wintry landscape beyond. The painterly techniques that lead us back into the picture space were learned from the Sienese, but the feeling for atmosphere and for winter light is new to Western painting. We feel the February cold not only from the graphic image of the servant girl huddled against the chill and blowing on her hands; we feel it in the cold light reflecting off the snow.

The attention paid to the details of daily life here speaks of an art on the borderline between medieval symbolism and a new enjoyment of beauty and skill for their own sake, reflecting the increasingly secular patronage under which these artists worked.

International Gothic under the Dukes of Burgundy

It was under the auspices of the dukes of Burgundy that the most far-reaching advances were made within International Gothic painting and sculpture. The four dukes — Philip and Bold (ruled 1363–1404), John the Fearless (1404–19), Philip the Good (1419–67), and Charles the Bold (1467–77) — were, despite the warlike nicknames of three of them, men of taste who loved art and who appreciated its value as propaganda. The most innovative of the artists working under these dukes came from Flanders, which Philip the Bold inherited on the death of his father-in-law in 1384.

In the work of Flemish artists of the fifteenth century, we find a dramatic change in style and feeling. The subjects of this art follow the same religious iconography we have seen throughout the history of medieval art, but the forms show a new technical mastery employed to express secular interests and temporal power as well as religious spirit.

The style of the sculptor Claus Sluter (died 1406), who worked for Philip the Bold in his court at Dijon, has little of the artificial prettiness of International Gothic works like the *Très Riches Heures*. Sluter's figures have the mass and solidity of Giotto's, and like Giotto he composed them to emphasize psychological character. The 'Moses Well' at Dijon (fig. 175) was originally the base for a large Crucifixion, calling upon the old symbolism of the Old Testament as the precursor and foundation of the New. Moses was traditionally given horns because of a mistranslation of the Hebrew word for rays of light. But if the iconography is familiar, the spirit is entirely new. The prophets are powerful individuals, carved so as to be almost completely independent of the architectural setting; they exist as important in themselves, rather than as decorative ornament.

175 Claus Sluter, The Prophets Moses and David, from the Moses Well, erected 1393–1402. Height of figures *c.* 72 in (180 cm). Dijon, Chartreuse de Champmol

Sluter's monumental figure style had a widespread effect on both sculpture and painting. In the work of his near-contemporary, the Master of Flémalle (1378/9–1444), we find the same solidity of figure and the same sense of individuality and psychological relationships between figures. The Master of Flémalle, generally identified as a painter named Robert Campin, painted a small portable altarpiece for a Flemish family, meant for their private worship, that gives us a view of the middle class paralleling the Limbourgs' portrait of aristocratic and peasant life. In the Mérode Altarpiece (fig. 174), the Master of Flémalle combined the solid naturalism of Sluter's figures with the spatial illusionism learned from the Limbourgs and from Italian painting. Here the Flemish artist tried to coordinate the space in all three panels so that it seems to open out as one view, seen naturalistically from where we stand. The sitting room, scene of the Annunciation, and the adjoining workshop where Joseph is at his carpentry, are deeply recessed and filled with objects. The windows and the garden gate open out into a minutely detailed city-scape populated with tiny figures. The perspective is not perfectly coordinated; Joseph's workshop ceiling slopes at a different angle from that of the main sitting room, but the painting gives the impression of natural space, outside and inside.

Despite his devotion to medieval allegory and encyclopedic detail, the Master of Flémalle treated his subject with a new and human naturalism. The garden lies beside the house, and the open door between allows the kneeling couple for whom the work was painted to watch the drama taking place inside while remaining apart from it. They are shown in their normal size instead of being hierarchically smaller than the Virgin. A figure standing near the garden wall (perhaps a portrait of the artist) is smaller merely because he is farther away from us, no longer because he is less important.

It was a novelty to place the Annunciation in such a domestic setting; this allowed the artist to portray not only the symbols associated with the Virgin, but the also trappings of a well-to-do household. The pot symbolizes Mary as a pure vessel, the lilies represent her purity and the prayerbook her devotion; even the mousetrap on Joseph's table is apparently an erudite reference to a sermon of Saint Augustine, yet all these items are also important for the way in which they contribute to the perspective and spatial relationships.

The roundness of forms comes not just from the skilful drawing but from an advance in the technology of painting. Most medieval painting was done in tempera, in which pigments are mixed with a binding element such as egg, but the Master of Flémalle added oil, which slows the drying and thus permits a blending of colours to give a luminous effect of light and shadow. The pot is clearly round because of the way light reflects off its surface. The smoke from the recently extinguished candle has a very realistic transparency.

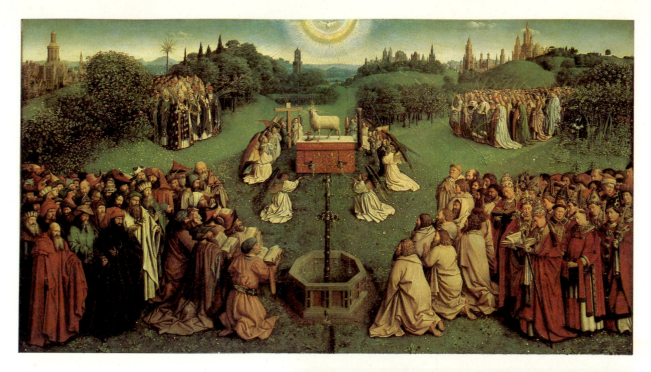

176 (*above*) Hubert and Jan van Eyck, *The Adoration of the Lamb*, centre panel of the Ghent Altarpiece, completed 1432, Panel, 53 × 93½ in (134.5 × 237.5 cm). Ghent, church of St. Bavo.

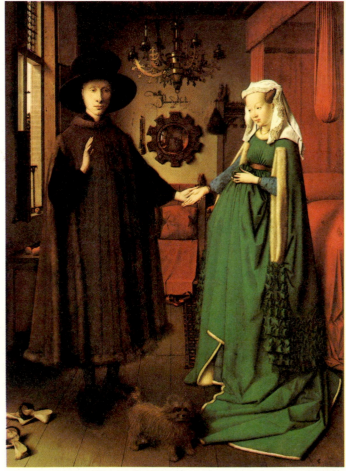

177 (*right*) Jan van Eyck, *The Bethrothal of the Arnolfini, c.* 1434. Oil on panel, 32¼ × 23½ in (80.6 × 58.8 cm). London, National Gallery

178 (*far right*) Jan van Eyck, *The Madonna of Chancellor Rolin, c.* 1433–4. Oil and tempera on panel, 26½ × 24¾ in (66 × 62 cm). Paris, Louvre

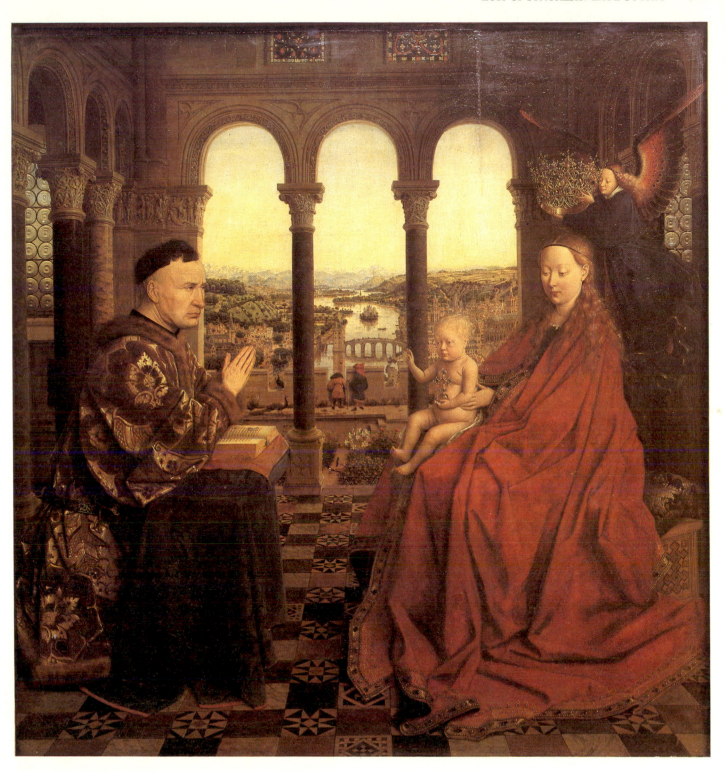

This painterly achievement in atmospheric perspective reached a new height in the work of Jan van Eyck (c.1390–1441), who was slightly younger than the Master of Flémalle, and who worked for Philip the Good. The duke thought highly enough of van Eyck to stand as godfather to the artist's son.

It was not only artists who were beginning to acquire individual personality. Jan van Eyck painted a portrait of the duke's powerful chancellor kneeling before the Virgin and Child (fig. 178). Portraits of those who commissioned works of art had been included in earlier paintings, but always in humble attitudes, like the couple in the Mérode Altarpiece, not as a main feature of the composition. In the fifteenth century we find portraits like this in which the secular personage is just as prominent as the religious; the Virgin is a conventional type, but the chancellor an important individual.

Jan van Eyck was so skilful in the technique of oil painting that he has been credited with inventing it. In his portrait of Chancellor Rolin, the picture space recedes from the two figures in the foreground to a middle ground outside, where a garden lies, bounded by a wall over which two small figures peer at the town and landscape lying below and beyond. The greatest charm of the painting is in the background, where a river winds through the town under a hump-backed bridge and into the countryside beyond. Jan van Eyck blended colours so subtly that his background gives a real feeling of atmosphere softening into a hazy distance.

The skill with which he handled light and atmosphere in landscape is very evident in an altarpiece he painted with his brother Hubert for the church of St. Bavo in Ghent. Here the main scene (fig. 176) takes place out of doors, in a landscape whose perspective is coordinated between the central panel and the two wings. The scene depicts Christ as the sacrificial lamb standing on an altar, his blood flowing into a chalice, and the cross of his martyrdom behind him. The groups of figures — Old Testament prophets, saints and martyrs — are arranged within the convincing perspective that leads back to cities, rivers, valleys, and mountains. The light strikes naturally from behind the spectator and illuminates the Apostles and female saints, casting the Old Testament figures appropriately but also naturally in shadow. The haziness of the background suggests accurate observation of natural phenomena; objects seen at a distance are perceived less distinctly, losing definition and colour. Painters in Antique times had observed this and had blurred background details (see fig. 37), but never with the coordination of atmospheric and linear perspective of Jan van Eyck.

In 1434 van Eyck painted a full-length portrait for Giovanni Arnolfini, an Italian merchant in Bruges who wanted a picture to celebrate his betrothal to Giovanna Cennini. The portrait (fig. 177) shows the same painterly concern with arranging forms so that light reflects off the surfaces. As in the Mérode Altarpiece, the objects can all be read as symbols of

the sacrament of marriage, but they are first and foremost beautiful objects highly prized by their owner.

The greatest novelty in the painting lies in the unity of picture space. The room is naturally lit by a window. The couple, although they seem close to us, stand in the middle of the room; van Eyck used a trick of illusion to show us the rest of the room reflected in the mirror. Here we see not only the back view of the couple but two other people, the painter and a friend, apparently acting as witnesses.

The skill with which Jan van Eyck handled the smallest details, from the mirror reflections to the tactile realism of the dog's hair, the fur and velvet of the couple's clothing, and the wood and brass furnishings, shows the heights to which the painterly achievements of International Gothic art could rise. Before van Eyck, no one had explored fully the luminous possibilities of oil paint, as tempera and gold leaf suited flat, bright panel painting and lightened the dark interiors of churches. But however skilled in naturalistic painting, van Eyck was working and thinking within the framework of the late Middle Ages; the naturalism achieved in oil painting by the Dutch and Flemish two centuries later came not just from the Flemish successors of van Eyck but also from Italy. Here, painters were opening the way towards a more classical and far-reaching naturalism, which they, in turn, could never have attained without the example of oil painting provided by Jan van Eyck and his followers.

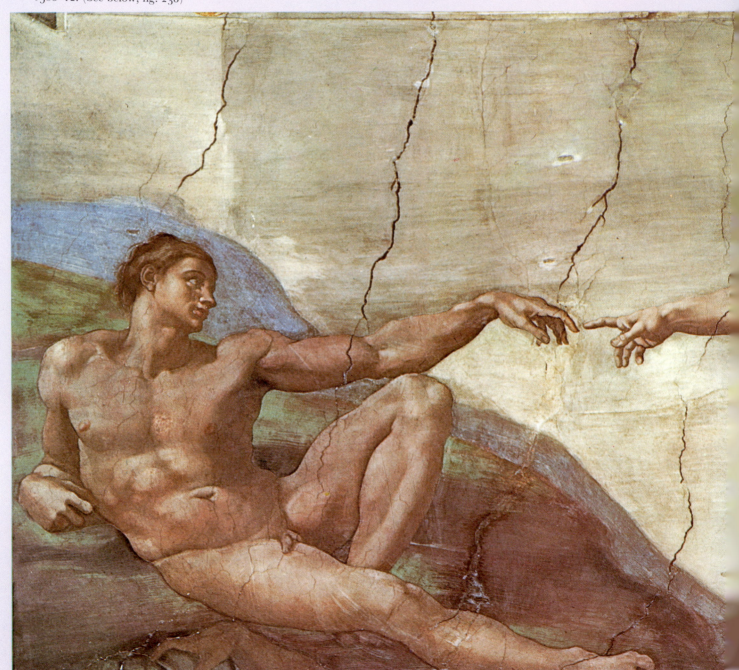

PART 3 The Renaissance

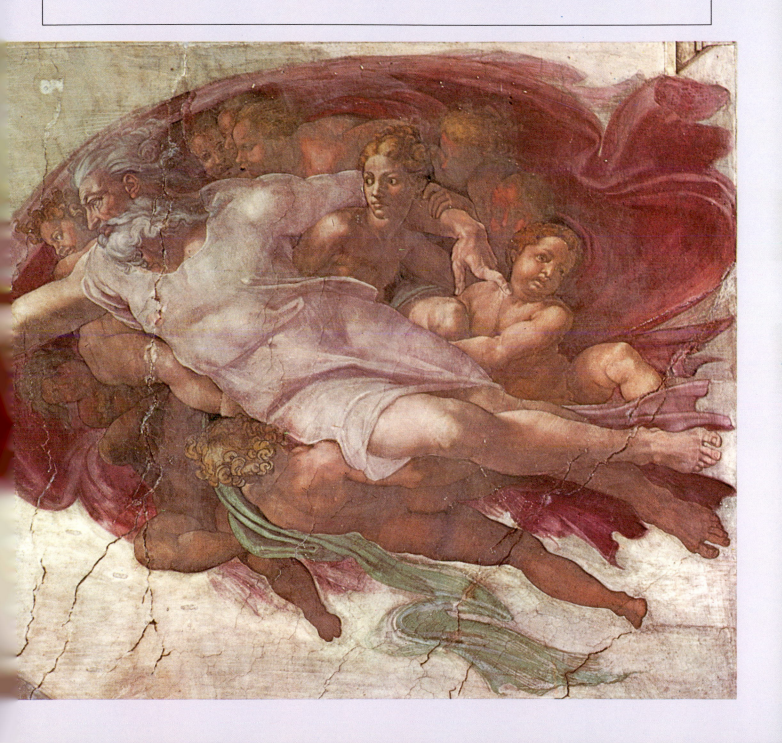

INTRODUCTION

'Romanesque' and 'Gothic' are terms used by later historians seeking to distinguish between two major styles of medieval art. 'Renaissance', on the other hand, is a label coined by the age it refers to, an age in which people participated in what they saw as a rebirth of Classical culture — not only in art but in literature, philosophy, and politics as well. The period of art covered by this term extends through four separate styles and three and a half centuries. Beginning in medieval Italy at the turn of the fifteenth century, the Renaissance ended in a world of separate states and separate faiths, no longer centred on the Mediterranean Sea but voyaging to the ends of the earth and colonizing the American continent.

The era of colonialism and expansion that ended by westernizing much of the globe sprang from a reaction against the theocratic, feudal confinement of the Middle Ages and from a new confidence in the possibilities of human achievement born of a revival of Classical learning and art. From the first stage of the Renaissance, Classical art was admired for more than its beauty and its connections with early Christianity; it was admired because it put man at the centre of the universe. The Renaissance view was summed up in a popular quotation from the Greek philosopher Protagoras, 'Man is the measure of all things.' Man was seen as the microcosm, the 'little world made cunningly', from whom all the workings of the universe, the macrocosm, could be learned.

It took a long time for medieval institutions to lose their place in Western society; the narrow streets with Gothic gabled houses, crowded with traffic, gave way only slowly to the new classicism of spacious squares and houses with straight façades blending together. Gothic architecture still held sway in Shakespeare's England, while in Germany popular taste capitulated only to the fourth style of the Renaissance, the Baroque, a style as romantic and ornate as the late Flamboyant Gothic it replaced.

The four periods of style in the Renaissance are distinct, separated by aim, technique, and form, yet are connected by shared views on art theory and history. In the Early Renaissance, artists in Italy developed the principles of three-dimensional perspective from a much more theoretical and learned approach than the painterly illusionism of Flemish art. Their methods were based on fresh studies of Classical art, yet go far beyond anything the Greek and Roman painters had achieved in turning a flat surface into an illusion of three-dimensional space. This phase occurred only in Italy, from the beginning through to the end of the fifteenth century, for which reason it is often called by the Italian word for the century, *quattrocento* (four hundred).

The second period, from the last decades of the fifteenth century to roughly 1530, was dominated by Leonardo, Michelangelo, and Raphael, and is justly called the High Renaissance. In the history of Western art this was the moment of closest harmony between emotional romanticism and the cool restraint and stability of Classical art. The apparent perfection of its balance between form and feeling was so overwhelming that it seemed impossible for succeeding artists to surpass such works as Leonardo's *Mona Lisa* or Michelangelo's *David*. The third phase of Renaissance style (*c.* 1530–90) has been called Mannerism because its artists — who included Michelangelo in his later years — exhibited personal mannerisms of style in distorting the harmony of space and form achieved by the High Renaissance.

The Mannerist treatment of form and space then gave way to a new, more dramatic and illusionistic style in which the object was to obscure natural boundaries between space and mass. Covering a period from about 1580 to 1700, it has been named Baroque, a word synonymous with the absurd, or bizarre. In its fascination with complexity of line and illusionistic effect, the Baroque style had something in common with the last phases of other styles, for example, Hellenistic and International Gothic. Thus we can see the four styles of Renaissance art as successive phases of a single style, connected by shared attitudes towards Classical art as well as by common assumptions about the importance of art and artists.

But to do this is to see the whole period only in terms of style, as though the arts had no relation to social, political, or economic pressures. Each period was stamped by unique conditions affecting patron and artist, from the city-states of fourteenth-century Italy to the absolute monarchy of Louis XIV in seventeenth-century France. So we will examine the Renaissance as four separate, yet closely related, episodes in the development of Western art.

CHAPTER 7

Man the Measure of All Things: The Early Renaissance

The Early Renaissance belongs to Italy. Italy in the 1400s was an ideal place for the growth of new ideas and a new sense of the meaning of life. Being at the centre of the old Roman Empire, the Italians always felt closer to the Classical past than did the rest of Europe. Gothic architecture was never popular in Italy; there are close links between Roman, Italian Romanesque, and Renaissance buildings. Moreover, the political circumstances at the beginning of the century opened the way for a genuine rebirth of Classical art and learning. Italy was divided into city-states, all engaged in shifting alliances to maintain a balance of power between the three territorial overlords: the king of Naples, the pope, and the Holy Roman Emperor. By the second half of the century, the balance of power was maintained more by diplomacy than by war, so that the larger states enjoyed periods of peace and prosperity at the very time when cultural inclinations and technical skills were at a level to be exploited in a rebirth of art and learning. While England was torn apart by the Wars of the Roses, while France was struggling to recover from the ruinous Hundred Years War, and the Holy Roman Emperor was in conflict with the duke of Burgundy in the west and with Hungary in the east, the independent states in Italy were left free from foreign intervention until late in the century.

The political, economic, religious, and social changes that Europe underwent in passing from the Middle Ages to the modern period all appeared first in Italy. The art of diplomacy and the term 'balance of power' came from Italian Renaissance history. The evolution from an agrarian to a capitalist economy happened throughout Europe, but all except two of the leading Renaissance bankers were Italian. The ideal of the Renaissance court arose in towns such as Florence, Urbino, and Mantua. The Reformation did not commence with Martin Luther; it was in part an outgrowth of the Classical humanism fostered in these courts. Previous revivals of Classical learning had been the work of churchmen intent upon clarifying and strengthening Catholic doctrine. The Renais-

sance scholars were professional intellectuals who loved Classical literature and philosophy and who saw antiquity as a lost golden age. In this, they weakened the traditional view of history as a continual line of progress according to God's predetermined plan. By their attitude of questioning, the Renaissance philosophers paved the way for the Reformation to challenge the absolute authority of the Catholic Church. Renaissance historians were the first to treat history thematically and selectively, emphasizing parallels with the past. It was they who first referred to the Middle Ages as a dark period between the golden age of Greece and Rome and the rebirth of culture in their own period.

For Florence in particular, 1400 appeared as a watershed. The balance of power between the Italian cities was being threatened by the expansionist policies of the Duke of Milan, Giangaleazzo Visconti, who, with the backing of the Holy Roman Emperor, invaded one city after another until Florence faced the enemy alone. The duke died in 1402, before he could conquer Florence, but where an earlier generation would have seen his death entirely as the will of God, the Florentines found a parallel with ancient Athens which had faced the might of Persia. Florence had emerged unscathed because she had stood fast, like the young David facing the mighty Goliath. This is the first indication since antiquity of Western people believing that their own actions could change their destiny.

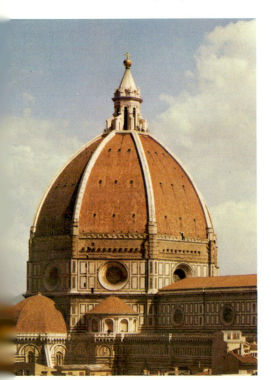

180 Filippo Brunelleschi, dome of Florence Cathedral, 1420–36

The First Generation

The first third of the fifteenth century was marked by the careers of artists whose training had been in the craft guilds, but whose outlook and temperament were stirred by the collapse of the Milanese threat and the resulting outburst of patriotism and self-confidence. Brunelleschi, Ghiberti, Masaccio, and Donatello made new strides in art and architecture technically no more astonishing than van Eyck's achievements, but philosophically and psychologically more far-reaching. We know virtually nothing about van Eyck as a person; we know a great deal about the four Florentines — for example, that Brunelleschi and Donatello were friends, whereas Brunelleschi and Ghiberti were rivals. Artists were important enough for gossip to be circulated and passed down to later generations. Nor did they leave the judgement of posterity to others; the pride of the age is seen in Ghiberti's *Commentaries,* a history of art written to publish his own achievements, in which he asserted, 'Few things were made in our country that were not designed and planned by me.'

Filippo Brunelleschi (1377–1446), an architect, made his reputation by his design for the dome of Florence's cathedral (fig. 180). By drawing and studying Roman ruins, he had learned more than anyone before him of the actual engineering principles the Romans had followed. From this knowledge and his familiarity with Gothic building techniques he was able to

solve the problem of the dome. The nave of the cathedral had already been built, as well as the drum, the octagonal wall that carries the dome, without a sound structural scheme for covering this area. The space was too wide for the vertical ribs of Gothic architecture, while the drum wall had been made too thin to carry the weight of a semicircular dome like that of the Pantheon. Brunelleschi devised an ingenious scheme that married the vertical lightness of Gothic design to the impressive stability of a Classical dome. He built two thin shells rather than one massive vault, thereby lightening the load on the drum. The inner, weight-bearing shell consists of twenty-four vertical ribs that support horizontal layers in narrowing concentric rings (fig. 181). The outer dome, also supported by vertical ribs, protects the inner structural members from the weather.

The result is neither Classical nor Gothic; it is a Renaissance design. Brunelleschi understood thoroughly the principles of Classical architecture, but in being forced to modify the design to fit the existing drum, he softened the heavy grandeur of Roman building by mixing it with the light, soaring quality of Gothic. All of his architecture demonstrates this adaptation — rather than copying — of antique models.

Brunelleschi was given an opportunity to develop his classicizing style of architecture by the enlightened patronage of the most powerful family in Florence, the Medici. Giovanni de' Medici (1360–1429) founded the family fortune through trading and banking in Italy and abroad. His son Cosimo (1389–1464) was able to convert wealth into political power; he became absolute ruler of Florence without ever holding a fixed office.

Despite the prevalence of lending and borrowing in the fifteenth century, usury, the lending of money at interest, was still considered a sin. It was to atone for this that Giovanni de' Medici commissioned Brunelleschi to build a public orphanage. Along the front of this building, Brunelleschi designed an open arcade, or loggia, that became a much-copied model in Early Renaissance architecture (fig. 182). This loggia was a return to the Classical balance between vertical and horizontal forces. The upper-storey windows and their classical pediments form a unifying band, while the slender colonnade makes a graceful vertical counter-accent. The bays of the loggia are not groin-vaulted like Gothic cloisters, but are simple domed bays. Each one is formed into a perfect square, lending a sense of proportion to the whole. Yet we are not aware of the loggia as a series of bays, but rather as a unified whole, lighter and more graceful than Roman arcades.

Brunelleschi's buildings were increasingly inventive adaptations of Classical designs to fifteenth-century needs. He gave form not so much to Classical architecture as to Classical humanist philosophy. He achieved a human scale in architecture because he designed buildings from the point of view of the spectator, who is drawn into the proportions and perspective of the structure. The Pazzi Chapel (fig. 183), commissioned in 1430 by a wealthy Florentine family as the chapter house of the convent attached to

181 (*below*) Schematic drawing of Brunelleschi's dome (after Peter Murray)

182 (*bottom*) Filippo Brunelleschi, Loggia of the Ospedale degli Innocenti, Florence, 1421–4

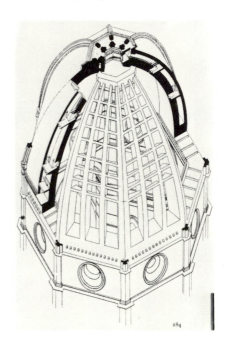

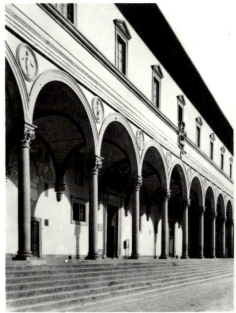

CHART 4 THE RENAISSANCE, 1400—1600

EVENTS			ART AND CULTURE
1402 Duke of Milan dies; Florence preserves freedom	1400		
1417 Popes return from Avignon to Rome			
			1420-36 Brunelleschi, dome of Florence Cathedral
1422-68 Sigismondo Malatesta ruler of Rimini			
	1425		c. 1427 Masaccio, *Holy Trinity*
1429 Death of Giovanni de' Medici in Florence			c. 1430-2 Donatello, *David*
1434-64 Rule of Cosimo de' Medici in Florence			c. 1435 Ghiberti, *Doors of Paradise*
			1435 Van der Weyden *St Luke Painting the Virgin*
			c. 1440 Fra Angelico, *Annunciation*
1444-82 Federigo da Montefeltro ruler of Urbino		EARLY RENAISSANCE	
1445-78 Lodovico Gonzaga ruler of Mantua	1450		c. 1450 Invention of printing
1452-93 Frederick III Holy Roman Emperor			
1453 Turks capture Constantinople			
			1456-7 Piero della Francesca, *Flagellation*
1458-64 Pius II pope			1459-63 Gozzoli, *Journey of the Magi*
			c. 1460 Alberti, Palazzo Rucellai
1467-77 Charles the Bold, last duke of Burgundy			
1469-92 Rule of Lorenzo de' Medici 'Il Magnifico'	1475		1473-4 Mantegna, Camera degli Sposi, Mantua
1480-99 Lodovico Sforza, ruler of Milan			c. 1480 Bellini, *St Francis in Ecstasy*
			1481 Perugino, *Giving of Keys to St Peter*
			1485-1503 Bosch, *Garden of Earthly Delights*
1494-1512 Florentine Republic			1492-5 Bramante, Santa Maria delle Grazie
1495 Death of Savonarola			1495-7 Leonardo, *The Last Supper*
1499 French expel Lodovico Sforza from Milan			
1500 France and Spain partition Italy	1500		
			1501-4 Michelangelo, *David*
			c. 1502 Leonardo, *Mona Lisa*
1503-13 Julius II pope		HIGH RENAISSANCE	1504 Raphael, *Betrothal of the Virgin*
			c. 1505 Giorgione, *The Tempest*
			1506 Rebuilding of St Peter's begun in Rome
1509-47 Henry VIII king of England			1508-12 Michelangelo, Sistine Chapel ceiling
1512 Restoration of the Medici in Florence			1510-15 Grünewald, Isenheim Altarpiece
1513-21 Leo X pope			1513 Dürer, *Knight, Death and the Devil*
1515-47 Francis I king of France			1514 Raphael, *Madonna della Sedia*
1517 Martin Luther's 95 Theses, signalling the			1516-18 Titian, *Assumption of the Virgin*
Reformation			
1519-56 Charles V emperor			1519 Château of Chambord begun
1519-40 Federigo Gonzaga ruler of Mantua			1520 Titian, *Bacchus and Ariadne*
	1525		1524-34 Michelangelo, Medici Sacristy tombs
1527 Sack of Rome by the Emperor Charles V			1525-35 Giulio Romano, Palazzo del Tè
			1532-40 Parmigianino, *Madonna of the Long Neck*
1534 St Ignatius Loyola founds Jesuit Order		MANNERISM	1533 Holbein, *The Two Ambassadors*
1535 Thomas More beheaded for refusing to recognize			
Henry VIII as head of English Church			
			1536 Sansovino, Library in Venice begun
			1536-41 Michelangelo, *Last Judgement*
			1538 Titian, *Venus of Urbino*
1545-68 Council of Trent ushers in Counter-Reformation	1550		1550 Vasari, *Lives of the Artists*
1556-98 Philip II king of Spain			
1558-1603 Elizabeth I queen of England			1565 Bruegel, *Hunters in the Snow*
			1566-80 Palladio, San Giorgio Maggiore, Venice
1572 Dutch wars of liberation begin	1575		1575-8 Della Porta, Il Gesù
			1577-9 El Greco, *Assumption of the Virgin*
1582 Death of Saint Teresa of Avila			
1588 Defeat of the Spanish Armada			1592-4 Tintoretto, *Last Supper*

Santa Croce, is a centrally planned design in which Brunelleschi balanced the axes of the chapel so that the main domed space, running north and south, is countered by the east–west axis between the altar and the entrance. The plan (fig. 184) shows the intellectual force behind the unity of space in this chapel. Mathematics governs the scheme by which a circle and two semicircles fit into a rectangle, while the loggia and main chapel together form a perfect square. The decorative details articulate the harmony of proportion between the walls, arches, and dome, drawing the whole space into perspective from wherever the spectator stands.

Brunelleschi's feeling for perspective came from his study of Classical texts as well as buildings. He worked out theories of perspective that became enormously important to the arts, and especially to painting. Using mathematics, he derived a formula for linear perspective in which lines recede back to converge on a single point, at which they appear to vanish. By coordinating perspective in a painting with the viewpoint from which it was seen, an artist could achieve the effect of opening the wall in a continuous flow of space from where the viewer stands.

Brunelleschi's theories of perspective enabled Early Renaissance artists to emphasize a sense of psychological relationships within a scene. When Lorenzo Ghiberti (1378–1455) cast the final pair of doors for the Florence baptistery, he modelled a series of scenes in rectangular frames and used linear perspective to unify each composition. The result, nicknamed by Michelangelo *The Doors of Paradise*, is illusionistic in a manner closer to painting than to sculpture (fig. 187). Ghiberti even used the painter's technique of *chiaroscuro*, the Italian word for contrasting shadow and light, to add to the illusion of depth by gilding all but the outlines. The linear perspective knits the elements of the story together to dramatize the relationships between the human actors.

Ghiberti probably learned the technique of perspective from another sculptor with whom he worked on a baptismal font in the cathedral of Siena in the late 1420s. This was Donato di Niccolò Bardi, called Donatello (1386–1466), a friend of Brunelleschi. Like Brunelleschi, Donatello used Classical models to create works that were not copies of the past but were wholly new. He cast the first large-scale nude figure since antiquity, a bronze statue of the young David (fig. 185). David is shown here as the victor, already having slain Goliath. Except for his youth, which is true to the Biblical story, and his boots and helmet connecting him to fifteenth-century Florence, this is a strikingly classical figure, not only in its relaxed contrapposto, but in its nudity, for which there was no iconographical precedent. Throughout the Middle Ages nude figures were generally restricted to Adam and Eve or the dead rising from their graves on Judgement Day. In contrast to the self-conscious nakedness of such medieval figures, David is serenely unaware of his unclothed state; he belongs to this natural condition as surely as the Greek statues of nude gods.

183 (*top*) Filippo Brunelleschi, interior of the Pazzi Chapel, Florence, designed *c.* 1430

184 (*above*) Pazzi Chapel, plan

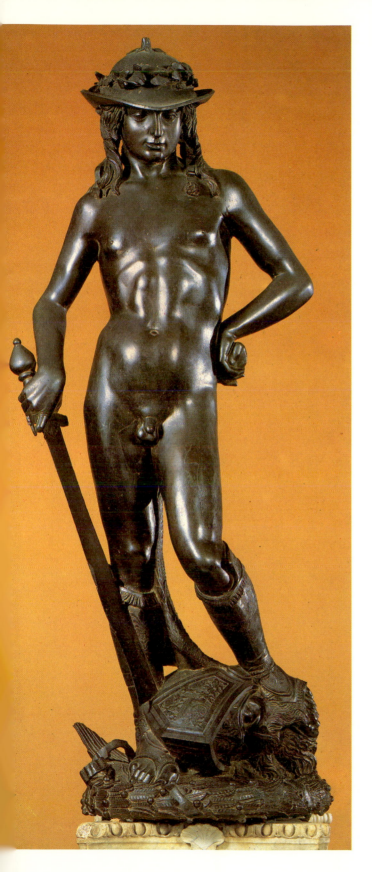

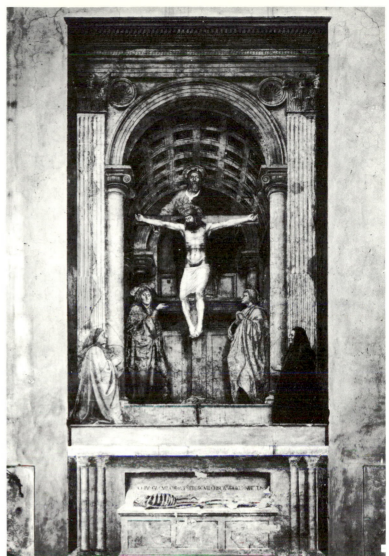

185 (*left*) Donatello, *David*, *c.* 1430–2. Bronze, height 62¼ in (156 cm). Florence, Museo Nazionale (Bargello)

186 (*above*) Masaccio, *Holy Trinity with the Virgin, St. John, and Donors*, *c.* 1427. Fresco, 260½ × 114¾ in (667 × 317 cm). Florence, Santa Maria Novella

In bronze reliefs made for the Siena baptistery, Donatello used Brunelleschi's theory of perspective to turn a flat plane into an illusion of three-dimensional space close to the effect of a painting. In *The Feast of Herod* (fig. 188) the rows of patterned tiles lead the eye towards a vanishing point that seems well behind the surface. Herod and his courtiers are seated not in the front of the picture space but well inside it. The line of movement towards the vanishing point is given a counter-thrust by the action of Herod, recoiling in horror from the head of John the Baptist. The foreground drama is in marked contrast to the serenity of the top half of the picture, where rows of arches recede to a second vanishing point above the first; here no counter-motion creates a tension of forces.

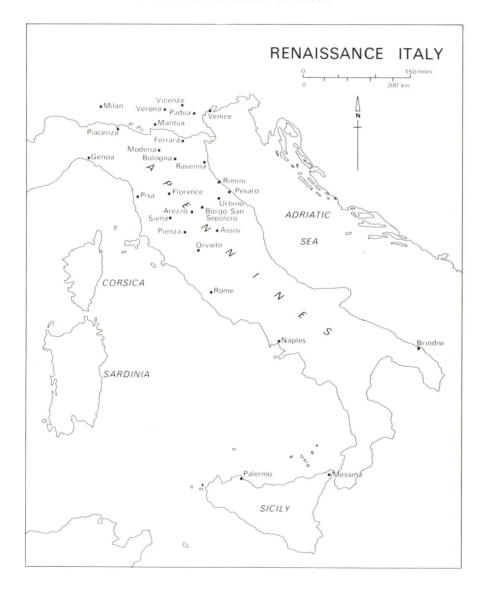

RENAISSANCE ITALY

0 150 miles
0 200 km

N

Milan • Vicenza
Verona • Padua
Piacenza • Mantua • Venice
R Po
Ferrara
Modena •
Genoa • Bologna •
Ravenna
Rimini
Pisa • Florence • Pesaro
Arezzo • Urbino
Siena • Borgo San Sepolcro
Pienza • Assisi
Orvieto

ADRIATIC

SEA

CORSICA

Rome

SARDINIA

Naples
Brindisi

Palermo • Messina

SICILY

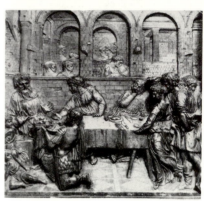

187 (*top*) Lorenzo Ghiberti, *Cain and Abel*, from the 'Doors of Paradise', *c*. 1435. Gilt bronze, $31\frac{1}{4}$ in (78 cm) square. Florence, Baptistery

188 (*above*) Donatello, *The Feast of Herod*, 1427. Gilt bronze, $23\frac{1}{2}$ in (58.8 cm) square. Siena, Baptistery font

If Donatello used a painter's techniques in achieving an illusion of depth in relief carving, his younger contemporary Tommaso di Ser Giovanni di Mone, called Masaccio (1401–28), drew on architecture and sculpture to create a painted illusion of a recessed chapel in his fresco of *The Holy Trinity* (fig. 186). Masaccio used Brunelleschi's achitectural style as well as his theories of perspective in creating a *trompe l'oeil* illusion (one which fools the eye) of a real chapel with a marble ledge extending out in front of it and a tomb beneath, including a skeleton, imitating the traditional carved *memento mori*.

Compared to the elegant artifices of International Gothic, Masaccio's *Holy Trinity* appears massive and severe. The figures are arranged in a double pyramid working upwards from the donors kneeling on the painted ledge to the figure of God the Father above the cross, and inwards to the back wall of the chapel. The vertical pyramid is medievally hierarchic, a symbol of life aspiring from the material to the spiritual through Christ's sacrifice and the intercession of the Virgin and the saints. To this Christian view Masaccio added the Classical view of art as an imitation of life; his horizontal pyramid opens the picture space back from our viewpoint. The Brunelleschian coffered ceiling converges towards the back wall, convincingly behind the figures. The cross is set in the middle of the chapel, with the Virgin and Saint John in front of it, and God is seen standing on a shelf behind the cross, supporting its weight. Mary's gesture joins us to the scene by inviting us both farther in and higher up.

The Holy Trinity is somewhat static and overweighted by its architectural and mathematical symmetry, relieved only by Mary's three-quarter stance and gesture. But Masaccio could paint a subject as dramatic and emotional as Donatello's *Feast of Herod*. For the chapel of the Brancacci family at Santa Maria del Carmine he painted a group of frescoes in *c*.1427 that includes *The Expulsion from the Garden of Eden* (fig. 189). This was the first work in Western art to catch the impact of the Fall as a human tragedy and a personal loss. Eve's howl of despair and Adam's simple, powerful gesture of hiding his face in his hands dominate the scene, while the background has been reduced to a bare minimum, the wall of Paradise (providing perspective) and a faint impression of landscape. The angel, foreshortened to add to the illusion of depth, gazes compassionately rather than fiercely at the couple, emphasizing their loss as a human sorrow. The light comes from the direction in which the couple move rather than from the garden behind, which we may interpret as a hopeful sign, but more important is the fact that the light is natural and enhances the physical solidity of the figures. No wonder that the Florentine artist and historian Vasari, writing in the sixteenth century, praised Masaccio for his realism: '... Masaccio can be given the credit for originating a new style of painting; certainly everything done before him can be described as artificial, whereas he produced work that is living, realistic, and natural.'

The immense strides made by Masaccio, Brunelleschi, and Donatello in

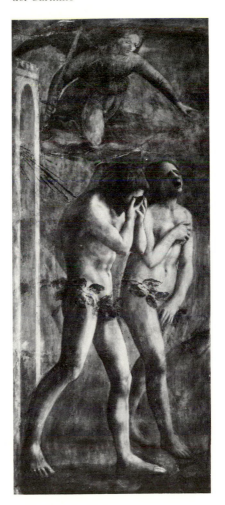

189 Masaccio, *Expulsion from the Garden of Eden*, begun *c*. 1425. Fresco, 81 × 34¾ in (208 × 88 cm). Florence, Brancacci Chapel, Santa Maria del Carmine

the first third of the century gave colour to the contemporary feeling that they were participating in a rebirth of culture beside which the achievements of the preceding millennium of Western art paled into insignificance. No wonder succeeding centuries overlooked the Flemish painters and gave the Italians all the credit for restoring realism to art. Van Eyck's naturalism was achieved within the medieval guild system, surrounded by the conventions and restrictions of medieval society. By contrast, the workshops of the Florentines were dominated by the personalities of the masters, whose theories were imbibed along with technique. Florentine artists were still guild members, but they no longer felt that the arts were merely crafts to be learned and taught like masonry or carpentry; as the century progressed, under the patronage of wealthy and art-loving families like the Medici, art in Italy became a high calling. In the North, the static condition of late medieval institutions served to divorce art from intellectual life and to divide painting and sculpture from architecture. In the dynamic climate of fifteenth-century Italy, artists rose on a tide of modernism and self-assertion.

Perspective and Perspectives

Donatello and Brunelleschi enjoyed long lives and influenced the course of architecture and sculpture from the beginning of their careers. In painting, however, the impact of the new style was less immediate. Masaccio died young, in 1428, and the full effect of his influence was delayed till the next generation. The theory of perspective affected all painters to the extent that it modified the expectations with which people came to regard picture space; the naive charm of Gothic make-believe no longer seemed an adequate substitute for realistic space. But the ornamental charm of the International Gothic style was not overthrown all at once, and in the first half of the fifteenth century we find various attempts to mix its essentially flattening decorative details with an introduction of one-point perspective.

In an altarpiece painted for the church of St. Francis in Borgo San Sepolcro, a Sienese painter, Stefano di Giovanni Sassetta (c. 1400-50) combined the colour and graceful line of Sienese art with an effort to harmonize mass and space according to the principles of Brunelleschi and Masaccio (fig. 190). He used perspective to coordinate the composition of each scene without trying to unify the overall viewpoint between different frames, and without the psychological force of Masaccio's frescoes. In figure 190 we see Saint Francis giving his cloak to a poor knight, standing in a roadway outside a house; inside, the saint is asleep, dreaming of the celestial city, which floats above. Individual elements like the visionary city are given careful perspective from the point of view of a spectator looking up at the scene, yet the parts do not quite fit together. The house, for example, is set at an impossible angle to the street, pulling away from

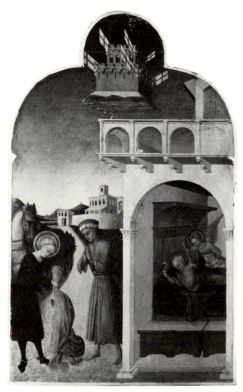

190 Stefano di Giovanni Sassetta, *Saint Francis Giving his Cloak to a Poor Knight*, 1430–2. Panel from an altarpiece, $34\frac{1}{4}$ × $20\frac{1}{2}$ in (85.6 × 51.3 cm). London, National Gallery

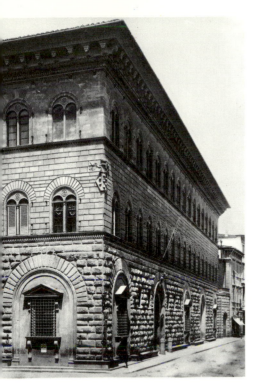

191 Michelozzo di Bartolommeo, Palazzo Medici–Riccardi, Florence, 1444–59.

the receding diagonal of the roadway, and thus working against the overall sense of space.

The Florentine painters following Masaccio were enthusiastic about perspective, yet they too tried to adapt it to the flat, decorative line of International Gothic that is so far removed from Brunelleschian line and mass. A stylistic eclecticism was encouraged by the taste of the ruling Medici, Giovanni's powerful and astute son Cosimo, who used the power of his wealth to establish virtual control over all aspects of Florentine life. Cosimo valued Brunelleschi and Donatello, but he also patronized the International Gothic painters; his new palace was filled with art and objects of all styles. For the building itself, he turned down Brunelleschi's plan on the grounds that it was too impressive and would excite jealousy. Instead, he employed a follower of Brunelleschi, Michelozzo di Bartolommeo (1396-1472), who also designed the lantern above Brunelleschi's dome on the cathedral. Michelozzo's palace (fig. 191) is rusticated, that is, faced in massive blocks of rough stone with deeply cut joints, in a manner derived from Classical Roman and medieval buildings. Its courtyard (fig. 192) is a copy of Brunelleschi's Orphanage loggia bent around a square, its windows framed not with Gothic trefoils and rosettes but with classically rounded arches and circular windows called *oculi*.

The Medici palace was decorated by artists as different as Donatello, whose *David* stood in the courtyard, Benozzo Gozzoli (*c.* 1421–97), a painter who adhered to the flat, bright colours and gold leaf of International Gothic, and Paolo Uccello (1397–1475), who enthusiastically pursued excercises in three-dimensional drawing. For Cosimo's son Piero de' Medici Gozzoli painted a fresco of *The Procession of the Magi* that covers the walls of the palace chapel (fig. 194). It provided an opportunity to celebrate Medici history in the framework of a religious subject. Various members of the Medici family and household are portrayed in flattering proximity to the Magi; Cosimo and his son Piero ride behind the young king, and the youths next to them may be Piero's sons Lorenzo and Giuliano. The procession winds its way around the walls of the chapel in a series of episodes connected by the landscape. It is the artificial stage scenery of International Gothic brought technically up to date but without an attempt to coordinate perspective to a particular viewpoint.

Paolo Uccello's three paintings of the Battle of San Romano, a past Florentine victory, which decorated Cosimo's bedroom (fig. 197), are dominated by the attempt to organize the composition by the rules of one-point perspective. Uccello laid out the fallen lances like a checkerboard on the ground to lead the eye back in receding diagonals, yet the background itself is an unrealistic toy landscape with a strange and mythical hunt spread across it. The horses are carefully drawn to appear round and solid, yet they have the appearance of wooden toys, frozen into improbable positions.

The painter most successful in combining the light prettiness of the

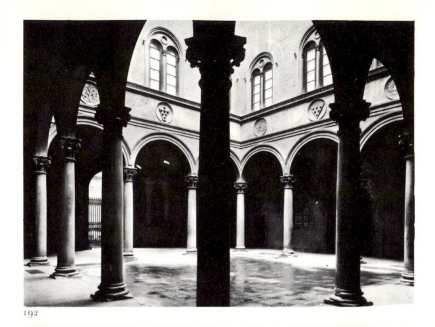

192

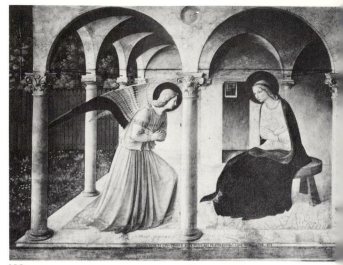

193

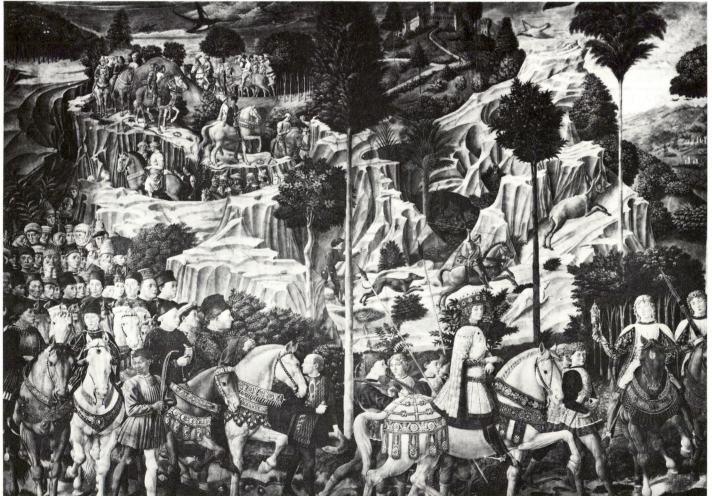

194

progression from simple to ornate capital attracts the eye upwards, counter-acting the strong horizontal effect of the bands dividing the three storeys. The unity of decoration within each level strengthens the total sense of harmony and symmetry, while the variety between storeys keeps the façade from being boringly repetitive.

The close relationship between intellectual and aesthetic principles exhibited by Alberti's architecture was based on a redefinition of Greek humanism that came from a fresh examination of Classical texts. His scholarly approach to a theory of art helped to raise art to the rank that the ancients accorded to the seven Liberal Arts. To consider art as being on the same level as mathematics or rhetoric was to place it on a more intellectual level than that of the guilds and workshops of anonymous craftsmen.

Alberti's patrons differed widely in character and attitude. At the same time as he was working on the Rucellai palace, Alberti drew up designs for one of the most notorious of the tyrant-condottieri, Sigismondo Malatesta, lord of Rimini. The condottieri, a new breed of professional soldiers who led their own armies, were profiting from the continual warfare between the Italian towns. They differed from feudal knights in that they were not bound by any vow of loyalty, and often proved treacherous allies. Sigismondo was one of the least trustworthy; his successes in battle against the pope's armies infuriated the Church as much as his sacrilegious behaviour. It was the latter, however, that led the pope to consign him officially and publicly to Hell. Sigismondo, a humanist who loved the myths and pagan gods of Greece and Rome, kept a court of philosophers, scholars, and poets whom he valued so highly he planned to have them buried beside him. The intended burial place was the church of St. Francis in Rimini, which he commissioned Alberti to turn into a classical temple. Nothing is more illustrative of the violent contrasts of the age than that the church dedicated to such an unworldly saint should become, without ever officially changing its name, a pagan temple erected to earthly glory.

Alberti's design included a dome which was never built; the existing façade provides an example of his inventiveness in adapting Classical forms (fig. 200). He used the form of the Roman triumphal arch, drawing on the Arch of Constantine in Rome (fig. 48) and a Classical arch in Rimini. Sigismondo intended the sarcophagi containing his and his mistress's remains to be placed within the triumphal arch, thus articulating the pagan view of a triumph over death gained not through Christian salvation but through earthly fame. The columns are thrust forward as they are on the Arch of Constantine to give the façade a plastic quality; its mobile and three-dimensional surface was especially influential on later Renaissance architecture.

Alberti's ideas were also adapted to town planning. Italy was more predisposed to planning space and buildings in a rational and harmonious manner than was the North, with its narrow, crowded, winding streets; the squares of towns like Siena had been laid out in the Gothic period with a

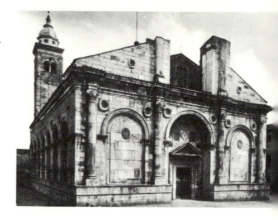

200 Leon Battista Alberti, Tempio Malatestiano, Rimini, 1446–55

201 Intarsia (wood inlay) from the studiolo of Duke Federigo, 1472–82. Urbino, Ducal Palace

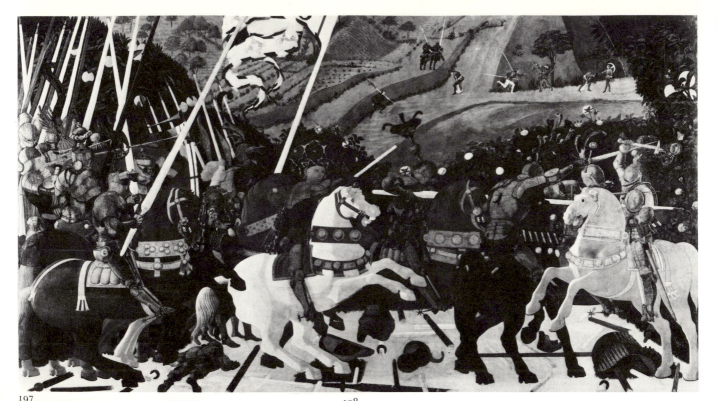

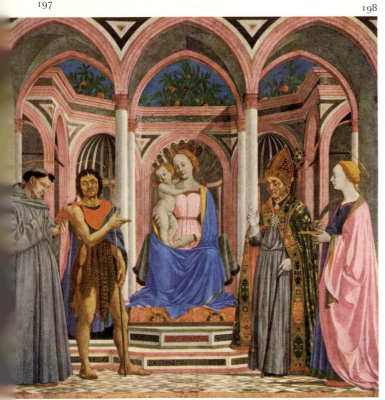

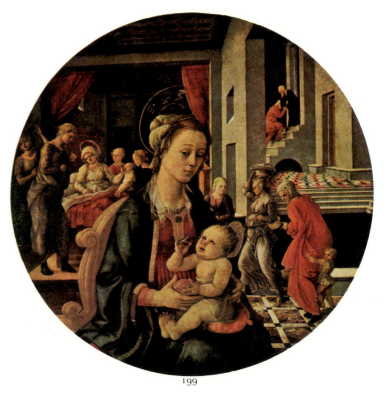

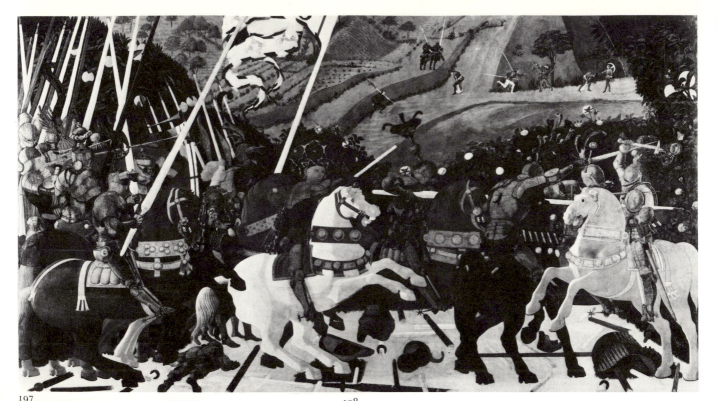197 198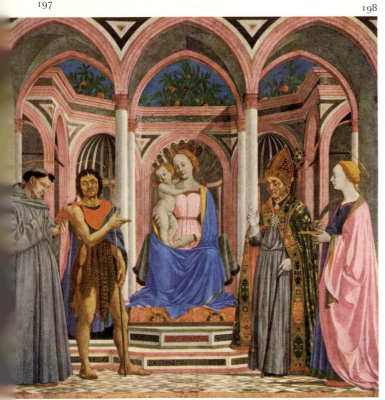

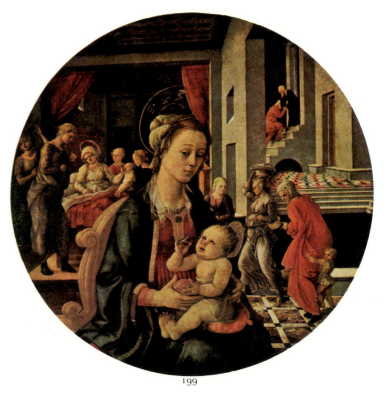199

Renaissance humanists differed from earlier scholars who had studied the Classics in that they deliberately sought to restore the standards of Classical Latin and studied Greek, a language few earlier scholars could read. At the age of twenty, the precocious Alberti wrote a Latin comedy that passed as an original Classical play. He wrote three treatises, one on painting, one on sculpture, and one on architecture, that form a vital link between Brunelleschi and the theory of art as it came to be taught and handed down until the twentieth century. Alberti was impressed by the work of Masaccio, Donatello, and Brunelleschi, and included them in the dedication to the first of his treatises, *De Pictura* (*On Painting*), published in 1435. It speaks for the connection the Early Renaissance restored between the arts that Alberti dedicated this work to an architect, three sculptors, and a painter.

Like Brunelleschi, Alberti was drawn to mathematics as the perfect science that linked the visible to the invisible world. He built his theory of aesthetics on the philosophy implied in Vitruvius' treatise (see above, p. 41), focusing especially on Vitruvius' use of the human body as the paradigm of proportion:

> If a man lies on his back with hands and feet outstretched and a pair of compasses is centred on his navel, then his fingers and toes will touch the circumference of the circle: in the same way it is possible to fit the human figure into a square, since the height from the top of the head to the sole of the foot is the same as the width of the outstretched arms.
>
> VITRUVIUS, *De Architectura*, Book III

This principle, later illustrated by Leonardo (fig. 196), was central to the aesthetic basis from which Alberti designed his buildings, a literal application of the idea that 'man is the measure of all things'. It is in the exterior façades that we see his use of mathematics most clearly. From a combination of Vitruvius and his observance of Roman ruins he gained the conviction that one of the most important principles in Classical decoration was the use of the orders (see fig. 32) so that the plainest was on the bottom storey and the most ornate on the top, as they were used on the Hellenistic portico from Pergamon (fig. 29). A palace that Alberti designed in 1446 for a wealthy Florentine family has a more classical and symmetrical and at the same time more varied exterior than the conservative rustication of Michelozzi's Medici palace (fig. 195). On the ground floor he used an order neither Doric nor Tuscan, the simplest of the Roman orders, but definitely plain; the next storey has Corinthian pilasters, and the top storey a version of Corinthian similar to the Composite. Through one of those interesting twists of fate, this principle of a hierarchy of orders, probably never consistently practised in Classical architecture, became the basis of any architecture from Alberti on that could call itself classical, but there is a typically Renaissance principle of harmony involved. The

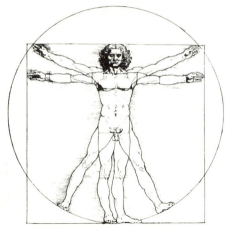

196 Leonardo da Vinci, *The Proportions of the Human Body*, after Vitruvius, *c.* 1492. Pen and ink on paper, $13\frac{1}{2} \times 9\frac{3}{4}$ in (34.3 × 24.5 cm). Venice, Accademia

197 Paolo Uccello, *The Battle of San Romano, c.* 1450. Panel, $71\frac{1}{2} \times 125\frac{3}{4}$ in (182 × 317 cm). London, National Gallery
This is one of three paintings of the same subject done by Uccello.

198 Domenico Veneziano, Saint Lucy Altarpiece, *c.* 1445. Panel, $82\frac{1}{4} \times 84$ in (206 × 210 cm). Florence, Uffizi

199 Fra Filippo Lippi, *Madonna and Child with Scenes from the Life of the Virgin*, 1452. Panel, diameter $53\frac{1}{8}$ in (135 cm). Florence, Pitti Palace

192 Inner courtyard, Palazzo
Medici–Riccardi, Florence, begun 1444

193 Fra Angelico, *Annunciation*, *c*. 1440.
Fresco, 91½ × 127¼ in (230 × 321 cm).
Florence, Monastery of San Marco

194 Benozzo Gozzoli, *The Procession of
the Magi*, 1459–63. Fresco, detail,
showing Piero and Cosimo de' Medici.
Florence, Palazzo Medici–Riccardi,
chapel

195 Leon Battista Alberti, Palazzo
Rucellai, Florence, designed *c*. 1460.

older style with linear perspective was Fra Angelico (1387-1455), a friar in
the Dominican convent of San Marco. This convent had been rebuilt by
Michelozzo for Cosimo de' Medici. The loggia setting of Fra Angelico's
Annunciation (fig. 193) imitates the Early Renaissance style of the convent
library. The lines recede back into a room with an open window, the
vanishing point, through which we glimpse a wood beyond. The open
window was a traditional motif in Annunciation scenes to signify the
entrance of the Holy Spirit, but here it was employed to achieve per-
spective. The feeling of a natural and defined space is enhanced by the
wooden fence, in line with the back wall of the room. Yet the angel and the
Virgin are drawn in graceful rather than natural postures, while the lawn
surrounding them is an artificial tapestry decorated with ornamental
flowers and tufts of grass.

Masaccio's closest follower was another monk, Fra Filippo Lippi (*c*.
1406–69), who painted solid figures in monumental Brunelleschian set-
tings, amid the clutter of detail from Gothic painting. Figure 199 is
composed along lines of perspective drawn through architectural details
which recede to a vanishing point behind the Virgin's head. Yet this firm
delineation of space is at odds with the active scenes behind the still figures
of the Virgin and Child. The bustling figures add interest to the scene while
distracting from the sense of a single unity of space.

Along with Masaccio's frescoes, one of the most innovative composi-
tions to come out of Florence in the first half of the century was an
altarpiece (Fig. 198) painted by Domenico Veneziano (*c*. 1400-61). This
work used a new form of composition in which the saints pictured with the
Virgin and Child are no longer isolated from the holy pair but are gathered
around them as if in a conversation, like a group of learned philosophers
discussing high matters. This new arrangement, known as a *sacra conver-
sazione* (sacred conversation), became very popular. The setting of this
work is also innovative; Domenico placed the group in a loggia designed in
the style of Brunelleschi's architecture and lit with natural light. For the
first time we can tell that the scene takes place on a bright sunny day.

Fifteenth-Century Synthesis

The most complete synthesis of Early Renaissance style involving architec-
ture, painting, and sculpture was the achievement of the generation
following Masaccio, Brunelleschi, and Donatello. The most important
figure of this generation was an architect and a man of letters, Leon
Battista Alberti (1404–72). Alberti was a Florentine by parentage, al-
though his family had been exiled in one of the political windstorms
sweeping Italy and he did not see his native city until 1428.

Alberti made his reputation first as a humanist; as an architect he drew
up plans, but left an assistant to superintend the work in progress. The

sense for matching façades and open space. It was easy, too, to integrate Romanesque houses with those of Renaissance design, for both tended to flat surfaces and differed chiefly in decorative elements. Although actual town planning in the Early Renaissance was almost entirely a matter of small-scale rebuilding and compromise, in one instance a new town was designed. It was commissioned by the pope whose birthplace it was. This pope was a humanist and an admirer of Classical literature; born Aeneas Sylvius Piccolomini, he took the papal name of Pius, in reference to the hero of Virgil's *Aeneid*, often called 'pious Aeneas.' As Pius II, this was the pope who consigned Sigismondo Malatesta to Hell, yet in hiring an assistant of Alberti's to convert the little village of Corsigiano into the town of Pienza, he displayed as much desire for an earthly monument as the lord of Rimini.

Architecture poses real problems demanding real solutions in which some compromise has to be made between engineering and aesthetics. In painting an artist is unhampered by such practicality, and it is in painting that we find the image of the ideal town. Far removed from the feverish activity and jumbled architecture in the backgrounds of Flemish painting, figure 202 shows us an eerily hushed, unpopulated square dominated by empty space. It is the ultimate in man-made environment, without so much as a tree growing The laws of perspective reign as they seldom do in a real town; the streets recede diagonally to a vanishing point behind the circular temple in the centre. This classical building is a perfect example of the principles of Early Renaissance architecture. The symmetry of the square is absolute, yet note that no two of the façades lining the streets are the same. All blend together in a pleasing harmony. At its best, Renaissance art and architecture could play both themes, variety and symmetry, in perfect balance.

This painted *Ideal City* hangs in the palace in Urbino, the centre where mathematics and art were most closely associated, and where the concepts developed by Alberti were most influential. The painting has been attributed to Piero della Francesca (*c.* 1410/20–92), whose style was very much influenced by Alberti; it has also been variously attributed to the two architects most closely involved with the rebuilding of the palace Urbino, Luciano Laurana (*c.* 1420/5–79) and Francesco di Giorgio (1439–1501/2). The palace was built for the lord of Urbino, Federigo da Montefeltro, a notable humanist; it was a place where Alberti was a welcome visitor, and his ideas influenced the painting and architecture in the palace.

The beauty of its design is owed chiefly to Laurana, its architect from 1468 to 1472. The courtyard in the centre of the palace (fig. 203) was derived from Brunelleschi's Orphanage loggia, by way of the Medici palace courtyard, but Laurana strengthened the articulation of the corners, which bend somewhat limply in Michelozzo's design, by replacing corner columns with stout piers faced with pilasters. The windows on the

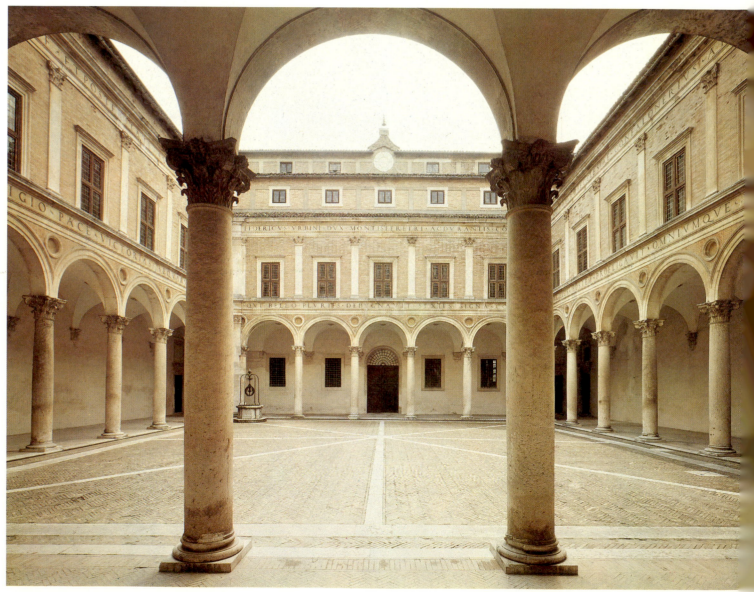

upper storey are rectangular at Urbino, with pilasters between them, which gives a more articulated and linear accent than the softer and less clearly defined facade of the Medici courtyard.

Urbino in the second half of the fifteenth century was one of the most civilized courts in Europe. It was the birthplace of two geniuses of the High Renaissance, Raphael and Bramante. Its ruler, Federigo da Montefeltro, was a successful condottiere; it was he who finally defeated Sigismondo Malatesta, and in 1474 the pope rewarded him with the title of duke. Yet this warrior was a devoted humanist whose court was the setting for elevated philosophical discussions. He was a notable patron of the arts who also collected manuscripts; Federigo would not have any of the new printed books in his library.

It was his library, or study, that was the centre of the humanist's world and the chief glory of the palace at Urbino. It is decorated with intarsia, a technique of making pictures with inlaid strips of wood that owed its popularity in the fifteenth century to its adaptability to linear perspective. The illusionism of the intarsia in the study of Urbino is a triumph; with a startling trompe-l'oeil realism, flat surfaces are turned into cupboard doors that appear open, revealing shelves with objects on them; books, musical instruments, and mathematical tools casually lie about as if the owner had been interrupted in his erudite pursuits and was about to return to them. Even nature is man-made; a 'window' opens out to a view, and an intarsia squirrel nibbles a nut on the window ledge (fig. 201)

The arrival in Urbino of the painter Piero della Francesca was a fortuitous example of something happening at the right time in the right place. His temperament and intellect were particularly suited to Federigo's court, where the respect accorded him for his knowledge of mathematics earned him higher position than that of a hired painter; he was a courtier as well, and a welcome member of the intellectual group gathered around the duke. Piero's pupil Luca Pacioli wrote an influential book on proportion that drew on Piero's unpublished writings and was illustrated by Leonardo da Vinci.

By the time Piero reached Urbino, he had already worked out the basis of his mature style from a variety of influences. Born in Borgo San Sepolcro, he grew up under the influence of the Sienese art popular there. Sassetta's altarpiece (fig. 190) was brought to Borgo by 1444; Piero may have learned some of his remarkable handling of colour from it. But he also learned much when he went to Florence in 1439, where he worked in the chapel of Sant' Egidio with Domenico Veneziano. In Florence he saw and admired the works of Brunelleschi, Masaccio, and Donatello.

Piero's painting is more closely connected to architecture than that of any other Early Renaissance painter, partly because of the close association with architects at Urbino, and partly because of his interest in mathematics. He organized picture space into geometrical cubes, following the mathematical rules he saw as governing the universe, and he set his

202 (*top*) Circle of Piero della Francesca (?), *Ideal City, c.* 1470. Panel, 79 × 23½ in (200 × 60 cm). Urbino, Ducal Palace.

203 (*bottom*) Luciano Laurana, courtyard of the Ducal Palace, Urbino, 1468–74

paintings in the cool, rational architecture idealized at Urbino. He exercised considerable influence on the design of the palace; classical decorative motifs often appear first in his painting and afterwards in the decoration of the palace. He placed his *Flagellation* (fig. 209) in an open loggia that includes an accurately detailed composite capital derived from Alberti. The painting apparently stimulated Laurana to use the same capital in his courtyard (fig. 203).

A painting obviously can take liberties with its architectural structures that a building cannot, but Piero's loggia in *The Flagellation* is constructed on such strict mathematical principles that it could be a model for an actual building. The use of a classical coffered ceiling and tiled floor emphasizes the spatial geometry; it is drawn from a single perspective, viewed from slightly below and leading to a vanishing point behind the head of the bound Christ.

The importance of proportion and perspective is underscored by the fact that the subject of the painting is relegated to the background. This small scene is frozen in mid-action; no medieval fervour intrudes. The emphasis seems to be on Christ's stoical fortitude, yet he is the smallest figure in the composition, in an eloquent departure from medieval hierarchy. The eerie quality of the painting comes from the apparent lack of connection between the foreground figures and the scene of Christ's scourging (John 19: 1-3) in the background. There is no relationship of time or action; the connection is solely intellectual. The three who refuse to notice what is going on behind them are probably Renaissance philosophers, perhaps real figures from the group at Urbino, who by their philosophical disputations connect the historic event of Christ's sacrifice to the temporal present of the painting and to the eternal and infinite universe. Piero states his theme through the laws of mathematics, using the Golden Section (see above, p. 30). The painting as a whole is a rectangle, but the area containing the Passion scene is a square, marked off by columns. If you divide this square vertically in half, the dividing line will intersect the base of the square at a point marked by a small shadow on the tiles. A circle constructed with this point as its centre, and its radius extending to the upper right hand of the square, will intersect the lower right-hand corner of the rectangle. By starting with a square, anyone can thus arrive at a rectangle with the same aesthetically pleasing ratio (1:1.618) that governs the proportions of the Parthenon, and also a house built by the modern French architect Le Corbusier (fig. 525). To Piero and his contemporaries, the connection between mathematical law and aesthetics, generally regarded as a matter of taste, could be shown to follow rules. This rational approach to aesthetics was, largely through the influence of Alberti, the central connecting link between the four Renaissance styles; it was to have a profound, and in the end restrictive, influence on the attitudes and expectations of Western artists and their public.

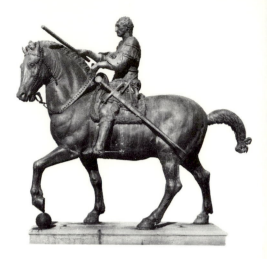

204 Donatello, *Gattamelata*, 1445–50. Bronze, 11 × 13 ft (330 × 390 cm). Padua, Piazza del Santo

What makes *The Flagellation* an appealing painting, though, is the naturalness with which everything is handled, especially the bright light flooding the courtyard and the blue sky and dark trees glimpsed over the wall. Vasari, writing a history of the Renaissance artists, praised Piero's realism above all else. Vasari was particularly impressed by a series of frescoes Piero painted in Arezzo, illustrating the Legend of the Holy Cross, a fanciful account that connects the cross of Christ's Crucifixion with the tree in the Garden of Eden. The most dramatic part of the story is the finding of the cross by Constantine's mother, Saint Helena (fig. 208). This episode as painted by Piero appealed to Vasari for its humanness: '. . . there is a peasant who, while the three crosses are being disinterred, is leaning with his hands on his spade and listening with such an attentive air to the words of Saint Helena that the effect could not be more convincing.'

Mathematician and scholar though he was, Piero never stopped learning and advancing in the painter's craft and in his aim to reproduce the world as his eye saw it. This led him to study the effects of light and to reproduce natural atmosphere beyond anything achieved before him in Italian painting. His handling of natural light and atmosphere was aided by the examples of Flemish painting circulating in Italy by the 1450s. At the time that Piero was working in Urbino and Arezzo, one of the greatest of the Flemish artists, Rogier van der Weyden (*c.* 1400–64), journeyed through Italy; he may actually have met Piero at Ferrara in 1450. At any rate, Piero could have seen some of the paintings there which the Este family, the lords of Ferrara, purchased from van der Weyden.

Rogier van der Weyden was a pupil and follower of Robert Campin; the closeness of his style to that of the Master of Flémalle is the chief reason for identifying Campin, known to be Rogier's teacher, as the painter of the Mérode Altarpiece (fig. 174). Van der Weyden seems to have influenced Piero in his ability to capture atmospheric perspective, a sense of spatial recession through the softening of light in the background. In this he himself owed much to Jan van Eyck and to the technique of mixing oil with tempera. His *Saint Luke Painting the Virgin* (fig. 205) has almost the same background as van Eyck's portrait of Chancellor Rolin (fig. 178). Van der Weyden improved the spatial coordination between foreground, middle ground, and background; the figures peering over the wall are more in proportion to the figures of Saint Luke and the Virgin. This he may have learned from his Italian contemporaries. But the soft, hazy light hovering over the hills in the background was a Flemish accomplishment, gained through the use of oil; Piero began to experiment in this medium as a direct result of seeing the effects that could be gained with it in Flemish painting.

In the mid-1460s Piero painted two portraits of the duke and his duchess to stand in the study at Urbino. By mixing oil with tempera he captured the soft light and atmosphere of the region as he had never done before. We see Federigo's realm as he would have seen it from the window of his

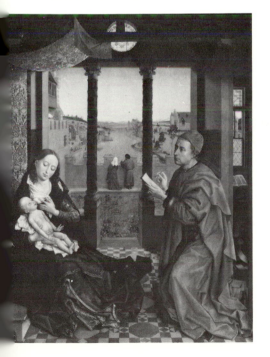

205 Rogier van der Weyden, *Saint Luke Painting the Virgin, c.* 1435. Oil on panel, $53\frac{1}{4} \times 43$ in (135 × 109 cm). Boston, Museum of Fine Arts

palace, looking down from the high rocky promontory to the wide plain below (fig. 207). Nature has been subordinated to the magnificent scale of the duke, the microcosm by which we are to measure the macrocosm. We are not overwhelmed by the vast stretch of landscape but charmed by its beauty.

The controlled, learned, rational aspect exemplified by the architecture and art at Urbino was only one side of Renaissance art. A more emotional and romantic side is seen in the works of another great painter working in the hill towns, Andrea Mantegna (1431–1506). Mantegna, also influenced by Alberti, developed a massive and classical style, but one that heightened emotional content where Piero subdued it. Piero was chiefly influenced by architecture; Mantegna's style is primarily sculptural. His teacher, Vasari tells us, set him to copy his collection of antique statues, an unusual procedure in those days, and one that developed in Mantegna a scholarly feeling for Classical art; in his painting he reproduced Roman ruins so accurately that they might be textbook illustrations. In the Early Renaissance the Church prohibited both dissection of corpses and studies from nude models, so that antique sculpture provided the chief source for correct anatomy and proportion.

Another sculptural influence on Mantegna as he was growing up in Padua was that of Donatello, who had moved his workshop there in 1443 to work on an equestrian statue of a Venetian condottiere, Erasmo da Narni, nicknamed Gattamelata (the honeyed cat). This statue (fig. 204) was the first large equestrian bronze statue since Roman times and was modelled on the statue of Marcus Aurelius in Rome (fig. 42). Like all of Donatello's works, it shows his individual approach towards Classical models. He deliberately made the rider small in proportion to the horse; Gattamelata is all the more impressive because he is the master of such a grand animal. Despite the outward calm of man and horse, there is a feeling of tension and excitement, although firmly held in check.

This sense of suppressed energy and tension appears in Mantegna's painting. His first major work was a cycle of frescoes in Padua, unfortunately destroyed during the Second World War, depicting the martyrdom of Saint James. Four scenes were constructed to share the same point of view so that the spectator looking up at the upper two saw their figures in correct relation to those in the two lower scenes. Mantegna's attitude towards picture space differed from Piero's; where Piero divided a picture into separate cubes, Andrea let one area flow into another. In figure 206 the saint delivers his last blessing; the eye travels from him to the arch and back down to the outburst of violence on the right, where two figures struggle, one pushing the other almost out of the picture in an eruption of the tension we feel throughout the scene.

In his mature style, Mantegna characteristically set massive sculptural figures in a foreground of minutely detailed Classical architecture, against a soft, picturesque landscape background. A painting of the martyrdom of

206 (*below*) Andrea Mantegna, *Saint James on the Way to his Execution*, completed 1455. Fresco. Padua, Eremitani Church, destroyed in World War II

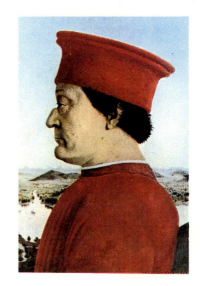

207 (*bottom*) Piero della Francesca, *Federigo da Montefeltro, c.* 1465. Oil and tempera on panel, 18½ × 13 in (47 × 33 cm). Florence, Uffizi

208 (*above*) Piero della Francesca, *The Finding of the True Cross*, 1452–9. Fresco, *c.* 11 × 24 ft (3.3 × 7.2 m). Arezzo, church of San Francesco

209 (*right*) Piero della Francesca, *Flagellation*, *c.* 1456–7. Panel, 23¼ × 32 in (59 × 81.5 cm). Urbino, Galleria Nazionale delle Marche

Saint Sebastian from 1480 places the saint, a heroically statuesque figure, amidst a classical ruin; his executioners pass below him (fig. 211). Behind the martyred saint rises a craggy hillside dotted with ruined and half-ruined buildings. The idea of setting New Testament scenes, especially the Nativity, in ruins to symbolize Christianity's breaking with Jewish law was a medieval tradition, but Mantegna goes beyond Christian symbolism. The Early Renaissance view of history is built into the hillside; one above the other he placed three cities: a ruined classical forum, dotted with tiny figures, a semi-ruined medieval fortress, and, on top, a Renaissance city. The new era, built on the shards of the old, demonstrates the Early Renaissance feeling that the fifteenth century could surpass even the golden age of Greece and Rome. The disturbing lack of transition from the harshly lit and sculptural foreground to the wild and mysterious background adds a dramatic tension to the work that arises, in part, because the religious subject is at odds with the classical and naturalistic style.

Mantegna came into contact with Alberti in 1460, when he went to Mantua. Alberti was at work there on the first of two churches he designed for the lord of Mantua, Lodovico Gonzaga. In 1470 Alberti designed the second and larger church, Sant' Andrea, the most expressive and monumental of all his buildings. Sant' Andrea was based not on the early Christian churches like Santa Sabina, but on the ruins of Roman baths and of a monumental basilica from the time of Constantine. Instead of using a light and open colonnade to divide the nave from the aisles, Alberti designed Sant' Andrea with a heavy, coffered, barrel-vaulted ceiling resting on vast piers which do not open into side aisles but are scooped out, alternately, into chapels (fig. 210). Brunelleschi's rectilinear forms were replaced here by a curvilinear rhythm of space flowing around monumental, rounded forms.

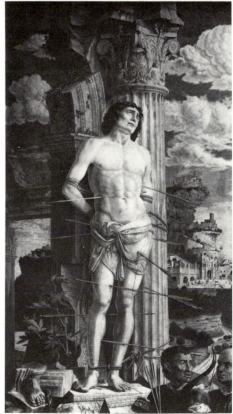

Lodovico Gonzaga, who brought both Alberti and Mantegna to Mantua, had tastes similar to those of Federigo da Montefeltro; both men had been educated at the famous school established by Lodovico's father and taught by one of the foremost humanists of the time, Vittorino da Feltre. Mantegna, although not the scholar that Piero della Francesca was, was also highly valued by his patron. It says a great deal for the changing status of artists, though, that he was reluctant to change the independence of his own workshop in Padua for the security of a permanent post which, while it assured him food and lodging, necessitated a good deal of labour on impermanent projects such as the elaborate scenery constructed for masques and other entertainments. But it was in the Gonzagas' palace in Mantua that he created one of the great monuments of Early Renaissance art.

In a reception room called the *camera degli sposi* (room of the husband and wife) Mantegna painted a series of frescoes that gives us a record of Gonzaga family history and an uncanny sense of their real presence. Nothing is accidental, yet everything seems natural and unposed. In figure

210 (*above*) Leon Battista Alberti, basilica of Sant' Andrea, Mantua, designed 1470

211 (*left*) Andrea Mantegna, *Saint Sebastian*, c. 1475–80. Canvas, $101\frac{1}{2} \times 56\frac{1}{8}$ in (257 × 142 cm). Paris, Louvre

212 Lodovico Gonzaga is seen at his daily business; he interrupts reading a letter to speak to his secretary, while his wife watches. Their young daughter leans comfortably on her mother's lap, munching an apple. The sense of catching the family in a moment of their ordinary life is closer to the spontaneity of a photograph than anything before, but the casualness is deceiving; the composition is carefully arranged to overcome the physical boundaries of the architecture. Mantegna opened out the walls of the room into an imaginary vista, exactly drawn to perspective, and realistically extended the real space so that the secretary, his foot overlapping the picture frame, seems to be half in our world. The painting denies the architectural surroundings altogether; instead of framing his scene to correspond to the lines of the chimney and fireplace, Mantegna wrapped it around the corner, using a painted stairway to fool the eye into seeing the space as a flowing continuity. In these frescoes the background is full of towering rocky promontories dotted with castles, caves, and mysterious tiny figures, unexplained small details left for our imagination to fill in.

To understand how far humanism had changed man's view of himself and his place in the world, we have only to compare the frescoes in Mantua with Gozzoli's *Procession of the Magi*, which celebrates Medici family history in the context of a Biblical subject. Mantegna painted the Gonzagas just as themselves; no further symbolism was necessary beyond showing them in their own dignity and ordinary human nature.

Cross Currents: Flemish and Italian Art

The sunlit sky and ample, round-faced people in Mantegna's frescoes seem removed from Flemish painting. Nevertheless, Mantegna, like Piero, absorbed a great deal from Northern art, especially in the minutely detailed and busy scenes found in the backgrounds of his paintings. These small vignettes have a Northern counterpart in what was probably the most influential Flemish work to come to Italy during the fifteenth century. This was an altarpiece given to the Florentine chapel of Sant' Egidio by the Medici representative in Bruges, Tommaso Portinari (fig. 213). Brought to Florence by 1483, it was painted by an artist from Ghent, Hugo van der Goes (active c. 1467–82). He was a follower of van der Weyden, but with more originality than the Flemish guilds encouraged; his career was marked by a difficult and temperamental character and ended in suicide. The Portinari Altarpiece is full of contrast and character.

In the Nativity scene we are struck by the contrast between the stiffly posed Gothic angels and the naturalness of the Virgin, a plain and simply dressed peasant girl. Homely, honest shepherds (who, curiously, carry gardeners' tools instead of shepherds' crooks) gaze raptly at the child. Behind them we find small, lively scenes unfolding against a background of rolling hills, wrapped in a chill and silvery winter light. The Annunciation to the Shepherds takes place on a hillside behind the adoring

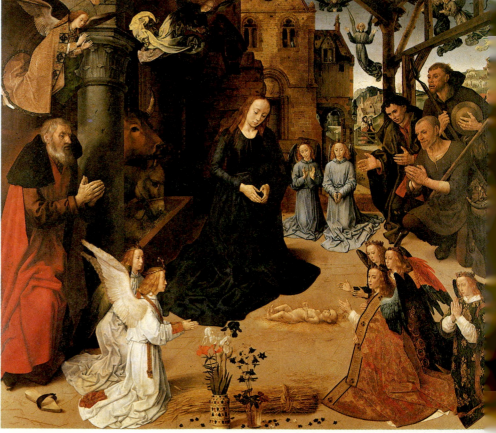

212 (*left*) Andrea Mantegna, *Lodovico Gonzaga and his Family*, Camera degli Sposi (room of the husband and wife), *c.* 1473–4. Fresco in the Ducal Palace, Mantua

213 (*below*) Hugo van der Goes, Portinari Altarpiece, *c.* 1476. Oil on panel, centre panel 99½ × 120 in (249 × 300 cm), wings 99½ × 55½ in (249 × 139 cm). Florence, Uffizi

peasants, and the Visitation is enacted by a gate to the left of them. Behind Tommaso Portinari and his sons and their patron saints a solicitous Joseph guides Mary down a steep path on the way to Bethlehem. In the right-hand wing we find the Journey of the Magi; a servant asks directions of an elderly peasant, whose friends are much intrigued by the splendid retinue of the kings. The dramatic vitality of these tiny scenes contrasts vividly with the static and hierarchic Nativity scene and donor portraits. A gulf had opened up by this time between traditional iconography and the new naturalism of style. Conventional treatments of religious subject were no longer sufficient for imaginative artists like van der Goes or Mantegna.

It was the expressive vein of the little background scenes in the Portinari Altarpiece that influenced Italian artists. While Northern artists adopted the monumental architectural perspective of the Italians, the Italians absorbed the atmospheric perspective and picturesque aspects of Flemish painting. Throughout the fifteenth century it was the Italian artists who clarified and organized space, while the Flemish were masters of the minute and the infinite. Early in the century the Italian influence appears to have been stronger, but by the end of the 1400s Italian painting leaned towards Flemish soft-edged sweetness.

Van der Weyden represents the high point of Italian influence on Northern painting in the fifteenth century. After him Flemish painting moved back to a more frankly pictorial style closer to International Gothic. We can see this direction being taken by van der Weyden's pupil, and van der Goes's contemporary, Hans Memling (d. 1494). Memling began in a style so close to his master's that their works have been confused, but there is in Memling's style a softness and a mannered trick of posing figures, easily seen in comparing works by the older master to copies made by his pupil. For example, in the central panel of his Columba Altarpiece (fig. 214), van der Weyden painted *The Adoration of the Magi* in a ruined stable, with a town and a landscape behind it. The figures are all caught in suspended motion. The youngest king, perhaps a portrait of Charles the Bold, last duke of Burgundy, is portrayed in an elegant contrapposto; he turns away from us, sweeping off his hat. This is a lively scene, full of action and character.

Memling did at least two versions of this scene. In figure 217 he widened the original composition to create more space between the figures. He softened the outlines and features of the people, while hardening the lines of the architecture, opening the back of the stable into a curved apse-like stall for the traditional ox and ass; this classical-Romanesque structure is oddly out of keeping with the ruined timber and thatch stable roof. Memling emphasized the theatrical effect by turning the figures to face us; Joseph and the middle king have traded places from the earlier version, and Charles the Bold has been replaced by a young black king. In the Columba Altarpiece the characters are involved in their own drama, whereas in Memling's work they pose self-consciously for us.

214

215

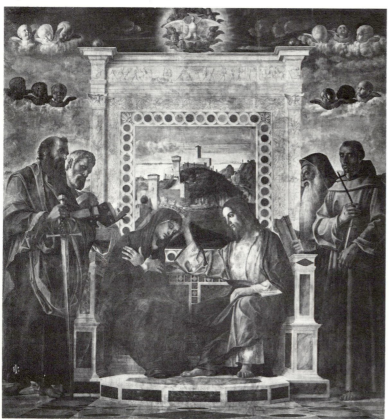

216

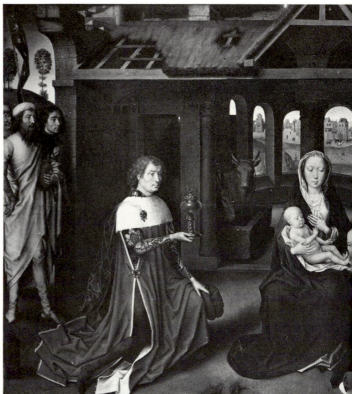

217

214 Rogier van der Weyden, *The Adoration of the Magi*, centre panel of the Columba Altarpiece, early 1470s. Panel, 54¼ × 60¼ in (138 × 153 cm). Munich, Alte Pinakothek

215 Giovanni Bellini, *Saint Francis in Ecstasy*, c.1480. Oil and tempera on panel, 49½ × 56¾ in (124 × 142 cm). New York, Frick Collection

216 Giovanni Bellini, *Coronation of the Virgin*, early 1470s. Panel, 105 × 96 in (262 × 240 cm). Pesaro, church of San Francesco

217 Hans Memling, *Adoration of the Magi*, c. 1470. Oil on panel, 23¾ × 21¾ in (60 × 55 cm). Madrid, Prado

Mantegna's affinities with van der Goes and Flemish art make it seem likely that he was influenced by the Portinari Altarpiece, but there was another cross-current of Flemish influence in Italy which may have affected his handling of light and background. In about 1453 he married the daughter of Jacopo Bellini, a Venetian painter and father of a more famous painter, Giovanni Bellini. In the 1460s Mantegna and Giovanni were both painting in a similarly hard-edged style. In 1476 an Italian painter from the south of Italy, Antonello da Messina (c. 1430–79), who had learned oil painting from the Flemish, arrived in Venice and introduced the technique. Whether or not this was an influence on Mantegna's later work, the use of oil was important in Giovanni Bellini's transition from the sculptural lines of his brother-in-law to a softer, more luminous style.

Venice and the Early Renaissance

Situated on the Adriatic Sea, Venice was the major gateway to the East, and consequently a centre marked by Oriental influences. Byzantine art and architecture modified both the Romanesque and the Gothic styles to strengthen their glittering, decorative side, as we saw in the basilica of Saint Mark (fig. 98). A powerful and favoured centre of trade throughout the Middle Ages, Venice wore her wealth with gorgeous ostentation; Venetian artists responded to Renaissance humanism by emphasizing the sensuous possibilities of colour and light rather than monumental and statuesque Classical forms.

Giovanni Bellini (c. 1430-1516) was the first Venetian painter fully to develop the humanistic Renaissance style, but he did so without losing his strong emotional attachment to Christian subjects. In his religious paintings we feel none of the disjunction between style and subject that is so strong in Mantegna's *Saint Sebastian* (fig. 211). In his *Coronation of the Virgin* (fig. 216) Bellini managed to harmonize the supernatural subject with the natural setting. Christ and the Virgin sit on a throne in a landscape; we see the Heavenly City through a window in the back of the throne, but it is a city governed by rational perspective. We could reach it by walking back from the throne. It is, in fact, a real place, the castle of Costanzo Sforza, lord of Pesaro, who commissioned the work. The religious message is conveyed in a natural and visual way; by containing the view of the Heavenly City within the frame of the throne, Bellini made the Virgin and Christ, flanked by four saints, the natural gateway through which one would have to pass to reach the city.

Bellini was less philosophical than Piero or Mantegna, and more fervently Christian. In his *Saint Francis in Ecstasy* (fig. 215), he mixed a humanistic approach with the message and symbols of Christianity in a manner reminiscent of the Mérode Altarpiece (fig. 174). Painted in a

mixture of tempera and oil, this painting glows brilliantly. The composition is organized by the natural features of landscape, and every detail seems to have been painted from close observation. The story of Saint Francis receiving a vision of the crucified Christ so powerful that it left the stigmata, the marks of the nails, on his own hands and feet was traditionally indicated by a crucifix descending on rays of light. Bellini resorted to no such symbolism; he illustrates the force of the saint's vision by flooding the painting with the glow of natural light that casts natural shadows.

Yet the theme is expounded through symbolism. Virtually every detail of flora and fauna is an image connected to the humility of Saint Francis that made him worthy to receive the vision. The hare who peeps out from the stone wall so realistically is a symbol of man's helplessness and his need to trust in Christ's sacrifice. The donkey in the middle distance signifies humility and is associated with Christ's ride into Jerusalem just before the Passion. The shepherd tending his flock is another reference to Christ and to the clergy as Christ's shepherds, or pastors. The stump of an oak by the saint is connected to the Crucifixion; it was a species popularly believed to have been used for the cross. The skull, too, is associated with the Crucifixion, which took place in Golgotha, the place of the skulls. Even the fig tree roofing the saint's shelter is a symbol, associated with the Fall which made Christ's sacrifice necessary.

In medieval art these symbols were meant to be interpreted literally as part of the method of telling the story. Here, like the musical and mathematical instruments pictured in the study intarsia at Urbino, they are not separate aspects of the narrative, but are combined to express the theme of the saint's humility and deep faith. It is a theme that embraces us too, for only through humility, Bellini tells us, can man, as helpless as the hare, receive salvation.

In his later paintings, as we shall see, Bellini approached the brilliant harmonies of the High Renaissance style; his pupils Giorgione and Titian carried on his experiments in oil painting to make Venetian art famous in later generations. But meanwhile, the Early Renaissance style was undergoing a change from the monumentality and stability established in Urbino and Mantua to a more artificial and mobile style emanating from Florence.

Neoplatonism and Virtuosity in Medici Florence

The courts of Urbino and Mantua provided Piero della Francesca and Andrea Mantegna with opportunities to develop with the full support of their patrons and without competition. In Florence the situation was different; Lorenzo de'Medici, grandson of Cosimo, came to power by surviving an attempted assassination in 1478, and in the bloody aftermath

218 (*right*) Sandro Botticelli, *Primavera*, 1477–8. Panel, $81\frac{1}{4} \times 125\frac{1}{2}$ in (203×314 cm). Florence, Uffizi

219 (*below right*) Sandro Botticelli, *Birth of Venus, c.* 1485. Tempera on canvas, $68\frac{7}{8} \times 109\frac{7}{8}$ in (174.9×279.1 cm). Florence, Uffizi

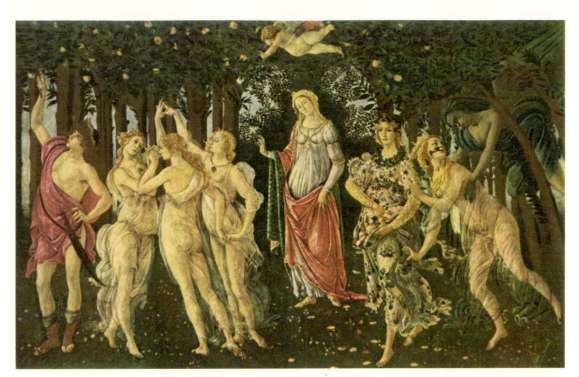

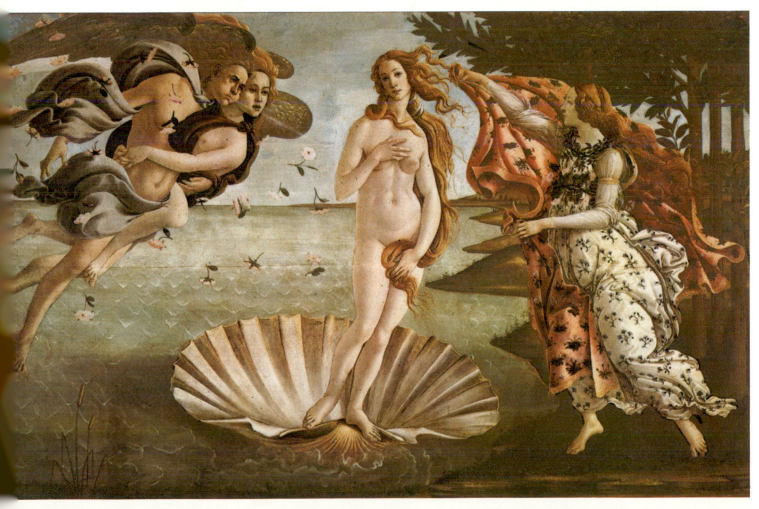

of the unsuccessful coup he strengthened his hold over the council to the point of overseeing every aspect of Florentine life, including the development of the arts.

Lorenzo was himself a highly educated humanist, trained in the academy founded by his father and modelled on Plato's academy in ancient Athens. Here philosophers such as Marsilio Ficino and Pico della Mirandola studied and translated Greek works, many from texts brought to the West by Byzantine scholars fleeing the advancing Turks, who captured Constantinople in 1453.

In Lorenzo's Florence philosophy had an importance comparable to that of science in the modern world. Lorenzo surrounded himself with philosophers, artists, and poets who debated abstruse points of Neoplatonic doctrine and wrote and read their own poetry. Lorenzo's younger contemporary, the historian Guicciardini, characterized him as a 'universal man', gifted in everything and patron of all the arts: 'Lorenzo showed the same favour to poetry in the vernacular, to music, architecture, painting, sculpture, and to all the arts of mind and hand, so that the city overflowed with all these exquisite things.' Guicciardini shrewdly pointed out that Lorenzo's lavishness in the arts and his habit of buying power with costly gifts was, however beneficial to artists, in the long run disastrous to the family fortune. Nevertheless, Lorenzo deserved his title 'Magnificent' and embodied the ideal of the Renaissance man, the gifted and cultured prince who could converse in Latin, write poetry, play the lute, and still find time to govern the state, an ideal that stands out against the darker side of intrigue and assassination.

Under Lorenzo's aegis, the arts in Florence achieved a very high level of technical virtuosity and at the same time embodied the exacting concept that art should communicate ideas. Revived interest in Classical literature created a taste for using Greek and Roman myths as subjects for painting and sculpture; often the ancient stories were subjected to erudite philosophical interpretations. First formulated by Alberti, the idea gained currency that a work of art which told a story, especially one with a symbolic meaning, was more significant, because it involved more intellectual effort, than a mere imitation of nature. Such subjects became known as history paintings, from the Italian word for story. The Bible continued to provide popular subjects for the genre, but a whole new range of stories from Classical mythology proved stimulating to the artists' imaginations.

In the hands of artists working for the Medici circle, Classical stories were given Neoplatonic meaning that would have astonished the Greeks and Romans. For example, Sandro Botticelli (1445–1510) painted two paintings for Lorenzo de' Medici's cousin Lorenzo di Pierfrancesco that were closely related to the philosophical discussions of the circle around Marsilio Ficino and which conveyed a hidden message understood only by a privileged inner circle. To those who do not possess the key, they have an air of tantalizing mystery.

220 (*right*) Antonio Pollaiuolo, *Daphne and Apollo*, c. 1470. Panel, 11¾ × 8 in (29.5 × 20 cm). London, National Gallery

221 (*below*) Antonio Pollaiuolo, *Battle of the Ten Naked Men*, c. 1465–70. Engraving, 15¼ × 23¾ × in (38.3 × 59.5 cm). New York, Metropolitan Museum of Art

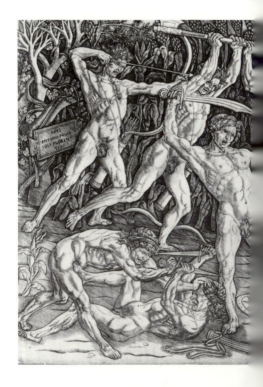

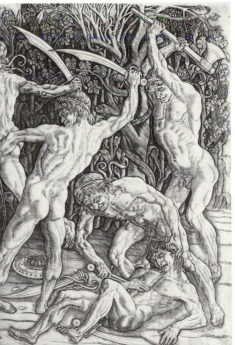

Figure 218, called *Primavera*, or *Spring*, presents us with a lively scene in which eight figures are arranged in a dance. The three on the right hurtle into the picture space; abruptly the action stops at the tranquil figure who stands by herself in the middle, to resume at a more decorous pace with the trio who have joined hands in a circle. The figure at the end of the chain appears aloof from the dance, but by his leaning posture he directs the eye back to the beginning of the action, thus emphasizing its continuity.

The key to the story is found in various Classical texts. The subject is not really spring; only the tumultuous three on the right, from a tale in Ovid's *Fasti*, are related to the season. The figure pursuing the fleeing maiden, his cheeks puffed out and his garments blowing around him, is Zephyrus, god of the west wind and harbinger of warm spring weather. The nymph Chloris, frightened by the god's rough wooing, fled him in vain; he caught her and she became transformed into the goddess of abundant spring, called Flora. Botticelli shows the fleeing Chloris at the moment of her capture, a spray of flowers actually issuing from her mouth. The Flora she becomes stands in the spot where Chloris would land if she completed her next step.

This rough love affair and its metamorphosis of the chaste Chloris into the lusty Flora is one kind of initiation into the mysteries of love presided over by Venus, the figure who stands by herself. A more elaborate and more temperate initiation takes place to the right of Venus. These three maidens are the three Graces of Classical mythology (fig. 33), who symbolize an endless chain of giving, receiving, and returning in a dialectical process by which love pursues and is united with beauty. The girls seem identical at first, but their expressions and the differences in dress indicate their separate roles in the ceremony. The girl with her back to us is a shy creature who expresses restraint and suppressed longing, as she sways between the elaborately dressed, elegant girl on her right and the voluptuous, wind-blown one on her left. Overhead Cupid takes accurate aim at the chaste maiden; she is about to be initiated into the mystery of love. Her partners and teachers are the two components of the Platonic ideal of love, beauty and desire. The three sway together, locked in an endless dance, moving from beauty to chastity to desire and back to beauty. They are also part of the winding chain of the larger dance that ends with the figure of Mercury, who pokes his wand up through the orange trees, indicating that love moves from the purely physical plane illustrated on the right, through a higher level of love as an appreciation of beauty, to an entirely spiritual level.

It is the spiritual side that is the subject of *The Birth of Venus* (fig. 219), in which the sea-born goddess floats to the shore on a scallop shell. This is a simpler and more classical composition, despite the gothicism of the figure and her billowing ropes of hair. To the Renaissance philosopher as to the ancient Greek, her nudity symbolized her chastity; compare the modesty of her pose and expression to that of the Venus who presides over the stages

of earthly love in figure 218). Together these works refer to a doctrine expounded in Plato's *Symposium*, which postulates the existence of two Venuses, one the goddess of physical desire, the other of a more spiritual kind of love.

The elaborate Neoplatonism of these two paintings would have been stifling if the technical skill of the artist had not been so great. We notice in Botticelli's style a reversion to the linear insubstantiality of International Gothic figure drawing, in marked contrast to the static monumentality of Mantegna and Piero. In late Quattrocento painting, movement and ornamental beauty seemed more important than the clear delineation of three-dimensional space, and stunning painterly effects almost overwhelm the subject. In figure 220, by Antonio Pollaiuolo (*c.* 1432-98), we are aware first of colour, material, and motion; we feel the soft velvet of the girl's dress, hear the rustling leaves and sense the urgent rush of the pursuing youth. The story, from Ovid's *Metamorphoses*, tells of a love affair similar to that of Zephyrus and Chloris, but with a different ending. It is the god Apollo who is chasing the nymph Daphne, daughter of the river god Peneius; she called on her father to save her, and he responded by transforming her into a laurel tree. Pollaiuolo picked the most dramatic moment to portray, when the god catches the fleeing girl just as her metamorphosis takes place, and his momentary triumph turns to sorrow and remorse as he realizes what is happening. From this episode, Apollo chose the laurel wreath as his personal symbol.

The technical skill that gives these paintings such charm was accompanied in late fifteenth-century Florence by a loss of the coordination between the arts that had been so evident in Urbino. Many technical strides were made; in all the arts we find increasingly a desire to display the effects suited to a particular medium. This was a period of rapid expansion in the graphic arts; the introduction of paper-making and various methods of printing created new fields. Engravings and wood-cuts were easy to reproduce in large numbers and cheap to buy; as book illustrations and as individual prints, they were the media through which the Renaissance style was widely disseminated through Europe.

By their very nature, engravings and wood-cuts emphasize sharp outlines. Pollaiuolo's painting is characterized by soft colours and luminous texture, while the figures show little sense of detailed anatomy. In his engravings, however, the drawing is hard and linear and emphasizes musculature. Figure 221 does not so much tell a story as it provides an excercise in drawing human anatomy in motion. In sculpture, too, Pollaiuolo stressed bulging muscles and straining sinews; he chose the subject of his little statue (fig. 224), the legend of Hercules overthrowing the giant Antaeus, for its violent conflict. Working here in the medium of cast bronze, he achieved a highly finished, polished surface. He chose the difficult pose to exhibit his skill in modelling, a pose that emphasizes drama and tension at the expense of balance. Earlier bronze statues like

222 (*below*) Andrea del Verrocchio, *David*, *c.* 1475. Bronze, height 49½ in (126 cm). Florence, Museo Nazionale (Bargello)

223 (*right*) Andrea del Verrocchio, equestrian statue of Bartolommeo Colleoni, begun 1479. Bronze, height *c.* 13 ft (4 m). Venice, Campo di SS. Giovanni e Paolo

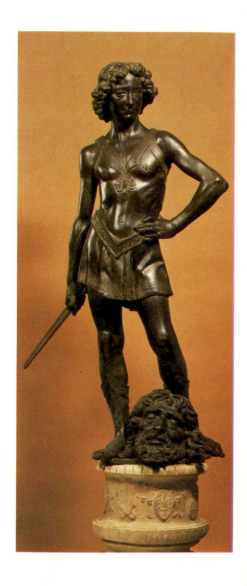

MAN THE MEASURE OF ALL THINGS: THE EARLY RENAISSANCE

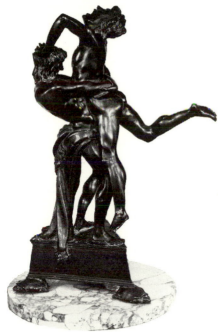

224 Antonio Pollaiuolo,
Hercules and Antaeus, c. 1475. Bronze,
height 18 in (45 cm). Florence, Museo
Nazionale (Bargello)
Antaeus was invincible as long as his feet
touched the earth; Hercules defeated him
by lifting him off the ground.

Donatello's *David* imitated marble sculpture by keeping within the limits of a single block, but the limbs of Hercules and Antaeus extend far from their torsos as they pull away from each other yet cling fiercely in an opposition of force to counterforce.

Bronze, melted and poured into a mould, is a medium well suited to rendering details on the surface. Pollaiuolo's contemporary Andrea del Verrocchio (*c.* 1438–88) raised the technical virtuosity of the medium to a new level. Legend has it that he left off painting because he was surpassed in this by his pupil Leonardo da Vinci, but he was no less constrained in sculpture, where he spent much time trying to outdo Donatello. His *David* (fig. 222) is a great technical achievement, displaying consummate crafts-manship. David stands gracefully — almost girlishly — in a swaying contrapposto, with Goliath's head at his feet. Without the head we might doubt the subject, for this beautiful, reflective youth seems an unlikely slayer of giants. Verrocchio clothed the figure in a tunic so smoothly modelled that the folds clinging to the body look damp. Every detail of hair and face is smoothly perfect. Rather than the excitement Donatello gives us of a young hero facing great odds, we are presented with a figure deep in thought, at ease in his world.

Verrocchio's equestrian bronze statue of the Venetian condottiere Bartolommeo Colleoni (fig. 223) is similarly in contrast to Donatello's *Gattamelata* (fig. 204). Verrocchio's work was a technical tour-de-force; the horse is balanced on three legs, as in the Roman statue of Marcus Aurelius, whereas Donatello had had to place a ball under the foot of his mount's raised foreleg to support the statue. But what we chiefly notice in the statue of Colleoni is the rippling muscles under the taut skin of the horse, and the ferocious expression of the rider, more a swaggering bully than a Classical hero.

Despite the virtuoso handling of materials, the mannerisms in late fifteenth-century art point up the fact that the Early Renaissance never solved completely the problem of setting moving figures into a still space. Piero and Mantegna had achieved a harmony between space and figure by sacrificing motion to monumentality; Botticelli and Pollaiuolo did the opposite and gained a sense of movement at the expense of perspective and delineated space. It was the High Renaissance that solved the problem, working out of the experience of the Early Renaissance, a fact that makes it appropriate to consider these two periods as two phases of one style. If we compare two paintings by Verrocchio's contemporary Pietro Perugino (*c.*1445/50–1523) to one by Perugino's pupil Raphael (1483–1520), we can see how the problem was tackled but not quite solved by the older man and the solution superbly achieved by Raphael. Perugino painted his *Christ's Presentation of the Keys to Peter* (fig. 225) as one of a series of frescoes in the Sistine Chapel of the Vatican palace. In this wide, rectangular frame, space seems large and empty, its square and buildings recalling the hushed and motionless *Ideal City* at Urbino (fig. 202). Christ, the disciples, and

spectators are ranged along the foreground, some of them drawn at a three-quarters angle to us to direct our sight back along the diagonal lines of the pavement squares. Thus the figures are convincingly set into a picture space directly related to where we stand. But the arrangement left a vast and empty middle ground, which Perugino filled with bustling little figures enacting scenes from the New Testament. These tiny figures moving in the vast stillness of the otherwise empty space create a note of conflict between motion and space.

In his *Marriage of the Virgin* (fig. 226), Perugino used the scheme again, this time lowering the horizon and narrowing the focus to the now enormous central temple. But we still sense a sharp separation of grounds; the natural activity of the small figures is oddly contrasted to the stiff lining up of figures around Joseph and Mary. Raphael painted his version at about the same time (fig. 227). He reversed the main actors in the drama and narrowed the focus still further, creating a strong pull back towards the temple, a circular building with no horizontal line to counteract the inward flow of space. His figures are more naturally posed; compare the boy who in both paintings bends a rod across his leg. Raphael was already at home with the solution Perugino was still striving to reach; in his painting space is not static, creating a disharmony with the motion of figures, but moves naturally around them. It was the unity of space and figure that was the achievement of the High Renaissance.

225 (*below*) Pietro Perugino, *Christ's Presentation of the Keys to Peter*, 1481. Fresco, 134 × 220 in (335 × 550 cm). Rome, Sistine Chapel

226 (*right*) Pietro Perugino, *Betrothal of the Virgin*, c. 1503–4. Oil on panel, 93½ × 74 in (234 × 185 cm). Caen, Museum

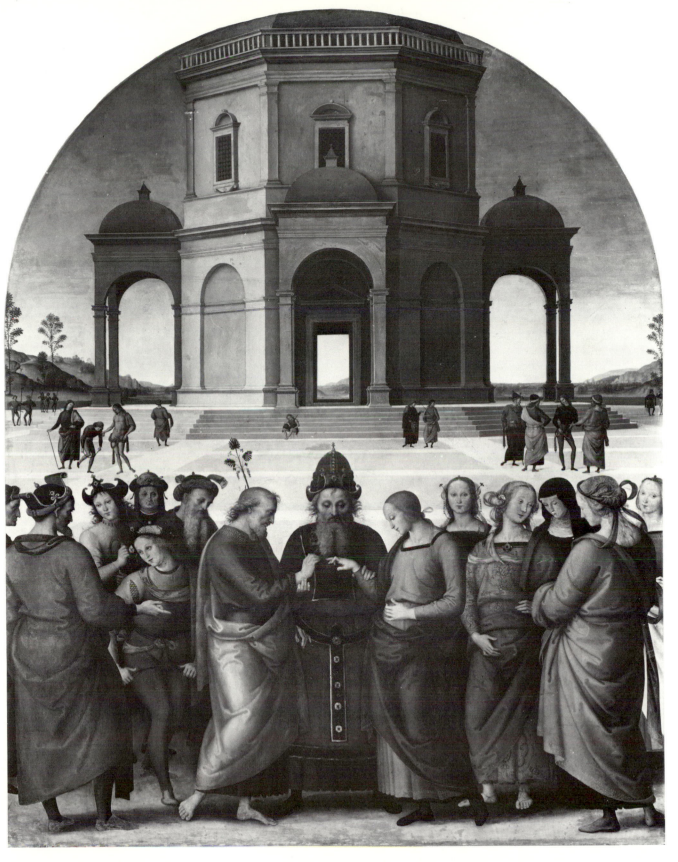

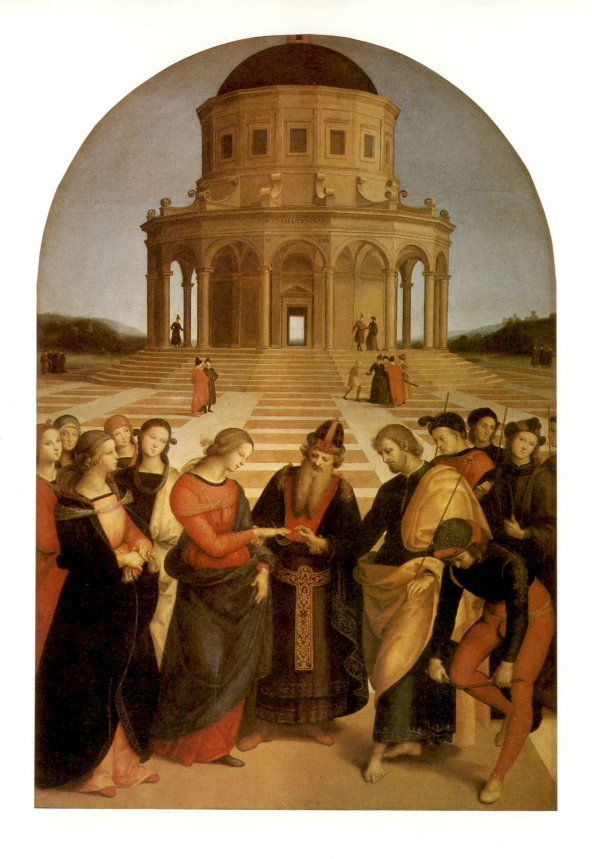

CHAPTER 8

Wholeness and Harmony: The High Renaissance

The circular temple in Raphael's *Marriage of the Virgin* is a High Renaissance building related to the architectural designs of Donato Bramante (1444–1514) and to sketches by Leonardo da Vinci (1452–1519). Both Leonardo and Bramante were at work in Milan at the end of the fifteenth century; from their union of the mathematical, structural approach from Urbino and the bold virtuosity of Florence came what is recognized as the High Renaissance style. Both Bramante and Leonardo belonged to the generation of Perugino, Leonardo's fellow student in the workshop of Verrocchio. But by inclination and genius, these two belong to the High Renaissance, the period in which the Early Renaissance dilemma between space and motion was solved.

Leonardo's background was that of Florence in her golden age under Lorenzo de' Medici. He spent his childhood in the neighbouring countryside, where he sharpened his observation of natural phenomena, learning to capture the flight of a bird or the gait of a horse, the rush of flooding waters, or a clump of wild flowers. In Florence he was able to study anatomy by dissecting bodies in a hospital, for Medici power was strong enough to counteract the Church's opposition to interference with the dead. Leonardo's interest in how things worked went beyond an artist's observation; his sketchbooks are filled not only with drawings but also with notes exploring in scientific terms the fundamental nature of whatever he was copying. From his dissections and his own observations he tried to explain, for example, how the eye actually receives its impressions, and from this he went on to theorize how we perceive distant views. Thus his treatment of receding space in his paintings became impressively realistic.

Figure 233 shows early signs of his particular genius. It is the underpainting of an altarpiece undertaken for the monks of San Donato a Scopeto, and its subject, the Adoration of the Magi, gave Leonardo the opportunity to mass crowds of figures together. They are placed in a sharply receding and strictly controlled perspective, but with a new sense

227 (*left*) Raphael, *The Betrothal of the Virgin*, 1504. Oil on panel, 68 × 46¾ in (170 × 117 cm). Milan, Brera Gallery

of harmony. His figures do not stand out from space, but emerge gradually, their outlines blurred in a softening of light and shadow. It was from his realization that we do not in fact see objects in space with clearly defined outlines that Leonardo developed his hazy technique, called by the Italian word for smoky, *sfumato*.

The underpainting promises a revolutionary treatment which was not always evident in Leonardo's practical achievements. Because of the very curiosity that enabled him to realize so much in his imagination, he was frequently unable to finish works and so lost commissions to lesser but more efficient artists. *The Adoration of the Magi* never progressed beyond the underlay stage. When Lorenzo de' Medici recommended Leonardo to the court of Milan for employment, it was as a musician, while Leonardo's own letter to Lodovico Sforza, the ruler of Milan, stresses his qualifications as an engineer.

During his stay at the court in Milan, Leonardo spent much of his time making elaborate but temporary settings for masques and revels. He worked on an irrigation project and plans for a canal, and he entered a competition to design a crossing tower for Milan's late Gothic cathedral, but, typically, he did not go on to furnish a model. He also painted portraits of the ducal household. The court was nominally governed by the heir to Francesco Sforza, his grandson Gian Galeazzo, but was in fact ruled by the youth's tyrannical uncle, Lodovico, and its cultural tone set by Lodovico's brilliant, bluestocking wife, Beatrice d'Este.

228 Leonardo da Vinci, project for a domed church, *c.* 1488–9. Drawing. Paris, Institut de France

The High Renaissance in Milan

In Milan Leonardo came into contact with the mathematical bent of the Urbino circle not only through Bramante but also through Luca Pacioli, whose book *On Divine Proportion*, based on the theories of Piero della Francesca, Leonardo illustrated. But it was the acquaintance with Bramante, in Milan by 1481, that changed the course of his art. Born in 1444, Bramante was raised in the court of Federigo da Montefeltro. Tradition has it that he learned painting from Piero della Francesca and Mantegna; some of the intarsia in the Ducal Palace in Urbino is thought to be by his hand.

The first appearance of the High Renaissance in Milan was equally Bramante's and Leonardo's. Both arrived there with the basic components of the style already developed. We can see from works that were done soon after each arrived in Milan that both men could treat space and mass as interrelated without sacrificing the grace and picturesque beauty of late fifteenth-century style. In about 1485 Leonardo painted his *Virgin of the Rocks* (fig. 231), which reflects the almost too sweet prettiness of contemporary Florentine painting, especially in the Virgin's pose. But these figures are arranged in a flowing composition that is neither static nor

229 (*below*) Donato Bramante, Santa Maria Presso San Satiro, Milan, begun 1492

230 (*bottom*) Donato Bramante, Santa Maria delle Grazie, Milan, apse, *c.* 1492–5

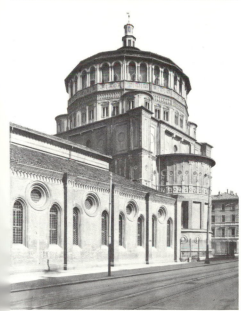

caught in suspended motion. By putting the infant Christ in front of the other three, Leonardo kept his pyramidical grouping from standing flatly out of the background. By softening the outlines of his figures he made space and bodies merge, enveloping the figures in a misty atmosphere that is almost tangible. The finely detailed brush strokes with which he rendered the curling tendrils of the angel's hair and the clumps of flowers in the foreground were not in themselves far removed from the skilled brushwork of Perugino or Pollaiuolo, but the softness with which the details blend into the whole represents a new harmony between objects and space. If we examine the clump of flowers in the left foreground, we can see that every petal and every leaf is accurately represented, yet every brush stroke is part of the rhythmic motion of the whole plant. Leonardo's acute observation of natural forms was united with his sense of universal energy, so that his painting of nature is both realistic and at the same time charged with a feeling that goes beyond surface realism. His figures are infused with a poetic grace; like the Greek statue of Hermes (fig. 2), they are convincingly life-like yet not entirely human.

Bramante's first work in Milan, also dating from around 1485, was the rebuilding of the church of Santa Maria presso San Satiro (fig. 229). The space for the sanctuary of this church was restricted because the building abutted a street, but Bramante wanted an impression of depth to balance the length of the nave. He achieved a trompe-l'oeil impression of a Greek cross design by harking back to the illusionism of Masaccio's *Holy Trinity* and Donatello's *Feast of Herod*. We 'see' a recess of three bays that is really a stucco relief on a flat wall. By a painter's trick of perspective, Bramante was able to convey the feeling of a centralized plan.

Early Renaissance architecture was designed outwardly, for its effect on the viewer. Bramante's second building in Milan, very close in its design to sketches found in Leonardo's notebooks (fig. 228), shows a different approach, that of achieving its visual effect from the wholeness of form and proportion. The sanctuary of the church of Santa Maria delle Grazie (fig. 230) follows the strictly rational, geometric combinations of circles and squares characteristic of Alberti, but with a rhythm of convex and concave surfaces that Alberti only approached in Sant' Andrea (fig. 210).

The marriage of mathematical regularity and flowing space resulted in a balance between stability and dynamic tension that is characteristic of the High Renaissance style. It appears in Leonardo's painting of the Last Supper (fig. 232) on the refectory wall of the convent of Santa Maria delle Grazie. In this fresco, he replaced the picturesque elements in *The Virgin of the Rocks* with an architectural ordering of space gained from Bramante. The confidence with which both men approached their work marks a style already in its maturity. Leonardo said, 'The painter who draws merely by practice and by eye, without any reason, is like a mirror which copies all things placed in front of it without being conscious of their existence.' This is the statement of a painter who takes for granted his ability to represent

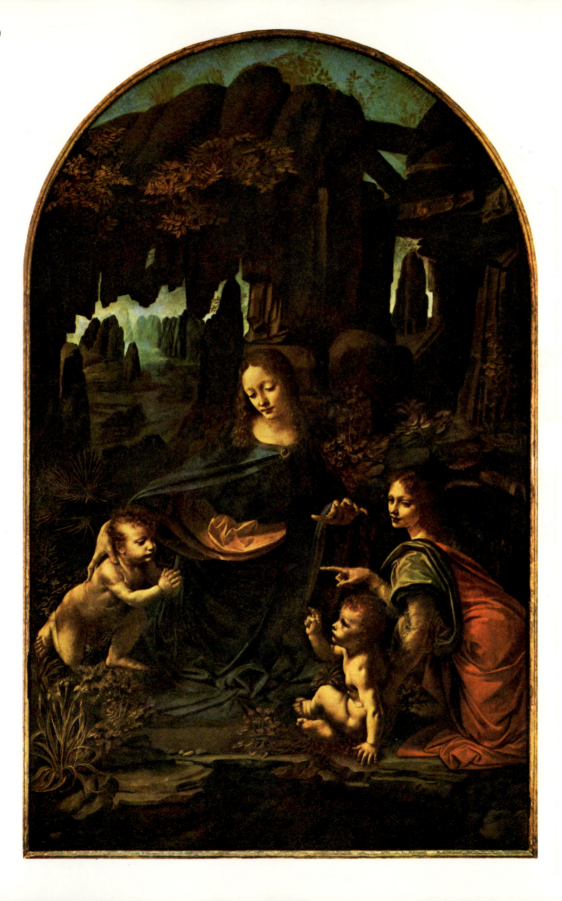

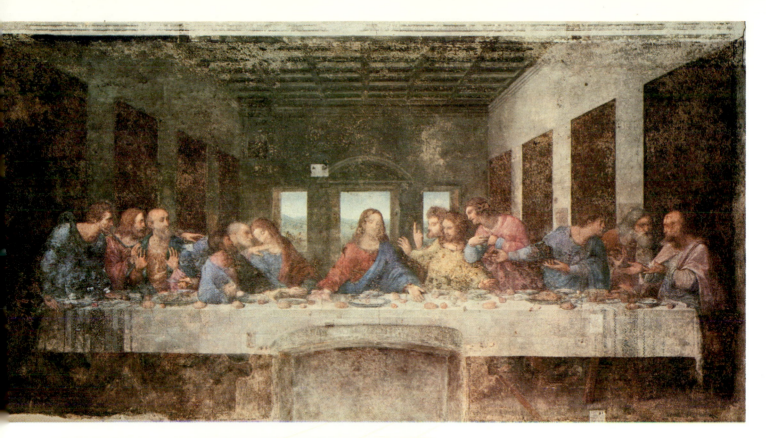

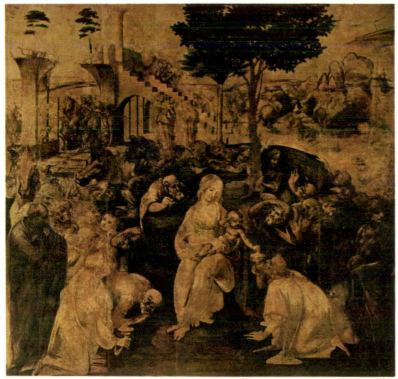

231 (*facing page*) Leonardo da Vinci, *The Virgin of the Rocks*, 1483–6. Oil on panel, 79¼ × 49¼ (198 × 123 cm). Paris, Louvre

232 (*above*) Leonardo da Vinci, *The Last Supper*, 1495–7. Fresco, 15¼ × 29¼ ft (460 × 880 cm). Milan, Santa Maria delle Grazie

233 (*left*) Leonardo da Vinci, *Adoration of the Magi*, 1481. Oil on panel, 98½ × 97 in (246 × 243 cm). Florence, Uffizi

the forms of nature accurately; technical skill was not enough, but had to be combined with imagination and intellect.

In *The Last Supper* Leonardo's increased use of sfumato softens the architectural perspective so that the receding lines of the room are not obtrusive; we receive an impression of space rather than clear articulation. Yet the great step forward from his earlier work is in the strict control of the architectural forms, which parallel Bramante's real architecture. The walls create an absolutely symmetrical frame leading to the vanishing point, the pediment over the window behind Christ. But the rigid symmetry is softened by the hazy sfumato and further relaxed by the natural mobility of the figures, who are neither frozen in suspended motion nor unduly agitated. Leonardo abhorred late Quattrocento overdramatization: 'Some days ago I saw the picture of an angel who, in making the Annunciation, seemed to be trying to chase Mary out of the room, with movements showing the sort of attack one might make on some hated enemy; and Mary, as if desperate, seemed to be trying to throw herself out of the window.'

Yet there is no lack of drama in *The Last Supper*. Leonardo chose the most poignant moment of the story, not the celebration of the Passover usually shown, but the point at which Christ tells the disciples that that night one of them will betray him (Matthew 26:22). Each asks, 'is it I?' Their reactions flow both towards and away from Christ in a continuous movement always centring back to him. The Apostles fall naturally into four groups of three each, drawn together in ripples of motion and countermotion. Earlier paintings of the Last Supper usually placed Judas alone on the opposite side of the table from the others, but here he is psychologically rather than physically isolated. He is the only one whose face is cast in shadow, and it is he who retreats most sharply from Christ.

Unfortunately the marriage of science and art did not work well in the medium Leonardo employed. Trying to achieve in fresco some of the luminosity of oil paint, he bonded the wet plaster with a layer of oil, effectively sealing in the damp. Already in 1566, when Vasari saw it, *The Last Supper* had decayed to a faint blur. It was restored several times to the point where next to none of the paint on the surface had been put there by Leonardo. Recently, after it miraculously survived an air raid in World War II that demolished the refectory, modern methods succeeded in removing the earlier restorers' pigments, but it is still only a shadow of its original glory, when it made Leonardo's reputation overnight.

At this point Leonardo's sojourn in Milan was interrupted by politics; Lodovico Sforza, to head off intrigues between his nephew's wife, a Neapolitan princess, and the king of Naples, plotted with Charles VIII of France, who held a tenuous claim to Naples. In 1494 Charles invaded Italy, entering Naples in May 1495; he retreated only when he outran his supply lines. Charles's heir, Louis XII, entered Milan in 1499 and claimed the duchy as a French fief; Lodovico ended his days in a French prison.

The High Renaissance in Florence

In December 1499 Leonardo left Milan and travelled to Mantua and Venice, returning to Florence in April 1500. It was a very different city from the Florence he had left. Lorenzo had died in 1492, during a wave of religious puritanism and repentance touched off by the preaching of the monk Savonarola. Even Lorenzo, on his death bed, asked for the intercessions of this fanatical monk, and Botticelli was so moved by his sermons that he repented wasting his time on frivolous mythologies and passed his last years painting religious works. Savonarola's hold on Florence lasted until Pope Alexander VI, the infamous Borgia pope, decided the monk was a threat to his authority and excommunicated him. Imprisoned by the Florentines, Savonarola confessed under torture to false preaching and was both hanged and burned. His chief legacy to Florence was that he had forced Lorenzo's incompetent son Piero out of office; for over a decade after the monk's death in 1498 the Florentine Republic flourished under the rule of its council.

Leonardo now found himself with a rival. In 1501 the young Michelangelo (1475–1564), 23 years younger than Leonardo, returned to Florence from Rome, where he had carved the *Pietà* now in St. Peter's (fig. 236), a statue that made his reputation as quickly as *The Last Supper* had made Leonardo's.

Like Leonardo, Michelangelo came from a family with no artistic interests; he began his career as a student of Domenico Ghirlandaio (1449-1494), a painter who had been Leonardo's fellow student in Verrocchio's studio. Here Michelangelo learned all that was ever taught him in the way of painting. It was as a sculptor that he caught the attention of Lorenzo de' Medici. By 1489 he was installed in the Medici school for sculpture, directed by the sculptor Bertoldo. Here he had the run of the Medici collection of antique statues, and here too he was exposed to the Neoplatonism of the Medici Academy, where he was educated along with the young Medici princes. Neoplatonism exerted a lasting influence on his outlook, and he acknowledged the value of his connection with the Medici family by adopting a version of their insignia of three golden balls as his stonemason's mark.

The Hellenistic phase of Greek sculpture was all that the West knew of Greek art at this time, and the technical skill and virtuosity of works such as the Apollo Belvedere (fig. 234) appealed enormously to artists of Michelangelo's generation. The Apollo was discovered during excavations for a building project in Rome, in 1490; although it is actually a Roman copy of a Greek work, to Michelangelo and to succeeding generations it came to represent all that was admirable in Classical art. The striving for impressive dramatic effect in this late Greek style occurs in Michelangelo's first important commission, the *Pietà*, for which the contract stipulated

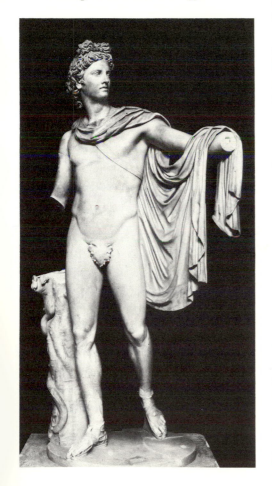

234 Apollo Belvedere, Roman copy after Greek original of *c.* 350 BC. Marble, height 88 in (220 cm). Rome, Vatican
This statue was discovered during building works in Rome in 1490.

that it should be 'the finest work in marble which Rome can show, and that no master of our days shall be able to produce a better ...'

The statue is life-sized, again according to the contract. If the Virgin were to stand up, however, she would actually be seven feet tall; because of the angle at which she is seated, her stature seems normal and in proportion to the body of Christ stretched across her knees. 'It is necessary to keep one's compass in one's eyes and not in the hand,' the artist declared, 'for hands execute, but the eye judges.' The confidence of this statement demonstrates the distance art had travelled from the first steps of the Early Renaissance; Michelangelo was sure of the technique by which he could achieve the vision in his mind's eye. The virtuosity of his carving is impressive by itself; the folds of the Virgin's skirts are so thin as to be translucent, resembling fine bone china. But it was not technical skill alone that has won such admiration from generations of viewers of this work.

The Neoplatonism Michelangelo learned in the Medici Academy led him to emphasize not the immediate tragedy of the Crucifixion but the eternal victory won by the sacrifice; he chose to illustrate Christ's goodness through ideal beauty. He portrayed the Virgin as a young girl, younger than the son she holds, to convey a Platonic truth, not a historical reality. She expresses love and tenderness more than sorrow, and the dead Christ she holds appears to sleep; the wounds of his death are barely sketched so as not to mar the smooth marble flesh. Traditionally, the Pietà was a subject meant to evoke remorse and repentance; the broad humanism of Michelangelo's version says much about the changes taking place within the Catholic faith.

When Michelangelo returned to Florence with the *Pietà* behind him, he was not yet 30, but he felt confident enough to compete for a block of marble owned by the city, a vast piece of perfect Carrara marble which the sculptor Agostino di Duccio had begun blocking out and had then abandoned. The council had thoughts of giving it to Leonardo or to the sculptor Andrea Sansovino.

The plan that Michelangelo submitted was for a statue of David. His *David* is as much a summation of High Renaissance style as Donatello's is of the Early Renaissance. The block had been nicknamed 'the giant', and the figure that emerged from it (fig. 235) is truly a giant, a naturalistic yet superhuman hero, literally larger than life; only the slingshot connects him to the young boy who outfaced the giant Goliath. Charged with suppressed energy, he is a companion to the Greek gods and demi-gods like Hercules; his pose owes much to the Apollo Belvedere, but he is a more forceful and muscular figure than that smoothly beautiful god. The narrowness of the block, and the cuts already made in it by Agostino, to some extent dictated the static quality of the pose, but Michelangelo made a virtue of necessity in stressing the force of tension and emotion which is held in check.

Michelangelo's self-confidence while *David* was in the making is clear from his deliberate challenge to Leonardo, not in the field of sculpture, but

235 (*below*) Michelangelo, *David*, 1501–4. Marble, height 13 ft 5 in (4 m). Florence, Accademia

236 (*right*) Michelangelo, *Pietà*, 1497–9. Marble, height 68½ in (174 cm). Rome, St. Peter's

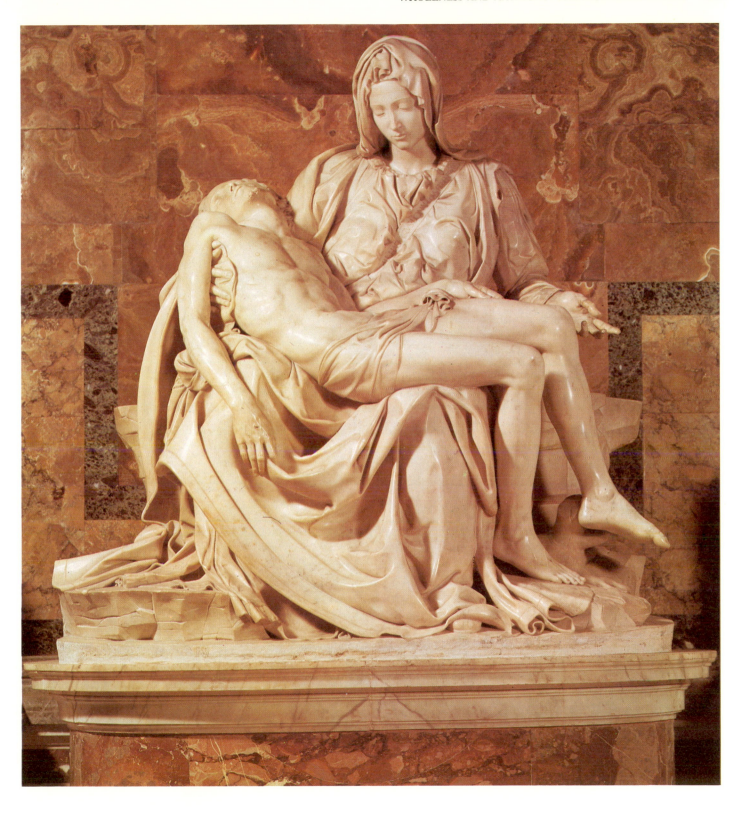

in painting, a medium he had not undertaken since his apprenticeship in Ghirlandaio's studio. Leonardo had been commissioned to paint a fresco on one wall of the Council Chamber in the Palazzo Vecchio portraying a scene from Florentine history. He had chosen the Battle of the Anghiari, a cavalry battle that gave him opportunity to arrange a complex jumble of men and horses, in which he excelled. Now Michelangelo requested, and was awarded, another wall, on which he planned to paint a subject calling for his specialty, nude male anatomy. This was the Battle of Cascina, in which the Pisan army surprised the Florentine soldiers bathing in the River Arno. The duel of the Council Chamber was recognized as a struggle between two giants; people came from far and wide to watch, among them the young Raphael. Raphael was much influenced by what he saw; his mature style was a blend of the clear sculptural line of Michelangelo softened by the colour and sfumato of Leonardo.

The battle was never concluded. Leonardo, who had started first, lost time in experiments with sealing the wall. At one time the wet paint ran so much that a bonfire had to be lit in the chamber to dry it out. All we have left are his sketches, a tantalizing glimpse of what might have been. And Michelangelo was forced to drop his fresco in 1505 to answer an imperative summons from Pope Julius II.

The High Renaissance in Rome

Pope Julius was one of the most formidable personalities of the Renaissance. More of a condottiere than a churchman by temperament, he earned the nicknamed of 'warrior pope' from his habit of leading his own troops into battle; he was successful in winning back much of the former territory of the papal states. The city over which he presided when he ascended the papal throne in 1503 was a city of ruins and unfinished projects begun by his immediate predecessors. He swept away much of the debris and instituted a building programme that kept artists and architects busy for years. His ambitions coincided with the moment when the High Renaissance style had come to maturity; the result was a hothouse forcing of blooms, and for a few short years every great artist — except Leonardo — came to Rome to seek work and to view the projects under way.

An incidental benefit of Julius's rebuilding programme was the unearthing of several antique works; the Laocoön (fig. 6) came to light while Michelangelo was visiting his friend Giuliano da Sangallo, and when a messenger from the pope told them of the find they rushed off to see it; it was Sangallo who identified it from descriptions in a Classical text. Its elaborate composition of intertwining limbs must have appealed enormously to Michelangelo.

Julius was much preoccupied with the project of rebuilding St. Peter's. The Constantinian basilica was in ruinous repair, yet so venerated for its

antiquity that, like Suger (see above, p. 104), Julius did not at first announce plans to pull it down; he proceeded with caution, citing the impossibility of repair before he moved. By 1506, however, the destruction of the old building had begun and the foundation of the first part of the new basilica had been laid. The architect chosen to design the new building was Bramante. Although he lived only long enough to see one pier built and the foundations of the others fixed, Bramante put his stamp on the aesthetic impression of the whole design by fixing the proportions of the crossing. We have only a design on parchment supposed to be by his hand and a medal cast into the foundation of the first pier to show us his intentions; whether from suspicion that his ideas might be stolen by his rivals or because he worked and redesigned as he went, he left no models or working blueprints. But we know that his design was a centralized plan that harks back to his association with Leonardo in Milan.

The design for St. Peter's also recalls the circular temple in Raphael's *Betrothal of the Virgin* (fig. 227). Raphael's painted temple, dating from the beginning of the work at St. Peter's, is close in design to a small, circular temple Bramante erected on the supposed site of Saint Peter's martyrdom. The Tempietto (fig. 237) is a more consciously classical edifice than any Early Renaissance building, partly because of the historical significance of using a style that was believed to have prevailed during the saint's lifetime. Bramante chose the Doric order because it was considered the strongest, most masculine of the orders. He saw no incongruity in modelling his monument to the first bishop of Rome on the temples built to the pagan gods, nor did he see anything unsuitable in incorporating elements of the most famous surviving pagan temple, the Pantheon, into his design for Saint Peter's new basilica.

Bramante died in 1514, before work on St. Peter's had progressed beyond the crossing piers; he was succeeded as architect in charge by Raphael, who did little, apparently, to change Bramante's original design. Its intended appearance is suggested in a fresco painted by Raphael in the Vatican apartments (fig. 239); there is a tradition that the coffered arches in the background of *The School of Athens* were designed by Bramante, whose sense of classical order and symmetry pervades the whole work.

One of a series of frescoes programmed to harmonize Christian and pagan doctrine, *The School of Athens* represents the life of the mind at its highest point. On the opposite wall Raphael painted a work glorifying the Eucharist as the supreme spiritual mystery. In *The School of Athens*, the coffered arches open into a vast but finite space, enclosing an impressive environment that is none the less in proportion to the humans who occupy it. Within the completely symmetrical space, groups of figures move about freely, conversing with one another, in a natural flow of movement that echoes the motion of figures within a rigid architectural frame in Leonardo's *Last Supper*. Following these deceptively casual groupings, the eye is led back to the vanishing point just between the two central figures of

237 Donato Bramante, San Pietro in Montorio (the Tempietto), Rome, 1502

238 (*above*) Michelangelo, ceiling,
Sistine Chapel, 1508–12. Fresco,
44 × 128 ft (13.6 × 38.6 m). Rome,
Vatican

239 (*left*) Raphael, *The School of Athens*,
1509–11. Fresco, base 308 in (770 cm).
Rome, Vatican

240 (*right*) Leonardo da Vinci, *Mona
Lisa*, c. 1502. Oil on panel, 30¼ × 20⅞ in
(77 × 53 cm). Paris, Louvre

Plato, who points upwards to indicate his concern with universal abstractions, and Aristotle, who gestures towards the earth, as his writings were more concerned with natural phenomena. Plato has been taken to be a portrait of Leonardo; his expressive face and gesture bring to life not only the academic milieu of ancient Athens but the brilliance of the High Renaissance. There are other presumed portraits; the romantically brooding figure leaning on his elbow in the foreground has been identified as Michelangelo, and Raphael himself as the figure on the far right, while the figure of Archimedes, bending over his slate to illustrate a theorem, is probably Bramante. This portraiture is more than allusive fancy; it illustrates the relationship which the High Renaissance artists felt to exist between their own achievements and those of the most glorious age of the past.

The vast expenditure involved in the projects undertaken by Pope Julius II led to a shortage of money, and his artists were often left unpaid for long stretches, which did nothing to soothe the suspicions fostered by rivalry and jealousy in the competition for commissions. Tradition assigns the bitterest feud to Bramante and Michelangelo, each of whom seems to have assumed that any favour shown by the pope to the other meant neglect of himself. The hothouse climate resulting from the pope's imperious and driving character lends colour to the popular story that Bramante suggested Michelangelo to the pope as painter for the Sistine Chapel ceiling because he hoped the sculptor would be a failure as a painter. When we reflect that Michelangelo had done very little painting since leaving Ghirlandaio's studio, the tale gains credence. Certainly Michelangelo tried to avoid the commission, which Julius began pressing on him as early as 1505. Equally certainly, from 1509, when work was begun, until 1512, when the impatient pope virtually snatched the scaffolding from under his painter, Michelangelo had no time to think of plots against Bramante.

Only a man of Julius's temperament would have forced a sculptor to turn painter on such a vast scale. Michelangelo assembled a workshop of assistants to help him, but could not get along with them and ended up doing the whole ceiling by himself. He built his own scaffold, apparently not trusting the one erected for him by Bramante. He painted the whole ceiling lying on his back, the paint dribbling into his beard. In the beginning he put the paint on while the plaster was too wet, so that it grew mouldy and had to be done over again; the first scenes took him almost as long as the rest of the ceiling. As he progressed he gained confidence and his drawing grew bolder, so that the last figures burst out of their frames.

Michelangelo painted the story of Genesis backwards, beginning with *The Drunkenness of Noah*, illustrating the frailty of fallen man, and working towards *The Creation of the Universe*. It was probably his Neoplatonist thinking that led him to compose the scenes to progress from the frightened faces of men and women fleeing the flood, people who have lost the ability

241 Domenico Ghirlandaio, *Old Man and his Grandson*, c. 1480. Panel, 24½ × 18 in (62.2 × 45.7 cm). Paris, Louvre

to deal with destiny, to the heroic ideal of man expressed in *The Creation of Adam*, and from there to the final scene at the altar end, both the beginning of the story and its awaited end (fig. 238).

These frescoes are an impressive example of the balance between dramatic expression and classical restraint that has come to characterize our view of High Renaissance art. For all the tension rippling under the surface, no force is allowed to disrupt the flow of motion within the picture space. In *The Creation of Adam* (fig. 179) the dynamic figure of God arrives in a flurry of wind-blown hair and garments, Eve held protectively in his arm. The force of motion is played off against the languor of the unawakened Adam, who awaits the touch of God's outstretched finger to spark him into life. We are witnessing a scene just before something happens; the actors, already in motion, leave us with a sense of heightened expectation.

The ceiling was unveiled four months before Julius's death in 1513. The imperious warrior-pope was succeeded by a man of a very different stamp, but one who came naturally by a love of the arts: Lorenzo de' Medici's son Giovanni, who had studied in the Medici Academy with Michelangelo and later boasted of their childhood acquaintance. His accession to the papacy as Leo X meant further expenditure on the arts; it was Pope Leo's method of raising money for his building projects by the sale of ecclesiastical indulgences, pardons bought for the forgiveness of sins, that inflamed a large part of Germany into following Luther in his open break with the Roman Catholic Church.

Although he was kind to Michelangelo, Leo preferred the easier temperament of Raphael, who had the reputation of painting easily and fluently to achieve without apparent effort a balance between dynamic vitality and classical repose. His paintings have an inspired quality, which Vasari termed *grazia* (gracefulness), that is far less violent or turbulent than Michelangelo's forcefulness, which the Italians called *terribilità*. It is Raphael's many versions of the Madonna and Child that have evoked for subsequent generations the epitome of the High Renaissance style's particular marriage of the real and the ideal.

The popular *Madonna della Sedia* (*Madonna of the Chair*), for example, appeals to us first because of the warm human reality of a mother holding her child (fig. 242). We respond, too, to the soft, sensuous glow of light on skin and embroidered cloth. But this is no everyday mother, nor are the soft, plump babies ordinary children. The formal concept of idealized beauty gives all three a remote grace rather than the familiarity of particular individuals. The circular *tondo*, expressing the 'perfect' form of the circle, was a popular shape for this subject, and a difficult one, for it imposes upon the composition its sweeping circular motion. Like a good writer of sonnets, Raphael was able to balance a freedom of line with the discipline of the form, so that the pose seems natural and unforced and yet fits perfectly within the circle.

243 Raphael, *Pope Leo X with two Cardinals*, c. 1518. Oil on panel, $33\frac{1}{2}$ × $23\frac{1}{2}$ in (85 × 60 cm). Florence, Uffizi

242 (*left*) Raphael, *Madonna della Sedia* (*Madonna of the Chair*), 1514–15. Oil on panel, diameter 28 in (71 cm). Florence, Palazzo Pitti
The second child, often included in scenes of the Holy Family, is Jesus' cousin John, later John the Baptist.

The very unity of such a work illustrates why the High Renaissance achievements dominated art style for so many centuries afterwards. In discussing the *Madonna della Sedia*, E.H. Gombrich relates that when he first wrote his *Story of Art* he found himself calling every work of art he particularly admired a 'harmonious whole'. This view, which goes back to Aristotle, was the ideal to which most artists aspired up to the nineteenth century. The High Renaissance changed the whole way of seeing art so that a painting or a statue was expected to be in complete harmony with natural form and proportion, and yet involve the artist's personal vision and inspiration to raise the subject above ordinary reality.

A religious or a mythological subject has intellectual or spiritual aspects built into it. But the High Renaissance artists brought the ideal of heightening a subject to all art, and their naturalistic idealism is just as evident in portrait painting. Early Renaissance portraits tended to the stiff formality of Piero's portrait of Duke Federigo (fig. 207), although late in the century we find Michelangelo's teacher Ghirlandaio painting a charmingly realistic portrait of an old man with his grandson (fig. 241). He contrasted the physical ugliness of old age with the fresh beauty of childhood and at the same time conveyed the special love between the two generations. It is an affectionate portrait of an old man who is not a grand or remote personality; he is someone we might have known and liked.

Raphael's portrait of his patron Leo X (fig. 243) makes no effort to disguise the pope's pudgy features and ominously stubborn mouth. Yet it is not only the dignified pose and the gorgeous robes that lend him dignity, nor the beautifully painted manuscript and bell, the signs of his office, that indicate that we are in the presence of an important person. Raphael infused the portrait with the solemnity of the pope's office by bringing out a feeling of his inner character and by keeping him at a psychological, not a physical, distance from us. Leo is shown with two younger companions, one his cousin, Cardinal Giulio de' Medici, later Pope Clement VII. Giulio gazes affectionately at his uncle, but there is no sentimentality in this human touch, nor does it make the central figure seem more approachable.

The most famous portrait of the period is Leonardo's *Mona Lisa* (fig. 240). Who she was is disputed; tradition favours Vasari's story that she was the wife of a Florentine businessman, but it does not matter, for the portrait was never really intended as a personal record for a family history. Leonardo never gave it up to the patron who ordered it; he found one excuse after another to say it was not yet finished, and when he journeyed to France at the end of his life he took it with him. Mona Lisa is not a beautiful woman, nor even particularly feminine, and her famous smile is not especially appealing, yet she has entranced generations of museum-goers with her majestic presence. She has an arresting quality that challenges us to penetrate the veil of mystery surrounding her; she is more than natural, 'older than the rocks among which she sits', in Walter Pater's famous phrase.

Part of the mystery comes from the subtle light and moist atmosphere, a triumphant peak in Leonardo's development of the misty, tangible air that envelops *The Virgin of the Rocks*. The blending of light and shadow was more than a technical trick for Leonardo; figure, air, and landscape are fused in a way that instils the woman's personality with the mysterious power of nature.

The chiaroscuro of High Renaissance painting was very much a part of the age in which elaborately conducted court diplomacy contrasted with frequent brutality and assassination. The ideal balance between reason and self-confidence on the one hand and emotion and demand for spiritual satisfaction on the other soon tipped towards the latter. The loss of balance that signals the end of the High Renaissance has often been blamed on external events; the date of Raphael's death (1520) has also been cited as the end of the era. But it was not so sudden a change as that; Raphael himself moved from the static balance of *The School of Athens* and the pastoral repose of his Madonnas to a more dynamic and unbalanced style in his last years.

Two years after *The School of Athens* Raphael painted figure 244, a fresco in the Villa Farnesina in Rome. It depicts the nymph Galatea fleeing from the Cyclops Polyphemus. The picture is full of sweeping motion carried through flying limbs, hair, and drapery. The figures are still in harmony with one another and with the space that moves around them; dramatic as the sense of motion is, there is no feeling of urgent haste. A controlled force moves clockwise around the picture space; the upward motion of the nymphs and satyrs is brought down again by the cupids taking aim above them. Galatea, in the centre, draws the movement in towards her. She stands in a posture that is an extreme contortion of contrapposto, yet it appears as a natural stance; she is bracing herself against the rapid motion of the dolphin-drawn seashell. The dramatic tension is allowed to stretch the classical balance but does not yet rupture the self-contained and defined space of the painted world.

What was happening to the High Renaissance style was not just a response to a taste for sensationalism, but a natural development of the idea that art existed for its own sake, on as high a plane as any other branch of learning, not only for the instructional value of its subject, but also for the artist's ability, part skill and part imagination and insight, to overwhelm and move the viewer with beauty alone. Given this ambition, it was natural for artists to keep experimenting and trying to outdo all previous efforts, so that late Renaissance art was in a more sensational vein than the Vatican frescoes of Raphael, the Sistine Chapel ceiling, or Leonardo's *Last Supper*.

244 Raphael, *The Nymph Galatea, c.* 1514. Fresco, 118 × 90 in (295 × 225 cm). Rome, Villa Farnesina

The High Renaissance in Venice

At the end of his life, Giovanni Bellini merged into the High Renaissance stream; he outlived his pupil Giorgione and was influenced by the softened light and sensuous beauty of the younger man's painting. Bellini's *Young Woman with a Mirror* (fig. 245), painted after Giorgione's death, is closer to the sfumato of Leonardo than to the brighter contrasts of his own *Saint Francis in Ecstasy* (fig. 215). Here the soft play of light reflects off the model's skin with a warm glow.

Nude painting was popular in Venetian art of the High Renaissance; in the hands of Bellini's two pupils, Giorgione (1477–1510) and Titian (1487–1576), mythological references to Venus seldom predominate over the artist's obvious pleasure in conveying the beauty of a living model. Shortly before he died in 1510, Giorgione began a nude Venus asleep in a landscape (fig. 246); it was finished after his death by Titian, who had been studying with him. Their styles were at this point so similar it is impossible to tell which parts are by which artist. The landscape is generally credited to Titian, but the soft, elegiac mood of the work is typical of both. Later, Titian used the pose in his *Venus of Urbino* (fig. 248), but with a significant difference, for his goddess is awake and gazes directly into our eyes with an open and engaging glance. The direct sensuous appeal is enhanced by the fact that she is not in a landscape but in her bedroom.

Venetian High Renaissance painting favoured colour and dramatic effect. Landscape and the contrasts of natural light were handled with particular skill by both Giorgione and Titian. In Giorgione's *The Tempest* (fig. 247), the landscape is a powerful force. The precise subject of this painting remains a mystery; X-rays show that the soldier was painted in as a second thought, replacing another woman bathing her feet in the stream. The two figures in this picture are entirely separate from one another, co-existing without communication and both apparently oblivious of the storm about to overwhelm them. The approaching tempest creates a feeling of tension; Giorgione captured with vivid realism the breathless moment just before a storm breaks. The foreground is without motion, while the clouds seem to rush forwards from the distance.

In Titian's paintings we find a sense of dramatic conflict from opposing forces in the composition. As in Raphael's *Galatea*, the movement is kept within the picture space. In his altarpiece, *The Assumption of the Virgin* (fig. 250), for example, there is an upward rush from the bottom of the painting, where the earth-bound Apostles strain up as if to follow the ascending Virgin. This rising motion is met and contained within the picture by the downward thrust from the figure of God. It is a highly dramatic composition, boldly coloured, with sharp contrasts of light and shadow which heighten the sense of space. It was one of the largest works to be painted on canvas to that date, and Titian made full use of the

245 Giovanni Bellini, *Young Woman with a Mirror*, 1515. Oil on panel, 24½ × 31⅛ in (62 × 79 cm). Vienna. Kunsthistorisches Museum

246 Giorgione, *Sleeping Venus, c.* 1509–10. Oil on canvas, $42\frac{3}{4} \times 68\frac{7}{8}$ in (108.5 × 175 cm). Dresden, Gemäldegalerie

247 Giorgione, *The Tempest, c.* 1505. Oil on canvas, $32\frac{1}{4} \times 28\frac{3}{4}$ in (82 × 73 cm). Venice, Accademia

248 Titian, *Venus of Urbino, c.* 1538. Oil on canvas, 87 × 105 in (218 × 263 cm). Florence, Uffizi

249 Titian, *Bacchus and Ariadne, c.* 1520. Oil on canvas, 68 × $72\frac{7}{8}$ in (173 × 185 cm). London, National Gallery

247

246

248

249

250 Titian *The Assumption of the Virgin*,
1516–18. Oil on panel, 22 ft 7½ in × 11 ft
(6.9 × 3.6 m). Venice, Santa Maria dei
Frari

translucence which can be achieved with oil paint on a canvas surface. It seemed revolutionary enough at the time for the friars who commissioned it to refuse at first to accept it; they changed their minds, and the work soon established Titian's fame.

In a mythological work, *The Meeting of Bacchus and Ariadne* (fig. 249), Titian gave an even freer rein to his feeling for drama and violent motion; this work comes closer to breaking the harmony of space. Arriving on the island of Naxos, Bacchus finds Ariadne, deserted by Theseus. The god hurtles into the picture, leaping from his chariot, his cloak flying, as his attendant revellers tumble into the scene behind him and the amazed girl recoils. The sharp diagonal line rising from Ariadne and Bacchus to the upper right-hand corner of the picture is countered by an opposing diagonal from the cloud and crown of stars, down to the figures in the right-hand foreground. The bright colours add to the sense of excitement. But the motion is contained within the picture and follows the laws of gravity.

Titian lived a long and productive life, and only at the end of his career do the forces of motion seem to disrupt the sense of space in a break with High Renaissance balance. There were other artists of great technical skill who practised a style of grace and harmony well after Raphael's death (see fig. 301), so that the High Renaissance cannot be said to have come to an abrupt end with Raphael. But the moment of balance between calm order and dynamic bravura was a brief period precisely because it represented the optimum solution to the problem set by the Early Renaissance, of placing figures in a space that flows around them in a wholly naturalistic manner. Once the problem had been solved so definitively, even the one genius remaining — Michelangelo — moved on to distort the solution into a new set of problems. Artists were left with the choice between repeating the style of Raphael, Leonardo, and Michelangelo, or looking for new ground altogether.

Renaissance Humanism in the North: the Reformation

North of the Alps the classicism of Renaissance art was slow to make an impression on the Gothic style. Long before the new style made any significant headway in painting, sculpture, or architecture, the Renaissance arrived in the other arts of music, letters, and politics. The three great monarchs who held the political stage in the early sixteenth century, Henry VIII of England, Francis I of France, and Charles V, the Holy Roman Emperor, all exemplified the ideal which Castiglione set out in *The Courtier;* well educated, gifted linguists, practitioners and patrons of the arts, they were also strong personalities. Yet for all the humanistic tenor of their courts, and despite the fact that Francis I was Leonardo's patron and Charles V Titian's, these monarchs were housed in Gothic palaces and surrounded by Gothic furnishings.

Francis, whose excursions into Italy brought him into contact with Italian art, was enthusiastic about the Renaissance style; he built a number of new châteaux, or country palaces, that incorporate Renaissance design. Chambord (fig. 252) was built with a classical emphasis on symmetry. It has a double-spiral central staircase so wide the king's courtiers are said to have ridden their horses up and down it. This staircase and a wealth of other classical details like the decoration of windows and turrets (fig. 254) suggest the presence of an Italian architect at Chambord. Yet the turrets and towers are fundamentally and picturesquely Gothic in style. The interior was furnished with International Gothic trappings in the style of the Unicorn tapestries (fig. 253), which may have belonged to Francis. They were designed with a knowledge of Italian chiaroscuro and perspective, but display a Gothic complexity of detail and multiple levels of meaning, weaving together the hunt of the mythical unicorn with the death and resurrection of Christ and the idea of love as a softening and civilizing influence on man.

Individual works of the Italian Renaissance were known in the North, particularly through the medium of engraved copies; a few works were actually imported, to co-exist incongruously with their Gothic settings. Francis I was the only monarch to persuade a High Renaissance artist to move to his court; Leonardo came to France and finished his days peacefully in a house near the king's château at Amboise. A wealthy merchant in Bruges purchased a statue of a Madonna and Child from Michelangelo, while another Florentine, Pietro Torrigiano, went to London to carve a classical marble tomb for Henry VII and his queen, which sits in an intricate late Gothic setting in his chapel at Westminster Abbey.

Although the Renaissance idea that a work of art was important for its own sake was still foreign to the North, the Renaissance style of portrait painting suited Northern temperament. In van Eyck's *Virgin and Child with the Chancellor Rolin* (fig. 178), we saw how the artist's desire to convey the character of his patron stretched the conventions of the medieval donor portrait to the breaking point. Portraits painted with an entirely secular setting, divorced from religious subjects, gained popularity in the North as well as the South, and by early in the sixteenth century we find portraits that are entirely free of medieval formality, painted to express the personality and individual character of the sitter. Fifteen years before Raphael's portrait of Leo X, the German artist Lucas Cranach the Elder (1472–1553) painted a young intellectual from Vienna (fig. 251). Despite the Gothic character of its landscape background, no more eloquent statement could be made of man at the centre of the universe, the measure of all things. The sitter is placed out in the open; the landscape is full of symbolic images but is a rationally organized space drawn from a single viewpoint. The figure is modelled with a soft chiaroscuro and delicate brush strokes which highlight his attractive features; his intensely thoughtful expression conveys personality and intelligence.

251 Lucas Cranach, *Portrait of Johannes Cuspinian*, 1502–3. Oil on panel, $23\frac{1}{4} \times 17\frac{3}{4}$ in (59 × 45 cm). Römerholz, Winterthur, Oskar Reinhart Collection

252

253

252 Château of Chambord, Loire, France, begun 1519

253 'The Unicorn Defends Himself', from the *Hunt of the Unicorn* tapestries, late 15th or early 16th century. Silk and wool, silver and silver-gilt threads, 145 × 158 in (3.68 × 4 m). New York, Metropolitan Museum of Art, Cloisters Collection

254 Château of Chambord, detail of exterior decoration

255 Hieronymus Bosch, *The Garden of Earthly Delights*, 1485–1505. Oil on panel, centre panel, 86½ × 76¾ in (220 × 195 cm). Madrid, Prado

254

The humanism in this portrait is very much connected to advances in the field of letters, for its subject, Johannes Cuspinian, was one of the most talented of the new scholars who left medieval scholasticism behind and turned as avidly as the Italians to the Classics in the original Latin and Greek. At the time of his portrait Cuspinian, only 29, was already rector of the University of Vienna. In the North the centres of learning were not the courts of princes but the universities, and intense interest in Classical works led not to abstruse Neoplatonism but to a questioning of the position of the Church as sole interpreter of all religious writings and arbiter of education. The humanist emphasis on an individual's power to change his own destiny led directly to an attack on clerical authority, especially the foreign domination of the papacy, and to a puritanical reaction against the corruption and worldliness of both secular and clerical society.

The Reformation was not, as the Counter-Reformation later claimed, caused by the study of pagan Classical writings, but it was certainly fuelled by the spread of learning and the questioning frame of mind gained from reading the Classical authors. A more widespread literacy went hand in hand with the new trade of book-printing; the availability of cheap paper and the invention of movable type meant that printed books and pamphlets now reached a wider and more informed public than ever before. An illuminated manuscript is a beautiful object, but a printed book is a powerful instrument in the spread of ideas. A humanistic education enabled men like Erasmus of Rotterdam and Sir Thomas More, Henry VIII of England's chancellor, to make eloquent attacks on the corruption of Church and society, couched in clear, Classical Latin, and the printing trade spread their works to an eagerly waiting public.

A popular form of criticism was satire, which by exaggeration and ridicule often achieves what straight argument fails in. In the painting of Hieronymus Bosch (*c.* 1450–1516) we find a savage and bitter indictment of folly that comes close to contemporary literary satire. Bosch was a Flemish artist trained in the tradition of van der Goes and Memling, but his work is intensely personal and like that of no other artist. He was little touched by the classicizing trends of the Renaissance style. Deeply religious, he held so pessimistic a view that his paintings yield no promise of salvation; rather, they seem to say that Christ's sacrifice was in vain, for humankind is too much wedded to folly to be redeemable. This is the theme of his triptych traditionally called *The Garden of Earthly Delights* (fig. 255). The central scene depicts a garden full of people whose nudity suggests the innocence of the Garden of Eden, but who are bent on every kind of extravagant and ridiculous behaviour, turning Paradise into a riot of earthly perversions. Blind to their own folly, these inhabitants of a fool's paradise are headed straight for the hell painted in the right-hand wing.

The monsters and grotesques in Bosch's paintings have no equals for sheer, tortured horribleness. But a deep and troubled piety is seen in the art of two great German artists of the Reformation period, Mathis Gothardt-

256 (below) Albrecht Dürer, *Knight, Death and the Devil*, 1513. Engraving, $9\frac{5}{8} \times 7\frac{1}{2}$ in (24.4 × 18.9 cm). London, British Museum

257 (bottom) Albrecht Dürer, *Self-portrait*, after 1500. Oil on panel, $26\frac{1}{4} \times 19\frac{1}{4}$ in (66.7 × 48.9 cm). Munich, Alte Pinakothek

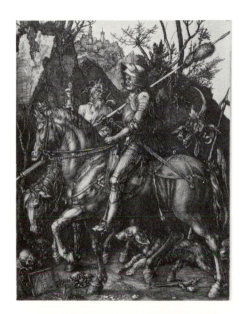

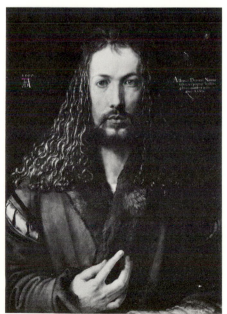

Neithardt, called Grünewald (c. 1460–1528), and Albrecht Dürer (1471–1528). We know very little of Grünewald's background, but he was an artist of individuality who developed a highly coloured and expressive style that achieves emotional impact through violent contrasts of light and dark. For the Knights Hospitalers of Isenheim, in Alsace, he painted an altarpiece that presents a searching view of late medieval Christian faith. On weekdays the altarpiece remained closed, showing the Crucifixion (fig. 258). This is a stark and painful scene with no softening grace. The emaciated figure of Christ expresses the extreme of human agony in his tortured and strained limbs. Even his outstretched fingers are an eloquent sign of pain and suffering. In its anatomical realism, this scene is far from the Romanesque and Gothic Crucifixions and Pietàs. The realism of correct proportion and anatomy, the body flecked with blood and sweat, the head pierced by the thorns of his crown, combine with the starkness of the composition to give a startlingly modern force to the work. Nothing distracts us from the manner of Christ's dying.

On Sundays the grim doors opened to an entirely different mood (fig. 259). The Annunciation, Nativity, and Resurrection all stress the joyful and hopeful side of the Gospel. Here, too, emotion is heightened through the use of colour, but in the opposite direction. In contrast to the harsh, drab tone of the Crucifixion these panels present violently dramatic contrasts of dark and brilliant light. The central scene mixes supernatural with natural light, but outside the chapel we find the Nativity set in a natural landscape, lit by natural light, despite the rays emanating from the figure of God overhead. The contrasts of light and dark are inherent in the religion itself; Grünewald painted the innocent child wrapped in the torn loincloth of the Crucifixion scene. But, in contrast to the pessimism of Bosch, the ultimate triumph of faith is suggested here in the fact that the child is playing with his mother's rosary.

There is no evidence that Grünewald ever visited Italy; his intense colouring is closer to Gothic painting than to the natural chiaroscuro of the Renaissance. The first German artist genuinely to absorb the Italian High Renaissance from its source was Albrecht Dürer, who made two visits to Italy, the first in 1494, the second in 1505–6. Even before he set foot in Italy he had been excited by Renaissance art seen in engravings which circulated in the North. He learned engraving techniques in his father's goldsmith's shop, and early in his apprenticeship he experimented with woodcuts, a medium made popular as illustrations in printed books. From the beginning of his career Dürer discovered a means of economic independence by selling woodcut prints in the market-place; he came to do the same thing with engravings. He was the first artist to find an open market for works done not to please a particular patron but according to his own taste and imagination. His high reputation in his own lifetime rested mainly on the wide distribution of these relatively cheap and popular prints (fig. 256).

258 (*below*) Matthias Grünewald, *Crucifixion*, Isenheim Altarpiece (closed), *c.* 1510–15. Oil on panel, 106 × 121 in (269 × 307 cm). Colmar, Musée d' Unterlinden

259 (*opposite*) Mathias Grünewald, *Annunciation*, *Nativity* and *Ascension*, Isenheim Altarpiece (second stage), *c.* 1510–15. Oil on panel, left wing, 105⅞ × 55⅞ in (269 × 142 cm); centre, 104⅜ × 119⅝ (265 × 304 cm), right wing, 105⅞ × 56¼ in (269 × 143 cm). Colmar, Musée d' Unterlinden

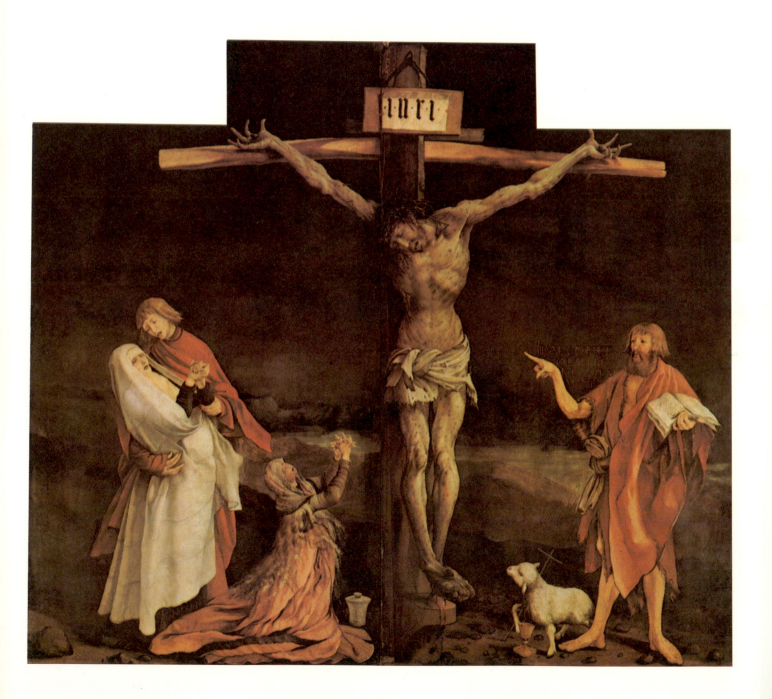

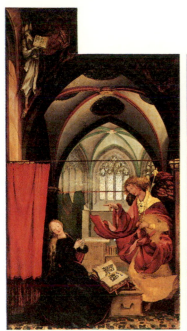

260 Albrecht Dürer, *House by a Pond*, c. 1495. Watercolour, $8\frac{3}{8} \times 8\frac{3}{4}$ in (21.3 × 22.2 cm). London, British Museum

From his first trip south of the Alps Dürer learned more than techniques of anatomy and perspective; he learned to see the world with Italian eyes. For his own pleasure and memory, he made watercolour sketches of the countryside he passed through that are close to the landscape drawing of Bellini and Leonardo. Although there is no proof that Dürer ever met Leonardo, many of his studies of plants and animals show a similar curiosity and observation that goes beyond surface appearance to the heart of natural phenomena. A painting of a house by a pond (fig. 260), done after the first Italian trip, shows the influence of the Renaissance in the clarity of its composition, which recedes from the sharp focus of the boat in the foreground and the reeds on the near bank to the softened curve of the pond's edge and the still more blurred island with its Gothic building. The scene is reflected in the pond; the soft, heavy light of evening envelops the whole painting and shows a fundamental understanding of High Renaissance art that goes beyond the use of linear perspective.

In much of his art, however, Dürer's northern temperament pulled against the soft light of the South. He was the first German painter to adopt the Renaissance view of the artist as a man of rank and learning; he was the companion of scholars and gentlemen, and something of a dandy. But his view of the artist as a genius and inspired creator took an emotional and religious twist in a self-portrait (fig. 257), in which he drew himself in the traditional pose of Christ as the saviour of the world. Where the Italians had placed the artist as a creator in a secular setting such as that of Raphael's *School of Athens*, Dürer's piety demanded a religious symbolism. Other Northern artists had expressed the theme through the humbler image of Saint Luke painting the Virgin (see fig. 205), but Dürer's commitment to the professional status of the artist required the bolder image to suggest more directly the divine source of artistic creation.

This mixture of classicism and Gothic piety is evident in an engraving called *Knight, Death and the Devil* (fig. 256). The solid figure of the knight and his muscular horse resemble Verrocchio's equestrian statue of Bartolommeo Colleoni (fig. 223), which Dürer would have seen in Venice, but they are in the company of grotesques worthy of Bosch. The scenery is full of Gothic fantasies: withered stumps, crags, and a towering city on a distant pinnacle. Death, who carries his hourglass to warn us of the grave's imminence, and the horned, goat-like devil are frightening creatures from the darker corners of the artist's imagination. But the animals are of the real world; if the knight's mount seems to come by way of an equestrian statue, Death's sorry nag and the faithful dog are very true to life.

Dürer identified his stout-hearted knight with Erasmus. Like many, he sympathized both with Erasmus, who never left the Catholic Church, and with Luther, who did. The Reformation formed a web that bound the great talents of Northern Europe together. Albrecht von Brandenburg, the cleric who provoked Luther's 95 theses by buying three archbishoprics through the sale of indulgences, was Grünewald's patron. Grünewald

261 (*above*) Hans Holbein the Younger, *The Circle of Sir Thomas More*, 1528. Pen and ink, 15¼ × 20½ in (38.7 × 52.5 cm). Basel, Kunstmuseum, Kupferstichkabinett
Holbein journeyed to England in 1526, when he stayed with More; by his second visit in 1532, More was out of favour. Holbein entered the king's service from *c.* 1536 until his death.

262 (*left*) Lucas Cranach, *Portrait of Martin Luther*, 1529. Oil on panel, 14½ × 9 in (37 × 23 cm), Florence, Uffizi

avoided openly siding with the rebels, but his sympathy was on the side of reform. Dürer, Cranach, and Holbein were drawn to the Protestants and painted revealing portraits of both Luther and Erasmus which bring out the difference in temperament that led the one to break into active rebellion and the other to retreat from the consequences of an actual break. Luther was a man of action, a crowd-pleaser who had the popular touch; Cranach's portrait of him (fig. 262) indicates the burning sense of injustice that led him into open confrontation with the papacy. Holbein's Erasmus (fig. 264) shows us the intellectual character of the man, seen writing in his study, a sanctuary from the active world. He is placed close to us, at the front of a shallow picture space, so that we share an intimate glimpse of a man engaged in private study, but by highlighting only the chiselled profile and fine hands, submerging the rest in black fur and dark shadow, Holbein conveys an austere, remote, superior intelligence.

Hans Holbein the Younger (1497/8–1543) was the most talented German portraitist of the Reformation years. Like Dürer, he was strongly influenced by the High Renaissance. When Holbein settled in Basle, he met Erasmus, who gave him an introduction to Sir Thomas More in London. Holbein sent Erasmus a sketch he made of the great English humanist and his family (fig. 261), which was a study for a full-length group portrait. The portrait itself has been lost, but the sketch shows the great skill with which Holbein could bring out the character of his sitters in a few sharp lines. We can recognize in the figure of Sir Thomas the stubborn and uncompromising nature that led him to the scaffold for refusing to recognize Henry VIII as the head of the English Church.

After More's downfall, Holbein secured the patronage of Henry VIII himself. Henry trusted Holbein's ability to convey the character of the various princesses the king sought in marriage better than he trusted the descriptions given him by his envoys. Holbein's portraits of Henry were less personal and more hidden behind the elaborate trappings of monarchy, but his paintings of non-royal personages at court show the great range of invention which Protestant iconoclasm (the rejection of religious images) and the lack of a market in England for mythological subjects channelled almost exclusively into portrait painting.

The most unusual of his portraits from the London years is a life-size double portrait of two French ambassadors at the court (fig. 263). It is in a very different key from the sketch of the More family. The two men, one soberly clad in a black robe, the other more flamboyantly elegant and colourful, stand at either side of a table which—like the intarsia 'shelves' at Urbino—displays objects symbolizing a humanistic background. It is the table, not the human beings, that is the central focus, thus stressing symbolism more than naturalism. But the artist's most radical break with Renaissance naturalism and perspective is seen in the object floating across the bottom of the picture; when viewed from the lower left-hand corner, this image returns to its natural form and becomes a human skull.

The Two Ambassadors marks a breaking, not just a stretching, of Renaissance harmony and balance. The turn from classical wholeness to deliberate distortions and tricks of style this represents has been credited to the loss of self-confidence brought about by the Reformation, but it was a development that followed inevitably from the perfection of the High Renaissance style. However, the Reformation did lead to the devastating religious and civil wars of the sixteenth century; for Rome, the event that made a decisive break in artistic patronage was its sack in 1527 by the troops of Charles V. Although the emperor was a Catholic, many of his soldiers were Lutherans, and their destruction was deliberate and violent. It was specifically aimed against the Church; the Germans stabled their horses in the Sistine Chapel and lit bonfires in the famous *stanze* decorated by Raphael. The sack of Rome scattered the artists gathered by the papacy to less troubled parts, and when peace was restored and Rome again offered patronage to the arts, it was under the aegis of the Counter-Reformation, when Mannerism was succeeding the High Renaissance as the dominant style in art.

263 (*below left*) Hans Holbein the Younger, *The Ambassadors*, 1533. Oil on canvas, 83 × 84 in (207 × 209.5 cm). London, National Gallery

264 (*below*) Hans Holbein the Younger, *Portrait of Erasmus*, c. 1523. Oil on panel, 16½ × 12½ in (42 × 32 cm). Paris, Louvre

CHAPTER 9

Retreat from Harmony: Mannerism

265 Agnolo Bronzino, *Lodovico Capponi*, *c.* 1550–5. Oil on canvas, 45⅞ × 33¾ in (116.5 × 85.7 cm). New York, Frick Collection

When we compare the two Holbein portraits at the end of Chapter 8 — the More family sketch and *The Two Ambassadors* — we are at once aware of a totally different attitude towards space and motion, even allowing for the difference between a preparatory drawing and a finished painting. Sir Thomas and his family are gathered in a semicircle, naturally posed to give us the feeling of having dropped in on the family unexpectedly, while they are still unaware of our presence. In contrast, the two Frenchmen seem as if frozen self-conciously in an air that moves freely around their still figures; the formal treatment harks back to late Gothic portraiture without losing the High Renaissance flow of space.

Where a High Renaissance portrait brings us close to the subject through a psychological insight on the part of the artist, the Mannerist portrait was generally designed to flatter the subject by the painter's skill and virtuosity, and holds the subject aloof from us, giving us no clue to an individual personality. In the North this artificial formality was natural to the great courts and a continuation of the stiff late Gothic style of portraiture. But Mannerism originated in Italy, where its cold elegance was neither confined to royal sitters nor connected to rank. A portrait by Agnolo Bronzino (1503–72) of a page in the household of Duke Cosimo de' Medici (fig. 265) holds its subject completely aloof from us; despite the boy's youth and beauty, we do not feel any sense of intimacy, nor receive any glimpse of his true character or emotion. What we do see is that the portrait is rendered with great skill and apparent effortlessness; we cannot help but be impressed by the way the artist has brought out the textures of skin, hair, and cloth.

This emphasis on skill and beauty came partly from the sixteenth century's admiration of the High Renaissance, and of Raphael in particular, and the wish of his followers to emulate his facility of line while at the same time capturing his emotional impact. The strain this imposed on artists of lesser talent led them away from High Renaissance principles

towards an emphasis on achieving perfection in painting through adherence to established rules. These rules set out to lead the artist towards ideals of courtly elegance, sophistication, and — most of all — gracefulness, all of which Vasari included under the heading 'de maniera', best translated as 'stylishness'. The transition from the High Renaissance to Mannerism is most clearly visible in painting, but the move away from classical balance and stability is also visible in sculpture and architecture.

Breaking the Rules of Perspective

In such works as his *Galatea*, Raphael stretched the balance between harmony of form and a feeling of excitement without rupturing the sense of picture space. But once the rules of proportion and perspective were established, a certain impact could be gained by flouting them. When Raphael's pupil Giulio Romano (c. 1499–1546) built a new palace for the Gonzagas in Mantua, he broke away from the self-containment of the High Renaissance style in favour of an elaborate game of illusion and pretence that involves the viewer's participation. He was influenced by Mantegna's illusionistic frescoes, but in the Palazzo del Tè the object was to remove all distinctions between painting and architecture. Vasari tells us that Giulio 'determined to construct an apartment, of which the masonry should be accommodated to the requirements of painting, thereby the more effectively to deceive the eye of the spectator'. This defines a major intention of the Mannerist aesthetic which Vasari did as much as anyone to promote, and it is opposite to the Early and High Renaissance practice of maintaining the articulation between architecture and decoration, between the foreground and background in painting, and between picture space and real space.

Giulio *Fall of the Gods and Titans* (fig. 268) is conceived in the opposite of an articulated style; it is impossible to tell where one structural element ends and another begins. From the ceiling where Jupiter hurls his thunderbolts, down to the walls where huge broken columns topple to crush the hapless giants, everything is tumbled together. As Vasari says, '... it has neither beginning nor end: the whole is nevertheless well connected in all its parts, and continued throughout unbroken by division or the intervention of framework or decoration ...' The gods who crush their enemies with such force in this hall would seem to have constructed the palace itself, for Giulio moulded the decorative elements on a huge scale and on a scheme of fantasy. In a courtyard of the nearby Palazzo Ducale, rusticated columns wriggle up and down like fat worms (fig. 270). Rusticated stone, used in earlier Renaissance architecture as a natural base for the more elaborately finished upper storeys, was turned by the Mannerists into a sophisticated, and in this case witty, illusionistic effect.

The Palazzo del Tè is a Mannerist work that breaks the rules de-

266 Michelangelo, plan for St. Peter's. Engraving by Etienne Dupérac, 1569

267 Michelangelo, Capitoline Square, Rome, begun 1544

268 Giulio Romano, *Fall of the Gods and Titans*, detail of fresco in the Palazzo del Tè, Mantua, 1525–35

269 Michelangelo, New Sacristy, San Lorenzo, Florence, 1524–34

270 Giulio Romano, courtyard of the Palazzo Ducale, Mantua, 1538–9

266

267

268

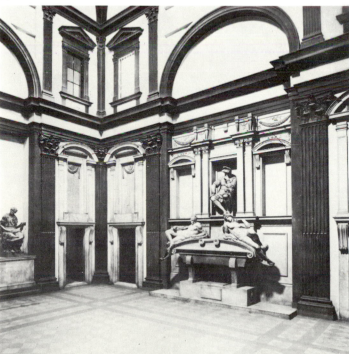

269

270

liberately to achieve a dramatic reaction. The playful wit with which it was designed is a far cry from the stark drama of figure 271, painted by the Florentine artist Rosso Fiorentino (1494–1540). But this is also a Mannerist work that deliberately distorts visual appearances to create an impact. Next to the soft chiaroscuro of a Raphael Madonna, Rosso's *Descent from the Cross* is a shocking denial of Renaissance naturalism. The colours are lurid, the lines sharp and angular, and the figures placed at odd angles to one another. The man who grasps Christ's knees must surely fall from the ladder at any moment, while the youth holding the ladder on the right seems to be pulling it out from under the figures precariously balanced on it. In addition to breaking the laws of gravity, Rosso has defied the understanding of three-dimensional space as established by the Renaissance. There is no real sense of picture space defined behind the group; they are all right at the front of the painting, and a dark void opens behind them.

Rosso's friend Jacopo Pontormo (1494–1557) painted a similar subject (fig. 272) with a similar distortion of spatial relationships. His figures are elongated out of proportion; they too inhabit the front of the picture space, arranged to lead the eye up rather than back. The feeling conveyed by these disruptions of spatial harmony is disturbed and uneasy.

Both Rosso and Pontormo owed much to the High Renaissance art of Michelangelo; in both these works the figure of Christ is derived from Michelangelo's *Pietà* (fig. 236). After 1520, the debt was reversed, and Michelangelo was drawn to their distortion of perspective and balance to heighten tension, breaking the rules he himself had helped establish. The High Renaissance had kept a separation between the three visual arts; united by a common aesthetic, painting, sculpture, and architecture each had its own rules. Mannerism often deliberately blurred distinctions between them, as we saw in Giulio Romano's work in Mantua; this confusion of boundaries owed much to the dominating influence of Michelangelo, who practised all three.

Late in his career Michelangelo turned seriously to architecture, although few of his major buildings were completed in his lifetime. For the Medici he designed a sacristy attached to the church of San Lorenzo to balance the fifteenth-century one by Brunelleschi (fig. 269). The effect of Michelangelo's architecture is entirely different from that of Brunelleschi, even though the two sacristies follow the same basic plan; in the 'new' sacristy the treatment of the wall-surfaces is freer and the decorative elements are more obtrusive. The sculptures present varying impressions as the spectator moves around the chapel, adding to the theatrical effect of the architecture. Two Medici dukes, Lorenzo, Duke of Urbino, and Giuliano, Duke of Nemours, sit uneasily and apprehensively over the four startling personifications resting on the tombs below. These tense and muscular figures represent Night and Day (see fig. 7), cowering beneath the Duke of Nemours, and Dawn and Dusk, precariously perched below

271 (*left*) Rosso Fiorentino, *Descent from the Cross*, 1521. Oil on panel, 132 × 77½ in (335 × 197 cm) Volterra, Pinacoteca

272 (*below left*) Jacopo da Pontormo, *Deposition*, 1526. Oil on panel, 123¼ × 75⅝ in (313 × 192 cm). Florence, Santa Felicità

273 Michelangelo, *Madonna and Child*, 1524–34. Marble, 89½ in (227 cm). New Sacristy, San Lorenzo, Florence

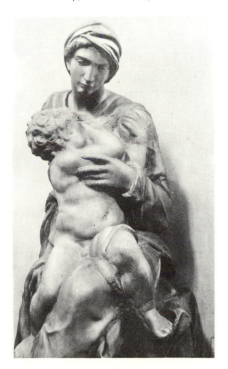

the Duke of Urbino. Twisted into difficult and strained postures, they are disturbing figures who appear frightened by unseen terrors.

This expression of emotion stems from Michelangelo's deliberate straining of the harmony he had earlier achieved. But the result of a disruption of balance is a feeling of shock. There is a vivid contrast between the effect of the unfinished *Madonna and Child* in the sacristy (fig. 273) and his earlier *Pietà*. In the *Pietà* the two figures flow together in a polished blending of line. The *Madonna and Child* is carved in sharp angles, with forces opposed to one another; the Madonna twists forward, supporting herself against the weight of her child, while he squirms away from us, pushing hard into her protective bosom. Ironically, the *Pietà*, traditionally a sorrowful subject, is the more comforting of the two works.

In his architecture, Michelangelo emphasized the sculptural aspects of buildings through decorative details of columns, pilasters, and cornices that blur rather than articulate boundaries. In Rome, he redesigned the Capitoline palaces in the old centre of the city, so that the three buildings are placed with a Mannerist predilection for surprising and eye-deceiving views. The square is not rectangular; it narrows as it draws near the steps, thus minimizing the interruption of the street openings so that the eye moves continually around the square. His pavement design of concentric circles — which was constructed in recent times — adds to this sense of motion (fig. 267).

The horizontal accent of the two palaces on either side of the square is deliberately de-emphasized by the giant pilasters that run the full height of the two storeys, cutting through the upper-storey balustrade. Michelangelo used the same classical ornament as Bramante had used, but to an entirely different end; Bramante's pilasters, columns, pediments, and cornices are stable, marking where one part of a building ends and another begins; Michelangelo's elements recede and advance as we move, changing our impressions as we change our viewpoints.

Michelangelo was appointed chief architect of St. Peter's in 1547, and some idea of his driving character can be seen from the fact that although, up to that point the building had progressed little since the death of Bramante, when Michelangelo died in 1564, the sanctuary and crossing had almost reached the level of the dome. The dome and apse follow his design, which harked back to Bramante's original plan for a Greek cross. But, with a Mannerist's desire for movement and surprise, Michelangelo turned the plan from a square to a diamond and put the entrance across one corner (fig. 266). The intention of this was to let space flow without interruption around the diagonal, as it does around the diagonal piers of a Gothic cathedral.

Michelangelo's largest Mannerist painting was a fresco he painted on the wall behind the altar in the Sistine Chapel, where Early Renaissance frescoes had been damaged by fire. The vast gap between the humanism of his ceiling frescoes and the terrifying *Last Judgement* (fig. 275) on the wall

indicates the sharp break between the High Renaissance and Mannerism. A huge and muscular Christ hurls the damned into Hell in the manner of Jupiter hurling his thunderbolts. Even the elect seem apprehensive, while the damned offer a penetrating portrait of terror and despair.

A devout Christian, Michelangelo was undoubtedly upset by the upheavals of the Reformation, and as a Florentine patriot he was certainly tormented by the ill-fated struggle between the Florentine Republic and the papacy, in which he was forced to take sides against his friends and patrons, the Medici. Yet, it would be a mistake to attribute the emotional force of *The Last Judgement* solely to his spiritual state, for we have his own testimony that he was always striving for new stylistic effects and greater technical virtuosity. The violent distortions of perspective and form which trouble our emotions were employed to win our admiration for the artist's skill; he advised other artists, for example, to use foreshortening frequently because it is more difficult and and would enhance their reputations. The image of loss and horror that pervades the painting stems from the massing of bodies heaped in a chaotic turbulence. The artist's interest in portraying crowds of nude figures can be seen earlier, for example in the studies for the Battle of Cascina and in the scene of *The Deluge* on the Sistine Chapel ceiling, where he massed the fleeing figures to heighten the impression of terror.

Michelangelo's Mannerism was an individual style compounded of inner vision and technical bravura. His enormous prestige had an inhibiting effect on his contemporaries and followers, who, aware that an age of giants had passed, were left with the dilemma of choosing to make sterile copies of a former style or breaking new ground. Novelty was a valued element in art, but a dangerous one in an age that also demanded beauty and inspiration. Vasari recognized the dilemma; he praised Michelangelo for deliberately breaking the rules of classical art, but went on to point out that from Michelangelo's inspired imagination other artists simply drew licence to depart from tradition to 'new kinds of fantastic ornament containing more of the grotesque than of rule or reason'.

For both the Early and High Renaissance art had been an intellectual, rational pursuit. While the Mannerists followed the High Renaissance in understanding imitation of nature to mean an imaginative and intellectual selection of natural details, they put more emphasis on imagination and 'gracefulness', defined by Vasari as a certain indefinable but immediately recognizable quality distinct from beauty. Vasari wrote his *Lives of the Painters* and founded his Academy of Design to preserve art from declining in standards from the High Renaissance and to consolidate the artist's social standing. His method of maintaining quality was to codify as much of earlier art and theory as possible into a set of teachable rules, to persuade young artists to spend much time copying both Classical and High Renaissance models, and to teach the technical skill and facility with which a reasonably talented artist could convey the gracefulness Vasari felt to be essential.

Some of the Mannerists became weighed down by theory; statements that for Alberti and Leonardo had been a rational explanation of their own thoughts and experience became a large and much argued body of doctrine written down by less than first-rate practitioners of the arts. These rules came to inhibit rather than instruct those who followed them too literally. Much of the cold aloofness of paintings like the Bronzino portrait (fig. 265) came from the feeling that one could prove objectively what good art was and could then go on to teach this. In all the arts technique — a polished exterior, a difficult pose convincingly executed — became an end in itself. Figure 277, a statue by Giovanni Bologna (1529–1608), is typically Mannerist, composed with a deliberately complex vertical intertwining of three bodies so that we receive changing impressions as we walk around the sculpture. We are reminded of Pollaiuolo's small bronze *Hercules and Antaeus* (fig. 224), where the artist was also concerned with skilful execution, but the startling effect and anatomical bravura of Giovanni's work obviously owe much to Michelangelo.

Revealingly, Giovanni carved his statue without a particular subject in mind; he had only the conception of three struggling figures; and the title was settled after the work was completed. This reflects the decline in the importance of a subject in itself as it developed into a vehicle for the display of virtuosity. Almost any story could provide such a vehicle; the Mannerists made little distinction between history, Classical mythology, and Biblical themes. The lack of distinction between pagan and Christian subjects is illustrated in the strangely erotic *Madonna of the Long Neck* (fig. 274) by Francesco Parmigianino (1503–40). In this work there is a sharp break in the spatial relationships between grounds; a dizzying sense of vertigo comes from the fact that the column, seen as standing below the Virgin, actually rises from a point above her. The physical distortions of perspective and the oddly elongated proportions of the figures create a sense of psychological disturbance. The most startling aspect of the work is the incongruity of the nearly nude, androgynous figures attending the refined yet voluptuous Madonna; all of these figures would be equally at home in a mythological painting.

274 Parmigianino, *The Madonna of the Long Neck*, 1532–40 (incomplete). Oil on canvas, 85 in × 52 in (216 × 132 cm). Florence, Palazzo Pitti

Mannerism and the Counter-Reformation

The particular quality that is disturbing in the *Madonna of the Long Neck* is not wholly a matter of tricks of style. Mannerist desire to achieve a shock effect by breaking rules was partly a stylistic response to the Renaissance; the particular chilly dissonances that Mannerist art produced from its disruptions of harmony and balance also reflect the religious turmoil sweeping all Europe, for in the fierce struggle between Protestantism and Catholicism, humanism retreated in Italy, where people were losing their confidence in human capabilities and their faith in the established Church.

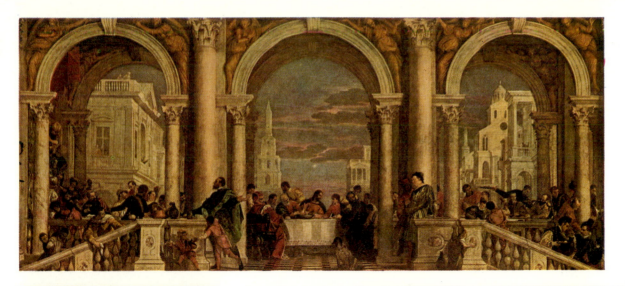

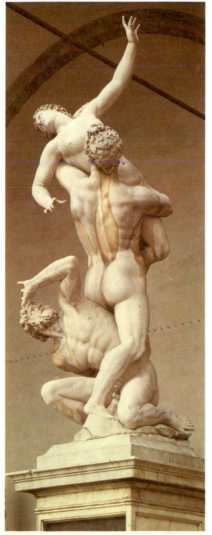

275 (*facing page*) Michelangelo, *Last Judgement*, 1536–41. Fresco, 45 × 40 ft (13.7 × 12.2 m). Rome, Sistine Chapel

276 (*top*) Paolo Veronese, *The Feast in the House of Levi*, 1573. Oil on canvas, 222 × 512 in (555 × 1280 cm). Venice, Accademia

277 (*left*) Giovanni Bologna, *Rape of a Sabine*, completed 1583. Marble, height 13ft 6in (3.9 m). Florence, Loggia dei Lanzi

278 (*above*) Giacomo Vignola, interior of Il Gesù, Rome, 1575–84

It is this that gives Parmigianino's painting the queer sense of belonging neither to one world nor the other.

In the struggles, Italy lost the precarious independence which had given birth to the Renaissance. Charles V, whose troops sacked Rome in 1527, was the king of Spain before he succeeded his grandfather as Holy Roman Emperor. He brought much of Italy under his control through a Spanish viceroy in Naples and a Spanish government in Milan. Spain, the most undividedly Catholic nation in Europe, dominated Italian affairs; under largely Spanish leadership the Counter-Reformation, a Catholic counter-attack on Protestantism, took shape.

The Counter-Reformation carried out much-needed reforms to clear away the corruptions within the Catholic Church that had led to the Reformation. In the process, the Church excercised an inhibiting effect even on secular art by its attack on humanism. Artists continued to produce mythological subjects and nudes for the nobility, but Catholic puritanism distorted the frank sensuality of a Titian nude into the submerged eroticism so evident in Parmigianino's *Madonna*.

The clergy only interfered directly with art when decorum appeared to be offended in religious painting. When Paolo Veronese (1528–1588) filled his huge canvas of *The Feast in the House of Levi* (fig. 276) with extraneous characters including dogs, dwarves, clowns, and soldiers, he was called before the Inquisition. He gave as his justification that an artist should be free to put in whatever his imagination suggested; it was his work of art. This is a far cry from medieval iconography, and to the Inquisition judges was no defence at all, yet the changes they forced were minor and the secular atmosphere was left intact. It was typical of the Counter-Reformation that Michelangelo's nude figures in *The Last Judgement* were given wispy loincloths, yet no objection was made to the proliferation of pagan mythological subjects, more widespread in Catholic than in Protestant countries; these, however, became allegorical and moralistic.

It was architecture that benefited most positively from the stimulus of the Counter-Reformation. Catholic reform was ignited by such people as Ignatius Loyola, a Spaniard who founded the Society of Jesus (the Jesuit order) in 1540. The new reforms created a demand for new churches and challenged architects, by the new emphasis placed on the sermon, to improve acoustics and to organize space to bring people closer to the pulpit and to make the altar clearly visible. Giacomo Vignola (1507–73) designed Il Gesù, the mother church of the Jesuit order in Rome, which became the basic model for a Counter-Reformation church. Its interior (fig. 278) goes back to Alberti's Sant' Andrea (fig. 210); it is an aisleless church with chapels opening between the nave piers. Vignola employed barrel vaulting for its acoustical properties, rather than the sound-absorbing coffered ceilings favoured by Brunelleschi and Alberti. Il Gesù was finished after Vignola's death in the opulently ornamental Baroque style rather than with the relatively plain interior he had intended.

279 Giacomo della Porta, Il Gesù, Rome, façade, c. 1575–84

The façade of Il Gesù (fig. 279) was designed by Giacomo della Porta (c. 1537–1602) and also derives from Alberti; the reverse scrolls used to connect the narrower top section to the wider lower half were modelled on a church Alberti had designed in Florence. At Il Gesù, however, della Porta emphasized Mannerist rhythms by breaking the bottom storey and its entablature into separate blocks alternately recessed and brought forward to create a pulsing effect.

Outside Rome and Florence, the most fruitful centre of Mannerist art was Venice, where many of the artists dispersed by the Sack of Rome found a welcome niche. One of these was the Florentine Jacopo Sansovino (c. 1486-1570). It is his design for the library of Venice (fig. 281) that appears in a modified form as the loggia background in Veronese's *Feast in the House of Levi*. The façade of this building was forced to compete with both the Romanesque basilica of St. Mark's and the Gothic Doges' palace. It is a striking design; the piers of the double loggia are faced by large columns thrust forward between the arches to give a sculptural effect of shifting space and mass, emphasized by the deep contrasts of light and shadow. This massive yet picturesque façade echoes the late Gothic delicacy of the Doges' palace and also holds its own with the extravagantly ornate Romanesque basilica.

Sansovino's library was imitated by Andrea Palladio (1508–80), a native of nearby Vicenza, in the new exterior he designed for the town hall of his birthplace (fig. 283). Palladio thrust the columns even more obtrusively forward, breaking the line of the entablature, to create a wavy curvilinear motion more plastic and more startling than Sansovino's library façade.

Palladio was the most deliberately classical of the great Mannerist architects; his archaeological studies and careful reading of Vitruvius reflect the practice of Bramante and Alberti. His buildings have the harmony and balance that comes from an organic development of structure rather than superficial pictorial effect. His most severely classical building was a private villa (fig. 282) which is a completely symmetrical structure even to the arrangement of rooms inside; he repeated the massive temple portico on all four sides. For Palladio, the correct use of orders was important; on the Vicenza basilica, for example, he used the Doric on the ground floor and the lighter Ionic on the upper storey. Yet his approach to Classical architecture was never merely academic, and many of his works like the basilica display a Mannerist love of picturesque and startling effect that is quite unclassical.

Palladio's classicism led him, like Bramante before him, to a preference for centrally planned church design, but he was an ardent Counter-Reformation Catholic and fully awake to the demands of liturgy. For this reason he designed the church of San Giorgio Maggiore, in Venice, on the plan of a Latin cross. It differs from Vignola's Il Gesù by following the old scheme of a nave with side aisles. This gave Palladio a different problem in

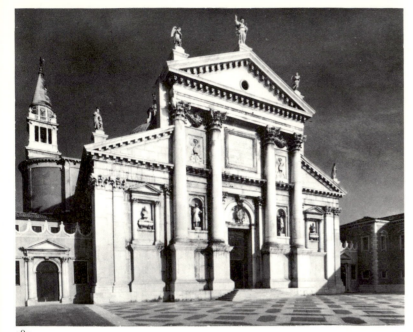

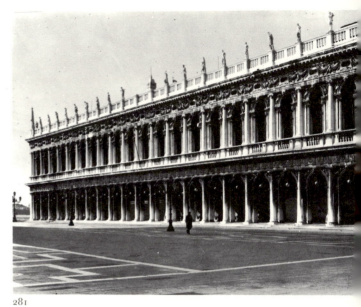

280

281

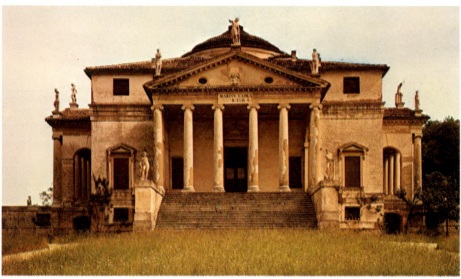

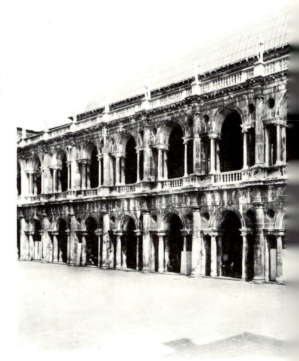

282

280 Andrea Palladio, San Giorgio Maggiore, Venice, 1566–80

281 Jacopo Sansovino, St. Mark's Library, Venice, begun 1536

282 Andrea Palladio, Villa Rotonda, near Vicenza, 1550–1

designing the façade from that della Porta faced with Il Gesù. His solution (fig. 280) was also derived from Alberti, from the temple front at Rimini, but Palladio combined two temple fronts, a wide horizontal one rising from the aisles and a steeply vertical one masking the nave. By thrusting the giant columns of the central block sharply forward, Palladio gave the façade a typically Mannerist sense of motion.

Inside San Giorgio Maggiore hangs a *Last Supper* by Jacopo Tintoretto (1518–84). Just as the High Renaissance forms of Bramante's architecture and Leonardo's *Last Supper* complement each other at Santa Maria delle Grazie as a statement of the High Renaissance, so the architecture of Palladio and the painting by Tintoretto (fig. 286) work together as a summation of Mannerist stylishness and drama. Yet the architect and the painter approached this effect from opposite poles; the white interior of the church is brightly lit, revealing its architectural structure clearly, while in the painting individual forms are deliberately obscured in dark shadow. Tintoretto painted in a violently sensational mode that carried Titian's dramatic force to the point of bursting the confines of the picture space. His *Last Supper* is the opposite of Leonardo's in its manner of conveying drama and emotion. Leonardo's painting is architecturally composed; the table is horizontally set across the picture space, and Christ is precisely in the centre. Motion is perfectly balanced by stability. In Tintoretto's version, the whole room is in motion. The tables recede sharply on the diagonal, the figures are radically foreshortened, and the whole picture plunged into violent contrasts of dark and light. Christ would be hard to locate if it were not for the supernatural aureole of light blazing around him. Whereas Leonardo had lit his painting with the natural light of day, Tintoretto plunged his room in darkness in order to light it with the unearthly glow of the oil lamp, whose smoke turns into shadowy cherubs. The exaggerated chiaroscuro and the jerky, unconnected lines of motion create a highly dramatized sense of excitement that represents the romantic, sensational side of Mannerist art.

Mannerism in Northern Europe and Spain

Mannerism was the first Renaissance style to make a widespread impression on late Gothic art and architecture north of the Alps. It was adopted, on the whole, as a superficial classicism that redirected painting and sculpture from religious to mythological subjects and changed architectural decoration from cusps and quatrefoils to classical ornament, all still within the clutter and intricacy of the Gothic style. Mannerism caught on as a novelty, with precisely the appeal International Gothic had exercised, that of something sophisticated and stylish. Princely patrons imported Italian artists or artists trained in the Italian style to show off their modernity, and in each case the style was modified by local taste and

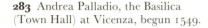

283 Andrea Palladio, the Basilica (Town Hall) at Vicenza, begun 1549.

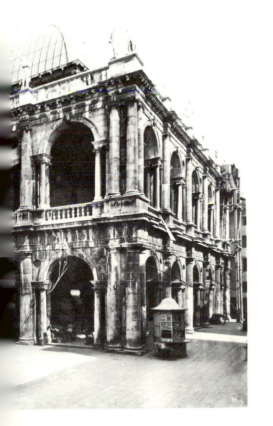

tradition. Even in Italy it was a collection of individual modes loosely united by a common treatment of High Renaissance space and form; in the North the situation was further complicated by the separation of Catholic and Protestant states.

The first country to import Italian art enthusiastically was France, and the speed with which the Renaissance was adopted there was largely due to the taste and energy of Francis I, whose appreciation of the High Renaissance we have already seen. The king's vast building programme, which provided employment for so many artists, was motivated by his determination to control the French nobility; it was he who first realized the benefits of keeping the whole court under one roof, where he could watch over them. His centralization of authority furthered the spread of the Italian style in France and made France a main centre for the diffusion of Mannerism throughout the North.

The artistic centre of France under Francis I was Fontainebleau, near Paris, the most ambitious of the king's new châteaux. Here two gifted Italian Mannerists were in charge: Rosso and a pupil of Giulio Romano's named Francesco Primaticcio (1504–70), who had worked on the Palazzo del Tè. Rosso and Primaticcio brought to France the Mannerist distortion of perspective and proportion. The influence of the Palazzo Ducale (fig. 270) is seen in the illusionistic wit of Primaticcio's grotto at Fontainebleau, where rough-hewn giants half emerge from a heavily rusticated arcade (fig. 285). The illusionistic bravura of Giulio's interior decorations at Mantua are also behind the elaborate and deliberately confusing decorative scheme at Fontainebleau. Large stucco frames, covered with figures, animals, and floral garlands, surround paintings much smaller and less visible than the frames (fig. 287). Primaticcio's disproportionately long-legged figures emerge almost as free-standing statues, holding up strips of plaster made to look like bands of leather, a decorative device called strapwork.

Mannerism in the court of Francis I was a style devoted to luxury and sophistication; no distinction was made between fine art and household furnishings. Objects of daily (if not quite ordinary) life were produced with the same painstaking skill and design as large-scale works of art. The Florentine goldsmith Benvenuto Cellini (1500–71) fashioned a gold and enamel salt cellar for Francis I that was as elaborately conceived as any of Cellini's statues (fig. 292). The symbolism is elaborate and the figures elongated and set off balance; they seem to be sliding off their pedestals in the same manner as Michelangelo's statues in the Medici chapel. Neptune, seated by the salt that comes from the sea, and Earth, who guards the pepper that grows on land, lean back at an impossible angle, their legs intertwined. In his *Autobiography*, a fascinating mixture of self-advertisement and information about the times, Cellini tells us that this is 'in the same way as certain long branches of sea cut into the land'. The elaborate conception and ornamental virtuosity of this work raise it above the level

284 Philibert de l'Orme, gateway, Château d'Anet, 1552

285 Francesco Primaticcio, Grotte des Pins (Grotto of the Pines), c. 1543. Château of Fontainebleau, Paris (photo Anthony Blunt)

286 Tintoretto, *Last Supper*, 1592–4. Oil on canvas, 146 × 227 in (365 × 568 cm). Venice, San Giorgio Maggiore

287 Francesco Primaticcio, Bedroom of the Duchesse d'Étampes, Château of Fontainebleau, c. 1541–5

288 Jean Cousin, *Eva Prima Pandora*, c. 1550. Oil on canvas, 39 × 59 in (97.5 × 150 cm). Paris, Louvre
The title refers to Eve as the Classical Pandora who let trouble into the world.

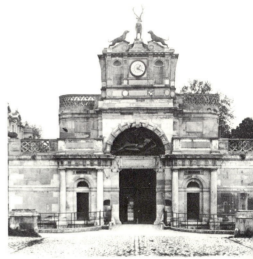

284

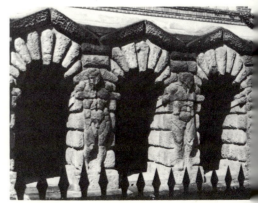

285

286

287

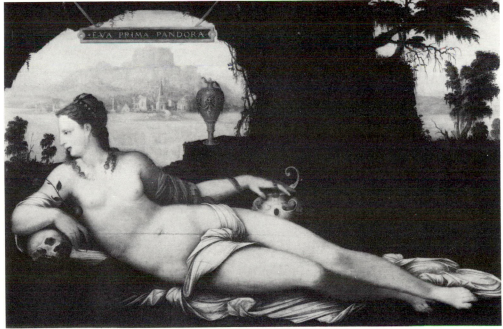

288

of a mundane condiment-holder. Since Mannerism is an illusionistic style and distorts natural relationships, it is a fundamentally Mannerist act to render a functional household item with all the high-flown symbolism employed in the major arts.

The presence of the Italians working for Francis I stimulated French artists to emulate the Mannerist style. It was Cellini's statue of Diana that filled the shell-shaped niche over the gateway of a château belonging to the mistress of King Henry II, Diane de Poitiers, but the gateway itself (fig. 284) was designed by the French architect Philibert de l'Orme (c. 1510–70). It shows the native inventiveness of de l'Orme in adapting rather than copying Italian classicism. Strictly speaking, it is classical only in its Doric columns and the half-shell niche. But it is not at all Gothic; its terraced blocks rise in horizontal symmetry to the central pediment. Here the treatment was particularly original; the stag and hounds associated with Diana surmount a clock and revolve with the striking of the hours.

The deliberately discordant elements of Mannerist art were more easily assimilated than High Renaissance naturalism. Jean Cousin (c. 1490–1560) painted *Eva Prima Pandora* (fig. 288) with the attenuated grace of Primaticcio's stucco figures. Eve reclines in the same pose as Titian's *Venus of Urbino* (fig. 248), but without her relaxed posture and direct, impelling gaze. Titian's Venus is a frank and natural sensualist; Cousin's Eve shows her bad conscience by looking away from us. Her hand touches not a bouquet of roses but a human skull, symbolizing the mortality her sin brought to mankind.

The atmosphere of chill uneasiness is evident also in a painting by François Clouet (before 1510–1572), which shows a lady of the court, possibly King Charles IX's mistress Marie Touchet, posed as Venus bathing. This was a popular Classical subject; Praxiteles' Aphrodite (Venus) of Cnidos (fig. 28) is shown just emerging from her bath; in the background of Titian's *Venus of Urbino*, servants gather clothes, preparing to dress her. But Clouet's version of the theme hovers disconcertingly between the real and the imaginary; the lady is so stiffly posed, and her hair so carefully dressed, she appears to be in the midst of a formal court function. (fig. 293).

Outside France, the lack of a centralized source of patronage on the scale practised by Francis I prevented the degree of stylistic coordination that emanated from the school of Fontainebleau. Elsewhere court patronage did more to inhibit the development of native talent and originality than otherwise. In England during the reign of Elizabeth the court exercised a strong influence over the development of poetry and drama, but had less effect on art and architecture. Elizabeth held the opposite view from Francis I on maintaining her courtiers; she preferred to descend on her subjects, to be entertained at their expense, rather than house them with her own purse. So there was very little in the way of royal building and decorating in this period, but a rapid development of the country

289 Albrecht Altdorfer, *Landscape with Church, c.* 1520. Watercolour, 8 × 5⅜ in (20 × 13.6 cm). Formerly Rotterdam, Museum Boymans van Beuningen, destroyed in World War II.
Altdorfer was one of a group of artists labelled 'the Danube School', who painted in the Alpine region of the Danube and who developed a romantic yet natural and localized treatment of nature typified by this watercolour and by the landscape background of figure 251.

290

291

290 Lucas Cranach, *The Judgement of Paris*, 1530. Oil on canvas, $13\frac{3}{4} \times 9\frac{1}{2}$ in (35×24 cm). Karlsruhe, Staatliche Kunsthalle

291 Robert Smithson (?), Longleat House, Wiltshire, 1547–80

292 Benvenuto Cellini, salt cellar of Francis I, 1539–43. Gold and enamel on an ebony base, $10\frac{1}{4} \times 13\frac{1}{8}$ in (26×33.3 cm). Vienna, Kunsthistorisches Museum

293 François Clouet, *Lady in her Bath*, c. 1570. Oil on panel, $36\frac{1}{4} \times 32$ in (92×81 cm). Washington D.C., National Gallery

292

293

houses built or remodelled by her ministers to accommodate these royal visitations. Thus the style of Tudor architecture developed in private houses like Longleat (fig. 291). The Tudor style is recognizably Gothic, but with a new symmetry and classicism in the decorative elements. At Longleat there is a strong accent on horizontality; the three storeys are sharply divided, with no vertical elements binding them together. The classical pilasters and oculi of inlaid marble decorate Gothic bays that protrude from the façade as obtrusively as the giant columns thrust forward in Palladio's façades.

In painting, too, Mannerist elements modified the Gothic traditions. Elizabeth preferred miniature portraiture, a jewel-like art descended from manuscript painting. Her favourite artist was Nicholas Hilliard (*c.* 1547–1619), a goldsmith by training, whose style is closely related to the delicate linear detail and colouring of International Gothic. Yet Hilliard was admired and extravagantly compared to Raphael by Richard Haydocke, an Englishman of classical taste who influenced the course of English art by translating the treatise on painting of an Italian Mannerist named Lomazzo. For all its archaic Gothicism, Hilliard's tiny *Young Man with Roses* (fig. 294) has much in common with large-scale Mannerist portraits in its sophisticated pastoral charm and its deliberate defiance of perspective. The young man's figure is elongated and set in an exaggeratedly graceful pose, while the briars of the eglantine rose grow so as to form a pretty and decorative pattern against his slender legs. In its worldly sophistication, it is the painted counterpart of the courtly pastoral poetry of the Elizabethan poets. The rose was the symbol of Queen Elizabeth, and the portrait may well be that of her favourite, Robert, Earl of Essex.

Expressive originality in painting was not much favoured by the aristocracy in Northern Europe, and the most original northern Mannerist art developed outside the influence of court patronage. The stifling effect of trying to please a prince's taste is seen in the career of Lucas Cranach, who left behind him the humanism of his High Renaissance portrait style when he found employment with the elector of Saxony and began producing works like *The Judgement of Paris* (fig. 290). The three goddesses, from whom Paris is to choose the most beautiful, are posed as the three Graces (see fig. 33), but these sixteenth-century German court beauties are self-consciously naked, without a hair out of place; one even wears a fashionable cartwheel hat, leaving us to wonder what they have done with the rest of their clothes. Paris, a fat Saxon knight, seems hardly worth the contest. Only the landscape escapes the courtly triviality; reminiscent of the picturesque setting behind Johannes Cuspinian (fig. 251), this is a pleasant fusion of Flemish and Italian traditions.

This mixture of Flemish space and detail and the softer light of Venetian landscape formed a new mode of landscape painting in the work of the Bavarian artist Albrecht Altdorfer (*c.* 1480–1538). Although Altdorfer worked for a number of aristocratic patrons, including the Emperor

294 Nicholas Hilliard, *Young Man with Roses*, *c.* 1588. Parchment, 5⅜ × 2¾ in (13.7 × 7 cm). London, Victoria and Albert Museum

295 Juan Bautista de Herrera, Church of the Escorial, Madrid, 1563–82 Herrera completed the work begun by his predecessor, Juan Bautista de Toledo, who died in 1567.

Maximilian, he achieved a marked degree of individuality and personal expression in his treatment of landscape. His *Landscape with a Church* (fig. 289) shows a striking attitude towards landscape as a subject in itself, unrelated to a human story. His forms are animated by a pantheistic spirit that foreshadows the Romantic movement of the nineteenth century. The sharp, scraggy pine trees thrust upwards across the mountainous countryside almost like a row of crosses. The painting is bathed in the eerie golden light of the setting sun.

A strong feeling for landscape dominates the work of another highly original artist, the Netherlander Pieter Bruegel (1525–69). Although Bruegel travelled to Italy between 1551 and 1555, he was little affected by Italian art; he was, however, stimulated by the scenery, particularly of the Alps, which he passed through. The influence of Bosch was very strong on his art; some of his works are filled with the grotesque images of the older master, but in Bruegel's painting there is a rationalism and an affection for his fellow men conspicuously absent from Bosch. From Mannerist art Bruegel absorbed the trick of composing space along diagonal lines and shifting planes to achieve a sense of space and distance, which we see in two scenes from a sequence based on the tradition of the Labours of the Months.

In both figures 296 and 298 Bruegel's debt to the Limbourg brothers is obvious, but he went far beyond the illustrators of the *Très Riches Heures* (fig. 171) in creating a feeling for the relationship between his figures and their landscape setting. Bruegel's peasants are at home in the natural world, not struggling with it. We can feel the cold of the winter light on the snow in his January scene (fig. 296) as clearly as in the earlier calendar. But the cold is no longer a menace; the hunters are well bundled up, and in the middle distance we see figures skating and enjoying winter life.

Genre painting, popular in the seventeenth and eighteenth centuries, features scenes from lower-class life, and really began with Bruegel's affectionate and humorous treatment of peasants in works like *The Harvest*, his illustration for August (fig. 298). The peasants are enjoying their lunch and a nap after a morning's labour harvesting the wheat. The glorious, warm sunlight shimmers on the grain, but this poetic beauty is played off against the solid figure uninhibitedly sprawled in slumber, whose companions are still enjoying their meal. These are not the romantic rustics of pastoral poetry and painting; they are the ones who brought in the harvest.

A less naturalistic, more visionary style of Mannerism is seen in the work of a Greek artist, Domenikos Theotokopoulos, better known as El Greco (1541–1614). El Greco reached his mature style in the heart of Counter-Reformation Spain, where artistic patronage emanated from the court of Philip II. Philip, an ardent Catholic, launched the Armada against Protestant England and subdued the rebellious Netherlanders with savage force. He was also Titian's last patron and acquired from him some of the Venetian master's most erotic mythological paintings. But his artistic

296

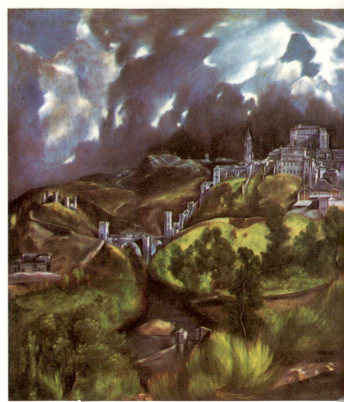

297

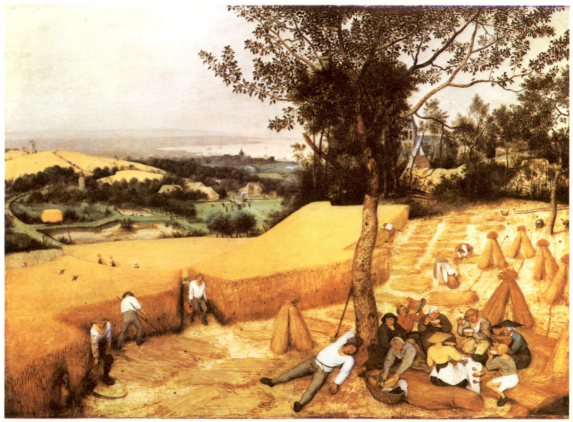

298

patronage was primarily directed towards the palace he built not far from Madrid to house his entire court, in the manner of Francis I at Fontainebleau. The Escorial, also built to house a monastery and a mausoleum for Philip's father, the emperor Charles V, is a vast Mannerist complex. Its plans were checked by Vasari's Academy of Design in Florence, and for the palace church Philip solicited plans from several Italian architects, including Palladio, and then had Vignola combine the various designs into one 'ideal' plan. This was in the end rejected, but the existing church (fig. 295) by Juan de Herrera (1530–97) owes its form to Vignola's Il Gesù.

Against this dominant Italian influence, El Greco was unsuccessful in gaining commissions from the court of King Philip, for his style was highly personal, influenced by the artistic experiences of his youth. A Greek born in the Venetian-governed island of Crete, he had learned the Byzantine style before coming to Venice, where he may have been a pupil of Titian. A comparison of El Greco's *Assumption of the Virgin* (fig. 299) with Titian's (fig. 250) shows both how much he borrowed from Titian and how far he moved away from Renaissance solidity. Titian's drama is contained within the picture space, but in El Greco's composition the Virgin's rising is not countered by a downward force, and she is on the point of shooting out of the picture altogether. Although she is as substantial a figure as Titian's Virgin, we see her at an angle that reduces the feeling of weight and solidity. A particularly Mannerist element in El Greco's work is the way in which he bent his figures into odd angles for dramatic effect, catching them in suspended motion. Although neither painting has a detailed background, Titian's gives a sense of opening back to a natural and limited space, whereas El Greco's takes place at the front of the picture space and opens back to a limitless void behind.

El Greco's Mannerism was unique; in fact it was so different from any other artist's that its idiosyncracies have been attributed to madness and even to astigmatism. The emotional vibrancy he invested in his figures outweighs their human substance; in the end his works became ethereal and ghostly. His portrait of Cardinal Guevara, the Grand Inquisitor and most dreaded man in Spain (fig. 300), makes a stunning contrast to the portraits of Luther and Erasmus painted by Cranach and Holbein (figs. 262 and 264). The energy and personality of these two reformers were seen in wholly human terms, but El Greco penetrates the physical exterior of his sitter to show his fanatical soul through burning eyes that curiously slide away and refuse to meet the viewer's gaze.

El Greco was the most romantic and the least classical of the great Mannerists. Near the end of his life he painted a pure landscape, a view of Toledo (fig. 297), from which he banished human life altogether. El Greco's city takes on the shapes of nature in an expression of supernatural power even more expressive than Altdorfer's watercolour (fig. 289). The ghostly city merges into the lurid, cloud-swept sky and the ominous hillside; this seems no place for human habitation.

By the end of the sixteenth century, the originality of El Greco's vision stood alone in Mannerist art, for the style had lost its earlier force and shock value and had run into a dry and academic vein summed up by the theoreticians' argument that beauty was a quality innate in the mind, not something to be learned from nature. The seventeenth century found its expression not in mannered abstractions but in the worldly and material glory of the Baroque.

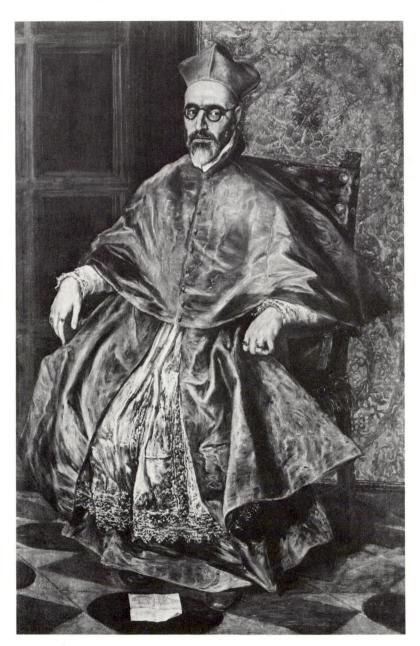

300 El Greco, *The Grand Inquisitor Cardinal Don Fernando Nino de Guevara*, 1596–1600. Oil on canvas, 67¾ × 42½ in (171 × 108 cm). New York, Metropolitan Museum of Art

CHAPTER 10

Art of the Absolute: The Baroque

The term *Baroque* was first applied to architecture, but the style originated as a consciously new direction in painting; it was a reaction against late Mannerism and a deliberate return to the classical naturalism of the High Renaissance, in a more dynamic mode. The name, which may come from its curving, irregular line, has come to mean something over-loaded and overdone. Because this style has much in common with the late phases of other styles, when the display of virtuosity and complexity replaces earlier clarity, its name has become an adjective often applied to the tail end of other periods.

Seen in this light, Baroque art was the ultimate phase of the Renaissance, sharing the same attitude towards Classical art but aiming at a more violent and romantic effect. Just as late Greek art bent the classic style of Praxiteles to the expressive, convoluted lines of the Laocoön (figs. 2 and 6), so Baroque art set the stable forms of Raphael and Bramante into a turbulence of perpetual motion; the Renaissance conquest of three-dimensional space developed into an illusion of an infinitely expanding universe, although still within the boundaries of the picture space. But even more markedly than Mannerism, the Baroque was a style in itself, one that spread through most of Europe and to its new dominions overseas, and flourished for over 100 years. In Mannerism the connections between art, music, and literature were tenuous and superficial; in the Baroque period there was a fundamental relationship between all the arts. It is more misleading than enlightening to see connections between the discoveries of Galileo and Copernicus and the Mannerist distortions of Renaissance perspective, but the new knowledge of planetary systems had a real influence on the Baroque attitude towards space (see fig. 313). The enormous advances made in science and medicine during the seventeenth century concurred with a flowering in music, literature, drama, and the visual arts.

The chiaroscuro of the age was even more dramatic than the contrasts

of the High Renaissance. Civil feuds were inextricably tied to religious struggles between Protestant and Catholic forces. At stake in the conflict between the Huguenots and Catholics in France, in the bitter struggle of the Netherlands to win freedom from Spanish rule, and in the Thirty Years War that racked Germany and Austria, was not only religious toleration but the political balance of power in Europe. In England, the war between the Stuarts, asserting the divine right of kings, and Parliament was a political as well as a religious conflict; both sides were aided by other powers seeking their own diplomatic advantage.

It was an age that could put its faith in scientific experimentation and empirical observation, yet still burned witches; the invention of the telescope led to new discoveries in astronomy without displacing belief in astrology and magic. So it should not surprise us to find the same violent contrasts in art, reflecting a wide range of society, from the apotheosis of Kings to realistic portraits of beggars and drunkards.

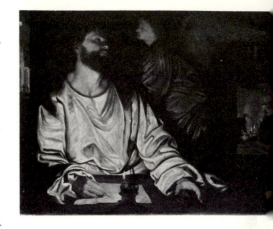

301 Giovanni Girolamo Savoldo, *Saint Matthew and the Angel, c.* 1535. Oil on canvas, 36¾ × 49 in (93.3 × 124.5 cm). New York, Metropolitan Museum of Art

Beginnings in Counter-Reformation Rome

The Baroque style first appeared in Italy under the aegis of the Counter-Reformation. Here, in the sessions of the Council of Trent, the Catholic Church legislated drastic internal reforms; by 1563, the Counter-Reformation ceased to be on the defensive and became a dynamic movement led by vigorous and fervent reformers like Teresa of Avila, Ignatius Loyola, and Charles Borromeo, nephew of Pope Pius IV. All three were canonized in the next century. Although the Council tightened ecclesiastical control over religious art, it also strengthened the role that art and architecture could play in arousing emotion and in attracting attention. In using the arts as a means of persuading the faithful by appealing to the senses, the Roman Catholic Church was deliberately countering the Protestant rejection of religious imagery. The sheer number of new commissions this policy fostered encouraged artistic achievement; their scale required a new treatment of space and an emphasis on sensationalism that developed concurrently as a reaction to Mannerist disharmony.

The first stages towards the new style appeared in the work of two painters who came to Rome in the last decade of the sixteenth century. Michelangelo Merisi da Caravaggio (1573–1610) and Annibale Carracci (1560–1609) differed widely in temperament and outlook but shared a determination to restore to painting classical balance and naturalistic treatment of figures in space.

Caravaggio was particularly concerned with naturalistic effects of light and shadow, heightened to induce emotion, but without supernatural personages such as Tintoretto's smoky cherubs (fig. 286). He was influenced by High Renaissance works like Girolamo Savoldo's *Saint Matthew* (fig. 301), in which a single oil lamp highlights the Evangelist's

302 (*top right*) Caravaggio, *The Conversion of Saint Paul*, 1600–1. Oil on canvas, 90½ × 69 in (230 × 175 cm). Rome, Santa Maria del Popolo

303 (*bottom right*) Caravaggio, *Death of the Virgin, c.* 1605–7. Oil on canvas, 145¾ × 96¾ in (369 × 245 cm). Paris, Louvre

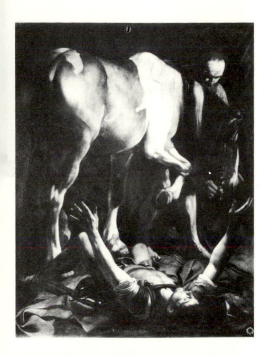

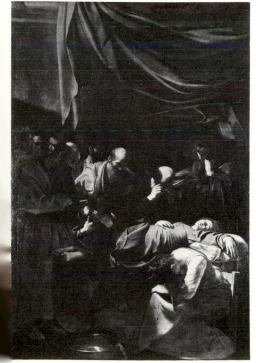

torso and face but leaves his eyes in shadow, allowing the angel to dissolve ethereally into the murky darkness behind the saint. In his *Conversion of Saint Paul* (fig. 302) Caravaggio used the same natural heightening of chiaroscuro to suggest supernatural vision without recourse to symbols. His painting is starkly simple in its composition, illuminated in a brilliant contrast of light and shadow. He set his few figures at sharp angles across the canvas; the sturdy horse fills most of the space, and the saint lies head towards us, radically foreshortened, his face hidden from our view. Despite the sharp angularity of the composition, no line leads outside the picture space; the eye circles around the centre. Caravaggio simplified the composition to dramatize the impact of Saint Paul's vision by the use of chiaroscuro rather than by a multitude of figures; the miraculous nature of the incident is emphasized by the helpless paralysis of the saint and also by the natural puzzlement of his horse and servant at their master's strange behaviour.

In works like this Caravaggio established a new standard of realism in painting and redirected art to the human focus lost in Mannerism. He used the Mannerist trick of bringing figures close to the front of the picture space and heightened the emotional impact through exaggerated chiaroscuro, but it is the ordinary humanness of his people that brings us so sharply into his world. Caravaggio's realism received instant notice and approval in Rome, but he outraged ecclesiastical decorum when he included lower-class models in religious works with no intermediate veil of idealization to soften the impact. In *The Death of the Virgin* (fig. 303) he portrayed her pitifully swollen body with such realism that it was said he had used the corpse of a prostitute drowned in the River Tiber as his model. Its lack of decorum and idealizing grace so offended the clergy who had commissioned it as an altarpiece that they refused to accept it. But there were other artists in Rome who were influenced by Caravaggio's realism. It was Peter Paul Rubens (see below, p. 252) who persuaded his patron, the Duke of Mantua, to buy the rejected *Death of the Virgin*. After the impact of Caravaggio, the term *realistic* came to mean something different from the Classical imitation of nature. Before Caravaggio, Classical art provided the authoritative model of realistic forms, but the un-idealizing, down-to-earth treatment of humble people that originated with Caravaggio eventually came to separate realism from the Classical *mimetic* tradition, which imitated nature through the rearranging intellect of the artist.

In Caravaggio's lifetime, however, the mimetic tradition and its careful reordering of nature to establish harmony and order was given a new vitality by his contemporary, Annibale Carracci. Annibale was one of a family of painters from Bologna who were concerned with establishing an ideal style out of the various elements of Classical and Renaissance models and who established an academy in Bologna to teach theory as well as practical technique. Thus Annibale took a more classical, idealizing,

direction than Caravaggio but he too was drawn to the most dramatic side of High Renaissance art as his point of departure. He was especially influenced by Antonio Correggio (*c.* 1489–1534), a painter who combined a sfumato derived from Leonardo with the soft, sensuous forms of Titian. Correggio explored the illusionist techniques of opening a ceiling to the sky; his figures, although solidly constructed, float freely upwards in a spiral through an apparently infinite space (fig. 308). This illusionistic bravura, which mixes corporeal forms with frankly fantastic illusions of space, is so unlike the rest of the High Renaissance — and so close to high Baroque painting — that Correggio has been labelled proto-Baroque.

Carracci based his *Coronation of the Virgin* (fig. 304) on a fresco, since destroyed, that Correggio had painted in the apse of a small church in Parma. In his own version, he drew on Correggio's arrangement of figures in space and repeated the natural curve of the apse. The composition is symmetrically balanced, but the stage formed by the semicircle of clouds is radically tilted, its concavity exaggerated so that the heavenly host melt into the distance. Below the seated figures a glimpse of space opens like a door to give the impression of infinite recession; the concave space is widened as if with the wide-angle lens of a camera to capture a wider and deeper horizon than the eye could normally see. In this we have what was to become the main concern of Baroque painting; since the basic problem of simulating a three-dimensional space had been solved in the High Renaissance, Baroque artists refined the problem to aim at an illusion of infinitely vast space that defies altogether the limitations of picture space while still appearing to remain within the defined boundaries of natural vision.

Space that recedes into an apparently infinite distance yet has visible boundaries is also an element natural to landscape painting. Drawing on the elegiac landscapes of Giorgione and Titian as well as on the atmospheric distances of Flemish painting, Annibale Carracci developed a type of landscape painting that existed for its own beauty rather than just as a background or setting of mood. Such landscapes had been painted before, by Giorgione and Altdorfer, for example, but with a more romantic feeling for the power of nature. Carracci's scenes combined the Classical pastoral tradition with a contemporary feeling for the charm of unspoilt countryside. In works such as his *Flight into Egypt* (fig. 307) he worked out his ideal of a landscape by choosing elements of composition as carefully as a poet chooses diction and phrasing. The landscape depends on figures to balance the receding planes, but the story itself is incidental. The countryside blends back in a misty glow that keeps us from seeing how carefully he built up the composition in three stages, directing the eye to the temple that dominates the middle ground. This elegiac, ordered, but seemingly natural style of landscape established a new and important branch of classical painting that was to flourish within the Baroque period.

Baroque painting developed out of the drama and realism of Cara-

304 Annibale Carracci, *Coronation of the Virgin*, *c.* 1595. Oil on canvas, 46½ × 56 in (118 × 142 cm). New York, Metropolitan Museum of Art

305 Carlo Maderna, façade, Santa Susanna, Rome, 1597–1603

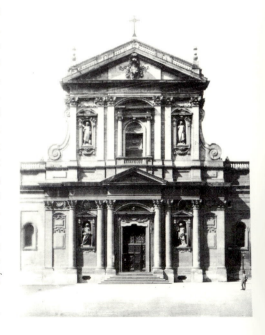

CHART 5 LATE RENAISSANCE: THE BAROQUE AGE 1590—1750

EVENTS		ART AND CULTURE
		1593 Founding of the Academy of St Luke, Rome
		c. 1595 Carracci, *Coronation of the Virgin*
1598 Edict of Nantes grants religious freedom to Protestant Huguenots in France		1597-1603 Maderna, Santa Susanna
	1600	1600-1 Caravaggio, *Conversion of St Paul*
1603-25 James I king of England		1605-6 Cervantes, *Don Quixote*
1607 Settlement of Jamestown, Virginia		
1610 King Henry IV of France assassinated		1619-22 Inigo Jones, Whitehall Banqueting House
		1621-3 Guercino, *Aurora*
1623 Urban VIII becomes pope		1623 Hals, *Yonker Ramp and his Sweetheart*
	1625	1623 Bernini, *David*
1633 Galileo condemned for heresy		1633-9 Cortona, ceiling of the Palazzo Barberini
		c. 1635 Van Dyck, *Portrait of Charles I*
1636 Harvard College, Cambridge, Mass. founded		1636 Rubens, *Landscape with the Château of Steen*
1642 Beginning of the English Civil War		1642 Rembrandt, *The Night Watch*
1642 Death of Richelieu		1642 Death of Galileo
1643-1715 Reign of Louis XIV of France		
1648 End of Thirty Years War between the European Powers; the Netherlands become independent		1648 Founding of the French Academy of Art
		1648 Poussin, *The Ashes of Phocion*
1649 Execution of King Charles I		Claude, *The Mill*
1649-60 Commonwealth period under Cromwell	1650	
		1656 Velázquez, *Las Meniñas*
		1656-67 Bernini, Colonnade in St Peter's Square, Rome
1660 Restoration of Charles II as king of England		
1666 Great Fire of London		c. 1662 Vermeer, *Young Woman with Water Jug*
		1667 Milton's *Paradise Lost* published
		1667 Borromini, San Carlo alle Quattro Fontane
		1668 Palace at Versailles begun
		1673 Death of Molière
	1675	1675-1710 Wren, St Paul's Cathedral
		1677 Death of Spinoza
		1684 Death of Corneille
1685 Revocation of Edict of Nantes; persecution of French Huguenots		
1685-8 Reign of James II		
1690 Accession of William and Mary to English throne		
	1700	1699 Death of Racine
		1702 Melk Abbey Church
		1704 Newton, *Opticks*
1703 Duke of Marlborough defeats French at Battle of Blenheim		1705 Vanburgh and Hawkesmoor begin work on Blenheim Palace
1713 Treaty of Utrecht establishes peace between France, Britain, Holland, Savoy, and Portugal		
	1725	c. 1725 Vivaldi, *The Four Seasons*
	1750	1745 Canaletto, *Bacino di S. Marco*
		1751-2 Tiepolo's ceiling in Bishop's Palace, Würzburg

vaggio and the idealism of Carracci, as a conscious reaction against Mannerist disjunctions and anti-classicism. In architecture we see less of a deliberate break in style, but we find a shift from dispersion of mass to a centripetal concentration such as also occurs in Baroque painting and sculpture. Carlo Maderna (1556–1629) based his façade of the church of Santa Susanna in Rome (fig. 305) on that of Il Gesù (fig. 279), but it establishes a very different sense of motion. Della Porta had broken the flat surface of the wall at Il Gesù by moving its blocks alternately backwards and forwards in a pulsing motion. Maderna also broke the entablature at Santa Susanna, but here the blocks move progressively forwards as they approach the centre, drawing motion from the outside to the central portal. This direction is emphasized by the articulation of the decorative members, which progress from flat pilasters on the outside to engaged columns to the free columns framing the doorway. The articulation of the upper storey is greater at Santa Susanna; the whole effect is more harmonious and more pronounced than that of Il Gesù.

Illusionism and Theatricality: High Baroque

Maderna also designed the nave and façade of St. Peter's, in which he was somewhat hampered by having to adhere as much as possible to previous designs. His attempt to concentrate mass in a centripetal rhythm was achieved half a century later in the high Baroque colonnade of Gianlorenzo Bernini (1598–1680). This dramatic, sculptural form sweeps around the piazza, reaching out to embrace space and mould it into a plastic entity as pronounced as the colonnade that surrounds it (fig. 306).

For all its Counter-Reformation roots, high Baroque was a worldly style. In 1623 Maffeo Barberini, a member of a wealthy and aristocratic Roman family, became Pope Urban VIII. Under Urban's extensive patronage, religious as well as secular themes found expression in a theatrical style dedicated to producing magnificent illusions that never pretended to be anything else, yet triumphed in the skill of their deceptions. The deliberate artifice of Baroque art connects it to Mannerism, but the Baroque was a style centred on the human actor, however glorified.

In the high Baroque, architecture, sculpture, and painting were fused into one art that also embraced town planning and landscape gardening to mould space with a sweep of sculptural architecture like Bernini's colonnade, to create drama with painterly sculpture (fig. 309), and to catch the spectator up in an infinitely expanding universe through architectural painting (see fig. 317). Bernini practised all three arts and had close connections with the stage; his Cornaro Chapel sculpture is typical of the age and of his sense of visual drama. Along the side walls of the chapel the Cornaro family sit in boxes watching the drama being enacted above the altar. The scene, theatrically 'lit' by golden rays, is the mystical revelation

306 Aerial view of St. Peter's Square, Rome, showing the façade of St. Peter's, designed by Carlo Maderna (1607–14), and the colonnade by Gianlorenzo Bernini (1656–67)

307 Annibale Carracci, *Landscape with the Flight into Egypt*, c. 1604. Oil on canvas, 48¼ × 90½ in (122 × 230 cm). Rome, Galleria Doria-Pamphili

308 Correggio, detail of the *Assumption of the Virgin*, 1526–8. Fresco, 36 × 39 ft (1093 × 1195 cm). Parma, Cathedral, interior of dome

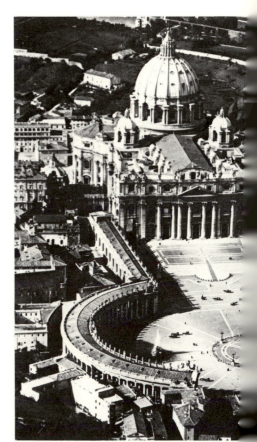

306

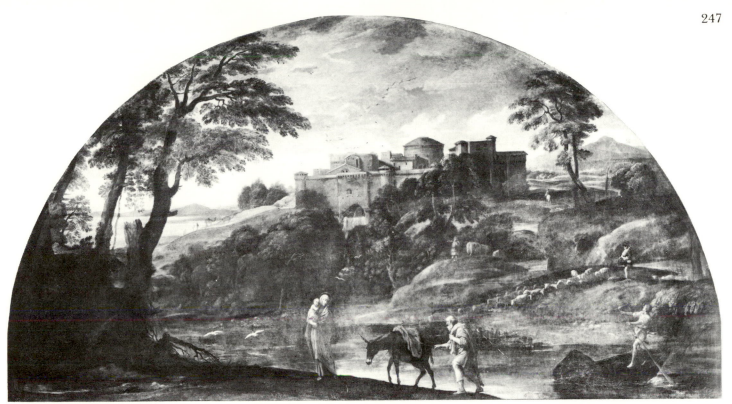

307

308

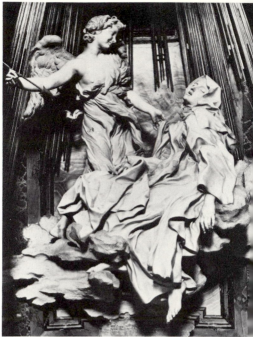

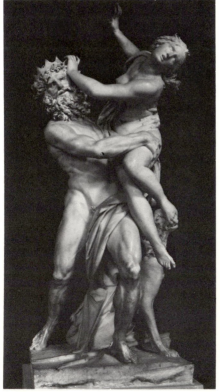

309 Gianlorenzo Bernini, Cornaro Chapel, 1645–52. Church of Santa Maria della Vittoria, Rome

310 Gianlorenzo Bernini, *The Ecstasy of Saint Teresa*, 1645–52. Marble, lifesize. Cornaro Chapel

311 Gianlorenzo Bernini, *The Rape of Proserpina*, 1621–2. Marble, over lifesize. Rome, Galleria Borghese

of Saint Teresa of Avila, who related a vision in which an angel repeatedly pierced her heart with a golden arrow (fig. 310). She is seen swooning in an ecstasy of surrender; the overpowering impact of divine love is expressed in the limp yet turbulent drapery enveloping all but her hands and bare feet.

Bernini combined the dramatic, dynamic rhythms of his compositions with a virtoso realism of detail close to Caravaggio. His sculpture has much of the immediacy of Caravaggio's painting and gives us a similar sense of something actually happening to a particular person. His subjects, like those of the Mannerists, were chosen for the challenge of difficult, struggling postures, but the effect is more convincingly dramatic. Compare his *Rape of Proserpina* (fig. 311) to Giovanni Bologna's *Rape of a Sabine* (fig. 277). The Mannerist work displays anatomical virtuosity more than it suggests a real situation. In Bernini's sculpture we feel the force of Proserpina's desperate shove against Pluto's head; his gripping hand leaves an imprint in her marble flesh.

Bernini was the Michelangelo of Baroque sculpture; it was his ability to combine astonishing realism in a marble surface with bold, active rhythms that established the norm of the style. In his *David* (fig. 312), we are plunged into the midst of violent action. Here the young hero is not shown as the victor; he is in the very act of launching the stone from his catapult at Goliath. So fiercely is this muscular young athlete concentrating on his enemy that if we stand in front of him we instinctively duck out of the way, for Bernini used his feeling for the relationship between actor and audience to imply the position of Goliath — right where we are standing.

The dynamic rhythms of Bernini's sculpture found echoes throughout the Baroque style. His own architecture was not as boldly illusionistic as that of his rival, Francesco Borromini (1599–1667), who explored the shifting effects of light striking alternating convex and concave surfaces to create highly original designs. For the little church of San Carlo alle Quattro Fontane (fig. 314), set in one corner of a crossroads, Borromini based his plan on an oval design. The corner of the church, with one of the crossroad's four fountains built into it, meets the street corner at an angle. The façade of the church ripples in an undulating play of concave and convex surfaces, richly decorated in both storeys. Inside, the ground-floor scheme of concave side bays and a straight central space rises to meet the oval dome (fig. 315), which comes down on pendentives to a massive, undulating entablature. The dome is so deeply coffered that it resembles a honeycomb and gives an illusion of depth and pulsing motion.

The Baroque desire to set space in motion in part reflects Copernican discoveries that removed earth from the centre of the universe and set the planets revolving around the sun. The Early and High Renaissance reflected the Ptolemaic system, which had put earth motionless in the centre of the universe. Mannerism set mass in motion but dispersed it centrifugally. Baroque art returned to the centre, but of a Copernican, not a Ptolemaic universe, and one which is in perpetual motion and asserts

312 Gianlorenzo Bernini, *David*, 1623–4. Marble, lifesize. Rome, Galleria Borghese

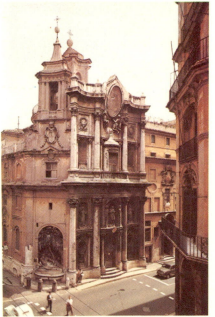

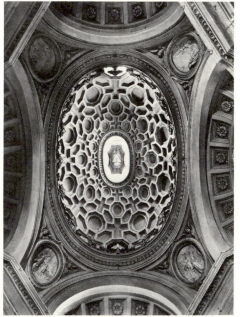

313 (*above*) Pietro da Cortona,
Glorification of the Barberini, 1633–9.
Fresco. Rome, Barberini Palace

314 (*far left*) Francesco Borromini,
façade of the church of San Carlo alle
Quattro Fontane, Rome, begun 1667

315 (*left*) San Carlo alle Quattro
Fontane, interior of dome

316 (*right*) Giovanni Battista Gaulli,
Triumph of the Name of Jesus, 1672–85.
Fresco. Rome, Il Gesù

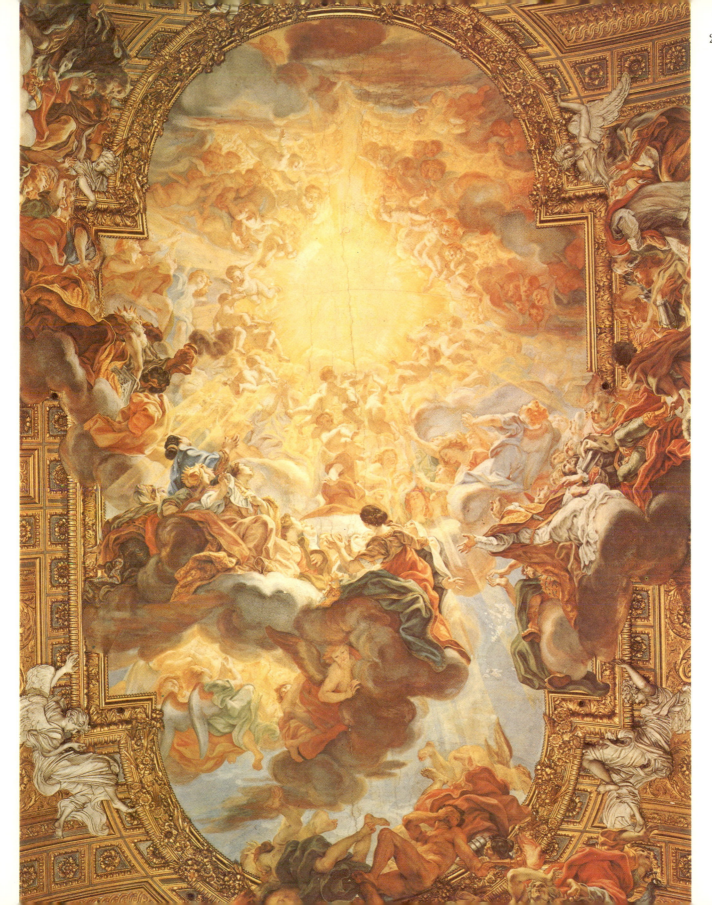

man's control over a dynamic, not a static universe. We find the most dramatic statements of this in Baroque decorative painting, and especially in the ceilings, where the confusion of boundaries and elements of Giulio Romano's Palazzo del Tè (fig. 268) was carried to new extremes.

In figure 317, Guercino (1591-1666), a Bolognese compatriot of of the Carracci, used the perspective of his painted architecture to seemingly open the ceiling to the sky; Aurora's chariot and horses thunder overhead, viewed from an oblique angle that adds to the sense of vertigo. From this trompe-l'oeil trick of perspective it was a logical step to the high Baroque ceiling of Pietro da Cortona (1596–1669) in the Palazzo Barberini (fig. 313). This was the family palace of Pope Urban VIII, and the fresco's subject, the glorification of the family through the elevation of one of its members to the papacy, was one that gave Cortona full scope in painting solidly human bodies floating freely in a dizzying perspective. Architecture, sculpture, and painting are all completely intermingled; it is all a painted illusion of apparently enormous height from which figures and clouds spill down out of the heavens to mix with figures and decorative details painted to appear as sculpture. In his late Baroque ceiling in Il Gesù, Giovanni Battista Gaulli (1639–1709) took a further step in illusionism; he used stucco clouds, painted as a continuation of the vault, to disguise the boundaries between vault and wall. These painted clouds are even more effective in creating an optical illusion, for they are reinforced by gilded shadows (fig. 316).

Such ceilings were at the most extravagantly dramatic pole of Baroque painting; they are an integral part of the space surrounding the spectator — and usually high overhead — so that the painted architecture succeeds in its deception; we believe in the simulated, not the real, limits of space. A canvas hung on a wall obviously can never deceive us in the same way, yet the dynamic bravura and motion of Cortona's ceiling is found in the painting of Peter Paul Rubens (1577–1640), not only in his decorative cycles (which influenced Cortona) but also in smaller works which — like Bernini's staging of *The Ecstasy of Saint Teresa* — engage us in a game where we willingly suspend disbelief. His *Lion and Tiger Hunt* (fig. 318) reflects the love of the exotic, as well as the desire to experience the thrill of danger, which led to aristocratic collections of wild animals such as the ones Rubens was using here as models.

Rubens, a Fleming, visited Rome at the turn of the century, when the new style was emerging. His Flemish talent for beautifully detailed brush strokes that could highlight separate curls of hair or the threads of a lace collar was combined with a flair for painting rapid, sweeping lines that enabled him to achieve the illusionistic and dynamic rhythms of the new style. He loved the dramatic idiom of Caravaggio and admired Annibale Carracci; his mature style also combines the muscular line of Michelangelo with the vibrant colours of Venetian painting. It was Rubens, the first non-Italian to paint in a fully Baroque style, who was paramount in spreading

317 (*above*) Guercino, *Aurora*, 1621–3. Fresco. Rome, Villa Ludovisi

318 (*below*) Peter Paul Rubens, *Lion and Tiger Hunt*, 1616. Oil on canvas, $100\frac{3}{4} \times 127\frac{1}{2}$ in (256 × 324 cm). Rennes, Musée des Beaux Arts

319 (*right*) Interior of the Whitehall Banqueting House, London (see below, fig. 339), showing the ceiling painted by Rubens, 1634. The central panel depicts the apotheosis (deification) of King James I of England

the style outside Italy. He received commissions from patrons in Italy, France, Spain, England, Flanders, and Germany; the *Lion and Tiger Hunt* was one of a series of hunt scenes painted for Duke Maximilian of Bavaria in which an improbable assortment of animals are portrayed in highly improbable struggles — in one a hippopotamus and a crocodile are attacked by deer hounds and riders — but all are rendered with such skill and observation that we can almost feel the soft fur of a tiger or the smooth flank of a horse. In Rubens's art the tactile quality inherited from Flemish traditions is never static; like Bernini's sculpture or Borromini's façades, his scenes are in constant motion. A wild tumble of movement circles clockwise in figure 318 to centre on the tiger who pulls a hapless rider from his rearing horse. The element of wild nature provides the thrill of a terror safely removed from being too real; the lack of struggle on the part of the tiger's victim suggests submission to forces beyond his control rather than a cruel and ugly death. For all the effect of perpetual motion, the next step in the drama is of no import; no matter that the soldier with the sword is on the point of cutting off his companion's arm, or that a tiger's newborn cubs are about to be trampled to death; the intention is in the surface movement, a colourful and continual dance of form and space.

The bravura of Bernini, Borromini, and Rubens represents the most romantic extreme attained in the four styles of the Renaissance. While these three artists all adhered to Classical models as the example of all that was finest in art, yet they were unclassical in the value they placed on emotional impact and dramatic effect. This side of Baroque art reflects the thinking of the period from Copernicus to Descartes and to Newton, when philosopher-scientists pursued the laws governing bodies in motion. Both philosophers and artists were suspended between old assumptions and the challenge of new ideas.

High Baroque as an International Style

Baroque art swept through Europe in the first half of the seventeenth century, concurrently with new advances in philosophy and the natural sciences. It was a period of nation states headed by monarchs wielding absolute power and believing in their divine right to rule; the worldly yet gloriously idealizing Baroque style seemed to convey the semi-deification of secular-minded kings. In England Charles I commissioned Rubens to paint the ceiling of the new Banqueting House at Whitehall, its central panel depicting the apotheosis of his father James I (fig. 319). In France, Rubens turned the life of Henri IV's prosaic queen Marie de' Medici into an exotic and spectacular mythology. In Germany the bold, dynamic rhythms finally swept away the tortuous lines of late Gothic, substituting one baroque style for another. In Spain and the Netherlands, two original native schools of painting grew from the influence of Italian painting,

especially that of Caravaggio. The exuberance of the style invaded all the arts; the combination of sharply etched detail and grand scale pervades the music, drama, and literature of the period.

The immense expansion of human knowledge in the seventeenth century was made possible by a high degree of technical craftsmanship; the advances made in astronomy would have been impossible without the steps made in contemporary optics and lens-grinding. Baroque music came to owe nearly as much to the still unsurpassed skill of the violin-makers of Cremona as to the genius of Vivaldi and Bach. These new advances were made across Europe, but the cultural centre was Rome, the necessary stopping place not only for artists but also for young noblemen completing their education with a Grand Tour. All through the Renaissance the aristocracy had been steadily replacing the Church as the source of patronage most influential on style. Wealthy aristocrats visited Italy repeatedly. Artists who attained the position of court painter to a wealthy prince were often sent to Italy on collecting trips, for already Leonardo, Raphael, and Titian were 'old masters', and a gallery full of Renaissance and Classical art was a necessary part of a wealthy nobleman's estate. Foreign artists passed through Rome in greater numbers than ever; a coveted goal was membership of the Academy of Saint Luke, founded in Rome in 1593 with the specific aim of enhancing the status and prestige of the artists admitted to it. The various currents of artistic development washed through Europe and back to the source, in the centripetal fashion of the style, to form a truly international art.

Realism and Baroque Painting in Spain and the Netherlands

In Spain the violent contrasts of light and shadow were especially evident. A miserably mismanaged government impoverished the countryside; despite the wealth coming in from America, Spain declined rapidly as a European power. Her arrogant assumption of leadership in the re-establishment of Catholic supremacy met with a series of reversals, the last and most expensive defeat resulting in the loss of the Netherlands. This long conflict began in 1579 with the union of the seven northern Dutch provinces under the leadership of Prince William of Orange; the struggle became intertwined with the Thirty Years War and its challenge to the Hapsburg dynasty. Peace came with the end of the Thirty Years War in 1648, and the Netherlands was recognized as an independent state. Yet despite these setbacks to Spanish dominance, this was also the golden age of Spanish literature and painting. The whole range of Spanish life, from the abject poverty of the peasants and their deep religious faith to the grandiose visions of past glory indulged in by the aristocracy, is mirrored in the plays of Calderón de la Barca and Lope de Vega, in Cervantes's *Don Quixote*, and in the paintings of Diego Velázquez (1599–1660). Picaresque

320 Diego de Velázquez, *Juan de Pareja*, 1650. Oil on canvas, 30 × 24¾ in (76 × 63 cm). New York, Metropolitan Museum of Art

321 Diego de Velázquez, *Las Meniñas (The Maids of Honour)*, 1656. Oil on canvas, 125¼ × 108⅝ in (318 × 276 cm). Madrid, Prado

322 Rembrandt van Rijn, *Belshazzar's Feast*, 1635 (?). Oil on canvas, 67 × 83½ in (167.5 × 209 cm). London, National Gallery

323 Diego de Velázquez, *The Drinkers (The Triumph of Bacchus)*, 1629. Oil on canvas, 65 × 88⅝ (165 × 225 cm). Madrid, Prado

320

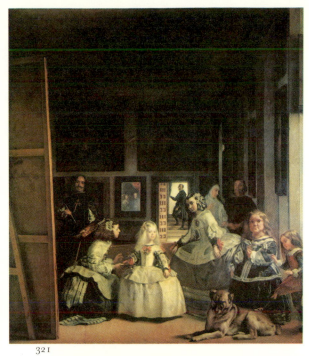

321

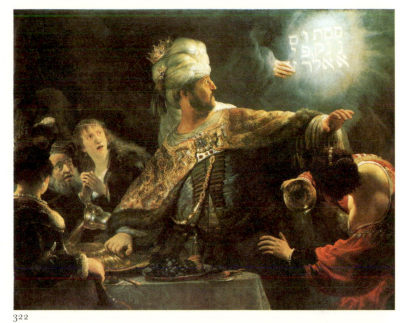

322

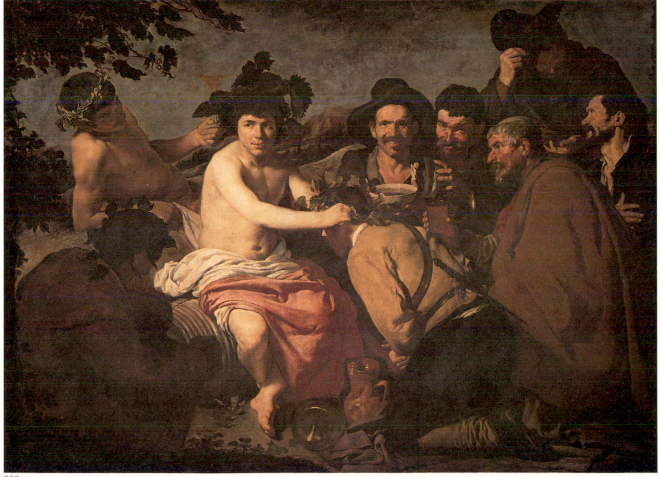

323

literature, which tells stories about rogues and thieves, and genre painting show us a new range of subjects, drawn from low life and portrayed with a sharp and vivid realism.

The influence of Caravaggio is evident in Velázquez's *The Drinkers* (fig. 323), where he portrayed a group of drunken villagers and a ragged, obsequious beggar in the company of Bacchus, the god of wine. The young god provides a romantic note of fantasy. But our eye is caught by the sharp realism of the seedy, sodden peasants, who face us with the impact of their presence; no sentimentalizing or moralizing mediates between us. These are the same half-attractive, always human rogues who tease and torment Don Quixote.

From his two trips to Italy, the first in 1629, Velázquez learned the Baroque style of composing picture space on tilted diagonal lines and extending the background into deep shadows or a far-distant horizon. He used Baroque techniques of composition to enliven the formal paintings he had to make as court painter to Philip IV. The most famous of these is *Las Meniñas* (The Maids of Honour), in which he depicted himself in the midst of painting the Infanta Margarita, while her maids of honour offer her refreshment to allay the boredom of sitting for her portrait (fig. 321). Two dwarves and a dog are there to amuse her, and when we look into the mirror behind the artist we find another pair of visitors, the king and queen. With the mirror trick invented by Jan van Eyck (fig. 177), Velázquez closed off the space behind us and was able to include all the actors in the drama without cluttering his stage. While he closed off space behind us, he opened it up at the back of the picture by opening a door, in which a courtier lounges. Within the contrived complexity of this composition, every figure seems naturally placed and naturally engaged in some action. Its realism is, in fact, a triumph of art and intellect.

Baroque portrait painting reverted to the High Renaissance emphasis on naturalism and individual personality, but dramatized the sitter with the self-assurance of the age. No one was better at creating a realistic yet impressive study of an individual than Velázquez; he was particularly skilful in painting a sitter's eyes. Figure 320 shows a portrait of his assistant, Juan de Pareja, which Velázquez painted during his second trip to Italy. Daringly, he clothed the man in black and set him against a dark background, omitting all extraneous detail to dramatize the luminous dark skin and vividly expressive face. It was a virtuoso performance and won him admission to the Academy of Saint Luke. The influence of Rubens is seen in the way Velázquez combined finely detailed brush strokes, especially in the treatment of hair and clothing, with a blurred impressionism that brings a sense of movement and vitality to the portrait.

The influence of Flemish painting on Velázquez reflects the close ties between the two countries after the death of Charles V in 1558, when Spain fell heir to Flanders. After the Peace of Westphalia ended the wars between Spain and the Netherlands in 1648, Holland became a separate

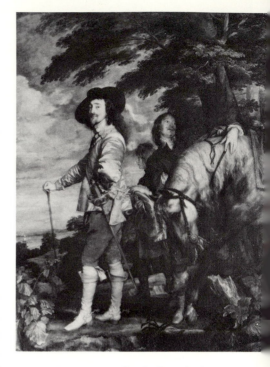

324 Anthony van Dyck, *Portrait of Charles I Hunting*, c. 1635. Oil on canvas, 107 × 83½ in (272 × 212 cm). Paris, Louvre

entity from Flanders, which remained under Spanish rule and reverted to Catholicism. Thus the artistic situation in the second half of the century was fundamentally different in the two states; Flemish patronage remained aristocratic and Church-oriented; art was dominated by the influence of Rubens, who returned to Antwerp from Rome in 1608 to become court painter to the Archduke and Archduchess of Austria, the Spanish king's viceroys in Flanders. Rubens's influence so overshadowed painting in Flanders that only his pupil and assistant Anthony van Dyck (1599–1641) was able to compete with him, and van Dyck made his reputation in portrait painting, chiefly in circles outside Rubens's immediate neighbourhood. He became the court painter to Charles I of England, where he introduced the Baroque style of portraiture with his elegant and flattering images of the king and court (fig. 324).

In Holland no single artist was as pre-eminent as Rubens or Velázquez; no single source of patronage influenced taste. The Dutch patrons were middle-class and had no taste for the vast decorative cycles so prevalent elsewhere, but they did encourage a variety of styles of portrait painting, landscapes, genre, and still-lifes, and also history painting, although the Protestant burghers preferred Biblical to mythological subjects.

The Dutch painter who came closest to the pronounced chiaroscuro and exoticism of Rubens was Rembrandt van Rijn (1606–69). In his *Belshazzar's Feast* (fig. 322), he delved into the romanticism of the Orient to highlight the dramatic climax of the story of the Babylonian king whose worldly excesses were interrupted only when the hand of God appeared in the midst of a banquet, to write on the wall, 'Thou hast been weighed in the balance and found wanting.' The drama of the moment is accentuated by Rembrandt's manner of composing the scene along brightly lit diagonal axes that tilt back into black shadows; the obscurity of the background in this work gives the impression of infinite space even though the action takes place within a closed room and nothing actually contradicts the presence of its four walls.

Frans Hals (1581/5–1666) used a similarly tilted composition to dramatize his cheerful young couple in figure 325. This picture is built on a diagonal plane that slopes back and downwards, so that the background seems to retreat sharply away from us. The spontaneous gestures of the young man add to the diagonal tilt, as he raises his glass with his right hand and scratches the dog's chin with his left. This bourgeois couple are as much at home in a vast and expanding universe as the royalty portrayed by Rubens and van Dyck, but they require no heroic idealizing to convince us of their importance; they are triumphantly, buoyantly themselves.

The Baroque portrait, which both dramatizes and reveals its subject, is a triumph of technical achievement that combines fine detail with a more blurred generality. The most innovative group portrait of the period makes full use of dramatic chiaroscuro and blends brightly lit details with shadowy imprecision. This is Rembrandt's *The Night Watch* (fig. 327),

325 Frans Hals, *Yonker Ramp and his Sweetheart*, 1623. Oil on canvas, 41½ × 31¼ (105.4 × 79.4 cm). New York, Metropolitan Museum of Art

326

327

328

326 Peter Paul Rubens, *Landscape with the Château of Steen*, 1636. Oil on panel, 53 × 93 in (134.6 × 236 cm). London, National Gallery

327 Rembrandt, *The Night Watch*, 1642. Oil on canvas, 143½ × 175¼ in (359 × 438 cm). Amsterdam, Rijksmuseum
The name 'Night Watch' was attached to this picture after years of accumulated dirt and revarnishing had darkened it; cleaning and removal of old varnish brought out the glow of daylight. Rembrandt actually painted as the company set off in the morning.

328 Pieter Claesz (*c.* 1597–1661), *Still-Life*, 1647. Oil on canvas, 25¼ × 32¼ in (64 × 82 cm). Amsterdam, Rijksmuseum

329 Rembrandt. *Self portrait*, 1659. Oil on canvas, 33¼ × 26 in (84.5 × 66 cm). Washington D.C., National Gallery

which really depicts not a night watch but a company setting off in the morning. It is supposed to have found disfavour with the regiment it depicts, as its composition hides some of the soldiers in shadow behind their companions, while highlighting others. But in fact it was recognized then, as now, as a highly original approach to group portraiture; Rembrandt wove the light through the picture to illuminate features so that he managed to suggest personality even in figures of whom we see little.

No portraits are more revealing of character than Rembrandt's numerous self-portraits. Figure 329 has much in common with Velázquez's portrait of Juan de Pareja, but Rembrandt went even further in cutting away extraneous detail to let light and shadow form the outline of the head, so that little emerges from the background but the artist's features. By this time Rembrandt had turned away from the Baroque bravura of *Belshazzar's Feast* and *The Night Watch* in favour of a more subtle realism, but this introspective and analytical self-portrait is no less dramatic.

In both Dutch and Flemish painting the realism derived from medieval Flemish tradition was, when combined with the luminous technical skill of the Baroque, a fitting vehicle with which to convey the beauty of ordinary objects. It was particularly in bourgeois Holland that the love of one's possessions led painters to specialize in still-lifes. From Classical art on, groups of objects had appeared in paintings, arranged for the appeal of colour and shape. In the hands of the Dutch painters, the skilful rendering of objects of different textures and densities became an end in itself, and a subject as popular as landscape or portraits. In figure 328, the glass of beer, the bread, and the fish are arranged as if casually left over from a meal, but in fact they are carefully composed to show the contrasting effects of light, which filters through the liquid in the glass, reflects off the hard surface of the bread, and is absorbed by the soft texture of the fish.

In landscape painting the Dutch Baroque painters made an enduring contribution. To their own tradition of light and atmosphere, descended from the Limbourgs, van Eyck, and Bruegel, the Baroque painters added a knowledge of Italian painting in the manner of Annibale Carracci, which stressed carefully built up foreground, middle ground, and background. Dutch landscapes were also infused with the strong feeling for natural divinity which we saw in Altdorfer's watercolour (fig. 289). Pantheism, a creed holding that everything in the world is a part of the whole, which is God, was articulated by the Dutch philosopher Spinoza (1632–77), who identified God with Nature; overtones of this play a strong role in Dutch and Flemish painting.

Rubens's landscapes were a highly original synthesis of these various currents, and influenced the Dutch painters. Figure 326 shows his own house, the château of Steen, but the light illuminates only the Gothic gateway, hiding the rest in the shadow of the trees. What interested the artist was the long, low sweep of field and woods; the natural flatness of the land lets us see a vast distance, and the sharply focused details in the

foreground merge imperceptibly back into the low hills on the horizon. The hunter stalking his prey in the foreground is reminiscent of Bruegel's figures; all the details close to us are more from Northern than from Italian art, but once we cross the river we are in Carracci's ideal landscape.

The Dutch shared with Rubens a Baroque sense of vast space and dramatic sky, but emphasized even more the realism of light and shadow. In Holland the light is constantly shifting from cloud to sunlight in a dramatic variety of shadow effects. The weather aided the Baroque intentions of painting both realistically and dramatically; the romanticism of the style is enhanced by the realism of sky and light. In figure 332, Jacob van Ruisdael (1628/9–82) caught the sunlight breaking through the clouds to highlight the bright field of wheat in the middle ground. The effect is realistic; at the same time, the painting is invested with a feeling of mystery and power. The small figures walking along the road are not threatened by nature's immensity; on the contrary, they are in complete harmony with the natural world.

A much cooler, clearer light bathes the interiors painted by Jan Vermeer (1632–75), who built his quiet scenes in geometrical blocks in a manner comparable with that of Piero della Francesca. In his *Young Woman with a Water Jug* (fig. 334), Vermeer cast the girl in a bluish daylight that contrasts to the bright blue of her dress, the dark blue shadows, and pale blue walls. The clear articulation of forms and controlled tones are a far remove from the dynamic chiaroscuro of Rubens and Rembrandt, but this work shares with all Baroque art the desire to create a dramatic effect. Light, space, and objects are handled to one end; we keep coming back to the figure of the girl, each time with a new feeling about the relationship between the figure and the room and its objects. As a person she is much more remote than the figures in Velázquez's *Las Meniñas* or in Hals's *Yonker Ramp and his Sweetheart*. It was the more romantic side of Baroque art that took its cue from Caravaggio and brought us close to the subject; in Vermeer there is a more classical distancing, an objectivity that reflects a reversal which overtook the style by the middle of the seventeenth century.

Baroque Classicism

By the middle of the century, the full tide of dynamic bravura and illusion was receding before a new wave of classicism that first appeared in the 1630s, in the work of two Frenchmen working in Rome, Nicolas Poussin (1593/4–1665) and Claude Lorrain (1600–82). Poussin came to Rome in 1624, when high Baroque was emerging; he began painting in its style of dramatic space and motion. Then, in the 1630s, he reacted against both Caravaggesque realism and the bravura of Cortona and Rubens, modelling his style more strictly on Classical Roman sculpture. He developed a

330 Nicolas Poussin, *The Arcadian Shepherds*, *c*. 1630. Oil on canvas, 39¾ × 32¼ in (101 × 82 cm). Devonshire Collection, Chatsworth, Derbyshire

way of building up his compositions by using a shadow box with wax figures as models.

Two paintings on the same subject illustrate his change of style. The subject was a popular one in an age that delighted in irony: the paradox that death dwelt even in the earthly equivalent of Paradise, Virgil's Arcadia, which was populated by perpetually young and beautiful shepherds and shepherdesses. The first version (fig. 330) is a lively composition and shows the influence of Titian, and of Bernini and Rubens. A group of youths and maidens have just come upon the tomb, which reminds them of the inescapable presence of death. The sense of surprise is heightened by the diagonal tilt and the forward motion of the figures.

The second version (fig. 333) shares only the subject and the soft pastoral background. It is static and horizontal; the figures have taken their place on stage before the curtain rises. The Titianesque girl of the first work has turned into an imposing Roman matron. The theme, 'Et in Arcadia ego' ('I dwell also in Arcadia'), is clearly inscribed on the tomb, and these people obviously know its meaning and accept it. The combination of the medieval *memento mori* and paradox in the earlier painting has given way in the second to stoicism, a philosophy of detachment which increasingly attracted Poussin.

Poussin built up his landscapes in separate and carefully organized planes, but they are prevented from seeming too stilted because he included the irregularities and chiaroscuro of nature. In figure 331, for example, the softened forms of the trees disguise the contrivance of the composition. The figures in Dutch landscapes are incidental, but here the action is important; this painting tells the story of an Athenian general who was executed by the city because his unyielding moral uprightness brought him into disfavour; he was not even allowed burial within the city walls, but his widow collected his ashes and kept them until changing fortunes allowed a proper burial. Poussin admired the stoicism of the story and designed the landscape and its forms to emphasize the moral fortitude of Phocion's wife. The composition is carefully built up in a triangle that directs the eye to the temple in the middle distance. The eye then moves to the rocky promontory above, where a distant ridge leads back into a deep yet naturally defined space. But the careful organization is not stultifying because the shapes of the stately, feathery trees are picturesque and irregular and soften the symmetry.

Poussin's countryman and fellow expatriate Claude Lorrain (see fig. 3) specialized in the ideal landscape, combining it with the intellectual character of history painting and also with the picturesque appeal of old buildings and ruins. Claude's synthesis of classicism and romanticism, of realism and idealism, was immensely popular in his own time and has been ever since, for in his pictures there is something to please everyone. The balance of forms and Arcadian figures would satisfy anyone who demanded Renaissance classicism, while the soft beauty of the countryside

331 (*below*) Nicolas Poussin, *The Ashes of Phocion Collected by his Widow*, 1648. Oil on canvas, $45\frac{5}{8} \times 69\frac{1}{4}$ in (116×176 cm). Knowsley Hall, Lancashire

332 (*right*) Jacob van Ruisdael, *The Wheatfield*, date unknown. Oil on canvas. $18\frac{1}{8} \times 22\frac{1}{4}$ in (46×56.5 cm). Basle. Kunstmuseum

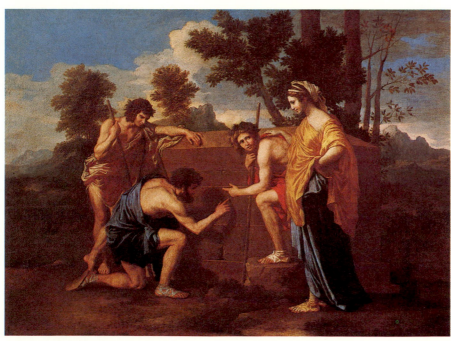

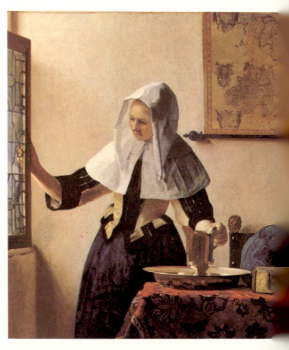

captures the heart of the nature lover; the viewer who simply likes to recognize what he sees can appreciate the shimmering, hazy sunlight and the cool freshness of a shady dell. The love of beautiful landscape and a nostalgia for a timeless paradise of eternal spring ran deep in the seventeenth century. Milton's first drafts for *Paradise Lost* were made a few years after his travels to Italy in 1637–9; the finished poem, completed some time between 1663 and 1667, contains a description of the Garden of Eden written in terms very similar to a painting by Claude:

> A happy rural seat of various view;
> Groves whose rich Trees wept odorous Gums and Balm,
> Others whose fruit burnisht with Golden Rind
> Hung amiable, *Hesperian* Fables true,
> If true, here only, and of delicious taste:
> Betwixt them Lawns, or level Downs, and Flocks
> Grazing the tender herb, where interpos'd,
> Or palmy hillock, or the flow'ry lap
> Of some irriguous Valley spread her store,
> Flow'rs of all hue, and without Thorn the Rose:
> Another side, umbrageous Grots and Caves
> Of cool recess, o'er which the mantling Vine
> Lays forth her purple Grape, and gently creeps
> Luxuriant; meanwhile murmuring waters fall
> Down the slope hills, disperst, or in a Lake,
> That to the fringed Bank with Myrtle crown'd,
> Her crystal mirror holds, unite thir streams.

Paradise Lost, Book IV, ll.247–63

The combination of the medieval garden and its rose without thorns, symbolizing the Virgin, with the Classical Garden of the Hesperides and its golden apples is typical of Baroque romanticization of Classical mythology, which we find also in Claude's painting.

Figure 335 is one of Claude's many landscapes which do not have a particular story in mind, but use human activity to balance and harmonize the forms of nature. He arranged his composition as carefully as Poussin did, but the natural features of the landscape are allowed to obscure the passage from one stage to the next. The wide foreground curves naturally back along the river's edge to where the ferry's rope stretches across to the opposite bank and its buildings, forming the middle ground. Beyond, the river merges into soft, sunlit woods and distant hills. The diagonal line of the river leads the eye back more naturally than the horizontal planes in Poussin's *The Ashes of Phocion;* the continuity is strengthened by the subtle change in atmosphere from the sharp clarity of the foreground, populated by picturesquely costumed rustics, to the melting, luminous haze of the background.

The rational yet poetic charm of Poussin and Claude exerted a pro-

333 *(far left)* Nicolas Poussin, *The Arcadian Shepherds*, c. 1655. Oil on canvas, 33½ × 47⅝ in (85 × 121 cm). Paris, Louvre

334 *(left)* Johannes Vermeer, *Young Woman with a Water Jug*, c. 1662. Oil on canvas, 18 × 16 in (45.7 × 40.6 cm). New York, Metropolitan Museum of Art

found influence on the course of Baroque art, and not only in painting. Classicism reasserted itself in architecture and in sculpture as well; all the arts moved away from the uninhibited exuberance of Bernini and Rubens to a more static self-assertion.

The shift in style was connected to a shift of influence from Counter-Reformation Rome to France under the authoritarian regime of Louis XIV. This was a king who believed very much in Baroque apotheosis; he was called the Sun King, a deliberate and flattering synthesis of the Classical myths of Apollo, the god of the sun, and the new astronomy that placed the sun in the centre of the universe. Out of the practical need to subdue the power of the aristocracy in order to govern the country, Louis XIV and his ministers developed a Baroque absolutism in government based on the doctrine of a king's divine right to rule. He was indeed the Sun King, with his entire court revolving around him; what Francis I had begun at Fontainebleau Louis carried to its climax in the building of his palace at Versailles.

In order to control the affairs of state, Louis's administration reached a level of bureaucracy unknown in Europe since Roman times. He controlled all fields of intellectual and artistic endeavour by establishing national academies to govern not only training in each field but the awarding of commissions. The French Academy of Art, founded in 1648, was taken over by the state in 1663; from then on its head, the artist Charles Lebrun (1619–90), was directly responsible to the king's chief minister, Colbert, and Colbert was directly responsible to the king. Under this system, the Academy provided an excellent technical training in both practice and theory, and opened the king's vast collection to young artists. It also provided security and opportunity for those artists who could meet the approval of the king, Colbert, and Lebrun. There was a tremendous flowering of French culture under Louis XIV, although in the confining atmosphere of absolute control it was architecture that flourished most, and painting least. Poussin, the ideal of the Academy, could not get along with its bureaucracy and after 1642 managed never to return to his native land.

Under such an authoritarian regime it was natural that the arts should turn away from the individualistic expressionism of high Baroque to a more magisterial style closer to the pomp of ancient Rome. But, although the undulating line and palpitating excitement of the style fell out of favour, the desire for grand effect and scale remained. In the court of the Sun King formality entered all the arts: the racy wit of Rabelais was replaced by the polished comedies of Molière; Corneille and Racine wrote classical tragedies, while Jean Baptiste Lully wrote operas in a heroic style, setting to music the classical gestures of a Poussin painting.

The idea of the absolute state, built like a pyramid with wealth, power, and style all flowing down from the king, was widely imitated in Europe, but nowhere else was the total coordination of every phase of life so

335 Claude Lorrain, *The Mill*, 1637. Oil on canvas, 24 × 33½ in (61 × 85 cm). Boston, Museum of Fine Arts

336 (*right*) Jules Hardouin-Mansart, Hall of Mirrors, Versailles, 1678–84

stunningly effected. In art and architecture, the contribution of this centralization of authority was to develop a team-work in which all phases of building and decorating were tied to a single plan. The summation of this team-work was the creation of the new palace at Versailles, in which design, decoration, and landscape gardening were all directed by the architect Louis Le Vau (1612–70, later replaced by Jules Hardouin-Mansart, 1646–1708), the artist Lebrun, and the landscape architect André Le Nôtre (1613–1700). It was in keeping with the Baroque attitude towards space that vast landscape gardens should have been visualized as an extension of the building. The gardens at Versailles extend from the palace (fig. 337), sharing the same axis; Le Nôtre grouped trees and shrubs around fountains in a careful arrangement of light and shadow that brings space into play in a thoroughly sculptural and painterly effect. The dark trees outline bright clearings accented by fountains, deliberately echoing the light and shadow playing on the façade.

Between the formal façade turned towards Paris and the more relaxed garden front runs a long gallery opening onto the gardens. Built by J.H.-Mansart, this gallery is faced entirely by mirrors to offer a spectacularly illusionistic effect (fig. 336). At either end of the gallery opens into a salon, symmetrically decorated as a hall of peace and a hall of war. The decoration, directed by Lebrun, is strict but far from stark; it looks back to Renaissance classicism in its respect for the articulation of structure.

Lebrun's admiration for Poussin led him to favour vast and rather stilted history paintings filled with classical borrowings like his own *Alexander the Great Entering Babylon* (fig. 338). This was a subject that enabled Lebrun to flatter his sovereign by the implied comparison while demonstrating that history painting (see above, p. 180) was the highest category of art; to Lebrun history painting was especially important because it dealt with the nobler aspects of human action. Figure 338 is full of classical poses and gestures; he borrowed several individual groups from actual Antique models. But it is devoid of life and demonstrates the deadening effect of academic theory when it is not united with artistic insight. Nevertheless, the rigorous training Lebrun wrote into the French Academy curriculum did ensure certain standards; French art continued to flourish, always with a high degree of technical skill, while after its one glorious century of originality Dutch painting sank to a low ebb until modern times.

High technical competence was ensured in all the arts and crafts. In directing the decoration and furnishing of Versailles, Louis XIV and Colbert demanded a high standard of craftsmanship. As a result, French porcelain, silver, and furniture became widely sought by the rich all across Europe. The interior of Versailles appears more austere today than it did in the Sun King's time because so many of the beautiful objects — inlaid tables, ornate candelabras, flower vases, sculptures, and a myriad other decorative notes that created a tone of luxury and glamour — are missing.

337 (*right*) Jules Hardouin-Mansart, garden façade, Palace of Versailles, 1668–78

338 (*below*) Charles Lebrun, *Alexander the Great Entering Babylon*, 1660–8. Oil on canvas, 177$\frac{1}{4}$ × 278$\frac{1}{4}$ in (450 × 707 cm). Paris, Louvre

339 (*right*) Inigo Jones, Banqueting House, Whitehall, London, 1619–22

340 (*below*) Inigo Jones, The Queen's House, 1616–35. Greenwich, now part of the National Maritime Museum

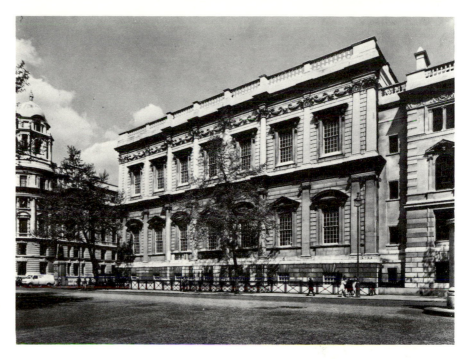

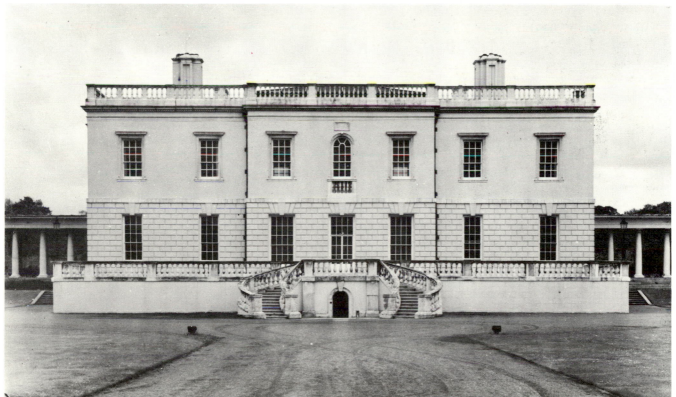

Versailles exerted a profound influence on art in other European courts, countering the dynamic illusionism of the high Baroque style with its more formal magnificence. By the end of the seventeenth century Paris had replaced Rome as the cultural capital of Europe; Rome remained an essential place to visit, but more for its past than for its part in contemporary developments. The monumental classicism of French art and architecture was more in tune with the developing nation states, even those at war with France.

In England the failure of the Stuart kings to maintain an authority as absolute as that of Louis XIV prevented the same degree of control over artistic developments as he enjoyed, but the influence of Versailles did affect English style; the monumental impressiveness of a classical façade opening onto stately gardens was imitated in a smaller way in country houses of the aristocracy.

The Baroque age was a stormy epoch in English history. It covered the period of struggle between the monarchy and parliament from the accession of James I in 1603 to the Glorious Revolution in 1688 which drove out the last Stuart king, James II, and opened the way for the accession of his daughter Mary and her consort William of Orange. For the arts it was a period of valleys and peaks. Under James I and Charles I the prevailing architectural style was based on Tudor Gothic. But James was responsible for commissioning the one classical Renaissance public building of the age: the Whitehall Banqueting House (fig. 339). This was a place of entertainment for the court; Inigo Jones (1573–1652), its architect, also designed the scenery for the masques written by Ben Jonson that were performed inside it. This hall, with its regular and classical exterior, its ceiling painted by Rubens (fig. 319), hung with tapestries made from cartoons by Raphael, burst across the cluttered Gothic horizon of London like a new star.

Inigo Jones was influenced less by the sweeping rhythms of Baroque architecture, then just emerging, than by the stricter classicism of Palladio. His style emphasizes clarity and logic, and above all rationalism. The first house he designed in a classical style was a private house for the Queen at Greenwich (fig. 340), which he built as a comfortable, relaxed retreat from the formality of the court. It was designed as two rectangular blocks connected by a bridge, one with an open central hall and the other opening onto a loggia, in imitation of Italian villas; the space between the two blocks was filled in later. The simple, graceful lightness of the Queen's House is a departure from Italian classicism and is in a style of domestic elegance that is wholly English; it is the forebear of the Neoclassical country houses of the eighteenth century.

The Banqueting House was a public building; its imposing façade was designed with its official function in view. It is a neo-Palladian building with a classical scheme of alternating pediments, articulated storeys topped by a balustrade, and a rusticated basement underneath the main

floor. The orders rise from the simpler Ionic on the ground floor to the more complex Corinthian of the upper storey, which also has a decoration of swags, or garlands of leaves and flowers. The Banqueting House, through one of whose windows Charles I passed on his way to the execution block, testifies to the Italian spirit which was also marked in the court poetry of Ben Jonson and in music, where the Italian suite form gained preference over the native madrigals.

From the Palladian classicism introduced by Inigo Jones, English Baroque architecture developed into a style combining French static mass with Italian plastic space and rhythm that was unique to England and found its finest expression in the work of Sir Christopher Wren (1632–1723). An energetic and dominating figure and a gifted scientist as well as an architect, Wren was in a position to influence the course of English architecture in a classical vein after the Great Fire burnt down much of the city of London in 1666. As the king's surveyor-general, a position akin to Lebrun's but with less authority, Wren was responsible for much of the rebuilding. His plan to rebuild the city with wide, straight streets and open spaces was blocked by home-owners' insistence on rebuilding on the foundations of their old houses. But he was given scope to exercise his inventive imagination in rebuilding many of the parish churches destroyed by the fire, and he had the opportunity to achieve a monumental and influential design in the new cathedral of St. Paul's.

Wren drew on French classicism, which he knew at first hand, but with a light and graceful elegance that indicates an awareness of the quickening rhythms of Borromini, and also of Bernini, whom he had met in Paris. In the London churches he found ingenious compromises between the Gothic tradition that the English associated with church building and Baroque classicism. At St. Stephen Walbrook he executed a particularly imaginative design that was in part a working out of his ideas for St. Paul's; it poses the same problem of marrying a rectangular church to a circular dome (fig. 341). At St. Stephen the dome is carried by pendentives to eight columns, which square the rectangle; four more behind fill in the square, and the heavy and elaborately decorated entablature cuts around the corners with something of the motion of Borromini's more undulating entablature at San Carlo (fig. 315). Through the arches of the pendentives one can see the groin vaults of the nave, sanctuary, and transepts, and of the four corner clerestories. The convex shape of the groins produces a continuous flow of space over curvilinear surfaces again evocative of Borromini. Wren used this play of convex and concave surfaces in his design of church steeples, a Gothic element he incorporated into the parish churches to lift them above the London skyline. He used a particularly Italian rhythm in the two towers at St. Paul's Cathedral (fig. 344).

Even before the fire the old Gothic structure of St. Paul's had been in poor repair. Inigo Jones had patched it up and dressed it in a classical temple façade. When the damage caused by the fire made it impossible to

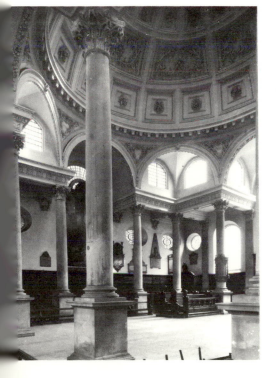

341 Sir Christopher Wren, St. Stephen Walbrook, London. 1672–9

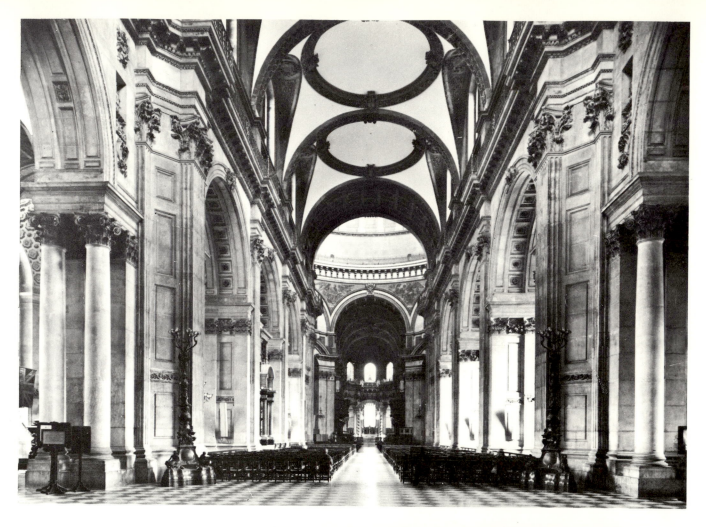

342 (*above*) St. Paul's Cathedral, interior of nave, looking towards choir

343 (*right*) Grinling Gibbons, Bishop's throne and choir stalls, 1696–8. St. Paul's Cathedral, London

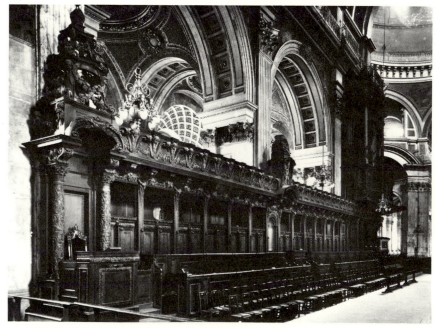

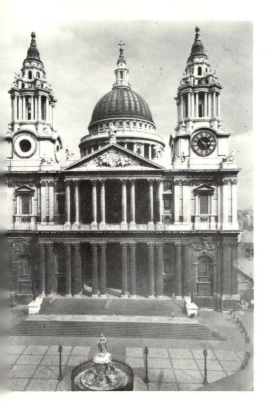

344 Sir Christopher Wren, St. Paul's Cathedral, London, 1675–1709

save the original structure, the commissioners reluctantly decided to raze the building and start afresh. Wren's first and favourite design harked back to the centralized type of the Roman Pantheon and of Michelangelo's design for St. Peter's, but this was too radical and too Roman Catholic for the commissioners. The eventual compromise uses the Latin cross form with circular and semicircular chapels opening off the nave in the manner of Il Gesù and St. Peter's (fig. 342).

The building of St. Paul's was carried out by a team not unlike the organization of talent behind Versailles. The decorative carving was directed by Grinling Gibbons (1648–1721), who had grown up in Holland, where he learned a realistic style of carving fruit and flowers. He himself was responsible for much of the rich ornamentation of flowers, fruit, birds, and cherubs sprouting over the choir stalls (fig. 343). These profuse forms are rooted in Gothic decoration, but the way in which they pile up in undulating curves over the bishop's throne shows an awareness of the style of Bernini.

In general English Baroque architecture avoided the overwhelming nature of either the Italian or the French manner. Ironically, though, the influence of France appeared at the moment when England was at war with France, in the monumental palace given by Queen Anne and the nation to the Duke of Marlborough in gratitude for his victory over the French army in 1704 in the Battle of Blenheim.

Blenheim Palace was designed by Sir John Vanbrugh (1664–1726), with the assistance of Nicholas Hawksmoor (1661–1736). Vanbrugh was an intellectual, a successful playwright and a member of the most exclusive circles. For the monument to the hero of Blenheim he pulled out all the stops of Baroque classicism. The palace is vast, impressive, and coldly formal. It was built at enormous expense, sacrificing comfort and simplicity to grandeur at every turn, which brought Vanbrugh into a long and bitter dispute with the duchess. The park extends over some 2,000 acres, 77 of which were planted, around the house, with formal terraces, flowerbeds, and fountains, in imitation of Versailles. Over a small and sluggish stream, Vanbrugh threw an elaborate bridge. In the eighteenth century the popular landscape gardener 'Capability' Brown replaced the terraces and gardens with lawn and dammed the stream to form two lakes, joined by a narrow channel under the bridge. Recently, some of the terraces and parterres have been restored.

The palace is a forbidding rank of blocks receding around a deep forecourt (fig. 345). The repetition of decorative elements knits the blocks together to lead the eye in a sweep that gains momentum with the double colonnade connecting the outer buildings to the central block. Triumphantly, the motion arrives at the grand and impressive main entrance, its pediment decorated with the arms of the duke carved by Grinling Gibbons.

Inside, the formality of the rooms reflects the influence of Italian and

345

346

347

345 Sir John Vanbrugh and Nicholas Hawksmoor, Blenheim Palace, Woodstock, Oxfordshire, 1705–20

346 William Talman, Chatsworth House, Derbyshire. Remodelled from 1686

347 The Saloon at Blenheim Palace. Mural painting by Louis Laguerre and marble doorways by Grinling Gibbons, *c*. 1720

348 Sir James Thornhill, the Sabine Room, Chatsworth House, 1706–7

French palace decoration. Carving by Gibbons and illusionistic mural painting create a total stage setting. The one native English painter who could work in this scale, Sir James Thornhill (1675–1734), was originally commissioned to supervise the painting; he had worked with Wren at St. Paul's and at Greenwich. But he had painted only the hall ceiling, with a majestic scene depicting the duke kneeling before Britannia, when the duchess dismissed him and brought in, at a cheaper rate, the French painter Louis Laguerre (1663–1721), a pupil of Lebrun. In the Saloon Laguerre painted a trompe-l'oeil peristyle that runs rather awkwardly around Gibbons's marble doorways to open the room out into perpetually sunny skies and a loggia along which are gathered personages from the four continents to pay homage to the duke (fig. 347).

The overblown rhetoric of such symbolism was out of character with English attitudes, and the cold formality of Blenheim too obviously a monument to its owner's heroic stature to be imitated in its vast and uncomfortable scale. But the Baroque concept of building large houses with a team of architect, decorator, and landscape gardener to provide a single, grand, and intimidating impression was widely imitated on a much reduced scale in the country houses built for wealthy aristocrats. Louis XIV might have his own factories to provide furnishings, but the English were no less fortunate, for they could import glass, china, and furniture from all over the continent. Baroque furniture repeated the reverse curves and shells and garlands of the stucco wall decoration. Elegant mirrors and chandeliers were part of the decorative scheme, designed into the plans from the beginning. The sculpture placed in wall niches and between the broken pediments over doors was an integral part of the carving around it, and painted carving and sculpture mock any attempt to divide one art from another; the whole intention was still to disguise reality and to create an illusionistic setting. At Chatsworth, the first Duke of Devonshire re-modelled an Elizabethan mansion into a monumental classical block (fig. 346), articulated by a giant order of Ionic pilasters and columns, which open onto formal gardens and fountains. The garden stairs are fancifully rusticated to resemble a grotto. Indoors, the state rooms are painted with mythological scenes by Laguerre and Thornhill and others. Thornhill painted a particularly dramatic and illusionistic room with scenes of the *Rape of the Sabines* spread around the four walls; cherubs and garlands drop out of the ceiling in the manner of Cortona and Gaulli (fig. 348).

The marriage of Italian romantic illusionism and French classical monumentality at Chatsworth shows that the two aspects of the style were never mutually exclusive. In all Baroque art, from Rubens and Bernini to the Dutch and Spanish painters to Lebrun and J.H.-Mansart, the object was to create a world of infinite space within a recognizable perspective. Whether set into perpetual motion or into frozen monumentality, the style reflects boundless confidence in man's ability to bring order and stability into an infinite and dynamic universe.

349 George Caleb Bingham, *Fur Traders Descending the Missouri*, 1845 (detail). (See below, fig. 406)

PART 4 The Romantics

PART 4: THE ROMANTICS

INTRODUCTION

The period from 1700 to 1835 was a time of revolutionary change in the social and political structure of the Western world, as we can see from the very names of its major events: the American Revolution, the French Revolution, and the Industrial Revolution. Despite the civil and religious wars of the previous century, the eighteenth century opened under the familiar authority of king and aristocracy. By 1835, all the institutions of the modern world had appeared; Europe was dominated by military states run by a middle-class civil service and supported by middle-class bankers and stock brokers. A lord was still a lord, but the voice of the bourgeoisie was increasingly powerful and the arts were increasingly aimed at the middle class.

This period of drastic change altered the situation of the artist as much as anyone by creating a new and wider art public, whose aims and aspirations differed from those of the aristocracy. The Renaissance had raised the status of the artist above the level of the medieval artisan. However, apart from religious art visible in churches, the artist's public was limited to the narrow circle of noblemen who collected art. The only people who saw these collections were other noblemen and the artists whom they patronized. From the mid-eighteenth century, the widening opportunities for the rising middle class opened the way to people with no background of cultural taste who were ambitious and anxious to ascend the social ladder. Imitating the taste and habits of the aristocracy, they wanted to own works of art. The concerns of the bourgeoisie affected both the style and subject-matter of art, directing it away from the trivial and pretty Rococo style invented early in the century as a flattering background for the aristocracy to a more didactic portrayal of middle-class morality seen in the Neoclassical art that gained popularity in the middle of the century. By the end of the eighteenth century middle-class aspirations, liberal politics, and a growing passion for nature merged in the Romantic movement, bringing all the arts together in a single philo-

sophical creed that championed individual and independent creative vision. The changes undergone as the century passed from an aristocratic to a bourgeois society are mirrored in art and in the institutions through which the middle class became an increasing factor in art patronage.

The institution through which the middle class became exposed to art was the public exhibition. The French Academy held its *Salons* more or less annually from 1737; in the latter half of the century English artists gathered to arrange their own exhibitions. From this collaboration the Royal Academy emerged in 1768; by the time of its first public show, looking at paintings had become an immensely popular recreation for Londoners who could afford the entrance fee. Such exhibitions, widespread throughout Europe by the end of the eighteenth century, became the principal means for an artist to establish his reputation, freeing at least the successful from the necessity of finding a particular patron. Whereas in the late 1600s an artist was still closely bound to the small class of aristocrats who could afford to commission his works, by 1835 he was, in theory at least, free to create works as he wanted, in expectation of sale through the publicity of the exhibition. Thus between the beginning of the eighteenth century and the end of the Romantic period, the relationship between artist, audience, and the development of style became increasingly complex.

CHAPTER 11

Rational Romanticism: Rococo to Neoclassicism

On the surface, the Baroque synthesis that merged all the arts, philosophy and science, politics and social patterns into one distinct European culture lasted well into the eighteenth century. But the same forces that had drawn European intellectual and artistic energies together in the first place worked towards their separation in the eighteenth century. For the most part, seventeenth-century philosophers began with the assumption that God exists and the inference that everything else stems from this fact. Yet at the same time, from Descartes to Locke, they worked out methods of reasoning from experiment and observation that ran contrary to theorizing from fixed assumptions. At the end of the seventeenth century Locke and Newton tipped the balance towards empirical method; the eighteenth century carried this further by jettisoning theology from the philosophical ship almost entirely. Everything had to be proven from observation of natural phenomena before facts could be ordered into systems. Newton had already drawn a distinction between metaphysics and physical science, and from the eighteenth century on, philosophy, theology, and pure science became separate pursuits. As a result the eighteenth century saw itself, and has been seen ever since, as the Age of Reason, or the Enlightenment. In its rational and inquiring character, this period was the watershed that separates the Renaissance from the modern world. In the aftermath of the bitter wars of religion, the eighteenth century chose a firmly secular course. Not all of its pursuits were serious or scientifically minded; taste ran from high-minded moralizing to trivial pleasure-seeking.

There was no one 'Enlightenment' style of art, nor was there a close agreement between the arts as there had been in the Baroque period. But in the music of Mozart and Haydn, the writings of Pope, Addison, and Voltaire, the painting of Watteau, Gainsborough, and Reynolds, and the architecture of Robert Adam there ran a common theme of lightening, clarifying, and ordering material according to reason and good taste.

350 Germain Boffrand (1667–1754), Salon de la Princesse, Hôtel de Soubise, Paris, *c.* 1735

The desire to make everything sensible and rationally ordered — a reaction to the overwhelming and overburdened effects of the Baroque style — worked more to the advantage of music, letters, and architecture than of painting and sculpture; in the fine arts the pursuit of system and concrete definition meant a further hardening of academic lines between categories of painting — history, landscape, portrait, genre, and still-life — and led to arguments over how beauty could be distinguished from other characteristics appealing to the senses or the intellect. Academies of art sprang up all over Europe, modelled on the French Academy. Ironically, these schools, founded on a genuine need to provide good teaching, especially for students of no financial means, soon became authoritarian and ended by stifling initiative. The aesthetic theorists dealt with art as scientists deal with natural phenomena, seeking logical and demonstrable conclusions. But they were caught between objective rules of form and the claims of intuition and imagination. Both of these things were to be found in art theory from Aristotle to Leonardo, but the eighteenth-century aestheticians were the first to try to define the whole process by which we are moved to consider a work of art beautiful. Throughout the period, therefore, artists and aesthetes pursued a confusing attempt to synthesize the objective rules of classical art — a style based on definable elements — with a subjective appreciation of the creative imagination, which produces not specific forms, but feelings.

The Rococo

A sense of release was felt in France immediately upon the death of Louis XIV in 1715. The nobility, released from the strict surveillance of the king's ministers at Versailles, moved to Paris and built town houses where they could pursue a life of pleasure and fashion. The theatre and concert stage followed them, so that Paris replaced Versailles as the cultural centre of France. As part of a reaction against the Baroque court, an elegant new style was created to decorate the town houses, necessarily on a smaller, lighter scale than palaces and country châteaux. Called *Rococo* after the *rocailles*, or shells and pebbles used to create artificial grottos, the decorative style was characterized by a curling line that turns back on itself in a graceful arabesque. Where the Baroque decorative schemes had been designed to stun and overwhelm a viewer, the lighter Rococo retired to the background. Everything tended towards lightness; the style favoured white and gold, light crystal chandeliers, and large windows. Furniture, too, was designed with a fragile grace. Walls were not articulated by heavy classical pilasters and pediments, but were given a mobile, flat surface encrusted with delicate gilt and stucco decorations and paintings (fig. 350).

Rococo décor created a pretty, artificial elegance that demanded a

pretty art to match it. Taste in art was still dominated by the French Academy, which controlled the public's awareness of new art because it held the only public exhibitions of art in France. Even in the Academy, however, the strict classicism of the older generation was passing; with the death of Lebrun in 1690, the dominance of Poussin's style yielded to a preference for the colouristic, dynamic rhythms of Rubens. It is Rubens's influence that is most obvious in the painting of Jean-Antoine Watteau (1684–1721), but he softened the forceful presence of the Baroque master into a Rococo style, blending it with a lighter atmosphere reminiscent of Titian and Giorgione (fig. 352).

A painter could only be admitted to the Academy as a specialist in a specific category such as history painting. It says much for the broad-mindedness of the age that the Academy relaxed its rules and created a new category specifically for Watteau, that of the '*fête galante*', or elegant entertainment, so that Watteau could be made a member. Figure 352 was his presentation piece to the Academy. It illustrates the difference between Baroque and Rococo intentions; where Rubens overwhelms us and pulls us into the vortex of exotic dramas, Watteau lets the painting retreat into a distance. Nothing is abrupt or dramatic; a soft, romantic light shimmers over the hazy figures reluctantly preparing to depart from the enchanted island of lovers. In its lingering magic wrought by light and colour, this work is closer to nineteenth-century French Impressionism than to any painting before it.

The novelty in Watteau's painting comes from the strong sense he conveys of the transience of life. His people are gaily costumed for a party, freed from the constraints of ordinary life and enjoying the soft, transparent atmosphere of an Arcadian summer, yet underneath the gaiety there is a bittersweet feeling of a dream on the verge of dissolving. It is this sense of fragile charm that connects Watteau to Jean-Baptiste-Siméon Chardin (1699–1779). Chardin, however, was influenced not by the illusionism of Rubens but by Dutch realism. While Watteau captured aristocratic fancies and sophisticated entertainment, Chardin conveyed the simple and sober pleasures of the bourgeoisie. Self-taught, he painted many still-lifes. This was a category the Academy held to be of a lower order than history painting because it was mere imitation, yet Chardin won favour for the beauty with which he could render ordinary forms. Figure 353 is a group of objects chosen not only for the arrangement of forms and reflections but as symbols; they are the ingredients of a Lenten meal. Through the soft, luminous treatment of the contrasting shapes and densities, Chardin conveyed the charm of life in a well-run middle-class household.

Chardin painted the *Boy Blowing Bubbles* (fig. 351) in response to the low opinion the official art world had of still-lifes. It is a scene that is neither genre nor history; it portrays a world of unruffled calm and beauty. By reducing the composition to a triangle formed by two figures with almost no background, Chardin concentrates our attention on the faces of the

351 Jean-Baptiste Chardin, *Bay Blowing Soap Bubbles*, c. 1730. Oil on canvas, 36⅜ × 29⅜ in (93 × 77 cm). Washington D.C., National Gallery of Art, gift of Mrs John W. Simpson

CHART 6 THE EIGHTEENTH CENTURY AND THE ROMANTICS, 1700—1835

EVENTS			ART AND CULTURE
1702-14 Reign of Queen Anne	1700	ROCOCO	1711-12 Steele and Addison publish *The Spectator* 1712 Pope, *Rape of the Lock*
1714 George I, Elector of Hanover, becomes king of England 1715 Death of Louis XIV 1715-74 Louis XV king of France			
	1725		1717 Watteau, *Embarkation for Cythera* *c.* 1725 Chiswick, Burlington House 1726-44 Thomson publishes *The Seasons*
1727-60 George II king of England			1737 First Salon of French Academy
1738 Excavation of Herculaneum 1740-8 War of Austrian Succession			1741 Handel, *Messiah* 1744 Hogarth, *Marriage à la Mode*
1745 Jacobite rebellion by Bonnie Prince Charlie 1748 Excavation of Pompeii		NEOCLASSICISM	*c.* 1748 Piranesi, *The Baths of Caracalla* 1749 Fielding, *Tom Jones* 1750-70 Walpole, remodelling of Strawberry Hill
1756-63 Seven Years War 1760-1820 George III king of England	1750		
			1762 Hamilton, *Hector's Farewell to Andromache* 1764 Walpole, *Castle of Otranto* *c.* 1765-70 Adam, Kedleston Hall 1768 Royal Academy founded 1770 West, *Death of Wolfe* 1770-1808 Monticello built for Thomas Jefferson
1775 Beginning of the American Revolution	1775		1781 Gainsborough, 'Perdita' Robinson 1784 Reynolds, 'Perdita' Robinson
1789 French Revolution 1789-97 George Washington first President of United States of America			1791 Death of Mozart 1793 David, *Death of Marat* 1796 Haydn, Mass in Time of War 1798 Wordsworth and Coleridge publish *Lyrical Ballads*
1804 Napoleon becomes Emperor of France	1800	ROMANTICISM	1805 Turner, *The Shipwreck* 1806 Beethoven, Pastoral Symphony
1811-20 George IV regent of England			1814 Goya, *The Third of May 1808* 1814 Dulwich Gallery opened; first art collection open to the public
1815 Battle of Waterloo ends Napoleon's reign; restoration of Louis XVIII			1818 Géricault, *Raft of the Medusa* 1818-20 Blake, Illustrations for the Book of Job 1819 Keats, *Ode to a Nightingale*
1820-37 George IV king of England 1821-32 Greek War of Independence	1825		1821 Constable, *The Haywain* 1824 Death of Lord Byron 1834 Delacroix, *Women of Algiers* 1836 Cole, *The Oxbow*

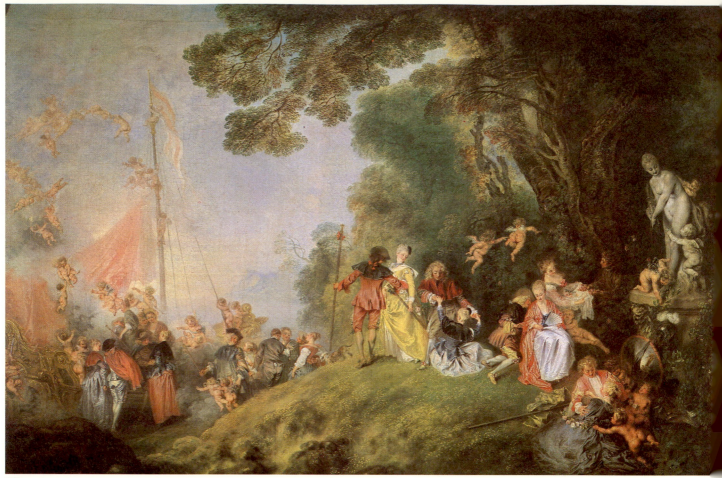

352

353

354

355 Jean-Honoré Fragonard, *The Lovers' Meeting*, 1773. Oil on canvas, 125 × 96 in (317 × 244 cm). New York, Frick Collection

opposite

352 Antoine Watteau, *Embarkation for Cythera*, 1717. Oil on canvas, 50⅜ × 76 in (128 × 193 cm). Paris, Louvre
Cythera was the island of love, birthplace of Venus in Greek mythology.

353 Jean-Baptiste Chardin, *Still-Life with a Bottle of Olives*, 1760. Oil on canvas, 28 × 38½ in (71 × 98 cm). Paris, Louvre

354 François Boucher, *The Toilet of Venus*, 1751. Oil on canvas, 42⅝ × 33½ in (108 × 85 cm). New York, Metropolitan Museum of Art

sober youth and the eagerly watching child. Transient as the soap bubble, the scene conveys the same sense of impermanency we find in Watteau.

The frothy bubble might be a symbol for the artificial world painted for the aristocracy by François Boucher (1703–70) and his pupil Jean-Honoré Fragonard (1732–1806), who both used the graceful arabesque of Rococo line to create a dream-world as fanciful as that of Watteau, but one that lacks Watteau's awareness of the impermanence of worldly pleasure. Boucher's painting has a harder edge than Watteau's and a more insistent sense of decorative outline. His portrait of Louis XV's mistress Mme de Pompadour as Venus performing her toilette renders the lady with the pink and white prettiness of a porcelain figurine (fig. 354). Its subject reminds us of François Clouet's Mannerist painting of another lady as Venus in her bath (fig. 293), but Boucher's blithe fantasy has none of the discordance between the real and the legendary that we find in Clouet. Unruffled by the fluttering dove (symbol of Venus) or the mischievous cupid at her feet, this goddess causes no disturbing sensations, for she has none of the immediacy of a real figure; it is a picture intended as a flattering background for the lady herself, painted to hang in her private apartments.

We are similarly detached from the tangled affairs of a pair of lovers whose insubstantial story is spread out over a series of panels painted by Fragonard (fig. 355). The forms have scarcely more reality than the story; the figures are drawn with elegantly sinuous curves, but little substance; they melt into the blurred and feathery foliage of the park behind them. The trees in the background resemble the stucco decoration of a Rococo interior more closely than they do real trees in a real French landscape.

The Rococo style's emphasis on elegance and lightness gave it an affinity to the music of Mozart and Haydn, who replaced Baroque dependence on dynamic change with an articulated harmonic structure. In its sophisticated wit, Rococo art also paralleled literature, particularly the writings of the 'Augustan' age in England, when writers like Alexander Pope and Joseph Addison deliberately imitated the cadences of the Latin writers from the time of Augustus. Pope's verses often perform the graceful Rococo arabesque of a line curling back on itself; his satirical *Rape of the Lock* is a mock epic actually on the subject of a curl.

The Rococo fashion in France coincided with a period in England when the liberal, Whig party was in power and popular taste ran against the kind of aristocratic display Rococo was designed to achieve. Rather than imitate the light and illusionistic French classical architecture, the English rediscovered the strict and sober regularity and articulation of the Palladian style introduced by Inigo Jones. The leader of this fashion was the wealthy amateur architect Lord Burlington, who built himself a summer-house near London (fig. 356), modelled on the Villa Rotonda (fig. 282). Despite its imposing and static classicism, this little villa is connected to Rococo's decorative, curling line through the landscaping of

its grounds. When Lord Burlington and his assistant William Kent (1685–1748) laid out the gardens at Chiswick they followed the Baroque ideal of harmonizing building and landscape in a coordinated perspective. But they departed from Baroque geometric formality to follow something closer to the sinuous curves of Rococo. Like the park setting of Fragonard's lovers, the grounds at Chiswick House are full of artful surprises half-hidden by the curling foliage of untrimmed bushes and trees. The more natural lines of Burlington's paths and plantings were praised by Pope, who imitated the style in his own garden at Twickenham. In a poem addressed to Burlington, Pope said:

> To build, to plant, whatever you intend,
> To rear the Column, or the Arch to bend,
> To swell the Terrace, or to sink the Grot;
> In all, let Nature never be forgot.
> But treat the Goddess like a modest fair,
> Nor overdress, nor leave her wholly bare;
> Let not each beauty everywhere be spied,
> Where half the skill is decently to hide.
> He gains all points, who pleasingly confounds,
> Surprises, varies, and conceals the Bounds.
>
> *Epistle to Burlington*, ll. 47-56.

356 Richard Boyle, Lord Burlington, Chiswick House, London, *c.* 1725

The features at Chiswick House that Pope found so natural were really Rococo in their deliberate artifice, consisting of serpentine paths and carefully designed perspectives.

Indoors the Rococo style of decoration did not make headway in England until after mid-century, by which time it was going out of fashion in France. Then a curling arabesque in stucco was popularized by Robert Adam, and the delicate lines of Louis XV furniture found an English counterpart in the work of Thomas Chippendale. As late as 1775 the owner of Osterley Park commissioned Adam to design a room for a set of Rococo tapestries from the Gobelins factory in France, woven from Boucher's series of paintings on the loves of the gods.

Rococo painting in the style of Boucher and Fragonard was never popular in England. But there was one really original Rococo artist in England who upheld the serpentine line as his ideal of beauty. William Hogarth (1697–1764) was a painter well in tune with the satirical wit of Pope, but he did not share Pope's taste for symmetry and balance and hated the Palladian style of architecture. Although he was Thornhill's son-in-law, Hogarth was never at home with large decorative mural painting, preferring smaller canvases on subjects neither history nor genre. His paintings share the wit and morality of Fielding's novels. He developed a highly individual style out of the serpentine Rococo line mixed with the art of caricature, which accentuates distinctive features. His was a style well suited to engraving and — like Dürer before him — he found he could

357 William Hogarth, *Captain Thomas Coram*, 1740. Oil on canvas, 94 × 54 in (239 × 137 cm). London, Thomas Coram Foundation

Overleaf

358 Canaletto, *Bacino di S. Marco* (Basin of Saint Mark's), *c.* 1745. Oil on canvas, 49⅛ × 60¼ in (125 × 153 cm). Boston, Museum of Fine Arts

359 William Hogarth, 'The Contract', from *Marriage à la Mode*, 1743–5. Oil on canvas, 27 × 35 in (68.5 × 89 cm). London, National Gallery

360 Interior of the church of Melk Monastery, Austria, completed about 1738, after designs by Prandtauer, Beduzzi, and Munggenast

361 The Kaisersaal in the Bishop's Palace (Residenz) at Würzburg, designed by Johann Balthasar Neumann, 1749–54. Ceiling fresco by Gianbattista Tiepolo, 1751–2

make a living independent of patrons by selling engraved copies of his paintings. His satirical wit reflects the taste of the hard-working middle class; particularly popular were series like *Marriage à la Mode*, in which he lampoons the willingness of impecunious aristocrats to force their heirs into loveless marriages with the daughters of wealthy merchants. Like Fielding, he protested against the artificiality of society's manners. The proud earl showing off his lineage in figure 359 is reduced to selling his title in this fashion because he has wasted his fortune in building a new Palladian mansion, seen through the window. Hogarth disliked the Palladian style because it was unnatural; he made his opposition to the classical theories of the Burlington circle clear in his treatise, *The Analysis of Beauty*, published in 1753. Here he stated that beauty in both nature and in art lay in undulating, irregular curves and in variety, not in symmetry. This was the very theme expounded by Pope in praise of Lord Burlington, but neither Pope nor Burlington was prepared to jettison classical symmetry in favour of irregularity in art and architecture. They and like-minded theorists were caught between a desire for rules and definitions on the one hand and spontaneous appreciation on the other.

In insisting that natural form was the paradigm of what we perceive as beautiful in art, Hogarth was ahead of his time; it was a theme English art was to rediscover later. His highly original portrait of Captain Coram (fig. 357), the benefactor of the new Foundling Hospital in London, brings nature and personality together in a new and romantic style of portraiture. Unusually grand for a portrait of a non-aristocrat, it was the forerunner of the dramatic and highly successful style popularized by Sir Joshua Reynolds in the second half of the century.

Late Baroque

Rococo was a style in conscious retreat from the universality of the Baroque. In Italy and Germany a late Baroque style survived well into the eighteenth century; although lightened and clarified by French influence, this style maintained the dynamic totality and the theatrical illusionism of high Baroque art and architecture.

The flow from high to late Baroque style is easily followed in Germany, where artistic development had been halted by the religious struggles of the Thirty Years War, so that high Baroque did not arrive until the very end of the seventeenth century. At this point the transition from the ornamental elaboration of late Gothic to similar forms of Baroque was made easily; we find in German Baroque buildings a feeling for lightness and prettiness that led into the light sophistication of late Baroque. At Melk Abbey in Austria, for example, the abbey church (fig. 360) was modelled on Il Gesù, with chapels opening from the nave arcade, but the interior strikes a peculiarly Gothic-Baroque note in the gallery level. From

358

359

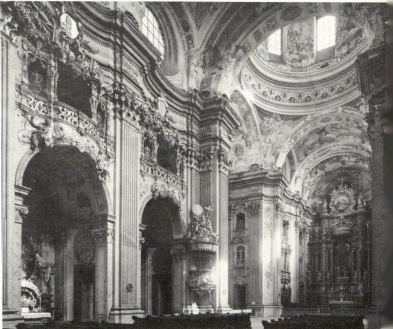

360

the Early Renaissance through to the Baroque, church designs omitted the gallery or triforium, which tends to disrupt the unity of space in an unclassical manner. Here a gallery was included, but it achieves an air of sophistication, opening out between the nave piers like boxes at a theatre. The undulating curves of high Baroque appear in the contrast between the convex bulge of the gallery openings and the concave motion of the entablature above. In the vaults, the complex interplay of rhythms opens into illusionistic painting derived from Cortona and Gaulli. Despite the heavy encrustation of ornament, there is an airy elegance about this church that has much in common with Rococo design.

Further west — and nearer to France — we find an outbreak of late Baroque illusionism that has much in common with the Rococo retreat from mass and solemnity, but which maintains the high Baroque intention of involving the viewer totally in its drama. In the Bishop's Palace in Würzburg, the term 'organic' is almost literally applicable, for the decoration appears to sprout from the architecture. Late Baroque art maintained the deliberate confusion of high Baroque between grounds and between painting, sculpture, and architecture. At Würzburg the visitor is drawn into the style's playful fantasies; in the cream and gilt Kaisersaal (fig. 361), architecture and stucco carving melt into the painted ceiling.

The painter of the illusionistic ceilings at Würzburg was a Venetian artist, Giovanni Battista Tiepolo (1696–1770). His style is characterized by bright colour and softness descended from Titian and Giorgione. He shows the wit of his age in many playful touches; in the Kaisersaal, for example, he painted a dog on the head of a column in place of a statue.

Tiepolo's colourful, poetic charm was part of a final flowering of the Venetian school in a late Baroque burst of light and atmosphere. His contemporary Giovanni Antonio Canaletto (1697–1768) shared his feeling for bathing a scene in the warm glow of a summer afternoon. Canaletto, however, was a painter of topographical views rather than fantasies. The aristocrats and wealthy bourgeois who travelled through Italy on the Grand Tour wanted paintings that would remind them of the places they had seen; at the same time, since their taste was based on the ideal landscapes of Claude Lorrain, they wanted more than just an accurate record of buildings and lagoons. Canaletto was particularly successful in blending the recognizable with the ideal; in figure 358 we can see the Doge's Palace on the left, and Palladio's San Giorgio Maggiore in the distance. Yet Canaletto's Venice is spread out in a vast, dreamy world of light and atmosphere more imaginary than real.

The fantastic illusionism of Tiepolo and the topographical details of Canaletto come together in the views painted by Francesco Guardi (1712–93), who invested his scenes with romantic trappings such as ruins dripping with moss and vines to create an atmosphere of mystery. Such scenes as figure 363 are more fanciful than real and are called *capricci* (caprices), meaning deliberate inventions or fancies. In the eighteenth

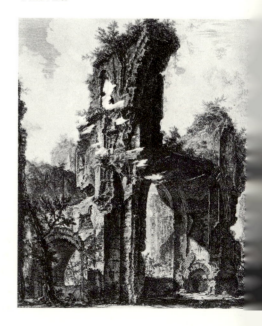

362 Giovanni Battista Piranesi, the Baths of Caracalla, from *Views of Rome*, 1761. Etching, $17\frac{1}{4} \times 27\frac{3}{8}$ in (43.8×69.5 cm). Boston, Museum of Fine Arts

century this whimsical introduction of the unexpected into a real scene became a popular motif.

The Picturesque

363 Francesco Guardi, *Caprice with Ruins on the Seashore, c.* 1780. Oil on canvas, 14½ × 10¼ in (37 × 26 cm). London, National Gallery

The mysterious atmosphere of Guardi's painting reflects a romantic attitude towards the subject that grew fashionable in the second half of the eighteenth century. Obscurity and mystery became ends in themselves, as artists attempted to arouse emotion by inducing the viewer to fill in from his imagination the missing elements. Ruins and wild scenery had fascinated artists of earlier ages. But it was in the rational and scientific Age of Enlightenment that the appeal of ruins became a mania. The English were attracted by the etchings of Giovanni Battista Piranesi (1720–78), who mixed a genuinely archaeological interest in Roman remains with a hauntingly romantic atmosphere of gloom and decay (fig. 362). Piranesi's capricci led the English to desire actual ruins. Early in the century Vanbrugh had tried to save the old manor house at Blenheim, in vain; the duchess had it pulled down. By the middle of the century Englishmen were actually building new 'ruins' to provide a romantic atmosphere in their parks.

The term 'picturesque' appeared early in the century to describe natural scenery that had the same appeal as a painting, especially one by Claude Lorrain. Later in the century taste swung towards wilder scenery that recalled Claude's contemporary Salvator Rosa, whose paintings seemed to arouse a sense of awe and mystery through their dark obscurity. It was Edmund Burke who first attached this quality in art to the Classical concept of the Sublime, a term taken from rhetoric and characterized by the highest emotions, such as the pity and fear aroused by Greek tragedy. Burke says:

> To make anything very terrible, obscurity seems in general to be necessary. When we know the full extent of any danger . . . a great deal of the apprehension vanishes . . . In painting a judicious obscurity in some things contributes to the effect of the picture; because the images in painting are exactly similar to those in nature; and in nature dark, confused, uncertain images have a greater power on the fancy to form the grander passions than those have which are much more clear and determinate.
>
> *A Philosophical Enquiry into the Origin of our Ideas of the Sublime and the Beautiful*

By the end of the century, in the codifying fashion typical of the age, *Picturesque* was defined by Uvedale Price as a quality separate from Beauty — which he said involved a finished, polished, and crafted form — and from the Sublime, which arouses emotional experience of the highest sort. The Picturesque fell between these two, being something which, in Price's words, 'has strong attractions for the painter, and yet is neither grand nor

Beautiful'. Thus ruins, having no longer the beauty of polished line and form of the original edifice, but still excercising an aesthetic appeal, were seen as quintessentially picturesque.

The Picturesque as an aesthetic end in itself appeared in English landscape gardening. Laying out the grounds of an estate developed from the Rococo naturalness introduced by Lord Burlington to the wide lawns and carefully planted 'clumps' of trees favoured by the popular mid-century gardener 'Capability' Brown and thence to a more genuinely picturesque wildness. The imaginative delights provoked by wilderness and ruins, which avoided the more arduous extremes of Beauty and the Sublime, appeared in literature and painting throughout the second half of the century.

Medieval Mania

The romantic imagination of the period, which delighted in surprising twists of landscape and decaying ruins, brought a new appreciation for the atmosphere of the past. Fancy was stimulated not only by ancient Greece and Rome, but also by the Middle Ages, which brought about a revival of interest in Gothic art. In the second half of the century, buildings were constructed with the irregular angles and turreted shapes of medieval castles. In 1750 the writer and critic Horace Walpole began remodelling his house at Strawberry Hill into a part Gothic, part Oriental, and wholly Picturesque affair of sprawling, irregular, asymmetrical parts (fig. 364). At the end of the century William Beckford had the architect James Wyatt (1746–1813) build Fonthill Abbey, a romantic extravagance with a tower 230 feet high (fig. 365). Beckford began Fonthill as a folly, designed to simulate the remains of a medieval priory; he kept adding to it, until in 1807 he decided to make the abbey his home. Soon after it was completed, by which time its eccentric owner had sold it, the insufficiently founded central tower collapsed, leaving its new owner with a genuine ruin.

Both these buildings shared a fairy-tales quality that derived from their being based on literary and pictorial sources more than on actual remains of medieval architecture. The exotic appeal of the Middle Ages enhanced the popularity of the novels of Sir Walter Scott and the 'Gothick' novels of Ann Radcliffe and Horace Walpole. The most spectacular example of the medieval craze in literature was a hoax perpetrated by a Scotsman, James Macpherson, who 'discovered' and 'translated' numerous Gaelic verses actually his own invention, which he claimed to have been written by an ancient Gaelic bard named Ossian. These fables, many of them based on existing poems, were accepted as genuine until after Macpherson's death; Ossian was hailed by the gullible as the equal of Homer. As with the revival of medieval architecture, scholarly interest came later, aroused by the romantic appeal of a far-off, misty, and half-forgotten past.

364 (*below*) Horace Walpole, Strawberry Hill, remodelled 1750–75. Twickenham, London

365 (*bottom*) James Wyatt, Fonthill Abbey, 1795–1807 (demolished). Engraving, *c.* 1822, by J. and H.S. Storer William Beckford, the eccentric millionaire who built Fonthill, was also a writer, and published a 'Gothick' novel, *Vathek*, in 1786

Classical Revivals

At the same time that romantic strains found expression in mysterious and shadowy picturesque forms, a reaction to late Baroque and Rococo hedonism encouraged a new surge of classicism in a movement centred on Rome, where all the travelling noblemen and dilettante scholars gravitated, and where a circle of artists from other countries settled. Though it grew out of the same romanticization of the past as the medievalism of the Picturesque, the Neoclassical movement was shaped by a more scholarly interest in actual examples, fuelled by the excavations of the ancient Roman cities of Herculaneum, begun in 1738, and Pompeii, begun in 1748. Their vast wealth of sculpture and wall painting remained remarkably well-preserved, buried beneath the ashes of Vesuvius since AD 79. By mid-century travel had improved enough for the ordinary (though hardy) traveller to visit the remains of temples and theatres in the ancient Greek colonies in Sicily and the south of Italy. In 1755 two Englishmen, James Stuart and Nicholas Revett, returned from a trip to Athens. Their reports led to the recognition of a distinction between ancient Greek architecture and its Roman derivatives. So, while the interest in reviving medieval atmosphere remained poetic and painterly, drawing more on imagination than on actual examples of Gothic architecture, Neoclassicism was infused with a thirst for factual knowledge.

The antiquarians were mostly wealthy amateurs, however, and were fonder of impressive results than of accuracy; a really scholarly revival of Classical architecture was left to the next century. The attitude of these dilettanti can be seen from the fact that a dealer in Rome who acquired an excellent torso of an ancient Venus, found by the painter Gavin Hamilton in the vaults of the Palazzo Barberini, was both perspicacious and unscrupulous enough to add to it a head from another statue, realizing that his wealthy clientele would never want a headless torso. The statue was bought by an Englishman, William Weddell, who valued it highly even after he knew the truth of its 'restoration.' (see fig. 366).

Greek taste became a fashionable rage; women wore their hair in a Greek mode and dressed in costumes à la Grecque; a Greek style of furniture appeared, and the English potter Josiah Wedgwood created a Greek-inspired style of pottery that is still popular. A rival interest in Roman design influenced the English architect Robert Adam, who built a Roman sculpture gallery for William Weddell in which to house his recapitated Venus (fig. 366). In the main, Neoclassical architecture was eclectic, mixing Greek Doric and Ionic porticos with Roman rotundas and employing the long-accepted classical vocabulary of pilasters, niches, mouldings, pediments over doorways, and windows framed with columns. The quest for the past was a mixture of scholarly zeal and romantic imagination that wanted anything as long as it was exotic and surprising.

366 Robert Adam, Sculpture Gallery, Newby Hill, Yorkshire, c. 1765
The statue on the left is the Weddell Venus.

367

368

369

367 Angelica Kauffman, *Virgil Reading To Augustus and Octavia*, 1788. Oil on canvas, 48 × 61¾ in (122 × 156.5 cm). Leningrad, Hermitage

368 Jean-Baptiste Greuze, *The Village Bride, c.* 1760. Oil on canvas, 36¼ × 46⅛ in (92 × 117 cm). Paris, Louvre

369 Gavin Hamilton, *Hector's Farewell to Andromache*, 1788. Oil on canvas, 10ft 4in × 13ft 1in (315 × 399 cm). On loan to the University of Glasgow from the Duke of Hamilton

370 Jean-Antoine Houdon, *Diana*, 1780. Marble, 82¾ in (210 cm). Lisbon, Gulbenkian Foundation

There was no real separation of romantic from classical taste in this period; the antiquarian Richard Payne Knight built himself a medieval castle but furnished it with a Neoclassical interior in order to have, he said, 'the advantage of a picturesque object and of an elegant and convenient dwelling'. Imagination and fancy rated high with both medievalists and classicists; the adulation bestowed upon the Ossian poems was paralleled by a passion for Homer's epics; Dante, criticized by the Augustans for his medieval obscurity, was greatly admired in the second half of the century for his imaginative visions of the supernatural.

Greek and Roman architecture found favour as part of a reaction against the worldliness and artificiality of Rococo elegance. The Neoclassical movement was strongest in Rome, where a group of foreign artists settled and turned their knowledge of antique art into a new style of painting. They rejected the illusionism and chiaroscuro of the late Baroque and Rococo styles in favour of a hard outline and simplified composition. Their subjects changes from the Baroque tales of high conquest and apotheosis to focus on acts of individual heroism and devotion to duty, themes closely identified with the values of the rising middle class. Gavin Hamilton (1723–98) depicts such a moment in his *Hector's Farewell to Andromache* (fig. 369). Here Hector is setting out to do battle with the Greek hero Achilles; we know he is going to his death. Hamilton's style is deliberately plain, unsoftened by any chiaroscuro; the accurately rendered Doric temple in the background was intended to emphasize the stern, masculine strength and fortitude shown by Hector's resolution.

Despite the determination of the Neoclassical painters to get away from the pretty triviality of Rococo, the influence of its soft beauty was still strong, as we can see in the painting of Angelica Kauffman (1740-1807). In figure 367 she verged on sentimental genre; Octavia is so moved that she swoons, while the poet stands abashed, scolded by Octavia's female companion. Kauffman's style is more painterly and softer in its outlines than that of Gavin Hamilton. In the last quarter of the century we find this soft-edged Neoclassicism replacing Rococo as the fashionable style in France. The expression of the *Diana* (fig. 370) by Jean-Antoine Houdon (1741–1828) is classically severe and remote, but the figure is akin to Boucher's Venus; both are descended from the long-legged nymphs of the school of Fontainebleau.

The Neoclassical emphasis on duty and moral action found favour with members of the hard-working and ambitious middle classes who thronged the annual Salons given by the French Academy. Since the Salons were firmly in the control of the Academy's officials, the shift in taste from Rococo to Neoclassicism indicates the increasing weight of the middle class as a factor in the art market. Their taste for moralizing and propriety, not unmixed with sentimentality, was well satisfied by the genre paintings of Jean-Baptiste Greuze (1725–1805), which express an anti-aristocratic praise of simple virtue in sentimental scenes of village people. Such scenes

as *The Village Bride* (fig. 368) echoed Neoclassical emphasis on moral behaviour and, by contrast, served to point up the licentiousness of the court. The effect is somewhat undercut, however, by the extreme sentimentality of the treatment and by the Rococo voluptuousness and softness of the figures. The Neoclassical movement was unable to free itself from the Rococo conventions it was trying to reject and never found a really satisfactory combination of antique forms and modern themes.

Classical Romanticism and the English Gentry

For both classicists and romanticists, the attitude towards nature was half admiration for nature untamed, manifestation of God and man's best teacher, and half a belief in man's ability to improve nature by his careful and rational handiwork. The clearest manifestation of this rational romanticism, or romantic rationalism, was seen in England in the style of life of the aristocrats and the gentry, whose houses built by Robert Adam and whose portraits by Reynolds and Gainsborough leave us with the impression of a perfect balance between natural man and educated man. In his novel *Tom Jones* (1749), Fielding satirized the too-earthy and uncultivated landowner in the character of Squire Western, lampooned an unquestioning parroting of learning in Tom's rival Mr. Blifil, and criticized the over-elegant and lascivious life of London society, against which Tom stands out as the honest innocent who manages to learn a greater sense of responsibility and ambition from his experiences without losing his natural charm.

The beauty of nature balanced with human industry is the theme of James Thomson's poem *The Seasons*, published between 1726 and 1730 and revised in the 1740s. Praising agricultural cultivation of the land that results in the harvest which ensures a comfortable winter, Thomson contrasts the hardships of a primitive savage with the safety and warmth of the well-provided, industrious farmer and landlord. He goes on to draw into the natural turn of the seasons the growth of British commerce and industry, which he saw as raising the standard of living to the best of all possible worlds through a judicious and inventive use of the earth's natural resources.

The standard of living Thomson praised so eloquently came to be realized in the many country houses of the aristocracy and gentry built in the Georgian period. The exemplar of the Neoclassical taste in architecture of the 1770s was Robert Adam, who created an elegant, rational style from the severe Palladianism of the Burlington circle, the more relaxed sophistication of Rococo, and antique Greek and Roman remains.

371 Thomas Jefferson, Monticello, Charlottesville, Virginia, 1796-1806

372 Robert Adam, Kedleston Hall, Derbyshire, south façade, *c.* 1761

373 John Wood the Younger, Royal Crescent, Bath 1767–75

374 Robert Adam, Drawing Room, Kedleston Hall, *c.* 1761

375 Robert Adam, Great Hall, Kedleston Hall, *c.* 1761

373

371

372

374

375

Adam's classicism was at the same time lighter and more grandly impressive than the stiff formality of the earlier Palladian houses. At Kedleston Hall, in Derbyshire, his preference for Roman architecture accorded with the taste of its owner, Sir Nathaniel Curzon. In his design for the garden façade (fig. 372), Adam combined the plasticity of Baroque architecture with the solidity and mass of Roman construction. The dome and the curving staircase are close to the design of a French Baroque château, Vaux le Vicomte, built by Le Vau and Le Nôtre, but the central block at Kedleston derives from the Roman triumphal arch of Constantine (fig. 48).

Inside, Adam designed an imposing entrance hall (fig. 375), dominated by vast marble pillars. Around the walls he placed niches for the owner's collection of antique sculpture, including the inevitable cast of the Apollo Belvedere. The austerity of the design is relieved by the colour of the columns and inlaid marble floor, and by the painted stucco and friezes. Adam's use of delicate stucco foliage carving on walls and ceilings was based on Roman decoration (see fig. 34). Its curling line is also akin to Rococo ornament, but Adam never allowed his decorative carving to confuse the articulation between wall, moulding, and ceiling.

Part of the Adam effect, both grand and gracious, comes from the fact that he created the whole décor, including the furniture, where he displayed the same ingenuity in adapting classical style to comfort and function (fig. 374). Architecture, decoration, and furnishings work together to create an environment that is both impressive and comfortable. The practical yet elegant Georgian style is visible not only in the great country houses, but also in the rows and crescents of brick or stone-faced town houses built for the upper middle class and the gentry. Here ornament was used to blend the houses in a row together, rather than for obtrusive individual effects. In Bath's Royal Crescent (fig. 373), the repeated Ionic columns create a visual sweep around the ellipse of façades. The crescent shape creates a dramatic effect, and one that is in harmony with its landscape.

The Georgian style of architecture spread to the American colonies before the Revolution, when life along the eastern coast had reached a stable degree of prosperity and culture. The Enlightenment philosopher, statesman, and amateur architect Thomas Jefferson used the Palladian model of Chiswick House for his own home at Monticello (fig. 371), although after the Revolution he altered it in a manner deliberately un-English, drawing directly on the influence of Roman villas. Adam's feeling for exteriors in natural brick and stone and his interior decoration influenced the style of houses in Colonial America.

The Grand Manner: English Painting

The English landowners who lived in the gracious houses built by architects like Adam were fortunate in having, at last, a native school of painters who could capture their character and self-esteem in a style of portraiture closer to the grand manner of the Renaissance and the Baroque than anything England had produced before. The circle of artists around Sir Joshua Reynolds (1723–92) made the greatest possible virtue of necessity; believing in the superiority of history painting, they had to make their living by painting portraits. Not to be inhibited by the limitations of portraiture, Reynolds and his followers put into it as much of the highly idealized style they admired in Renaissance history painting as was consistent with capturing a real likeness.

The grand manner that Reynolds successfully developed from High Renaissance, Mannerist, and Baroque models reflects his high ideals for the status of art and artists. He was, as Hogarth was not, a member of the most exclusive intellectual circles of his time and was influential not only in the founding of the English Royal Academy of Art but also in securing its independence from both the crown and the dilettante aristocrats. Reynolds was the first president of the Academy and guided it firmly into the paths of classical theory. Yet the theories expounded in his annual discourses to the Academy belie the deliberate sensationalism of his style, even in ordinary portrait commissions. For he and his colleagues favoured the Picturesque and the Sublime, which necessarily removes an artist from the defined boundaries of classical painting into the shadowy and the mysterious. For all the clarity of form he preached in his discourses, Reynolds's own style was derived from the bravura of Rubens and the grand scale of Michelangelo. He set his famous portrait of Commander Keppel (fig. 376) not in a cultivated parkland, but in the vast and lonely wastes of a rocky shore; in the background the expanse of stormy sea stretches to merge with an ominous sky. Even the pose raises the subject above the level of an actual individual, for it was borrowed from the Apollo Belvedere, reversed.

Reynolds's determination to achieve the lofty scale of history painting in his portraits becomes particularly clear when we compare him with his contemporary, Thomas Gainsborough (1727–88). Gainsborough's style has much of the Rococo arabesque of line; he handled a subject with grace and with a feeling for the harmony between the sitter and a landscape. His portrait of the actress 'Perdita' Robinson (fig. 377) places her in a sunny park which is picturesquely overgrown but not at all sublime; the tree behind her makes a natural frame for the lady and her dog.

Reynolds's portrait of the same actress is vastly more dramatic; he sets her at a sharp angle, turned away from us so that we see her tilted profile (fig. 378) Like Commander Keppel, she is set against a stormy seascape.

376 Sir Joshua Reynolds, *The Hon. Augustus (later Viscount) Keppel*, 1753–4. Oil on canvas, 91¾ × 57½ in (233 × 146 cm). Greenwich, National Maritime Museum

377 (*left*) Thomas Gainsborough, '*Perdita*' *Robinson*, 1781. Oil on canvas, 90 × 60¼ in (229 × 153 cm). London, Wallace Collection

378 (*below*) Sir Joshua Reynolds, '*Perdita*' *Robinson*, 1784. Oil on canvas, 30½ × 25 in (77 × 63 cm). London, Wallace Collection Mrs Robinson earned the nickname '*Perdita*' for her success in that role in Shakespeare's *Winter's Tale*.

379 (*left*) George Stubbs, *Lion Attacking a Horse*, 1770. Oil on canvas, $40\frac{1}{8} \times 50\frac{1}{4}$ in (102×127.6 cm). New Haven, Conn., Yale University Art Gallery, gift of the Yale University Art Gallery Associates

380 (*below*) Thomas Gainsborough, *River Landscape with Figures in a Boat*, *c.* 1768–70. Oil on canvas, $47 \times 66\frac{1}{4}$ in (119×168 cm). Philadelphia, Museum of Art

This work is close to achieving sublimity; while Gainsborough's version conveys his feeling for outline and painterly beauty, Reynolds's work is charged with energy and individual personality.

George Stubbs (1724–1806) was chiefly popular for painting the thoroughbred horses of the aristocracy, but in his several versions of a horse attacked and killed by a lion, he invoked the full terror of the Sublime. Figure 379 reflects a statement from Burke's *Philosophical Enquiry* that the mere sight of something terrible can produce intense feelings in the spectator. Stubbs's intentions in arousing our feelings of pity and terror clearly go beyond those of Rubens in the *Lion and Tiger Hunt* (fig. 318). We are not frightened by Rubens's drama, since its realism of painterly detail does not constitute a realism of scene. Here we are fully aroused to the fate of the horse because Stubbs did not stop at portraying skin and bones and muscle; we are convinced of a real danger threatening the animal. Nothing in the picture goes against nature, however dramatized; even the thunderstorm that adds to the victim's terror is a natural force.

Towards the end of the century, landscape painting was stimulated by the Picturesque movement and came to reflect the appeal of a dark and savage nature. William Gilpin, a clergyman of independent means, toured the wild mountains of Derbyshire and the Lake District and extolled their picturesque beauties in a series of guidebooks. Engraved prints of landscape paintings were widely sold. The English poets expressed an early Romantic appreciation of scenery and its ability to stimulate the imagination. Figure 380 shows attractively romanticized peasants pursuing their occupation in a harmonious relationship to the woodland surrounding them. There is a sense of mystery, but we are not moved by any intense feelings; rather, we are stimulated to fill in from our imagination the details so deliberately obscured. In just the same manner, in his famous Elegy, the poet Thomas Gray evoked the eerie, but hardly terrible, atmosphere of a country graveyard to stimulate imaginative reverie.

Emotional intensity belonged most naturally to the idealized storytelling of heroic action in a history painting, yet the Neoclassical histories of Gavin Hamilton's circle are undeniably dry and lacking in feeling, and Reynolds was no more successful in capturing genuine emotion in his attempts at history painting. It was the American artist Benjamin West who fused Neoclassical principles with a more expressive romanticism in the one really original history painting of the period, his *Death of Wolfe* (fig. 381). In this work West clothed his figures not in the classical garments of a traditional history painting but in their proper uniforms. Yet he made it clear that he was not merely recording the actual event by his careful posing of figures to idealize the action. Wolfe, shot just as he hears the news that his troops have taken Quebec, swoons in the arms of his soldiers in the posture of the dead Christ in a Pietà; the deliberate introduction of religious symbolism intensifies the emotional impact. West added the figure of an Indian, departing from factual truth, to stress the symbolic

force of the New World setting; this and the vast, wild landscape lift the individual heroism of a soldier dying in action to a more universal scale. Wolfe's immortality is not left to the verdict of history alone.

What West did in this painting was to fuse two separate traditions. Poussin had already turned a contemporary event, a story of a man fatally bitten by a snake, into a history painting, but he put his subject in classical costume to transfer the actual story to a mythological frame. On a different level, actual victories had been commemorated as important events, but as contemporary history, not as idealized mythologies. By merging these two strands — the idealized and the factual — West created a new type of history painting. Quite against his intentions, for he was a conservative classicist, he opened the way for a radical new treatment of the whole idea of history painting by the Romantics of the next generation.

381 Benjamin West, *The Death of Wolfe*, 1770. Oil on canvas, $59\frac{1}{2} \times 84$ in (151 × 213.4 cm). Ottawa, National Gallery of Canada

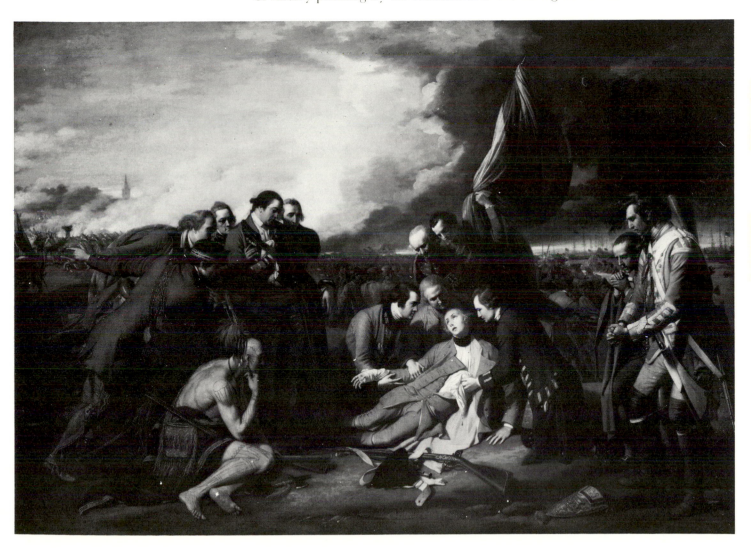

CHAPTER 12

Revolution and the Romantic Movement

Between the age of the Enlightment and the Romantic period lies the watershed of the French Revolution of 1789. The American Revolution over a decade earlier was an Enlightenment war fought for rational principles and the overthrow of an oppressive government, not of social order. It stimulated hopes for a more widespread liberation of common people from the oppressions of aristocracy, government, and the Church. The French Revolution was greeted at first with the optimistic expectation that it would parallel the American experience. But it was a far more extreme overturning of the old order, genuinely a revolution. The first bold bid for constitutional government on the part of liberal aristocrats and bourgeois was followed by massacres during the Reign of Terror; order was re-established only by a new despotism more dangerous than the old regime. The violence of events created a gulf between reason and imagination, a gulf that cut the nineteenth-century Romantic movement off from the rational romanticism of the Enlightenment. Although it grew out of eighteenth-century romantic trends, from 1800 Romanticism was a radical movement divorced from rationalism or moderation, espousing the cause of individual freedom and imagination.

Romantic art was not a single style, but several different approaches sharing themes that are also found in Romantic poetry and philosophy. The Romantics longed for the religious faith of the Middle Ages, but could not find its equivalent within the rational piety of either Catholic or Protestant Christianity. The failure of the established religions either to satisfy society's need for emotional outlet or to secure social justice is reflected in expressions of anxiety and frustration that welled up throughout the nineteenth century. One manifestation of the period's dissatisfaction was an exaggerated devotion to the Middle Ages as a period when religion did provide both emotional satisfaction and stability. Another was the substitution of creative vision for religious experience. The dry rationalism of the Church could not respond to people's desire to be moved deeply, and so

the Romantic age found its god in nature. The post-French Revolution Romantic dealt in extremes; his pantheistic divinity was both beneficent and terrible, muse and destroyer:

> Nature, like the Sphinx, is of womanly celestial loveliness and tenderness; the face and bosom of a goddess, but ending in claws and the body of a lioness. There is in her a celestial beauty ... But there is also a darkness, ferocity, fatality, which are infernal ... Nature, Universe, Destiny, Existence, howsoever we name this grand unnameable Fact in the midst of which we live and struggle, is as a heavenly bride and conquest to the wise and brave, to them who can discern her behests and do them; a destroying fiend to them who cannot.
>
> THOMAS CARLYLE, *Past and Present*

The Romantics valued the imagination above all else, and among the visual arts it was only painting, which can achieve the hallucinatory indefiniteness of forms the Romantics associated with imagination and fancy, that was drawn directly into the main Romantic movement. Sculpture remained Neoclassical in form and theme, while architecture entered a period of scholarly revivals of past styles connected to the Romantic interest in history, but not part of the Romantic emphasis on creative imagination.

The aims of the Romantic painters were first formulated by German artists who chose to call themselves Romantics in allusion to the medieval tales of chivalry, or romances. But the Romantic vision blossomed everywhere virtually simultaneously. The poets, painters, and thinkers in various parts of Europe and America were united less by communication with each other than by a common background of nostalgia for the past, both Classical and medieval, by a widespread heightening of sensibility, and by a reaction to established order that was brought about by the French Revolution and the Napoleonic Wars. Although the Romantics expressed their belief in the commonality of all the arts, real sharing of ideas between painters, poets, and composers was the exception rather than the rule. There were striking parallels between painters and poets who never knew each other's work, and even where connections did exist — as between Constable and Wordsworth, who met at least once and who professed to admire each other's work — their similarity of vision came not from shared thoughts but from a common background in the Picturesque and the Sublime and from eighteenth-century philosophy that stressed man's innate capabilities over the value of education and experience.

Romantic art was a movement of many styles grouped around common themes. Poets, painters, and composers alike reacted against the self-satisfied complacency of an increasingly bourgeois society by cutting themselves off from the rest of humanity. The act of creating a work became an individual expression of intuition acting on a natural stimulus; the poem, painting, or musical composition expressed its creator's attempt to see past the tangible world and to capture a glimpse of infinity:

> Genius, inspired by invention, rends the veil that separates existence from possibility; peeps into the dark, and catches a shape, a feature, or a colour, in the reflected ray.
>
> HENRY FUSELI, Aphorism 51

The imagination could be stimulated by one of several things: real events, past or present; atmosphere and place; or romance and legend. All the separate experiences flow into one mainstream: the perception of divinity in nature, the harmony established by this perception, and the sense of loss and fragmentation men and women feel when cut off from it:

> Not in entire forgetfulness,
> And not in utter nakedness,
> But trailing clouds of glory do we come
> From God, who is our home:
> Heaven lies about us in our infancy!
> Shades of the prison-house begin to close
> Upon the growing Boy,
> But he beholds the light, and whence it flows,
> He sees it in his joy;
> The Youth, who daily farther from the east
> Must travel, still is Nature's Priest,
> And by the vision splendid
> Is on his way attended;
> At length the Man perceives it die away,
> And fade into the light of common day.
>
> WILLIAM WORDSWORTH, *Ode: Intimations of Immortality*

This theme of man's loss of the harmony existing in nature binds together such disparate stylists as William Blake, John Constable, J.M.W. Turner, Eugène Delacroix, and Caspar David Friedrich.

Revolution and Neoclassicism

The first thing we notice that separates Romantic art from older romanticisms is a new extreme of moral fervour and social concern. Its first appearance was in France, before the Revolution, in the painting of Jacques Louis David (1748–1825). David's style was the culmination of the Neoclassical movement that had begun in Rome in the 1760s, and as such it ought to belong to the Enlightenment. But there is a profound contrast between the sentimental morality of the circle of Gavin Hamilton and the radical intensity of David. David portrayed a severe and demanding world when he exhibited his *Oath of the Horatii* in 1785 (fig. 385). Its subject came from a story, told by Livy and dramatized by Corneille, of three Roman brothers who ended a war between Rome and a neighbouring tribe by volunteering to fight a personal combat with three of the

enemy. David illustrated not the actual fight but a scene in which the brothers swear an oath to their father to offer their lives for their country.

The novelty of the painting is not in the subject, an example of stoical virtue and self-sacrifice not in itself very different from *Hector's Farewell to Andromache* (fig. 369). What was new was the stark, geometrical simplicity of composition. Whereas Gavin Hamilton's painting maintained a Baroque sense of infinite space piled up with figures, David severely limited action and space. From Poussin he had learned the importance of gestures, but he was more economical with them. Only one of the sons appears in detail, opposite his father; the other two are shadowy echoes of their brother's forceful profile. The outward lean of the figures is counterbalanced by the opposing axis of their outstretched arms. There is no dramatic highlighting of expression; the tension is contained in the powerful and sculptural lines of the figures. The background, an enclosed courtyard whose plain Tuscan columns emphasize the masculine strength of the heroes, offers no distraction from the drama. Only the weeping sisters provide a softer, more painterly note. The work was greeted with a storm of approval at the Salon.

The difference between David's style and the softer Neoclassicism of the older generation stems in part from his own political involvement in the Revolution. He was far more radical than the liberal Whigs who welcomed the first stages of civil liberty, and then retreated from the savagery that followed. From the beginning he was an actor, not a spectator; he was among the more radical elements who seized control from the moderates. As a deputy of the Convention, he served a turn as its president and voted for the death of the king. His hero was the Jacobin leader Jean-Paul Marat, whose murder by Charlotte Corday brought about the Reign of Terror. David painted a memorial to his fallen leader with an intensity unparalleled in his work, or in the whole body of Neoclassical painting (fig. 382). *The Death of Marat* is not really Neoclassical in a strict sense. We are not held aloof from the subject, as we are in history paintings like *The Oath of the Horatii.* Instead we view the scene with a shocking directness as if we were witnesses of the murder. Marat still holds the letter Corday had given him to distract his attention; the knife lies where it has fallen on the floor. Marat often worked while soaking in a chemical bath to relieve a painful skin ailment, and David had seen him thus only the day before he died. The impact of direct reportage comes from the freshness of his memory. Only the simple testament written on the upturned box that served as Marat's desk departs from the photographic realism of the scene. But the stark composition, blocked out in geometric cubes, is icily controlled. The very coolness conveys David's feeling; nothing extraneous is allowed to interfere with our impression. As West had done in *The Death of Wolfe* (fig. 381), David heightened the meaning by calling on our associations of religious martyrdom, posing Marat in the manner of Christ in a Pietà, but without the faintest trace of sentimentality or deliberate emotionalism.

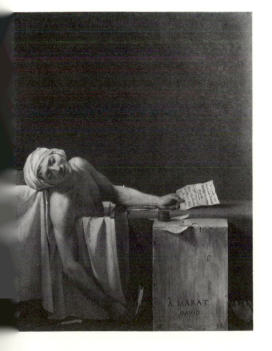

382 Jacques-Louis David, *The Death of Marat*, 1793. Oil on canvas, 65 × 50⅜ in (165 × 128 cm). Brussels, Musée Royal des Beaux-Arts

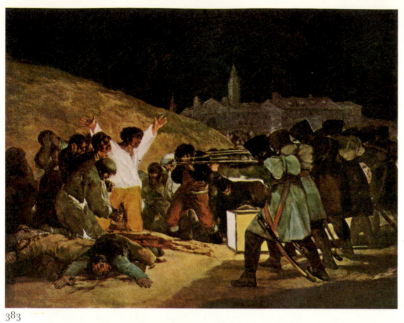

383

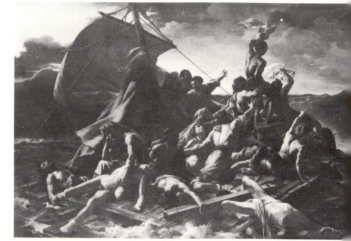

384

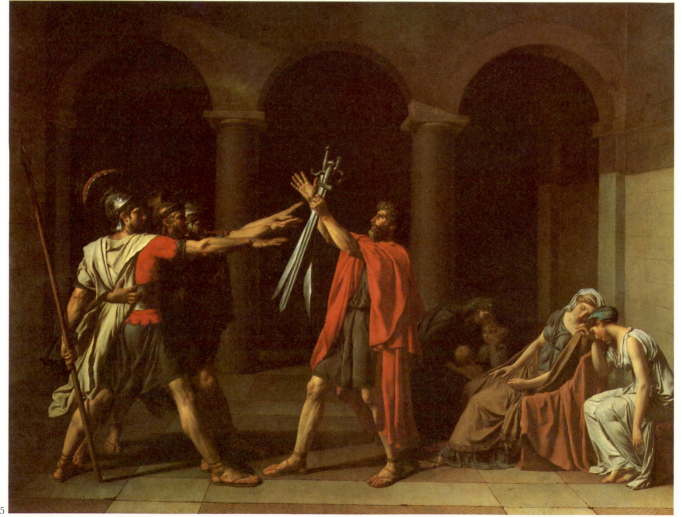

385

383 Francisco Goya, *The Third of May, 1808*, 1814. Oil on canvas, 104¾ × 135¾ in (266 × 345 cm). Madrid, Prado

384 Théodore Géricault, *The Raft of the Medusa*, 1818–19. Oil on canvas, 163 × 281¾ in (419 × 716 cm). Paris, Louvre

385 Jacques-Louis David, *The Oath of the Horatii*, 1785. Oil on canvas, 131 × 167¼ in (330 × 425 cm), Paris, Louvre

386 Jacques-Louis David, *Napoleon Crossing the Alps*, 1801. Oil on canvas, 106¾ × 91¼ (271 × 232 cm). Paris, Palace of Versailles

The Napoleonic Legend: Hero and Reaction

Napoleon rose to power in 1799 in the vacuum left by the failure of the revolutionaries to form a constitutional government; France was in economic ruins and at war with half of Europe, so it seemed that only a strong dictator could save the country. He was made consul for life in 1802; in 1804 he crowned himself emperor. The Romantic movement outside France, its optimism seared by the failure to achieve common liberty, found the tyrant an object of hatred and fear. But his successes made him a hero in France, and the arts were pressed into creating a new legend.

Napoleon himself favoured Neoclassical art and architecture; such monuments as the Arc de Triomphe (fig. 387) were intended to evoke the grandeur of imperial Rome. He made David his first painter, and it is symptomatic of the about-face required of many Frenchmen that the leading artist of the Revolution faithfully served the man who had destroyed it. David painted several portraits of Napoleon and a huge canvas depicting the emperor's coronation, but he never regained the intensity and vitality of *The Oath of the Horatii* or *The Death of Marat*. Neoclassicism could successfully reflect the struggles of common people seeking liberty, but the portrayal of Napoleon as a classical hero was patently absurd, for Napoleon was closer to the Romantic ideal of hero as exemplified in Goethe's *Faust*. Whereas Hercules, the paradigm of the classical hero, achieved legendary feats within the frame of human capability, the Romantic hero sought to pass the barriers of mortal understanding and pitted himself against fearful odds, never coming to terms with human limitations. Thus it was natural that Napoleon's painters, even the Neoclassicists, should have found themselves portraying him in a romantic light. David himself painted a portrait of Napoleon crossing the Alps (fig. 386) that is much closer to Baroque bravura than to Neoclassical clarity; its sharply tilted diagonal axis produces an unclassical sense of motion.

This portrayal of a hero challenging the world suited the period of Napoleon's rise to power, when even other Europeans admired his success. But Romantic art was not a style of apotheosis or a cult of the victorious. More quickly in the countries Napoleon desired to conquer, later in France, the glorification of victory was replaced by sympathy for the victims. Haydn wrote his *Mass in Time of War* (1796) during the height of Austria's struggle against Napoleon, and dedicated his *Nelson Mass* (1798) to the British admiral who defeated the French fleet in the Battle of the Nile. When Napoleon crowned himself emperor, Beethoven tore up the dedication to Bonaparte of his third symphony but kept the name *Eroica*, a hint that heroism would hereafter be found in resistance to tyranny, not in conquest. Six years after the event, the Spanish painter Francisco de Goya (1746–1828) painted an atrocity of the wars in Spain with the immediacy of an episode still fresh in his mind. *The Third of May*

1808 (fig. 383) depicts the savage reprisals inflicted by Bonaparte's troops after a riot in which Spanish civilians had killed some French soldiers. In retaliation, the French dragged hundreds of innocent inhabitants of the city out of their homes in the night and shot them. Goya's painting of this episode is a dramatic and romantic version of the same shock of death we feel in David's *Marat*. In both works the sense of immediacy comes from the realism with which they are painted. Goya focused on the actual death of one of the victims, grouping his figures to put us close to the action. He deliberately shaped our reactions, as David did not, by the use of colour and chiaroscuro. The white-shirted victim is bathed in a blaze of light from the lantern, which casts into dark shadows the row of soldiers, the huddled clumps of those awaiting death, and the sprawled corpses of those already killed. Like David, Goya calls on our associations with religious subjects by posing his victim in the manner of the crucified Christ. But here it achieves a bitter irony rather than a heightening of idealism; this man's death is meaningless and serves no purpose; identifying him with Christ strengthens our reaction to the horror and absurdity of war.

387 Jean-François Chalgrin, Triomphe de l'Étoile, Paris, begun 1806

Goya's dramatic use of chiaroscuro in *The Third of May 1808* derived from Spanish Baroque painting, but his work reflects a world far from the aristocratic assurance of the seventeenth century. The shock of revolution and war made it impossible for the Romantics to paint history paintings in artificial stage settings, and they found their subjects not in mythology but in real life. They made the victims of oppression and injustice their heroes, and in doing so, invented a new kind of history painting. The French painter Théodore Géricault (1791–1824) based his *Raft of the Medusa* (fig. 384) on an event reported in the newspapers, an episode in which an incompetent captain ran the French frigate *Medusa* aground and then allowed the officers to fill up the available lifeboats, leaving a number of passengers and ordinary seamen to trust their chances to a hastily constructed raft. The raft was to be towed by one of the lifeboats, whose crew, however, cut it adrift to ensure their own survival. After days of horrible suffering, including mutiny and cannibalism, the handful of survivors were picked up by another ship. Out of this example of selfishness and indifference, Géricault built up a dramatic composition. The pyramid of bodies on the raft surges upward in an expression of hope that rises to the youth on the mast, who waves his shirt to attract the distant ship just visible on the horizon. A counter-motion sinks back down to the sprawling figures in the foreground who are dazed and dying; a dead body slips into the sea.

Géricault's friend and follower, Eugène Delacroix (1798–1863), who posed for the figure on the masthead, painted his *Massacre at Chios* (fig. 389) from an episode in the Greek struggle for independence from the Turks. This was a war that stimulated the imaginations of many Europeans, who naturally sided with those whom they saw as the descendants of the ancient Athenians; Byron, the very model of a Romantic in his life as in his poetry, died while trying to aid the Greek cause. The episode that formed Dela-

croix's subject was the massacre by Turkish soldiers of some 20,000 helpless Greek civilians on the island of Chios. Like Goya, Delacroix was moved to sympathize with the victims, but he was not indicting war as such. Rather, he saw in the poignancy of dying in a hopeless struggle a more admirable subject than the classical hero's control over his actions.

Delacroix's style of painting owes much of its colouristic sparkle to Rubens and to Watteau. But it is also based on observation of detail; he made many studies for the painting, researching the geography of the island and the costumes of its inhabitants. His realism increases the emotional impact, while his romantic exaggeration heightens our emotional reactions to the scene. Although it is a history painting, which elevates the action to more than a single moment in time, the *Massacre at Chios* is a far cry from the mythological dramas of the Neoclassicists.

Line versus Colour: the War between Romanticism and Classicism

From 1800 to the mid-1830s the Romantics were politically and artistically a radical movement; their art was bound up with their hopes for liberty, while the Neoclassicists retreated to safe bourgeois respectability and upheld the values of the establishment. This situation was the opposite to that in the eighteenth century, when the Neoclassicists had been more in tune with the spirit of liberty and reform. The Romantic movement was one of rebellion against all restriction (which naturally pitted the establishment against it); if the Baroque age had postulated absolute authority, the Romantics espoused absolute freedom, including freedom in art from the fixed canon of artistic theory as handed down from the Renaissance. David was the last artist who could articulate the spirit of his age with a classical vocabulary; it was his very success that helped harden academic prejudice in favour of classical style and theory.

Artists were increasingly dependent on exhibitions to establish their reputations; the decline of the system in which an artist could be supported by a single patron left artists dependent upon the open market. Therefore, recognition at the official exhibitions was essential, especially in France, where the Salon was virtually the only opportunity for an artist to come before the public. The resistance of the national academies to any change from established doctrine helped to provoke the Romantic painters into opposing classicism, not just the Neoclassicists of their own time, but the authority that Renaissance painting had held since Vasari as embodying the highest possible achievement in art. It was not a rebellion against the Classical source itself; like the Romantic poets, many of the Romantic painters found subjects in Classical literature. But, like the Reformation Protestants, they felt that established doctrine stood between them and the direct inspiration of their source.

388 (*below*) Eugène Delacroix, *Women of Algiers*, 1834. Oil on canvas, 71 × 91¼ in (180 × 229 cm). Paris, Louvre

389 (*right*) Eugène Delacroix, *Massacre at Chios*, exhibited at the Paris Salon of 1824. Oil on canvas, 163 × 139¼ in (419 × 354 cm). Paris, Louvre

390 (*bottom*) Jean-Auguste-Dominique Ingres, *Odalisque*, 1814. Oil on canvas, 35¾ × 63¾ in (91 × 162 cm). Paris, Louvre

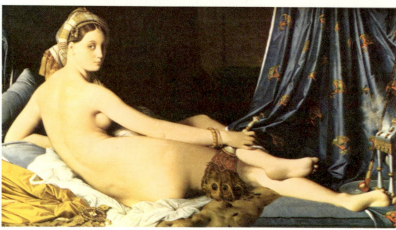

The academies were pushed by the very extremism of the Romantics into a similarly extreme opposition, hardening the lines of classical theory as a defence against the encroachments of what they saw as a debasement of style. They took their stand on the same ground as the proponents of classicism in the eighteenth century; their position had already been stated by Sir Joshua Reynolds, speaking to the Royal Academy in 1772: 'We need not be mortified or discouraged at not being able to execute the conceptions of a romantick imagination. Art has its boundaries, though imagination has none.' This was precisely the point the Romantics took issue with; art, they said, had no boundaries at all; whatever the imagination could conceive was proper to art. They were the first to challenge the Renaissance view of naturalism in art. They did not rebel against the academies, however, but tried to reform them from within; Turner, who received abusive criticism when he departed from acceptable perspective and outline, defended the Royal Academy even when it was most against him. Constable and Delacroix desired all their lives to achieve full membership in their respective institutes and continued to exhibit regularly at the academy shows even though each was denied membership until shortly before his death.

In France the old argument between the line of Poussin or the colour of Rubens was redefined around the personalities of Delacroix, the champion of romantic colour, and Jean-Auguste-Dominique Ingres (1780–1867), the defender of line. Ingres was a pure classicist; it was largely due to his very real talent that Neoclassical history painting was admired for so long in France. Ingres considered his greatest works to be his histories, painted in a deliberately archaic style to evoke the 'pure' art of Greece and Rome. But for us it is the portraits and his nude studies that best convey the ideal of beauty he felt could only be produced by clear outlines. His *Odalisque* (fig. 390) is symptomatic of the interest in exotic subjects stimulated by the Romantic poets, but there is little romantic about this work. It is an ideal of beauty directly descended from the Renaissance nudes of Titian and Giorgione, although visualized in a cooler and more aloof manner. The composition is dominated by a single curved line of the girl's back. The colour is subdued; not a breath of air moves. It is her hand, not a breeze, that holds the curtain at a slant that continues the curve of her body.

Ingres's *Odalisque* is removed from the contemporary world. It represents truth as Ingres saw it, filtered through eyes adjusted to Renaissance and Classical art. Delacroix articulated the Romantic opposition to the domination of line:

> That famous element, the beautiful, which some see in the serpentine line, others see in the straight line, but they are all resolved that it is to be seen only in line. I am at my window, and see the most beautiful landscape: the idea of a line does not come to my mind. The lark sings, the river sparkles with a thousand diamonds, the foliage murmurs; where are any lines to produce these charming sensations?
>
> *Journal*, 15 July 1849

From his words we can see how much direct observation of nature meant to Delacroix as a painter. From studying light reflecting off surfaces he came to see colour almost as a substitute for line. It is instructive to compare his *Women of Algiers* (fig. 388) to Ingres's *Odalisque*, for they are nominally on the same subject — women in a harem. But the style of Delacroix's painting is in every way the opposite of Ingres's. It is painted in warm colours, laid on in patches that ripple and blur the image, weaving forms through impressions of light and shadow. Ingres deliberately kept his cool beauty at a distance; Delacroix brings us into the same room with his sitters, so that we feel the suppressed tension of these bored, vibrant captives shut away from the world. The sense of our being a part of the scene comes from the fact that Delacroix had in fact sketched the women on the spot; when he visited Algiers he obtained permission to enter a harem to draw its inhabitants. Ingres, on the other hand, was drawing a French model, dressed in Turkish trappings, in his studio. In this we have a seeming paradox, for hitherto 'romantic' art had been unrealistic, distorting natural forms for emotional effect, while classical styles came closer to imitating nature. But the Romantics, participating in nature and seeking involvement in their creations, studied natural phenomena far more thoroughly than their Neoclassical contemporaries, so that even though their realism is heightened to convey feeling, it is their painting that appears the more naturalistic of the two schools.

The Creative Imagination

Because realism was never an end in itself for the Romantics, but a means of penetrating beyond the veil of the physical world, their naturalism always trembles on the verge of the Sublime. Nature was the source of inspiration; the Romantics were as much drawn to the stormy and catastrophic side as to the benign. Their participation in natural phenomena is what separates them from all previous romantic treatment of nature. The same gulf divides Carlyle and Wordsworth from the rational romanticism of Thomson; Constable from Gainsborough; and Beethoven from Vivaldi. Vivaldi wrote a set of four violin concerti called *The Seasons*, in which he imitates nature in an external fashion; the strings glide downwards to suggest slipping on the ice, and warm, vibrant tones evoke the pleasures of a fireside on a winter's day. He used nature humorously, as a background to set off the virtuosity of the solo violin. By contrast, in his *Pastoral Symphony*, Beethoven draws us right into nature through associations of sound; we hear birds singing, brooks babbling, peasants dancing, followed by the ominous muttering of distant thunder that swells to a full-bodied storm and then fades away. In this work nature is internalized for both composer and listener.

 The internalization of nature in the act of creation is the heart of the

Romantic theory of imagination. The passage of seasons was not the subject of either Vivaldi's concerti or Thomson's poem; rather nature was used as an image to convey a higher purpose. The real subject was human activity. Classical theory held that in both poetry and art 'truth' lay in the subject, properly conveyed. This is what Ingres was pursuing in his *Odalisque*. But for the Romantics the act of creation was a moment of vision that was its own truth; their subject was the poem, painting, or musical composition itself. This is the 'truth' of *Women of Algiers* as Delacroix saw it, an act of vision existing by itself in time, for its own sake alone. The artist's realistic rendering of light and shadow was a means of heightening the impact of that poetic vision. Classicistic artists were more or less objective about their subjects, picking one from a list, as it were, of suitable topics for history paintings. The Romantics sought inspiration first, finding the subject almost by accident.

The Romantic strove for a single moment of emotional charge, a moment of intense inner revelation, whatever the cost. The process of inspiration and creation was most clearly stated by the English poets: Blake, who belonged to the generation of Benjamin West; Wordsworth and Coleridge, who matured in the fiery days of the French Revolution; and Keats, Shelley, and Byron, a generation younger. The visual experience of natural scenery and its transformation into understanding of a universal truth was a central theme in Wordsworth's poetry. In his *Ode to a Nightingale*, Keats described the creative process and the aching void that follows the moment of expanded consciousness; the very formulation of an idea leaves the poet once more cut off from the heat of inspiration. The conflict between reality and imagination disappeared in the act of artistic creativity but was not resolved on the human level; Coleridge wrote of the profound despair he felt when the creative impulse had gone:

> A grief without a pang, void dark and drear,
> A stifled, drowsy, unimpassioned grief,
> Which finds no natural outlet, no relief,
> In word, or sign, or tear....
>
> *Dejection, an Ode*

The effort to pierce the veil of experience through the imagination could have grievous results; Goethe's Faust and Byron's Manfred cut themselves off from humanity in their quest for supernatural experience and knowledge. A revealing glimpse into the chaotic and destructive images of the subconscious mind was produced by Goya in a series of etchings which, like the capricci of Guardi and Piranesi, mix the fantastic with the real. The frontispiece shows the artist asleep with the dark creatures of the night fluttering around him (fig. 391). The title reads: *The Sleep of Reason Produces Monsters*, with the subtitle: 'Imagination abandoned by reason produces impossible monsters; united with her, she is the mother of the arts.'

391 Francisco Goya, *The Sleep of Reason Produces Monsters*, from *Los Caprichos*, 1796–8. Etching and aquatint, (16 × 24¾) in (43 × 63 cm). London, British Museum

The dark side of the Romantic imagination sank at times to a fascination with perversion and cruelty. Delacroix's *Death of Sardanapalus* (fig. 393), a subject from a poem by Byron, offended the public by its violence. Here an Assyrian tyrant awaits his own death, impassively watching his servants put to death his favourite concubines, dogs, even a horse; he has determined they shall not survive him. A chaotic turbulence surrounds him, the soft white forms of the helpless women contrasted to the dark-skinned servants who dispatch them; the horse plunges, terrified, and the whole atmosphere reeks of blood and smoke, while at the centre Sardanapalus remains unmoved.

The admiration Delacroix apparently felt for such a tyrant was not just a taste for brutality; it was a declaration against limitations. Any attempt to confine man's natural instincts, even his destructive ones, was abhorred by the Romantics because it interfered with creative imagination. The most striking and most visionary statements against fixed boundaries appear in the poetry and painting of William Blake (1757–1827), who sought to reconcile the opposites of good and evil, which he saw as falsely separated in Christianity. To Blake evil was allied with reason because reason represses the imagination.

Near the end of his life, Blake made a series of illustrations for the Book of Job (fig. 392). He dealt in his own way with the thorny question of why God should have allowed Job, an upright man, to suffer so much at the whim of Satan. Blake's Job is in a state of sin *because* he is so upright; he mistakes the forms of piety for genuine understanding, and his fault is a failure of imagination. The trials he undergoes at the hands of Satan force him to abandon his rationalizing and to confront God directly. Only imagination can perceive this totality; reason distorts and fragments the truth. Thus Job's vision of the Creation in figure 392 includes all things, good and evil, born together in harmony. For Blake art and religion were one and the same thing, so that Job's understanding of universal harmony is not complete until he and his family express their vision in song and story.

Blake's is a visionary art, as idiosyncratic as his theology. His style is compounded of medievalism and a mannered Neoclassicism; he was influenced by the energy and force of Michelangelo, yet his illustrations were conceived as modern versions of medieval manuscript illumination. His peculiar and personal combination of Neoclassical figure drawing with a pronounced Gothicism of line and detail is in itself a Romantic challenge to the authority of Sir Joshua Reynolds and the grand manner of the English academic establishment.

392 William Blake, 'When the Morning Stars Sang Together', one of the series of etchings done for the Book of Job, 1825. $5\frac{3}{4} \times 7\frac{1}{2}$ in (14.8 × 18.9 cm). London, Tate Gallery

393 (*right*) Eugène Delacroix, *The Death of Sardanapalus*, 1827. Oil on canvas, $154\frac{1}{4} \times 195\frac{1}{4}$ in (392 × 496 cm). Paris, Louvre

Nature and the Romantic Landscape

Nature as the source of inspiration and harmony plays a central role in Romantic landscape painting. The relationship between scenery and the human beings who inhabit it is more important in Romantic art than in Claude's landscapes; for the Romantics, religious experience was found only through oneness with nature. When the German artist Caspar David Friedrich (1774–1840) was asked to paint an altarpiece for a family chapel he expressed his faith through the forms of landscape, depicting a cross silhouetted on a mountain top, transfigured by the rays of the rising sun (fig. 394). The heightened glow bathes the whole scene in an unearthly light, and recalls the emotional charge by Altdorfer's watercolour (fig. 289). For Friedrich, the meaning of Christ's death and resurrection was incomplete without the forms of nature partaking in the ritual. Although neither could have known of the other's work, Wordsworth used the same image to describe a shepherd seen against the rays of the setting sun:

> His form hath flashed upon me, glorified
> By the deep radiance of the setting sun:
> Or him have I descried in distant sky,
> A solitary object and sublime,
> Above all height! like an aerial cross
> Stationed alone upon a spiry rock
> Of the Chartreuse, for worship.
>
> *The Prelude*, Book 8

Friedrich's landscapes are so invested with meaning that the very atmosphere is electric. In his *Large Enclosure* (fig. 395), title and composition symbolize the significance he found in a single, small, marshy inlet and its surrounding meadows seen at twilight. The foreground disconcertingly follows the earth's curvature; beyond the dark clumps of trees silhouetted against the sky, the distant meadows stretch out flat. A small, shadowy sail is the only indication of human presence in this sweeping expanse; the human element is completely in harmony with the natural world. Friedrich's realism is so exact and yet so charged with feeling that it approaches surrealism. It is instructive to compare this landscape with Dürer's watercolour study (fig. 260). Dürer's close observation of nature influenced the German Romantics, but his realism came from his desire to learn the rules of nature and had no pantheistic overtones, whereas for Friedrich *The Large Enclosure* embodies universal truth.

The emotional pitch of Romantic natural philosophy is less obvious in the landscape painting of John Constable (1776–1837). Yet Constable was just as intent as Friedrich on pursuing the inner essence of nature. Like Wordsworth he found his subjects in ordinary country life, in men working in harmony with nature. But Wordsworth invested his subjects with a

special, heroic, stature and surrounded them with an atmosphere of mystery. Constable painted the scenes of his boyhood without any obviously heightened tone or significance, so the public, trained to value landscape for its qualities of the Picturesque or the Sublime, could not see the originality of his vision. His early works, derived from Claude and the Dutch landscapists, and influenced by Gainsborough's paintings of the same countryside, were praised for their skilful execution but seemed too ordinary to excite much interest.

It is not, perhaps, so surprising that the public who saw Constable's landscapes at the annual Royal Academy shows underestimated the extent of his originality. His style is deceiving in its easy appeal, for he achieved a degree of realism that by its very charm and recognizable subject-matter obscures the amount of intellectual effort that went into his art. He went further than other artists had done in sketching from nature, and painted at least one complete picture outdoors. Yet he was far from merely reproducing the scene in front of him, as his critics complained. He never painted a major work without a subject around which the landscape is composed. In his determination to prove his native countryside as worth painting as Claude's Roman Campagna or a literary story, Constable came to paint the pieces intended for the annual exhibitions at the Royal Academy on large canvases, six feet wide, a scale heretofore used only in history painting.

The first of these 'six-footers', painted in 1818–19, had as its subject a stretch of the River Stour where the towpath changed sides to avoid a confluence of streams (fig. 396). At this point the barges using the river had to ferry their horses to the other side. It was the white horse, getting his few minutes of well-earned rest, that soon gave the picture its popular name, but Constable did not emphasize the human activity; at first he called the picture *A Scene on the River Stour*. The action forms a natural focus, but it was the harmony between human labour and nature that was important. The contrasts of light and shadow in the cloudy sky and thick foliage are obviously influenced by Dutch Baroque painting. But Romantic feeling for nature meant close involvement with natural phenomena; if we compare *The White Horse* to Jacob van Ruisdael's *Wheatfield* (fig. 332), we find that Constable's chiaroscuro is less dramatic and more natural than the deepened contrasts of the Dutch work. Another difference is that Constable composed his scene on a horizontal plane, compressing his landscape along the river's bank. The horizon comes down low, the sky filling more than half the canvas on the right-hand side. The foreground merges imperceptibly into the distant skyline. There is a real truth in this; we do not actually see landscape as the Renaissance painted it, in a marked recession of three grounds.

Although Constable avoided the exaggeration of tone that we associate with Romanticism, he was closely involved with the natural world that formed his subject. He painted the workaday life of the Stour valley not

394 (*left*) Caspar David Friedrich, *Cross on a Mountain*, 1808. 45¼ × 43¾ in (115 × 110 cm). Dresden, Staatliche Kunstsammlungen, Gemäldegalerie

395 (*below*) Caspar David Friedrich, *The Large Enclosure, c. 1832.* Oil on canvas, 29⅛ × 40½ in (74 × 103 cm). Dresden, Staatliche Kunstsammlungen, Gemäldegalerie

because of its ordinariness but because of his deep emotional attachment to it. In a letter to the friend who purchased *The White Horse*, he said:

> But the sound of water escaping from milldams, etc., willows, old rotten planks, slimy posts, and brickwork, I love such things . . . As long as I do paint, I shall never cease to paint such places . . . I should paint my own places best; painting is with me but another word for feeling.
>
> Letter to John Fisher, 1821

Constable's feeling that art existed 'under every hedge' influenced later artists seeking to break away from the notion that subjects had to be elevated to be artistic, but these are not the words of a realist painting objectively. Constable was fully a Romantic in his commitment to emotional values in painting. This depth of feeling comes to us more clearly in his sketches and studies, many of them painted in the open air, than in the exhibited works prepared under the constraint of academic standards of finish and detail. He made many studies of cloud formations, pursuing his sky-painting so successfully that he earned a somewhat ambivalent compliment from a fellow artist, the Swiss painter Henry Fuseli, who said that he liked the landscapes of Constable, 'but he makes me call for my greatcoat'.

Constable was unusual in painting in the open air as much as he did, and in using oil for his sketching rather than watercolour, which is easier to work quickly. He was unique in his habit of painting a full-sized sketch in his studio before beginning the final 'six-footers'. In the full-scale sketch for his third major work, *The Haywain*, he worked out all the elements of the composition in the sketch (fig. 397), roughly blocking in a balance of masses and tones in broad patches of colour over a dark ground. In the final version (fig. 398), nothing in the essential forms was changed (he painted out the woman on horseback after the work had been exhibited), but the nervous energy of the sketch vanished, along with the stormy sky and reddish-brown tones. The finished scene is bathed in the tranquil silvery-green atmosphere of high summer. The forms are more clearly articulated, but even here the colours are not blended in the smooth gradation of tone of earlier painting; Constable caught the appearance of light reflecting from the trees and water with small, rough patches of white, and the meadow beyond the river is not pure green; it is composed of a wide range of colours laid down in small unmixed patches.

In *The Haywain* Constable showed a surer grasp of the compositional unity that he had been striving for in *The White Horse*. Again he built the scene on a horizontal plane, and again lowered the sky on the right half of the canvas to bring the horizon in closer. In *The White Horse* the random buildings and clumps of trees block our view of the skyline, but in *The Haywain* the flat meadow interposed between river and sky gives a sense of depth and balance.

The Haywain was the first of Constable's works to find a buyer outside his

396 (*above*) John Constable, *The White Horse (A Scene on the River Stour)*, 1819. Oil on canvas, $51\frac{3}{4} \times 74\frac{1}{8}$ in (131.4×188.3 cm). New York, Frick Collection

397 (*above right*) John Constable, sketch for *The Haywain*, 1820–1. Oil on canvas, 54×74 in (137×188 cm). London, Victoria and Albert Museum.

398 (*right*) John Constable, *The Haywain*, 1821. Oil on canvas, $51\frac{1}{4} \times 73$ in (130×185.4 cm). London, National Gallery

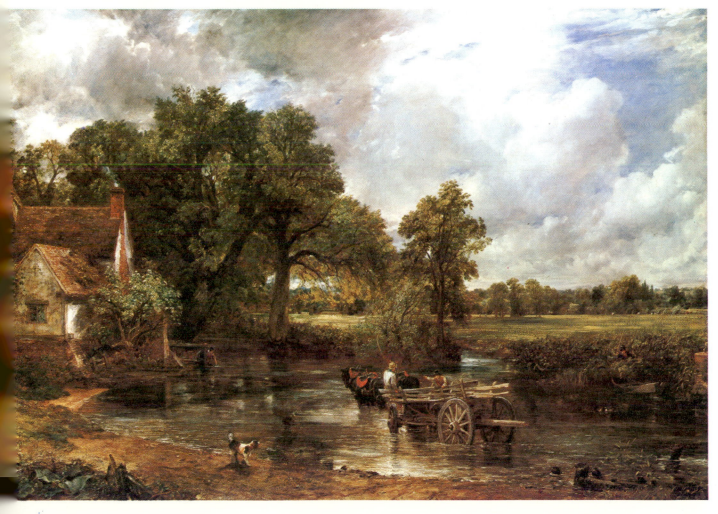

circle of friends. It was sold in 1824 to a French art dealer, who exhibited it in Paris, where it also appeared at the French Salon and won a medal. It had an instant and lasting effect on French painting, for Delacroix, on the point of exhibiting his *Massacre at Chios*, made significant changes to it after seeing *The Haywain*. In imitation of Constable he lowered his own skyline and repainted some of the colouring in Constable's technique of un-blended tints. It was Delacroix who experimented further with the im-pressionistic effects of unmixed colouring to create the ripple of light and shadow in *The Women of Algiers*.

The extent of Constable's Romanticism was not really perceived by his contemporaries because his tranquil summer scenes did not fit into any recognizable category, having neither the remoteness of a classical land-scape nor the drama of the Sublime. He rejected the charm of the Picturesque and was unmoved by the wild scenery of the Lake District that nourished Wordsworth and Coleridge. The subjects he preferred reflect nature as the benign goddess of Carlyle's dualism, not the destroying fiend.

The destructive side was, however, the favourite subject of Romantic poets and painters who sought the satisfying thrill of the Sublime in the elemental furies of nature unleashed against the puny efforts of hu-mankind. In addition to storms and shipwrecks, the Romantic imagina-tion was stimulated by nineteenth-century voyages of exploration into the remote and hostile polar regions; Coleridge placed the most harrowing adventures of his Ancient Mariner in the Antarctic. Shipwrecks and disasters formed a large part of the repertory of Joseph Mallord William Turner (1775–1851). While Constable stayed close to home and hardly ever travelled to a particular place for its pictorial aspects, Turner went to Italy and to the Alps. Constable obstinately stuck to his real-life subjects; Turner's imagination ranged through literature and history. It is not surprising, therefore, to find that the critics who appreciated Constable's naturalism disliked Turner's apparent lack of it, while those who found Constable unexciting appreciated the heightened emotion they saw in Turner. It was Turner's chief defender, John Ruskin, who disparaged Constable's atmosphere as 'mere great-coat weather', and an admirer of Constable, Sir George Beaumont, who dismissed a work of Turner's as 'all of pea-green insipidity'.

Turner achieved a reputation much faster than Constable, beginning within the recognized tradition of the ideal landscape and history paint-ing. He could imitate either Claude Lorrain or the Dutch painters with equal ease and was elected to full membership of the Royal Academy in 1802, when Constable was just beginning to exhibit as a student. Turner's *Shipwreck* (fig. 399) shows the reason for his early popularity; it is a subject close to the popular Dutch Baroque seascapes. But he did more than merely imitate the model. By piling up the rough seas in a towering spiral around the struggling seamen, he created a drama out of the forces of nature that outplayed the Dutch at their own game.

But to be a Romantic meant pursuing one's own ends, whatever the cost to oneself. A Romantic genius could not be expected to do just what the public wanted; in pursuing his own ends Turner cut himself off from the support of public approval. His ambition was to render light and atmosphere as he perceived it, not as he had learned to paint it in the manner of Claude. This earned him savage denunciations when he departed from the clarity of perspective and drawing recognized by the Academy as the only truth in painting.

Turner's paintings were derided for their lack of naturalism and science, yet scientific knowledge was precisely what he did convey. He was aided in his efforts to convey light and air by experiments with prisms and the popular new toy, the kaleidoscope, invented in 1814. He was also fascinated by photography, in its infancy in the 1830s and 1840s; he haunted the studio of the photographer Mayall, who had prints of Niagara Falls showing the light refracted through the foaming spray. Turner's study of light and colour led him increasingly to dissolve forms into the mist and froth of the elements, to the consternation of the public, who felt as Constable succinctly put it, 'Turner is stark mad — with ability'.

In his obsession with light and colour, Turner anticipated the French Impressionists. But he was a Romantic and participated in the storms he created on his canvas; his observations of natural phenomena were far from objective. One such storm was exhibited under the cumbersome title of *Snowstorm — Steamboat off a Harbour's Mouth making signals in shallow water, and going by the lead. The author was in this storm on the night the Ariel left Harwich* (fig. 400). Turner was not merely on the boat; he had the sailors lash him to the mast, the better to observe nature's elemental furies. But if he thought his explanatory title would convince critics of the realism of the work, he was disappointed; the indignant tones of a reviewer for the *Athenaeum* expressed the unwillingness of viewers to see anything as real that was not expressed in the perspective and spatial definitions of the Renaissance:

> This gentleman has on former occasions, chosen to paint with cream, *or* chocolate, yolk of egg, or currant jelly, — here he uses his whole array of kitchen stuff. Where the steamboat is — where the harbour begins, or where it ends — which are the signals, and which the author in the *Ariel* (all of which items figure in the catalogue) are past our finding out.

> *Athenaeum*, 14 May 1842

In his search for representational forms, this critic failed to recognize the powerful vortex of sea and sky coming together to suck the helpless ship into its terrible centre. There is a realism in the opaqueness of the storm-whipped sea more profound than that of the followers of Poussin, but it was a rare viewer in Turner's time who could perceive this.

By the 1840s Turner was finding his subjects in the world around him more than in literature and history, and his rendering of light and atmos-

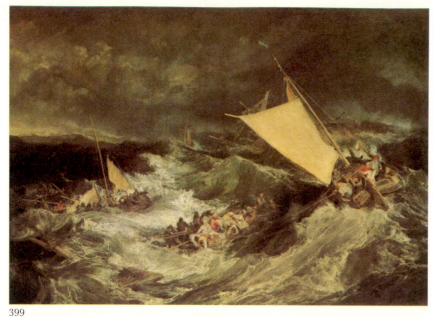

399

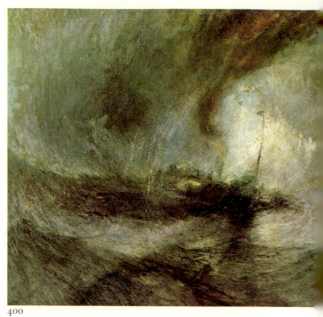

400

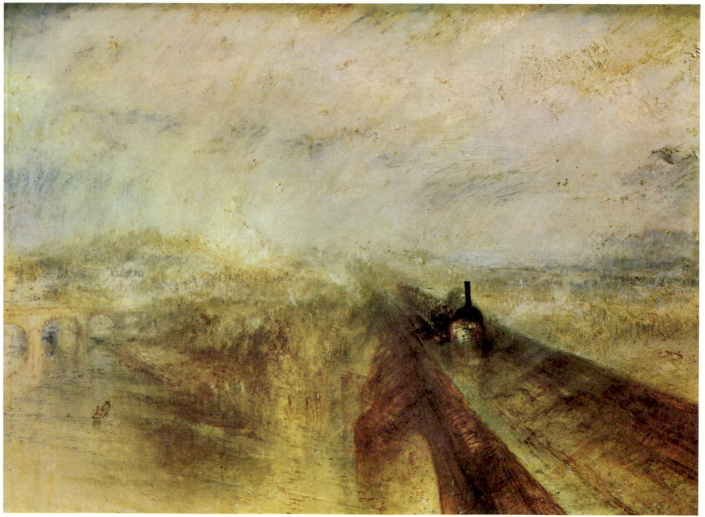

401

phere became an end in itself. His picture of a railway train crossing a bridge in a rainstorm (fig. 401) has a story attached to its genesis that illustrates the lengths to which he went in capturing natural effects. Lady Simon told how she was travelling to London in a railway carriage with a man who persisted in craning out of the window, in the rain. At his insistence she too put out her head and observed the effects of a train coming towards them, its headlamps seen through the driving rain. When she saw the painting in the Royal Academy exhibition she realized who the gentleman had been. With this work, Turner received a more perceptive review from the novelist William Makepeace Thackeray:

> He has made a picture with real rain behind which is real sunshine, and you expect a rainbow every minute. Meanwhile, there comes a train down upon you, really moving at the rate of 50 miles an hour, and which the reader had best make haste to see, lest it dash out of the picture and be away up Charing Cross through the wall opposite. All these wonders are performed with means not less wonderful than the effects are. The rain ... is composed of dabs of dirty putty *slapped* on to the canvass with a trowel; the sunshine scintillates out of very thick, smeary lumps of chrome yellow. The shadows are produced by cool tones of crimson lake, and quiet glazings of vermillion; although the fire in the steam engine looks as if it were red I am not prepared to say that it is not painted with cobalt and pea-green.

Fraser's Magazine, June 1844

Turner was unique in his own time, and much closer to modern artists, in his method of applying paint to a canvas. He fascinated his colleagues by using the 'varnishing days', which the Academy set aside for painters to touch up a work once it had been hung, virtually to paint the whole work.

The failure of the public to appreciate the originality of either Constable or Turner indicates the crisis facing the fine arts now that the public exhibition and the open market-place had virtually replaced the private patron who, by supporting the artist and commissioning his works, had substantially affected the course of taste and style. The emergence of the middle class, uneducated in taste but eager to imitate their betters in buying works of art, coincided with the appearance of a new class of taste-maker: the professional critic reviewing the annual exhibitions. Critics might be as perceptive as Thackeray; more often they were as conservative as the reviewer of Turner's *Snowstorm*. The unwillingness of the critics who reviewed the shows, of the national academies who held them, and of the public who attended them, to accept any real change in art from the perspective and form laid down in the Renaissance created a division between the art establishment and artists who wanted to follow their own visions. The public wanted the heightened romantic subjects Turner gave them but not his break with representational form, while they admired Constable's realism but not what Ruskin called his 'morbid preference for subjects of a low order'. Neither Turner nor Constable had any real

399 J.M.W. Turner, *The Shipwreck*, 1805. Oil on canvas, 67⅛ × 95⅛ in (170.5 × 241 cm). London. Tate Gallery

400 J.M.W. Turner, *Snowstorm — Steamboat off a Harbour's Mouth*, 1842. Oil on canvas, 36 × 48 in (91.5 × 122 cm). London, Tate Gallery

401 J.M.W. Turner, *Rain, Steam and Speed*, 1844. Oil on canvas, 35½ × 47½ in (90 × 121 cm). London, National Gallery

influence on English painters succeeding them; it was in France that Constable's colouring and Turner's luminous atmosphere bore fruit in a rebellion against academic conservatism initiated by the landscape painters of the Barbizon school and the Impressionists.

The New Eden: American Romanticism

The Romantic movement in America ran parallel to its European counterpart. It was inspired by Transcendentalism, the philosophy preached by Emerson and his circle, which was a mystical and pantheistic creed based on European Romantic writings. The American Romantics in their turn had a counter-influence on the Europeans; Emerson's essays were widely read, while the stories of James Fenimore Cooper, Nathaniel Hawthorne, and Edgar Allan Poe stimulated the imaginations of European writers. America might lack such Romantic trappings as ancient ruins and mouldering castles, but she possessed in abundance the wildness of primeval nature in her vast territories inhabited only by the Romantic ideal of the natural man, the Noble Savage. For the landscape painter, a Romantic view of vast expanses stretching past a single, tiny human habitation was no imaginary vision; to many on both sides of the Atlantic the unspoiled new land was seen as a new Garden of Eden.

But for Romantic painters the taste of the American public created a situation exactly the opposite of Constable's. Americans cared nothing for history painting or sensational subjects; like the Dutch burghers of the seventeenth century, they wanted portraits and landscapes. In the frontier conditions of colonial America there was little formal training to be had. The prevailing style was that of an unsophisticated folk art: primitive likenesses executed with wooden formality (fig. 402), and topographical scenes that were schematized and two-dimensional. As conditions improved in the eighteenth century, artists like Benjamin West and John Singleton Copley (1738-1815) could learn something from Europeans who had emigrated to the new continent, as well as from engravings of the old masters. But both men became mature, recognized painters only when they had travelled abroad to learn the painterly subtleties of European styles at first hand, and both settled permanently in England. West established a studio in London that became a mecca for American artists and thus helped establish a native American school of artists trained in the European tradition. His reputation was high both at home and abroad; despite his loyalty to the cause of American independence, he kept his post as historical painter to George III. In 1792 he was elected Reynolds's successor as president of the Royal Academy. He persuaded the talented young Gilbert Stuart (1755-1828) to visit London; Stuart returned to America to paint sophisticated and imaginative portraits in the Reynolds manner. Such works as his charming and flattering portrait of William

402 Anonymous, *Portrait of a Girl in Red, c.* 1830–40. Oil on canvas, $53\frac{1}{4} \times 39$ in (135.2 × 99 cm). Boston, Museum of Fine Arts. M. and M. Karolik Collection

403 Gilbert Stuart, *The Skater* (portrait of William Grant), 1782. Oil on canvas, 96⅝ × 58¼ in (245.5 × 147.6 cm). Washington, National Gallery of Art, Mellon Collection

Grant (fig. 403), which he exhibited at the Royal Academy, were influential in replacing the primitive native style with the grand manner of Reynolds and Gainsborough.

The first American painter to exploit the thrill of the Sublime was Washington Allston (1779–1843), who shared with Poe a taste for the weird and the abnormal, the twilight zone between the real and the supernatural. In his *Moonlit Landscape* (fig. 404) an ordinary scene is heightened in mood by the extraordinary luminosity of the moon's clear, cold light to create a sense of eerie calm and haunting beauty. The exaggerated quality of moonlight conveys Romantic sensibility more easily than daylight. In this expression of intense and personal emotional experience, Allston comes close to the romanticism of Friedrich.

The painter who first raised the colonial genre of topographical scene painting to the level of the ideal landscape was an Englishman named Thomas Cole (1801–48), who emigrated to the New World as a young man. Although he endured severe hardship and privation before he found his footing in the world of art, Cole never lost his love for the abundant natural wilderness of the new continent. His painting reflects a conflict between admiration for real scenery, so readily available and, in its vast, wild state, scarcely improvable by artistic imagination, and the painter's urge to idealize by lifting the particular present into the generalized past and future. His writings leave us little doubt that his ambition was to paint ideal landscapes and histories in the manner of Claude, for he repeatedly protested against the taste of a public that did not encourage this high vein. 'I am not a mere leaf-painter,' he said; 'I have higher conceptions than a mere combination of inanimate, unformed nature'.

Cole travelled to England and the Continent and saw at first hand the works of the old masters and the scenery that had inspired them. From his acquaintance with both the older landscapists and the Romantics he learned to coordinate perspective and lighting to paint a distant view softened by heavy atmosphere, glimpsed through a sharply focused foreground. Despite the European experience and his admiration for Claude, Cole never lost his grasp of what his friend William Cullen Bryant called 'that earlier, wilder image'. Such scenes as *The Oxbow* (fig. 405) closely reflect Emerson's summing up of the difference between a landscape and its physical components:

> When we speak of nature ... we mean the integrity of impressions made by manifold natural objects. It is this which distinguishes the stick of timber of the wood-cutter from the tree of the poet. The charming landscape which I saw this morning is indubitably made up of some twenty or thirty farms. Miller owns this field, Locke that, and Manning the woodland beyond. But none of them owns the landscape. There is a property in the horizon which no man has but he whose eye can integrate all the parts.

RALPH WALDO EMERSON, *On Nature*

404 Washington Allston, *Moonlit Landscape*, *c.* 1819. Oil on canvas, 24 × 35 in (61 × 88.9 cm). Boston, Museum of Fine Arts, gift of William Sturgis Bigelow

405 Thomas Cole, *The Oxbow*, 1836. Oil on canvas, 51½ × 76 in (130.8 × 193 cm). New York, Metropolitan Museum of Art, gift of Mrs Russell Sage, 1908

406 George Caleb Bingham, *Fur Traders Descending the Missouri*, 1845. Oil on canvas, 29¼ × 36¼ in (74.3 × 92.1 cm). New York, Metropolitan Museum of Art, Morris K. Jesup Fund, 1933 (see also fig. 349)

407 Asher B. Durand, *Forest Scene in the Catskills*, *c.* 1855–60. Oil on canvas, 15 × 24 in (38.1 × 61 cm). Detroit Institute of Arts, gift of Mr and Mrs Harold O. Love

404

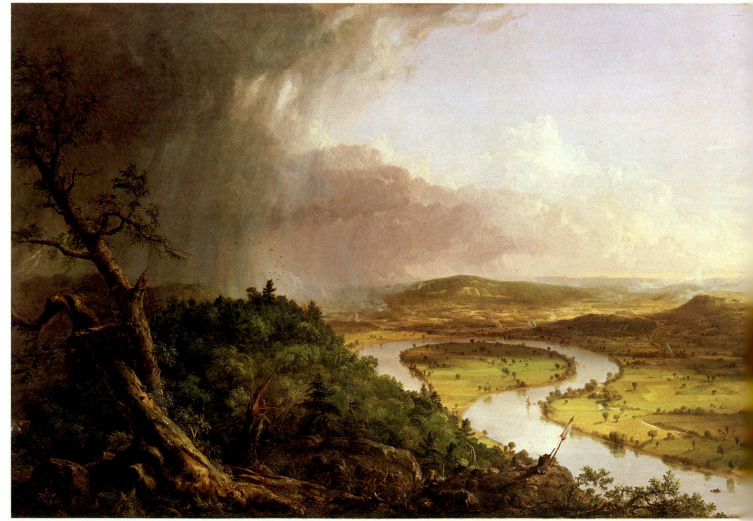

405

406

407

Cole painted the oxbow bend in the Connecticut River from a high pro-
montory which rears up from the plain. In the foreground a romantically
withered tree and dead stump, sharply detailed, frame the view, which
stretches vertiginously down and back to an immense distance of soft
atmosphere. The human element is as tiny as the figures in the *Expulsion*
(fig. 4); the barely visible form of the artist is seen sketching, and his
painting stool and sunshade are set on a rock in the foreground. But this
figure is not swallowed up by hostile forces, as Adam and Eve are; he is a
natural part of the landscape and in harmony with it. Cole wrote to his
friend Asher B. Durand:

> I never succeed in painting scenes, however beautiful, immediately on re-
> turning from them. I must wait for time to draw a veil over the common details,
> the unessential parts, which shall leave the great features, whether the beauti-
> ful or the sublime, dominant in the mind.

11 January 1838

Cole and his followers were dubbed the Hudson River school, although
not all of them painted in the Hudson Valley and none of them was
restricted to it. The artists after Cole accentuated the realism in his style
without losing the visionary atmosphere; they solved his conflict between
realism and idealism by painting soft visions of grand scenery, neither
ominous nor gentle, bathed in a Claudian yet American light, and framed
by nearby details in sharp focus. Cole's friend Asher B. Durand
(1796–1886) was the most pantheistic of the school, declaring that a
landscape was 'great in proportion as it declares the glory of God and not
the works of man'. For him, landscape was its own justification and did not
need an ideal subject. Works like *Forest Scene in the Catskills* (fig. 407)
encompass both the artist's specific observations and a timeless vision of
unspoilt wilderness.

The effect of light and atmosphere is strong in all the works of the
Hudson River school, perhaps because there was so much of it; the
luminous glow of Romantic landscapes continued to permeate American
painting despite a growing trend to realism. George Caleb Bingham
(1811–79) painted frontier life in a manner that combines a faithful
portrayal of trappers, Indians, and pioneers with an atmosphere of Ro-
mantic grandeur and mystery that reflects the poetry of Wordsworth and
Coleridge. In figure 406 the figures are hauntingly still, frozen on the
strangely mirroring lake. The light became more intense and the colours
more exotic in the paintings of Frederick Edwin Church (1826–1900), yet
his remote, jungle scenes were sketched from nature; they are not visions of
his imagination (fig. 408).

The realist side of American landscape painting at mid-century was a
native response to the new continent, but it also ran parallel to develop-
ments in Europe, particularly in France, where the naturalism of Con-
stable influenced a new direction in painting from nature and in capturing

natural reflections of light. European Romanticism as a dynamic movement embracing the real world did not survive the death of Turner and Delacroix; even before this the realistic strain had broken from the intuitive side to follow its own ends. Romanticism as an expression of imagination continued to exist in all the arts throughout the century, but as a style increasingly cut off from the active life of industrial Europe. The late-century Romantic landscapist had to go farther afield to capture the intuitions of spiritual truth that Constable found under every hedge; only in the Arctic and Antarctic, the American West and the jungles of South America could artists like Church find real landscapes grand enough to stimulate the Sublime. Other late Romantics journeyed inward into the realms of the subconscious, pursuing dreams and visions in hostility to the drabness of reality, sharing their dependence on imagination rather than on visual stimuli with late Romantic poets. Meanwhile, interest in nature as a source of artistic inspiration separated from Romanticism to follow a direction marked by Constable and Turner, but in an entirely objective vein.

408 Frederick Edwin Church, *The Heart of the Andes*, 1859. Oil on canvas, 66⅛ × 119¼ in (168 × 303 cm). New York, Metropolitan Museum of Art, bequest of Mrs David Dows, 1909

409 James Ensor, *Christ's Entry into Brussels*, 1888 (detail), see below, fig. 471

PART 5 The Modern World

PART 5: THE MODERN WORLD

INTRODUCTION

The modern age has been a period of rapid change. From the opening of the new Liverpool and Manchester Railway in 1830, the pace of industrialization and of urbanization increased steadily, fragmenting the old rural society and driving a wedge between the successful new rich and the poor, who were driven off the land and forced into city slums, looking for work.

The 1830s was a decade of political change with significant social consequences. Both the Reform Bill of 1832 in England and the July Revolution of 1836 in France widened the franchise among the middle classes; and many of this new electorate sided with established order against the threat of revolution. A tendency to see change as a threat to stability extended to the art world; the conflict intensified between conservative institutions and artists who wanted the freedom to treat new subjects in a new manner. From the 1830s and 1840s, when Delacroix struggled to gain recognition from a hostile Academy, to the *Salon des Refusés* in 1863, where Manet's *Déjeuner sur l'herbe* (fig. 423) was derided, to the bitter conflict between the Impressionists and their critics in the 1880s, the artists we now see as the most significant figures of the period were pitted against the academies, who sought to uphold Neoclassical tradition. Originally inaugurated with a forward-looking approach to art, the academies had by now become an entrenched arm of the conservative establishment. The Neoclassical style, which in the hands of David had been a powerful instrument for reform and change, was used by nineteenth-century artists to trivialize and to distance subjects with the precise aim of preventing too much emotional impact.

The rise of a prosperous middle class, determined to hold on to what they had gained, significantly strengthened the climate of intolerance towards the new in art. Napoleon III's coup d'état of 1851 was possible because upper and middle classes together feared dictatorship less than anarchy; although Napoleon opposed the aristocracy and undermined

their hold on the French Academy, opposition to revolutions in art continued and grew increasingly bitter. The violence with which artists in the early twentieth century attacked the remnants of Neoclassical tradition was a direct result of the intransigence towards modernism of the official exhibition juries and reviewers.

The independent art market expanded during the nineteenth century with the emergence of professional art dealers, frequented by an interested public. This, however, made little difference to what was bought, for the bourgeois art buyers, taking no chances, formed their taste from the reviews of the annual exhibitions and bought works approved by the critics. Although voices could be found to praise the new, the majority of the reviewers sounded the same cruelly satirical note that had greeted Turner's *Snowstorm* (see above, p. 321). The importance of recognition in the official exhibitions is seen in the vigorous protests of those excluded; not until the turn of the century was this stranglehold broken by the appearance of independent exhibitions which promoted the modern in art. By the eve of the First World War, the rise of rapid communications and the ease of photographic reproduction enabled the artists to reach the public directly through a variety of means, thus promoting and selling art works that dealt directly with the modern world, employing no Neoclassical veil of timeless illusion.

CHAPTER 13

Dealing with the Contemporary World

The artists who emerged as the progenitors of Modern art were a handful of painters who sought to be contemporary not only in theme but also in style, and who made a break with Renaissance form and perspective to achieve a fresh view of the way we see the world (fig. 5). In being contemporary they did more than challenge the authority of Renaissance perspective; they also claimed the right to paint anything they saw fit, for aesthetic ends alone. In this they ran counter to the taste of the buying public, who continued to want subjects that told a story. The most popular art in the nineteenth century, next to classical nudes and exotic antique or Oriental scenes, were moralizing genre scenes, sentimental anecdotes of middle-class domesticity.

Dubbed philistines by Carlyle because they seemed as benighted as the Biblical tribe opposing the Children of Israel, the middle class followed the lead of professional journals, which preached sermons on 'good' style that were hostile to the novel visions of the Pre-Raphaelites in England and of the Realists and Impressionists in France. Reading the outraged criticisms in these journals we may well wonder at the failure to find anything good in paintings which now seem so inarguably major works. But these critics and their public belonged to a world in which taste pointed in a very different direction from what we now see as the main line of developing style.

The Great Exhibition: a Lesson in Taste

In 1851 the achievements of a half-century of industrialism were proudly displayed in the first world's fair, the Great Exhibition in London. Nothing better illustrates the gap between art and industry than the disparity between the exhibits, brought from all over the world, and the gigantic iron and glass building in which they were housed. Painting was excluded

410 Joseph Paxton, Crystal Palace, built for the Great Exhibition of 1851. Contemporary lithograph by T.V. Jones

411 Pope and Sons, design for a Gothic engine, 1851. From the *Illustrated London News*, vol. 18

unless it illustrated some technical innovation, and sculpture was admitted as exemplifying material rather than fine art, but the aesthetic ideals of the century were well illustrated by the exhibits of industry. Predominantly, objects masqueraded as something else. Even the machines came in disguise (fig. 411). Furniture appeared in one material made to look like another, in a hodgepodge of styles from the past; a brass bedstead was machined to imitate Renaissance woodcarving, while papier-maché was used for a stuffed armchair which had 'a most comfortable and inviting appearance'. Even the coal grate, that symbol of progress in domestic comfort, came in the guise of a Renaissance, Rococo, Elizabethan, or even Moorish fireplace.

The building, however, came undisguised. Dubbed the Crystal Palace by *Punch*, it was a vast construction of glass and iron modelled after the greenhouses developed by its designer, Joseph Paxton (1803–65), who was not an architect but the Duke of Devonshire's head gardener. This startlingly modern edifice, built in Hyde Park and encompassing within its arched transepts two magnificent elm trees (fig. 410), was chosen over more traditional designs not because of its statement of contemporary technology but because it fulfilled the three basic requirements for an exhibition building. Its glass surface let in the maximum of daylight; it could be built within a short time because its parts were prefabricated and standardized; and, because it was bolted together, it could be taken down again after the fair was over. Its temporary nature proved crucial, for the exhibition was almost overthrown by opponents who feared a more traditional structure would permanently encroach upon the open space in Hyde Park.

Once built, the appearance of the structure captivated the public. The dramatic effect of this enormous bubble of glass rising with little sense of separation between wall and sky caused the Queen to remark that 'the sight of the Crystal Palace was indescribably glorious, really like fairy land'. Its cruciform shape did not go unnoticed either; without any sense of irony, the Crystal Palace was seen as a fitting cathedral to the new objects of veneration: science and industry. The building was so popular that, after the exhibition closed, it was taken down and re-erected at Sydenham, where it remained until destroyed by fire in 1936.

Yet, while the technology of the building influenced the course of engineering, it was not as true an example of taste as the exhibits inside. This taste was outlined in an article in the *Art Journal*, the chief voice of philistinism, entitled 'The Great Exhibition as a Lesson in Taste'. This article asserted that nothing was true design without ornament added to it, for ornamentation required a conscious choice of style, which choice separated true art from the merely functional. In the author's opinion, good design required the understanding of different styles and the adaptation of a particular style to the function of the object; he criticized a fruit-dish in the shape of a tulip because the load of fruit would crush a real tulip.

Style and History

We can only understand the views of critics like this if we understand their attitude towards the past. The feeling that complex and beautifully craft-ed decorated detail was in itself good design had existed before, in the International Gothic and Mannerist periods, for example. But the nine-teenth century was unique in deliberately refusing to be original, and in disguising the present in symbols of the past. This came in part from a feeling that no new style could adequately represent the new age. More positively, the urge to design Gothic steam engines reflected a greater knowledge and appreciation of the past. From the Romantics, the nine-teenth century inherited a view of history as a series of epochs each with its own circumstances and characteristics, to be judged only in the light of its own aims and situation. In contrast to the old idea that all history was a falling off from antiquity until the Renaissance, this view encouraged appreciation of a whole range of past styles which were becoming better known through archaeological advances. The variety of styles to choose from was further stimulated by the growth of new museums in which the public could wander at will through collections of ancient, medieval, and modern art. So the nineteenth-century designers cloaked the achievements of their age in the trappings of the past as a means of portraying their pride in the present through a parallel from another stage of civilization. That this choice of decorative style showed good taste was the dominant aes-thetic viewpoint right into the twentieth century; it is reflected in nu-merous public monuments of art and architecture. Monumental sculpture celebrating the technical achievements of the age gives us little sense of the transformations these advances wrought. A statue commemorating the opening of the Suez Canal does not portray the men and machines that dug the canal, nor does it suggest the impact of the new route on com-merce. It symbolizes the event with a classical allegory in which we see Europa, the personification of Europe, joining hands with the River Nile (fig. 412).

Perhaps the best example of the nineteenth century wrapping its tech-nological advances in the guise of the past is seen in the design of railway stations. The new railroads, cutting their way through the countryside and slashing into the cities from the 1830s, symbolized modern technology at its highest. The construction of the stations involved innovative use of new materials, yet these were hidden behind façades evoking slower-paced civilizations which give us a cross-section of the architectural styles revived throughout the period. Philip Hardwick (1792–1870) saw Euston Station, the terminus of the new London and Midland Railway, as the gateway to a classical city, and hid the metal-roofed sheds behind a Doric structure derived from the gateway to the Athenian Acropolis. By the 1860s the example of Paxton's Crystal Palace provided the technology to build glass

412 Pietro Magni, monument to commemorate the cutting of the Suez Canal, 1858–63. Marble, height of figures 75 in (190 cm). Trieste, Civico Museo Revoltella

CHART 7 THE NINETEENTH CENTURY, 1830—1900

EVENTS		ART AND CULTURE
1830 July Revolution, France: Charles IX replaced by 'constitutional' monarch Louis Philippe 1830 Manchester to Liverpool railway opened 1832 Reform Bill 1837 Queen Victoria comes to throne of England	**1830**	
		1836 Emerson, *On Nature*
	1840	
		1843 Ruskin, *Modern Painters* 1848 First Pre-Raphaelite Brotherhood
1848 Louis Napoleon elected President of French Republic		
		1849 Courbet, *The Stonebreakers*
	1850	1851 Great Exhibition, London
1852-70 Louis Napoleon rules France as Emperor Napoleon III		
		1857 Baudelaire, *Les Fleurs du Mal* 1859 Darwin, *The Origin of Species*
	1860	
1861 American Civil War begins 1861 Independence and unification of Italy		1861 William Morris forms company to distribute works produced by Arts and Crafts movement
		1862 Daumier, *The Third Class Carriage* 1862-75 Paris Opera built 1863 Salon des Refusés, Paris; Manet's *Déjeuner sur l'Herbe* exhibited 1863 Rossetti, *Beata Beatrix*
1865 American Civil War ends 1865 President Lincoln assassinated 1869 Suez Canal opened 1870 Franco-Prussian War: France defeated 1870 (4 September) Paris revolts and establishes Commune; capitulates January 1871 1871-91 Bismark, the 'Iron Chancellor' largely responsible for the unification of Germany	**1870**	1865 Washington, Capitol building completed 1867 Monet and Renoir at La Grenouillère 1870 Monet and Pissarro in London
		1872 Monet, *Impression, Sunrise*
1873 Napoleon III dies: Third Republic proclaimed in France		
		1874 First Impressionist Exhibition includes works by Monet, Renoir, Degas, Pissarro, and Cézanne
	1880	1877 Rodin, *Age of Bronze* 1884 Salon des Indépendants set up by Seurat and Signac 1884 Huysmans, *A Rebours* 1886 Seurat, *La Grande-Jatte*
1887 Queen Victoria's Jubilee		1888 Gauguin, *The Vision after the Sermon*
	1890	1890 Wilde, *Picture of Dorian Gray* 1890-1 Sullivan, Wainwright Building 1890-1915 Frazer, *The Golden Bough* 1893 Munch, *The Scream* 1893 Horta, 12 rue de Turin, Brussels 1896 Opening of the Maison de l'Art Nouveau in Paris 1897-9 Mackintosh, Glasgow Art School
1901 Death of Queen Victoria	**1900**	

413

414

415

413 F.-A. Duquesney, Gare de l'Est, Paris, begun 1852

414 Charles Garnier, The Opera, Paris, 1861–74

415 George Gilbert Scott, St. Pancras Station and Hotel, London, 1868–76

416 William Thornton, Stephen Hallet, Benjamin Latrobe, and Charles Bulfinch, Capitol, Washington D.C., completed 1863

and iron railway sheds at St. Pancras Station, but Sir George Gilbert Scott (1811–78) hid this innovative use of technology behind a monumental and ornamental façade, with an adjoining hotel, in a revival of the Gothic style (fig. 415). In France, F.-A Duquesney drew on the Renaissance for the Gare de l'Est, adding a highly original fan window to light the station behind (fig. 413). In Providence, Rhode Island, an American architect designed Union Station as a Romanesque castle. Even into the twentieth century, railway passengers continued to end their journeys in temples of the past; in New York City, both Penn Station (1906–10) and Grand Central Station (1903-13) were part of a final turn-of-the-century Neoclassical revival.

The sheer variety of revived styles came from a deliberate eclecticism and love of clutter, a feeling that led the author of 'The Great Exhibition as a Lesson in Taste' to write that if all the objects in a single room were of the same style, no matter how handsome each might be individually, together they would produce a dull and distasteful effect. In architecture the choice of certain styles reflected nationalistic feelings. The Greek Revival exemplified by the Euston Station gateway extended all over Europe, but it was particularly popular and long-lived in the United States, whose identification with Greek democracy was also spelled out in the names of towns such as Athens, Troy, and Ithaca. The new city of Washington D.C. was laid out in vast ranks of columns; in the case of the capitol building itself, the picturesque Neoclassical designs of Latrobe and Bulfinch became dwarfed by massive, static wings housing the Senate and the House of Representatives (fig. 416). All over the country, banks, libraries, town halls, and even private homes appeared as Greek temples with imposing Doric porticos.

France, rising from the dust of Waterloo, sought a new image in her own history. Napoleon's nephew Louis-Napoleon came to power in 1848 and was crowned Napoleon III in 1852. France entered a second period of Napoleonic empire rendered visible in a flamboyantly neo-Baroque mixture of Mannerist curves and gables combined with the massive classical ornamentation of Louis XIV. The Paris Opera (fig. 414) sums up with its glittering grandeur and extravagance the self-esteem of the aristocracy and the haute-bourgeoisie who entered a cultural centre not so much to see as to be seen.

In England a post-Waterloo nationalism led to a rejection of the Roman and Renaissance classicism associated with France, first in favour of strict neo-Greek façades, but by the 1830s a more native revival gained ground, that of English Gothic. When, in 1835, the committee in charge of building the new Houses of Parliament chose to employ the Gothic style, the Gothic Revival gained ground as a national style, for its origins were in undeniably English buildings, a claim the Grecophiles could not make. By mid-century the Gothic Revival had developed into a colourful, showy, and deliberately picturesque style employed in designing churches, public

buildings, entertainment halls, and private homes, as well as factories and railway stations such as figure 415. While distinctive in its replacement of classical pilasters, swags, and urns with cusps, canopies, and pointed arches, Victorian Gothic shared with all other revivals of the period a drive for monumentality and ostentatious display that conveyed as opulently as the Paris Opera the grand style of new wealth.

The Revolt against Sham: Looking Backwards

Although the Gothic Revival was a natural outgrowth of the romantic and antiquarian medievalism of the previous century, it drew into its orbit those in England who were opposed to the sham nature of design so eloquently illustrated in the Great Exhibition of 1851. The two men most central to the revival, Augustus Welby Pugin (1812–52) and John Ruskin (1819–1900), both condemned architecture that — like the Greek gateway fronting Euston Station — denied the function of the building. Yet, significantly, both Pugin and Ruskin disliked that superbly functional piece of design, the Crystal Palace; Ruskin dismissed it as an overgrown greenhouse. For in England, the opposition to Victorian bourgeois taste was tied to a reaction against the whole Industrial Revolution, a reaction that looked backwards to the Middle Ages rather than forwards to modern technology. Pugin and Ruskin introduced into the Gothic Revival a moral note that went beyond criticism of shams such as using stucco to imitate stone; they were concerned with the whole question of what industry had done to the quality of life. In Pugin's case this was combined with strong religious feeling. A convert to Roman Catholicism, he wrote a book contrasting medieval towns with their nineteenth-century counterparts half as an outcry against industry's destruction of beauty and half as a protest against the loss of faith since the Reformation. He gives the example of a town in which the medieval churches have not only been destroyed; they have given way to soulless symbols of modern technology, a gasworks and a prison, while the new public park has been built over the hallowed ground of the old graveyard.

Ruskin attacked modern aesthetics from the ethical standpoint of a fervent Protestant. To him the value of a building depended not on its design alone but also on the ethical considerations that went into the making of it, from the moral worth of its architect to the workmen's devotion to craft. Recognizing the tremendous gap between art and manufacture, Ruskin saw the medieval craft guild system as the best model for his own time. He was not alone in recognizing that the modern manufacturing process divorced work from creative design, but where others sought to strengthen the academic background of factory designers by establishing schools of design on lines similar to the fine arts academies, Ruskin resolutely set his face against industry altogether, and in so doing

he influenced the direction of those artists in England who sought to reject the sham nature of Victorian taste.

In England, the artists who rebelled against Renaissance classical theory were caught between high-minded idealistic retreat and a more modern attempt to paint from nature. The impossibility of combining realism and idealism in the mid-nineteenth century is nowhere more obvious than in the pictures of the Pre-Raphaelite Brotherhood. Strongly influenced by Ruskin, who had defended Turner's truth to nature, this group tried to paint natural light and forms as they appear in the open air. But their naturalism was at odds with the spiritual aspirations of the Brotherhood, which combined elements of the medieval craft guild with those of a religious order.

In trying to be true to nature, the Pre-Raphaelites experimented with painting out of doors in order to capture natural light and atmosphere. In this they went to great lengths. William Holman Hunt (1827–1910) set out to paint a Biblical subject from Leviticus (16:20–2), the Scapegoat on whom the sins of the Children of Israel were cast; with great care he painted the subject where it might have occurred, by the shores of the Dead Sea (fig. 420). He hired a goat and camped by the lake for a fortnight, but was attacked by robbers and had to retreat to civilization before he was finished. Nevertheless, he had taken great pains to observe exactly the goat's footsteps in the soft salt mud, and he painted the extraordinary sunset light from nature, working in colour during the few hours of each evening when the light was right. He was able to paint the mountain background from the roof of a house overlooking the Dead Sea. Yet, just as a modern film director may well make a more convincing Biblical spectacular on a movie set in Hollywood than on location in the Holy Land, so Hunt could have achieved much the same effect in his studio. For the sharp fidelity to detail and the bright, shadowless light are realities of the mind rather than an objective and photographic portrait of what is seen with the eye. The effect of such a sharpened realism recalls Friedrich's *Large Enclosure* (fig. 395). But that work clearly conveys the painter's feelings about nature, whereas in *The Scapegoat* there is an ambiguity and an unresolved tension between the obsessive realism of the goat's hair and footprints in the foreground and the visionary light and landscape background.

Hunt's choice of setting was bound up with the Biblical theme he was developing. A more strictly painterly attempt at realism is seen in the work of Ford Madox Brown (1821–93), who was never a member of the Pre-Raphaelite group, but a close friend who influenced their course towards realism. When he painted his wife and baby daughter looking at sheep on Clapham Common, Brown was primarily trying to capture the real light of an outdoor scene (fig. 417). He painted the background on the Common and the rest in his garden. Like Hunt he experienced many trials in his pursuit of reality; he suffered from sunstroke, and the sheep he imported

from Clapham Common ate the flowers in his garden. Yet, for all the trouble he took to paint directly from nature, *See the Pretty Baa-Lambs*, like *The Scapegoat*, is filled with a highly charged surrealistic flow of light; there is something too significant in the pose and gesture of the young mother to let us accept the painting at its face value. On the other hand, we cannot pin down a satisfactory interpretation; neither the realism nor the idealism is wholly convincing.

The Revolt against Sham: Looking Forwards

From the time that Renaissance art established the principles of suggesting three-dimensional space, this was the way in which everyone expected painted space to be visualized. From Raphael to Constable, artists set their subjects in the same frame of unified and defined space; a flowing line connects figures to each other and to the space they inhabit. But in the nineteenth century this unity and harmony of space did not reflect the rapidly moving changes that uprooted and isolated people from each other and from the natural world.

Realism is a term we have used throughout to convey truth to nature in art. But to some nineteenth-century artists it came to mean reproducing a subject with no idealizing or rearranging on the part of the artist. We find the beginnings of this new sense of realism in some of the Romantic painters, despite their commitment to ideas and vision; we saw it, for example, in Delacroix's *Women of Algiers*, and we find it in Goya's *The Forge* (fig. 419). His subject, three blacksmiths working in a forge, posed a classical problem of composition, the grouping of figures in action, and he used a classical solution by placing them in a triangle, its apex the upraised hammer. A flowing line binds the three men together into one motion and rhythm; this and the dramatic chiaroscuro come from Baroque art. But Goya's painting has the immediacy of a photograph, unfiltered through the interpretation of the artist. These are not picturesque, romanticized peasants; they are three ragged, dirty blacksmiths earning their living. Velasquez had portrayed a group of village drunks with the same unsentimental directness (fig. 323), but he placed them in a mythological context, as companions of a god, thereby placing a veil of illusion between us and their real situation.

Goya did no such thing; his labourers are cut off from the surrounding world, existing in a fragment of time and space. The background of the shop disappears entirely in shadow, leaving only the work of a particular moment. Not even their trade was important to Goya except for pictorial reasons; in an earlier sketch he had made them diggers, with an upraised mattock instead of a hammer. But diggers work out of doors and would have required a background; by setting them in the dark forge, he avoided suggesting a relationship between the figures and the outside world.

419 (*above*) Francisco Goya, *The Forge*, *c*. 1819. Oil on canvas, 75¼ × 48¼ in. (191 × 121 cm). New York, Frick Collection

420 (*right*) William Holman Hunt, *The Scapegoat*, 1854. Oil on canvas, 33½ × 54 in. (85.1 × 137.2 cm). Port Sunlight, Lady Lever Art Gallery

417 (*far left*) Ford Madox Brown, *See the Pretty Baa-Lambs*, 1851–9. Oil on canvas, $23\frac{1}{2} \times 29\frac{1}{2}$ in (59.7×74.9 cm). Birmingham, City Museums and Art Gallery

418 (*left*) John Brett, *The Stone-breaker*, 1857–8. Oil on canvas, $19\frac{1}{2} \times 26\frac{1}{2}$ in (49.5×67.3 cm). Liverpool, Walker Art Gallery

To Goya these figures were a subject for painting just in themselves. When Honoré Daumier (1808–79) painted *The Third Class Carriage* (fig. 422), he intended a social message. In a few incisive lines he captured the isolation and loneliness of the working class and the petit bourgeois who travelled third class. The train separates its passengers from the natural world outside. Even the style adds to the direct impact of these figures. Daumier began his career as a cartoonist for the newspapers, and in place of the flowing line that ties Goya's blacksmiths into a single motion, he employed the swift loops by which a caricaturist conveys character through a few details. The women and children in the foreground are clumped together to form a triangle, yet they avoid any contact; each woman is lost in her own thoughts, while the children are asleep. There is sympathy but not a trace of sentimentality in the artist's treatment.

Daumier was the author of a statement that became a rallying cry for artists who wanted to break with classical tradition. 'Il faut être de son temps,' he said; one must be contemporary. To Daumier, being contemporary meant to capture the essence of his world as well as the appearance. In the nineteenth century, an artist heeding Daumier's slogan could not find satisfaction in either the religious conviction of the Middle Ages or the moral assertions of Classical humanism, but feelings could be aroused by social concerns and the plight of the poor and helpless who suffered the effects of industrialization and urbanization. The distress of the poor, crowded into urban slums, was more obtrusive than at any period before.

To be contemporary, however, demanded more of an artist than an unsentimental, unpatronizing attitude towards a subject. It required a new view of space. This is what French artists understood as the Pre-Raphaelites did not, as we can see by comparing two paintings on the same subject, done by artists both anxious to portray the oppression of the working class by the wealthy. John Brett (1830–1902) was a younger associate of the Pre-Raphaelites. His brightly illuminated canvas, with its hard-edged outlines, shows their influence (fig. 418). The background is a recognizable scene near Dorking, Surrey; its exact location is marked by the milestone giving the distance from London. The subject is a young boy who has to make a living breaking up stones with a hammer to build the roads over which the well-to-do will drive their carriages. But the poor child labourer is actually a healthy, handsome boy (the model was Brett's younger brother), and he works in the company of an engaging little dog, who begs the child to play with him. We are moved to pity the hard lot of the child because he has to work instead of playing with the dog, but we do not react directly to the situation because we have to read it through symbols, and are distracted by the countryside in the background.

Some ten years earlier the French artist Gustave Courbet (1819–77) painted a similar subject (fig. 427), but without the deep landscape background. He chose instead to limit the background sharply, arbitrarily cropping it like a photograph. This is a novel treatment of space in which

421 Gustave Gourbet, *The Stone-breakers*, 1849. Oil on canvas, 84 × 120 in (213 × 312 cm). Formerly Dresden, Gemäldegalerie; destroyed in World War II

422 Honoré Daumier, *The Third Class Carriage*, *c*. 1862. Oil on canvas, 25¾ × 35½ in (65.4 × 90.2 cm), New York, Metropolitan Museum of Art, bequest of Mrs H.O. Havemeyer

the figures are not harmonized with their background but quite the opposite; they seem completely detached from it. In this way, Courbet focused directly on his two stonebreakers, who are grown men, not picturesque children. One is an old man moving with the stiffness of age; the other, a young man, staggers under his too-heavy burden. They pay no attention to us or to each other. But, despite the artist's apparent objectivity, we notice what he intended us to notice; that one man is too old for this work but cannot stop because he would have no money to live on, and the other, healthy now, will soon become broken and prematurely aged from the strain.

The realism of Courbet's work hits us with an immediate impact which Brett's painting lacks. Yet Courbet did not paint on the spot; he painted this work entirely in his studio. He had come upon the scene, and, according to his account, was struck at once by its value as a subject. He engaged the two labourers to come to his studio and spent much time experimenting with different poses before finding the one that best expressed their total lack of humanizing contact or mutual support. For this is what he had seen and remembered, and by rejecting anything that would distract from the impression of their misery he conveyed directly the brutalization undergone by the working class.

The objectivity with which Courbet recorded these stonebreakers is very close to that of the camera, especially in the way in which the background has been arbitrarily cropped and slightly tilted. Photography, though still in its early stages, was beginning to be used by painters, and Courbet valued the camera because it could record a scene without interpreting it. His truth to life earned for his painting the name of Realism. But Realism was far more for Courbet than photographic verity. It was a creed which carried Daumier's cry for contemporaneity to more philosophical lengths. He said: 'To be in a position to translate the customs, the ideas, the appearance of my epoch, according to my own estimation; to be not only a painter but a man as well; in short, to create living art — that is my goal.'

Realism

By 1855 Courbet had developed his ideas and his style to the point where he wanted to summarize the sources of his Realism. He called this work a 'real allegory', deliberately coining an oxymoron, or contradiction in terms, for 'allegory' implies a resort to imaginary personages. Entitled *The Painter's Studio*, this painting records everything that had gone into Courbet's art (fig. 425). The allegory begins with the studio, for that was where Courbet did all his painting, and, significantly, he is seen here at work on a landscape, showing his connection with the natural world through the medium of art. He is surrounded by various people rather self-

consciously posed, as if for a formal photograph. They are taken from a cross-section of society, from the poor country people seen on the left to the smartly dressed townsmen on the right. They also represent all the stages of human life, from the nursing infant by the artist's easel to the gravedigger in his shovel hat, signifying death. The skull near him is both an artist's prop and a *memento mori*. But these people are more than symbols of age and social status; they are real people whom Courbet knew. The country folk on the left are from his home town of Ornans, people he had grown up with; the fashionable and more prosperous figures on the right are his Parisian friends and associates, among them the poet-critic Baudelaire. All of these people played a part in forming the artist; all his life's experience went into his art. They are portrayed just as they were, unromantically; his denial of picturesque idealizing is implicit in the trappings of the Picturesque — a bandit's plumed hat, a dagger, and a guitar — discarded on the floor.

This is a 'real allegory' because these people are both real and at the same time personifications of the forces that made Courbet the artist he was. The allegory takes a satirical twist directed at classical tradition; the two children represent the value of innocent vision in art, as opposed to traditional academic views on training. One boy draws on the floor, a naive and untrained parallel to the grown-up painter; the other watches Courbet at work. He is the innocent viewer, who sees with a fresh and unprejudiced eye. The nude who stands at the artist's shoulder personifies Truth and embodies the artist's Muse; she is also, simply, the artist's model. Yet she was not in fact drawn from life but from a photograph.

It was in his assault on the theory that painting should be an intellectual act embodying abstract ideas rather than mere copying from nature that Courbet can be seen as a progenitor of modern art. He was the first painter to make a real break with classical idealism. Modern art, however, is distinguished by its refusal to place objects or figures in a unified and clearly defined three-dimensional space, and as such it begins not with Courbet, but with a younger French painter, Edouard Manet (1832–83). Courbet adhered to the classical technique of figure modelling through delicate shading; it was Manet who developed a style in which forms were deliberately flattened to resemble cardboard cutouts pasted against an undefined space (fig. 5).

Three influences led Manet in this direction, only one of which, photography, played a major role in Courbet's work. Courbet used the camera because it was incapable of idealizing a scene; he sometimes even painted landscapes directly from photographs, deliberately adding nothing of his own. Manet, however, observed that a photograph has the effect of flattening space. The camera lens does not record landscape in the flowing line of gradual recession as Leonardo taught us to see it. The camera as it existed in Manet's time also had the effect, partly from the length of time needed for an exposure, of detaching figures from the background.

423 Édouard Manet, *Le Déjeuner sur l'Herbe* (*Luncheon on the Grass*), 1863. Oil on canvas. $81\frac{7}{8} \times 104\frac{1}{8}$ in (208×264.5 cm) Paris, Musée de l'Impressionisme

424 Édouard Manet, *Olympia*, 1863. Oil on canvas, $51\frac{3}{8} \times 74\frac{3}{4}$ in (130.5×190 cm). Paris Musée de l'Impressionisme

425 Gustave Courbet, *The Painter's Studio*, 1855. Oil on canvas, 142×228 in (361×598 cm). Paris, Louvre

423

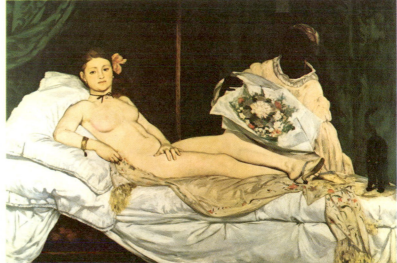

424

425

A second influence on Manet was the painting of Velázquez and of Goya. Spanish art was especially popular in France after Napoleon III had married a Spanish countess; its example encouraged Manet to use bright, vibrant colours and to choose subjects from ordinary life. The third influence was Japanese art, seen through prints that came to Paris in a succession of world's fairs following the London Exhibition of 1851. The highly stylized treatment of landscape and figure in Japanese art provided Manet with an entirely new way of depicting picture space which only hints at spatial depth through a delicate and economical use of atmospheric impressions.

The Spanish influence was strongest in Manet's first major exhibited work, a portrait of a popular Spanish singer performing at that time in Paris (fig. 426). The public recognized its debt to Velázquez and to Goya, and on the whole it was well received, despite some criticisms of the vulgarity of the subject, dressed in his ordinary clothes, filling the canvas, one critic said, with the odour of onions and tobacco smoke. Already, Manet was flattening figure and space by using contrasts of bright colour rather than a delicate and gradual chiaroscuro to outline forms. The background is deliberately undefined, its limits indicated only by the line of wall meeting floor; the feeling of distance between the player and the wall is suggested by the tilt of the bench alone.

Manet pursued this flattening of forms until, by the time he came to paint *The Fifer* (fig. 5), he had detached his figure from its background altogether. At first the fifer appears totally flat, but the delicate brushwork of his hands and the tilt of the fife give an impression of roundness; the buttons on his jacket suggest the swelling of his chest as he blows into his fife. Manet was not telling us that his figure was really flat; he was stating that we see forms not in a whole, coordinated view of roundness but in patches, through impressions of colour contrasts. For his departure from the norm he was severely criticized. In 1863 he exhibited several works in a one-man show in a private gallery, a rare and daring act for an unrecognized artist. He hoped to attract favourable notice from the Salon jury of that year, but he was disappointed; his subjects were found to be common and his technique crude: 'Goya in Mexico gone native to the heart of the pampas and smearing his canvases with crushed cochineal'.

The Salon des Refusés

Even without the adverse reviews of his one-man show, Manet would have fared badly with the Salon jury, for, concerned at the huge numbers of works crowding the past shows, the 1863 jury rejected over 4,000 paintings, including many by more popular artists than Manet. The harshness of the decision created such an uproar that Napoleon III was moved to demand that a separate exhibition be held for all the rejected works. The

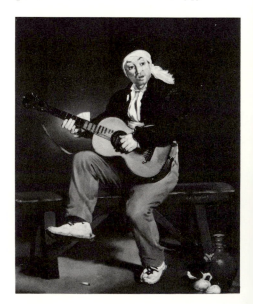

426 Édouard Manet, *The Spanish Singer*, 1860. Oil on canvas, 58 × 45 in (147 × 114 cm). New York, Metropolitan Museum of Art, gift of William Church Osborn, 1949

427 James Abbot MacNeill Whistler, *The White Girl*, 1863. Oil on canvas, $84\frac{1}{2} \times 42\frac{1}{2}$ in (214.6 × 108 cm). Washington, D.C., National Gallery of Art, Harris Whittlemore Collection, 1943

Salon des Refusés, as it was called, was doomed from the start by the academicians' hostility; they did everything in their considerable power to provoke public ridicule, even to the point of deliberately hanging the worst pictures in the best places. The storm of controversy in the press aroused an unprecedented interest in those rejected; to go and laugh at the show became the event of the social season.

Under the best of circumstances, a public critical even of Courbet, who at least modelled his figures in a delicate chiaroscuro, would have reacted with bewilderment and incomprehension to the two most radically modern works in the show, Manet's *Le Bain* (*The Bath*), soon nicknamed *Déjeuner sur l'Herbe*, or *Luncheon on the Grass* (fig. 423), and *The White Girl* (fig. 427) by the American painter James MacNeill Whistler (1834–1903). Both works represent a visible break with Renaissance perspective and space. Manet flattened his figures by sharp contrasts of dark and light colours with no intermediate tones. The flat figures are placed against a three-dimensional background, which has the effect of detaching them from the landscape. Whistler, who shared Manet's enthusiasm for Oriental art, achieved a two-dimensional effect by dressing his model in white and placing her against a white background, avoiding a defined perspective and concentrating instead on pure, almost abstract, design.

The Salon public, accustomed to three-dimensional modelling and flowing, defined space, found the technique of these two artists crude. But they were really shocked by the realism with which Manet had treated his obvious derivation from a painting by Giorgione called *Fête Champêtre*, in which there were two clothed men and two unclothed women. Critics found Manet's male figures (his brother and his future brother-in-law) far too ordinary-looking, and the female nude positively ugly. But far worse was the fact that by dressing the males in contemporary suits instead of pastoral costumes in the manner of Giorgione, he turned a timeless fête into an embarrassing scene of public nudity, its realism suggesting that such scenes really occurred in the Bois de Boulogne. It reveals Manet's naiveté that he never expected this criticism; he chose to paint a nude because it was a popular category in the Salons, and besides borrowing the subject from Giorgione he took the composition from a work by Raphael, adding only the figure of the woman in the background.

But this was, after all, the public who wanted shams and ornamental façades; in painting they wanted a similar veil of illusion to convey an ideal with no actual time or place. The most highly praised work of the official Salon was a painting of the birth of Venus by Alexandre Cabanel. This was a nude of voluptuous charms, but her mythological state was never in doubt, so that a taste for lasciviousness could be indulged in with no offence to morality. An Englishman reviewing both the official Salon and that of the Refusés admired the fakery of the Cabanel: 'Cabanel's Venus, though wanton and lascivious, is not in the least indecent.' Yet he found the realism of the *Déjeuner sur l'Herbe* intolerable:

I ought not to omit a remarkable picture of the realist school, a translation of a thought of Giorgione into modern French. Giorgione had conceived the happy idea of a fête champêtre, in which although the gentlemen were dressed, the ladies were not, but the doubtful morality of the picture is pardoned for the sake of its fine colour … Now some wretched Frenchman has translated this into modern French realism, on a much larger scale, and with the horrible modern French costume instead of the graceful old Venetian one …

P.G. HAMERTON, *Fine Arts Quarterly Review*, Oct. 1863

Manet tried once more to please the public with a nude, this time drawing on Titian's *Venus of Urbino* (fig. 248). If naive about the public's distaste for his realistic handling of the old masters, Manet was stubbornly true to his genius; *Olympia* (fig. 424) is in many ways the finest summation of what he was trying to achieve up to this point. Whereas the figures in the *Déjeuner* seem to have borrowed their setting from another painting, in *Olympia* the flattened perspective is coordinated so that we are not aware of the stages by which Manet had freed himself from the graduated recessions of Renaissance perspective; he brought off an entirely new relationship of figure to space that gives us the impression of reality without showing us how it is done.

There were criticisms of its flatness; Courbet said the girl looked like the Queen of Spades on a playing card. But again it was the frank reality of the girl's nakedness that aroused the worst antagonism. Her saucy look has nothing of the sensuous appeal of Titian's Venus. There is nothing of the goddess about her; she is obviously a Parisian courtesan, and the exotic touches of the black cat and the negro maid do not distract from the realism. By the directness of her gaze, Manet forces upon the spectator the role of the admirer who has just come to visit her, bringing flowers. Such a scene was often enacted in Paris, no doubt by many who saw the painting, but Parisian society preferred not to be reminded of the fact.

Landscape: the Barbizon School

That Realism in painting ran counter to the mid-century idea of what was good style, as well as good taste, can be seen from the attitude of the critics and public to landscape painting. Landscape was, after all, a recognized category, even though not as praiseworthy as history painting; from 1817 on landscapes were eligible for a prize at the Paris Salons. But there was a group of French painters, contemporary with Courbet, who painted, from sketches made in the open air, pictures not of idealized and picturesque landscape with pastoral figures, but of ordinary, everyday countryside near Paris. Their concern was not to rearrange a scene so as to capture an ideal form, but to represent natural patterns of light and shadow as they observed them, and in pursuing this end they did more painting in the open air than their predecessors. In their realization that

428 Théodore Rousseau, *The Edge of the Forest of Fontainebleau at Sunset*, 1848. Oil on canvas, 56 × 77¾ in (142 × 197.5 cm). Paris, Louvre

forms are shaped by the light reflecting around them, these painters were the connecting link between Constable and the French Impressionists.

The Barbizon school is the name given to these painters because they painted in and around the village of Barbizon, in the forest of Fontaine-bleau. But not all of the men who set up their easels side in the forest can be properly called a school; the group of friends included Jean-François Millet (1814–75), who painted haunting views of peasants labouring in the fields, a romanticized version of Courbet's social commentary, and two very individual figures, Camille Corot and Charles-François Daubigny. Courbet often joined these painters in his later years, when he turned from social themes to landscapes and voluptuous female figures. What connected all of these artists was a shared awareness of the preciousness of open space, a result of nineteenth-century industrialization also found in the novels of George Sand, and a common commitment to capturing the real beauty of the actual scene in front of their easels.

The Barbizon style of romanticized realism is typified by Théodore Rousseau (1812–67), the leader of the group, who settled in Fontainebleau and made the pictorial possibilities of its ordinary countryside his only subject. His views of the forest shimmer in a deepened light, evoking quiet wildness as a source of peace and refreshment. From Constable and Dela-croix he learned to paint in patches of unblended colour that give the effect of movement, suggesting a soft breeze ruffling the curtain of trees through which one glimpses a clearing. In figure 428 cows water peacefully in a pond seen framed by a gap in the foreground trees and bathed by the soft, pink light of sunset. Like Constable, Rousseau compressed his composition by lowering the horizon, bringing the background forward to avoid a marked recession of grounds. This work is closer to Constable's sketches than to the finished paintings; it was the Barbizon painters who began to narrow the gap between what was considered a sketch and what was a 'finished' picture.

Rousseau's romantic but unidealized views of common country scenery made little headway against the the conservative classical taste of the Salon juries until the 1848 revolution had swept away the constitutional monarchy and with it the narrow concentration of power in the hands of the aristocratic élite. Louis-Napoleon was a liberalist and opposed to aris-tocratic privilege; elected president of the Second Republic, he made himself emperor by a coup d'état, but his dictatorship brought about a more liberal and anti-classicist climate in the Salons. By then, too, the more obvious shocks of Courbet and Manet made simple landscape seem safe and pleasant. But even then, although Rousseau found acceptance, it was the silvery, poetic landscapes of Camille Corot (1796-1875) that were really popular, because they were still connected to the idealizing, Arca-dian mode (fig. 430). Corot began as a classical landscape painter, but he spent summers sketching with the Barbizon painters; in the less restrictive climate of the Second Empire he exhibited paintings that were really sketches, conveying a scene as seen in a fleeting moment, rather than

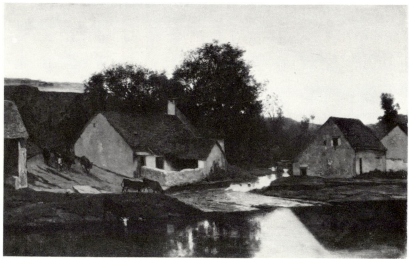

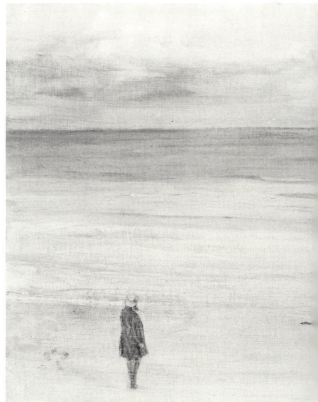

431 (*above*) Charles-François Daubigny, *Gobelle's Mill at Optevoz, Evening*, 1857. Oil on canvas, $22\frac{3}{4} \times 36\frac{1}{2}$ in (57.8 × 92.7 cm). New York, Metropolitan Museum of Art, bequest of Robert Graham Dun, 1911

432 (*right*) James Abbot MacNeill Whistler, *Harmony in Blue and Silver*, 1865. Oil on canvas, $19\frac{3}{4} \times 30$ in (50 × 76 cm). Boston, Isabella Stewart Gardner Museum

429 (*far left*) Gustave Courbet. *Low Tide at Trouville,* mid-1860s. Oil on canvas, 23½ × 28⅝ in (59.6 × 72.6 cm). Liverpool, Walker Art Gallery

430 (*left*) Camille Corot, *The Lake,* 1861. Oil on canvas, 52⅜ × 62 in (133 × 157.5 cm). New York, Frick Collection

worked up in the Salon fashion to suggest the permanence of memory. His style underwent a change from classical linear clarity to the blurred images of figure 430. From Constable he learned the trick of using small flecks of white to suggest reflections of light. He may also have been influenced by photographers, who were discovering the impressionistic effects of bright sunshine dissolving details on a negative.

Corot's feeling for light and atmosphere was shared by his friend Charles Daubigny (1817-79), the only one before the Impressionists to paint regularly the whole of a picture out of doors. His fascination with the role that light plays in our perception of landscape led him to construct a studio on a boat, a device Monet copied. In Daubigny's painting we feel the reality of the sunlit forms, for no atmospheric veil intervenes. Looking at his *Gobelle's Mill at Optevoz, Evening* (fig. 431), we can appreciate both his debt to Dutch Baroque and to Constable and his decisive break with the way in which they handled light to enhance mood and to unify composition. In his painting of the mill in the evening light, the light relects off the geometrical blocks of the buildings individually; rather than co-ordinating the image into a single whole, Daubigny presents the scene in the way the eye perceives what is necessarily only part of a much larger scene. Even in Constable's cloud studies, light conveys feeling, but Daubigny was more objective. His closeness to the Impressionists is underscored by the fact that before the label was pinned on their work, critics referred to Daubigny's paintings as 'impressions', or sketches, suggesting the preoccupation he and they shared with capturing natural light in a rapidly executed, on-the-spot sketch and going no further.

As the technical problem of conveying natural light became increasingly an end in itself, the coast of Normandy and Brittany became a popular rendezvous for artists attracted by the constantly changing reflections of light on water. By 1865 a summer colony of artists in the resort of Trouville, in Normandy, included Courbet, Whistler, Daubigny, and the young Claude Monet (1840–1926), whose family had moved to Le Havre. In the works painted by these artists in and around Trouville we see all the various currents of the period's avant-garde painting. Whistler was equally at home in the art circles of Paris and London; in the mid-1860s he was under the influence of Courbet's realism, but he was also acquainted with the Pre-Raphaelites, who had abandoned their fiercely moral view of art for a more purely aesthetic approach.

Both Whistler and Courbet were fascinated with the problems of composition posed by the wide sweep of sky and sea seen from the beach at Trouville. In Courbet's *Low Tide at Trouville* (fig. 429) and in Whistler's *Harmony in Blue and Silver* (fig. 432), the horizon runs straight across the picture, reducing the subject to an abstract pattern of waves and clouds. Courbet chose a low horizon and injected a feeling of motion into the sweeping curls of his clouds. Whistler, adding his infatuation with Japanese art to Courbet's realism, made a more textural design with a high

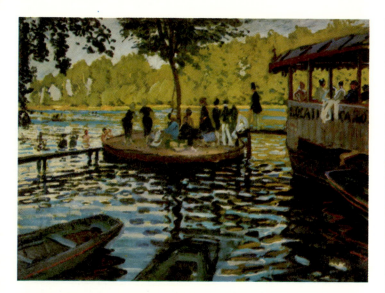

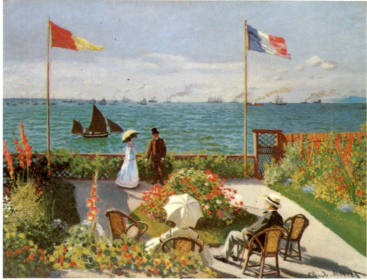

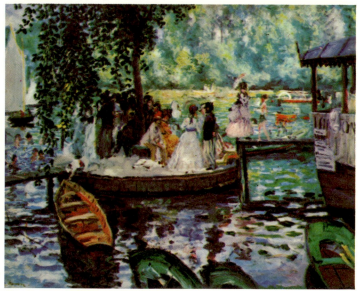

435 (*above*) Pierre-Auguste Renoir. *La Grenouillère*, 1869. Oil on canvas, 26 × 31¾ in (66 × 81 cm). Stockholm, National-museum

436 (*right*) Camille Pissarro, *Lower Norwood under Snow*, 1870. Oil on canvas, 13⅞ × 18 in (35.3 × 45.7 cm). London, National Gallery

433 (*far left*) Claude Monet, *La Grenouillère*, 1869. Oil on canvas, 29⅜ × 39¼ in (74.6 × 99.7 cm). New York, Metropolitan Museum of Art

434 (*left*) Claude Monet, *Terrace at Sainte-Adresse*, 1866–7. Oil on canvas, 38½ × 51⅛ in (98 × 130 cm). New York, Metropolitan Museum of Art

horizon; the figure of Courbet on the beach and the sails on the water are variations in the weave rather than solid forms.

Other painters were affected by the strong light. The bright sun striking water and sand dazzles the eye and creates its own forms, a fact that particularly influenced the young Monet. The dazzling light that illuminates his *Terrace at Sainte-Adresse* (fig. 434) creates the effect of seeing forms through eyes half closed against the glare. The bright flowers on the terrace appear only as splashes of vivid colour; the sunshine sparkles on the sea. In this work Monet foreshadowed his later Impressionist handling of bright, unblended patches of colours to create forms as one perceives them in a momentary glance.

Impressionism

All the painters subsequently brought together under the umbrella of Impressionism were studying in Paris by 1863, and were thoughtful visitors at the Salon des Refusés, where it was not only the paintings of Whistler and Manet that impressed them, but also the courage of the older men in standing against official disapproval. These young painters, who in the late 1870s painted in a style so uniform that it is hard to tell them apart, all began in very different ways. Like the Barbizon school before them, they were brought together by a common disgust at the Academy's reactionary insistence on the classical tradition rather than by shared ideas of style. They were anxious to paint the bustling, colourful life of city and country pleasure spots rather than classical subjects; they were a hedonistic group and rejected the high moral tone of the academic painters.

In 1869, Monet and Pierre Auguste Renoir (1841–1919) went together to a bathing resort on the Seine, La Grenouillère (the frog-pond), and painted the same view, side by side, in what was obviously intended to be the same manner (figs. 433, 435). In these two versions of the same subject, Impressionism was born; the real subject of both is the light reflected off the water. They had made the decisive discovery that all colours are modified by the way light strikes them, so that nothing in nature has a particular colour of its own; shadows are not always grey, tree trunks are not brown, and the sky is not blue; all these traditional values can be changed by a change in the light.

Constable and Delacroix had already shown that paint changes tone according to the juxtaposition of colours on a canvas. Combining this knowledge with their realization that light dissolves outlines, the Impressionists set out to capture the exact image seen at a given moment and in a particular light. This gives their paintings a vivacious sparkle. In figure 440 Renoir captures the light-hearted enjoyment of the middle class on holiday by means of rapid, unblended brush strokes of pure colour. Outdoor sketching had previously been an important first step to capture a

feeling of spontaneity as a basis of the finished work. To the Impressionists spontaneity was not a looked-for end; it occurred because they had to work at speed and could not touch up a scene afterwards without spoiling the effect of the light already caught.

The Franco-Prussian war of 1870 interrupted their joint explorations and delayed Impressionism's arrival in the public's awareness. Monet and Camille Pissarro (1830–1903) spent the war months in England, where they saw works by Constable and Turner and the Pre-Raphaelites. They were less affected by the English Romantics than one might have expected; Constable's sketches, which seem so close to their style, were unknown until the end of the century. Although Turner's handling of light impressed them, they were repelled by his Romantic striving for effect. But the short exile was fruitful for them; they painted together, sharing ideas, so that Pissarro came to adopt the small, rapid brush strokes of the Grenouillère paintings (fig. 436). Moreover, in London Daubigny introduced them to the art dealer Durand Ruel, whose stubborn support became the chief means of survival to the group that reconvened after the war.

The group that came together in Paris in 1871 was more tightly knit and more sure of its rightness than ever. They gained the support of Edgar Degas (1834–1917), a natural rebel against the authority of the Salon, and of Berthe Morisot (1841–95), a friend and pupil of Manet, who soon became influenced by the Impressionist style (fig. 437) and who influenced Manet to experiment with its rapid, unblended brush strokes. In the late 1870s Degas brought in his friend the American painter Mary Cassatt (1845–1926), whose income and whose wealthy friends were a badly needed asset. Throughout the decade all of these painters, despite individual differences, shared something of the Impressionist style of forming images through patches of unblended colour.

Failing entry to the 1873 Salon, the group of friends turned to Monet's idea of holding their own exhibition, and so the first Impressionist exhibition was held the following year. Degas enthusiastically joined in, although Manet did not; Morisot exhibited several works, including *The Cradle*. Pissarro persuaded Monet and Renoir to include Cézanne; his *House of the Hanged Man* (fig. 438), shown at the exhibition, demonstrates the influence of Impressionism on his style at this point, although he was less interested in catching a fleeting impression than in analysing the structure of nature.

To make the critics take them seriously, the group invited the participation of other, more respectable artists and titled the show 'Exhibition of Independent Painters, Sculptors and Engravers'. Nonetheless the critics fastened their ridicule squarely on Impressionism, which received its name from a derisive review by Louis Leroy. Leroy picked the name from one of Monet's paintings, called *Impression, Sunrise*. The lack of detailed outline infuriated critics, who considered an impression to be an unfinished sketch

437 Berthe Morisot, *The Cradle*, 1872. Oil on canvas, 22 × 18⅛ in (56 × 46 cm). Paris, Musée de l'Impressionisme

438 Paul Cézanne, *The House of the Hanged Man at Auvers-sur-Oise* 1873. Oil on canvas, 21⅞ × 26¼ in (55.6 × 66.7 cm). Paris, Louvre

439 Edgar Degas, *Carriage at the Races*, exhibited 1874. Oil on canvas, 13¾ × 21½ (35 × 54.5 cm). Boston, Museum of Fine Arts, Arthur Gordon Tompkins Residuary Fund

440 Pierre-Auguste Renoir, *Dancing at the Moulin de la Galette*, 1876. Oil on canvas, 51½ × 69 in (131 × 175 cm). New York, John Hay Witney Collection

437

438

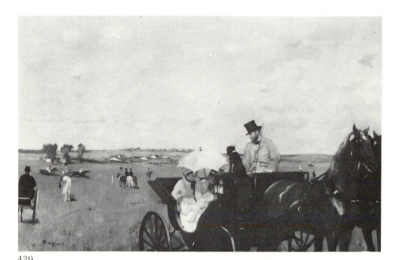

439

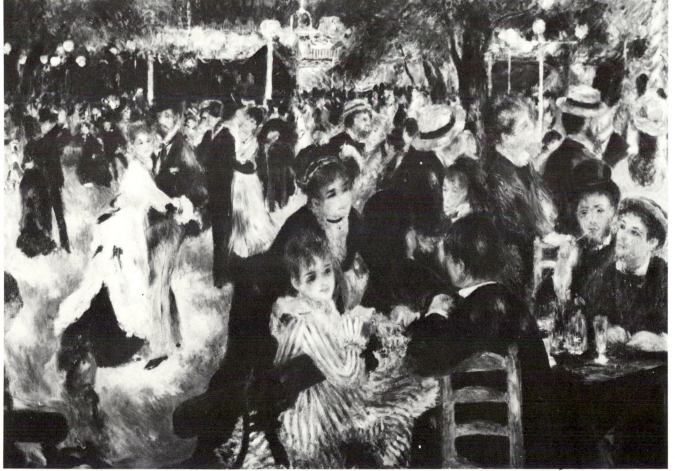

440

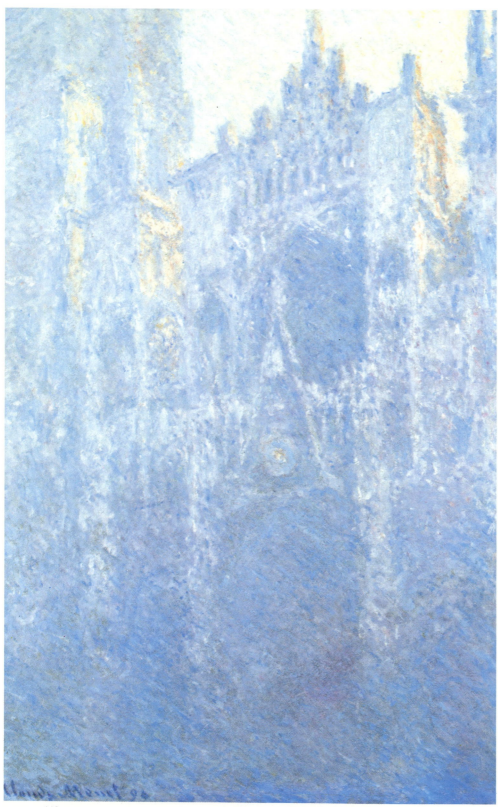

441

441 Claude Monet, *Rouen Cathedral*, 1894. Oil on canvas, $39\frac{3}{8} \times 25\frac{1}{2}$ in (100×65 cm). Essen, Folkwang Museum

442 Edgar Degas, *Absinthe*, 1876. Oil on canvas, 36×27 in (92×68 cm). Paris, Musée de l'Impressionisme

443 Mary Cassatt, *Five O' Clock Tea*, 1880. Oil on canvas, $25\frac{1}{2} \times 36\frac{1}{2}$ in (64.7×92.7 cm). Boston, Museum of Fine Arts (Maria Hopkins Fund)

444 Paul Cézanne, *Mont Sainte-Victoire*, 1904–6. Oil on canvas, $25\frac{1}{2} \times 31\frac{7}{8}$ in (65×81 cm). Zürich, Kunsthaus

445 Georges Seurat, *Sunday Afternoon on the Île de la Grande-Jatte*, 1884–6. Oil on canvas, $81\frac{1}{2} \times 121\frac{1}{4}$ in (207×308 cm). Chicago, Art Institute, Helen Birch Bartlett Memorial Collection

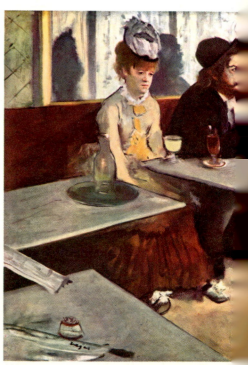

442

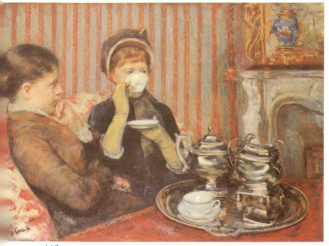

443

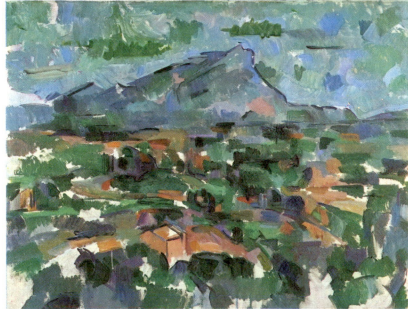

444

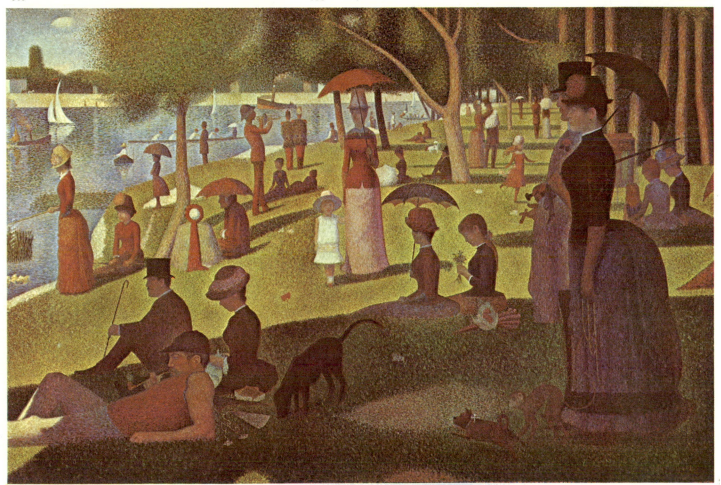

445

and were not interested in fleeting glimpses masquerading as finished paintings. Degas offended people with works like his *Carriage at the Races* (fig. 439) because it ran off the canvas at the edges, cutting off a horse on one side and a man in a carriage on the other. The Impressionists' out-of-focus treatment of form and lack of pictorial boundaries could not be seen as representational art by people used to judging line, colour, and composition.

Yet the Impressionists were obsessed with form, and were more classical than their academic opponents in insisting on painting from nature. The apparently haphazard compositions of Degas and Cassatt that ran off the edges and split figures in two were carefully constructed to focus the eye on a particular detail. As in the Japanese art that influenced them, nothing in a composition was randomly chosen. Cassatt's *Five O'Clock Tea* (fig. 443) conveys a sense of claustrophobia by squeezing the figures between the vertical stripes of wallpaper and the diagonal of the table. The two women are isolated, each in her own thoughts; the snap-shot effect catches the visitor with her cup obscuring her face, and with it her personality. Her little finger, elegantly extended, proclaims the one striking thing about her, her good breeding.

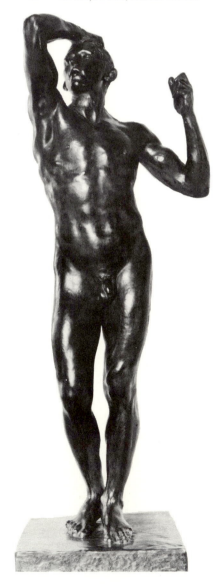

446 Auguste Rodin, *The Age of Bronze*, 1876. Bronze, 69 × 23½ × 23½ in (175 × 60 × 60 cm). Paris, Museé Rodin

Degas's *Absinthe* (fig. 442) creates a similar feeling of oppression in a different class of subject. The sharp diagonal lines of the tables in the foreground pin the couple against the wall in the corner; the blank space in the foreground emphasizes the isolation of alcoholic stupor and creates a moving glimpse of two lost and lonely individuals.

By 1886, when the last Impressionist exhibition was held, the participants were no longer a cohesive body. Renoir became depressed at his inability to draw and spent some time studying the art of the past, struggling to find the solidity of form and line. Eventually the examples of Watteau and Fragonard led him back to seeing forms through light and reflections in a manner even more consciously pretty than the paintings of the 1870s like figure 440). Monet became more fascinated than ever with changing light and painted series of a single subject at different times of day, moving from one canvas to another as the light changed (fig. 441).

Cézanne, who never really found himself in the Impressionist style, moved towards a greater abstraction of forms and began to see landscapes in layers of flat, geometric shapes. His bold and analytical view of landscape reached into the far distance, unlike the close-up views of Impressionism. But he flattened his distant views into overlaid planes of squares, circles, and triangles (fig. 444). As we shall see, Cézanne's post-Impressionist abstraction of natural landscape was really the beginning of Modern painting.

Monet's late, translucent style was influenced by pointillism, the invention of two newcomers whose introduction into the Impressionist shows split the group apart. Georges Seurat (1859–91) and Paul Signac (1863–1935) painted pictures with nothing but small dots of colour. The colours merge, when seen from a proper distance, to create the impression

447 Edgar Degas, *Seated Woman Wiping her Left Hip*, c. 1900. Bronze, height 17½ in (44.5 cm). New York, Metropolitan Museum of Art, bequest of Mrs H.O. Havemeyer, 1929

448 Auguste Rodin, *The Crouching Woman*, 1882, Bronze, 33½ × 23¾ × 19¾ in (85 × 60 × 50 cm). Paris, Museé Rodin

of forms (fig. 445). This technique, also called divisionism, does away with line and linear perspective altogether; it is really carrying Impressionist colouring to its logical conclusion, so that no pigment is mixed on the palette. Each colour receives its tonality in the perception of the eye, by its relationship to the colours around it.

Impressionism is a term properly confined to painting, as the rapid impressions of light can be caught, and held as the eye catches them, only on the flat surface of a painting. But there were artists who treated sculpture with the same direct and momentary realism. The one major nineteenth-century sculptor who broke with Neoclassical idealism was Auguste Rodin (1840–1917). Rodin was impressed by the Impressionists' radical stand for modernism, and despite the difference between painting and a plastic art, he brought something of the immediacy of Impressionist painting to sculpture. His first major work (fig. 446) was a striking statement for realism, aimed against the decorous and sentimental treatment of a subject in academic art such as figure 412. This figure is so realistic that Rodin was accused of casting it directly from life; there is no softening of detail, no decorative drapery. The theme of mankind emerging from tribal primitivism into the dawn of civilization and his derivation of the pose from a work by Michelangelo reflect nineteenth-century pride and historicism, but the feeling of this statue is entirely modern. In his sculpture, Rodin managed to convey the immediate impression of a sketch through the actual handling of material. He avoided marble carving, in which the finished work was done mostly by assistants, preferring bronze casting. *The Age of Bronze* was cast by the lost-wax method used by the ancient Greeks (see above, p. 28). The bronze cast reproduces clearly the artist's intentions as realized in the clay model; clay is a medium that takes form quickly from the hand kneading it into shape.

The Impressionists were interested in a subject for its formal aspects rather than its intrinsic meaning, and we find this also in works by Rodin such as the tightly compact *Crouching Woman* (fig. 448). This figure, contorted into a strained and tense knot, is seen as volume and mass rather than as carefully proportioned anatomy. The same attitude of form as subject, rather than subject as form, is found in the sculpture of Degas, who aimed to capture in bronze the same sense of motion and straining anatomy he caught in his sketches of dancers. In figure 447 the subject is a trivial everyday fragment important only because the artist made of it a work of art. Both Rodin and Degas closed the gap in sculpture, as the Impressionists had in painting, between the sketch and the 'finished' work.

The Native School: American Impressionism

Realism and Impressionism made an impact on American painting in the latter half of the nineteenth century, when more artists were able to travel

449

450

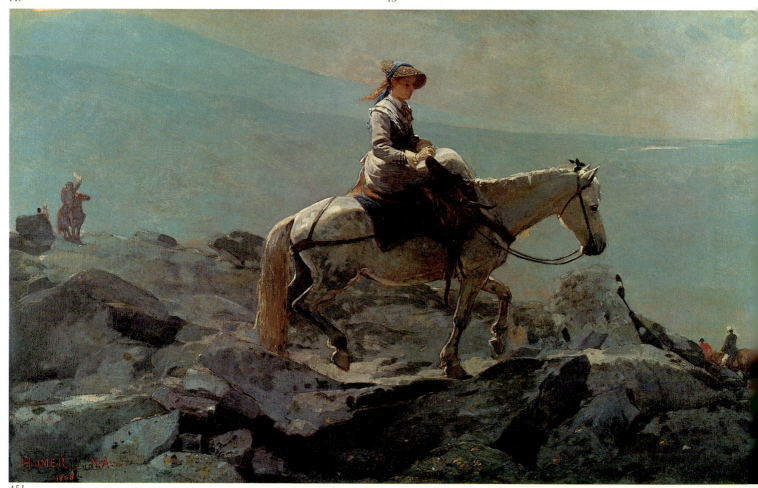

451

449 George Inness, *The Coming Storm,* 1878. Oil on canvas, 26 × 39 in (66 × 99 cm). Buffalo, N.Y., Albright–Knox Art Gallery

450 Thomas Eakins, *Max Schmitt in a Single Scull*, 1871. Oil on canvas, 32¼ × 46¼ in (81.9 × 117.5 cm). New York, Metropolitan Museum of Art, Alfred N. Punnett Fund and gift of George D. Pratt, 1934

451 Winslow Homer, *The Bridle Path, White Mountains*, 1868. Oil on canvas, 24⅛ × 38 in (61.3 × 96.5 cm). Williamstown, Mass., Sterling and Francine Clark Art Institute

452 Albert Pinkham Ryder, *Toilers of the Sea*, before 1884. Oil on canvas, 11½ × 12 in (29.2 × 30.5 cm). New York, Metropolitan Museum of Art, George A. Heane Fund, 1915

abroad and see at first hand contemporary art as well as the old masters. But the bright light and colour that made their way into the canvases of George Inness, Winslow Homer, Thomas Eakins, and Albert Pinkham Ryder were as much a derivation from the Hudson River landscape tradition as a foreign import; despite strong correlations with contemporary painting in Europe, the work of these four was determined by American experience and attitudes. The impact of the Civil War cut short romantic yearnings for the Sublime and brought about a new appreciation of small-time, homespun realism. In this atmosphere, the poet Walt Whitman, the novelist Mark Twain, and the painters Eakins and Homer forged a new and specifically American combination of the grand and the intimate that brought significance without sentimentality to the common, ordinary, and often inelegant facets of everyday life in nineteenth-century America.

George Inness (1825–94) was born at the high point of Hudson River painting — he was a year older than Frederick Church (fig. 408) — and the landscapes he painted fall within this school. But repeated trips abroad brought him under the spell of the Barbizon painters, from whom he learned a more compressed perspective, with less subtle transitions of light and atmosphere; his style is closer to the open air sketches of Rousseau and Corot than to the carefully graded deep perspectives of Cole, Durand, and Church. In *The Coming Storm* (fig. 449), only the right foreground is painted with the objective accuracy of the Hudson River painters. The approaching storm is signalled by broad patches of black shadow contrasted with broad patches of luminous green meadow. It has the direct impact of Constable's sketches rather than the subtle distancing of Cole's *Oxbow* (fig. 405). Inness was a romantic in emphasizing the elemental forces of nature, but the colouring and the contrasts of light and dark come from careful observation and capture exactly the eerie light that glows just before a thunderstorm breaks.

The Coming Storm shows that an American painter could adjust foreign ideas to American vision. The Native School developed in many ways parallel to their French contemporaries, but the best of them showed the grand independence of Whitman and Twain. Nowhere was this trait more marked than in the art of Winslow Homer (1836–1910). In Homer's paintings the transluscent atmosphere of Impressionism suggests direct influence, yet this quality had appeared in his work before he travelled to France. He certainly knew the French modernists at first hand, but the exact results of this exposure are impossible to define accurately. Like Monet, he spent his life studying the effects of light on forms and the changing light of different times of day, but he never saw forms as flickering patches of reflected colour. The earthy solidity of his figures is closer to Courbet, while from the Hudson River tradition he derived a luminous glow against which his figures stand out, often cast in shadow. The result was a style close to Impressionism yet entirely original. In *The Bridle Path* (fig. 451), the bright summer light dissolves the background

into an Impressionist haze while picking out the foreground rocks with the sharp focus of the Hudson River style. The light is behind the girl and her mount; far from dissolving their forms the reflections glinting off the horse's flank and neck serve to emphasize its solidity.

The French Impressionists set out to record only what the eye saw, but in the Americans a vein of Transcendentalism ran strong, creating over-tones of meaning from the way in which memory and feeling modify an actual visual experience. We find this in the painting of Thomas Eakins (1844–1916), the only one of the four to receive a classical academic training in Paris. Eakins was influenced by the Baroque realists, especially Velázquez, and by Courbet and Manet. His subjects are ordinary, yet are cast in a heroic mould. His scientific bent led him to combine on-the-spot observations with mathematically precise excercises in perspective and studied effects; his style is an expressive and personal mixture of things seen and things felt. Figure 450 is a picture of himself and a friend rowing on the Schuylkill River, a sport he loved. The perspective of the boats and river banks is laid out on a grid of intersecting diagonal lines. Yet the trees and their reflections are handled with the impressionistic blur of direct outdoor sketching. This is in marked contrast to the hard, polished surface of the river, with the wakes of the two boats etched across it, which recalls the luminous reflections of Bingham's *Fur Traders* (fig. 406). The result of the mirroring water and the static pose of Max Schmitt in the foreground is to suggest a particular meaning supplied by memory and imagination that overlies the immediate visual experience.

Eakins's feeling for realism of detail increased as he grew older, making much of his work unpopular with a public more in tune with the romantic realism of Inness and Homer. In training and philosophy he was the complete opposite of Albert Pinkham Ryder (1847–1917), a self-taught visionary who painted what he felt more than what he saw. Moved by the grandiose and apocalyptic late operas of Wagner and by the full-blown emotionalism of Baroque art, Ryder was really closer to the late-century Romantics dealt with in Chapter 14 than to Inness, Homer, or Eakins. In his seascapes, especially, visual and emotional experiences coalesce in a reduction of formal elements to a nearly abstract pattern (fig. 452). Ryder's way of expressing emotion through the paint itself, laid on in thick, oozy layers, echoes the primitive energy of Vincent van Gogh's landscapes (see fig. 458). As Ryder was a recluse and an eccentric it is perhaps not surprising that his style should have affinities with that of van Gogh, but they were visionaries in different ways; Ryder conveys a feeling of Oriental calm and acceptance not found in van Gogh. The breakdown of separation between boat, sea and sky in *Toilers of the Sea* reflects the Transcendentalists' merging of the self into the Cosmos. Ryder was the least influenced of his countrymen by contemporary European currents, yet in the extreme simplicity of its components this painting is a forerunner of the Post-Impressionists and the early Moderns.

CHAPTER 14

Late Century Romantics

453 Jean-Léon Gérôme, *The Slave Market*, exhibited 1867. Oil on canvas, 33¼ × 24¾ in (84.3 × 63 cm). Williamstown, Mass., Sterling and Francine Clark Art Institute

The Impressionists were concerned with the objective portrayal of external appearances and took care to exclude any feeling towards a particular subject other than aesthetic pleasure. Monet painted the interior of a railway station not to express pride in industry and progress but because he found beauty in the light shining through the smoke. But there were artists of a more romantic temperament who, although they shared the aesthetic view that art should exist for itself alone, deplored the lack of ideas and imagination in Impressionist art. Influenced by the music of Richard Wagner and the poetry of Baudelaire and Poe as well as by Romantic art, painters contemporary with Monet and his friends shunned the naturalistic school in favour of a more visionary art. These explorers of the unconscious, the heirs of Blake and Goya, were stimulated by researches into myth and folklore such as *Grimm's Fairy Tales* (1812–15) and Sir James Frazer's treatise on myth and ritual, *The Golden Bough* (1890–1915).

Like their predecessors, these late century Romantics were united more by theme and purpose than by style; they chose violent exaggerations of expression in reaction to the stuffy and repressive bourgeois society around them. They were repelled by the drab, cluttered surroundings of ordinary middle-class people who were so repressed by a strict code of behaviour that the very furniture inhibited them and provoked the mannerisms so devastatingly described by Leo Tolstoy in *The Death of Ivan Illich* (1884):

> The room was so cluttered with all sorts of furniture and knick-knacks that, as the widow made her way to the sofa, her black lace shawl got caught on the edge of a table. Peter Ivanovich raised himself to help her free it, and the hassock, relieved of his weight, came to life and started pushing him up. The widow, however, started to free her shawl herself and Peter Ivanovich sat down again, once more pressing the rebellious hassock down. But the widow's efforts to free her shawl proved vain and Peter Ivanovich rose again, and again the hassock rebelled and even let out a snapping sound.

This façade of upright, moral behaviour hid a prurient interest in sex for which there was no direct outlet, but which was indirectly appealed to in popular academic art like *The Slave Market* (fig. 453) by Jean-Léon Gérôme (1824–1904). The success of works like this lay in the fact that they allowed an indulgence in pleasurable fancies at a sufficiently proper remove, something the direct realism of Manet's *Olympia* emphatically did not.

Symbolism

It was in protest against such hypocrisy and repression that late century aesthetes pursued fantasy and imagination, often in expressions of despair and horror as exaggerated as the upright behaviour of Tolstoy's characters. In the last decades of the nineteenth century romanticism gained ground in all the arts, its various strains coming together under the general umbrella of the Symbolist movement. *Symbolism* was the name attached to a group of French poets who used symbols not to draw concrete images but to create atmosphere and feeling through a deliberate ambiguity that draws on our own associations. This dream-like flow of shadowy images found its way into painting partly through connections between painters and poets and partly from earlier Romantic paintings and a visionary strain in medieval and Renaissance art (see fig. 255). The deliberately vague use of symbols connects French painters associated with the poets Mallarmé, Verlaine, and Rimbaud to the English artists of the later Pre-Raphaelite Brotherhood, and to Whistler.

The associational nature of Symbolist art was used by the Pre-Raphaelite Dante Gabriel Rossetti (1828–1882) in a portrait of his dead wife (fig. 454). Its morbid ambivalence reflects his own feelings; he had married his mistress when he no longer loved her, and her death is generally supposed to have been a suicide. He identified her with Dante's Beatrice to suggest the purifying side of love; he emphasized the aspect of divine love by using a symbol associated with the Virgin: the dove with its halo, signifying the Holy Ghost in scenes of the Annunciation. Yet, without its halo, this blood-red dove could also be the attribute of Venus, suggesting love of a more carnal nature. Through the pallid flesh-tones and heavy atmosphere, Rossetti perfumed the whole work with the odour of decay; his feelings of grief and guilt are mixed into the identifiable subject through a congruence of ideas and associations.

The diseased air of *Beata Beatrix* pervades much of Symbolist art. From the exaggerated images of decay and unwholesomeness the label *Decadent* became attached to certain artists and writers associated with the Symbolist movement in France. The paradigm of the Decadent was Jean Floressas des Esseintes, the hero of the novel *À Rebours* (*Against the Grain*) by J.K. Huysmans. Surfeited with mere satisfaction of the flesh, des Esseintes seeks solitude and the pleasures of the imagination in books and art. His

454 (*below*) Dante Gabriel Rossetti, *Beata Beatrix*, c. 1863. Oil on canvas, 34 × 26 in (86.4 × 66 cm). London, Tate Gallery

455 (*right*) Gustave Moreau, *The Apparition*, c. 1876–86. Oil on canvas, 21¼ × 17½ in (54 × 44.5 cm). Cambridge, Mass., Fogg Art Museum, bequest of Grenville L. Winthrop

tastes reflect those of his author, who was highly appreciative of Symbolist poetry and art; in the novel, des Esseintes owns beautifully bound copies of Mallarmé and Verlaine and paintings by Gustave Moreau (1826–98) and Odilon Redon (1840–1916).

Moreau's *The Apparition* (fig. 455) was one of the works that most excited des Esseintes, and presumably Huysmans as well. Depicting Salome haunted by a vision of the head of John the Baptist, executed at her command, it is painted in the exotic vein of Delacroix's *Death of Sardanapalus* (fig. 393) and is filled with the same smoky blend of blood and eroticism. But Delacroix's full-blooded romanticism plunges us into the action, whereas Moreau treats his subject with the chilly remove of a sixteenth-century Mannerist. He described Salome in Symbolist terms of decadent ennui: 'This bored, temperamental, highly sensual woman is given very little pleasure at seeing her enemy laid low, so sick is she of always having her every desire satisfied'.

Huysmans described Redon's drawings in equally Symbolist terms as a 'fantasy of sickness and delirium'. Redon's vision in figure 456 suggests the world of the imagination to which Des Esseintes wishes to withdraw. In a style reminiscent of Goya's etchings (fig. 391), it is one of a series of lithographs inspired by Darwin's *Origin of Species*. Redon worked entirely in monochrome drawing and printing until the 1890s, which is perhaps why he achieved such a startling simplification of style; even in his later colour works, background is virtually eliminated. Here the image stands out of impenetrable darkness as a combination of passivity and vitality. The flower, collapsed and dying, hangs limply over the vibrant eyeball; the evolution of the imagination begins with nature but passes beyond it. This is the visualization of an idea in Symbolist terms; any more specific identification evades the viewer in the shifting shadows of the rich and subtle chiaroscuro.

The atmosphere of Symbolist art is at once more exaggerated and less electric than that of the earlier Romantics. The refusal to be pinned down to a specific image arose from the central creed of Symbolist literature: that once it is made concrete an experience vanishes; only in the imagination can an idea have reality. A love consummated is a love destroyed; this is the theme of Stéphane Mallarmé's poem 'The Afternoon of a Faun', which inspired a composition of the same name by Debussy, who wished to capture in music the dream-like quality of Symbolist imagery. It is also the theme behind Oscar Wilde's novel *The Picture of Dorian Gray*, in which a beautiful young man of exquisite sensibility is led into a life of debauchery through his fascination with beauty and imagination. Dorian Gray is in love with an actress, but when he is confronted by her genuine feeling his passion, more a product of his imagination than of human emotion, dies. He is rescued from despair by his friend and mentor, who explains to him that his emotion never had a physical reality:

456 Odilon Redon, 'Il y a peut-être une vision première essayée dans la fleur' ('Perhaps sight was first tried out in the flower'), from *Les Origines*, published in 1883. Lithograph, $9 \times 7\frac{1}{4}$ in (23.1 × 18.4 cm). London, British Library

The girl never really lived, and so she has never really died. To you at least she was always a dream, a phantom that flitted through Shakespeare's plays and left them lovelier for its presence, a reed through which Shakespeare's music sounded richer and more full of joy. The moment she touched actual life, she marred it, and it marred her, and so she passed away. Mourn for Ophelia, if you like. Put ashes on your head because Cordelia was strangled ... But don't waste your tears over Sibyl Vane. She was less real than they are.

Liberated by this, Dorian Gray reads a Symbolist novel, presumably *À Rebours*. He is drawn deeper and deeper into a life of debauchery in order to feed his imagination. Wilde was wit enough to play on his own theme by making art literally more alive than real flesh; the unspeakable practices of the aging Decadent never mar his youth and beauty, which remain to the end; instead the features of his portrait, painted in his innocent youth, are deformed. In the end the despairing Dorian Gray plunges a knife into the portrait and in so doing kills himself.

Post-Impressionism

Not all painters associated with the Symbolists were obsessed with images of decay and deliquescence. In the work of Vincent van Gogh (1853–90), Paul Gauguin (1848-1903), and Henri Rousseau (1844-1910), a primitive vitality formed a counterweight to the over-sophisticated refinements of Decadence. Warm primary colours, not dark, muddy purples and sickly yellows, invest their paintings with the warmth of real sunshine. These three were artists as concerned with formal problems as with imagination and vision. Van Gogh and Gauguin, together with Cézanne and Seurat, are now regarded as the fathers of Modern art; Rousseau, although less dominant a figure, intrigued Modern artists such as Kandinsky by his naive and untrained visions. The term Post-Impressionism, coined as the title of an exhibition in 1910, has become attached to these figures, despite their differences in style, in recognition of their place in the development of Cubist and abstract art. Cézanne and Seurat, however, pursued formal problems with a more analytical than intuitive approach and were never associated with the Symbolist movement.

Van Gogh's style was chiefly influenced by the Impressionist approach of seeing forms through light and colour rather than line. Although interested in Symbolist art, he drew his subjects from the world around him, with no overt references to Symbolism. But — even before the attacks of insanity which have been credited with forming his intense and personal visions of nature — he avoided the strict objectivity of Monet and Renoir and conveyed his emotional response to nature through vigorous, nervous brush strokes that animate the forms of nature (fig. 457). The vibrant tension between the visible world and the visionary increased as his bouts

457 Vincent van Gogh, *Wheatfield with a Lark*, 1887. Oil on canvas, 21 × 25½ in (53.3 × 64.8 cm). Amsterdam, Rijksmuseum Vincent van Gogh

458 Vincent van Gogh, *Starry Night*, 1889. Oil on canvas, 28¾ × 36¼ (73 × 92.1 cm). New York, Museum of Modern Art, acquired through the Lillie P. Bliss Bequest

459 Paul Gauguin, *The Vision after the Sermon*, 1888. Oil on canvas, 28¾ × 36¼ (73 × 92 cm). Edinburgh, National Galleries of Scotland

460 Paul Gauguin, *Ia Orana Maria*, 1891. Oil on canvas, 44¾ × 34½ in (113.7 × 87.6 cm). New York, Metropolitan Museum of Art

461 Henri Rousseau (Le Douanier), *The Dream*, 1910. Oil on canvas, 79½ × 117¾ (204.5 × 299 cm). New York, Museum of Modern Art

457

458

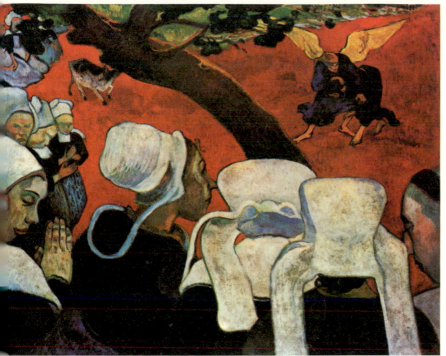

459

460

461

of illness grew worse. He painted *Starry Night* (fig. 458) while in a sanatorium in Saint-Rémy, in the south of France. Here the strain between nature and imagination is acute. The painting is charged with a primeval energy in the great whorls of fire that spiral across the starlit sky. The hillside and houses nestled against it seem to slide helplessly downward, while the cedar in the foreground quivers upward in a single, black flame.

Driven by the conflicting desires of portraying the outer forms of nature in Impressionist terms of light and colour and of capturing at the same time the spiritual force he saw invested in these forms, Van Gogh broke free of traditional coordinated one-point perspective in a more radical and primitive way than Manet had done, almost reducing forms to abstract patterns. In *Starry Night* the curling lines spread right across the canvas; what is actually a very shallow picture space seems to open into a vast area.

A similar need to escape the illusionism of Renaissance perspective led Gauguin to primitive and Japanese art for new ways of handling picture space. Gauguin, a close friend of van Gogh until the latter's illness brought about a quarrel that separated them, was van Gogh's chief contact with the Symbolists. He was more systematic and deliberate than van Gogh in choosing elements from folk and tribal art and from pre-Renaissance European art — all of which were increasingly finding their way into museums and international exhibitions — to form a style of his own.

In his desire to achieve a more truly primitive vision, Gauguin removed himself from urban Paris to settle in Brittany, where he was the focus of a group of artists seeking to capture Symbolist poetry in painting, and who were stimulated by the freshness of primitive art. In this company, Gauguin evolved the style of *The Vision after the Sermon* (fig. 459), a work far removed from the art taught in the academies, which still favoured works like Gérôme's *Slave Market*. Gauguin's painting shows a deliberate attempt to get outside everything the West had learned; he turned to bright primary colours and flat shapes, with no linear perspective, no horizon, and no chiaroscuro. The contrasting colours and heavy black outlines resemble the art of cloisonné (see fig. 69). Yet this painting is no more child-like than a carefully arranged Japanese print; it is a carefully worked out synthesis of elements from art and nature combined to visualize an idea. The shapes of the women's bonnets and black dresses form a pattern in the curve of the foreground, divided by the curving tree-trunk from the arena, where their vision of Jacob wrestling with the angel — prompted by the sermon they have just heard — takes shape.

Obsessed with the idea of a genuinely primitive source for his art, Gauguin left France for Tahiti in 1891. He found inspiration in the natural beauty of the unspoiled land and its inhabitants. Here he was able to find a personal vision that was true to nature and to imagination, combining a Westerner's long history of artistic education with the freshness of a new and innocent vision. His *Ia Orana Maria* (fig. 460) is not so much the attempt of a Symbolist to raise emotional reactions through the

462 Philip Webb, the Red House, Bexley Heath, Kent, 1859–60

association of a native woman and her child with Christian paintings of the Madonna as a statement of genuine and new-found religious feeling derived from its real source. Inner and outer vision come together, as Gauguin recreated in his art a true paradise of the unspoilt tropics.

A true primitivism of style invests the work of Henri Rousseau, for Rousseau was self-taught; his art has the appeal of a child's drawing. Like Gauguin, he was fascinated with myth and with the Romantic idea of the Noble Savage living in harmony with nature. His tropical forests and deserts peopled by fierce animals and innocent humans are far more imaginary and romanticized than the tropics painted by Gauguin. Yet his paintings have a genuine naiveté that comes close to the primitive vision Gauguin sought (fig. 461).

Arts, Crafts, and Design

Symbolist art attests to the deep division in the nineteenth century between art and the crafts, between the artist's view of art as a high calling and the manufactured objects that surrounded daily living. At the very end of the century the gap closed in a new harmony of architecture, decoration, furnishing, and art, that included writers and composers already drawn together by the Symbolist movement. The style known as Art Nouveau was the first style to involve the whole environment since the Rococo.

The name came from a shop opened in Paris in 1896, which called itself the Maison de l'Art Nouveau (house of the new art) and specialized in the objects of this new style. The roots of Art Nouveau go back to the decorative line of Rococo and to Blake's drawings and engravings, but it was more closely and consciously connected to the recent developments in design that started with the Arts and Crafts movement in England, pioneered by William Morris (1834–96).

Morris was an artist associated with the Pre-Raphaelites Rossetti and Edward Burne-Jones, but he perceived, as other artists did not, the unhealthy state of an art that was an élitist occupation totally divorced from the lives of the vast majority of ordinary people, whose taste was satisfied by manufacturers interested chiefly in profits. Morris was a socialist and wanted art to benefit everyone; he was also, however, a medievalist and a follower of Ruskin, determined to re-create the atmosphere of the medieval craft guild. By his insistence on handicrafts, on only those processes in which an artist could control the entire production of a work, he bypassed the cheap mass production of industry and necessarily created works only affordable by the wealthy; thus he excluded the very people he wanted to reach.

Nevertheless, Morris had a profound, although delayed, impact on the course of modern design. He went into furniture-making for the practical reason that he could not buy any furniture he wanted to live with. When

he married, he asked his friend the architect Philip Webb (1831–1915) to build him a house. The result was in many ways revolutionary (fig. 462), for it redirected attention to a scale of domestic architecture at once practical and aesthetically pleasing. Although the Red House is drawn partly from the picturesque asymmetry of the Gothic Revival, it departs entirely from sham façades and encrustations of non-functional ornament. Its straightforward forms and natural materials derive partly from seventeenth-century English country manor houses, rather than from the cathedrals and churches upon which the Gothic Revival was based. The Red House was influential in creating a style of architecture that combined the restraint and the feeling for surface of Wren and Adam with the picturesque asymmetry of the Gothic.

Morris's experiments in furnishing led to his forming a company in 1861 to manufacture designs by Rossetti and Burne-Jones and their friends for everything from floor tiles to wallpaper and fabrics, glass and tableware, all created from a mixture of high-minded design and practicality, combining the attractions of medievalism with comfort. The most enduring of Morris's designs were his wallpapers and fabrics (fig. 463), which are still being reproduced today.

Morris's work in decorating stimulated Whistler's imaginative entrance into this field; his Peacock Room (fig. 464) was created for the millionaire F.R. Leyland, who had bought Whistler's Japanese-inspired *Princess from the Land of Porcelain* (seen hanging over the fireplace) and wanted a room to display it in. This extraordinary room, with its gilt-painted leather and panels and its oriental peacocks, displeased its patron, but caused a sensation. Its attenuated decorative line contributed to the genesis of Art Nouveau (fig. 465).

An immediate benefit of the Arts and Crafts movement was the revitalization of crafts of all sorts and a closing of the gap between art and craft that had been so disastrously evident at the Great Exhibition. Magazines like *The Hobby Horse* and *The Yellow Book* established a very high standard of print and design, creating a common ground for practical designers, aesthetes, and decadent dandies. The proliferation of such magazines at the turn of the century helped spread the achievements of their contributors to a wide audience. The aesthetic standards of *The Hobby Horse*, published by the Century Guild, stimulated Morris to found his own press, from which he published beautiful editions, including a Chaucer illustrated by Edward Burne-Jones.

The furniture and wallpaper that Morris produced are characterized by a curling line that weaves the design together, balancing symmetry with variety. It derived from Rococo design, from William Blake, and from Celtic art. In the designs of Morris's followers in the Arts and Crafts movement this undulating line took on a life of its own.

It is this same vigorous whiplash curl that connects Symbolist art to Art Nouveau. We find this whiplash line appearing almost simultaneously

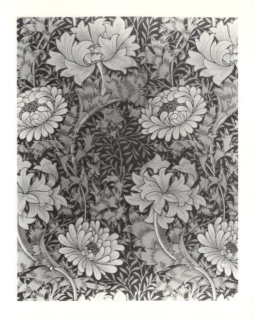

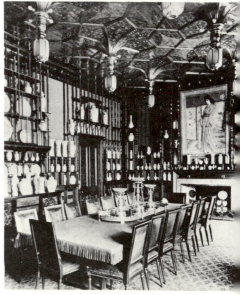

463 (*top*) William Morris, chrysanthemum wallpaper, 1876. London, Victoria and Albert Museum

464 (*above*) James Abbot MacNeill Whistler, the Peacock Room, 1876–7. Contemporary photograph showing Whistler's painting *The Princess from the Land of Porcelain* above the mantelpiece

465 (*right*) James Abbot MacNeill Whistler, the Peacock Room, 1876–7, now reassembled in the Freer Gallery of Art, Washington D.C.

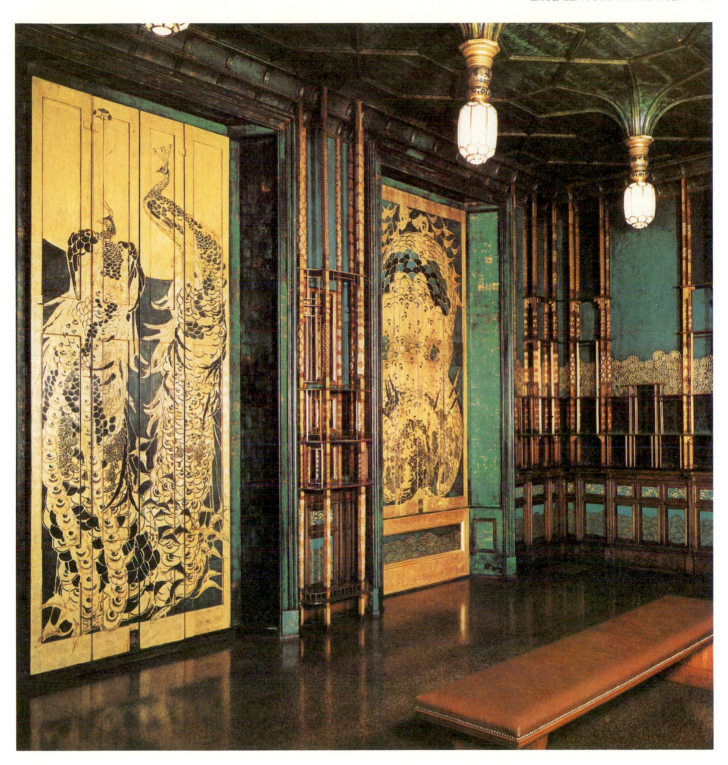

throughout the Western world in architectural decoration, glassware, and furniture. It injected a new tension into Symbolist painting to accentuate feelings of violence and anguish that lay behind the façade of order and propriety. The Dutch artist Jan Toorop (1858–1928) painted his *Three Brides* (fig. 469) as a Symbolist variant on the Three Graces in Botticelli's *Primavera* (fig. 218). This startling painting exposes the age's unhealthy ambivalence towards sex and femininity by exaggerating the extremes of spiritual love, lust, and innocence. Its dream-like fluidity is intensified by the immense curling locks of hair flowing from the mermaid-like creatures floating across the foreground.

The Norwegian painter Edvard Munch (1863-1944) portrayed a psychological horror underlying the surface of calm respectability in *The Scream* (fig. 470). Here the fear of madness is conveyed through violent distortions of form and space; the pier slashes a diagonal across the picture surface to trap the victim. The menacing curves of land, water, and cloud engulf him as if in visible sound waves. Munch recalled the experience as it had actually happened to him:

> One evening I was walking along a path ... I stopped and looked out over the fjord — the sun was setting, and the clouds turning blood-red. I sensed a scream passing through nature; it seemed to me that I heard the scream. I painted this picture, painted the clouds as actual blood.

<div align="right">Diary, 1889.</div>

The Belgian artist James Ensor (1860-1949) drew on the macabre grotesques in Flemish art, especially in Bosch and Bruegel, to convey modern anxiety caused by loss of religious faith. Figure 471 uses the carnival atmosphere of religious festivals such as Shrove Tuesday, the celebration that takes place just before the penitential season of Lent, to parody Christ's triumphal entrance into Jerusalem on Palm Sunday. If Christ were to enter modern Brussels, Ensor tells us, he would be greeted by crowds much too intent on enjoying the frenzied revels of the carnival to pay any attention to the demands of faith and sacrifice. Like the fools misusing the pleasures of Paradise in Bosch's altarpiece (fig. 255), these people pursue only pleasure and folly. The grotesque carnival masks emphasize their spiritual emptiness and lack of genuine feeling. The expression of ideas through violent distortion of form and space in these three paintings points straight towards the Expressionist movement in Modern Art.

For a brief period Art Nouveau brought all aspects of the arts together. There was no separation of art and craft; posters were works of art as serious as paintings. The French glassmaker Émile Gallé (1846-1904) indicated the intellectual effort put into designing his vases (fig. 467) by calling them *études*, in the manner of musical studies. Music, drama, and poetry were included in the movement; in 1894 the first exhibition of what

467 (*above*) Émile Gallé, vase, *c.* 1900. Glass, height 9½ in (24 cm). New York, Museum of Modern Art.

466 (*left*) Baron Victor Horta, Tassel House, 12 Rue de Turin, Brussels, 1892–3

became recognized as Art Nouveau, put on in Brussels by a group calling itself the Libre Esthétique (the free aesthetic), included paintings by both Symbolists and Impressionists, books from Morris's Kelmscott Press, Beardsley's illustrations for Wilde's play *Salome*, Toulouse-Lautrec's posters, and a concert featuring Debussy's Quartet in G-minor and *La Demoiselle Élue,* his setting of Rossetti's poem 'The Blessed Damozel'.

Although Art Nouveau was principally a style of interior design, the term belongs equally to the architectural style created for these interiors. Art Nouveau architecture marks a radical departure from the past and — despite the romantic extravagance of its decorative details — it is connected to the spare, rectangular forms of Modern architecture. For, at long last, the technology of iron and glass was used not just as a practical measure but with conscious aesthetic intentions; iron, which can be bent, and glass, which can be moulded into irregular shapes, suited the asymmetrical undulating line of Art Nouveau as no other materials could. We see the use of iron, bent into a whiplash line, in the extravagant design of the first piece of Art Nouveau architecture, a house built in 1893 by Victor Horta (1860-1947) in Brussels (fig. 466). Despite the complexity of line, the ornament is delicate and open and gives a sense of space rather than clutter.

The most organic and picturesque use of Art Nouveau design is seen in the work of a Spanish architect, Antonio Gaudí (1852–1926), who was influenced by the plasticity of Spanish Gothic and Baroque architecture. His Casa Batlló in Barcelona (fig. 472) is a highly romantic structure whose façade undulates like a living organism. The free forms of the stone ribs surrounding the windows create a weird and picturesque appearance.

The frankly fantastic effects of Horta and Gaudí were not easily repeated. But Art Nouveau was directly connected to the starker, more abstract forms of Modern architecture in its use of iron and steel technology and in its marriage of structure and ornament. Throughout the nineteenth century, wherever cast-iron buildings were built for practical reasons, if money was available their visible members had been cast into classical columns and decorated with cast-iron swags and even statues. It was Art Nouveau architecture that redirected attention to the materials used, without recourse to sham. At the end of the century we find a marriage of Art Nouveau ornamental line with the technology of steel structure in the skyscrapers built in Chicago by Louis Sullivan (1856–1924). The Wainwright Building (fig. 473), built in 1890–1, is ornamented with a curling Art Nouveau foliate design. But its façade also foreshadows twentieth-century design in the way it accentuates the flat, rectangular form of the building and lets the material speak for itself.

The refinement of iron into much stronger steel, which permitted the construction of buildings supported entirely by steel skeletons, did away with the necessity for weight-bearing interior walls. This led to an entirely new concept of interior space, flee-flowing and uninterrupted by walls,

468 (*below*) Charles Rennie Mackintosh, library, Glasgow School of Art, Glasgow, 1897–9

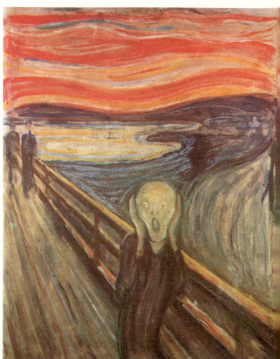

469

470

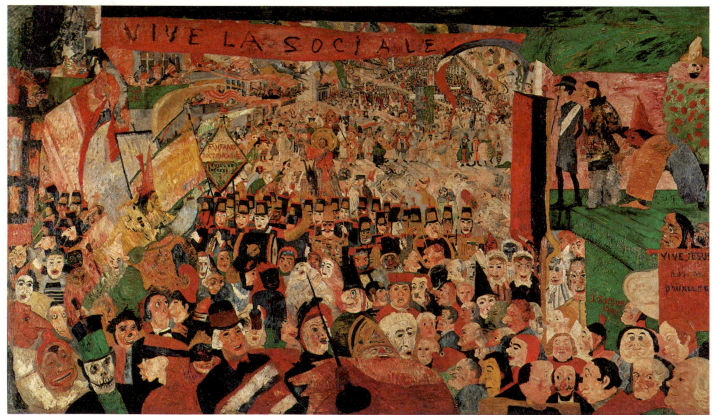

471

469 Jan Toorop, *The Three Brides*, 1893. Oil on canvas, 30¾ × 38½ in (78 × 98 cm). Otterlo, Rijkmuseum Kröller-Muller

470 Edvard Munch, *The Scream*, 1893. Oil, pastel and casein on cardboard, 35¾ × 29 in (91 × 73.5 cm). Oslo, Nasjonalgalleriet

471 James Ensor, *Christ's Entry into Brussels*, 1889. Oil on canvas, 101½ × 169½ in (258 × 430.5 cm). London, private collection (See also fig. 409.)

472 Antonio Gaudí, Casa Batlló, Barcelona, 1905–7

473 Louis Sullivan, the Wainwright Building, St. Louis, 1890–1

which was fully developed in the twentieth century, but the possibilities of more open space were explored earlier by the Scottish architect Charles Rennie Mackintosh (1868–1928). He worked on the Glasgow School of Art from 1897 to 1899, and on its library from 1907 to 1909. By the time he came to build the library, although the fanciful forms of Art Nouveau appear, they are directed in straight, vertical lines; the ornament becomes a new way of dividing space (fig. 468). The pillars holding the gallery jut out beyond it for no structural reason; in doing so they create spaces moulded by their rectangular lines.

Art Nouveau was a transitional style and a short-lived phenomenon in the arts. In its extravagant decorative line and its rather limp forms, it was a mannerist art, deliberately seeking its models in other mannerist periods. It was also an art of protest and relied on a single statement which, once made, left no room for future modification. But that statement had a profoundly liberating effect on the arts; for all its pose of languid refinement, it was Art Nouveau that injected excitement into the art world and supplied the shock that finally freed the imagination of artists and public to accept and expect new treatments of form and space. Thus it was no backwater movement, but rather the channel through which currents from the nineteenth century poured into the twentieth.

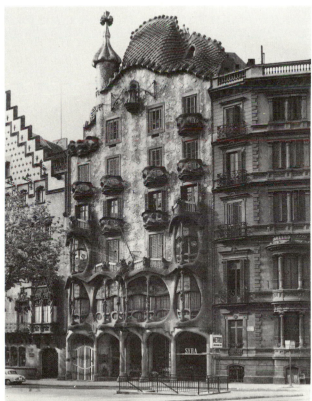

472

473

CHAPTER 15

Being Avant-Garde: Modern Art before the First World War

New though it was, Art Nouveau was still connected to the long tradition of pictorial representation descended from the Early Renaissance and part of a thread of leisurely continuity that came to an abrupt end in the twentieth century. The slower-paced civilization disappeared in the clang and clatter of machines, assaulted by the rapid communication of the telegraph, the telephone, and the radio, dislocated by new ease of transportation. The twentieth century replaced the turn-of-the-century pose of decadent ennui with reckless plunges into spiritualism and mysticism; the sophisticated dandies and aesthetes gave way to raffish bohemians. Art Nouveau bequeathed to its successors the excitement of novelty, but from its beginnings Modern art was more vitally connected to the industrial and urban world. The acceleration of change and the rapidity of communication created a situation in which to be modern meant being not only of one's times but ahead of them, in the *avant-garde,* the vanguard. The public, responding to the excitement of change, was more willing to accept novelty; the history of twentieth-century art differs from that of the nineteenth in that no matter how far out a movement might be, and how much ridiculed by the press, at least some people could be induced to buy its works. Thus artists now found more support for exploring new avenues. The new century achieved a revolution in perception more radical than the Renaissance invention of one-point perspective, for Modern art not only broke with the naturalistic treatment of picture space; it became non-objective, ignoring the natural world as a source of subject and drawing instead directly on the artist's ideas and intuitions.

Just as the evolution of three-dimensional perspective in the fifteenth and sixteenth centuries grew out of the achievements of International Gothic artists, so the Modern rejection of representational form developed logically out of the nineteenth-century rebellions against the Renaissance. From the moment that Manet began flattening figures and picture space, and the Impressionists learned to model forms through colour rather than

outline, the path to abstract art lay open through repeated experiments in the expressive capabilities of paint and canvas, stone or bronze, with correspondingly less dependence on recognizable forms. Two lines developed from late nineteenth-century art and approached abstract art by different means, one through analysis of space and form, the other through intuitive self-expression. From Cézanne's rendition of nature which, he said, should be treated 'according to the cylinder, the sphere, and the cone', came an impulse to abstract natural forms into geometrical patterns. From the Symbolists the line led to more intensive explorations of inner vision. Modern artists, stimulated by the psychological researches of Freud and Jung, sought not only a new vitality in style but the very roots of the human imagination in the subconscious mind.

Modern art was also connected to modern physical science, reacting to Einstein's theory of relativity which shook our whole idea of fixed space and continuous time. Modern literature and music followed the same path as art in breaking structure apart to escape the prison of established patterns of sequence and harmony. In the random associations and non-sequential, overlapping vignettes of Imagist poetry and the stream-of-consciousness novel, and in the atonal music constructed on a system of twelve tones instead of a harmonic scale, writers and composers sought not freedom from structure but wholly new structures.

The development of abstract art in the twentieth century was both interrupted and accelerated by two world wars; the shock of total war and totalitarian government shattered Western humanistic faith in man's ability to shape his own destiny. The speed of change was also connected to the rapid pace of communications; ease of travel and exchange of publications devoted to the arts meant that each group of experimentalists soon learned what other avant-garde groups were doing. As a result, the history of twentieth-century art is a bewildering succession of experimental styles and philosophies, of '-isms' each accompanied by manifestos proclaiming its own art theory in a terminology often more confusing than enlightening. Since these are our own times, for which we have more works of art and more statements by artists than for any other era, with less accepted distinctions between good and bad, the proliferation of schools and movements seems at first glance hopelessly chaotic. But from the early years of the century to the present day there runs a continuous and logical pattern of development.

By the first years of the twentieth century the opportunity for an artist to exhibit his work had improved considerably. In Paris, in addition to the annual Salons of the Academy, which had split in two parts to allow a slightly more liberal selection of modern art, the Salon des Indépendants, established 1884 as a juryless exhibition open to anyone, provided a showcase for truly progressive art. In 1903 a fourth annual exhibition was established; incorporating a jury system of selection, it was less anarchic than the Salon des Indépendants, and was also open to serious avant-garde

474 Henri Matisse, *La Serpentine*, 1901. Bronze, height 22¼ in (56.5 cm). Baltimore, Museum of Art

art. Called the Salon d'Automne, it was the only exhibition held in the autumn, and as such attracted attention. It was here that the first group of truly *Modern* artists appeared in 1905.

The Fauves

Led by the French painter and sculptor Henri Matisse (1869–1954), these artists were instantly labelled *Fauves*, meaning 'wild beasts', on account of their violent colour and distorted forms (fig. 476). In contrast to the picturesque and representational paintings surrounding them (which included a retrospective of Manet and Ingres), the Fauve style appeared to substitute raw energy for draughtsmanship and technique.

Part of the energy came from the number of sources that went into the Fauves' painting; by the end of the nineteenth century a powerful mixture of cross-influences came together through the continuing stream of world's fairs and a growing number of galleries devoted to Oriental, folk, and primitive art. The quickening pace of communications between centres ensured the rapid spread of every new development; not only did new artists become known; long-neglected figures like Daumier and El Greco were brought before the public eye. Wandering artists and critics made discoveries for themselves; the Russian painter Wassily Kandinsky (1866–1944) and the Irish poet William Butler Yeats (see above, p.54) were captivated by the spiritual abstraction of Byzantine mosaics in Ravenna. Huysmans, visiting Colmar in 1905, discovered Grünewald's Isenheim altarpiece (fig. 258) and was stunned by its power. His description of it as a 'typhoon of unrestrained art' would have astonished Grünewald but sums up what the Modernists sought.

The most powerful influence on the Fauves came from Seurat, Cézanne, Gauguin, and van Gogh, whose works were exhibited to the public for the first time in a series of retrospective shows from 1901 to 1907. The impact made on the younger artists by the older generation was tremendous. Matisse, while he shocked the public by the novelty of painting his wife's face in unblended hues of green and yellow, was obviously thinking of van Gogh's *L'Arlésienne* (fig. 477), in which the figure is also flattened, and the light reflecting against the background casts a yellow tinge on her face. Matisse had almost acquired this painting in 1898; instead he bought a Cézanne.

The tilted and flattened perspective of van Gogh and Cézanne was exaggerated by the Fauves to the point where contours are indicated only by patches of bright colour. But they made no actual break with the natural world; their views were still based on a three-dimensional space seen from a single viewpoint. In figure 475, by Maurice Vlaminck (1876–1958), the scene is radically flattened but does not actually contradict visual experience. The eye mentally readjusts the horizontal bands

475 (*left*) Maurice de Vlaminck, *Riverbank at Carrières-sur-Seine*, 1906. Oil on canvas. Paris, Collection Guy Roncey

476 (*below left*) Henri Matisse, *Woman with a Hat* (Mme Matisse), 1905. Oil on canvas, $31\frac{7}{8} \times 25\frac{5}{8}$ in (81 × 65 cm). San Francisco, private collection

477 (*below*) Vincent van Gogh, *L'Arlésienne* (Mme Ginoux), 1888. Oil on canvas, 36 × 29 in (91.4 × 73.7 cm). New York, Metropolitan Museum of Art

CHART 8 THE TWENTIETH CENTURY

EVENTS		ART AND CULTURE
	1900	
1905 Attempted revolution in Russia		1903 Salon d'Automne, first exhibition of 'modern art'
		1905 Einstein's General Theory of Relativity
		1905 Fauvism — Matisse and his followers
		1905 'Die Brücke' Expressionist group formed in Berlin
		1907 Picasso, *Les Demoiselles d'Avignon*
		1907 Cubism — movement led by Picasso and Braque
		1908-9 Lloyd-Wright, Robie House: beginnings of the 'International Style'
		1909 Marinetti publishes Futurist Manifesto
	1910	1910 First issue of *Der Sturm* in Berlin
		1912 Blue Rider group founded by Marc and Kandinsky
		1912 Futurist exhibition in Paris
		1913 Suprematism in Russia and Vorticism in England
		1913 Armory Show in New York: first exhibition of Modern Art in America
1914-1918 First World War		1916 Dada movement founded in Zurich, with Arp as its principal exponent
1917 Russian Revolution		1917 Magazine *De Stijl* founded by Mondrian and Doesburg
		Constructivism — Pevsner and Gabo
1919 Treaty of Versailles imposes crippling reparations on Germany		1919 Bauhaus formed in Weimar under Gropius with Klee and Kandinsky among its teachers
1920 League of Nations formed	1920	
1921 Hitler becomes leader of Nazi party in Germany		
1924-43 Mussolini Fascist dictator of Italy		1922 Eliot, *The Waste Land*
		1924 Surrealist Manifesto published
		1925 Bauhaus moves to Dessau; its new buildings designed by Gropius
1929 Collapse of New York Stock Exchange; beginning of the Great Depression	1930	
1933 Hitler becomes chancellor of Germany; systematic persecution of Jews starts		1931 Dali, *The Persistence of Memory*
1936-7 Spanish Civil War		1937 Picasso, *Guernica*
1938 Hitler invades Czechoslovakia		
1939 Poland attacked by Germany; World War II begins		
1941 Pearl Harbor bombed; United States enters war	1940	
1944 Allied forces land on Normandy beaches		
1945 End of World War II		
1945 United Nations formed		
1948 Beginning of Cold War		*c.* 1948 Abstract Expressionism
1950 India gains independence from Britain	1950	
1950-3 Korean War		1950s Post-Painterly Abstraction
		1952 Le Corbusier, designs Unité d'Habitation at Marseilles
		c. 1952 Op Art
1953 Death of Stalin		
1956 Hungarian uprising		
1963 President Kennedy assassinated	1960	1960s Pop Art and art of assemblage
1965 American forces become involved in Vietnam War		
1970 First landing on the moon	1970	1970s Super Realism, Happenings, Conceptual Art, Earth Art
1973 US withdraws from Vietnam		

of bright colour into three grounds. We can imagine ourselves standing on the river bank, looking across the river to the houses on the far bank. Its style owes much to van Gogh, who exercised a strong influence on Vlaminck.

To the public who had accepted Manet's art only after his death in 1883 and who were still not entirely inured to Impressionism, Cézanne, van Gogh, and Gauguin still seemed radical and the Fauves a subject for ridicule. But some, like Gertrude Stein and her brother Leo — who bought Matisse's *Woman with a Hat* — appreciated Modern art and constituted an avant-garde public. Encouraged by this, Matisse and his friends worked out a new type of pictorial expression in which the paint — its colour, texture, and design — has more effect on the viewer than the objects represented, Matisse said:

> What I am after, above all, is expression . . . I am unable to distinguish between the feeling I have for life and my way of expressing it.
>
> Expression to my way of thinking does not consist of the passion mirrored upon a human face or betrayed by violent gesture. The whole arrangement of my picture is expressive. The place occupied by figures or objects, the empty spaces around them, the proportions, everything plays a part. Composition is the art of arranging in a decorative manner the various elements at the painter's disposal for the expression of his feelings.

Notes of a Painter

This marks a profound change of attitude towards the representation of forms in art and towards the meaning of a subject. Matisse's statement focuses classically on the harmony between forms and space, but it is the antithesis of Classical humanism. It emphasizes the ordered relationship between objects and space but says nothing of natural perspective. Using both Classical and primitive sources, Modern artists developed a sophisticated and logical twentieth-century perspective that treats forms as lines in space. In Matisse's little statue *La Serpentine* (fig. 474), for example, he imitates a child's stick figure drawing to give the effect not so much of a body as of a single, expressive line. In her classical pose, elbow resting on a pillar, this relaxed figure recalls the closed triangular composition of Praxiteles' Hermes and Dionysus (fig. 2), but with a vital difference; here the triangle is wide open and the figure reduced to an outline enclosing space. Degas and Rodin had still viewed sculpture as the rendition of a subject with anatomical verity, however impressionistically drawn: Matisse was moving towards the concept of sculpture as an abstract expression of material interconnected with space.

Fauvism as a style focused on the pictorial possibilities of paint and canvas was a French phenomenon based in Paris, and it was the work of French-trained artists. Matisse was a pupil of Gustave Moreau (fig. 455); this gave him the benefit of a liberal and open-minded teacher and also connected him to the long tradition of painterly beauty going back

through Delacroix to Claude and Poussin and the Renaissance. There is virtually no social content in Matisse's art; it is a pure art for art's sake and balances the harshness of colour with organization and harmony.

Expressionism

In Germany a style very close to that of the Fauves developed in the hands of artists more concerned with voicing the social and political concerns of the time than with painterly effects. Although national rivalries and political polarization affected France as much as Germany, it was German artists who conveyed a sense of isolation and despair underneath a surface of gaiety in Europe on the eve of World War I. Their style was so exaggeratedly expressive that it earned the name *Expressionist*. In this, the Germans were following a long tradition of expressionism we have already seen in Ottonian, Romanesque, and Gothic art and in the religious works of Dürer and Grünewald. Graphic art descended from Dürer's woodcuts and engravings provided an example for the angular and deliberately crude style of a group of artists who lived and worked in Dresden in a quasi-medieval craft-guild atmosphere and called themselves 'Die Brücke' (the bridge) because they saw themselves as a bridge between art of the past, present, and future, a link to whatever was new and experimental. Their primitive, forceful style is seen in *Two Men at a Table* (fig. 481) by Erich Heckel (1883–1970), illustrating a scene from Dostoevsky's *The Brothers Karamazov*. In the background hangs a crucifixion scene, placed horizontally; the distended and skeletal Christ evokes pain and anguish as clearly as a Gothic Pietà (see fig. 148). The angular figures of the men and the tilted table and chairs derive from Cézanne and van Gogh, but the work is imbued with a pessimistic gloom absent from their painting but close to Dostoevsky.

The Brücke artists' grotesque exaggeration of human features was also influenced by the art of the Symbolists Munch and Ensor. The painting of Emil Nolde (1867–1956) reflects the spiritual emptiness conveyed in Ensor's painting through similarly harsh splashes of colour. Nolde was deeply religious, yet his paintings of religious subjects are darkly pessimistic, bringing no comfort. He borrowed from Ensor the use of carnival masks to veil human expression, but turning the mask into the actual face. In his *Last Supper* (fig. 478) the stretched and skull-like features of Christ and his disciples turn the Gospel story into a nightmare. The figures are packed into a shallow picture space, violently coloured, and imbued with an unbearable tension and a sense of impending tragedy. If we compare this work to Leonardo's fresco (fig. 232), a painting very familiar to Nolde's audience, the stark, anti-humanist pessimism of Expressionist art hits us with shocking force.

This pessimism found echoes in all the arts in Germany during the early

478

478 Emil Nolde, *Last Supper*, 1909. Oil on canvas, $33\frac{7}{8} \times 42\frac{1}{2}$ (86 × 108 cm). Copenhagen, State Art Museum

479 Franz Marc, *The Large Blue Horses*, 1911. Oil on canvas, $41\frac{1}{4} \times 71\frac{1}{4}$ in (104.8 × 181 cm). Minneapolis, Walker Art Center

480 Wassily Kandinsky, *Black Arc*, 1912. Oil on canvas, $74 \times 77\frac{1}{8}$ in (188 × 196 cm). Paris, Musée National d'Art Moderne, Centre d' Art et de Culture Georges Pompidou, gift of Nina Kandinsky

481 Erich Heckel, *Two Men at a Table*, 1913. Oil on canvas, $38\frac{1}{4} \times 47\frac{1}{4}$ in (97 × 120 cm). Hamburg, Kunsthalle

479

480

481

decades of the century. Germany was a vital centre of experiment until the Nazis came to power in the 1930s; before Hitler's suppression of Modern art, Expressionist exaggeration pervaded avant-garde theatre, film, music, and poetry as well as art. The nature of the movement is implied in the title of a magazine, *Der Sturm* (*The Storm*), which appeared in 1910, giving prominence to the Brücke group and coining the term 'Expressionist' to describe their art. The nihilism of the movement was partly a reaction to a sense of loss of freedom and individuality in an increasingly uncaring, bureaucratic, polarized society on the brink of war.

By 1911, just as the Brücke group ceased to exist as a cohesive organization, a second group of Expressionist artists came together in Munich, centred on Kandinsky and the German artist Franz Marc (1880–1916). Marc was at that time painting in a warmly romantic variant of Fauvist style; his *Blue Horses* (fig. 479) conveys the beauty and strength of the animals through voluptuous curves and vivid, unnatural colouring. Both Marc and Kandinsky were less nihilistic and less concerned with social questions that the Brücke artists. In 1912 they published the *Blue Rider Almanac*, named after a painting of Kandinsky's; the name became attached to all the artists associated with him and with Marc. The almanac publicized the sources of their style, containing illustrations of folk and primitive art and reproductions of El Greco, Cézanne, Henri Rousseau, and Picasso. Kandinsky's essay, *Concerning the Spiritual in Art* (1911-12) laid out the basic thesis for intuitive Modern art; in it he elaborated his theory of art as a direct expression of pure feeling. His own efforts to convey spiritual experience directly onto a canvas without the intervention of reason and intellect led him to dematerialize his subject to the point of leaving objective reality behind (fig. 480). Knowledgeable in science yet fascinated by mysticism, Kandinsky was also a synaesthetic — one who perceives things through one sense, but in terms of another. This led him to 'see' colours in terms of musical sounds; like Whistler, he gave his paintings musical titles, distinguishing between spontaneously conceived *Improvisations* and more carefully worked over *Compositions*. The painter and composer Arnold Schoenberg was a fellow Blue Rider; the almanac contained examples of twelve-tone compositions by Schoenberg, Berg, and Webern.

Cubism

Kandinsky reached an abstract style by exploring feeling and imagination. The opposite path, that of abstracting pure form from natural subjects, was taken by the Cubists, in an analytical and intellectual approach that was the antithesis of Expressionism. Cubism was invented by two men, the Spaniard Pablo Picasso (1881–1973) and the Frenchman Georges Braque (1882–1963), while both were living in Paris.

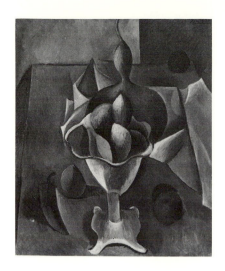

482 Pablo Picasso, *Still Life with Fruit Dish*, 1908–9. Oil on canvas, 29¼ × 24 in (74.3 × 61 cm). New York, Museum of Modern Art, acquired through the Lillie P. Bliss Bequest

Overleaf

483 Georges Braque, *Man with a Guitar*, 1911. Oil on canvas, 45¾ × 31⅞ in (116 × 81 cm). New York, Museum of Modern Art, acquired through the Lillie P. Bliss Bequest

484 Pablo Picasso, *Les Demoiselles d'Avignon*, 1907. Oil on canvas, 96 × 92 in (244 × 234 cm). New York, Museum of Modern Art

Both Picasso and Braque were influenced by Cézanne's dictum that nature was to be rendered by the cylinder, the sphere, and the cone. Cézanne's influence was still strong on Picasso when he began painting *Les Demoiselles d'Avignon* (fig. 484), which depicts women in a brothel in Avignon Street in Barcelona. But he went far beyond Cézanne in breaking with Renaissance form and perspective. The composition is sparse and severe; Picasso compressed the picture space to a nearly two-dimensional area. The forms of the women look as though he had crumpled a sketch and then composed the figures from the folds of wrinkled paper. He drew on Byzantine and Spanish Romanesque art for the three figures on the left, but the other two owe their startling visages to a visit he made, while working on the painting, to a museum exhibiting African sculpture. He was fascinated by the powerful expressionism of tribal ritual masks which he adapted to give these two women a particularly violent and brazen aspect. It is a violent painting, full of twists and distortion. The woman on the right is seated with her back to us, yet her head and shoulders are wrenched around to face us. Although her face is seen frontally, the nose is painted in profile, while one eye is lower than the other.

The Renaissance painters deliberately coordinated picture space to reflect one viewpoint; Picasso broke with this to show more in a single picture than the eye could see from the apparent position of the viewer. In this he was reverting to primitive and symbolic styles such as Egyptian art (fig. 14), but with the sophistication of an artist going beyond the achievements of one-point perspective. It is as if we had walked around the seated figure and were putting together in memory the views from the front and from the back. In working with more than one viewpoint, Picasso was drawing on Cézanne, who in his late still-lifes tilted the table top to expose more of the objects than we would actually see standing in front of the table (fig. 485). Picasso's *Fruit Dish* (fig. 482) goes a step further; it is composed almost exclusively on a vertical plane. Our experience, strengthened by a hint of a diagonal line outlining the table and by the shadow cast by the dish, tells us that the table sticks out horizontally from the wall and that the fruit dish sits upright on its surface. But whereas Cézanne's distorted perspective is easily adjusted to our understanding of spatial relationships, Picasso deliberately strained against our recognition of forms in space to make us look at the objects as patterns on a flat surface, reducing the picturesque element, which is still strong in Cézanne, to an abbreviated shorthand.

Braque was painting in a Fauve manner until he saw the *Demoiselles* in Picasso's studio; the shock of its novelty turned him to draw on Cézanne in trying to combine the way we see with the way things are constructed. In *Houses at L'Estaque* (fig. 486), a part of southern France much painted by Cézanne, the influence is clear, although Braque went further than the older master in abstracting the houses into geometrical cubes, thereby earning from critics the name 'Cubist'. From 1909 until 1911 Braque and

484

485 (*above left*) Paul Cézanne, *The Basket of Apples*, 1895. Oil on canvas, 24⅜ × 31 in (62 × 78.7 cm). Chicago, Art Institute, Helen Birch Bartlett Memorial Collection

486 (*above*) Georges Braque, *Houses at l'Estaque*, 1908. Oil on canvas, 28¾ × 23⅜ (73 × 59.8 cm). Berne, Kunstmuseum

487 (*left*) Pablo Picasso, *Still-life with Chair Caning*, 1912. Oilcloth and oil on canvas, 11⅜ × 4⅝ in (28.9 × 37.1 cm). Paris, Museés Nationaux, Picasso Bequest

Picasso worked together to develop the analytical Cubist style, in which space was reduced to a flat plane and the subjects sliced into small strips of cubes which they then put back together in shifting and overlapping planes intersecting triangles of empty space. A sense of volume comes from this faceting; Cubist pictures are never flat, although the design is very near the surface. In figure 483 form and space are reduced to a geometrical pattern, but without losing the subject; it is visible among the intersecting planes, indicated by a curved chair arm, a hand grasping the instrument, the bend of an elbow.

When the geometrical analysis of form seemed in danger of becoming anti-human and abstract, Picasso and Braque began introducing elements of daily life foreign to painting, first letters in the sytle of newspaper headlines, then fragments of newspapers themselves, and scraps of fabric, wallpaper, and the like, to create the collage, a painting that incorporates materials and textures. A collage creates its own illusory effects and provokes the question of what is 'real' and what is not. In his *Still-Life with Chair Caning* (fig. 487), Picasso pasted onto the canvas a piece of oil-cloth printed with a trompe-l'oeil chair caning design. Around this he painted Cubist forms of a still-life that cast shadows on the oil cloth, as if they were standing on it. He added to the illusion of a tray holding the still-life by framing the oval canvas in ordinary rope. By juxtaposing the photographic realism of commercial art and the abstracted, intellectualized forms of a specific style, Picasso forces us to come to terms with what we mean by reality in art.

This phase of Cubism, given the name Synthetic, differed from the earlier analytical phase, which started with an image and broke it down to a near-abstraction of its original form. In collage one starts with the materials, and the subject emerges as they are synthesized into the finished work. Collage, being three-dimensional, impinges on sculpture; Picasso's experiments in assembling works out of scraps of wood were a logical extension of the scraps of cloth and paper glued to a canvas. His *Violin and Bottle on a Table* (fig. 488) seems to have emerged from the scrap pile; its subject is indicated only by the strings and the painted f-hole of the violin.

Variations on the Cubist Theme

For the avant-garde artists seeking to break away from the traditional continuity of line and space, Cubism provided a liberating technique of breaking a subject apart and splicing it together in a wholly new view of objects in space. In sculpture this led to the opening up of figures to reverse the traditional concept of sculpture as a solid surrounded by space. Matisse opened up the line of his sculpture in *La Serpentine* to emphasize the void outlined by the figure, but without breaking into the anatomy of the human form. Cubist art led to sculpture like the *Walking Woman* (fig. 493)

488 Pablo Picasso, *Violin and Bottle on a Table*, 1915–16. Painted wood, tacks and string, height 18½ in (47 cm). Paris, Musées Nationaux, Picasso Bequest

489 (*opposite*) Marc Chagall, *I and the Village*, 1911. Oil on canvas, $75\frac{1}{2} \times 59\frac{1}{2}$ in (192 × 151 cm). New York, Museum of Modern Art

490 (*left*) Umberto Boccioni, *The Dynamism of a Soccer Player*, 1913. Oil on canvas, $76\frac{1}{8} \times 79\frac{1}{8}$ in (193 × 201 cm). New York, Museum of Modern Art, Sidney and Harriet Janice Collection

491 (*below left*) Marcel Duchamp, *Nude Descending a Staircase*, No. 2, 1912. Oil on canvas, 58 × 35 in (147.3 × 89 cm). Philadelphia Museum of Art, Louise and Walter Arensberg Collection

492 (*below*) Franz Marc, *Tower of Blue Horses*, 1912. Oil on canvas, 80 × $48\frac{3}{4}$ (203 × 124 cm). Formerly Berlin, State Museum (destroyed, World War II).

by Alexander Archipenko (1887–1964), in which the centre of the figure is pierced so that solid anatomy becomes interchangeable with void.

Cubist fracturing of objects into geometrical facets seen from multiple viewpoints was adopted by avant-garde artists whether their individual emphasis was more on form or more on feeling. For artists whose aim was to convey spiritual or emotional experience, Cubism provided a way of drawing directly on the imagination. The individualistic and romantic painter Marc Chagall (b. 1887) used Cubist faceting to convey memories of life in his native Russian village in picturesque multiple views of superimposed images. In figure 489 small scenes of action take place inside larger, static images to evoke the pattern of memory and dream in which normal occurrences can coexist with the fantastic. So a woman milks a cow inside the cow's head, and a man strides sturdily along, feet on the ground, while a woman floats upside down, in the manner in which events as we remember them are overlaid with memories of feeling.

The Expressionists found in Cubism a technique for exploring the purely emotional facets of subconscious, primitive energy by reorganizing the picture surface. When Franz Marc adopted the Cubist style he left behind the picturesque naturalism of his earlier Fauvist stage. His *Blue Horses* of 1911 (fig 479) was still closely connected to real horses in a real pasture. In 1912 he painted *Tower of Blue Horses* (fig. 492) in a Cubist style and confronts us more directly with the innate sense of power and mystery he found in the subject. Recognizable though their forms are, these are not familiar flesh and blood animals, but creatures of myth and dream.

Artists more concerned with structure and form than with spontaneous feeling found in Cubist fracturing of an image a new way of organizing picture space closely connected to the new discoveries in mathematics and physics. Picasso's and Braque's still-lifes, landscapes, and portraits were essentially static, lending themselves to the objective analysis these two artists sought. A group of Italians calling themselves *Futurists* were more insistent on bringing art into the machine age; they also attempted to convey in their painting and sculpture the effect of Einstein's theory that time is a fourth dimension of space. Picasso had shown the way to convey multiple viewpoints of a single object; the Futurists attempted to show several simultaneous motions. *The Dynamism of a Soccer Player* by Umberto Boccioni (1882–1916) occurs in a warp of space; the action is blurred like a film speeded up and crammed into a shallow picture space (fig. 490). The elasticity of this space is the antithesis of the defined limits and continuity of Renaissance perspective.

Of all the Europeans, the Italian avant-garde felt itself most under the shadow of the Renaissance. So the Futurists were the shrillest in proclaiming the superior merits of the twentieth century, delighting in the noise and smoke of machine and factory. The founder of the movement, the poet Filippo Tommaso Marinetti, proclaimed:

493 Alexander Archipenko, *Walking Woman*, 1912. Bronze, height 26⅜ in (67 cm). Switzerland, private Collection

We shall sing the nocturnal, vibrating incandescence of arsenals and shipyards, ablaze with violent electric moons, the voracious stations devouring their smoking serpents ... the broad-breasted locomotives that paw the grounds of their rails like enormous horses of steel.

The Futurist passion for machinery led other artists to find machines relevant to art. The French sculptor Raymond Duchamp-Villon (1876–1918) invoked the image of the iron horse and mechanical horse-power in his statue of a horse (fig. 494). In this work the only element clearly representing the animal is one shapely hoof, attached to the body by a piston-like leg. Machine and animal are fused together; the powerful barrel-chest, opened up to weave mass and void together, sums up a modern appreciation of energy and force.

Duchamp-Villon's brother Marcel Duchamp (1887–1968) also combined Futurist machine imagery with the Cubist abstraction of form in a painting titled *Nude Descending a Staircase* (fig. 491). Influenced by photographic studies of figures in motion, Duchamp painted his robot-like nude in a multiple-frame sequence contained within a very shallow space. The result is a subject from the past in a wholly modern context, a figure detached from conventional fixed space or sequence of time. It is not only in the overlapping of time and space that this work represents a new stage in Western art; more stridently than Cubist art, it denies the charm of the objective world and substitutes a cerebral and mechanical art of structure.

The interdependence of time and space implied by Einstein's theory provided a framework for shortcutting the rational and sequential development of an idea, substituting an increasingly abstract overlapping of parts of images. The same fragmentation of structural development occurred in literature; the stream-of-consciousness novels written by Virginia Woolf and James Joyce were experiments in cutting through the external framework of time to tell a story by imitating the way in which the mind jumps from one fragment of thought to another. Ezra Pound's Imagist poetry parallels Cubist art even more closely in collapsing time and space by leaving out all explanatory and sequential detail:

> The apparition of these faces in the crowd;
> Petals, on a wet, black bough.

When Keats wrote his *Ode to a Nightingale* he spread out in a continuous line the process by which the creative imagination perceives an image and realizes it in poetic terms. Pound compresses the same process by overlapping two separate things: the image of disembodied faces resembling petals on a branch and the poet's feelings as the image takes shape in his mind. For the Romantics, as for the Symbolists after them, it was the poet's inner feeling that sought some correspondence in the external world; for Pound it was the other way around. In this short stanza imitating the Japanese haiku he was, he said, trying to 'record the precise instant when a

494 Raymond Duchamp-Villon, *Horse*, 1914. Bronze, height 15⅜ in (39 cm). New York, Museum of Modern Art

thing outward and objective transforms itself, or darts into a thing inward and subjective'. Pound was a member of a group of artists who painted and sculpted in a manner close to the Futurists, but who saw motion accelerating not across the surface but inwards into a vortex, from which they called themselves Vorticists. Figure 495 by the English artist and writer Wyndham Lewis (1884–1957) is a mixture of Cubist and Futurist elements that is wholly abstract. Its hard-edged forms, precise and machine-like, bend inwards towards the centre of the canvas. This work is related to Pound's definition of an image:

> The image is not an idea. It is a radiant node or cluster; it is what I can, and must perforce, call a VORTEX, from which, and through which, and into which ideas are constantly rushing. In decency one can only call it a VORTEX. And from this necessity comes the name 'vorticism'.

In the years from 1912 to 1914 a number of painters broke through to a completely non-objective art that left any subject other than the work itself behind. Kandinsky, whose *Concerning the Spiritual in Art* was known to Pound and Wyndham Lewis, independently followed a similar line in cutting his art free from the external world. Continuing to substitute colour and pattern for objective forms, Kandinsky produced a number of completely abstract works in which he aimed, like Pound, to record the moment of spontaneous creation rather than to develop an idea.

The same desire to convey sensation directly, without the interference of external structure, led another Russian painter, Kasimir Malevich (1878–1935), in a different direction. Malevich suddenly began producing works of stark simplicity and limited form, relying totally on geometric shapes (fig. 496). 'In my desperate attempt to free art from the ballast of objectivity', he said, 'I took refuge in the square.' He did so because the square is a form never found in nature; he sought the supremacy of feeling, calling his art *Suprematist*. He shared with Kandinsky the feeling that adherence to the natural world impeded changes that must take place in art before it could perfectly represent personal expression.

The Anti-Modern Modernists: American Realism

In 1913 Modern art arrived in America in an exhibition put on by a group of American artists in the New York Armory on Lexington Avenue at Twenty-fifth Street, home of the 69th Regiment of the New York National Guard. The show had been intended by its sponsors principally as an independent exhibition for their own work, but in order to attract the widest possible audience they allowed the chairman of the committee, Arthur B. Davies, to include contemporary European works. Davies was one of the few Americans who knew and appreciated the new art. A torso he had bought from the Romanian sculptor Constantin Brancusi

495 (*below*) Wyndham Lewis, *Composition*, 1913. Watercolour, pen, and pencil on paper, $13\frac{1}{2} \times 10\frac{1}{2}$ in (34×26.5 cm). London, Tate Gallery

496 (*bottom*) Kasimir Malevich, *Eight Red Rectangles*, before 1915. Oil on canvas, $22\frac{3}{4} \times 19\frac{1}{8}$ in (57.8×48.5 cm). Amsterdam, Stedelijk Museum

497 Constantin Brancusi, *Mademoiselle Pogany*, 1913. Bronze, height 17¼ in (43.8 cm). New York, Museum of Modern Art, Lillie P. Bliss Collection.

(1876–1957) was in the exhibition, as was Brancusi's startling bronze bust *Mlle Pogany* (fig. 497). Under Davies's direction, the show was arranged to demonstrate the history of Modern art, beginning with Ingres and Delacroix and ending with a selection of twentieth-century works, chiefly by Fauves and Cubists. It was America's first real exposure to Cézanne, Gauguin, and van Gogh as well as to contemporary art. In general the crowds were as scandalized as the Parisians viewing the Salon des Refusés; the target of the most virulent hostility was Duchamp's *Nude Descending a Staircase*.

The comparison between New York seeing the Armory show and Paris in the 1860s is more than superficial, for America in the early decades of the twentieth century was witnessing essentially the same battle between the academies, which preached classical form and idealizing generality, and painters who chose to portray the real and immediate scenes of their own times. Except for a small group gathered around the photographer and artist Alfred Stieglitz and his gallery at 291 Fifth Avenue who were interested in Cubist and Expressionist art, the 'Modern' artists in America were realists painting in the tradition of Homer, Eakins, and Ryder. They were also connected to a school of realism in literature which developed in Chicago. The same concern and sympathy for poor people crowded into the industrial cities of the New World invest the paintings of Robert Henri and his associates and the writings of Theodore Dreiser, Edgar Lee Masters, and Sherwood Anderson.

The mild impressionism of Robert Henri (1865–1929) seems innocuous enough today (fig. 498), but to an age that demanded classical idealism and heroic subjects, his and his friends' unvarnished scenes of ordinary city life seemed to violate the canons of good taste, for which they were dubbed the Ashcan School. At the turn of the century the very rich in America displayed their aristocratic splendour in neoclassical mansions on Fifth Avenue and as patrons of art preferred academic idealism to realism.

By the time of the Armory show the Realists had essentially won their battle; by this time America had begun to take pride in its industrial wealth and frontier vitality, in the spirit of Walt Whitman and Mark Twain. Henri's gifted pupil George Bellows (1882–1925) won popularity even in academic circles for his unsentimental renditions of ordinary events that seemed to capture the masculine vigour and rugged individualism on which the nation prided itself (fig. 499). The few modernists showing at Stieglitz's '291' gallery were greeted with derision if not ignored. The shock of Modern art at the Armory was, therefore, all the more painful to the American realists who had felt themselves to be in the forefront. They were dependent on an art of subject-matter and were confronted with an art that either minimized subjects or did away with them altogether. Even more galling, the European art sold, despite official hostility; sales from the Armory exhibition formed the basis of many outstanding collections of Modern art in the United States. The effect of the show on American art

was to abort realism as a primary movement; it survived as a minor but enduring strain depicting rural and small town life.

New Directions in Architecture

Nothing as dramatic as the Armory show occurred to create a collision between the old and the new in American architecture; it was in this field that the New World made its first positive contribution to the course of Western style. Although the streets were still dominated by classical façades, American city skylines were rapidly being built upwards; the skyscraper, made practical by the invention of the electric elevator in 1880, was particularly advantageous in crowded Chicago and New York, where land was expensive. The technology of steel framing and non-weight-bearing walls, which Sullivan had pioneered in the nineteenth century, was developed further in the twentieth.

This technology was applied to the smaller scale of private homes by Sullivan's assistant Frank Lloyd Wright (1869–1959). Wright's 'prairie houses' built in and around Chicago in the first decade of the twentieth century were the first fruits of his pioneering genius and virtually the first works of Modern architecture on a domestic scale. Houses like the Robie House (fig. 501) were revolutionary in two ways; they functioned easily and informally as living space, and they were designed with particular regard for the natural contours of the site. The emphatic horizontal sweep of the roof of the Robie House, repeated in the horizontal terraces, creates a dramatic visual sweep that fits with the wide, flat expanses of the midwestern prairie.

A trip to Japan in 1907 had strengthened Wright's predilection for light, sparse architecture whose only ornamental aspect comes from the nature of the materials employed. It was his experience with the technology of non-weight-bearing walls that led him to treat exterior walls as light screens. Inside (fig. 500), the possibilities of removing walls produced an even more complete break with the past; he did away with box-like rooms closed off from one another, opening up the floor plan to create a continuous flow of space from area to area. This was a revolutionary new concept of living space and is still an accepted approach to domestic architecture, especially in the United States.

The Robie House, built in 1908–9, antedates the earliest Cubist paintings, yet in its treatment of architecture as volumes of space intersected by horizontal and vertical lines it is close to the interdependence of mass and void as developed by Picasso and Braque, and even closer to the abstract painting of Piet Mondrian (see fig. 519), which did not appear until the end of the First World War. For all that it is now 70 years old, the Robie House still seems an incredibly modern design.

498 (*top*) Robert Henri, *Snow in New York*, 1902. Oil on canvas, 32 × 25¾ in (81.3 × 65.5 cm). Washington D.C., National Gallery of Art, gift of Chester Dale, 1954

499 (*above*) George Wesley Bellows, *Stag at Sharkey's*, 1907. Oil on canvas, 36¼ × 48¼ in (92 × 123 cm). The Cleveland Museum of Art, Hinman B. Hurlbut Collection

500 (*right*) Frank Lloyd Wright, Robie House, interior, with furniture designed by Wright

501 (*below*) Frank Lloyd Wright, Robie House, Chicago, 1909

CHAPTER 16

Art Between the Wars

The First World War dispersed the various pre-war groups of artists. Its worst effects fell on the Germans, for whom the decay they saw in the pre-war social structure became total collapse. The violence and inhumanity of mechanized war provoked violent reactions against it that spilled into art movements, strengthening the vein of nihilism already present in Expressionism. Post-war Modern art continued to turn away from the natural world and to develop abstract styles.

Art in which spontaneous intuition and imagination was predominant over formal concerns followed two routes: Expressionism, still centred in Germany, conveyed personal experience of artists in the political and economic chaos following defeat; Surrealism, a school of fantastic art centred in Paris, drew on methods of psychoanalysis and sought images in the unconscious mind. Meanwhile, Analytical Cubism gave rise to a school of abstract art that took as its purpose the reduction of objective forms to geometrical patterns by fixed and universal rules.

Expressionism

Expressionism was fed by the horrors of post-war political, moral, and economic bankruptcy in Germany, where the collapse of democratic government was succeeded by Fascism. Wartime suffering found outlet in Expressionist art by drawing on medieval Christian iconography, as the Romantics had done before, using familiar religious imagery to add impact to secular subjects. Kathe Kollwitz (1867–1945) had lost her own son in the war and poured her emotion into a statue of a mother grieving for a dead child (fig. 502). In this work the iconography of a Pietà is used to heighten the sense of sorrow and loss. These two figures melt into one another in an outcry of pain that was the artist's tribute to all innocent suffering. Max Beckmann (1884–1950) chose a more grotesque vein, as

extreme as the visions of Bosch, when he painted *The Night* (fig. 505). Here he conveyed war's breaking down of social order by using the iconography of a Last Judgement, in which the punishments of the damned are visited on the innocent.

Expressionist concern for social justice found a practical outlet in architecture. Concurrently with Frank Lloyd Wright's revolution in living space, a number of architects in Germany pursued the technology of glass and steel handed down from Art Nouveau to design innovative buildings that combine self-expression with Utopian visions of a better world.

Before the war, idealism and desire for reform had brought art and factory design together in various arts and crafts alliances, of which the most influential was the Deutscher Werkbund, a co-operative formed in 1907 that included members of those professions — the arts, education, and business — interested in improving standards of living and of taste. A successor of Morris's Arts and Crafts movement, the Werkbund differed in the stress it laid on the machine's ability to improve social conditions. Thus many of the important buildings its members designed were factories and stores. For a Werkbund exhibition in 1914, Walter Gropius (1883–1969) designed a model factory, in collaboration with Adolf Meyer, that approached Wright's treatment of architecture as volumes of space (fig. 503). Large areas of glass, made possible because the steel frame bore the weight, admitted light and acted as a transition, rather than a separation, between indoors and out; the rounded shape of the glass staircases on the corners softened the severity of the rectangular design. Such impressive yet understated style was stimulated by industrial commissions, for factory owners had no money to waste on frills but were discovering that good designs cost no more than bad to produce.

At the same time, Expressionist architects experimented with materials that were more sculptural in their effect than glass and steel. The most versatile was concrete, which is easily moulded and lends the appearance of fluid, rather than static, form. The tower that Erich Mendelsohn (1887–1953) built to house Einstein's astronomical laboratory (fig. 504) visually expressed popular appreciation of Einstein's theories. Although postwar shortages forced Mendelsohn to substitute brick and stucco for much of the concrete, the concave and convex flow of the tower nonetheless evokes the idea of space that can be bent and stretched.

Expressionist Utopianism found its most influential outlet in the formation of the Bauhaus in 1919, when Walter Gropius assumed direction of Saxony's two state art and craft schools in Weimar. He reorganized them as a single entity to break down the division between training in the fine arts and in the crafts. Its foundation course, taught by the Expressionist painter Johannes Itten, acquainted every student with the basics of a wide variety of craft techniques and materials, with the aim of releasing creativity by widening the students' interests and experience.

The early members of the faculty appointed by Gropius were Ex-

502 Kathe Kollwitz, *Mother and Child*, 1917. Bronze, 28½ × 18 × 19 in (72 × 46 × 48 cm). Washington D. C., Hirshhorn Museum

503

504

505

506

503 Walter Gropius and Walter Meyer, office wing of model factory, designed for exhibition of the Deutscher Werkbund, Cologne, 1914

504 Erich Mendelsohn, Einstein Observatory, Potsdam, 1921 (destroyed)

505 Max Beckmann, *The Night*, 1918–19. Oil on canvas, $52\frac{1}{2} \times 60\frac{1}{2}$ in (133 × 154 cm). Düsseldorf, Kunstammlung Nordrhein-Westfalen
At the end of the war, Beckman voiced his deep pessimism, saying his paintings were 'a reproach to God for all that he does wrong'.

506 Paul Klee, *Dance You Monster to My Soft Song!*, 1922. Watercolour and oil transfer drawing on plaster-grounded gauze mounted on gouache painted paper, $17\frac{5}{8} \times 12\frac{7}{8}$ in (45 × 33 cm). New York, Solomon R. Guggenheim Museum

507 Jean Arp, *Squares Arranged According to the Laws of Chance*, 1916–17. Collage, $19\frac{1}{8} \times 13\frac{5}{8}$ in (48.6 × 34.6 cm). New York, Museum of Modern Art

pressionists. They included Kandinsky, who had spent the war years in Russia. There he had participated in the brief but far-reaching developments in abstract art that followed the Russian Revolution. Influenced by Malevich, Kandinsky left the freely spontaneous style of his pre-war works; he came to the Bauhaus painting in a more controlled geometrical style (fig. 508). But compared to Malevich's severely simplified non-objectivism, Kandinsky's painting is vibrantly in motion and conveys intuitive feeling.

Another early Bauhaus teacher was the Swiss artist Paul Klee (1879–1940). Klee was close in temperament and outlook to Kandinsky; he, too, was concerned with conveying directly the intuitive and spiritual elements in art. Although rarely a non-objective painter, he drew from imagination and memory rather than from nature, experimenting with different materials in a deliberately childlike approach. His *Dance You Monster to my Soft Song!* (fig. 506) is painted on gauze mounted on paper. It avoids specific symbolism; its figure is a child's monster, neither particularly menacing nor beneficent, but a creature to come and go as the imaginative child bids it.

Art of Fantasy: Dada and Surrealism

While Expressionist art and architecture developed and underwent clarification and abstraction at the Bauhaus, a wartime rebellion against definitions in art developed into a style of fantasy and the grotesque. In reaction to the war, artists sought violent challenges to reason and reality in the fantastic and the nonsensical. An antagonism to rules and structure in the arts appeared simultaneously in several places, notably in New York, where Marcel Duchamp spent the war years, and in Zurich, the gathering place for a number of writers and artists, one of whom is said to have chosen the name Dada, a French word for hobby-horse, by sticking a penknife into a dictionary. The word was uttered at intervals in Dada plays, scenes of non-action punctuated by non-dialogue.

The roots of Dada art were in the naive art of Henri Rousseau, in the dream visions of Chagall, and in the melancholy and mysterious atmosphere of a romantic Italian painter, Giorgio de Chirico (1888–1978), whose deep perspective, uncanny clarity, and dark shadows arouse dreamlike sensations of fear and foreboding (fig. 509). Dada art also emphasized the element of chance in art; for example, Jean Arp (1887–1966) composed figure 507 from torn squares of paper arranged in a random and unpremeditated design.

A good deal of Dada art was deliberately anarchic and outrageous. Marcel Duchamp challenged the idea that art is a special category of created works by taking common manufactured objects such as a snow-shovel, a bottle rack, a hat-stand, and even a urinal, and exhibiting them

508

509

510

508 Wassily Kandinsky, *Little Dream in Red*, 1925. Oil on canvas, $13\frac{3}{8} \times 16\frac{1}{8}$ in (34 × 41 cm). Paris, formerly collection Nina Kandinsky.

509 Giorgio de Chirico, *Mystery and Melancholy of a Street*, 1914. Oil on canvas, $33\frac{1}{2} \times 27\frac{1}{4}$ in (85.1 × 69.2 cm). Private collection

510 Max Ernst, *The Horde*, 1927. Oil on canvas, $45\frac{1}{4} \times 57\frac{1}{2}$ in (115 × 146 cm). Amsterdam, Stedelijk Museum

511 Joan Miró, *Composition*, 1933. Oil on canvas, $68\frac{1}{2} \times 77\frac{1}{4}$ in (174 × 196.2 cm). New York, Museum of Modern Art, gift of the Advisory Committee

512 Salvador Dali, *The Persistence of Memory*, 1931. Oil on canvas, 10 × 14 in (25 × 36 cm). New York, Museum of Modern Art

511

512

with preposterous titles as sculpture. With these 'ready-mades' he was attacking taste as a factor in art, saying that any object is a work of art if we look at it that way. The very people who scoff at his claim often prove him right by collecting driftwood or seashells because the natural shapes suggest hand-crafted sculpture.

More a state of mind than a style, Dada did not survive long after the war, but its rebellion against definitions was passed on to a successor movement: Surrealism. Surrealism was founded by a group of Dadaists in Paris who formulated a more positive theory of art as an act of spontaneous creation, a theory closely connected to Freudian psychology. The poet André Breton stated the group's aim to convey directly the sensations of dreams and of the subconscious mind, ungoverned by reason. The Surrealists experimented with various methods of creating spontaneous, biomorphic (life-imitating) images, including automatic, or spirit, writing used in séances. Max Ernst (1891–1976) mixed collage with rubbings from various surfaces, called frottages, and experimented with transferring oil paint to canvas from another surface, achieving a design in which strange creatures emerge half-formed from the texture of the paint (fig. 510). The Spanish painter Joan Miró (b. 1893) evokes the innocence of childhood dreaming, uninformed by knowledge or experience; his images spread across the canvas like the images we find in cracks in a plaster wall or clouds in the sky (fig. 511). Jean Arp sculpted three-dimensional biomorphic forms in soft-edged blobs that take form as we look at them (fig. 513).

A more deliberately formal style of Surrealist painting evolved as a reaction to the flattened space of abstract art; artists like Salvador Dali (b. 1904) placed fantastic images in a deep, architecturally constructed perspective derived from de Chirico. Dali was the most colourful personality among the Surrealists; it is his combination of meticulous draughtsmanship with unpleasantly harsh colouring that has become the most familiar version of Surrealist painting. He created landscapes of the unconscious mind by juxtaposing natural and man-made objects in what he called a 'paranoiac-critical formula', by which he referred to the irrational and spontaneous way, similar to paranoia, in which he perceived images. In the *Persistence of Memory* (fig. 512) he drew objects with a brittle outline and set them in a landscape of unearthly clarity, yet the objects themselves are in a state of advanced decay, softening like overripe cheese. In the process of decay, these soft watches form new and grotesque images; one becomes a saddle on the back of a strange fetal creature. Ants crawl over another, as they would over rotting food; their brittle forms create a jewel-like ornament encrusting the watch's surface. The barren landscape and atmosphere of eerie calm echo the sterile world of T.S. Eliot's poem *The Waste Land:*

513 Jean Arp, *Concrétion humaine*, 1933. Stone, 22 × 31⅞ × 21¼ in (56 × 81 × 54 cm). Zurich, Kunsthaus

What are the roots that clutch, what branches grow
Out of this stony rubbish: Son of man,
You cannot say, or guess, for you know only
A heap of broken images, where the sun beats,
And the dead tree gives no shelter, and the cricket no relief,
And the dry stone no sound of water.

Dedicated to spontaneous imagery of fantasy and imagination, Surrealism was at the opposite pole from Cubism. But the differences between the various styles of Modern art were more superficial than real; Expressionism, Surrealism, and Cubism and its abstract descendants all held a common ground in breaking away from logical continuity in order to convey the mind of the artist more directly. There were no hard and fast lines separating one school from the other; Dali was a great admirer of Picasso, who had abandoned the formal structure of Cubism after 1921 to work through a variety of experiments to a more expressionistic and violent distortion of form. In his *Girl Before a Mirror* (fig. 515), Picasso played a provocative trick with the convention of using a mirror's reflection to open up picture space and show multiple views naturalistically. In this painting the picture space remains flat and compressed; it is the girl herself, not the mirror image, that shows us both profile and front view. The mirror's reflection doubles the distortion and challenges us to say which is the 'real' girl.

If Picasso's style is expressionistic in the *Girl with a Mirror*, he approached Surrealism in a series of paintings of dry, metamorphic organisms constructed out of bone-like parts, paintings which in turn influenced an overtly expressionistic work by Dali (fig. 516). This work was stimulated by the onset of civil war in Spain which saw fascists armed by Nazi Germany destroy the Spanish republic. As a personal expression of Dali's own feeling, it is an emotional outcry far less restrained than the cool fantasy of the *Persistence of Memory*. The limbs of this tortured, fragmented figure come from Picasso's bone figures; its features are borrowed from the violent side of Expressionist painting.

A year later a small Basque town of no military importance was destroyed in the first blitzkrieg bombing of a defenceless citizenry. Picasso painted *Guernica* (fig. 514) as a passionate protest against the violence done by modern war to innocent people. It is painted in black and white, with no lightening effect of colour or softening chiaroscuro. The imagery comes from Spanish bullfighting, where neither horse nor bull act as conscious participants; rather, the natural ferocity of the bull is simply unleashed, like the savagery of human nature in war, against whatever is in its way. The fragmented and distorted images of the dying horse, disembowelled like the town of Guernica, a dying soldier, grieving mother, and helpless, terrified citizens, one of whom floats overhead holding a lamp, like a dismayed figure of Truth, are a powerful portrayal of an experience shortly to be undergone also by the rest of Europe.

Overleaf

514 Pablo Picasso, *Guernica*, 1937. Oil on canvas, 11 ft 5½ in × 25 ft 5¾ in (3.49 × 7.76 m). Madrid, Prado Picasso loaned *Guernica* to the Museum of Modern Art in New York City until such time as democracy returned to Spain. It remained there until 1981.

515 Pablo Picasso, *Girl Before a Mirror*, 1932. Oil on canvas, 64 × 51¼ in (162.6 × 130.2 cm). New York, Museum of Modern Art, gift of Mrs Simon Guggenheim

516 Salvador Dali, *Soft Construction with Boiled Beans: Premonition of Civil War*, 1936. Oil on canvas, 39½ × 39½ in (98 × 98 cm). Private collection

514

515

516

517 Piet Mondrian, *Horizontal Tree*, 1911. Oil on canvas, $29\frac{5}{8} \times 43\frac{7}{8}$ in (75.2×111.4 cm) Utica, N.Y., Munson–Williams–Proctor Institute

518 Piet Mondrian, *Façade* (Composition No. 7), 1914. Oil on canvas, $47\frac{1}{4} \times 39\frac{1}{2}$ in (120×100 cm) Zurich, Kunsthaus, on loan from E. Hulton

519 Piet Mondrian, *Composition with Red, Yellow and Blue*, 1920. Oil on canvas, $20\frac{1}{2} \times 23\frac{1}{2}$ in (52×60 cm). Amsterdam, Stedelijk Museum

517

518

519

De Stijl

Surrealism and Expressionism were the intuitive side of Modern art, stemming from the individual personality of the artist. Both schools contained abstract, or abstractionist, art in the biomorphic images of Miró and Arp and in the abstract Expressionism of Kandinsky; both moved art logically closer to complete non-objectivity by rejecting the natural world as a source of subject. Being romantic and inner-directed, neither Expressionism nor Surrealism developed a single style with formal rules.

A more classically structural and geometric abstract art developed from the analytical side of Cubism into a style concerned not with inner visions but with external problems of composition and harmony. This style came out of Holland, from a group of artists and architects centred around Piet Mondrian (1872–1944), whose style developed from a naturalistic manner imitating the Barbizon school through Cubist abstraction to a purely geometric style completely detached from the picturesque irregularities of nature. In 1911 Mondrian had gone to Paris, where first-hand exposure to Cubism led him to abandon naturalistic composition. He began by severing the object from its background and bringing it close to the surface. In figure 517 the space between the branches is broken into lozenge-shaped voids intersected by crossing branches. From this stage he went on to reduce the subject entirely to lines and spaces that emphasize vertical and horizontal axes with very little linear perspective (fig. 518).

The First World War forced Mondrian to return to Holland, where he renewed his acquaintance with other Dutch artists of the avant-garde. He found that his interest in wholly abstract art was shared by Theo van Doesburg (1883–1931). Together they founded the magazine *de Stijl* (*The Style*), which proclaimed their new style, called Neo-Plasticism. In figure 519, the rectangles of bright primary colours indicate mass, while the muted grey or white squares represent space; both are limited and directed by the black lines separating the squares. Although they began by abstracting design from natural objects, Mondrian and van Doesburg soon found they did not need a subject as a starting point; they banished nature entirely to give their art the 'truth' of pure intellection.

In its theoretical and geometrical foundations, Neo-Plastic painting was a rational and classical art close to the cool, geometrical ordering of space in Vermeer and even closer to the style of Piero della Francesca. There are striking parallels between the de Stijl group and fifteenth-century Urbino; in both cases all the arts were centred upon a rational ordering of the universe aimed at creating an ideal environment. The de Stijl group produced sculpture, furniture, and architecture that was Neo-Plastic painting in three dimensions, based on the same fundamental rectangles of solids and voids. De Stijl architecture (fig. 520) achieved a balance between negative space and positive mass through the placing of large

520 Gerrit Reitveld, Schroeder House, Utrecht (now demolished), 1924.

rectangular windows and by enclosing space within recessed blocks and balconies articulated by the slender vertical and horizontal lines of their railings. To achieve these values, the de Stijl architects borrowed freely from Frank Lloyd Wright's prairie house designs, adopting the free-flowing spaces of Wright's interiors as well as their strong horizontal emphasis.

De Stijl's classical emphasis on harmony and balance affected the course of Modern art and architecture through the influence of van Doesburg on the Bauhaus. Although he was never on the faculty of the school, he settled for a time in Weimar, where his charismatic personality attracted many of the students and staff, creating a counter-balance to the Expressionist emphasis on personal creativity.

Constructivism

De Stijl was not the only influence to lead the Bauhaus towards formal abstraction in the early 1920s. In the brief flowering of abstract art that followed the Communist Revolution in Russia, the intuitive approach to non-objective art of Malevich and Kandinsky co-existed with another school much closer to the analytical abstraction of Neo-Plasticism. Two members of this group, Naum Gabo (1890–1977) and his brother Antoine Pevsner (1884–1962), invented a form of sculpture that broke entirely with traditional attitudes towards material. Before them, abstraction of form in Modern sculpture had occurred within traditional methods of carving, moulding, or casting stone, clay, or bronze. Constantin Brancusi's *Mlle Pogany* (fig. 497) is an expressive work that makes full use of the metal surface in conveying a sense of personality in a novel treatment of anatomy. But Brancusi was still operating within the convention of materials as a mass to be shaped into a form that remains intrinsically solid. The Russians took a radically different approach, one closer to architecture; they built up forms out of various materials, often wood or plastic (fig. 521). This approach, the opposite of whittling away a mass of stone or wood, they called Constructivism. They created forms that were not conceived as a solid entity, as were even the pierced works of Cubist sculpture like figure 493, but as parts brought together in space.

When in the early 1920s the Russian state began to suppress abstract art in favour of a style of realism more outwardly propagandist, a number of talented and original artists including Pevsner and Gabo left Russia, taking their experimental art to the West. Gabo and the Constructivist architect El Lissitzky settled in Berlin and were in close contact with members of the Bauhaus staff.

521 Naum Gabo, *Construction in Space with Balance on Two-Points*, 1925. Metal, glass, plastic, and wood, height 26½ in (67.3 cm). New Haven, Conn., Yale University Art Gallery

Abstract Art at the Bauhaus

From 1923 the Bauhaus was increasingly a centre of development of abstract art and architecture. At this time the Expressionist Johannes Itten left the staff, and the basic course fell to two abstract artists influenced by Constructivism and de Stijl, Laszlo Moholy-Nagy (1895–1946) and Josef Albers (1888–1976). Their scientific experiments in perception, including extensive use of photography, led to a more standardized approach to the course, away from Expressionist reliance on individual intuition and towards a methodology based on the understanding of common experiences such as the way in which colours affect our perception of size and shape (see fig. 548). Albers pursued his interest in the the way we see form and space both in his painting and in the laboratory. Moholy-Nagy, a painter, sculptor, and photographer, broke down all barriers among these arts; he pioneered the art of the abstract film and, influenced by Naum Gabo, experimented with kinetic sculpture, constructing motor-driven machines that flashed lights as they moved. By their studies of light, motion, and colour, these two artists profoundly influenced our understanding of how we perceive objects.

The rational approach of Moholy-Nagy and Albers affected all areas of production at the Bauhaus. The trend towards abstract art and architecture was accompanied by an emphasis on practical designs for mass-production, so that everything from the fine arts to graphics and household furnishings arrived at the same stripped-down elegance of style, an elegance compounded of understatement, functionalism, and the clever use of materials. The de Stijl group designed furniture that took its forms from Neo-Plastic painting but was constructed out of wood like conventional furniture. Marcel Breuer (b. 1902) designed a chair whose rectilinear form (fig. 523) derives from a de Stijl chair by Rietveld. But Breuer's use of canvas and tubular steel made his design cheap and easy to mass-produce. It was this aspect that led to the wide-spread penetration of Modern design into the daily life of millions; the Bauhaus designs have become so standardized and so familiar that we forget how original they once were.

When in 1925 the town of Weimar became a centre of Nazi influence, the Utopian socialism of the Bauhaus forced the school to move to the more liberal climate of Dessau. Here Gropius had the opportunity to start afresh with new buildings of his own design. The school complex reflects an imaginative approach to functional design that was a continuation of Gropius's own pre-war factory designs. The appearance of the buildings (fig. 522) matches the abstract art and the spare, unornamented furnishings emerging from its workshops. It is an unornamented architecture and derives its beauty solely from the shape of its forms and the character of the materials used. The multi-storeyed sheet of glass that forms the wall of the workshop wing lets in light and, like the glass staircases of his model

522 Walter Gropius, the Bauhaus, Dessau, designed 1923, built 1925–6

523 Marcel Breuer, chair, 1925. Chrome-plated steel and canvas, 28 in (71 cm). New York, Museum of Modern Art, gift of Herbert Bayer

factory (fig. 503), provides a subtle transition between the outdoor environment and the space inside.

The International Style

The harmony between form and function seen in the Bauhaus buildings derived from the influence of Frank Lloyd Wright, whose designs were publicized in Europe; from de Stijl's abstract cubism; and from the experiments of Art Nouveau and Expressionism. Although it was the Bauhaus that provided the most fertile ground for the integration of all the arts with the new architecture, the style was not uniquely a Bauhaus creation but appeared simultaneously in many places, in the work of architects familiar with the structural and aesthetic possibilities of steel framing filled in by light screen-walls. By the end of the 1920s the style was so widespread that it earned the label 'International Style'. It was the first new international style to emerge from a wholly new technology since the Gothic. Characteristically cubic in shape, it was an architecture that expressed volume rather than mass, that achieved harmony and balance through proportion and regularity rather than by strict symmetry, and elegance from the natural appearance of material. By the Second World War it had appeared throughout Europe, North and South America, and even Japan, whose tradition of light, open, sparsely furnished houses had already contributed to the style through its influence on Wright.

In its structural and aesthetic characteristics, International Style architecture was the antithesis of the Renaissance tradition it finally replaced. But like the Early Renaissance, the Bauhaus affirmed the philosophy that man should be the measure of all man-made things, and, like Alberti, the architects of the International Style sought their harmony of proportion in universal laws. The French architect Le Corbusier (Charles Edouard Jeanneret, 1887–1965) designed an apartment house (fig. 524) that, like Piero's *Flagellation*, is based on the 'Golden Section' (see above, p. 168). In this building, a second 'Golden' rectangle appears in the vertical area to the left of the stairs.

The architects of the Renaissance had incorporated nature into their designs by opening rooms onto loggias, courtyards, and gardens, but they could only do so through heavy masonry arcades. The modern technology of steel supports and glass walls allowed rooms to open directly onto gardens and terraces, even in colder climates; cantilevered steel beams could support an open terrace leading off an upper storey. Le Corbusier's Villa Savoie (fig. 525) is built on steel columns that create an open effect in the ground level, like a loggia, but one that emphasizes space more than mass. The upper level floats effortlessly on its slender steel columns. On the roof, a curved concrete screen surrounds a solarium; the screen and the stairway approaching it act as monumental abstract sculpture.

524

525

526

524 Le Corbusier, *Les Terrasses,*
Garches, Seine-et-Oise, France, 1927–8

525 Le Corbusier, *Villa*
Savoie, Poissy, France, 1929–31

526 Ludwig Mies van der Rohe,
German Pavilion, Barcelona, 1929
(demolished)

527 El Lissitzky, *Proun 99*, 1924–5. Oil
on wood, 50¾ × 39 in (129 × 99 cm).
New Haven, Conn., Yale University
Art Gallery, gift of Collection Société
Anonyme

The most abstract of the International Style architects, and the closest to de Stijl painting, was Mies van der Rohe (1886–1969), who was so much influenced by van Doesburg that at one stage he drew plans that resemble de Stijl paintings. Mies became famous for his dictum 'less is more', by which he meant that the functional nature of the building should speak for itself, with no need for ornamentation or other aesthetic dressing up. A classic application of his statement was the German pavilion he designed for a trade fair in Barcelona in 1929 (fig. 526). This was a deceptively simple building whose beauty came from the harmony of its proportions, the handling of spatial volumes, and the choice of structural materials. Mies not only opened the interior into free-flowing continuous space; he used transparent and reflective materials extensively to expand the illusion of space. Glass walls not only open a building out from the inside; viewed from the outside, they become mirrors reflecting trees and sky in a perpetually changing mural.

The International Style developed in concert with the other arts in a unity of style and purpose that stemmed from the sharing of practice and theory at the Bauhaus. The division between the arts was progressively broken down; Cubist collage had already mixed sculpture with painting, while the Constructivists married sculpture to architecture. The gap between painting and architecture was bridged, as it had been in the Renaissance, by linear perspective. But whereas in the Renaissance artists wanted to create an illusion of real space opening back from the viewer's standpoint, the Modern artist's intent was to distort space. The Russian Constructivist El Lissitzky (1890–1941) used perspective to give the impression of objects protruding out towards us; his 'prouns' (a word meaning new art objects) were collages without three-dimensional materials, and painted versions of Moholy-Nagy's kinetic sculpture (fig. 527). They approach the Modern architect's volumes of space, and were, in El Lissitzky's own words, 'stations for changing trains from architecture to painting'.

CHAPTER 17

Late Modern Art

By the Second World War the International Style had developed a new and total style of living that brought all the arts and crafts within its orbit and necessitated a wholesale adoption of all Modern art to achieve its full value; the light, open interiors did not suit over-stuffed furniture or dark paintings in heavy gilt frames. Modern architecture needed Modern paintings and Modern sculpture. Yet, although it was the only style that integrated art and craft, the abstract art and architecture promoted by the Bauhaus was by no means universally accepted as *the* Modern style. The majority of the public still preferred beauty and picturesque charm, which ensured the survival of more decorative styles of architecture and the popularity of artists who were unwilling to accept the rejection of the natural world required by abstract painting and sculpture. Paris, the gathering place for artists of all nations, was the centre of more romantic styles; here in 1925 an exhibition of the decorative arts gave rise to a popular decorative style known as Art Deco, which, while severer in its lines than Art Nouveau, was similarly ornamental and reflected the opulence and extravagance of the Jazz Age. The birthplace of Surrealism, Paris was also the home of Matisse and Chagall and other artists exploring a Modern art of pictorial beauty and sensuous appeal. Matisse's style by the 1930 became decorative, reminiscent of Rococo, and reflected the contrasting textures of collage by juxtaposing the bright, assertive patterns of floor tiles, carpets, wallpaper, fabric, and pottery (fig. 528). A similarly decorative art exploring the picturesque quality of interiors is seen in the work of Pierre Bonnard (1867–1947). Bonnard had been a member of the Nabis, a Symbolist group influenced by Gauguin; he soon left the flat colouring of Gauguin for an impressionist technique influenced by Seurat. Between the wars, he was painting in an attractive style that combined impressionistic brush strokes with Fauvist flat perspective (fig. 529).

The Second World War brought the pursuit of beauty and pleasure in art to an abrupt halt. In the drastic and rapid rebuilding of war-torn

528 Henri Matisse, *The Magnolia Branch*, 1934. Oil on canvas, 60¼ × 66⅛ in (153 × 168 cm). Baltimore, Museum of Art, Cone Collection

529 Pierre Bonnard, *The Dining Room*, 1934. Oil on canvas, 50 × 53½ in (127 × 136 cm). New York, Solomon R. Guggenheim Museum

Europe, and in the post-war expansion in America, it was the International Style and the abstract painting and sculpture connected to it that emerged as the only style critics or public would allow to be 'Modern'. The post-war acceptance of the International Style was partly due to technology; the development of prefabricated units of steel and concrete allowed cheaper and faster construction than buildings using extensive masonry. But the light, soaring aspect of the ferro-concrete architecture of space and volume also came to express a new age rising from the ashes of the old.

Abstract painting emerged as the dominant style in part because the holocaust of war and the tensions of cold war suppressed any impulse towards natural beauty. Post-war art emphasized anti-humanist feelings of alienation and isolation, closely mirroring the Existentialist philosophy of Jean Paul Sartre, which denies any existence beyond the present and emphasizes personal action as the only way of creating meaning in our lives. Influenced by this creed, a school of painting developed in Paris and in New York, simultaneously but independently, to draw a new synthesis out of the common pre-war roots of Surrealism, Expressionism, and abstraction, a synthesis in which the act of painting itself became a substitute for any other meaning.

Abstract Expressionism

Paris was still a pre-eminent centre; many of the older figures — Chagall, Picasso, Kandinsky — were still in France. But more had fled to the United States: the presence of most of the Bauhaus figures, Mondrian, and the major Surrealists had a profound effect on American artists who, for the first time, moved out as leaders rather than as followers of style. The younger Americans of the abstract school that grew out of the '291' circle had already been influenced by Kandinsky. Then in the 1940 these artists came into contact with the spontaneity and fantasy of the Surrealists and, at the same time, with the formal concreteness of Mondrian's Neo-Plasticism. At this point, the apparently irreconcilable elements of subconscious expression and clarified form and space came together in a new mode that became known as Abstract Expressionism. In Cubism and Neo-Plasticism these painters found a method of formal construction on the picture plane; from Surrealism they took the liberation of subconscious emotions. They achieved a balance between the two by substituting the spontaneous act of painting for the realization of an idea. The New York Abstract Expressionist group included painters who were expressionist but seldom entirely abstract and artists whose work was wholly abstract but not expressionist. What united all of them was the concept of getting the paint onto the canvas in various ways of automatic gesture.

The method of 'action' painting was epitomized by Jackson Pollock

(1912–1956), who, after various experiments in free gestural brush strokes, took his canvas off the easel and tacked it onto the floor, where he would stand over it, dripping paint from the brush in patterns that followed the writhing, dancing motions of his body. The feeling of uninhibited dance has always attracted artists as a subject for painting, but it was Pollock who first expressed its rhythms directly through the medium of the paint. As we follow the swirling lines of thick, gooey colour we participate in his own spontaneous choreography (fig. 532). Yet his work is not the product of uninhibited freedom; Pollock balanced the intuitive act with external control, ordering the spatial progression so that motion always returns to the centre. He explained the process thus:

> When I am *in* the painting I'm not aware of what I'm doing. It is only after a sort of 'get acquainted' period that I see what I have been about. I have no fears about making changes, destroying the image, etc., because the painting has a life of its own. I try to let it come through. It is only when I lose contact with the painting that the result is a mess. Otherwise there is pure harmony, an easy give and take, and the painting comes out well.

Pollock's ability to balance random chance with external ordering was aided by his technique of painting without regard for the edge of the canvas, which he cut to fit the painting after it was done. This allowed him to move freely without losing control over the picture space. It is extraordinary how completely the dripped pattern knits together the empty spaces between lines; more than anything else, it is the sureness of Pollock's integration of form and space that easily distinguishes him from imitators who assume that drip painting is easy.

The excitement generated in the viewer by Abstract Expressionist painting is the excitement of the artist in the midst of creation. In the works of this school there is an emphasis on non-objectivity which is neither aesthetic nor formal; objects were extinguished to make room for the act of painting. But in its aim of making the creative act the whole object — and subject — of a painting, Abstract Expressionism takes us back to the Romantics and the roots of Modern art in the sketches of Constable and in Turner's 'action painting' on the 'varnishing days'. The Abstract Expressionists were influenced by the earlier Romantics and attempted to gain a similar effect of vast, mysterious space in which the very indefiniteness of detail acts upon the spectator. In pursuit of this awesome infinity of space, the Abstract Expressionists revived the huge scale of the nineteenth-century 'salon machine' and made up for the lack of depth with an expanded surface.

Some of the Abstract Expressionists explored the effect of pure colour brushed over large areas, reducing the gestural quality and eliminating all accidental figuration to contract everything into a contrast of two or three tones. The 'colour field' side of Abstract Expressionism is cooler and more controlled than the heated energy of Pollock's painting. Mark Rothko

530 Francis Bacon, *Head Surrounded by Sides of Beef*, 1954. Oil on canvas, 50⅞ × 48 in (129 × 122 cm). Chicago, The Art Institute of Chicago, Harriott A. Fox Fund

531 Alexander Calder, *The Spiral*, 1958. Sculpture in metal. Paris, UNESCO

(1903–70) replaced flat colours and sharp lines with a reintroduction of chiaroscuro and luminosity; his colours melt into one another and change subtly, giving a slight feeling of depth to counteract the spreading surface (fig. 535).

Parallel to the action and colour field painting of the American Abstract Expressionists, another school developed in Paris, unaware of the Americans until the late 1940s. The German artist Wols (Wolfgang Schülze, 1913–51) worked out independently an energetic style of splash painting that is very close to that of Pollock (fig. 533). George Mathieu (b. 1921) arrived at a scribble style even closer to the American, but his works (fig. 534) are more randomly constructed and lack the tension between line and space that both Pollock and Wols achieved. There are many striking similarities between American and European artists that were the result of the common background of pre-war Modern art; drawing on the same sources, the Europeans arrived at the same Existentialist substitution of the act of painting for an idea worked out and then transferred to the canvas.

In England a more strongly figurative and brutally expressionist art appeared in the painting of Francis Bacon (b. 1909). Bacon's mixture of Expressionist social concern and Surrealist psychological exploration led to a style that seems savagely inhuman and alienated (fig. 530). In paintings like this he took subjects from the past, but juxtaposed elements — in this case a portrait based on Velázquez with sides of beef from Dutch Baroque art — so that they arouse a sense of nightmare and madness. In general, European painters through the 1950s conveyed more Existentialist anxiety than the Americans, who were drawn to more passive Oriental religions, especially to Zen Buddhism.

Abstract Expressionist painting is precariously balanced between the claims of non-objective abstraction and the painterly matter of forms and picture-space. In the best works of this school we are made to feel the tension of this conflict. It was a style deliberately self-dramatizing and egocentric; in this and in its emphasis on technical tour-de-force, it has much in common with other late phases of style; this was true of late Modern architecture and sculpture as well. Like the Baroque artists, the late Moderns mixed painterly, sculptural, and architectural qualities in a conscious blurring of distinctions and boundaries. Calder's mobile sculptures epitomize this quality; they are Miró paintings in three dimensions, architecturally constructed and delicately engineered so that they always remain in balance, yet are constantly changing, in a twentieth-century equivalent of the Baroque fountain (fig. 531).

As in the Baroque period, late Modern architecture coordinated the other arts. The expanding canvases of Abstract Expressionist painters were designed for the open volumes of modern architecture, where they provide not only a dramatic focus against the light, bare walls, but also contribute directly to the sense of space; by their very size they play an active rather

532 (*top*) Jackson Pollock, *Number I*, 1948. Oil on canvas, 68 × 88 in (172.7 × 123.5 cm). New York, Museum of Modern Art

533 (*left*) Wolfgang Schülze, known as Wols, *Painting*. New York, collection of John Lefèvre

534 (*above*) Georges Mathieu, *Painting*, 1959. Private collection

535 Mark Rothko, *Sassrom*, 1958. Oil on canvas. Venice, Cardazzo Collection

than a passive role in the creation of an environment. Late Modern sculpture continued the development of architectural constructions projected into and enveloping space. Even where artists approached sculpture from the traditional concept of mass whittled down and moulded into form, the forms grew more interdependent with space. Figure 538, *Interior–Exterior Reclining Figure* by Henry Moore (b. 1898), is an exercise in the interpenetration of mass and void which considers the relationship from within rather than from the point of view of a body surrounded by air. In a similar manner, Barbara Hepworth (1903–75) scooped out her abstract wooden forms from the inside. Her *Two Figures* (fig. 540) are opened out to follow the natural grain of the wood; anatomy is interchangeable with space.

Constructivist principles of building up a work out of its component parts found a new vitality by replacing the chisel with the welding torch and using industrial materials rather than traditional wood and stone and bronze. One of the most innovative artists following this direction was David Smith (1906–65), who was never trained as a sculptor, but learned welding in engineering workshops. From this background he created large structures by welding together elements of cast-off machinery, and then went on to fabricate cubes and cylinders of stainless steel which he assembled into architectonic structures he called Cubi (fig. 537). His use of hard materials in rigid construction influenced younger artists to turn away from the curved, sculpted forms of Moore and Hepworth; even more architectural than the Cubi are the constructions Mark di Suvero (b. 1933) puts together out of building components such as steel I-beams. Di Suvero often includes whimsical touches like a working swing (fig. 539), thereby bringing sculpture out of the museum-piece category and into the environment of the playground.

As painting and sculpture grew increasingly architectural, late Modern architecture became more sculptural. Postwar buildings emphasized the structural frame in a manner evocative of the great Gothic cathedrals. Here, as in the classic phase of the International Style, the prophet was Frank Lloyd Wright and the style's most dramatic evangelist Le Corbusier.

By the time the International Style took form, Wright, whose prairie houses had contributed so much to it, moved away from Cubist volumes to use rough, natural materials inside and out in a more picturesque and sculptural effect. His most famous house of the 1930s has affinities with the International Style in its massing of rectilinear blocks (fig. 536), but it is more dramatic and self-expressive, and less self-contained. Wright exploited modern engineering techniques to adapt a house to a hillside rather than the hillside to the house; at 'Falling Water' the sharply angled concrete terraces are cantilevered to overhang the waterfall that gives the house its name. The whole ensemble emerges naturally from the rocky hillside, an effect accentuated by the use of local field stone for the main body of the house.

536

537

538

536 Frank Lloyd Wright, Edgar J. Kaufmann house, called 'Falling Water', 1936. Bear Run, Pennsylvania

537 David Smith, *Cubi XVIII*, 1964. Steel, height 115¾ in (294 cm). Boston, collection of Stephen D. Paine

538 Henry Moore, *Interior–Exterior Reclining Figure*, 1951. Bronze, height 14 in (35.6 cm). Washington D.C., Hirshhorn Gallery

539 Mark di Suvero, *X-Delta*, 1970. Iron, steel and wood. 132 × 216 × 120 in (335 × 539 × 305 cm). Hanover, New Hampshire, Dartmouth College Museum and Galleries

539

540 Barbara Hepworth, *Two Figures* (Menhirs), 1954–5. Teakwood. Formerly collection of the artist

In 1952 Le Corbusier designed an apartment complex in Marseilles that marks a change from his earlier use of concrete smoothed over to imitate plaster; here the concrete is left in its rough state to dramatize the vertical and horizontal ribs of the façade (fig. 541). Late Modern architecture moved away from the understatement of 'less is more' to a much more assertive style of chunky segments thrust forward and proclaiming the character of rough concrete or unpolished stone.

New technology played a major role in the aesthetics of late Modern architecture as it had in the earlier stages. Modern architecture as a style descended from Paxton's Crystal Palace came full circle soon after the war, when the Italian Pier Luigi Nervi (b. 1891) constructed an exhibition building in Turin in 1948–9. Under similar pressure to construct a large space fast and cheaply, Nervi developed prefabricated units of steel and concrete that could be fastened in place to vault a huge area in a short time. Nervi went on to refine this system in a vast sports arena built for the 1960 Olympic Games in Rome. This arena is covered with a concrete dome that soars as effortlessly as the domes of Santa Sophia (fig. 60). The dome rests on an intertwining network of supports in which form and function are as triumphantly merged as in the flying buttresses of a Gothic cathedral (fig. 543).

The plastic characteristics of late Modern architecture were vividly realized by Frank Lloyd Wright's Guggenheim Museum in New York City (fig. 542). The gallery is a spiral seated on its smaller end, expanding upwards; inside, a continuous ramp encloses an open central space that expands as it rises. Like most city buildings, the Guggenheim lacks a proper setting and is too crowded by other buildings to achieve its proper effect, but it is still a remarkable example of architecture realized almost wholly in sculptural terms.

New Reactions, New Directions

By the early 1960s, Modern architecture and abstract painting and sculpture had become as academic and as firmly established as the classical style they had originally replaced. Modern style has proved — and is still proving — to be all too easy to copy and to vulgarize, and it has led to a dehumanizing and impersonal quality in the environment, especially in our cities. As the style has become stereotyped, the term 'Modern' has ceased to be a term of meaning and, confusingly, has become the name for a style that has virtually passed away. Contemporary avant-garde art is no longer 'Modern' and 'Modern' art is no longer avant-garde.

Throughout the development of abstract art, the dominant issue was the need to come to new terms with the flatness of the picture surface. The Cubists rejected Renaissance one-point perspective, but adhered to the illusion of three-dimensional space. The de Stijl painters saw form and

541

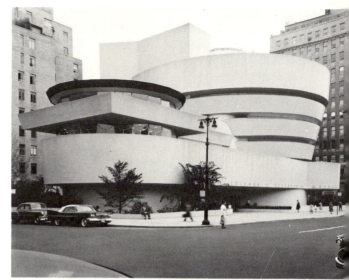

542

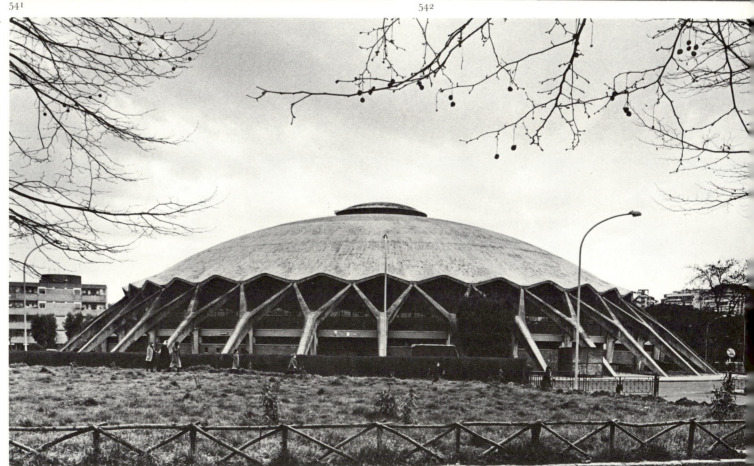

543

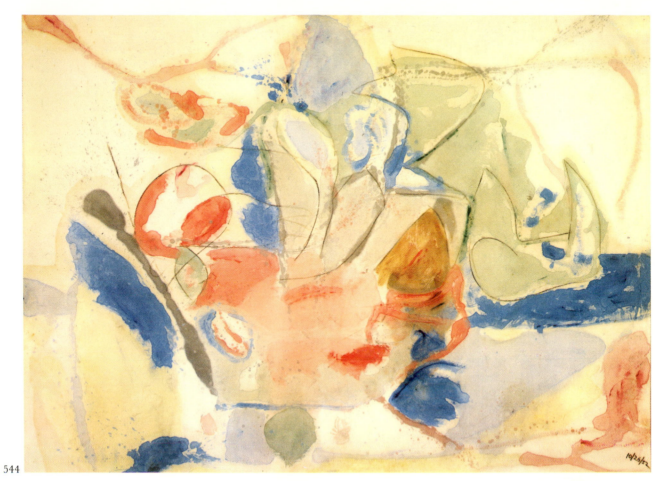

544

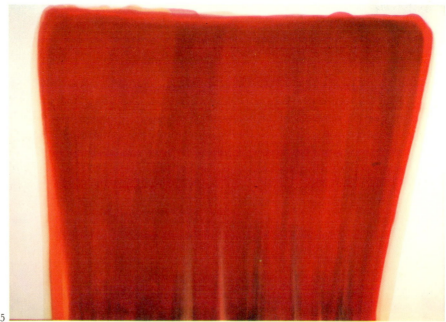

541 Le Corbusier, 'L'Unité d'Habitation', apartment block in Marseilles, 1947–52

542 Frank Lloyd Wright, The Solomon R. Guggenheim Museum of Art, New York City, 1943–59

543 Pier Luigi Nervi and Annibale Vitelozzi, Palazzetto dello Sport, Rome, 1957. Photo Richard Bryant

544 Helen Frankenthaler, *Mountains and Sea*, 1952. Oil on canvas, $86\frac{3}{4} \times 117\frac{1}{4}$ in (220×298 cm). Artist's collection, on loan to the National Gallery of Art, Washington D.C.

545 Morris Louis, *Vav*, 1960. Acrylic on canvas, $102\frac{1}{2} \times 142\frac{1}{2}$ in (260×362 cm). London, Tate Gallery

545

space strictly in terms of a flat surface. The Abstract Expressionists re-treated from Mondrian's on-the-surface painting; their pigment floats just behind the surface, its thick impasto emerging from an illusion, albeit tightly compressed, of depth. It was in reaction to this painterliness that younger artists reverted to the Neo-Plastic flatness of surface.

From Late Abstract Expressionism to Op Art and Post-Painterly Abstraction

Jackson Pollock had experimented with dripping paint straight from the can. Helen Frankenthaler (b. 1928) adopted this method to create designs much closer to the surface and with none of the roughened texture of gestural brush strokes (fig. 544). Following her lead, Morris Louis (1912–62) discovered the merits of acrylic, a modern synthetic medium which can be used thick or thinned to a wash and which dries quickly, so that colours can be poured over one another without completely blending as watercolour does, to form the effect of superimposed gossamer veils of colour (fig. 545). When Louis poured paint onto raw canvas without the traditional preparatory layer of paint, the result was closer to dyeing than painting.

The revisions of Abstract Expressionist painting techniques to achieve an on-the-surface effect brought into prominence a line of abstract paint-ing that favoured the closed geometrical forms of Mondrian and Albers over the freely intermingling patterns of the Abstract Expressionists. Albers himself was still exploring colour relationships in clear-cut forms through his *Homage to the Square* series (fig. 548), in which perception of the relative size of the squares depends on the use of complementary or contrasting tones. His optical illusionism influenced the emergence of Op Art, a movement much in tune with the kinetic entertainment forms emerging in the discotheques of the 1960s. Such a work as *Mach-C* (fig. 547) by Victor Vasarely (b. 1908) is descended from the experiments in perception made by Albers and Moholy-Nagy at the Bauhaus, but Op art was also easily integrated into the frenetic rhythms of rock and roll, the roving strobe lights of the discotheques, and their psychedelic images. The art of Albers, Frankenthaler, and Louis was and is intended for the small but appreciative audience of people buying paintings to live with. Op Art was conceived as a public entertainment, merging into popular culture in dress fabrics, interior décor, record jackets, and even film sets.

The clearly defined, closed shapes of geometrical abstract art painted in flat, unshaded colours deny completely the painterly illusionism that gives paint and canvas their particular aesthetic appeal. Frank Stella (b. 1935) and Kenneth Noland (b. 1924) removed abstract style still further from the traditional concepts of easel painting by exploring the effect of shaped paintings in which the form of the design was dictated by the picture's

edge. In figure 550, for example, Noland used Louis's staining techniques on a diamond-shaped canvas hung on the diagonal; it is the shape of the canvas that determined the placement of each coloured chevron. Because of their denial of any painterly quality, works in this style gained the label 'Post-Painterly Abstraction'.

Art of Assemblage

Abstract painting as the expression of a flat surface quickly reached its outer limits; the avenue that offered more room for experiment was sculpture, and the combination of sculpture with painting. Here the spirit of Dada reasserted itself in the 1960s with the emergence of a collage-like art of 'assemblage', a term whose vagueness suggests the wide range of possibilities in form and materials it covers. At one end of the scale, the term applies to the ingenious construction of Louise Nevelson (b. 1900), in which small found objects — bed-knobs, newel posts, and the like — are set in stacked crates and painted, to form an infinitely expandable universe of miniature parts (fig. 549). At the other extreme is the 'combine painting' of Robert Rauschenberg (b. 1925), which is drawn from the ordinary environment around us, using the paraphernalia of our consumer-oriented, cast-off style of living in combinations that are sometimes funny and often gruesome (fig. 546). Assemblage sculpture is literally constructed from scraps from the junk-yards, cast-off objects found in city streets, or pieces of wrecked automobiles and broken machinery, all of which symbolize the life of an affluent society wedded to disposable goods.

Pop Art and Super Realism

In its dependence on borrowed materials, assemblage sculpture is intimately connected to Pop Art, a form of representational art that emerged in the 1960s, not as a reassertion of pictorial values but quite the opposite, as a more complete denial of painterly illusionism than even abstract art provided. The term first appeared in England and quickly became applied to diverse experiments in London, New York, and Paris. Pop artists turned their back on non-representational abstraction and substituted instead the photographic realism of commercial art. Its images are drawn from magazine ads, television, the cinema, and the supermarket; *Green Coca-Cola Bottles* (fig. 551) by Andy Warhol (b. 1930) suggests the endless repetitiveness of a super-marketed society and crystallizes the thesis of the late Pop philosopher Marshall McLuhan that 'the medium is the message'.

Despite its insistence on the representational image, Pop Art was not a backward-looking revival; the Pop artists were connected to contemporary anti-painterly developments in abstract painting through their deliberate

546 Robert Rauschenberg, *Bed*, 1955. Combine painting, $75\frac{1}{4} \times 31\frac{1}{2} \times 6\frac{1}{2}$ in ($191 \times 80 \times 16.5$ cm). New York, collection of Mr and Mrs Leo Castelli

547

548

549

550

547 Victor Vasarely, *Mach-C*, 1952–3. Photo Galerie Denise René, Paris

548 Josef Albers, study for *Homage to the Square: Departing in Yellow*, 1964. Oil on board, 30 × 30 in (76 × 76 cm). London, Tate Gallery

549 Louise Nevelson, *Total Obscurity*, 1962. New York, Pace Gallery

550 Kenneth Noland, *Mach II*, 1964. Acrylic resin on canvas, 98 × 208 in (249 × 528 cm). Aspen, Colorado, collection of Mr and Mrs John Powers

551 (*right*) Andy Warhol, *Green Coca-Cola Bottles*, 1962. Oil on canvas, 82¼ × 57 in (209 × 145 cm). New York, Whitney Museum of Modern Art, gift of the Friends of the Whitney Museum

withholding of personal commentary and in the care they took to re-produce their borrowed images with no addition of pictorial illusionism. The link between the two styles becomes clearer when we consider the debt both owed to Jasper Johns (b. 1930), a painter who turned from Abstract Expressionism to painting representational images in a deliberately abstract manner that denied the value of the image as an image. In figure 553 the subject, an American flag, is immediately recognizable, yet it has no reality as a flag; it is stretched perfectly flat with no suggestion of the suppleness of cloth. It is, in fact, indistinguishable from the surface of the canvas it is painted on. This on-the-surface painting connects Johns to the shaped canvas-as-object Noland created; its deliberately banal treatment of the image makes Johns the forerunner of Pop Art. Neither Pop Art nor Post-Painterly Abstraction used the picture surface to create a painterly illusion of pictorial space.

The commercial art of media advertising, from which much of Pop Art borrowed its images, is in itself a form of abstraction, for it strips away all inessential details so as to convey the essence of its message quickly and directly. Pop artists borrowed not only the style but the various mechanical techniques of reproduction from commercial art. The comic strip, a form more abstract than the magazine ad, fascinated Roy Lichtenstein (b. 1923) by the strict economy with which it conveys in as few lines as possible an instantly recognizable situation. It was the conventions of the style as much as its banal subject-matter that intrigued him. He enlarged frames of popular comic romances literally, even reproducing the colour dots used in printing the strips, and including the words without which the story would be unintelligible (fig. 552). Thus enlarged, the banal clichés of love and heroism become nearly abstract images that force us to look at colour and pattern before we take in the story. Yet the story is inseparable from the painting; in reproducing this basic part of contemporary popular culture, Lichtenstein created a modern form of genre painting, one that makes its point with humour but without sentimentality or moralizing.

The use of photography as a means of avoiding pictorial individualization was by itself nothing new; Courbet had painted landscapes that were exact copies of photographs in order to escape the sentimentalizing effect of the painter's eye. But the modern slide projector opened up a more exact means of transferring the image from photograph to canvas with no possible question of form or composition. As a result, a work like figure 554, by Ralph Goings (b. 1928), is indistinguishable in reproduction from the original photograph; it is only the full-sized painting itself that conveys the eerie effect of super-realism, in which the artist's complete suppression of individual style or perception forces us to react entirely to the non-painterly qualities of the subject. We do gain something of the impact of Super Realism from photographs of the sculpture of Duane Hanson (b. 1928), whose grotesquely realistic figures are created from life casts (fig. 555). Derived both from store window mannequins and from the soap-

552 Roy Lichtenstein, *M-Maybe*, 1965. Oil on canvas, $59\frac{3}{4} \times 59\frac{3}{4}$ in (152×152 cm). Cologne, Wallraf-Richartz-Museum

opera drama of Mme Tussaud's waxworks, dressed in real clothes and wigs and carrying real accessories, his creations are a startling commentary on the vulgarity, and the vitality, of our society.

Happenings and Conceptual Art

Much contemporary art is not produced in the expectation of private sale and is closer to theatre than to the museum; like the culture that produces it, it stresses impermanence and change. Pop Art created 'happenings' derived from Dada plays; in some of these art was created by improbable means. More recently the 'happening' has taken the place of art altogether; one artist produced his 'work' by staying submerged in a tub of cold water, surrounded by animal entrails and sprayed by a hose, an idea that goes back to Surrealist exhibitions before the war. Such theatrical art lives permanently only in reproduction; its chief value is in the concept. It has captured an audience curious and willing to be amused but generally unsympathetic to the artists' claims that they should be taken seriously on aesthetic grounds — a claim the original Dadaists never made. The major direction of art in the 1970s was towards a rejection of art as a category of special objects created for public appreciation and in favour of art as a creative idea which only the artist understands and can explain. The public, meanwhile, shows it appreciation for art of the past by crowding the museums, which attract yet more people with increasingly ambitious and well-mounted historical exhibitions.

Late Modernists exaggerated the aesthetic and technical aspects of the Cubist–abstract interrelationship between mass and volumes of space; this exaggeration in turn produced purist reactions against a technical overload. It is the deliberately complex interpenetrations of solids and voids of late Modern sculpture like figure 538 that sparked the reversion to solid objects firmly occupying their own space; this is the concept behind the Minimalists' piles of bricks and stones that just sit in a corner, 'minding their own business'. The pattern of over-emphasis on aesthetic and formal aspects followed by denial of painterly appeal has been repeated many times, for example, in the Neoclassical reaction to Baroque illusionism. Not even the current dismay over the spectacular prices asked for a work that involves little or no artistry is new; in about 70 AD the elder Pliny complained of the gap between craftsmanship and value: 'It is extraordinary that when the price given for works of art has risen so enormously, art itself should have lost its claim to our respect.'

History, however progresses not in circles but in a spiral, never intersecting the same plane twice. Pliny's complaint came at a time when the Classical tradition was still creative and was yet to produce Trajan's column and the Pantheon. The long history of Classical art and theory — its survival in the Middle Ages, its kindling in the Renaissance, and its

553 (*left*) Jasper Johns, *Flag*, 1945–6. Encaustic, oil, and collage on fabric, mounted on plywood, $42\frac{3}{4} \times 60\frac{5}{8}$ in (107 × 154 cm). New York, Museum of Modern Art

554 (*below*) Ralph Goings, *Hot Fudge Sundae*, 1972. Oil on canvas, 40 × 56 in (102 × 142 cm). Malmo, Gallerie Ostergren

recent suppression in the Modern period—suggests that this remarkably resilient tradition may be due for another revival; certainly signs point to a renewal of picturesque beauty in art. The Neoclassical academicians who tried to cling fast to the beauty of Renaissance illusionism paid the price of stifling the natural progress and change without which art dies; in breaking the stranglehold of this artifically maintained tradition, Modern artists paid the opposite price of cutting art off from the natural world that had nourished it for the whole of its previous history. These two extremes suggest the need to reoccupy a middle ground. Yet this is not easy, for Modern art has radically altered our perception of what is art; by its explorations of the expressive nature of various materials, new and old, the twentieth century has successfully challenged the idea that there is a 'traditional' approach to art. Artists now face the problem of ordering and clarifying the overwhelming range of possibilities that Modern art has contributed to the continuing history of the human imagination and the visible forms of art and architecture it has conceived.

555 Duane Hanson, *Couple with Shopping Bags*, 1976. Cast vinyl polychromed in oils, life-size. New York, O.K. Harris Gallery

Bibliography

General Histories and Reference Works

GOMBRICH, E. H., *The Story of Art*, 13th edn., Phaidon Press, Oxford, 1978

HARTT, FREDERICK, *Art: A History of Painting, Sculpture, Architecture* (2 vols.), McGraw Hill, New York and London, 1977

HATJE, URSULA (ed.), *The Styles of European Art*, Thames and Hudson, 1965

JANSON, H. W., *History of Art*, 2nd rev. edn., Abrams, New York, 1977

MURRAY, PETER AND LINDA, *A Dictionary of Art and Artists*, rev. edn., Penguin, Harmondsworth and Baltimore, 1968

MYERS, BERNARD S., *McGraw–Hill Dictionary of Art*, 5 vols., McGraw Hill, New York and London, 1969

OSBORNE, HAROLD (ed.), *The Oxford Companion to Art*, Oxford University Press, Oxford and New York, 1979

PEVSNER, NIKOLAUS, *Outline of European Architecture*, Penguin, Harmondsworth and Baltimore, 1974

Phaidon Encyclopedia of Art and Artists, Phaidon Press, Oxford, 1978

General Background

ARNHEIM, RUDOLF, *Art and Visual Perception: A Psychology of the Creative Eye*, University of California Press, Berkeley, 1974

CLARK, KENNETH, *Landscape Into Art*, new edn., Murray, London, 1979; Harper & Row, New York, 1979

COOKE, HEREWARD L., *Painting Techniques of the Masters*, Watson-Guptill, New York, 1972

ELSEN, ALBERT E., *Purposes of Art*, Holt, Rinehart & Winston, New York, 1972

FOCILLON, HENRI, *The Life of Forms in Art*, 2nd edn., Wittenborn, New York, 1958

GOMBRICH, E. H., *Art and Illusion*, 5th edn., Phaidon Press, Oxford, 1977

HAYES, COLIN (ed.), *The Complete Guide to Painting and Drawing Techniques and Materials*, Phaidon Press, Oxford, 1978

PANOFSKY, ERWIN, *Meaning in the Visual Arts*, Doubleday, New York, 1955

SUMMERSON, JOHN, *The Classical Language of Architecture*, Methuen, London, 1964

Prehistoric Art and Art of the Ancient Near-East

FRANKFORT, H.-A. GROENEWEGEN-, AND ASHMOLE, B., *Art of the Ancient World*, Abrams, New York, 1971

HIGGINS, REYNOLD, *Minoan and Mycenaean Art*, Oxford University Press, New York, 1967; Thames and Hudson, London, 1967

SANDARS, N. K., *Prehistoric Art in Europe*, Penguin, Harmondsworth

SMITH, W. STEVENSON, *The Art and and Architecture of Ancient Egypt*, Penguin, Harmondsworth and Baltimore, 1965 (Pelican History of Art)

STROMMENGER, EVA, *The Art of Mesopotamia*, Thames and Hudson, London, 1964

WOLF, WALTHER, *The Origins of Western Art: Egypt, Mesopotamia, The Aegean*, Universe Books, New York, 1971; Weidenfeld & Nicolson, London, 1972

Classical Art

BOARDMAN, JOHN, *Greek Art*, rev. edn., Oxford University Press, New York, 1973; Thames and Hudson, London, 1973

BRILLIANT, RICHARD, *Arts of the Ancient Greeks*, McGraw Hill, New York, 1973

BRILLIANT, RICHARD, *Roman Art from the Republic to Constantine*, Phaidon Press, London, 1974

BROWN, FRANK E., *Roman Architecture*, Braziller, New York, 1961

CHARBONNEAUX, JEAN, MARTIN, ROLAND, and VILLARD, FRANÇOIS, *Archaic Greek Art 620–480*, Braziller, New York, 1971; Thames and Hudson, London, 1971 (Arts of Mankind series)

CHARBONNEAUX, JEAN, MARTIN, ROLAND, AND VILLARD, FRANÇOIS, *Classical Greek Art*, Braziller, New York, 1972; Thames and Hudson, London, 1973 (Arts of Mankind series)

CHARBONNEAUX, JEAN, MARTIN, ROLAND, and VILLARD, FRANÇOIS, *Hellenistic Art*, Braziller, New York, 1973; Thames and Hudson, London, 1973

LAWRENCE, A. W., *Greek and Roman Sculpture*, Cape, London, 1929; Harper and Row, New York, 1972

RICHTER, G. M. A., *A Handbook of Greek Art*, 7th edn., Phaidon Press, Oxford, 1974

STRONG, DONALD, *Roman Art*, Penguin, Harmondsworth and Baltimore, 1980 (Pelican History of Art)

TOYNBEE, JOCELYN, *The Art of the Romans*, Thames and Hudson, London, 1965; Praeger, New York, 1965

Early Christian and Byzantine Art

BECKWITH, JOHN, *Early Christian and Byzantine Art*, rev. edn., Penguin, Harmondsworth and Baltimore, 1979 (Pelican History of Art)

DU BOURGUET, PIERRE, *Early Christian Art*, Weidenfeld & Nicolson, London, 1972; Reynal, New York 1971

GOUGH, MICHAEL, *The Origins of Christian Art*, Thames and Hudson, London, 1973; Praeger, New York, 1974

GRABAR, ANDRÉ, *The Beginnings of Christian Art, 200–395*, Thames and Hudson, London, 1967; published in the US as *Early Christian Art*, Odyssey Press, New York, 1968 (Arts of Mankind series)

GRABAR, ANDRÉ, *The Golden Age of Justinian: From the Death of Theodosius to the Rise of Islam*, Odyssey Press, New York, 1967

KRAUTHEIMER, RICHARD, *Early Christian and Byzantine Architecture*, 2nd edn., Penguin, Baltimore, 1975, Harmondsworth, 1976 (Pelican History of Art)

WEITZMANN, KURT, *Late Antique and Early Christian Book Illumination*, Braziller, New York, 1977; Chatto and Windus, London, 1977

Early Medieval Art

BACKES, MAGNUS, AND DOLLING, REGINE, *Art of the Dark Ages*, Abrams, New York, 1969

CONANT, K. J., *Carolingian and Romanesque Architecture, 800–1200*, Penguin, Harmondsworth and Baltimore, 1973 (Pelican History of Art)

DEMUS, OTTO, *Byzantine Art and the West*, New York University Press, New York, 1970; Weidenfeld & Nicolson, London, 1970

DODWELL, C. R., *Painting in Europe 800–1200*, Penguin, Harmondsworth and Baltimore, 1973 (Pelican History of Art)

HUBERT, J., PORCHER, J., AND VOLBACH, W. F., *Europe in the Dark Ages*, Thames and Hudson, London, 1969 (Arts of Mankind series); published in the US as *Europe of the Invasions*, Braziller, New York, 1969

HUBERT, J., PORCHER, J., AND VOLBACH, W. F., *The Carolingian Renaissance*, Braziller, New York, 1970; Thames and Hudson, London, 1970 (Arts of Mankind series)

LASKO, PETER, *Ars Sacra, 800–1200*, Penguin, Harmondsworth and Baltimore, 1972 (Pelican History of Art)

ZARNECKI, GEORGE, *Art of the Medieval World: Architecture, Sculpture, Painting, and the Sacred Arts*, Abrams, New York, 1976

Romanesque and Gothic Art

CONANT, K. J., *Carolingian and Romanesque Architecture, 800–1200*, Penguin, Harmondsworth and Baltimore, 1973 (Pelican History of Art)

CUTTLER, CHARLES, *Northern Painting from Pucelle to Breugel: 14th, 15th & 16th Centuries*, Holt, Rinehart and Winston, New York, 1968

EVANS, JOAN, *Art in Mediaeval France, 987–1498*, Oxford University Press, 1969, reprint

FOCILLON, HENRI, *The Art of the West in the Middle Ages*, 2 vols., ed. J. Bony, Phaidon Press, Oxford, Cornell University Press, Ithaca, 1980, reprint

FRANKL, PAUL, *Gothic Architecture*, Penguin Books, Harmondsworth and Baltimore, 1962 (Pelican History of Art)

GRODECKI, LOUIS, *Gothic Architecture*, Abrams, New York, 1977

KRAUS, HENRY, *The Living Theatre of Medieval Art*, University of Pennsylvania Press, Philadelphia, 1972, reprint

KUBACH, HANS ERICH, *Romanesque Architecture*, Abrams, New York, 1975

LANDHOLT, HANSPETER, *German Painting: The Late Middle Ages, 1350–1500*, World Publishing Co., Cleveland, 1968

MARTINDALE, ANDREW, *Gothic Art from the Twelfth to the Fifteenth Centuries*, Praeger, New York, 1967; Thames and Hudson, London, 1967

MARTINDALE, ANDREW, *The Rise of the Artist in the Middle Ages and the Early Renaissance*, Thames and Hudson, London, 1972; McGraw Hill, New York, 1972

PANOFSKY, ERWIN, AND PANOFSKY-SOERGEL, GERDA trans. and eds., *Abbot Suger on the Abbey Church of St. Denis and its Art Treasure*, Princeton University Press, 1978

POPE-HENNESSY, JOHN, *Gothic Art*, Thames and Hudson, London, 1967

POPE-HENNESSY, JOHN, *An Introduction to Italian Sculpture*, vol. 1, *Italian Gothic Sculpture*, 2nd edn., Phaidon Press, London, 1972

RICKERT, MARGARET, *Painting in Britain: The Middle Ages*, 2nd edn., Penguin, Harmondsworth and Baltimore, 1965

STONE, LAWRENCE, *Sculpture in Britain: The Middle Ages*, rev. edn., Penguin, Harmondsworth and Baltimore, 1973 (Pelican History of Art)

WEBB, GEOFFREY, *Architecture in Britain: The Middle Ages*, 3rd edn., Penguin, Harmondsworth and Baltimore, 1975 (Pelican History of Art)

WHINNEY, MARGARET, *Early Flemish Painting*, Praeger, New York, 1968; Faber, London, 1968

WHITE, JOHN, *Art and Architecture in Italy, 1250–1400*, Penguin, Harmondsworth and Baltimore, 1970 (Pelican History of Art)

ZARNECKI, GEORGE, *Art of the Medieval World: Architecture, Sculpture, Painting, and the Sacred Arts*, Abrams, New York, 1975

The Renaissance in Italy: 1400–1600

BAXANDALL, MICHAEL, *Painting and Experience in Fifteenth Century Italy: A Primer in the Social History of Pictorial Style*, Oxford University Press, Oxford and New York, 1974

BENEVOLO, LEONARDO, *The Architecture of the Renaissance*, vol. 1, West-view Press, Boulder, Colorado, 1977

BLUNT, ANTHONY, *Artistic Theory in Italy, 1450–1600*, Oxford University Press, 1962

FREEBERG, S. J., *Painting in Italy, 1500–1600*, Penguin, Harmondsworth and Baltimore, 1975 (Pelican History of Art)

GILBERT, CREIGHTON, *History of Italian Renaissance Art; Painting, Sculpture, Architecture throughout Europe*, Abrams, New York, 1973

GRIFFITHS, ANTONY, *Prints and Printmaking: an Introduction to the History and Techniques*, British Museum Publications, London, 1980

HALE, JOHN, *Italian Renaissance Painting: A Survey from Masaccio to Titian*, Phaidon Press, Oxford, 1977

HARTT, FREDERICK, *History of Italian Renaissance Art, Painting, Sculpture, Architecture*, 2nd edn., Abrams, New York, 1979; Thames and Hudson, London, 1971

HEYDENREICH, LUDWIG H., AND LOTZ, WOLFGANG, *Architecture in Italy 1400–1600*, Penguin, Harmondsworth and Baltimore, 1974 (Pelican History of Art)

LOWRY, BATES, *Renaissance Architecture*, Braziller, New York, 1962

MURRAY, LINDA AND PETER, *The Art of the Renaissance*, Praeger, New York, 1963; Thames and Hudson, London, 1963

MURRAY, LINDA, *The High Renaissance and Mannerism, Italy, the North and Spain 1500–1600*, Praeger, New York, 1977; Thames and Hudson, London, 1978

MURRAY, PETER, *Architecture of the Italian Renaissance*, Thames and Hudson, London, 1969; Abrams, New York, 1971

PAATZ, WALTER, *The Arts of the Italian Renaissance: Painting, Sculpture, Architecture*, Abrams, New York, 1974

POPE-HENNESSY, JOHN, *An Introduction to Italian Sculpture*, vol. 2, *Early Renaissance*, and vol. 3, *High Renaissance and Baroque*, Phaidon Press, London, 1970 and 1972

SMART, ALASTAIR, *The Renaissance and Mannerism in Italy*, Thames and Hudson, London, 1971

SEYMOUR, CHARLES, JR., *Sculpture in Italy, 1400–1500*, Penguin, Harmondsworth and Baltimore, 1966 (Pelican History of Art)

WIND, EDGAR, *Pagan Mysteries in the Renaissance*, new edn., Norton, New York, 1968; Faber, London, 1968

The Renaissance in the North: 1400–1600

BENESCH, OTTO, *The Art of the Renaissance in Northern Europe*, rev. edn., Phaidon Press, London, 1965

BLUNT, ANTHONY, *Art and Architecture in France, 1500–1700*, Penguin, Harmondsworth and Baltimore, 1973 (Pelican History of Art)

CUTTLER, CHARLES, *Northern Painting from Pucelle to Breugel: 14th, 15th and 16th Centuries*, Holt, Rinehart and Winston, New York, 1968

FRIEDLÄNDER, MAX J., *From Van Eyck to Bruegel*, Phaidon Press, Oxford, Cornell University Press, Ithaca, 1981, reprint

KUBLER, GEORGE, AND SORIA, MARTIN, *Art and Architecture in Spain and Portugal and their American Dominions, 1500–1800*, Penguin, Harmondsworth and Baltimore, 1959 (Pelican History of Art)

LASSAIGNE, JACQUES, *Flemish Painting*, vol. 2 (from Bosch to Rubens), Skira, New York, 1957

OSTEN, GERT VON DER, AND VEY, HORST, *Painting and Sculpture in Germany and the Netherlands, 1500–1600*, Penguin, Harmondsworth and Baltimore, 1969 (Pelican History of Art)

RING, GRETE, *A Century of French Painting, 1400–1500*, Phaidon Press, London and New York, 1949

SMART, ALASTAIR, *The Renaissance and Mannerism Outside Italy*, Thames and Hudson, London, 1972

SUMMERSON, JOHN, *Architecture in Britain, 1530–1830*, 6th edn., Penguin, Harmondsworth and Baltimore, 1977 (Pelican History of Art)

WATERHOUSE, ELLIS, *Painting in Britain, 1530–1770*, Penguin, Harmondsworth and Baltimore, 1978 (Pelican History of Art)

WHINNEY, MARGARET, *Early Flemish Painting*, Praeger, New York, 1968; Faber, London, 1968

Baroque and Rococo Art

BAZIN, GERMAIN, *Baroque and Rococo Art*, Praeger, New York, 1964; Thames and Hudson, London, 1964

BENEVOLO, LEONARDO, *The Architecture of the Renaissance*, vol. 2 (1600–1750), Westview Press, Boulder, Colorado, 1978

BLUNT, ANTHONY, *Art and Architecture in France, 1500–1700*, Penguin, Harmondsworth and Baltimore, 1959 (Pelican History of Art)

HELD, JULIUS S., AND POSNER, DONALD, *Seventeenth and Eighteenth Century Art: Baroque Painting, Sculpture, Architecture*, Abrams, New York, 1971

HEMPEL, EBERHARD *Baroque Art and Architecture in Central Europe*, Penguin, Baltimore, 1965, Harmondsworth, 1975 (Pelican History of Art)

KUBLER, GEORGE, AND SORIA, MARTIN, *Art and Architecture in Spain and Portugal and their American Dominions, 1500–1800*, Penguin, Harmondsworth and Baltimore, 1959 (Pelican History of Art)

MILLON, HENRY A., *Baroque and Rococo Architecture*, Braziller, New York, 1961

NORBERG-SCHULTZ, CHRISTIAN, *Baroque Architecture*, Abrams, New York, 1972

NORBERG-SCHULTZ, CHRISTIAN, *Late Baroque and Rococo Architecture*, Abrams, New York, 1975

ROSENBERG, JAKOB, SLIVE, SEYMOUR, AND TER KUILE, E. T., *Dutch Art and Architecture, 1600–1800*, rev. edn., Penguin, Harmondsworth and Baltimore, 1977 (Pelican History of Art)

SUMMERSON, JOHN, *Architecture in Britain, 1530–1830*, 6th edn., Penguin, Harmondsworth and Baltimore, 1977 (Pelican History of Art)

WATERHOUSE, ELLIS, *Painting in Britain, 1530–1770*, Penguin, Harmondsworth and Baltimore, 1978 (Pelican History of Art)

WHINNEY, MARGARET, *Sculpture in Britain, 1530–1830*, Penguin, Harmondsworth and Baltimore, 1964 (Pelican History of Art)

WITTKOWER, RUDOLF, *Art and Architecture in Italy, 1600–1750*, rev. edn., Penguin, Harmondsworth and Baltimore, 1973 (Pelican History of Art)

Neoclassicism and the Picturesque

BENEVOLO, LEONARDO, *The Architecture of the Renaissance*, vol. 2 (1600–1750), Westview Press, Boulder, Colorado, 1978

BRAHAM, ALLAN, *The Architecture of the French Enlightenment*, University of California Press, Berkeley, 1980; Thames and Hudson, London, 1980

GAUNT, WILLIAM, *The Great Century of English Painting: Hogarth to Turner*, Phaidon Press, Oxford, 1978

HERRMANN, LUKE, *British Landscape Painting of the Eighteenth Century*, Faber, London, 1973; Oxford University Press, New York, 1974

HONOUR, HUGH, *Neoclassicism*, Penguin, Baltimore and Harmondsworth, 1968

KALNEIN, WEND GRAF, AND LEVEY, MICHAEL, *Art and Architecture of the Eighteenth Century in France*, Penguin, Harmondsworth and Baltimore, 1972 (Pelican History of Art)

LEVEY, MICHAEL, *Painting in Eighteenth-Century Venice*, 2nd edn., Phaidon, Press, Oxford, 1980

PEVSNER, NIKOLAUS, *Studies in Art, Architecture and Design*, vol. 1, Walker and Co., New York, 1968; Thames and Hudson, London, 1968

SUMMERSON, JOHN, *Architecture in Britain, 1530–1830*, 6th edn., Penguin, Harmondsworth and Baltimore, 1977 (Pelican History of Art)

WATERHOUSE, ELLIS, *Painting in Britain, 1530–1770*, Penguin, Harmondsworth and Baltimore, 1978 (Pelican History of Art)

WHINNEY, MARGARET, *Sculpture in Britain, 1530–1830*, Penguin, Harmondsworth and Baltimore, 1964 (Pelican History of Art)

Romanticism

BRION, MARCEL, *Art of the Romantic Era: Romanticism, Classicism, Realism*, Praeger, New York, 1966; Thames and Hudson, London, 1966

CLARK, KENNETH, *The Romantic Rebellion: Romantic versus Classic Art*, Harper & Row, New York, 1974; Futura, London, 1976

FRIEDLANDER, WALTER, *From David to Delacroix*, Schocken Books, New York, 1968

HONOUR, HUGH, *Romanticism*, Allen Lane, London, 1979; Harper & Row, New York, 1979

NOVOTNY, FRITZ, *Painting and Sculpture in Europe, 1780–1880*, Penguin, Harmondsworth and Baltimore, 1970 (Pelican History of Art)

VAUGHAN, WILLIAM, *Romantic Art*, Oxford University Press, New York, 1978; Thames and Hudson, London, 1978

American Art in the Nineteenth Century

BROWN, MILTON, AND OTHERS, *American Art: Painting, Sculpture, Architecture, Decorative Arts, Photography*, Abrams, New York, 1979

FLEXNER, JAMES THOMAS, *That Wilder Image: Paintings of America's Native School from Thomas Cole to Winslow Homer*, Dover Books, New York, 1970

NOVAK, BARBARA, *American Painting in the Nineteenth Century: Realism, Idealism, and the American Experience*, Harper & Row, New York, 1980

NOVAK, BARBARA, *Nature and Culture; American Landscape and Painting,*

1825–75, Oxford University Press, New York, 1980; Thames and Hudson, London, 1980

WILMERDING, JOHN, *American Art*, Penguin, Harmondsworth and Baltimore, 1976 (Pelican History of Art)

European Art in the Nineteenth Century

CLARK, KENNETH, *The Gothic Revival*, Murray, London, 1974; Harper and Row, New York, 1974

DUNLOP, IAN, *The Shock of the New: Seven Historic Exhibitions of Modern Art*, Weidenfeld & Nicolson, London, 1972

HAMILTON, GEORGE HEARD, *Nineteenth and Twentieth Century Art: Painting, Sculpture, Architecture*, Abrams, New York, 1973

HITCHCOCK, H.-R., *Architecture: Nineteenth and Twentieth Centuries*, Penguin, Harmondsworth and Baltimore, 1977 (Pelican History of Art)

HOFMANN, WERNER, *The Earthly Paradise: Art in the 19th Century*, Braziller, New York, 1960; *Art in the 19th Century*, Faber, London, 1960

LICHT, FRED, *Sculpture, 19th and 20th Centuries*, New York Graphic Society, Greenwich, 1967

NOCHLIN, LINDA, *Realism*, Penguin, Harmondsworth and Baltimore, 1971

NOVOTNY, FRITZ, *Painting and Sculpture in Europe, 1780–1880*, Penguin, Harmondsworth and Baltimore, 1970 (Pelican History of Art)

PEVSNER, NIKOLAUS, *Studies in Art, Architecture and Design*, vol. 2, Walker & Co., New York, 1968

PEVSNER, NIKOLAUS, *The Sources of Modern Architecture and Design*, Praeger, New York, 1968; Thames and Hudson, London, 1968

POOL, PHOEBE, *Impressionism*, Thames and Hudson, London, 1976, reprint; Oxford University Press, New York, 1967

REWALD, JOHN, *History of Impressionism*, 4th edn., Museum of Modern Art, New York, 1973; Secker & Warburg, London, 1973

RHEIMS, MAURICE, *Nineteenth Century Sculpture*, Abrams, New York, 1977; Thames and Hudson, London, 1977

Symbolism and Art Nouveau

DAVAL, JEAN-LUC, *Modern Art, The Decisive Years, 1884–1914*, Rizzoli, New York, 1979

HOFMANN, WERNER, *The Earthly Paradise: Art in the 19th Century*, Braziller, New York, 1961; *Art in the 19th Century*, Faber, London, 1960

JULLIAN, PHILIPPE, *Dreamers of Decadence: Symbolist Painters of the 1890s*, Phaidon Press, London, 1971; Praeger, New York, 1971

LÖVGREN, SVEN, *The Genesis of Modernism: Seurat, Gauguin, van Gogh and French Symbolism in the 1880s*, Indiana University Press, Bloomington, 1971

LUCIE-SMITH, EDWARD, *Symbolist Art*, Thames and Hudson, London, 1972; Praeger, New York, 1972

MADSEN, S. TSCHUDI, *Art Nouveau*, McGraw Hill, New York, 1967; Weidenfeld & Nicolson, London, 1967

REWALD, JOHN, *Post-Impressionism: from van Gogh to Gauguin*, 3rd edn.,

Museum of Modern Art, New York, 1978

SELZ, PETER, AND CONSTANTINE, MILDRED (eds.), *Art Nouveau: Art and Design at the Turn of the Century*, Museum of Modern Art, New York, 1976; Secker & Warburg, London, 1976

Art of the Twentieth Century

ARNASON, H. H., *History of Modern Painting, Sculpture and Architecture*, Abrams, New York, 1977; Thames and Hudson, London, 1977

BARR, ALFRED H. JR., (ed.) *Cubism and Abstract Art*, Museum of Modern Art, New York, 1936; Arno, New York, 1966; Secker and Warburg, London, 1975

BARR, ALFRED H., JR. (ed.), *Fantastic Art: Dada and Surrealism*, Museum of Modern Art, New York, 1936; Arno, New York 1970, reprint

BROWN, MILTON, *American Painting from the Armory Show to the Depression*, Princeton University Press, Princeton, 1970

DAVAL, JEAN-LUC, *Modern Art, The Decisive Years, 1884–1914*, Rizzoli, New York, 1979

DUNLOP, IAN, *The Shock of the New: Seven Historic Exhibitions of Modern Art*, Weidenfeld & Nicolson, London, 1972

GIEDION, SIEGFRIED, *Space, Time and Architecture, The Growth of a New Tradition*, Harvard University Press, Cambridge, Mass., 1968

GOLDWATER, R. J., *Primitivism in Modern Art*, rev. edn., Random House, New York, 1968

HITCHCOCK, H. R., AND JOHNSON, PHILIP, *The International Style*, Norton, New York, 1966, reprint

HUNTER, SAM, AND JACOBUS, JOHN, *Modern Art from Post Impressionism to the Present, Painting, Sculpture and Architecture*, Abrams, New York, 1977

LICHT, FRED, *Sculpture, 19th and 20th Centuries*, New York Graphic Society, Greenwich, 1967

LUCIE-SMITH, EDWARD, *Late Modern: The Visual Arts since 1945*, Oxford University Press, New York, 1975

LYNTON, NORBERT, *The Story of Modern Art*, Phaidon Press, Oxford, 1980; Cornell University Press, Ithaca, 1980

RICHARDSON, TONY, AND STANGOS, NIKOS (eds.), *Concepts of Modern Art*, Harper & Row, New York, 1974

ROSE, BARBARA, *American Art Since 1900*, rev. edn., Thames and Hudson, London, 1975; Praeger, New York, 1975

ROSENBLUM, ROBERT, *Cubism and Twentieth-Century Art*, rev. edn., Abrams, New York, 1976; Thames and Hudson, London, 1977

SELZ, JEAN, *Modern Sculpture: Origins and Evolution*, Braziller, New York, 1963

SELZ, PETER, *German Expressionist Painting*, University of California Press, Berkeley, 1974, reprint

SHARP, DENNIS, *Modern Architecture and Expressionism*, Braziller, New York, 1967

WILLETT, JOHN, *Expressionism*, McGraw Hill, New York, 1971; Weidenfeld & Nicolson, London, 1971

SOURCES OF QUOTATIONS

p. 41 Vitruvius, *De Architectura*, quoted in Peter Murray, *Architecture of the Italian Renaissance* (Thames and Hudson, London, 1969; Abrams, New York, 1971), p. 41. The complete text of Vitruvius is translated by F. Granger in the Loeb Classical Library (Heinemann, London; Putnams, New York, 1931–4).

p. 72 Bede, *A History of the English Church and People*, transl. Leo Sherley-Price (Penguin Books, Harmondsworth and Baltimore, 1965), p. 246.

p. 79 John Scotus Erigena's version of the Pseudo-Dionysius's *Celestial Hierarchy* has been translated into English by J. Parker (London, 1897–9).

p. 85 Geoffrey Chaucer, prologue to the *Canterbury Tales*, translated into modern English by Nevill Coghill (Penguin Books, Harmondsworth and Baltimore, 1953).

p. 98 Bernard of Clairvaux, letter to Abbot William of St. Thiery, quoted in Meyer Schapiro, *Romanesque Art* (George Braziller, New York, 1977), p. 6.

p. 106 Abbot Suger, *On the Abbey Church of Saint Denis*, ed. and transl. Erwin Panofsky (Princeton University Press, Princeton, 1946), pp. 91–5.

p. 136 *Gawaine and the Green Knight* is translated into modern English by Brian Stone (Penguin Books, Harmondsworth and Baltimore, 1964).

p. 151 Lorenzo Ghiberti, *Commentaries*, quoted in Michael Batterberry, *Art of the Early Renaissance* (McGraw Hill, New York, 1968), p. 55.

p. 157 Giorgio Vasari, *Lives of the Artists*, sel. and transl. by George Bull (Penguin Books, Harmondsworth and Baltimore, 1965), p. 125.

p. 162 Vitruvius, op. cit. (see p. 41), quoted in Peter Murray, op. cit., pp. 53–4.

p. 162 Leon Battista Alberti's *On Painting* and *On Sculpture* are ed. and transl. C. Grayson (Phaidon, London, 1972).

p. 169 Vasari, *Lives of the Artists*, p. 194.

p. 180 Francesco Guicciardini, *History of Florence*, transl. C. Grayson (Twayne Publishers Inc., New York. 1964). p. 5.

p. 189 Leonardo da Vinci, *The Literary Works*, ed. J. P. Richter (Sampson Low, London, 1883), p. 18.

p. 192 Leonardo da Vinci, *Treatise on Painting*, ed. A. P. MacMahon (Princeton University Press, Princeton. 1956), quoted in Michael Baxandall, *Painting and Experience in Fifteenth Century Italy* (Clarendon Press, Oxford, 1972), p. 56.

p. 194 quoted from *The World of Michelangelo*, Time-Life Books (Time Inc., New York, 1966), p. 73.

p. 194 Ibid., p. 74.

p. 203 E. H. Gombrich, *Norm and Form* (Phaidon, London, 1966), p. 71.

p. 220 Vasari, *Lives of the Painters*, trans. Mrs. Foster (Henry G. Bohn, London, 1851), vol. 4, pp. 42, 45.

p. 224 Vasari, *Lives of the Artists* (Penguin Books), p. 366.

p. 232 Benvenuto Cellini, *Autobiography*, trans. George Bull (Penguin Books, Harmondsworth and Baltimore, 1956), p. 290.

p. 289 Edmund Burke, *A Philosophical Enquiry into the Origin of our Ideas of the Sublime and the Beautiful*, ed. James T. Boulton (University of Notre Dame Press, Notre Dame, 1968), pp. 58–9. 62.

p. 303 Thomas Carlyle, *Past and Present* (Dent, London, 1960; Everyman's Library), p. 7.

p. 304 Henry Fuseli, Aphorism 51, *Life and Writings*, 3 vols., ed. Knowles (Colburn and Bentley, 1831).

p. 311 Sir Joshua Reynolds, *Discourses*, ed. Stephen O. Mitchell (Bobbs-Merril, Indianapolis, 1965), p. 59.

p. 311 Eugène Delacroix, *Journal*, Sel. and transl. Walter Pach (Viking Press, New York, 1972), p. 199.

p. 318 John Constable, Letter to John Fisher, 23 October 1821, *John Constable's Correspondence*, ed. R. B. Beckett (Suffolk Records Society, Ipswich, 1966); see also C. R. Leslie, *Memoirs of the Life of John Constable*, ed. J. Mayne (Phaidon, Oxford; Cornell University Press, Ithaca, 1980), pp. 85–6.

p. 318 John Constable, Letter to John Fisher, 9 May 1823, *John Constable's Correspondence*.

p. 321 Review of Turner's *Snowstorm*, *Athenaeum* (London, 14 May 1842).

p. 323 W. M. Thackeray, review of Turner's *Rain, Steam and Speed*, *Fraser's Magazine* (London, June 1844).

p. 325 Ralph Waldo Emerson, 'On Nature', *Works* (Riverside Press, Cambridge, Mass., 1883), vol. I, p. 14.

p. 328 Thomas Cole, letter to Asher B. Durand, 11 January 1838, quoted in L. L. Noble, *The Life and Works of Thomas Cole*, ed. Elliot S. Vessel (Belknap Press, Cambridge Mass., 1964), p. 185.

p. 345 Gustave Courbet, 'Realist Manifesto', quoted in Linda Nochlin, *Realism and Tradition in Art 1848–1900*, Sources and Documents Series (Prentice-Hall, Eaglewood Cliffs, 1966), pp. 33–4.

p. 348 Paul de Saint-Victor, review of Manet's show, *Presse*, 27 April 1863, quoted in George Hamilton, *Manet and his Critics* (Yale University Press, New Haven, 1954), p. 39.

p. 350 Philip Gilbert Hamerton, 'The Salon of 1863', *Fine Arts Quarterly Review* (London), October 1863.

p. 356 Louis Leroy, review of first Impressionist Exhibition, quoted in J. Rewald, *History of Impressionism* (Museum of Modern Art, New York, 1973), pp. 318–24.

p. 368 Gustave Moreau, letter to Henri Rupp, quoted in Robert Delevoy, *Symbolists and Symbolism* (Skira, New York, 1978), p. 42.

p. 376 Edvard Munch, diary, 1889, quoted in J. P. Hodin, *Edvard Munch* (Praeger, New York, 1972), p. 48

p. 382 J. K. Huysmans, quoted in John Willet, *Expressionism* (McGraw Hill, New York, 1971), p. 45.

p. 385 Henri Matisse, *Notes of a Painter*, quoted in A. H. Barr, *Matisse and his Public* (Museum of Modern Art, New York, 1951), p. 119.

p. 397 Filippo Tommaso Marinetti, quoted in Richardson, Stangos, and others, *Concepts of Modern Art* (Harper and Row, New York, 1974), p. 97.

p. 397 Ezra Pound, *Selected Poems* (New Directions, New York, 1957).

p. 398 Ezra Pound, *Gaudier-Brzeska*, London, 1916, quoted in Donald Davie, *Ezra Pound: Poet as Sculptor* (Oxford University Press, Oxford and New York, 1964), pp. 56–7.

p. 398 Kasimir Malevich, *The Non-Objective World*, transl. Howard Dearstyne (Chicago, 1959), quoted in Hunter and Jacobus, *Modern Art from Post-Impressionism to the Present* (Abrams, New York, 1976), p. 145.

p. 420 Jackson Pollock, 'My Painting', *Possibilities*, vol. I, quoted in E. Lucie-Smith, *Late Modern* (Oxford University Press, Oxford and New York, 1969), p. 34.

p. 433 Pliny the Elder, *Natural History*, XXXIV. This work has been translated by H. Rackham (Loeb Classical Library, Cambridge, Mass. and London, 1968). See p. 129.

Index

Principal references are in bold type

A

Aachen, Germany, 74, 75, 77;
palace chapel, 75, *fig. 79*
Abbot Suger. *See* Suger
Abstract art: early twentieth century,
381, 388;
in Russia, 405, 413;
Neo-Plasticism, 412–13;
and the Bauhaus, 414–15, 417;
post-World War II, 418–33
Abstract Expressionism, **419–23**, 428
Acropolis, Athens, 22, 29, 30;
Erechtheum, 30, 32, *fig. 26*;
Parthenon, 29, 30, 31, *fig. 24*;
proportion and golden section, 30, 168;
sculpture, **29–32**, 40, *figs. 25, 27*;
gateway, 22, 29;
model for entrance of Euston Station,
London, 336
Actium, Battle of, 33, 34
Academies. *See* French Academy, Royal
Academy
Academy of St. Luke, Rome, 254, 256
'Action' painting, 419–20
Adam, Robert, 279, 284, **294–6**;
Kedleston Hall, 296, *figs. 372, 374, 375*;
Newby Hall, 291, *fig. 366*;
Osterley, 284
Addison, Joseph, 278, 283
Aegean islands, 21
Aeschylus, 28
African art: influence on Picasso, 389
Agamemnon, 21
Agincourt, Battle of, 137
Agilbert, Bishop, 67;
his sarcophagus, *fig. 71*

Agilulf's helmet, 63, *fig. 68*
Agostino di Duccio, 194
Akkadian art, 18
Albers, Joseph, 414, **428**;
Homage to the Square, fig. 548
Alberti, Leone Battista, **161–4**;
On Painting, 162;
influence on Urbino circle, 165, 168;
influence on Mantegna, 170;
in Mantua, 172;
on supremacy of history painting, 180;
influence of theory, 225, 415;
influence on della Porta, 229;
influence on Palladio, 231;
Palazzo Rucellai, 162, *fig. 195*;
Sant'Andrea, **172**, 189, 228, *fig. 210*;
Tempio Malatestiano, **164**, 231, *fig. 200*
Albrecht von Brandenburg, Archbishop
of Mainz, 216
Alcuin of York, 74, 75
Alexander VI, Pope, 193
Alexander the Great, 28, 32, 33
Alexandria, Egypt, 44
Allston, Washington, 325;
Moonlit Landscape, 325, *fig. 404*
Altdorfer, Albrecht, **236–37**, 244,
316;
Landscape with a Church, 237, 316, *fig. 289*
American Civil War, 363
American Revolution, 276, 302
Amiens cathedral: sculpture, 113, 114,
116, 119, 127;
Labours of the Months, 114, *fig. 135*;
'Vierge Dorée', 114, **116**, 127, *fig. 135*;
south transept rose window, 124, *fig. 151*;
.west façade, 112, *fig. 131*
Amphora, geometric, 22, *fig. 15*
Anet, Château of, 234, *fig. 284*

Anderson, Sherwood, 399
Anne, Queen of England, 271
Apocalypse Tapestry, 131, *fig. 173*
Apollo Belvedere, 193, 296, 297, *fig. 234*
Ara Pacis, **40**, 42, *fig. 34*
Archipenko, Alexander: *Walking Woman*,
393–6, *fig. 493*
Arezzo, frescoes in church of San
Francesco, 169, *fig. 208*
Aristotle, 28, 32;
influence on Scholastic philosophy, 113;
and eighteenth-century art theory, 279
Armada, 237
Armory Show, New York, 398–9
Arp, Jean, 405, 408; *Concrétion humaine*,
408, *fig. 513*;
*Squares Arranged According to the Laws of
Chance*, 405, *fig. 507*
Art Deco, 418
Art Journal: reviews the Great Exhibition
of 1851, 335, 339
Art Nouveau, 373, **374–9**;
and Modern art, 380;
compared to Art Deco, 418
Arthur, king of Britain, 61
Arts and Crafts Movement, **373**, 403
Ashcan School, 399
Assemblage, 429
Atheneum: reviews Turner, 321
Attila the Hun, 51
Augustan Age in England, 283
Augustine, Saint, 51
Autun cathedral, **97**, 98, 109, 128;
Angel Appearing to the Wise Men, 97,
fig. 113;
tympanum, 97, 98;
compared to Chartres cathedral, 109;
compared to Orvieto cathedral, 128
Avignon: palace of the popes, 123

B

'Babylonian Captivity', 123
Bach, Johann Sebastian, 254
Bacon, Francis, 421;
 Head Surrounded by Sides of Beef, 421, *fig. 530*
Barbarian art, 63–4
Barberini, Maffeo. *See* Urban VIII
Barbizon School 350–3, 355;
 influence on American landscape painting, 363;
 influence on Mondrian, 412
Bath: Royal Crescent, 296, *fig. 373*
Baudelaire, Charles: and Courbet, 346;
 and the Symbolists, 365
Bauhaus, the: formed in 1919, 403–5;
 and abstract art, 414–15, 417, 418;
 and mass production, 414;
 moves to Dessau, 414, *fig. 522*;
 and Early Renaissance philosophy, 415
Bayeux tapestry, 94, *fig. 111*
Beardsley, Aubrey, 377
Beaumont, Sir George, 320
Beckford, William, 290
Beckmann, Max, 402–3;
 The Night, 402–3, *fig. 505*
Bede, the Venerable, 72
Beethoven, Ludwig van: *Eroica Symphony*, 307;
 and the Romantic imagination, 312;
 Pastoral Symphony, 312–13
Bellini, Giovanni, 177–8, 205;
 Coronation of the Virgin, 177, *fig. 216*;
 Saint Francis in Ecstasy, 177–8, *fig. 215*;
 Young Woman with a Mirror, 205, *fig. 245*
Bellini, Jacopo, 177
Bellows, George Wesley, 399;
 Stag at Sharkeys, 399, *fig. 499*
Benedict, Saint, 69
Benedictine Order, 69–72
Berg, Alban, 388
Bernard of Clairvaux, Saint, 98, 104
 compared to Rubens, 252, 253;
 influence on Poussin, 261;
 influence on Wren, 269;
 Cornaro Chapel, 246–9, *figs. 309, 310*;
 David, 249, *fig. 312*;
 Rape of Proserpina, 249, *fig. 311*;
 St. Peter's Square, Rome, colonnade, 246, *fig. 306*
Bernward, bishop of Hildesheim, 82
Berzé-la-Ville: 93, *fig. 105*
Bingham, George Caleb; *Fur Traders Descending the Mississippi*, **328**, 364, *figs. 349, 406*

Black Death, 123
Black-figure style of Greek pottery, 24, *fig. 16*
Blake, William: and nature, 304, **314**;
 and the Romantic imagination, 313;
 influence on Symbolists, 365;
 influence on Art Nouveau, 373;
 Book of Job, 314, *fig. 392*
Blenheim Palace, Oxfordshire, 271–3, *figs. 345, 347*
Blue Rider Almanac, 388
Boccioni, Umberto: *Dynamism of a Soccer Player*, 396, *fig. 490*
Boffrand, Germain: Hôtel de Soubise, Paris, 279, *fig. 350*
Bologna, Italy, 103
Bologna, Giovanni: *Rape of a Sabine*, **225**, 249, *fig. 277*
Boniface VIII, Pope, 122–3
Bonnard, Pierre, 418;
 The Dining Room, 418, *fig. 529*
Book of Durrow, **69**, 72, *figs. 73, 74*
Borgo San Sepulcro: Sassetta's altarpiece, 158, *fig. 190*;
 birthplace of Piero della Francesca, 167
Borromeo, Charles, Saint, 242
Borromini, Francesco, **249**, 253, 269;
 San Carlo alle Quatro Fontane, 249, *figs. 314, 315*
Bosch, Hieronymus, **212**;
 influence on Bruegel, 237;
 compared to Dürer, 216;
 compared to Ensor, 376;
 compared to Max Beckmann, 403;
 Garden of Earthly Delights, 212, *fig. 255*
Botticelli, Sandro, 180, **181**, 193;
 compared to Jan Toorop, 376;
 Birth of Venus, 181, *fig. 219*;
 Primavera, 181, *fig. 218*
Boucher, François, **283**, 284, 293;
 Toilet of Venus, 283, *fig. 354*
Bourges: Hôtel Jacques Coeur, 136–7, *figs. 170, 172*
Boyle, Richard, Lord Burlington, 283–4, 285;
 Chiswick House, 283–4, *fig. 356*
Bramante, Donato: born in Urbino, 167;
 and Raphael, 187, 197;
 and Leonardo, 188, 189;
 and Michelangelo, 200;
 compared to Palladio, 231;
 and Baroque style, 241;
 Saint Peter's, Rome, 197;
 San Pietro in Montorio, 197, *fig. 237*;
 Santa Maria delle Grazie, 189, *fig. 230*;
 Santa Maria presso San Satiro, 189, *fig. 229*

Brancusi, Constantin: *Mlle Pogany*, 398–9, 413, *fig. 497*
Braque, Georges, 388, **389**, 393;
 Houses at L'Estaque, 389, *fig. 486*;
 Man with a Guitar, 393, *fig. 483*
Breton, André, 408
Brett, John: *The Stonebreaker*, 344, *fig. 418*
Breuer, Marcel, chair, 414, *fig. 523*
Bronzino, Agnolo, 219, 225;
 Lodovico Capponi, 219, 225, *fig. 265*
Brown, Ford Maddox: *See the Pretty Baa-Lambs*, 341–2, *fig. 417*
Brown, Launcelot ('Capability'), 271
Brücke, Die, 386, 388
Bruegel, Pieter, **237**, 259;
 the Harvest, 237, *fig. 298*;
 Hunters in the Snow, 237, *fig. 296*
Brunelleschi, Filippo, **151–4**, 157, 158;
 and Cosimo de'Medici, 159;
 and Fra Angelico, 161;
 and Alberti, 162, 172;
 ducal palace, Urbino, 165;
 influence on Piero della Francesca, 167;
 Florence Cathedral, dome, 151–2, *figs. 180, 181*;
 Orphanage, 152, *fig. 182*;
 Pazzi Chapel, 152–4, *figs. 183, 184*
Bryant, William Cullen, 325
Burgos cathedral, Spain: choir, 119–20, *fig. 142*
Burke, Edmund, *A Philosophical Enquiry*, 289;
 and George Stubbs, 300
Burlington, Lord. *See* Boyle, Richard
Burne-Jones, Edward, 373, 374
Byron, George Gordon, Lord, 308, 313;
 Manfred, 313;
 Sardanapalus, 314
Byzantine art, 53, 54;
 influence on barbarian art, 63;
 influence on Ottonian art, 82;
 and Romanesque painting, 93;
 and Cimabue, 129;
 influence on Modern art, 382;
 Madonna Enthroned, 129, *fig. 160*
Byzantine empire: under Justinian, 54–7;
 after Justinian's death, 60;
 links with Charlemagne's empire, 75;
 links with Ottonian empire, 80–2;
 last Western territory lost to Normans, 84;
 contacts with Venice, 89, 177;
 influence on medieval learning, 103
Byzantium. *See* Constantinople

C

Cabanel, Alexandre: *Birth of Venus*, 349

Caedmon, 72–3
Caen: abbey church of St. Etienne, 101, *fig. 119*
Caesar Augustus: battle of Actium, 33, 39;
 as emperor, 37, 39;
 patron of the arts, 40;
 wife Livia, 41
Calder, Alexander: *The Spiral*, 421, *fig. 531*
Calderón de la Barca, 254
Campin, Robert. *See* Master of Flémalle
Canaletto (Giovanni Antonio da Canale): *Bacino di San Marco*, 288, *fig. 358*
Canigou: abbey church of St. Martin, pp. 87–8, *fig. 91*
Canterbury: cathedral choir, 119, *fig. 141*
Canterbury Tales, 85
Capet, Hugh, king of France, 80
Capricci, pp. 288, 313
Caravaggio, **242–3**, 249, 252;
 influence on Rubens, 252;
 influence on Spanish art, 254, 256;
 Conversion of Saint Paul, 243, *fig. 302*;
 Death of the Virgin, 243, *fig. 303*
Carlyle, Thomas: *Past and Present*, 303;
 and the Romantic imagination, 312;
 and Constable, 320;
 on middle-class philistinism, 334
Carracci, Annibale, 242, **243–4**;
 influence on Rubens, 252;
 influence on Dutch landscape painting, 259;
 Coronation of the Virgin, 244, *fig. 304*;
 Landscape with the Flight into Egypt, 244, *fig. 307*
Carthage, 39
Cassatt, Mary, 356, 360;
 Five O'Clock Tea, 360, *fig. 443*
Castiglione, Baldassare: *The Courtier*, 208
Catacombs. *See* Rome
Cellini, Benvenuto, 232–4;
 Autobiography, 232;
 Diana, Château d'Anet, 234;
 Salt cellar of Francis I, 232–4, *fig. 292*
Century Guild, 374
Cervantes, *Don Quixote*, 254, 256
Cézanne, Paul: as an impressionist, 356;
 and Post-Impressionism, 360, 369;
 as a progenitor of Modern art, 381;
 and the Fauves, 382, 385;
 and Expressionists, 386, 388;
 and Cubists, 389;
 Basket of Apples, 389, *fig. 485*;
 House of the Hanged Man, 356, *fig. 438*;
 Mont Sainte-Victoire, 360, *fig. 444*
Chagall, Marc, **396**, 405;

I and the Village, 396, *fig. 489*
Chalgrin, François: Arc de Triomphe, Paris, 307, *fig. 387*
Chambord, Château, 209, *figs. 252, 254*
Chardin, Jean-Baptiste-Siméon, 280–3;
 Boy Blowing Bubbles, 280–3, *fig. 351*;
 Still-Life with a Bottle of Olives, 280, *fig. 353*
Charlemagne, **73–7**, 79, 84
Charles I, king of England, 253, 268
Charles IV, king of France, 133
Charles V, Holy Roman Emperor:
 Titian's last patron, p. 208;
 sack of Rome, 218, 228;
 mausoleum in the Escorial, 239
Charles VIII, king of France, 192
Charles the Bald, king of West Francia, 79, 80
Charles the Bold, Duke of Burgundy, 140, 175
Charles Martel, 73
Charles the Simple, king of France, 79
Chartres cathedral, 88, **108–12**, 114, 116;
 crypt, 88, *fig. 92*;
 flying buttresses, 110, *fig. 126*;
 nave, 110, *fig. 128*;
 rose windows, 112, *fig. 127*;
 Royal Portal, 108–9, *figs. 121, 123, 125*;
 Stonemason's Window, 116, *fig. 136*;
 transept porch sculpture, 112, *figs. 129, 130*
Chatsworth House, 273, *figs. 346, 348*
Chaucer, Geoffrey, 85, 134
Chevet, 88
Chippendale, Thomas, 284
Chirico, Giorgio de, **405**, 408;
 Mystery and Melancholy of a Street, 405, *fig. 509*
Chiswick House, **283–4**, 296, *fig. 356*
Church, Frederick Edwin, **328**, 363;
 The Heart of the Andes, 328, *fig. 408*
Churchill, John, Duke of Marlborough, 271
Cimabue, 129;
 Madonna Enthroned, 129, *fig. 159*
Cistercian Order, 104, 117
Claesz, Pieter, *Still-Life*, 259, *fig. 328*
Claude Lorrain, 260, **261–3**;
 and eighteenth-century view painting, 288;
 and the Picturesque, 289;
 influence on Constable, 317;
 influence on Turner, 320;
 Landscape with Hagar and the Angel, *fig. 3*;
 The Mill, 263, *fig. 335*
Clement VIII, Pope, 203
Cleopatra, Queen of Egypt, 33, 39

Cloisonne, **63**, 372
Clouet, François, **234**, 283;
 Lady in her Bath, 234, *fig. 293*
Clovis, king of the Franks, 64, 73
Cluny, order of, 91;
 third abbey church, 91–3, *figs. 99, 103, 104*;
 lectionary, 93, *fig. 106*
Coeur, Jacques, 136
Colbert, Jean-Baptiste, 264, 265
Cole, Thomas, 11–12, 325–8, 363;
 Expulsion from the Garden of Eden, 11–12, *fig. 4*;
 The Oxbow, 325–8, *fig. 405*
Coleridge, Samuel Taylor, 313, 320;
 poetry compared to Hudson River School, 328
Collage, 393
'Colour field' painting, 420–1
Conceptual art, 433
Constable, John, 304, 311, 312, **316–20**;
 and Wordsworth, 303, 316–17;
 influence on Delacroix, 320;
 compared to Turner, 320;
 influence on the Barbizon School, 328–9, 351, 353;
 influence on the Impressionists, 355, 356;
 compared to Inness, 363;
 compared to Abstract Expressionists, 420;
 The Haywain, 318–20, *fig. 398*;
 sketch for *The Haywain*, 318, *fig. 397*;
 The White Horse, 317–18, *fig. 396*
Constantina, daughter of Constantine, 48
Constantine the Great, 45, 47;
 Triumphal Arch, 47, *figs. 46, 48*
Constantinople (formerly Byzantium, now Istanbul): made capital of empire, 49;
 in reign of Justinian, 53, 54–6;
 capture by Turks, 60, 180;
 Santa Sophia, **56**, 89, 425, *fig. 60*;
 See also Byzantine empire
Constructivism, **413**, 423
Contrapposto, 11, 28
Cooper, James Fenimore, 324
Copernicus, 241, 249, 253
Copley, John Singleton, 324
Coptic art, 67, 69
Corbusier. *See* Le Corbusier
Corday, Charlotte, 305
Corinthian order 26, *fig. 32*
Corneille, Pierre, 264, 304
Coronation Gospels, 77, *fig. 82*
Corot, Camille, **351–3**, 363;
 The Lake, 351–3, *fig. 430*
Correggio, Antonio, 244;

Assumption of the Virgin, 244, *fig. 308*;
Coronation of the Virgin, 244
Cortona, Pietro da, **252**, 273, 288;
Glorification of the Barberini, 252, *fig. 313*
Corvey, abbey church, 75, *fig. 78*
Council of Ephesus, 51
Council of Trent, 242
Counter-Reformation, 212, 218;
and Mannerism, **228**, 237;
and the Baroque, 242
Courbet, Gustave: and Realism, 344–6;
influence on Manet, 350;
compared to the Barbizons, 351;
and Whistler, 353;
influence on Eakins, 364;
Low Tide at Trouville, 353, *fig. 429*;
Painter's Studio (L'Atelier), 345–6, *fig. 425*;
Stonebreakers, 344–5, *fig. 421*
Cousin, Jean: *Eva Prima Pandora*, 234, *fig. 288*
Craft guilds, 103;
and the Arts and Crafts movement, 340, 373
Cranach, Lucas, 209–12, 217, 236;
Judgement of Paris, 236, *fig. 290*;
Portrait of Johannes Cuspinian, 209–12, *fig. 251*;
Portrait of Martin Luther, 217, *fig. 262*
Crusade, First, 84, 92
Crucifix of Abbess Matilda of Essen, 82, *fig. 90*
Crucifix of Bishop Gero, 82, *fig. 89*
Cubism, **388–93**;
synthetic and analytic, 393;
influence on abstract art, 412, 419, 425
Curzon, Sir Nathaniel, 296
Cuspinian, Johannes, 212, *fig. 251*

D

Dada, **405–8**, 433
Dali, Salvador, 408–9;
Persistence of Memory, 408, *fig. 512*;
Soft Construction with Boiled Beans, 409, *fig. 516*
Dante 131, 293
Daubigny, Charles-François, 351, 353, 356;
Gobelle's Mill at Optevoz, Evening, 353, *fig. 431*
Daumier, Honoré, **344**, 382;
Third Class Carriage, 344, *fig. 422*
David, Jacques Louis, **304–5**, 307;
and Goya, 308;
and Neoclassicism, 332;
Death of Marat, 305, *fig. 382*;
Napoleon Crossing the Alps, 307, *fig. 386*;

Cath of the Horatii, 304–5, *fig. 385*
Davies, Arthur B., 398
Debussy, Claude: *Afternoon of a Faun*, 368;
and Art Nouveau, 376, 377
Decadents, 366–9
de Chirico, Giorgio. *See* Chirico
Decorated style, 124, *fig. 150*
Degas, Edgar, 356, **360**;
sculpture, 361, 385;
Absinthe, 360, *fig. 442*;
Carriage at the Races, 360, *fig. 439*;
Seated Woman Wiping her Left Hip, 361, *fig. 447*
Delacroix, Eugène, 304;
and Romantic history painting, 308–9;
and Ingres, 311–12;
hostility of French academy, 311, 332;
and Romantic imagination, 313, 314;
and Constable, 320;
influence on Barbizons, 351;
influence on Impressionists, 355;
Death of Sardanapalus, **314**, 368, *fig. 393*;
Massacre at Chios, **308–9**, *fig. 389*;
Women of Algiers, 312, 313, 320, *fig. 388*
della Porta, Giacomo. *See* Porta
de l'Orme, Philibert: gateway of Château d'Anet, 234, *fig. 284*
Delphi, Greece: Archaic moulding patterns, 26, *fig. 18*;
Battle of the Gods and Giants, from the Syphnian Treasury, 26, *fig. 20*
Denis, Saint, 79
Der Sturm, 388
Descartes, René, 253, 278
De Stijl (*see also* Neo-Plasticism), **412–13**, 425
Deutscher Werkbund, 403
Diane de Poitiers, 234
Dio Cassius, 43
'Dionysius the Areopagite'. *See* Pseudo-Dionysius
Divisionism. *See* pointillism
Doesburg, Theo van, 412, 413, 417
Donatello, 151, 154–6;
influence on Early Renaissance, 157, 158;
influence on Alberti, 162;
influence on Piero della Francesca, 167;
influence on Mantegna, 170;
in Padua, 170;
compared to Verrocchio, 183;
David, **154**, 159, *fig. 185*;
Feast of Herod, 156, *fig. 188*;
Gattamelata, 170, *fig. 204*
Doric order, 26, *fig. 17*
Dostoevsky, Fyodor, 386
Dreiser, Theodore, 399
Duccio, **129–31**, 133;

Madonna Enthroned, 129–31, *fig. 161*;
Temptation of Christ, 131, *fig. 162*
Duchamp, Marcel, **397**, 399;
ready-mades, 405–8;
Nude Descending a Staircase, 397, *fig. 491*
Duchamp-Villon, Raymond: *Horse*, 397, *fig. 494*
Duquesney, F.-A: *Gare de l'Est, Paris*, 339, *fig. 413*
Durand, Asher B., **328**, 363;
Forest Scene in the Catskills, 328, *fig. 407*
Durand-Ruel, Paul, 356
Dürer, Albrecht, **213–16**;
and the Reformation, 216, 217;
compared to Hogarth, 284;
compared to Friedrich, 316;
influence on Expressionists, 386;
House by a Pond, 216, *fig. 260*;
Knight, Death and the Devil, 216, *fig. 256*;
Self-Portrait, 216, *fig. 257*
Durham cathedral, 100, *fig. 118*
Dyck, Anthony van, 257;
Portrait of Charles I Hunting, 257, *fig. 324*
Dying Gaul and his Wife, 33–4, *fig. 31*

E

Eakins, Thomas, **364**, 399;
Max Schmitt in a Single Scull, 364, *fig. 450*
Edmund, Saint, 134
Ebbo, Bishop, 77
Edward the Confessor, Saint, 134
Egyptian art, 17–21;
influence on Greek art, 23;
and Picasso, 389
Einstein, Albert: influence of relativity on Modern art, 381, 397, 403
Eliot, T.S.: *The WasteLand*, 408–9
Elizabeth I, Queen of England, 234, 236
Emerson, Ralph Waldo, 324, 325
Engraving. *See* Graphic Arts
Ensor, James, **376**, 386; *Christ's Entry into Brussels*, 376, *figs. 409, 471*
Ephesus, Council of, 51
Equestrian statue: of Marcus Aurelius; 43, *fig. 42*;
of a Carolingian king, 73, *fig. 76*;
see also Donatello, Verrocchio
Erasmus of Rotterdam, 212, 216, 217, *fig. 264*
Erechtheum. *See* Acropolis
Ergotimos, 24, *fig. 16*
Erigena, John Scotus, 79
Ernst, Max: *The Horde*, 408, *fig. 510*
Este, Beatrice d', 188
Exhibitions: growth and importance, 277, 309;
Salon des Refusés, 348–50

first Impressionist, 356;
last Impressionist, 360;
Libre Esthétique and Art Nouveau,
377;
Salon des Indépendants, 381;
Salon d'Automne, 382;
New York Armory Show of Modern
art, 398–9
Existential philosophy, 419
Expressionism, 386–8, 402–5
Eyck, Hubert van, 144
Eyck, Jan van, 144–5;
and Italian Renaissance, 151, 158;
influence on van der Weyden, 169;
influence on Velázquez, 256;
influence on Dutch Baroque landscape
painting, 259;
Betrothal of the Arnolfini, 144, *fig. 177*;
Ghent Altarpiece, 144, *fig. 176*;
Madonna of the Chancellor Rolin, **144**, 209,
fig. 209

F

Fauves, 382–6
'Fête galante', 280
Ficino, Marsilio, 180
Fielding, Henry, 284;
Tom Jones, 294
Flamboyant style, 124, 127, *figs. 151, 154*
Flanders, 102, 256
Florence, Italy, 151, 180, 193;
cathedral dome, 151–2, *figs. 180, 181*;
orphanage, 152, *fig. 182*;
Palazzo Medici-Riccardi, 159, *fig. 191*;
Palazzo Rucellai, 162, *fig. 195*;
Palazzo Vecchio, 196;
Pazzi Chapel, 152–4, *figs. 183, 184*;
San Lorenzo: new sacristy, 9, 11,
222–3, *figs. 7, 269, 273*;
Santa Croce, **120**, 154, *fig. 144*;
Santa Maria Novella, frescoes, *see*
Masaccio
Flying buttress, 91, 110, *fig. 126*
Fontainebleau, Château, 232–4, *figs. 285, 287*
Fontainebleau forest, 351
Fonthill Abbey, 290, *fig. 365*
Fra Angelico, 161;
The Annunciation, 161, *fig. 193*
Fra Filippo Lippi, 161;
*Madonna and Child with Scenes from the
Life of the Virgin*, 161, *fig. 199*
Fragonard, Jean-Honoré, **283**, 284, 360;
The Lovers' Meeting, 283, *fig. 335*
Francesco di Giorgio, 165
Francis I, king of France, 208, 209, 232
Franco-Prussian war, 356

François Vase, 24, *fig. 16*
Frankenthaler, Helen: *Mountains and Sea*,
428, *fig. 544*
Frazer, Sir James: *The Golden Bough*, 365
Frederick Barbarossa, Holy Roman
Emperor, 128
French Academy of Art: under Louis
XIV, 264, 265;
salons, 277;
influence on European academies, 279;
and Neoclassicism, 293;
under Napoleon III, 333, 351
French Revolution, 276, 302, 303;
Reign of Terror, 302, 305
Freud, Sigmund, 381
Friedrich, Caspar David, 304, **316**;
compared to Washington Allston, 325;
compared to William Holman Hunt,
341;
Cross on a Mountain, 316, *fig. 394*;
Large Enclosure, 316, *fig. 395*
Frottage, 408
Fuseli, Henry: *Aphorisms*, 304;
on Constable, 318
Futurism, 396–7

G

Gabo, Naum, 413;
Construction in Space, 413, *fig. 521*
Gainsborough, Thomas, 278, 294, **297**,
312;
'Perdita' Robinson, 297, *fig. 377*;
River Landscape with Figures in a Boat,
300, *fig. 380*
Galileo, 241
Galla Placidia, 53
Gallé, Émile: glassware, 376, *fig. 467*
Garnier, Charles: Paris Opera, 339,
fig. 414
Gaudí, Antonio: *Casa Batlló*, 377, *fig. 472*
Gauguin, Paul, 372–3;
and Post-Impressionism, 369;
compared to Henri Rousseau, 373;
and the Fauves, 382, 385;
Ia Orana Maria, 372–3, *fig. 462*;
Vision after the Sermon, 372, *fig. 459*
Gaulli, Giovanni, 252, 273, 288;
Triumph of the Name of Jesus, 252,
fig. 316
Gawaine and the Green Knight, 134–5, 137
Genre painting: and Bruegel, 237;
in Spanish Baroque painting, 256;
in Neoclassical painting, 293–4;
popularity in the nineteenth century,
334
Geometric style, 22, *fig. 15*
George III, king of England, 324

Géricault, Théodore: *Raft of the Medusa*,
308, *fig. 384*
Gero, Bishop, 82
Gérôme, Jean-Léon: *The Slave Market*,
366, *fig. 453*
Ghibellines and Guelphs, 128
Ghiberti, Lorenzo, 151, 154;
Doors of Paradise, 154, *fig. 187*
Ghirlandaio, Domenico, 193, **203**;
Old Man and his Grandson, 203, *fig. 241*
Gibbons, Grinling, 271, 273;
decoration at Blenheim, 271, 273,
fig. 347;
decoration at St. Paul's cathedral, 271,
fig. 343
Giorgione, 178, **205**;
influence on Annibale Carracci, 244;
influence on Watteau, 280;
influence on Tiepolo, 288;
compared to Manet, 349, 350;
Sleeping Venus, 205, *fig. 246*;
Tempest, 205, *fig. 247*
Giotto, 131–2, 133;
*Annunciation of the Virgin's Birth to Saint
Anne*, 131, *fig. 164*;
Lamentation, 131–2, *fig. 163*
Giovanni Bologna. *See* Bologna
Giselbertus: tympanum at Autun
cathedral, 97, *fig. 115*
Giulio Romano, 220–2;
influence on School of Fontainebleau,
232;
influence on Baroque art, 252;
Palazzo del Té, 220–2, *fig. 268*;
Palazzo Ducale, 220, *fig. 270*
Glaber, Raoul, 86, 92
Glasgow: School of Art, library, 379,
fig. 468
Glorious Revolution, 268
Gloucester Candlestick, 96, *fig. 112*
Gloucester cathedral: choir, 127, *fig. 153*
Gobelins factory, 284
Godescalc Gospels, 77, *fig. 81*
Goes, Hugo van der: Portinari Altarpiece
173–5, *fig. 213*
Goethe, Johann Wolfgang von, 307, 313
Gogh, Vincent van, **369–72**;
compared to Albert Pinkham Ryder,
364;
influenced by Impressionism, 369;
influence on Fauves, 382, 385;
influence on Expressionists, 386;
L'Arlésienne, 382, *fig. 477*;
Starry Night, 372, *fig. 458*;
Wheatfield with a Lark, 369, *fig. 457*
Goings, Ralph: *Hot Fudge Sundae*, 432,
fig. 554
Golden section: in the Parthenon, 30;

used by Piero della Francesca, 168;
used by Le Corbusier, 415
Gonzaga, Lodovico, 172
Gospel Book of Bishop Ebbo, 77, *fig. 83*
Gospel Book of Otto III, 83, *fig. 88*
Gospels. *See* Coronation, Godescalc, Lindisfarne
Gothic Revival, **339–40**, 374
Goya, Francisco de, 307–8, 313, 342;
 compared to Delacroix, 309;
 influence on Manet, 348;
 influence on the Symbolists, 365;
 Forge, 342, *fig. 419*;
 Los Caprichos, 313, *fig. 391*;
 Third of May, 307–8, *fig. 383*
Gozzoli, Benozzo: *Procession of the Magi*, 159, *fig. 194*
Graphic Arts: development in Early Renaissance, 182;
 bookprinting and illustration, 212;
 independent market, 213, 284;
 and the Picturesque, 289, 300;
 influence of Japanese prints, 348;
 and Expressionist art, 386;
 Daumier, 344;
 Dürer, 213;
 Goya, 313;
 Hogarth, 284;
 Pollaiuolo, 182
Gray, Thomas, 300
Great Exhibition, London, 1851, 334–5, 340
Great Schism, 123
Greco, El, 237, **239–40**;
 influence on Modern art, 382, 388;
 Assumption of the Virgin, 239, *fig. 299*;
 Grand Inquisitor, 239, *fig. 300*;
 View of Toledo, 239, *fig. 297*
Greek Revival, 336, 339
Greenwich: Queen's House, 268, *fig. 340*
Gregory VII, Pope, 85, 122
Greuze, Jean-Baptiste: *The Village Bride*, 293, *fig. 368*
Grimm's *Fairy Tales*, 365
Gropius, Walter, 403–5, 414–15;
 Bauhaus school complex, 414–15, *fig. 522*;
 model factory, Cologne, 403, *fig. 503*
Grünewald, Matthias, 213;
 influence on Modern art, 382, 386;
 Isenheim Altarpiece, 213, *figs. 258, 259*
Guardi, Francesco, **288**, 313;
 Caprice with Ruins at the Seashore, 288, *fig. 363*
Guelphs and Ghibellines, 128
Guercino: *Aurora*, 252, *fig. 317*
Guevara, Cardinal, 239, *fig. 300*
Guicciardini, Francesco, 180

H

Hals, Franz, **257**, 260;
 Yonker Ramp and his Sweetheart, 257, *fig. 325*
Hamilton, Gavin, 291, 293;
 compared to David, 304, 305;
 Hector's Farewell to Andromache, 293, *fig. 369*
Hanson, Duane: *Couple with Shopping Bags*, 432–3, *fig. 555*
Happenings, 433
Hardwick, Philip: Euston Station, London, 336, 339
Hawksmoor, Nicholas, 271;
 Blenheim Palace, with Sir John Vanburgh, 271, *fig. 345*
Hawthorne, Nathaniel, 324
Haydocke, Richard, 236
Haydn, Joseph, 278, 283;
 Nelson Mass, 307;
 Mass in Time of War, 307
Heckel, Erich: *Two Men at a Table*, 386, *fig. 481*
Hellas, 22
Henri, Robert, 399;
 Snow in New York, 399, *fig. 498*
Henry IV, German emperor, 85
Henry V, king of England, 137
Henry VIII, king of England, 208, 217
Henry II's Book of Pericopes, 80, *fig. 84*
Hepworth, Barbara: *Two Figures*, 423, *fig. 540*
Herculaneum, 291
Herrera, Juan de, Church of the Escorial, 239, *fig. 295*
Hildesheim: St. Michael's Church, **82–3**, 120, *figs. 85, 86*
Hilliard, Nicholas, 236;
 Young Man with Roses, 236, *fig. 294*
History painting, 180;
 and Reynolds, 297;
 and historical events, 300, 308
Hitler, Adolf, 388
Hobby Horse, 374
Hogarth, William, 284–5, 297;
 The Analysis of Beauty, 285;
 Captain Thomas Coram, 285, *fig. 357*;
 Marriage à la Mode, 285, *fig. 359*
Holbein, Hans, the Younger, 217–18, 219;
 The Ambassadors, 217–18, 219, *fig. 263*;
 Circle of Sir Thomas More, 217, 219, *fig. 261*;
 Portrait of Erasmus, 217, *fig. 264*
Holland: war with Spain, 237, 242, 254;
 after Peace of Westphalia, 256–9, 260
Homer, 25, 293

Homer, Winslow, **363–4**, 399;
 The Bridle Path, 363–4, *fig. 451*
Honorius, Roman emperor, 53
Horta, Victor, 377:
 Tassel House, Brussels, 377, *fig. 466*
Houdon, Jean-Antoine: *Diana*, 293, *fig. 370*
Hudson River School, 328, 363
Huguenots, 242
Hundred Years War, 123, 137, 150
Hunt, William Holman, 341;
 The Scapegoat, 341, *fig. 420*
Hunting in a Papyrus Thicket, 18, *fig. 14*
Huysmans, J.K., 366–8, 382

I

Iconography, 8;
 early Christian, 44, 49, 67;
 Roman imperial, 47, 64;
 Romanesque, 97
Icons, 129
Ignatius Loyola, Saint, 242
Imagists, 381, 397
Impressionists, 334, 353, **355–61**;
 and American painting, 361–3
Industrial Revolution, 276, 340
Ingres, Jean-Auguste-Dominique, 311–12, 313;
 works exhibited with Modern art, 382, 399;
 Odalisque, 311, 312, 313, *fig. 390*
Inness, George, 363;
 The Coming Storm, 363, *fig. 449*
International Gothic, 132–45;
 and Early Renaissance style, 157, 158–61
International style of architecture, 415–17, 418, 419
Ionic order, 26, *fig. 17*
Itten, Johannes, 403, 415

J

James, Saint, 86
James I, king of England, 253, 268
James II, king of England, 268
Japanese art: exhibited in Paris, 348;
 influence on Manet, 348;
 influence on Whistler, 353–5, 374;
 influence on Cassatt, 360;
 influence on Degas, 360;
 influence on Gauguin, 372
Jefferson, Thomas, 296;
 Monticello, 296, *fig. 371*
Jerome, Saint, 49
Jerusalem: Church of the Holy Sepulcre, 92

Jesuit order, 288
Joan of Arc, 123
John II, king of France, 137
John, Duke of Berry, 137
John the Fearless, Duke of Burgundy, 140
Johns, Jasper, 432;
 The Flag, 432, *fig. 553*
Jones, Inigo, 268–9;
 Queen's House, 268, *fig. 340*;
 Whitehall Banqueting House, 268, 269, *fig. 339*
Jonson, Ben, 268, 269
Josephus the Jew: *De Bello Judaico*, 89, *fig. 97*
Jouarre Abbey, France, crypt, 67, *figs. 70, 72*;
 sarcophagus of Bishop Agilbert, 67, *fig. 71*
Joyce, James, 397
Julius II, Pope, 196, 200
July Revolution, 1830, 337
Jung, Carl Gustav, 381
Junius Bassus, prefect of Rome, 49;
 sarcophagus, 49, *fig. 55*
Justinian, Roman emperor, 53, 54, 60

K

Kandinsky, Wassily, **388**;
 influenced by Henri Rousseau, 369;
 admires Byzantine art, 382;
 Concerning the Spiritual in Art, 388;
 and Vorticism, 398;
 joins Bauhaus staff, 405;
 and Russian abstract art, 413;
 influence on Abstract Expressionism, 419;
 Black Arc, 388, *fig. 480*;
 Little Dream in Red, 405, *fig. 508*
Kauffman, Angelica, 293;
 Virgil Reading to Augustus and Octavia, 293, *fig. 367*
Keats, John, 313, 397
Kedleston Hall, 296, *figs 372, 374, 375*
Kelmscott Press, 374, 377
Kempe, Margery, 123
Kent, William, 284
Kinetic art, 414, 428
Klee, Paul, 405;
 Dance you Monster, 405, *fig. 506*
Kleitias, 24, *fig. 16*
Knight, Richard Payne, 293
Kollewitz, Kathe, 402;
 Mother and Child, 402, *fig. 502*
Kore, 23–4
Kouros, 9, 23–4, *fig. 1*

Kritios Boy, 28, *fig. 21*

L

Labours of the Months. 114, 137, 237, *fig. 135*
Laguerre, Louis, 273;
 Blenheim, Saloon, *fig. 347*
Landscape painting: Classical, 35–6;
 Annibale Carracci, 244;
 Dutch Baroque, 259, 261;
 Roman Baroque, 260–4;
 and topographical view painting, 288;
 and the Picturesque, 300;
 Romantic, 316–24;
 Hudson River School, 328;
 Barbizon School, 350–3
Languedoc, France, 94
Laocoön, 11, 34, *fig. 6*;
 discovered during Renaissance, 196;
 compared to Baroque style, 241
Lascaux, France: Palaeolithic cave painting, 16, *fig. 9*
Laurana, Luciano, 165;
 Ducal Palace, Urbino, courtyard, 165, *fig. 203*
Lebrun, Charles, 264, **265**, 280;
 Alexander the Great Entering Babylon, 265, *fig. 338*
Le Corbusier (Charles Edouard Jeanneret), **415**, 423, 425;
 and the Golden Section, 168, 415;
 Les Terrasses, 415, *fig. 524*;
 L'Unité d'Habitation 425, *fig. 541*;
 Villa Savoie, 415, *fig. 525*
Le Notre, André: landscape gardens at Versailles, 265
 at Vaux le Vicomte, 296
Leo I, Pope, 51
Leo III, Pope, 73
Leo X, Pope, 201, *fig. 243*
Leonardo da Vinci, 149, **187–92**;
 illustrates Pacioli's *On Divine Proportion*, 167, 168, *fig. 196*;
 and Bramante, 188, **189–92**, 197;
 duel of the Council Chamber, 197;
 portrait in *School of Athens*, 200;
 and High Renaissance portrait painting, **203–4**;
 in France, 209;
 art theory, 225, 279, 346;
 Adoration of the Magi, 187–8, *fig. 233*;
 Battle of the Anghiari, 196;
 Last Supper, 189–92, 231, *fig. 232*;
 compared to Emil Nolde, 386;
 Mona Lisa, 149, 203–4, *fig. 240*;
 Sketchbooks, 187, 189, *fig. 228*;
 Virgin of the Rocks, 188–9, *fig. 231*

Lepcis Magna, North Africa: arch of Septimius Severus, 43, *fig. 41*
Leroy, Louis, 356
Le Vau, Louis, 265, 296
Lewis, Wyndham, 398;
 Composition, 398, *fig. 495*
Liberal Arts, 102, 109, 164, *fig. 121*
Libre Esthétique, 377
Lichtenstein, Roy, 432;
 M-Maybe, 432, *fig. 552*
Limbourg Brothers: *Les Tres Riches Heures*, 137–40, *figs. 161, 171*;
 influence on Bruegel, 237;
 influence on Dutch Baroque landscape painting, 259
Lincoln Cathedral: Angel Choir, east façade, *fig. 150*;
 choir vaults, 124
Lindisfarne Abbey, 72
Lindisfarne Gospels, **72**, 96, *fig. 75*
Lissitzky, El, 413, 417;
 Proun 99, 417, *fig. 527*
Livia, wife of Augustus, 41
Livia's Garden 40–1, *fig. 37*
Livy, 304
Locke, John, 278
Lomazzo, Giovanni, 236
London: Crystal Palace, 335, *fig. 410*;
 Euston Station, 336, 339;
 Foundling Hospital, 285;
 Houses of Parliament, 339;
 St. Paul's Cathedral, 269–71, *figs. 342, 343, 344*;
 St. Pancras Hotel and Station, 339, *fig. 415*;
 St. Stephen Walbrook, 269, *fig. 341*;
 Westminster Abbey, Henry VIII Chapel, 127;
 Whitehall Banqueting House, 268, 269, *figs. 319, 339*
Longleat House, 236, *fig. 291*
Lope de Vega, 254
Lorenzetti, Ambrogio, 132;
 Allegory of Good Government, 132, *fig. 65*
Lorrain, Claude. *See* Claude
Lorsch Abbey, Germany: gateway, 74, *fig. 77*
Lost wax process, 28
Louis VII, king of France, 104
Louis IX, king of France, 116;
 his Psalter, 117, *fig. 139*
Louis XII, king of France, 192
Louis XIV, king of France, 149, 264–5, 279
Louis XV Style, 284
Louis, Duke of Anjou, 137
Louis the Pious, son of Charlemagne, 77
Louis, Morris, 428;

Vav, 428, *fig. 545*
Loyola, Ignatius, 228
Lully, Jean Baptiste, 264
Luther, Martin, 217, *fig. 262*

M

Mackintosh, Charles Rennie: Glasgow
 School of art, library, 379, *fig. 468*
Macpherson, James (Ossian), 290, 293
Madame de Pompadour, 283
Maderna, Carlo, 246;
 St. Peter's, façade, 246, *fig. 306;*
 Santa Susanna, façade, 246, *fig. 305*
Madonna Enthroned, Byzantine, 129,
 fig. 160
Madrid: Escorial, 239, *fig. 295*
Magni, Pietro: Monument to the Suez
 Canal, 336, *fig. 412*
Maison de l'Art Nouveau, 373
Maitani, Lorenzo, 128;
 Orvieto cathedral, façade, 128, *figs. 155,
 158*
Malatesta, Sigismondo, 164, 165, 167
Malevich, Kasimir, 398, 405, 413;
 Eight Red Rectangles, 398, *fig. 496*
Mallarmé, Stéphane, 366;
 Afternoon of a Faun, 368
Malmesbury Abbey, 94, 96, *fig. 109*
Manet, Edouard, 9, 332, **346–9;**
 and the Barbizon School, 351;
 and Impressionism, 356;
 influence on Eakins, 364;
 and van Gogh, 372;
 and the Fauves, 382;
 Déjeuner sur l'Herbe, 332, **349**, *fig. 423;*
 Fifer, 9, 346, **348**, *fig. 5;*
 Olympia, **350**, 366, *fig. 424;*
 Spanish Singer, 348, *fig. 426*
Mansart, J.-H., 265;
 Versailles Palace, 265, *figs. 336, 337*
Mantegna, Andrea, 170–3, 177, 178;
 Camera degli Sposi, 172–3, *fig. 212;*
 Martyrdom of St. Sebastian, 170–2,
 fig. 211;
 Saint James on the Way to his Execution,
 170, *fig. 206*
Mantua: Palazzo Ducale, 172-3, 220,
 figs. 212, 270;
 Palazzo del Tè 220–2, *fig. 268;*
 Sant' Andrea, 172, *fig. 210*
Manuscript Illumination: Celtic, 69, 72;
 Carolingian, 77–8;
 Ottonian, 83;
 Romanesque, 89, 93;
 Gothic, 117, 133, 137–40
Marat, Jean-Paul, 305
Marc, Franz, 388, 396;

Blue Horses, 388, 396, *fig. 79*
Tower of Blue Horses, 396, *fig. 492*
Marcus Aurelius, 42, 43;
 Column, 43, *fig. 43;*
 Equestrian statue, 42, *fig. 42*
 compared to Carolingian statue, 74;
 compared to Donatello, 170;
Marinetti, Filippo, 396–7
Martini, Simone, 133,
 Guidoriccio da Fogliano, 133, *fig. 166*
Masaccio, 151, **156–8;**
 influence on Early Renaissance,
 159–61;
 influence on Alberti, 162;
 influence on Piero della Francesca, 167;
 Expulsion from the Garden of Eden, 157,
 fig. 189;
 Holy Trinity, 157, *fig. 186*
Master of Flémalle (Robert Campin),
 141–4, 169, 177;
 Mérode Altarpiece, 141–4, *fig. 174*
Master of the Garden of Paradise: *Garden
 of Paradise*, 123, 133, *fig. 149*
Masters, Edgar Lee, 399
Mathieu, George: *Painting*, 421, *fig. 534*
Matilda of Essen, 82
Matisse, Henri, 382, 385, 418;
 and Cubist sculpture, 393;
 La Serpentine, 393, *fig. 474;*
 Magnolia Branch, 418, *fig. 528;*
 Woman with a Hat, 382, *fig. 476*
Maxentius, Roman emperor, 45
Maximilian, Holy Roman Emperor, 237
Maximilian, Duke of Bavaria, 253
McLuhan, Marshall, 429
Medallion, Swedish, 63, 64, *fig. 66*
Medici, Cosimo de', 152, 159, 161
Medici, Duke Cosimo de', 219
Medici, Giovanni de', 152
Medici, Giovanni de' (Pope Leo X), 201
Medici, Giuliano de', Duke of Nemours,
 222
Medici, Giulio de' (Pope Clement VII),
 203
Medici, Lorenzo de' (The Magnificent),
 178–80, 193
Medici, Lorenzo de', Duke of Urbino,
 222
Medici, Piero de' (father or Lorenzo the
 Magnificent), 159
Medici, Piero de' (son of Lorenzo the
 Magnificent), 193
Medici Academy: founded, 180;
 influence on Michelangelo, 193, 194;
 Pope Leo X and Michelangelo, 201
Melk Abbey, Austria, 285–8, *fig. 360*
Memling, Hans, 175;
 Adoration of the Magi, 175, *fig. 217*

Mendelsohn, Erich: Einstein observatory,
 Potsdam, 403, *fig. 504*
Merovingian art, 64–7
Mesopotamia, 18, 22
Mesopotamian art, 18
Messina, Antonello da, 177
Meyer, Adolf, 403
Michelangelo, 9, 11, 149, **193–6, 200–1;**
 nicknames Ghiberti's baptistry doors, 154;
 portrait in *School of Athens*, 200;
 rivalry with Bramante, 200;
 influence on Rosso and Pontormo, 222;
 and Mannerism, 222–4;
 compared to Bernini, 249;
 influence on Reynolds, 297;
 influence on Blake, 314;
 architecture
 Capitoline Square, Rome, 233,
 fig. 267,
 St Peter's 223, *fig. 266;*
 San Lorenzo, New Sacristy, 222,
 fig. 269;
 painting
 Battle of Cascina, 196, 224;
 Last Judgement, 223–4, *fig. 275;*
 Sistine Chapel ceiling, 200–1, 224, *figs.
 179, 238;*
 sculpture
 Bruges Madonna, 209;
 David, 149, 194, *fig. 235;*
 Madonna and Child, 223, *fig. 273;*
 Pietà, 9, 193–4, 223, *fig. 236;*
 tombs of the Duke of Urbino and the
 Duke of Nemours, 9, 11, 222–3, *figs.
 7, 269*
Michelozzo di Bartolommeo, 159, 161;
 Convent of San Marco, 161;
 Palazzo Medici–Riccardi, 159,
 figs. 191, 192
Mies van der Rohe, Ludwig, 417;
 German Pavillion, Barcelona, 417, *fig.
 526*
Milan: Sant' Ambrogio, 89, 91, 100,
 fig. 100;
 Santa Maria delle Grazie, 189, *fig. 230;*
 Santa Maria presso San Satiro, 189, *fig.
 229*
Miletus, Asia Minor: great gate from the
 South Agora, 34, *fig. 30*
Millet, Jean-François, 351
Milton, John: *Paradise Lost*, 263
Minimal art, 433
Minoan art, 21
Minos, king of Crete, 21
Mirandola, Pico della, 180
Miró, Joan: *Composition*, 408, *fig. 511*
Mobile sculpture, 421
Moholy-Nagy, Laszlo, 414

Moissac Abbey, France: Church of St. Peter, 89, 96, *figs. 96, 110*; *De Bello Judaico*, 89, *fig. 97*
Molière, Jean-Baptiste, 264
Monasticism: early, 67, 69; in Carolingian period, 74–75; Romanesque, 85, 91
Mondrian, Piet, 412, 419; *Composition*, 412, *fig. 519*; *Façade*, 412, *fig. 518*; *Horizontal Tree*, 412, *fig. 517*
Monet, Claude, 353, **355,** 365; in England, 356; late style, 360; compared to Winslow Homer, 363; compared to van Gogh, 369; *Impression, Sunrise*, 356; *La Grenouillère*, 355, *fig. 433*; *Rouen Cathedral*, 360, *fig. 441*; *Terrace at Sainte-Adresse*, 355, *fig. 434*
Montefeltro, Federigo da, 167, 172, 188, *fig. 165*
Moore, Henry, 423; *Interior-Exterior Reclining Figure*, 423, *fig. 538*
More, Sir Thomas, 212
Moreau, Gustave, **368,** 385; *The Apparition*, 368, *fig. 455*
Morisot, Berthe, 356; *The Cradle*, 356, *fig. 437*
Morris, William, 373–4; Kelmscott Press, 377; influence on Deutscher Werkbund, 403; wallpaper, 374, *fig. 463*
Mozart, 278, 283
Munch, Edvard, **376,** 386; *The Scream*, 376, *fig. 470*
Mycenae, 21, 22
Mycerinus, Egyptian pharoah, 17, *fig. 10*

N

Napoleon I, 307
Napoleon III: coup d'état, 332, 351; and Second Empire style, 339; marriage, 348; Salon des Refusés, 348–9
Napoleonic Wars, 303
Naram-Sin, Akkadian king, 18
Naumburg cathedral: choir screen, 120, *fig. 145*
Neoclassical movement, 291, 293–4, 339
Neoclassicism: and nineteenth-century sculpture, 303; and David, 305; admired by Napoleon I, 307; opposed by Delacroix, 309; and art academies, 332;

attacked in twentieth century, 333
Neo-Palladianism, 268, 269, 283; and Robert Adam, p. 294–95
Neo-Plasticism, **412–13,** 419, 427–8
Neoplatonism, 44–5; and Christianity, 56, 79, 97–100; in Medici Florence, 180–1, 182; influence on Michelangelo, 193–4, 200
Nervi, Pier Luigi, 425; Palazzetto dello Sport, Rome, 425, *fig. 543*
Netherlands. *See* Holland
Nevelson, Louise, 429; *Total Obscurity*, 429, *fig. 549*
Newton, Sir Isaac, 253, 278
New York City: Grand Central Station, 339; Guggenheim Museum, 425, *fig. 542*; Pennsylvania Station, 339
Noland, Kenneth, 428–9, 432; *Mach II*, 428–9, *fig. 550*
Nolde, Emil, 386; *The Last Supper*, 386, *fig. 478*
Normans: settle in Normandy, 79; conquer England, 84, 94; conquer Byzantine territory in southern Italy and Sicily, 84
Northumbria, Anglo-Saxon kingdom, 72–3

O

Odoacer, barbarian king, 51, 60
Op Art, 428
Orders: Greek usage, 26, 34, *fig. 17*; Roman, 41, *fig. 32*; Alberti's use of, 162–3
Orvieto cathedral: façade, 128, *figs. 155, 158*
Ossian. *See* MacPherson
Osterley Park, 284
Ostrogoth Cloak Pin, 63, *fig. 69*
Otto I, German emperor, 80
Otto II, German emperor, 80
Otto III, German emperor, 77, 82; his Gospel Book, 83, *fig. 88*
Ovid: *Fasti*, 181; *Metamorphoses*, 182

P

Pacioli, Luca, 167, 188
Padua: Arena chapel frescoes, *see* Giotto; equestrian statue of Gattamelata, *see* Donatello; Eremitani Chapel frescoes, *see* Mantegna
Paestum,: Temple of Athena, 26, *fig. 19*

Palaces. *See* Blenheim, Florence, Fontainebleau, Mantua, Urbino
Palaeolithic art, 16, *fig. 9*
Palladio, Andrea, **229–31,** 239; influence on Inigo Jones, 268; Basilica, Vicenza, 229, *fig. 283*; San Giorgio Maggiore, Venice, 229–31, *fig. 280*; Villa Rotondo, **229,** 283, *fig. 282*
Pantheism: and Dutch Baroque landscape painting, 259; and Romantic landscape painting, 316; and transcendental philosophy, 324
Paradise gardens, 40–1, 123, 133
Paray-le-Monial: church of the Sacre Coeur, 91–2, *figs. 101, 102*
Paris: Arc de Triomphe, 307, *fig. 387*; Gare de l'Est, 339, *fig. 413*; Hôtel Soubise, 279, *fig. 350*; Notre Dame cathedral, *fig. 138*; Opera, p. 339, *fig. 414*; St.- Denis 79, 104–8, *figs. 122, 124*; Sainte-Chapelle, 116, *fig. 137*; University of Paris, 103, 113
Parmigianino, 225–228; *Madonna of the Long Neck*, 225–228, *fig. 274*
Parrhasius, 29
Parthenon. *See* Acropolis
Pater, Walter, 203
Patrick, Saint, 67
Paxton, Joseph, 335; Crystal Palace, 335, 336, 425, *fig. 410*
Peloponnesian War, 28, 32
Pepin, father of Charlemagne, 73, 75
Pergamon; 33–4; *Dying Gaul and his Wife*, **33–4,** 43, *fig. 31*; Propylaion of Sanctuary of Athena, **34,** 162, *fig. 29*
Pericles, 29
Perpendicular style, 127, *figs. 152, 153*
Persian Wars, 28
Perspective: in Classical art, 34–5; Duccio, 131; Giotto, 131–2; linear perspective in Early Renaissance, 9, 154, 156; Donatello, 156; Bramante, 189; in landscape painting, 188–9, 244, 259, 261, 263; Constable, 317–18; Manet, 9, 346–8, 350; Cézanne, 372; van Gogh, 372; Fauves, 382–5; Picasso, 389; linear perspective in Abstract art, 417

Perugino, Pietro, 183–4, 187;
 Christ's Presentation of the Keys to St. Peter,
 183–4, *fig. 225*;
 Marriage of the Virgin, 184, *fig. 226*
Petrarch, 131
Pevsner, Antoine, 413
Pheidias, 30
Philip, king of Macedon, 32
Philip II, king of Spain, 237
Philip the Bold, Duke of Burgundy, 140
Philip the Fair, king of France, 122–3
Philip the Good, Duke of Burgundy, 140,
 144
Phoenicia, 22
Photography, influence of: on Turner,
 321;
 on Courbet, 345, 346, 432;
 on Manet, 346;
 on Corot, 353;
 on Super Realism, 432
Picaresque literature, 254–6
Picasso, Pablo, 388, 389, 393, 409;
 Girl Before a Mirror, 409, *fig. 515*;
 Guernica, 409, *fig. 514*;
 Les Demoiselles d'Avignon, 389, *fig. 484*;
 Still-Life with Chair Caning, 393, *fig. 487*;
 Still-Life with Fruit Dish, 389, *fig. 482*;
 Violin and Bottle on a Table, 393, *fig. 488*
Picaud, Aimery, *The Pilgrim's Guide*, 86,
 88–9, 94
Pienza, Italy, 165
Pierfrancesco, Lorenzo di, 180
Piero della Francesca, 165, **167–70**, 178;
 and Alberti, 165, 168;
 and Luca Pacioli, 167, 188;
 and van der Weyden, 169;
 compared to Vermeer, 260;
 compared to Mondrian and
 Neo-Plasticism, 412;
 Federigo da Montefeltro, 169–70, *fig. 207*;
 Finding of the True Cross, 169, *fig. 208*;
 Flagellation, 168, *fig. 209*
Pietà, German, 123, *fig. 148*
Pilgrim's Guide, 86, 94
Piranesi, Giovanni Battista, **289**, 313; *View
 of Rome*, 'Baths of Caracalla', 289, *fig. 362*
Pisano, Giovanni, 127;
 Pisa cathedral pulpit, 127, *fig. 157*
Pisano, Nicola, 120, 127;
 Pisa baptistery pulpit, 120, *fig. 146*;
 Siena cathedral pulpit, 120, *fig. 147*
Plantagenet dynasty, 119
Pissarro, Camille, 356;
 Lower Norwood Under Snow, 356, *fig. 436*
Pius II, Pope, 165
Plato, 28;
 and Neoplatonism, 45;
 influence on Scholastic philosophy, 113;

Symposium, 182
Pliny the Elder, 28–9, 433
Plotinus, 44–5, *fig. 45*
Poe, Edgar Allan, 324, 365
Pointed arch, 91, 108
Pointillism, 360
Poitiers, baptistery of St. John, **64**, 67,
 fig. 67
Pollaiuolo, Antonio, 182–3;
 Battle of the Ten Naked Men, 182, *fig.
 221*;
 Daphne and Apollo, 182, *fig. 220*;
 Hercules and Antaeus, **182–3**, 225, *fig. 224*
Pollock, Jackson, **419–20**, 428;
 Number I, 420, *fig. 532*
Pompeii: mural of *The Three Graces*, 35–6,
 fig. 33;
 excavations in the eighteenth century,
 291
Pontigny: abbey church, 104, *fig. 120*
Pontormo, Jacopo: *Deposition*, 22, *fig. 272*
Pop art, 429–32
Pope, Alexander, 278, 285;
 The Rape of the Lock, 283;
 garden at Twickenham, 284;
 Epistle to Lord Burlington, 284
Pope and Sons: design for a Gothic
 engine, 335, *fig. 411*
Popes. *See* Alexander, Boniface, Clement,
 Gregory, Julius, Leo, Pius, Stephen,
 Urban
Porta, Giacomo della, 229, 246;
 Il Gesù, façade, 229, *fig. 279*
Portinari, Tommaso, 173
Portrait painting, 144, 169–70;
 in the High Renaissance, 203–4,
 217–18;
 Mannerist, 219–20, 225;
 Baroque, 256, 257–9;
 English School, pp. 285, 297–300
Portrait of a Girl in Red, 324, *fig. 402*
Portrait of Hesy-ra, 18, *fig. 12*
Post-Impressionism, 360, **369–73**
Post-Painterly Abstraction, 428–9
Pound, Ezra, 397–8
Poussin, Nicolas, 260–1, 263–4, 301;
 and Louis XIV, 264;
 influence on French painting, 280, 305,
 311;
 Arcadian Shepherds, 1630, 261, *fig. 330*;
 Arcadian Shepherds, 1655, 261, *fig. 333*;
 Ashes of Phocion collected by his Wife,
 261, *fig. 331*
Prandtauer, Jacob: Melk Abbey church,
 285–8, *fig. 360*
Praxiteles, 11–12, 28, 32–3;
 and Baroque art, 241;
 Aphrodite of Cnidas, 33, 234, *fig. 28*;

Hermes with the Infant Dionysus, 11,
 12, 28, 32, *fig. 2*;
 compared to Leonardo, 189;
 compared to Matisse, 385
Pre-Raphaelites, **341–2**, 334;
 and the Symbolists, 366;
 and the Arts and Crafts movement, 373
Price, Uvedale, 289
Primaticcio, Francesco, 232, 293;
 Château of Fontainebleau: bedroom of
 the Duchesse d'Étampes, 232, *fig. 287*;
 Grotte des Pins, 232, *fig. 285*
Primitive art, influence on Modern art,
 389
Proclus, Neoplatonist philosopher, 58
Protagoras, 148
Psalters. *See* Saint Louis's Psalter, Utrecht
 Psalter
'Pseudo-Dionysius': places Neoplatonism
 in Christian framework, 56;
 translated by John Scotus Erigna, 79;
 influence on Romanesque art, 98;
 influence on Abbot Suger, 106
Ptolemaic universe, 249
Pucelle, Jean, 133–4;
 Petites Heures of Jeanne d'Evreux,
 133–4, *fig. 165*
Pugin, Augustus Welby, 340
Punic Wars, 39
Pyramids, Egyptian, 21
Pythagoras, 109

R

Radcliffe, Ann, 290
Raphael, 149, 167, 196
 compared to Perugino, 184, 187;
 and Bramante, 197–200;
 and High Renaissance portraiture,
 201–3;
 influence on Mannerism, 204, 219;
 compared to Giulio Romano, 220;
 compared to Nicholas Hilliard, 236;
 and Baroque art, 241;
 cartoons for Whitehall tapestries, 268;
 and Manet's *Déjeuner sur l'Herbe*, 349;
 Betrothal of the Virgin, **187**, 197, *fig. 227*;
 Madonna della Sedia, 201–3, *fig. 242*;
 Nymph Galatea, **204**, 220, *fig. 244*;
 Pope Leo X with two Cardinals, 203
 fig. 243;
 School of Athens, **197–200**, 216, *fig. 239*
Racine, Jean, 264
Rauschenberg, Robert, 429;
 Bed, 429, *fig. 546*
Ravenna: capital of Western Empire,
 53–7;
 part of Papal States, 73;

Mausoleum of Galla Placidia, 53, 64, *fig. 61*;
San Vitale, 56–7, *figs. 62, 64;*
Sant'Apollinare Nuovo, 53, *fig. 63*
Rayonnant style, 116, 124, *fig. 138*
Realism, art movement in nineteenth century, 334, 342, 345;
and sculpture, 361;
and American painting, 361–3, 399
Red-figure style of Greek pottery, 29
Redon, Odilon, 368;
Les Origines, 368, *fig. 456*
Reform Bill of 1832, 332
Reims cathedral, 113, 119
Reitveld, Gerrit, 412–13, 414;
Schroeder House, 412–13, *fig. 520*
Rembrandt, 257–9;
Belshazzar's Feast, 257, *fig. 322;*
Night Watch, 257–9, *fig. 327;*
Self-Portrait, 259, *fig. 329*
Renoir, Auguste, 355–6, 360;
Dancing at the Moulin de la Galette, 355–6, *fig. 440;*
La Grenouillère, 355, *fig. 435*
Revett, Nicholas, 291
Revolution. *See* American Revolution, French Revolution, Glorious Revolution, Industrian Revolution, July Revolution, Russian Revolution
Reynolds, Sir Joshua, 278, **297–300**;
and English portrait painting, 285, 294;
on art and the imagination, 311;
Hon. Augustus Keppel, 297, *fig. 376;*
'*Perdita*' *Robinson*, 297–300, *fig. 378*
Rib-vault, 100, *fig. 39; see* Vaulting
Richard II, king of England, 134
Rimini: Tempio Malatestiano, 164, *fig. 200*
Rococo style, 279–85;
and Neoclassicism, 293–4;
and Robert Adam, 294;
and William Morris, 374
Rodin, Auguste, **361,** 385;
Age of Bronze, 361, *fig. 446;*
Crouching Woman, 361, *fig. 448*
Roland, hero of *Song of Roland*, 61
Rollo the Norman, 79
Roman Empire: established, 39;
and the arts, 40;
divided, 45;
collapse, 51, 60
Roman Republic, 39
Rome: sacked by Huns, 51;
sacked by German troops, 218, 228, 229;
Ara Pacis, 40, *figs. 34, 35;*
Arch of Constantine, 47, *figs. 46, 48;*
model for Alberti's tempio in Rimini,

164;
model for Adam's south front, Kedleston Hall, 296;
Capitoline Square, 223, *fig. 267;*
Catacomb of Domitilla, 44, *figs. 44, 47;*
Catacomb of Priscilla, 45, *fig. 49;*
Colosseum, 41–2, *fig. 38;*
Column of Marcus Aurelius, 43, *fig. 43;*
Il Gesù, 228, 229, *figs. 278, 316;*
Palazzetto dello Sport, 425, *fig. 543;*
Pantheon, 42, *fig. 36;*
St Peter's Basilica:
Constantinian church, 48, *fig. 50;*
Renaissance church, 196–7, 223, 246, *fig. 306;*
San Carlo alle Quattro Fontane, 249, *figs. 314, 315;*
Santa Costanza, 48–49, *Figs. 8, 51, 52;*
Santa Maria Maggiore, 51–52, *figs. 54, 58;*
Santa Sabina, 52, *fig. 57;*
Santa Susanna, 246, *fig. 305;*
Trajan's Column, 40 *fig. 40*
Romulus Augustulus, 51, 60
Rosa, Salvator, 289
Rossetti, Dante Gabriel, **366,** 374, 377;
Beata Beatrix, 366, *fig. 454*
Rosso Fiorentino, **222,** 232;
Descent from the Cross, 222, *fig. 271*
Rothko, Mark, 420–1;
Sassrom, 420–1, *fig. 535*
Rouen: Gothic houses, 136, *fig. 169;*
St. Maclou, *fig. 154*
Rousseau, Henri (Le Douanier), 369, 373;
included in *Blue Rider Almanac*, 388;
influence on Dada, 405;
The Dream, 373, *fig. 461*
Rousseau, Theodore, **351,** 363;
Edge of the Forest, 351, *fig. 428*
Royal Academy of Art; founding and early exhibitions, 277;
and Reynolds, 297;
and Turner, 311;
and Constable, 317;
Turner and varnishing days, 323;
Benjamin West as president, 324
Rubens, Peter Paul, 243, **252–3;**
paints life of Marie de' Medici, 253;
influence on Velazquez, 256;
influence on Flemish painting, 257;
compared to Rembrandt, 257;
and landscape painting, 259–60;
influence on Poussin, 261;
influence on Watteau, 280;
influence on Reynolds, 297;
compared to Stubbs, 300;

compared to Delacroix, 309;
Landscape with the Château of Steen, 259–60, *fig. 326;*
Lion and Tiger Hunt, 252–3, *fig. 318;*
Whitehall Banqueting House ceiling, 268, *fig. 319*
Ruisdael, Jacob van, 260, 317;
The Wheatfield, 260, *fig. 332*
Ruskin, John: defends Turner, 320;
on Constable, 323;
and the Gothic Revival, 340–1;
on the Crystal Palace, 340;
influence on Morris and the Arts and Crafts movement, 373
Russian Revolution, 413
Ryder, Albert Pinkham, 364;
Toilers of the Sea, 364, *fig. 452*

S

Saint Louis's Psalter, 117, *fig. 139*
Saints. *See under their personal names*
Salisbury cathedral, 91
Salon des Refusés, 332, **348–50,** 355
San Callisto Bible, 79, *fig. 87*
Sand, George, 351
Sangallo, Giuliano da, 196
Sansovino, Andrea, 194
Sansovino, Jacopo, 228, 229;
Library, Venice, 229, *fig. 281*
Saqqara, 18
Sarcophagus of Bishop Agilbert, 67, *fig. 71;*
of Junius Bassius, 49, *fig. 55;*
of Stilicho. 51, *fig. 53*
Sartre, Jean-Paul, 419
Sassetta, **158–59,** 167;
Saint Francis Giving His Cloak to a Poor Knight, 158–9, *fig. 190*
Scenes from the New Testament, ivory panel from Henry II's *Book of Pericopes*, 80, *fig. 84*
Schism, Great, 123
Schoenburg, Arnold, 388
Scholastic philosophy, 113
Scott, Sir George Gilbert: St. Pancras Hotel and Station, 339, *fig. 415*
Scott, Sir Walter, 290
Second Empire, 351
Second Republic, 351
Seurat, George, **360–1,** 369, 382;
La Grande Jatte, 360–1, *fig. 445*
Severus, Septimius, 43
Sforza, Costanza, 177
Sforza, Gian Galeazzo, 188
Sforza, Lodovico, 188, 192
Shelley, Percy Bysshe, 313
Signac, Paul, 360

Simon, Lady, 323
Sluter, Claus, 140–1; Moses' Well,
 Moses' Well, 140–1, *fig. 175*
Smith, David, 423;
 Cubi XVIII, 423, *fig. 537*
Society of Jesus (Jesuit Order), 228
Socrates, 28
Souillac: Church of Sainte Marie, *Isaiah*,
 94, 96, *fig. 107*
Sparta, 32
Spinoza, 259
Stained glass: used by Suger, 106;
 in high Gothic cathedrals, 110, 112,
 116; *figs. 127, 136*
 and tracery, 116–17, 124;
 and late Gothic technology, 124
Stein, Gertrude and Leo, 385
Stella, Frank, 428–9
Stephen II, Pope, 73
Stieglitz, Alfred, 399
Stilicho the Vandal, 51;
 his sarcophagus, *fig. 53*
Still-life painting, 259, 280;
 Cubist, 393
Stoic philosophy, 261
Strawberry Hill, Twickenham, 290,
 fig. 364
Stuart, Gilbert, 324–5;
 The Skater, 324–5, *fig. 403*
Stuart, James ('Athenian'), 291
Stubbs, George, 300;
 Lion Attacking a Horse, 300, *fig. 379*
Suger, abbot of St.-Denis, **104–8**, 197
Sullivan, Louis, **377**, 400;
 Wainwright Building, Chicago, 377,
 fig. 473
Super Realism, 432–3
Suprematism, 398
Surrealism. **408–9,** 433
Suvero, Mark di, 423;
 X-Delta, 423, *fig. 539*
Swäbisch Gmünd: Church of the Holy
 Cross, 127, *fig. 156*
Symbolist movement, 366–9, 374–6;
 influence on Modern art, 381
Synod of Whitby, 69, 72

T

Talman, William: Chatsworth House,
 273, *fig. 346*
Teresa of Avila, Saint, 242, 249
Terracotta Vase, Minoan, 21, *fig. 13*
Thackeray, William Makepeace, 323
Theodemir, Spanish bishop, 86
Theoderic, Ostrogoth king, 53–4, 63
Theodosius, Roman emperor, 51
Thirty Years War, 242, 254, 285

Thomas Aquinas, Saint, 113
Thomson, James: *The Seasons*, 294, 312
Thornhill, Sir James, **273,** 284;
 Sabine Room, Chatsworth House, 273,
 fig. 348
Three Graces, from Pompeii, 34–6,
 fig. 33;
 compared to Botticelli, 181;
 to Jan Toorop, 376
Three Women at the Sepulcre and the
 Ascension, ivory panel, 51, *fig. 56*
Tiepolo, Giovanni, 288;
 Kaisersaal, Würzburg Residenz, 288,
 fig. 361
Tintoretto, 321;
 Last Supper, 231, *fig. 282*
Titian, 178, **205–8;**
 influence on Annibale Carracci, 244;
 influence on Poussin, 261;
 influence on Watteau, 280;
 influence on Tiepolo, 288;
 influence on Manet, 350;
 Assumption of the Virgin, **205–8**, 239,
 fig. 250;
 Bacchus and Ariadne, 208, *fig. 249*;
 Venus of Urbino, **205,** 234, *fig. 248*
Tolstoy, Count Leo: *The Death of Ivan
 Illich*, 365
Toorop, Jan 376;
 Three Brides, 376, *fig. 469*
Torrigiano, Pietro, 209
Toulouse: Herod and Salome, from St.
 Etienne, 96, *fig. 114*;
 St. Sernin, 88, 89, *figs. 93, 94, 95*
Toulouse-Lautrec, Henri de, 377
Transcendental philosophy, 324, 364
Trent, Council of, 242
Très Riches Heures. See limbourg brothers
Triforium, 110, 119
Trouville, Normandy, 353
Turner, J.M.W., 304, 311, **320–4;**
 compared to Constable, 320;
 death, 329;
 influence on Impressionism, 356;
 compared to Abstract Expressionists,
 420;
 Rain, Steam and Speed, 323, *fig. 401*;
 Shipwreck, **320,** 333, *fig. 399*;
 Snowstorm, 321, *fig. 400*
Twain, Mark, 363, 399
Twelve-tone music, 381, 388

U

Uccello, Paolo, 159;
 Battle of San Romano, 159, *fig. 197*
Unicorn Tapestries. 209, *fig. 253*
Urban II, Pope, 92

Urban VIII, Pope, 246, 252
Urbino, Italy, 165–8, 169;
 Ducal Palace: courtyard, 165–7, 168,
 fig. 203;
 studiolo, 167, 178, 217, *fig. 201*
Utrecht Psalter, 78, *fig. 80*

V

Vanbrugh, Sir John, 271–3, 289;
 Blenheim Palace, pp. 271–3, *figs. 345,
 347*
Van der Goes, Hugo. *See* Goes
Van der Weyden, Rogier. *See* Weyden
Van Doesburg, Theo. *See* Doesburg.
Van Dyck, Sir Anthony. *See* Dyck
Van Eyck, Jan and Hubert. *See* Eyck
Van Gogh, Vincent. *See* Gogh
Vasarely, Victor, 428;
 Mach C, 428, *fig. 547*
Vasari, Giorgio: *Lives of the Painters*, 224;
 on Masaccio, 157;
 on Piero della Francesca, 169;
 on Mantegna, 170;
 on Raphael, 201;
 on Giulio Romano, 220;
 Academy of Design, 224, 239;
 influence on Neoclassicism, 309
Vatican Virgil, 49, 52, *fig. 59*
Vaulting: techniques, 41, 74, *fig. 39*;
 barrel-vaulting, 87, 88, 89;
 rib-vaulting, 100–1, 108;
 late Gothic, 124, 127
Vaux le Vicomte, 296
Velázquez, **256**:
 and the Spanish Golden Age, 254;
 compared to Vermeer, 260;
 influence on Manet, 348;
 influence on Eakins, 364;
 and Francis Bacon, 421;
 Drinkers, **256,** 342, *fig. 323*;
 Juan de Pareja, 256, *fig. 320*;
 Las Meniñas, 256, *fig. 321*
Veneziano, Domenico, **161**, 167;
 Saint Lucy Altarpiece, 161, *fig. 198*
Venice, 102, 177;
 Doge's Palace, 299;
 Library, 299, *fig. 281*;
 St. Mark's Cathedral, **89, 91,** 177, 229,
 fig. 98;
 San Giorgio Maggiore, 229–31, *fig. 280*
Verlaine, Paul, 366
Vermeer, Johannes, **260,** 412;
 Young Woman with a Water Jug, 260,
 fig. 334
Veronese, Paolo, 228;
 Feast in the House of Levi, 228, *fig. 276*
Verrocchio, **183,** 187;

Bartolommeo Colleoni, 183, *fig. 223*;
 David, 183, *fig. 222*
Versailles Palace, **264–5**, 268, 271,
 figs. 336, 337
Vesuvius, 291
Vézelay: Church of the Madeleine,
 narthex tympanum, 97–8, *fig. 116*;
 nave vaulting, 100, *fig. 117*
Vicenza: Basilica, 229, *fig. 283*;
 Villa Rotondo, 229, *fig. 282*
Victory Stele of King Naram-Sin, **18**, 24,
 fig. 11
Vignola, Giacomo, 228, 229, 239;
 Il Gesù, 228, 229, *figs. 278–279*
Villard de Honnecourt: *Notebooks*, 114,
 figs. 132, 133
Virgil. *See* Vatican Virgil
Virgin and Child, Lombard statue, 94,
 fig. 108
Visconti, Giangaleazzo, 151
Vitruvius, **41**, 52, **162**, 229, *fig. 196*
Vittorino da Feltre, 172
Vivaldi, 254:
 The Four Seasons, 312–13
Vlaminck, Maurice: *Riverbank at Carrières-
 sur-Seine*, 382–5, *fig. 475*
Voltaire, 278
Vorticism, 398
Vulgate Bible, 49

W

Wagner, Richard, 364, 365
Walpole, Horace, 290;
 Strawberry Hill, 290, *fig. 364*
Warhol, Andy: *Green Coca-Cola Bottles*,
 429, *fig. 551*
Wars of the Roses, 150

Washington D.C.: Capitol building, 339,
 fig. 416
Waterloo, Battle of, 339
Watteau, Antoine, 278, **280**;
 influence on Delacroix, 309;
 influence on Renoir, 360;
 Embarkation for Cythera, 280, *fig. 352*
Webb, Philip: Red House, Bexley Heath,
 374, *fig. 462*
Webern, Anton, 388
Weddell, William, 291
Wells cathedral, 119, *figs. 140, 143*
West, Benjamin, **300**, 305, 324;
 Death of Wolfe, 300, *fig. 381*
Westphalia, Peace of, 256
Westwork, 75
Weyden, Rogier van der, 169, 175;
 Columba Altarpiece, 175, *fig. 214*;
 Saint Luke Painting the Virgin, 169,
 fig. 205
Whistler, James Abbot MacNeill, 349,
 353–5;
 and the Symbolists, 366;
 interior decorating, 374;
 Harmony in Blue and Silver, 353–5,
 fig. 432;
 Peacock Room, 374, *figs. 464, 465*;
 White Girl, 349, *fig. 427*
Whitby, Synod of, 69, 72
White-ground vase painting, 29, *fig. 23*
Whitman, Walt, 363, 399
Wilde, Oscar: *The Picture of Dorian Gray*,
 368–9
William the Conqueror, 84, 94, 101
William of Orange (William III, king of
 England), 254, 268
William of Sens, 119
Wilton Diptych, 134, *fig. 167*

Winchester cathedral: west window,
 fig. 152
Woodcut. *See* Graphic art
Wols (Wolfgang Schülze): *Painting*, 421,
 fig. 553
Wood, John the Younger: Royal
 Crescent, Bath, 296, *fig. 373*
Woolf, Virginia, 397
Wordsworth, William, 304, 312, 313;
 Intimations of Immortality, 304;
 The Prelude, 316;
 and Constable, 303, 316–17, 320
World War I, 402
World War II, 418–19
Wren, Sir Christopher, 269–71,
 St. Paul's Cathedral, 269–71, *figs. 342,
 344*;
 St. Stephen Walbrook, 269, *fig. 341*
Wright, Frank Lloyd, 400, 423, 425;
 and Expressionist architecture, 403;
 and de Stijl, 413;
 Falling Water, 423, *fig. 536*;
 Guggenheim Museum, 425, *fig. 542*;
 Robie House, 400, *figs. 500, 501*
Würzburg, Germany: Bishops' Palace
 (Residenz), 288, *fig. 361*
Wyatt, James: Fonthill Abbey, 290,
 fig. 364

Y, Z

Yeats, William Butler, 54, 382
Yellow Book, 374
Zen Buddhist philosophy: influence on
 Abstract Expressionism, 421
Zeus (or Poseidon) 28, *fig. 22*
Zeuxis, p. 29